EGYPT

BY KURT LANGE
AND MAX HIRMER

PHAIDON

KURT LANGE AND MAX HIRMER

EGYPT

ARCHITECTURE · SCULPTURE · PAINTING
IN THREE THOUSAND YEARS

WITH CONTRIBUTIONS BY
EBERHARD OTTO AND
CHRISTIANE DESROCHES-NOBLECOURT

PHAIDON
LONDON · NEW YORK

ALL RIGHTS RESERVED BY PHAIDON PRESS LTD · 5 CROMWELL PLACE · LONDON SW7
FIRST EDITION 1956
FOURTH EDITION · REVISED AND ENLARGED · 1968

PHAIDON PUBLISHERS INC · NEW YORK
DISTRIBUTORS IN THE UNITED STATES: FREDERICK A. PRAEGER INC
III FOURTH AVENUE · NEW YORK · N.Y. 10003
LIBRARY OF CONGRESS CATALOG CARD NUMBER: 68-12257

FIRST ENGLISH EDITION
TRANSLATED BY R. H. BOOTHROYD
FROM THE ORIGINAL GERMAN EDITION
PUBLISHED BY HIRMER VERLAG · MUNICH

———————

ADDITIONAL MATERIAL IN THE FOURTH
GERMAN EDITION TRANSLATED BY
JUDITH FILSON AND BARBARA TAYLOR

SBN 7148 1349 4

TEXT PRINTED BY LONSDALE & BARTHOLOMEW LTD · LEICESTER
PLATES PRINTED BY KASTNER & CALLWEY · MUNICH
BOUND BY A. W. BAIN AND CO LTD · LONDON

CONTENTS

FOREWORD

THE FACT that it has been possible to publish a fourth edition of this book, after sixty to eighty thousand copies have been sold and after translation into six languages, has been due to the friendly reception accorded it. This has encouraged me to produce it this time with the text and illustrations in a greatly extended and consolidated version.

Thanks to the many new photographs of important works of architecture, sculpture, painting and the goldsmith's art, it has been possible to increase the number of classic works of Egyptian art illustrated in it to a considerable extent. These have greatly enriched and widened the scope of this review of the three thousand years during which ancient Egypt produced its masterpieces of art. The number of coloured plates has been increased to three times that included in the previous three editions, and these now offer a truly comprehensive impression of the use and importance of colour in the sphere of individual Egyptian arts.

The text of the book has been completely revised and very considerably enlarged. The descriptive section following the plates, which was placed under the general direction of Dr. Eberhard Otto, Professor of Egyptology at the University of Heidelberg, opens with an important contribution on the gods and temples of ancient Egypt. Based on the most authoritative sources, this article contains all that is essential concerning the world of the many gods of ancient Egypt, their appearance in many forms and their cults. From this survey a clear picture emerges of the structure of Egyptian religion as such.

In the last part of the book, where the works of art are described, more space than formerly has been given to historical summaries in the chapters dealing with the successive periods. History, together with religion, forms the background for the creation of all works of art, and its study is necessary in order that they may be understood. In particular the period of the empire is examined, its political history, its social history and the history of its art. I wrote all these sections in close collaboration with Professor Eberhard Otto and they are in line with his books *Ägypten, der Weg des Pharaonenreiches* and *Osiris und Amun*, and I owed a great deal to a continual interchange of ideas with this great scholar. The main works of literature, such as the texts of the Stela of Tuthmosis III, the sun-hymn of Akhnaton, the Qadesh Poem in praise of Ramesses II and his heroism, and the charming report of the progress of the Hittite princess coming to Egypt as a bride, in the so-called Marriage Stela, together with the smaller poetic texts from the tombs and the songs, provide a glimpse into the thought of the period.

As far as sculpture and painting are concerned, the interpretation of individual works of art illustrated in the book is still based partly on the work of the late Kurt Lange in the first three editions. As a whole the scope of the previous editions has been greatly enlarged and related to the history of art, and Professor Otto has undertaken the task of describing the bulk of the works of art which have been added. Not the least important alteration in the book has been the considerably greater space allocated to the different periods, many of which were dealt with too briefly in the previous editions, such as the Twelfth Dynasty of the Middle Kingdom, the brilliant period of artistic creation in the reign of Amenophis III, who has often been compared with Lorenzo il Magnifico, and the period of Akhnaton and Tutankhamun. To this has been added a really thorough analysis of the Ramesside temples, those colossal buildings which confront the amazed traveller on his journeys through Upper Egypt. Finally, space has been made for a more comprehensive and extended picture of the Ptolemaic series of temples, the last great achievement of antiquity on Egyptian soil. In the field of sculpture and painting in particular, as seen in the context of the history of art, I hope I may be forgiven if many of the ideas have been adapted from the book by Professor Walther Wolf, *Die Kunst Ägyptens*, as this important work has been my constant and treasured companion on my journeyings through Egypt and in my studies of Egyptian art.

It was obvious that the book must end with a special chapter on Nubia, appearing as it is at a time when there has been so much discussion of the threat to the Nubian temples and of their rescue. It is an honour that the text of this chapter should have been undertaken by Madame Christiane Desroches-Noblecourt, Conservateur en chef des Musées Nationaux au Département des Antiquités Egyptiennes, Paris, who surveyed the temples of Nubia in constant collaboration with the Egyptian Department of Antiquities and who has made them her special concern.

I should like to thank the leading authorities of the Egyptian Department of Antiquities for enabling me to take the photographs for this book, on three lengthy journeys through Egypt. For all the assistance and friendly help given me since 1954 I should like to express my thanks to: the late Dr. Mohamed Mahdi Ibrahim, former Director-General of the Department of Antiquities in Cairo; Dr. Abd-El-Hafiz Abd-El-Aal, Chief Inspector for Upper Egypt; Dr. Yacoub Farah, Inspector of Ancient Buildings in Luxor and Karnak; Dr. Ramadan, Inspector of the Theban Necropolis; and once more to Dr. Jean-Philippe Lauer, who is in charge of works on behalf of the Antiquities Service at Saqqâra. It is a pleasing task for me to discharge my obligations by expressing my very warmest thanks to my friend Dr. Labib Habachi, formerly of the Antiquities Service, for all the co-operation he has given me in my work during the last twelve years and for his constant readiness to help.

The new photographs have been made in close collaboration with my son Albert Hirmer and my daughter Irmgard Hirmer, photographer in the photographic department of the Hirmer Verlag. Both deserve my warmest thanks for their great help and constant willingness to undertake more work: and this applies no less to Frau Julia Petzi-Asen, who took the photographs on my first Egyptian journey with equally great skill and artistic sensibility. I should also like to thank Frau Angelika Bauer-Asen for her careful work on the preparation of the illustrations.

MAX HIRMER

INTRODUCTION

LIFE begins with fear of the unknown and, if it has been thoughtfully lived, ends with acknowledgement and self-restraint. That is true both of individuals and of the great civilizations produced by mankind. Many peoples seem to be called, but only a few are chosen to influence by the example of their achievements whole continents and periods.

The number of highly civilized peoples which, after an early rejection of barbaric elements, have contrived to develop a systematic style coinciding with the richest and purest possibilities of human endeavour is smaller than is generally supposed. As a rule they are river-valley civilizations, created by the periodical floods of rivers on the banks of which men settled and cultivated the fields. The most praiseworthy among them seem to us to be those who, owing nothing to preceding civilizations, achieved self-realization thanks to the wealth of their own talents and, without perceptible assistance, achieved the zenith of culture, thereby laying the foundations of further progress. Such seem to us the Sumerian, Chinese and Egyptian civilizations—original sources of human development which started from the primitive organization of early mankind and after an intense fulfilment of the possibilities open to them achieved a spiritual universality the influence of which continues to this day.

Simplified by the distance from which we view it, the great drama of Egyptian civilization, more than any other, gives us an idea of the life of a creative people, with all the ups and downs inherent in the course of its destiny.

It may be due to the consequentiality and concentration of Egyptian style that the attitude of posterity towards ancient Egypt has wavered between under- and over-valuation. That is true even today and it is noteworthy that even scholars cannot always free themselves from such suggestions.

The susceptible mind may go so far as to see in Egypt's achievement—to use Heinrich Schäfer's words—'the ultimate aim, already once achieved, but then unhappily lost again'. To many others the prevailing impression is that of an inability, doubly evident in many of its achievements and frankly incomprehensible, to free itself from the fetters of archaicism and to achieve free, progressive forms in all fields. One man sees on the banks of the Nile every phase of human development already experienced and thus anticipated as a grandiose and instructive example. Another, instead of this, sees a complacent persistence of inadequate elements in the attitude to religion, the practice of art, the progress of thought and the exercise of power—and even in the unquestionably great realization of the State he will see nothing but unalloyed despotism and the dictatorship of priests. He will agree with the saying that the Egyptians did not know how to make use of their greatest spiritual treasures. How penetratingly did Hegel in his philosophy of history explain the essence and will of Egypt—and how strangely biased and in the main supercilious is the usually cautious Jacob Burckhardt in his attitude to the Egyptian world.

This fantastically concentrated, peculiar and intransmissible civilization demands partisanship in the attitude of others towards it—either 'for me' or 'against me'. It is rarely that one comes across a sober valuation of its quality—without fantastic subtilization or extravagant enthusiasm, but also without

predominance of inner conflicts of feeling. This is probably because, according to our way of thinking, the Egyptians lack the ability to meet half-way, approachability, a readiness to listen. The severity of their attitude is not inviting. They admit no compromises. One has to adapt oneself to their sphere as well or as badly as one can, one must try to feel like an Egyptian, if one wishes to avoid distorted judgements. One must know how to grope one's way backward from the spatial conceptions of the Greeks to the magical and tranquil disposition on the surface and try to recover the obvious, ideal reality of the image with which these men, still childish despite all the variety, mastered the incomprehensible and the feasible. He who is not prepared to do this will never understand the substance of Egypt. He will be attracted by the aesthetic charm of many works, but it must be quite clear to him that in this way the core will never be revealed to his understanding. Everything Egyptian, wherever it may be, has its own atmosphere around it. Few manifestations have contrived to assert themselves for so long.

Since French fortification-works on the coast of the Nile Delta in 1799 brought to light, by pure chance, the 'Rosetta Stone', thereby discovering an important key to the deciphering of everyday Egyptian writing, further exploration has laid before our eyes an almost overwhelming abundance of the most varied materials. This material proves that no other people in the world had such a faculty, such a fixation for the production of images. Even in ancient times numerous Egyptian monuments were taken away to Rome, to Byzantium and other places, while in every civilized country most of the museums and many private collections have acquired treasures of pharaonic art; yet the number of works, large and small, still in their country of origin is incalculable. Scholars are busy sifting and evaluating the discoveries of archaeologists and philologists and drawing conclusions of deep import therefrom, while stylistic criticism is also gradually coming to maturity. Opinions are becoming more and more sharply defined. More clearly than ever before, the investigations of the past years are throwing light on the specific structure of Egyptian things.

Has the extension of knowledge confirmed the evaluation or merely altered it?

Do we see the pharaonic period with its increasingly evident transformations in another light than that in which it appeared to the pioneer Egyptologists fifty or a hundred years ago? And if that is the case, is the explanation perhaps that we are projecting our own essence and will into the unfathomable mystery of ancient Egypt? Can we of today ever penetrate to the core of the nature of an age-old creative community with a way of thinking foreign to us, based on another form of human life and drawing inspiration from a different milieu? In our efforts to know, to explain and to feel ourselves corroborated, are we not attempting to grasp a mirage?

Every seeker after knowledge is bound to ask himself such questions before he turns to the sources.

These sources are not always easy to apprehend. What do we learn when we examine them?

It is inspiring and instructive to study, with the aid of the various objects found in prehistoric Egyptian tombs, the way in which the essential Egyptian element developed its language of imagery, at first hesitantly, and then by gradual stages ever more clearly towards a definite aim.

It is common knowledge that the original naïve form-renderings of all peoples resembled one another so closely that in the absence of any indication of their origin even an expert cannot assign them with certainty to definite regions. Like ancient Greece, Egypt is no exception in this respect.

Curiously enough the most artistically gifted peoples show in their early years the fewest traces of their ultimate development. The little human figures from the predynastic period found in the Nile Valley reveal a marked variety: on the one hand we find a primitive carelessness, on the other hand a rigid adherence to a formal world of their own, by means either of naturalistic representation, or of a geometrical compression. But only in exceptional cases are we reminded of anything typically Egyptian. The most arbitrary expression of whims and chance is naturally found in the oldest plastic experiments in Nile mud and clay. The motive is grasped in a drastic manner and often very effectively, but in the construction there is no trace of law and order. If the material chosen is stone, it seems as if the very qualities of the material had guided the hand in a given direction: both human figures and animals are rendered with more decision. Neolithic figures of game animals in flint and flat palettes of hard greyish-green slate carved in the form of animals have a special place of their own. In them the outlines begin to speak a firmer language.

These so-called cosmetic palettes give a wonderfully complete picture of the beginning and development of methodical principles in early Egyptian plastic art. The owners of these palettes, most of which have a hole bored through them to take a string, used them for pulverizing malachite and other materials in order to make eye-paint. Towards the end of the early period their surfaces were filled with semi-plastic ornament. Their size and the extent of the decoration on the finest specimens show clearly that they were not intended for ordinary, everyday use. A small pan in the middle of the figure-covered surface is the only reminder of their original purpose, and such spaces rarely show any trace of having been used. Probably they were sacred offerings made by chieftains to local divinities, and they may have played a role in religious ceremonies. Ultimately they developed until they achieved a kind of official character as tablets commemorating victories.

In them we can see all the stages on the way leading from barbarism to civilization: the rejection of the uncouth, the conquest of the fear of empty spaces in the pictorial plane, the development from a multitude of figures spread incoherently over the surface to a logical division into zones, the first appearance of a co-ordinating idea, the invention of religious or political symbols which from then on became current, the stressing of some event worthy of commemoration. We can follow the remarkably rapid development of writing from the specifically Egyptian models, perhaps inspired by passing contacts with the Sumerian precedent, but essentially independent. From the deliberately ugly scene on the so-called Battlefield Palette, showing among other things a maned lion—probably symbolizing the victor himself—and numerous birds of prey about to fall upon the nude bodies of fallen enemies, is derived the representation of actual historical episodes on the votive tablets of Kings Scorpion and Narmer. Incarnations of royal power hack down the brick walls of conquered cities, of which the names are given. The slaying, already considered as a symbol, of a vanquished foe held by the hair, the inspection after their execution of the fettered bodies of enemy commanders, whose heads had been laid between their feet, have become state ceremonies, which the lord of the two crowns, barefooted, solemnly performs. Standards are borne before him in the triumphal procession, symbols of the divine powers which confirm his power and vouchsafe him protection, symbols which may at the same time have been provincial emblems connected with the political organization of the country. Thus a household article becomes a historical monument.

The path of this development runs from awkward experiments to a more and more rigorous and solid conception of form. A rigid selection limits the number of types, even down to those of household vessels. Gone is the preference for all kinds of hard stones of varied colour; taste is now restricted to a few sorts of fine stones. The relief becomes shallower, but on the other hand gains in decision. That which in figures of men and animals had hitherto produced a rather feeble effect becomes more tense. In the course of a few generations, the struggle to achieve an ideal pictorial realization, evolved from the observation of Nature, but at the same time side by side with Nature, is brought to a victorious conclusion, that ideal which in the consistency of its development according to laws of its own is one of Egypt's greatest achievements. By a process of gradual clarification and co-ordination of its characteristics, there was established a style more decisive and enduring than any the world has known. And this remarkable feat was achieved during the first two dynasties—approximately between 3000 and 2800 B.C.

We are too ready to consider the development of a style as a natural and inevitable process—one might almost say an arbitrary emanation of the spirit of a people predisposed thereto. In reality it is anything but that; it is a wilful act and an outcome of tension, it is an achievement of the conscience, of an exhausting intensity which cannot be maintained for long. And last but not least it is a determination to renounce. How short-lived, how uncertain is every creation of a standard, involved in a desperate struggle against the ever-present tendency towards sluggish approximation! What a high degree of youthful determination must have been required to build that autonomous world of artistic expression which was to be the basic framework for every expression of Egypt's national spirit for three and a half thousand years!

This development of its own 'essential reality' in drawing and relief has its parallel in architecture.

Here the path of development runs from the use of lumps of mud for building to that of rectangular, sun-dried bricks of Nile mud and finally to the great blocks of stone and thus to the lasting achievement of the artistically conceived monumental stone building. It had as its premise the ground-plan, and that in itself was a spiritual achievement in method of the highest order. The name and work of that man who, by order of his king, used the newly discovered materials to erect the first extensive and at the same time artistic complex of stone buildings known to us have been venerated by all succeeding generations and even the Greeks saw in him a god.

Today, on the sandy plateau of the Memphite desert cemetery near the village of Saqqâra, we can still see the gleaming white remains of those buildings which Imhotep erected as an eternal residence for his great king, Zoser: step pyramid and sacred temple, royal pavilion, government buildings, chapels of national divinities and storehouses. Lying in a great rectangle surrounded by a high wall with its bays and projections, and dominated in the centre by the 200-foot high step pyramid, the design of which was altered four times, the whole must have made a deep impression on the men of those days.

The methodical exploration of this area has brought with it one of the greatest surprises in the history of art during our own century: here we find, at the very beginning of the development of architecture, the fluted column, not, it is true, standing free—like the contemporary fasciculated column and the base of the papyrus column—but with one part incorporated with the adjoining wall.

It has no actual pedestal and resembles a plant with a grooved stalk and little leaves hanging down to form a capital at the top. The stone-cutter's work is as perfect as that of the mason who fashioned the blocks and drums out of fine-grained limestone. These fragments have an air of youth and purity. Although in the main it was a question of transferring to stone the forms hitherto used for objects made of other materials—wood in the form of whole trunks, beams and jambs, reeds and wicker-work plastered with clay—the stress is already laid on the language peculiar to stone and the original beauty of the architectural components has a stylistic emphasis which at once lifts it out of the world of imitation. Some elements without which architecture would now be unthinkable had in those days taken definite form as part of a powerful religious idea: column and pier, base and capital, astragal and flute, steps, wall niche and projection. At the same time there makes its first appearance that ornamental façade decoration like a continuous frieze, which henceforward becomes a permanent feature of Egyptian art.

In a chamber built on to the north side of the step pyramid has been found the oldest life-size statue of a king that has come down to us, the seated effigy of Zoser, looking out through two openings in the wall from eyes long robbed of their sparkling inlays, gazing at the complex of buildings erected for his burial. The effigy has its place there as a guarantee of the continued existence of the individual— a permanent body which, representing the deceased but yet filled with the actual powers of his being, offers the necessary corporal abode for his surviving personality (his 'Ka'), should it choose to visit its earthly sphere and accept offerings. It would appear that this idea of death was the origin of the portrait statue, for which the Egyptians had a special feeling. Yet certain statuettes of the first two dynasties found in Upper Egyptian temples give reason to think that there may have been another origin.

From this time on we find named portrait statues both in royal funerary temples and in the upper portions of the tombs of well-to-do private individuals, the statues being placed in inaccessible rooms and usually looking out through slits in the walls on the offerings laid before them, breathing the scent of incense and listening to the ritual prayers for the well-being of the inmates of the tombs. Both the man and his wife are commemorated by statues, sometimes with their children in a family group. To them are added at a later period figures of servants, smaller and less formal effigies of maidservants grinding corn, slaves preparing beer or sealing jars, or serving their master. At the end of the Third Dynasty and during the Fourth, all sculptured figures of members of the royal household, including the so-called reserve heads, have such a marked individual character that they remain in our memory. This in itself is, to a certain extent, an answer to the question, still the subject of lively discussion, whether here we have to do with essentially typical imaginary personages or with portraits reproducing faithfully the originals. Despite all the liberal simplification, at this stage of develop-ment the outstanding feature is the personal character of the faces, and sometimes even of the frames of the bodies. Since the discovery of the astonishing bust of Prince Ankhhaf, there can be no possible doubt that, at least in certain cases, there was a definite striving after lifelikeness. In this connection it is worth remembering that in the pyramid of King Teti near Saqqâra, in rubble two feet above the original floor-level, there was found the undoubtedly old Egyptian mould of a death-mask taken from the face of a young woman. One needs to be very insensitive to art or hidebound by theory if

one cannot perceive that the constant occurrence of personal names on the pedestals or backs of statues might very well be a counterpart to an attempt to portray individual features or the whole personal appearance, always within the limits imposed on all early portraiture. How else could we explain the striking variety of the numerous and famous Old Kingdom portrait statues, which is such that we can give them their names and retain them in our memories? Whether we consider them approachable or not, the fact remains that quite apart from their artistic value we can form a kind of personal friendship with a Rahotep and a Nofret, a Hemiun, Ti, or Ranufer, or with the so-called 'village magistrate', Ka-aper. With all their sublimity, they live in a kind of private sphere and excite our curiosity as to their manner of life, their habits and occupations. With the portrait statues from the neighbouring countries of Hither Asia this is only very rarely the case.

A similar function to that of the statue, storing up its strength in its chamber in the upper part of the tomb, is fulfilled by the reliefs covering the walls of the sacrificial chapel and other apartments in the mausoleum, like a carpet of inexhaustible themes. They and the sculptures in the round pre-suppose one another—there is a relationship of meaning which in a museum can seldom, and even then only partially, be perceived. We tend to regard this magical picture-book with its numerous hieroglyphs as a charming, amusing and instructive panorama of life in an old patriarchal country—and who will grudge this sensation to spectators unhampered by specialist knowledge? But in reality every one of the scenes in these cycles crowded with figures, which Ludwig Curtius has rightly called one of the greatest objective representations of human existence, has a close connection with the offerings to the dead which were made in these rooms. The material needs of the departed are thus assured in a magical way. Should it ever happen that no offerings are made, then the deceased, with his knowledge of magic, can conjure up and make use of everything he needs. He has everything with him for every possible eventuality; not only food, drink, clothing and toilet requisites, but everything necessary for the joys of the chase and for social relaxation. It enhances the significance of these carefully planned and yet unrestrained pictures that room is found in them for amusing and lovable, though useless, things. In spite of its amplitude, the theme—recurring time after time with slight modifications—preserves a strict order, even in the distribution of the single zones and masses. Like the custom, dating from the first dynasties, of using every kind of expedient in order to preserve the corpse, this provision for bodily needs is an expression of that determined affirmation, carried almost to the point of absurdity, of personal existence, which places the religion of Egypt in diametrical contrast with the negation of self in the teachings of Buddha.

In the meantime written characters had taken on their definitive form, which in vividness and clarity remained unsurpassed. One must compare them with the earliest examples on the jar sealings, the cylinder seals, ivory tablets and gravestones of the First Dynasty, in order to realize what an achievement this was. The uncertain outlines and faulty alignment have now been replaced by a noble rigidity, combining the highest degrees of expression with a sober economy in the employment of means. The little pictures which were the basis of Sumerian-Accadian writing and of the cuneiform characters of Hither Asia seem clumsy indeed when compared with the severe calligraphy of these eloquent hieroglyphs.

To the word-sign which alone or in combination with others stands for a consonant, a syllable or

the meaning of a word, and which preserved all its beauty on monuments throughout millennia, whereas in everyday use it tended more and more towards the cursive form, there is now added the significant symbol. This too achieved perfection of form and retained its magical power until the beginnings of Christianity. Indeed, even modern eyes cannot resist the charm of its suggestive significance. Egyptian sculpture has aptly been described as a three-dimensional hieroglyph. Starting with the conventional application of the image on the side of the square block it achieves spatial depth, though it never reaches the high quality of Greek statues. No one can understand the nature of Egyptian sculpture who has not realized this fact—the fact that every work of Egyptian sculpture is fundamentally a written representation, pointing to a higher spiritual relationship, however plastic and corporeal it may seem. It is practically never an aim in itself. And that is why a purely aesthetic valuation will never do full justice to it.

Nowadays no discerning critic will talk of the immutability of the form and manner of Egyptian art. The theory of an archaic rigidity excluding all change has been as thoroughly demolished as the theories of a dictatorship of priests opposed to all progress and the Egyptian incapacity to achieve clarity of thought and rid themselves of 'the ballast of obsolete stages of civilization'. Our knowledge and our ability to understand have become deeper in the course of the last decades. We know now that the impressive continuity of Egyptian civilization, which survived every crisis, was based on that very attachment to what had been sanctioned by usage and proved to be valid, that conservatism condemned by earlier critics as a whim of the Egyptians. At the same time we also know that the constant transformations characteristic of all life and thus also of the life of nations, those transformations which constitute the history of mankind, sometimes took place in Egypt with surprising rapidity and that these often stormy events, so pregnant with consequences, were clearly reflected in the world of Egyptian art. That is particularly true of the early and late Old Kingdom and also of the Middle Kingdom, the importance of which in the history of the human mind cannot be exaggerated. Even under the New Empire, when Egypt was a world power, there were continual changes: one need only think of the changes in the social structure, phase by phase, under the Eighteenth Dynasty and of the difference between the Egyptians of the Nineteenth and Twentieth Dynasties and those of the Eighteenth.

The first mighty achievement due to the combined efforts of the nation was the establishment of the Old Kingdom (c. 2778–2263 B.C.) around Memphis, with its strict social order and astonishing planned economy, which made immense undertakings possible and yet did not sever the individual from his rooted attachment to the soil.

Under Snofru, on whose outstanding figure recent excavations near Dahshûr have thrown further light, and the subsequent rulers of the Fourth Dynasty, of whose lives and doings we unfortunately know little, the genuine, standard type of pyramid was developed. As there are no indications of the presence in Egypt at that time of large numbers of prisoners of war or of the existence of a kind of slavery (the sources, on the contrary, reveal the prevalence of a patriarchal régime), we can only suppose that a youthful and pious people, by building the pyramids, with its hard and enthusiastic work extolled itself as well as its god-kings. Even we of today, accustomed as we are to the wonderful achievements of science, cannot withhold our admiration when we see them—royal tombs of

unequalled dimensions, the definitive form of which must be related to that of the sacred Benben stone in the neighbouring city of the sun, Heliopolis, and thus to the sun-god himself, as the sun-ships discovered in the rocky ground near the pyramids also prove. The idea of the monumental sun-throne coincides with that of the dominating royal tomb. The immortalized king enters once again into the mystical relationship with his father, the sun-god, every time the sun shines on the smooth gleaming sides of the gigantic triangles and rests upon them during its daily course through the heavens, as it did the first time it shone on the mysterious stone monument at Heliopolis.

The royal pyramid dominates the desert plateau and in the same way the might of the god-king dominates the community of the dwellers on the banks of the Nile. The king assigns to each of his subjects a suitable task and in return guarantees his existence. His family, courtiers and functionaries are grouped around him, just as their graves are grouped around his huge monument: a reproduction in stone of the state organization for the visitor of today. So limitless and all-pervading did the might of the incarnate 'Great God' appear to the Egyptians of those days, that no priests ministered to his person during his lifetime and no divine images were needed in the chambers of his tomb. The heedless touching of his emblems might be as lethal as a flash of lightning, if the king did not absolve the unwary with his blessing. When he appeared, there resounded, just as it did when the divine images appeared at festivals, the warning cry: 'Earth, beware! The god is coming!' That, notwithstanding this, the king was not abhorred as an incalculably tyrannical despot, as ignorant generations two thousand years later told the traveller thirsting for knowledge, is proved by the meaning of the proper names of the pyramid period, which attribute to the head of the state all the benevolent virtues of the god—'Cheops has shown mercy', 'Userkaf is friendly', 'Pepi it is who brings peace', 'Merire lives for us', 'Good is the love of a king'. Another proof of the popular regard for the person of the ruler is provided by the Sphinx at Giza—that huge couchant lion with its hooded king's head, gazing towards the sunrise, for all its mutilation and decay the greatest work of sculpture produced by mankind.

As the dynasties and rulers changed, this early form of human social organization and the divine monarchy on whose omnipotence it rested passed through many crises and many periods of tension, until after lasting for fifteen hundred years its mechanism broke down and it outlived itself under the all-too-long rule of a weak monarch.

It would seem that by the end of the Fifth or the beginning of the Sixth Dynasty the rise of individualism had led to a conventionalism which was too perceptibly oppressive.

Before that time there had been no lack of well-defined royal personalities: figures like Zoser and Snofru have all the characteristics of a sharply marked individuality. It would be making the problem too easy if we were to assume that the form of community life prevailing at that time was a kind of collective existence resembling that of insects and governed by impulses. On the contrary an autonomous individualism with definite social aims was beginning to come to the fore among categories which hitherto had been inarticulate. Royal pyramids became smaller and less massive, while the tombs of influential courtiers and landowners became more and more considerable in their dimensions and the number of chambers they contained. Whereas at the beginning sculpture in the service of royalty had achieved a lofty aloofness, it later began to lose ground to the art of the private portrait. There are many other signs that the local princes and vassals were becoming more and more

conscious of their importance and more and more headstrong in opposition to the claims of the crown. Moreover new hostile forces were pressing their way up from below. The provinces, awakening to historical consciousness, began to assert their claims. Finally the order which had lasted so long was shattered by a social catastrophe in which whole classes of the nation threw off the burden of obligations obviously felt to be intolerable, and resorted to violence in order to realize their claims to prosperity and possessions, thereby bringing about a revolution which left country and customs defenceless and brought the underdog to the top. The fury of the mob spared neither royal monuments nor the archives of government buildings, and even the hallowed tombs were not respected. From the cemeteries of the great, blocks of stone were removed and used for the tombs of little men.

As a result a whole world was rent asunder.

It can be taken for certain that no influences from outside brought about this supreme crisis. Before it broke, the Nile Kingdom, so far as we know, had not undertaken any important or lengthy military operations, nor had it been attacked by external enemies. Nor can it have been a question of over-exploitation of the national potential by indulging in vast building plans: the period of huge pyramids was a thing of the past. Moreover it is becoming more and more evident 'that this achievement did not imply the enslavement of the nation, but that an equally grandiose system of state-organized planning with a religious base was behind it. There must obviously have been some kind of official obligation to work, which made it possible to mobilize unemployed workers for building projects especially during the flood season, that is to say at a time of year when the transport of building materials, which in Egypt was always effected by water, was easiest. The provision of work at this season, however, meant economic security for innumerable members of the population, since the work was paid for (accounts relating to work have been preserved).' (E. Otto.)

It must therefore have been the steadily growing disproportion between the inviolable possessions of the economically independent pyramid towns, religious temples and private funerary institutions on the one hand, and the similarly increasing burdens imposed upon the rest of the population and on the country districts directly administered by the state on the other hand, which finally resulted in poverty, famine and serious social dissension. The pretensions of the gods and the departed, which religion recognized as natural and reasonable, became in practice too overwhelming in their totality and jeopardized the existence of large categories of the living. Conversely, every disturbance of the social order imperilled the flow of supplies to the chief centres, which by now had become populous cities. One may therefore say that the course of events in the Egyptian system was inevitably pre-destined and fulfilled itself according to a kind of fatal necessity.

A detailed account of the disturbed conditions at that time has come down to us in the 'Admonitions of Ipu-wer', which one cannot read without emotion and to which Egyptologists in our own time rightly attach a special importance. For a whole century or more the way of life and the practice of art declined, not only in the provinces, but also in the neighbourhood of the old capital, until it reverted to a helplessly primitive stage, and the unfettered impulses reigned triumphant, whereas at the courts of individual local rulers the remnants of the old tradition which remained after the radical upheaval were combined to form a new mode of existence.

The whole process is of great interest to students of the history of the mind. To see in it only an

Egyptian revolution would be to underrate its significance. It was a revolution in the story of human development.

Men learned that what had seemed to be inviolably permanent could be destroyed. They saw that statues of kings could with impunity be reduced to splinters, tombs desecrated, the most sacred monuments of the past destroyed.

Men who previously had felt themselves more or less secure in their bonds lost their innocence and their convictions—those convictions which were based on unthinking faith in the validity of tradition. Once the material impulse was stilled, there arose doubts and heart-searchings. Kings and gods could be destroyed. What had long seemed irremovable, reasonable and seemly, might become the reverse...

People now began to become gradually conscious of the loss of a moral perception which they had previously possessed without knowing it. From now on throughout the ages there resounds more or less clearly, but without ever ceasing completely, the lament that all guarantees against mortality and oblivion are of questionable value. Amidst the joys of feasting and merriment it may suddenly strike a sinister chord; the secret consciousness of the vanity of all efforts to achieve immortality in this world henceforth becomes part of the Egyptian attitude of mind. The soul of ancient Egypt never recovered completely from the shock of this decisive change. There is an echo of it in those harpers' songs inscribed in Theban tombs of the New Empire:

> '*I have heard all that happened to my forefathers—*
>
>
>
> *Their houses have fallen to ruins.*
> *Their market-places are no more.*
> *They are like to a thing that has never been*
> *since the days of the god.*
>
>
>
> *Think not of that day of the "Come!",*
> *until thou goest towards the West as a votary:*
> *lo! what the priests in panthers' skins strew on the ground,*
> *what they place on the table of sacrifice, to what purpose is it?*
> *Celebrate a beautiful day seemingly!*
> *Multiply the good by thy wisdom!*
> *Behold! Fate does not multiply its days,*
> *Time comes at its hour, no more is given . . .*
>
> *No man who has gone away, has ever returned.*'

The form which this consciousness took in the Late Period is vividly described by the Greek historian Herodotus: 'At feasts in the houses of the rich, when they have sat down, a man carries round in a coffin a wooden image of a dead man, which is very naturally painted and fashioned and is usually one or two ells long. He shows it to each guest and says: Look upon this, and then drink and make merry, for when thou art dead, thus wilt thou be! Thus do they do at their feasting.'

With the loss of the age-old belief that divinity and monarchy, sacred images and statues of rulers were inviolable things, began the conception of the responsibility of the individual. Such was the situation at the beginning of the Middle Kingdom. The objectivity of its funerary offerings and the

painful doubt of its laments breathe a profound scepticism. Personal loneliness—a new discovery—is silently expressed in the gravity of its portrait sculpture. It is significant that a long time has still to elapse before this newly acquired experience achieves a mature form in the features of royal statues. The strength of conviction in Old Kingdom portraits was based on a sublime ingenuousness, but the features henceforth are stamped with an inner, highly personal consciousness.

Energetic local kings endeavoured, by extending and consolidating their power, to put a stop to the spread of disorder in the country. The political instinct, gradually regaining strength, tended towards centralization. In opposition to it, the noble families, powerful in their own possessions, defended their privileges, many of which dated from long ago and had been exercised to the benefit of the population, not only in times of distress.

The monarchy ruled the country from Thebes. This hitherto insignificant provincial town became the home and residence of the new dynasty and consequently the capital. The strict and wise régime of the princes of Herakleopolis succumbed to its warlike fury after a hard struggle. Mentuhotep Nebhepetre, whose strong-limbed seated effigies in the funerary temple of his family in western Thebes express his ruthless energy, like Menes before him held both countries in a firm grip. One hundred and fifty years later, the great Sesostris Khakaure completely overcame the provincial princes and made them vassals of the crown. During his reign, the princes abandoned their custom of building imposing and at the same time commodious tombs in the cliffs of the desert plateau along the Nile.

The newly founded state had once again powerful and courageous monarchs. It reunited the areas into which Egypt inevitably splits after every political crisis; purposefully and coherently it organized all the forces of the Nile Valley for all national emergencies, and in particular for defence against foreign invaders. Something resembling a caste of professional soldiers, a royal army relying on the help of the provincial militias, began to form itself. Material civilization flourished, nobler and richer than ever before.

But this kingdom, which held undisputed sway over the country and the people, differed from the Old Kingdom.

It was now a monarchy based on its own strength—it knew that it was vulnerable and transient. It drew its strength not from the harmony but from the tensions within the state, the unity of which was henceforth symbolized by effigies of the national gods at the sides of the thrones of statues of kings. Its rulers had to be constantly on the watch to suppress opponents. We know that Ammenemes I, the founder of the glorious Twelfth Dynasty, was the victim of a court conspiracy. In a treatise on kingship, his son and successor, Sesostris I, attributes to him the following melancholy comment on those times: 'Trust not even thy brother, have no friends, no confidants; all that is of no avail. When thou sleepest, guard thy own heart, for on the day of misfortune no man has true followers. . .'

It was not by chance that nearly all the kings of this dynasty appointed their sons and heirs co-regents. The pledge of their security was the example they set—the strict fulfilment of their duties and the sense of responsibility which they showed to their subjects. That the energetic Sesostris III and his son Ammenemes III did not take life easily is proved by their striking portraits, even if, in the treatment of form and the worn, disillusioned expression, the spirit of the times found stronger expressions than in the actual features of the rulers. In these effigies the careful anatomical structure

of the faces endows the two kings with a striking personality, combined with a capacity for awakening human sympathy which we rarely find in Egyptian art.

The Middle Kingdom (*c.* 2133–1786 B.C.)—that second golden age with its many profound and mighty creations—eventually dissolved in a way which has not yet been historically explained. The decline lasted for more than half a century and during that time no outside attack weakened its foundations.

Why did its strength decline? Did the very loftiness of its ideas, its separateness and acquiescence, bring it to ruin? Did its gifted royal family in the end wear itself out? The conformity to rule of its instincts and works gained for its creations—and not least for its writings, the form and content of which still appeal to us—the reputation among succeeding generations of a classical validity. The portraiture of the early Late Period followed reverently in its footsteps, drinking in the mighty impulses of the models, which for all their formal severity are frequently impregnated with a kind of hopeless melancholy.

At the end—and in the circumstances it could hardly have been otherwise—all kinds of adventurers fought their way up to power—freebooters and generals and a few real, born rulers, though of all these happenings nothing has come down to us except long lists of names, huge mutilated statues and a dim inkling of changing and in the main barbaric conditions.

Then, after sporadic incursions of individual tribes into the Delta area, there came from Asia a flood of foreign invaders. First, under the pressure of an extensive migration of peoples in the North, came heterogeneous hordes lusting for plunder, who left no original monuments, no visible tokens of their ways and ideas. Their kings, some of whom bore Semitic names, controlled the valley of the Nile from their fortress of Avaris in the eastern Delta, imposing the yoke of foreign domination on the Egyptians for at least a century. This period, still obscure from the historical point of view, represented a decisive turning-point in the course of Egyptian civilization. It would seem that, as early as the end of the Old Kingdom, there was an influx of foreigners into Egypt, but they have left us no tangible traces. On the other hand, the domination of the so-called Hyksos effected considerable transformations in the character and customs of the Egyptians, though the material traces left by these fierce intruders were scanty. What is important is that their appearance widened the Egyptian outlook; only from that time onwards was there an Egyptian foreign policy in the strict sense of the word. It seems almost symbolic of this involuntary broadening of outlook that they brought to the conquered people horses and chariots, thus providing them with unexpected possibilities for what later became a successful method of fighting.

With the expulsion of the Asiatic oppressors and the ensuing pursuit, which brought a clan of minor Theban rulers, known as the Seventeenth Dynasty, into Palestine, the New Kingdom (*c.* 1552–1085 B.C.) began to take shape—that era of world power which was to offer Egyptian talent and skill its greatest opportunity.

Attention was now directed towards the outside world and it soon became evident that the power of Egypt had not been broken, but, after a temporary setback, had become greater than ever before.

It is true that no new fundamental cultural values were produced and no royal statue, no sphinx of the New Empire can vie in inner content and external form with those of the great eras of the

past. Activity takes the place of creativeness. But this activity is of such intensity and extent, that in this case quantity becomes in itself quality.

The utmost was accomplished in every field, especially in the subjection and administration of the Palestinian and Syrian principalities and in the final colonization of Nubia, which under the Hyksos appears to have made itself independent under its own chieftains. Egypt became an empire—and this in reality was foreign to its nature and was maintained by succeeding generations for several centuries only at the cost of tremendous effort; its Theban city-god became the imperial god whose glory outshone that of other gods and brought the sun-god Re under his sceptre. This essentially peace-loving nation of peasants, among whom the conscientious functionary was respected and the scribe revered as a sage, was seized with military ambition and the officer home on leave proudly flaunted in family gatherings the 'gold of honour' conferred upon him by the king. Thebes, the capital of Upper Egypt, whence had come on two occasions the idea of founding a unified state, now became a metropolis:

'. where the houses are rich in treasures,
she has a hundred gates and from each issue forth to battle
two hundred doughty warriors with their steeds and weapons.'
(Iliad IX, 381–4)

The wide circle of its fruitful countryside now became filled with huge temples and palaces, with increasingly splendid residential and industrial areas, stretching right to the edge of the desert. In the limestone foothills of the western mountains, the walls of the commodious chambers in the tombs were adorned with those cycles of pictures which vividly portray the life of the time, and even the details of costumes and usages: the performance of official duties and the exercise of professions, the supervision of the harvest and the joys of the chase, all kinds of characteristic figures from near and far, the monotonous passage of the weeks and gay festivals, and at the end of life's journey the solemn voyage on the Nile, the funeral procession 'to the West' and the rites solemnized by the priests of the dead before the mummy embalmed with myrrh at the gateway to the tomb.

The warlike, industrious and vigorous centuries of the kings named Tuthmosis and Amenophis have been called the golden age of the Pharaohs, and certainly Tuthmosis III was a statesman of universal talents like Julius Caesar—a military commander, an organizer and a ruler of the first rank—while the splendour-loving Amenophis III was a princely promoter of welfare of no mean proportions. But why is it that for all our admiration for their extent and magnificence and inventiveness we remain dissatisfied as we wander from building to building, from statue to statue, if we have previously steeped ourselves in the creations of the pyramid area? Why does the visitor feel a kind of homesickness for the golden desert silence of the pyramid zones and the Old Kingdom funerary mounds near Saqqâra? In the olden days a naïve confidence in this world and in the world to come, an affable self-assurance and human charm left their imprint on the rich abundance of works, but all this is now replaced by a reserved business civilization. Then, as now, the magical cult of the dead in their 'eternal dwellings' was depicted, but now there is no communication, in so far as private feelings and thoughts are concerned. At the same time convention has retreated inward. Courteous, one might almost say lovable, are the notably feminine stone features of the statues, even if they represent influential men—

officers and functionaries of the Pharaoh's immediate entourage—but they remain inscrutable. There is in them a gradual penetration of that Levantine-Oriental element which we hardly ever encounter in the older portraits of men. The architectural components are imposing and, in their way, noble, but their formal language is already too much imbued with superiority to make communication possible and it may be that on beholding their haughty features we feel a secret longing for the modest, appealing nobility of the past. In the one case dignity and restraint border on over-refinement, in the other on arrogance, and the monumental element has a touch of insolence. Among the innumerable masterpieces of craftsmanship, what was formerly a restrained obviousness and an aloof distinction now becomes merely charming and at times amusing. However great the effect of the material charm and artistic ability of the treasures from King Tutankhamun's tomb, nevertheless not one of his numerous gems can vie in intimate charm with the graceful jewels which the princesses of the Twelfth Dynasty took with them to their last dwelling-place.

The elements in the colossal statues and large edifices which served to heighten the national consciousness were used more and more for the glorification of power. The reaction under the self-willed and biased religious fanatic Akhnaton did not check this process for long. His authoritarian artistic experiment coupled with his programme of religious reform reveals, in addition to virtues which the chisels of sensitive masters converted into works of sublime charm, many signs of decadence. And this is true of other fields influenced by the example of the court. In the spiritual history of the East in ancient times there are not many figures of the same importance, concerning whom so much can be said in one breath to their credit and discredit. What happened was that arbitrariness and individualism threatened at that time to imperil the structure of Egypt, which was in any case being gradually transformed by influences from outside, and the reaction against this obvious degeneration signified—if one can call it so—a third salvation of the country. In this connexion it must not be forgotten that in the Amarna years the germs of vital and religious feeling reached a stage of development which subsequently ripened to a significant maturity, the results of which cannot be disregarded in the history of Egyptian spiritual development. It was at that time that a new ideal replaced that of the preservation of what was hallowed by custom, of the accumulation of wealth and the enjoyment of life. And can one ignore the fact that many of the sculptural works at Amarna have exercised a deep and lasting influence on the artistic ideas of our own time?

Akhnaton's religious campaign did not win the people over to his side. The claims of the royal ego were too absolute, in most cases not equal to the requirements of his office and at bottom thoroughly unpopular. The artistic style inspired by Akhnaton, however, achieved during the reigns of Tutankhamun and Horemheb a wonderful fusion with the old convention of Thebes and Memphis and its influence on sculpture in the round and on relief can be traced for a long time.

There followed the noble classicism, presented, it is true, with a certain academic coolness, of Sethos I, who in his military campaigns made a vigorous attempt to save the prestige which Egypt had almost entirely lost, especially in the north, owing to Amarna misrule. He evidently had a flair for finding unusually gifted masters to supervise artistic production in his workshops: his many-chambered tomb, driven deep into the heart of the western mountain at Thebes, surpasses in its layout and adornment all the other royal graves in the Valley of Tombs, and the beauty of the figured

mural decorations in the temple which he caused to be erected at Abydos, leaves an indelible impression on the minds of all who behold it.

Under the long reign of his famous son, Ramesses II, Egypt entered upon that problematic period which is the inevitable lot of every advanced civilization—that busy period in which a brisk vivacity takes the place of tranquil, creative emotion, but in which, on the other hand, understanding of the world and a non-dogmatic piety become more evident. A kind of evening glow suffuses the historically not very important but in their way venerable exponents of such late periods—a Ramesses, an Assurbanipal, a Nebuchadnezzar, or even a Hadrian.

The love of the colossal and the imposing now surpasses itself. It is as if the whole Nile Valley had become a gigantic stonemason's yard whose task it was to give monumental expression to the complacency of the rulers.

The massiveness of buildings and sculptures is such that one is tempted to call it a form of exhibitionism carried to a degree of titanical absurdity. Individual works of high quality are still produced. But viewed as a whole, all this magnification of the Good God, of his fellow gods and of the achievements of the time is spoilt by its exaggeration of effects, its disproportionateness, its unwieldiness and restlessness. What is certain is that at that time more stone was hewn than under any of the pyramid kings, and the visitor today has difficulty in discovering the traces of more refined stages of civilization amidst the all-pervading works of the great Ramesses. In view of the historical situation it is not surprising that during the sixty-six years of this Pharaoh's reign, there was a marked penetration of foreign elements into the manner of life and customs of the Egyptians, even in their everyday speech and dance steps. Disintegrating forces entered everywhere into the essence of Egyptian life. Scepticism and satire were rampant and openly derided the most sacred things.

When Egypt was drawn into the field of outside political forces, many changes occurred. The son of Re became a royal man of the world, foreign princesses populated his harem, while a continual stream of foreigners poured into the Nile Valley, as immigrants, as gifts of allied rulers or as captives taken in battle. For years the court of the Pharaohs had conducted active diplomatic negotiations with the kings and city governors of the western Asiatic countries—negotiations in which the queen participated. For imperative reasons of world policy the seat of government was moved to the area of the Delta, though Thebes retained its old glory and in their extent the new buildings put those of earlier periods in the shade. One has to have seen with one's own eyes the mighty witnesses in the area of Luxor to the assertiveness of the time, if one is to form a true idea of what those generations attempted and what by dint of titanic labour they achieved. The gigantic dimensions of buildings and sculptures surpass all expectation, however great: on every papyrus capital in the middle aisle of the great hypostyle hall at Karnak it has been calculated that a hundred men could stand, and the walls surrounding the complex of the Amun sanctuary could easily contain ten European cathedrals.

Ramesses III, with whom Egypt's Twentieth Dynasty begins, strove valiantly to rival his predecessor and namesake in the exercise of power and in building, but despite the eloquence of the reliefs of the period, with their instructive representations of foreign peoples and historical events, hardness and coarseness steadily invade the pictorial decoration of temple walls. The sense of proportion becomes uncertain, the execution noticeably uneven. The expression is that of a certain exhaustion of the

national strength, which is not surprising after such fantastic efforts. From the beginning of the Eighteenth Dynasty the Pharaohs had to be ever on the watch to defend their northern frontiers and to this end they recruited mercenaries wherever they could find them. For years the mode of life and artistic expression clung to the examples of the days of the great Ramesses II: even his features were perpetuated in the portraits of private individuals and—like Julius Caesar, who later bequeathed his name as the greatest of all titles to the great ones of our world—for many generations to come it was unthinkable that anyone could assume the office of Pharaoh without at the same time being a Ramesses.

A change in this respect came about, after many internal upheavals, only as a result of the foreign dominations which followed one upon the other during the first millennium B.C.—Libyans and Ethiopians, Assyrians and Persians, Greeks and Romans. What in the intervening period seems like new blood in the manner and expression of life is perhaps but a return to the achievements of the creative days of long ago. Naturally the conditions of existence and outlook underwent constant change and at the same time taste was evidently influenced by foreign ways. There was also no lack of genuine efforts to achieve a new artistic expression. Until a few years ago the criticism and evaluation of the phenomena of the Egyptian Late Period were treated far too light-heartedly; after all it was a period of intense historical and cultural development which lasted a full thousand years! Even if Egyptian civilization in its old age was incapable of providing the necessary energy for the exploitation of such attempts, that does not mean that it assumed an attitude of courtly senility and unapproachability, as is commonly believed even today. It is true that as regards the human portrait it adhered to a conventional type, which could not stand up to closer investigation, but this type, emptied though it was of all form, had yet enough consistency to inspire the evolution of the Greek sculptured figures of youths, destined to achieve an unparalleled artistic development. In any case it would be wrong to generalize from this case. With the close-fitting draperies, giving the impression of nudity, of the sculptured bodies of the Ethiopian and following periods, a feeling for the human body appears which exploits wantonness as a means of producing effect. More than ever before the treatment of the nude tends towards a plastic sensuality—long before the irresistible, mature Greek model became known to the Egyptians. And when this model finally revealed the full force of its charm, Egypt did not reject it. Meanwhile, especially in portraiture, plastic, individually striking solutions of single problems had been found, which prove that the age-old feeling for reserved, highly expressive form had not been extinguished. Side by side with the smooth stone features of the kings of the Late Period, smiling coldly and aloofly despite, in most cases, the bravure of the technique, we find masterpieces like the grandiose Mentuemhet in Cairo and the incomparably moulded 'Green Head' in the museum in Berlin, which in their way can hold their own beside the best creations of the older period. In particular, the late Memphite portraits have a kind of urbanity which makes many famous works of European art seem provincial by comparison. It is clear that this tradition had considerable influence on Roman portraiture of the late Republican era.

The fact that, not only under the able and talented Twenty-sixth Dynasty, but also under the last Egyptian rulers of the Thirtieth, a by no means despicable late flowering of the arts took place, is partly due to Egypt's firm adherence to the symbol and type as laid down by hieroglyphic tradition— that adherence to a fixed system which to the end was one of the mainstays of the state, of religious

practice and of society. Figured hieroglyphics from the Ptolemaic period, cleverly fashioned in coloured glass and inlaid in the wood of coffins, can vie in every respect, in severity and beauty of style and craftsmanship, with those of earlier times. Figures of animals—especially couchant lions—with a striking power of expression, produced by a later generation which had long lost all national feeling and had to be satisfied if it pleased foreign tastes, reveal a deliberate and daring return to New Kingdom models. There is something miraculous in the constancy of Egyptian sculptural vision through the millennia. To that must be added a gift for handling the materials and a degree of skill which made it possible for Egypt to produce convincing works even in its decline.

Are we not justified in assuming that this astonishing productive capacity was the natural result of a well-balanced national life?

The fantastic course of this national life, with its constant changes combined with conservatism, its outstanding achievements and renunciations, lends itself all the more easily to comparison with other civilizations and to the formulation of fruitful theories on the history of mankind, because its modes of expression can easily be grasped and in many respects are akin to our own. For all the strangeness of individual works, the European of today not only finds it easy to become conversant with the world of Egyptian art, but he even gets to like it, once he has decided to make a thorough study of it. Egyptian art is far more easy to approach than that of the Middle or Far East, or that of India, or even the ancient art of America, despite all the insight into this which we have recently acquired. Indeed, the spell which ancient Egyptian art casts upon many of us is accompanied by the danger that aesthetic delight and thoughtless assimilation of the strange elements to our own way of thinking may make us forget its peculiarity—a peculiarity which exhaustive studies are stressing more and more.

How are we to explain this ease with which we 'feel ourselves at home' in the Egyptian world, so different from our own in its mode of expression?

Is it the exotic charm, the fairy-tale element in all these people, animals, plants and articles of everyday use, so strange and yet so familiar in appearance, that attracts us? Is it because the Egyptians carried to its logical conclusion and then applied in practice that universal, original mode of representation which is that of children and of all adults uninfluenced by teaching or by models? The high quality of Egyptian architecture and sculpture is due mainly both to the admirable draughtsmanship and to a *mastery* convincing despite all the peculiarities, to a not easily definable classical element in substance and effect which I would tentatively describe as a 'protoclassical', to avoid bringing confusion into the normal terminology. No Sumerian-Babylonian work of sculpture in the round can vie in equilibrium of proportions and mastery of form with the Egyptian masterpieces, however expressive individual religious works of that astonishing race may be. Despite the innate dignity and authority of early Mesopotamian sculptures, they still—like the grandiose human figures of mature Assyrian art—retain an alien ethnographical element which keeps the spectator at a distance, and which Egyptian sculptors of all periods replaced with a universal, human effect. The ideal of the nude, as developed in the Nile Valley from the earliest times, is found nowhere else in the Eastern world, but on the other hand provided the immediate inspiration for the incomparable Greek conception. This nation of sculptors, with their happy knack of seeing things as Adam saw them, had a mysterious understanding

of the original scale of measurements dating from the Creation, on which, in reality, the whole persuasiveness and beauty of form is based. Goethe was right when he ranked the Egyptian works of sculpture 'of ancient basalt, black and severe' with those of the Greeks 'of marble, white and charming'. Works like the enthroned King Chephren receiving the blessing of the falcon-god, the noble statue of Ti, or the maned sphinx of Ammenemes III have never been surpassed in the power of their inner and external classicism. The admiration they arouse confirms their quality. If the term 'classic' were to be reserved for 'Antiquity' in the narrower sense of the term, what words could express this convincing, universal quality, perfect in itself?

Is it also possible to speak of a proto-Christian element in the ancient Egyptian moral code?

From the fall of the Old Kingdom Osiris played an increasingly important role in religious thought. This mythical king of olden times and god of agriculture, who was treacherously murdered by his brother Seth and rose again from the dead, became in Upper Egypt the Lord of the Underworld and the judge of the dead. It is true that the confession which the deceased had to make to him concerning their behaviour in this world was purely negative, consisting as it did of a recital of numerous punishable offences which they had *not* committed, wherein the influence of magic is evident. It is likewise true that the active spiritual attitude of Europeans in this respect begins only with the positive and categorical 'Thou shalt not' of the Commandments of Moses. Nevertheless, we find here for the first time—more than a thousand years before similar ideas became prevalent in neighbouring countries—a religious conviction that our fate in the world to come depends on our moral behaviour in this life, which we shall have to justify before the throne of God. On entry into the kingdom of the dead, apart from the simultaneous oral declarations, the heart of the deceased had to be weighed before the eyes of the divine Judge—and no other people except the Egyptians has expressed such an idea so clearly in words and in pictures. By contrast the old Mesopotamian conception of the world to come seems hopelessly gloomy, and that of the Greeks would have been colourless and inadequate, if the mysteries had not provided a certain compensation.

Whether we speak of a genuine monotheistic tendency in early Egyptian religion is debatable. There is, however, no doubt whatever that in the earliest phases of Egyptian religion known to us there emerges a God Almighty, whose presence fills the whole region of the skies and whose eyes shine like the sun and the moon; this god of heaven is called 'the Great', 'the Lord of All', and 'He who is'; and notwithstanding the multiplication of gods which soon took place, the surviving texts, whether inscriptions on tombs or treatises on worldly wisdom, refer to him simply as 'the God'. And those who have made a deeper study of the history of religion are acquainted with the solar monotheism of King Akhnaton, that doctrinal belief in one all-embracing, creative and protective divinity, worshipped in the image of the gleaming disk of the sun, which provides even the smallest of its creatures with all they need. That, however, is the sum of its activity, and there is no mention in this doctrine, in so far as we know it, of sin or repentance, or of right and wrong. Nevertheless it would appear that portions of the Amarna hymn to the sun have been incorporated in the 104th Psalm and it is certain that many axioms of Egyptian worldly wisdom found their way into the Jewish scriptures in the eighth or seventh century B.C. The primitive representation of the maternal Isis nursing her mystically conceived son in her lap, after passing through intermediate stages in Greek art, became

the Byzantine Madonna. And for the first Christians in the Nile valley it was easy to embellish their new faith with long-revered symbols and to identify the Cross of Jesus Christ with the hieroglyphic looped cross, or 'ankh', which for them signified 'life'.

If we can only free ourselves from the current prejudices, we perceive, when we study the sources, that from the earliest times a sense of fittingness and integrity was an Egyptian characteristic. Everywhere there emerges a tolerant way of thinking, averse to the violent or the drastic, which has a congenial 'bourgeois' touch, with a delicate respect for social propriety and the need for restraint. It is all these qualities that distinguish the inhabitants of the Nile valley, with their by no means robust physique, their rustic love of peace and their indefatigable zeal for writing, from many of the conquering peoples who later played a role in the history of the eastern Mediterranean countries.

Typical is the honourable place assigned to women in ancient Egypt. Their position was considerably better than that of the Greek women of antiquity. Old Kingdom portrait groups show them as the equals of their husbands—pillars of the state like the men. The title by which they were known, *nebt-per*—'mistress of the house'—is in itself significant. In Egyptian law a matriarchal trend can be clearly discerned. In the question of legitimate succession to the throne, the queen was as important as the descent of the king. Absolute legitimacy could thus only be achieved by marriages between royal brothers and sisters, which were probably far more frequent than would appear from the historical records that have come down to us. Even as early as the pyramid era, in a trial for high treason in the harem, we see the accused queen being interrogated by a tribunal specially created by the king for this purpose, a tribunal of which the chief judge—probably because he was too close to the king and might therefore be suspected of undue influence—did not form part. The great American orientalist J. H. Breasted rightly remarks in this connexion that it was a striking proof of the king's lofty sense of justice and of the surprising legal-mindedness of the time that a person suspected of a conspiracy in the king's harem could not be sentenced to death without a lot of fuss. Breasted goes on to say that an immediate death-sentence, without any attempt to prove the legal guilt of the accused, would have seemed quite justifiable barely a century ago in the same country.

Soon after the year 2500 B.C., the vizier Ptahhotep included the following among his rules of life: 'When thou hast achieved something and founded a household, love thy wife in thy house, as is seemly. Care for her bodily needs, clothe her back; ointments for the care of her body are a balsam for her limbs. Gladden her heart, so long as thou livest: she is a field, the tilling of which brings reward to him who possesses her'. One of the axioms of the sage Ani runs: 'Rebuke not a woman in her house, if thou knowest that she is capable. Say not to her: Where is that? Bring it to me! if she has put it in its right place. Let thy eye look, whilst thy tongue remains silent, so that thou canst appreciate her good deeds.' The following maxim is a reminder of the duty to love one's mother—a moral obligation which was profoundly felt: 'Double the bread which thou givest to thy mother; support her, as she bore you. She had much labour with thee; when thou wast born after thy months, she suffered still further, for her breast was in thy mouth for three years. She did not shrink from nursing thee; she sent thee to school, when thou hadst learned to write, and every day she was there with bread and drink from her house. When thou art a young man and takest unto thyself a wife and art thyself the head of a household, remember how thy mother bore thee and reared thee in all

PLATES

THINITE PERIOD

(Ca. 3000-2778)

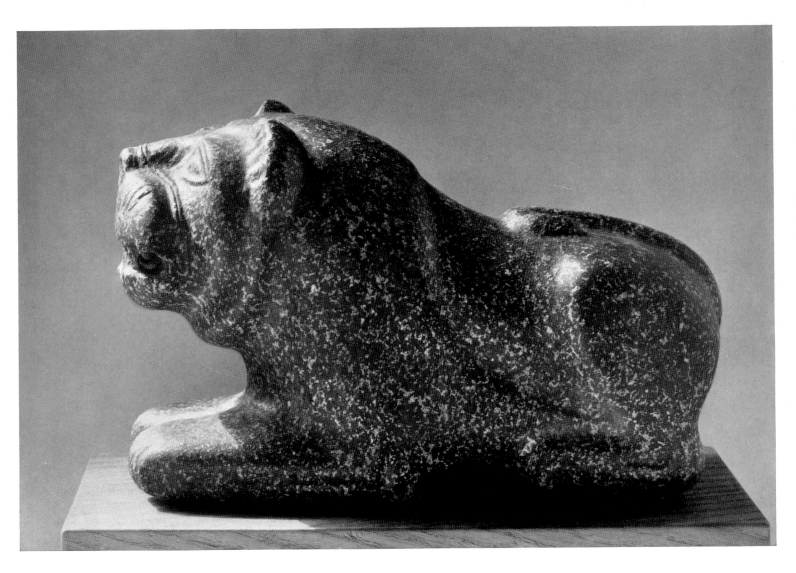

1 Lion. About 3000 B.C. Berlin

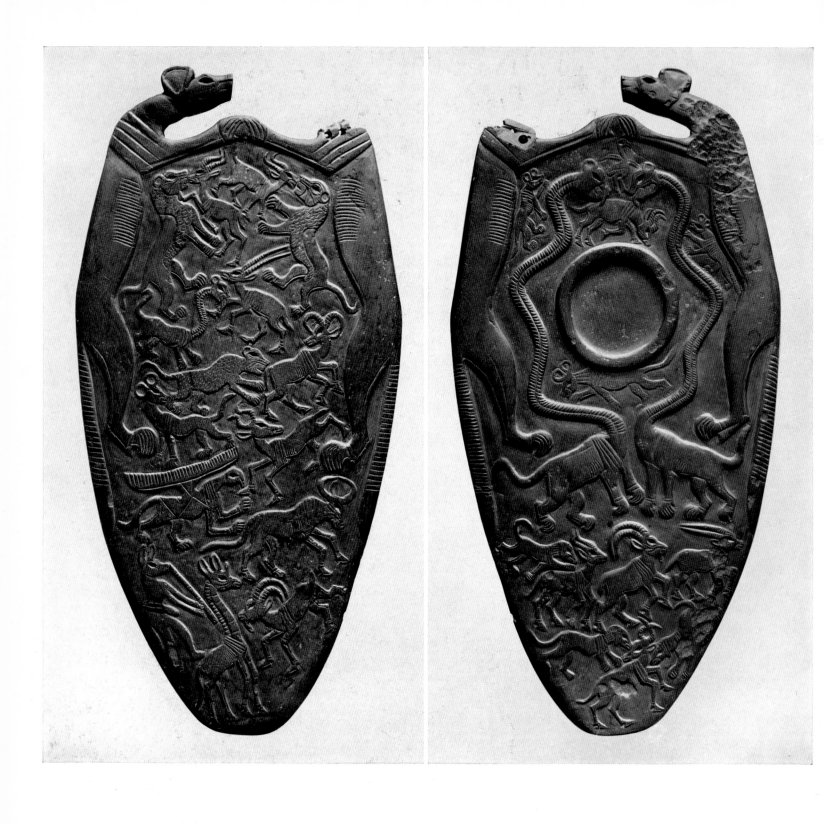

2 Cosmetics palette with desert animals and fabulous beings. Oxford

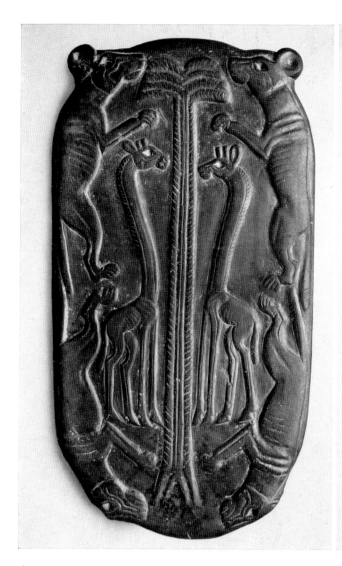
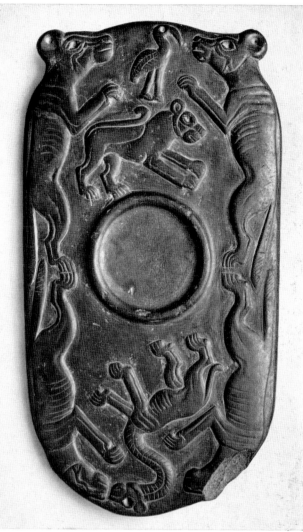
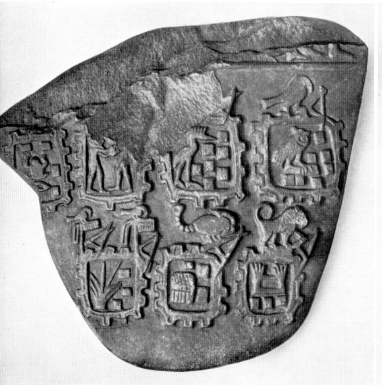
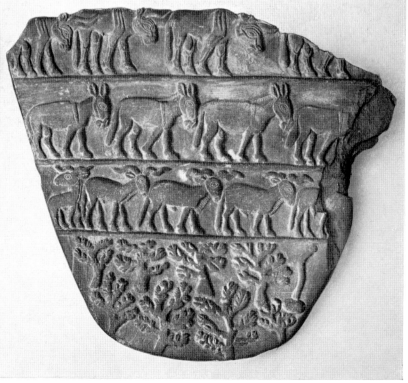

3 Above: Cosmetics palette with giraffes and palms. Paris. – Below: Part of a victory tablet. Cairo, Museum

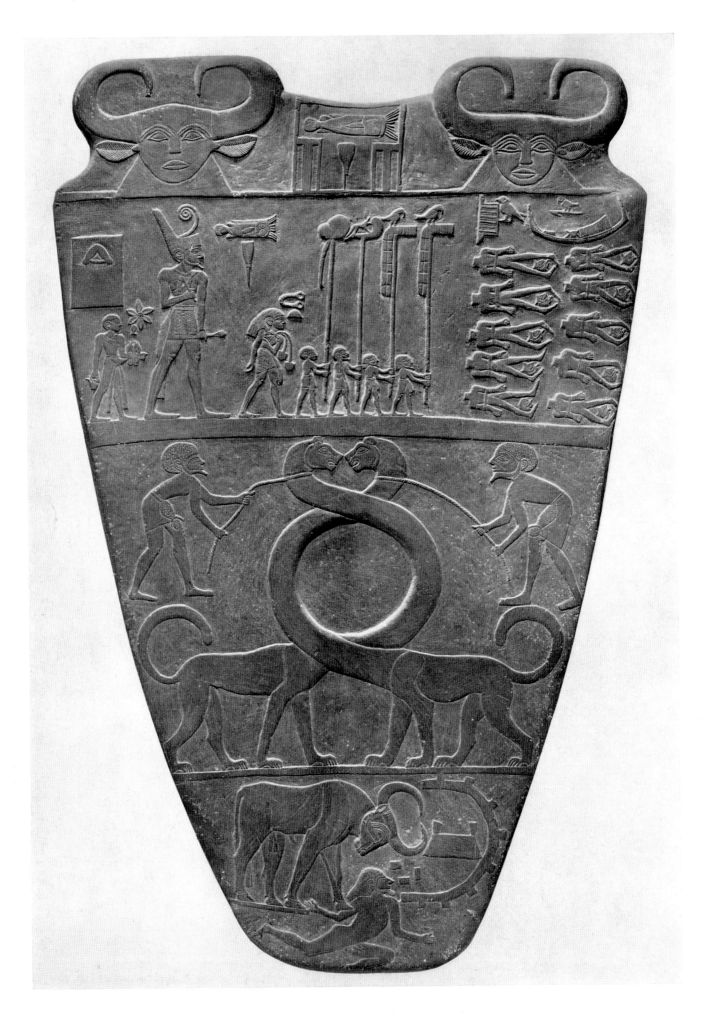

4 Victory tablet of King Nar-mer. Obverse. Cairo, Museum

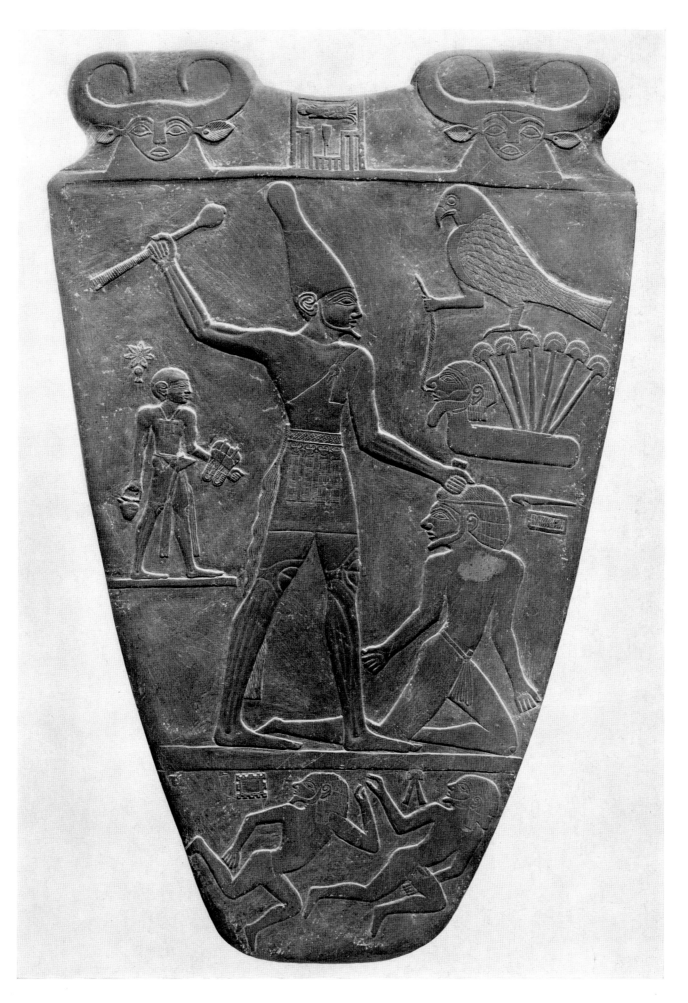

5 Victory tablet of King Nar-mer. Reverse. Cairo, Museum

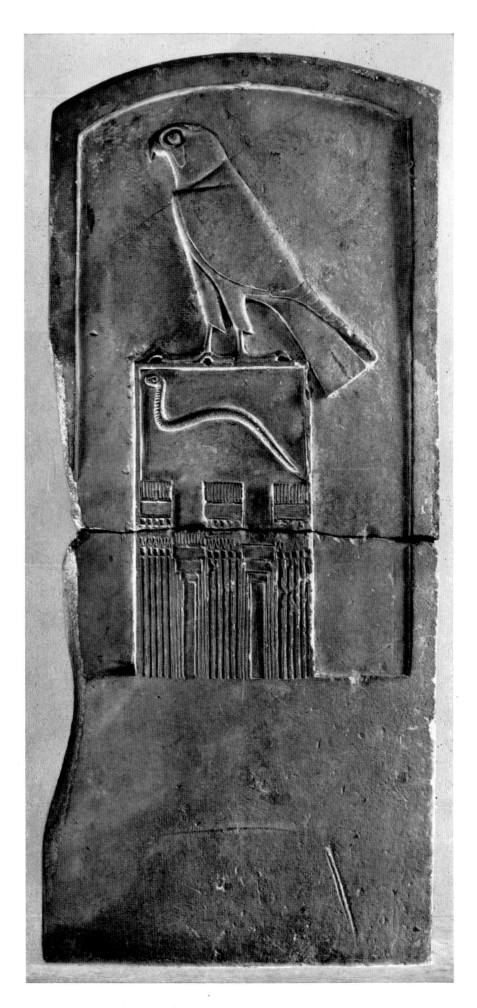

6 Tombstone of King "Snake"

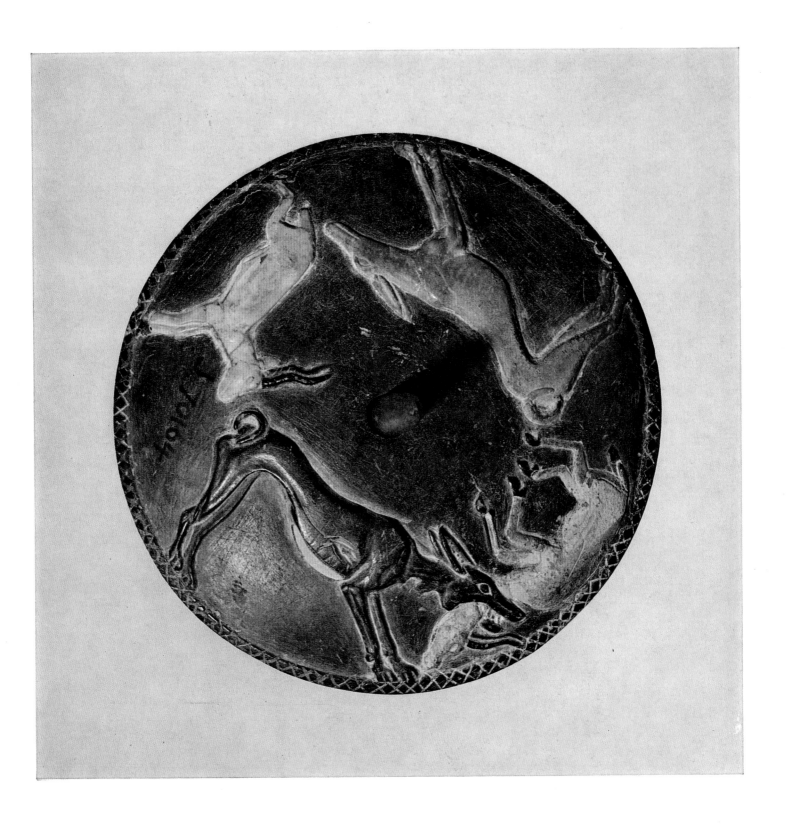

I Dogs hunting gazelles. Disc of steatite inlaid with coloured alabaster. Cairo, Museum

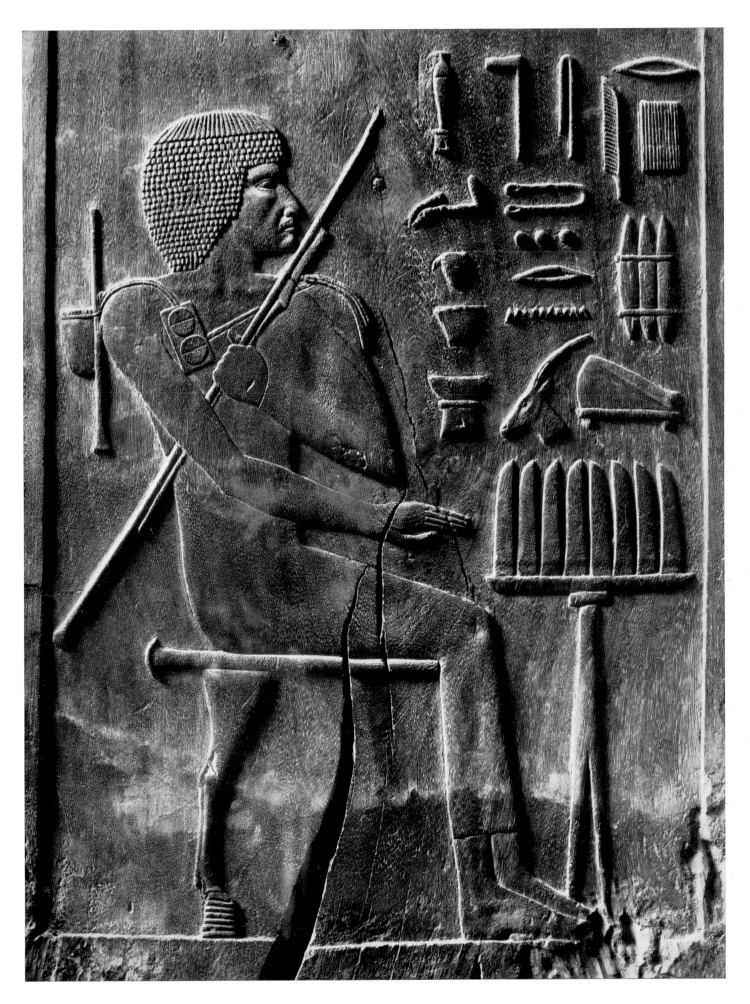

19 Hesirē at the offering-table. Cairo, Museum

FOURTH DYNASTY (2723-2563)

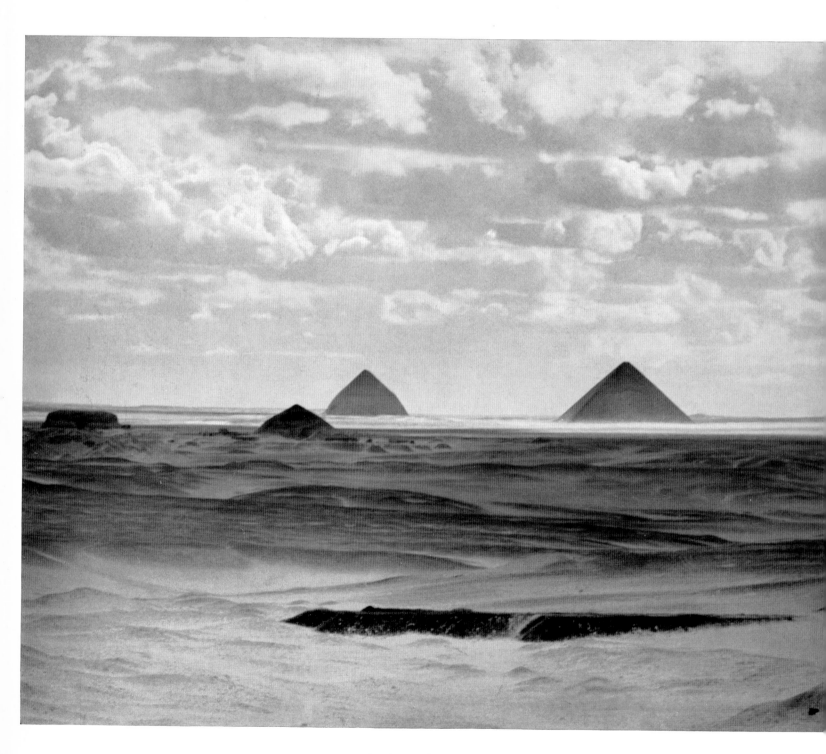

20 The Dahshur pyramids

21 Prince Rahotep and his wife Nofret. Cairo, Museum

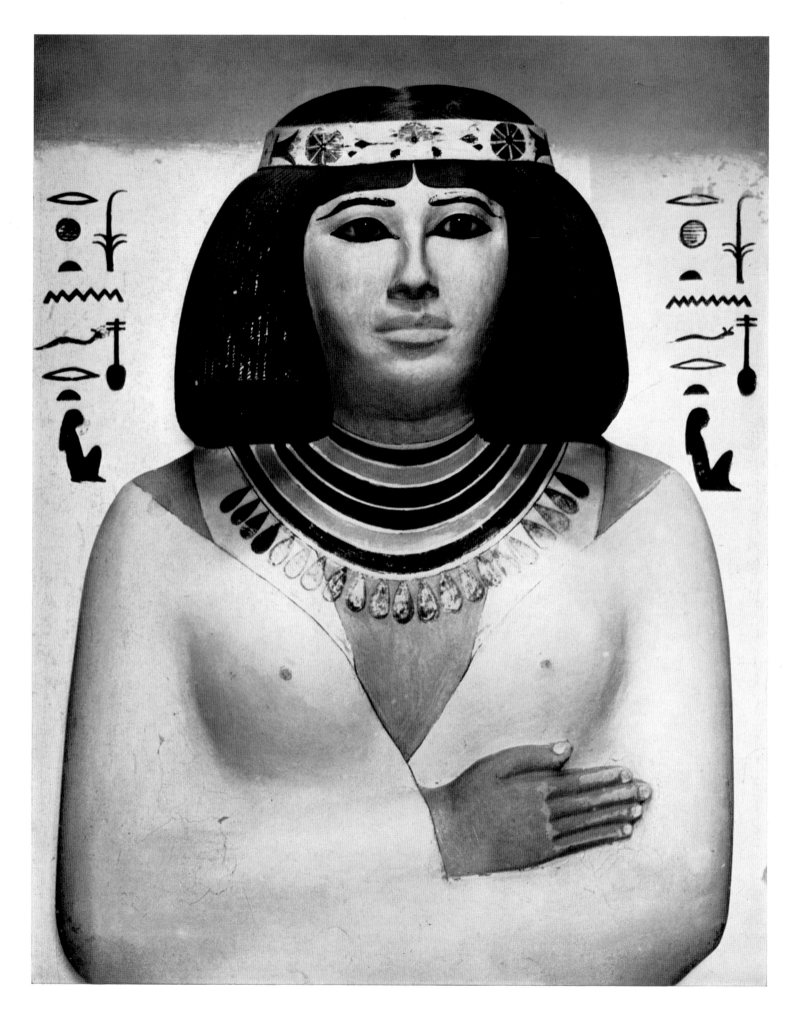

22 Nofret. Cairo, Museum

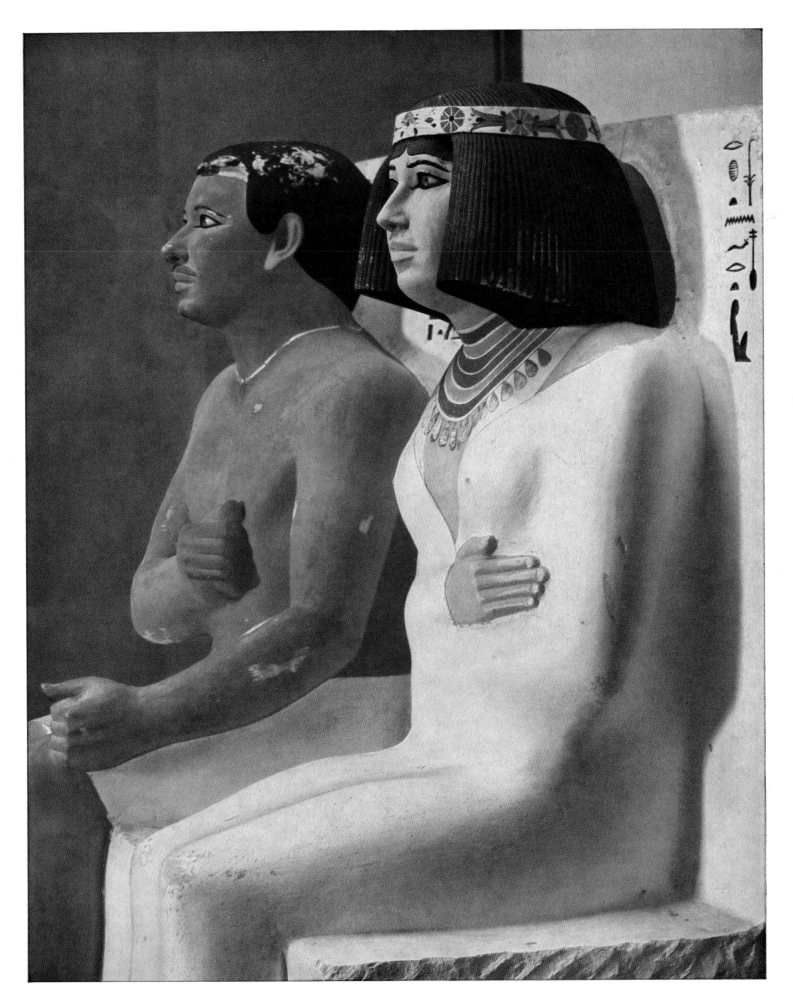

II Prince Rahotep and his wife Nofret. Cairo, Museum

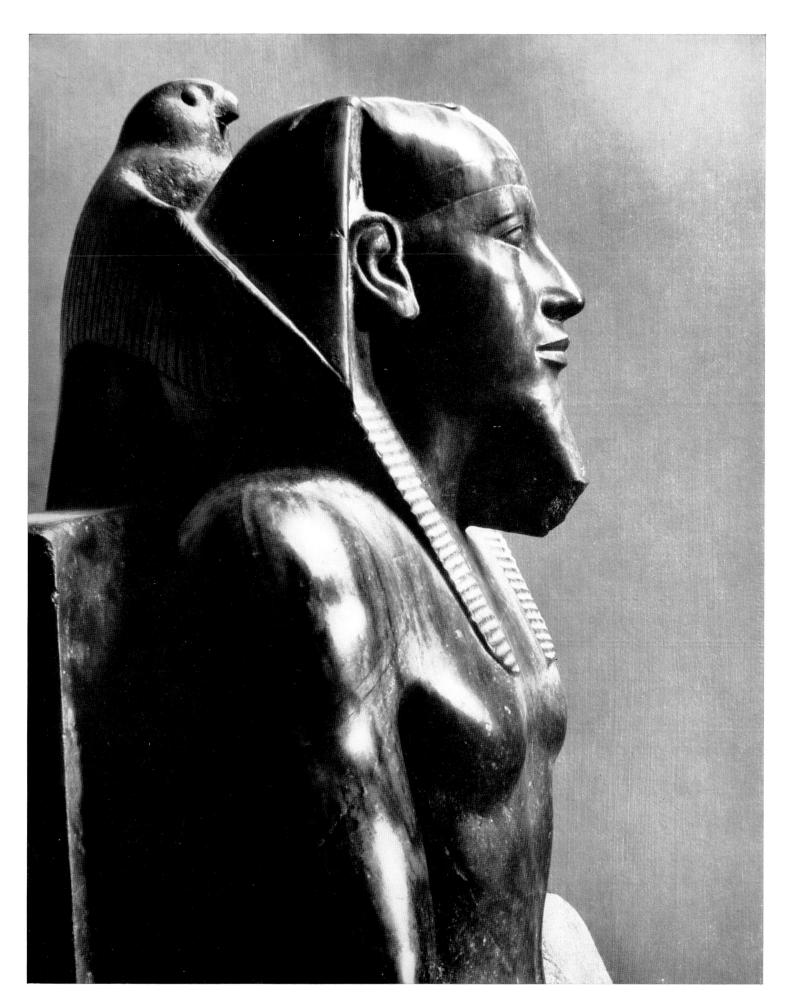

31 King Chephren. Cairo, Museum

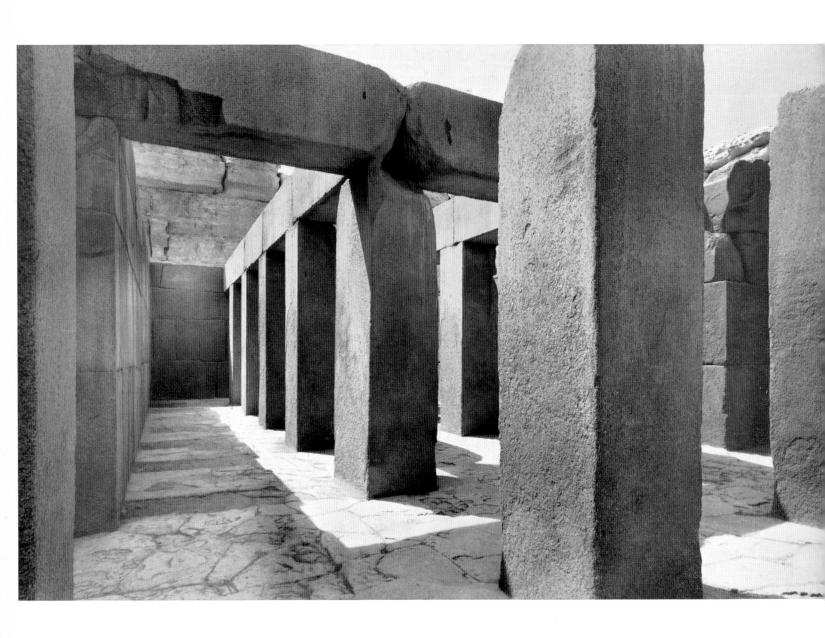

32 Valley Temple of King Chephren: the wide chamber and hall of pillars

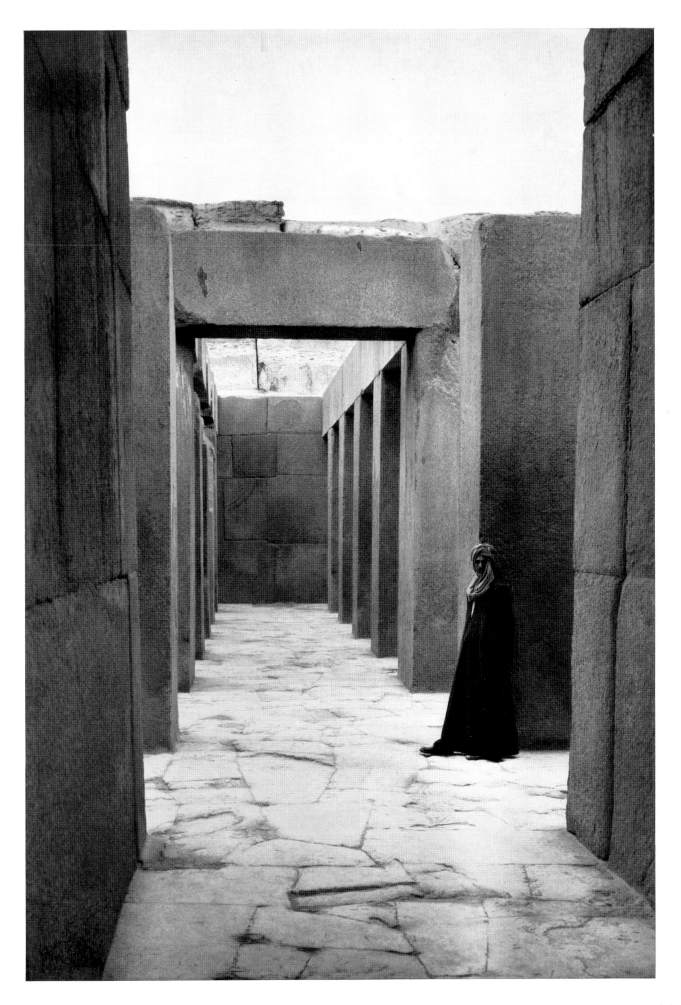

33 Valley Temple of King Chephren: middle aisle of the hall of pillars

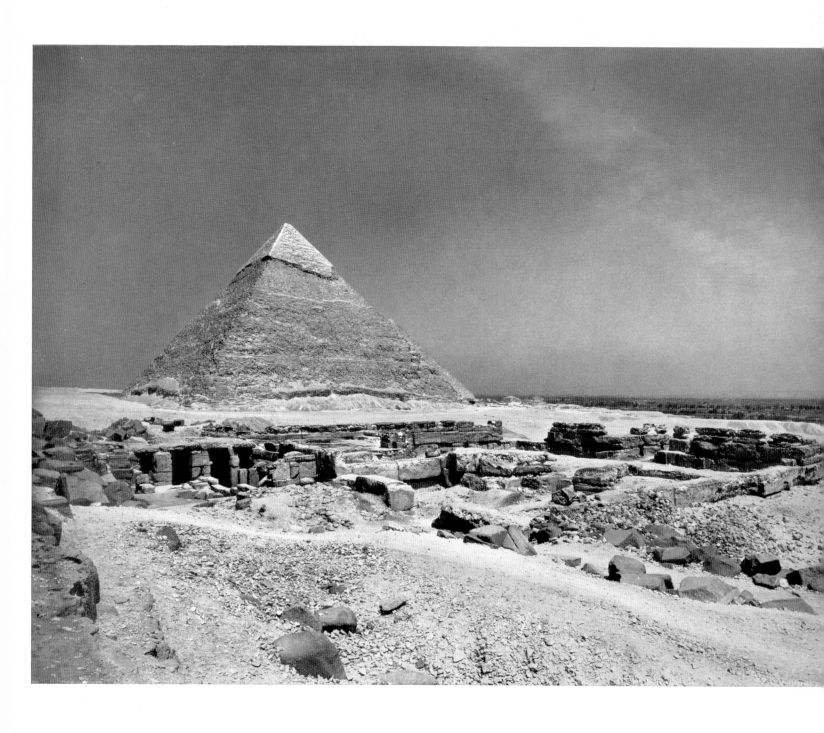

34 Funerary temple of King Mycerinus, in background the pyramid of King Chephren

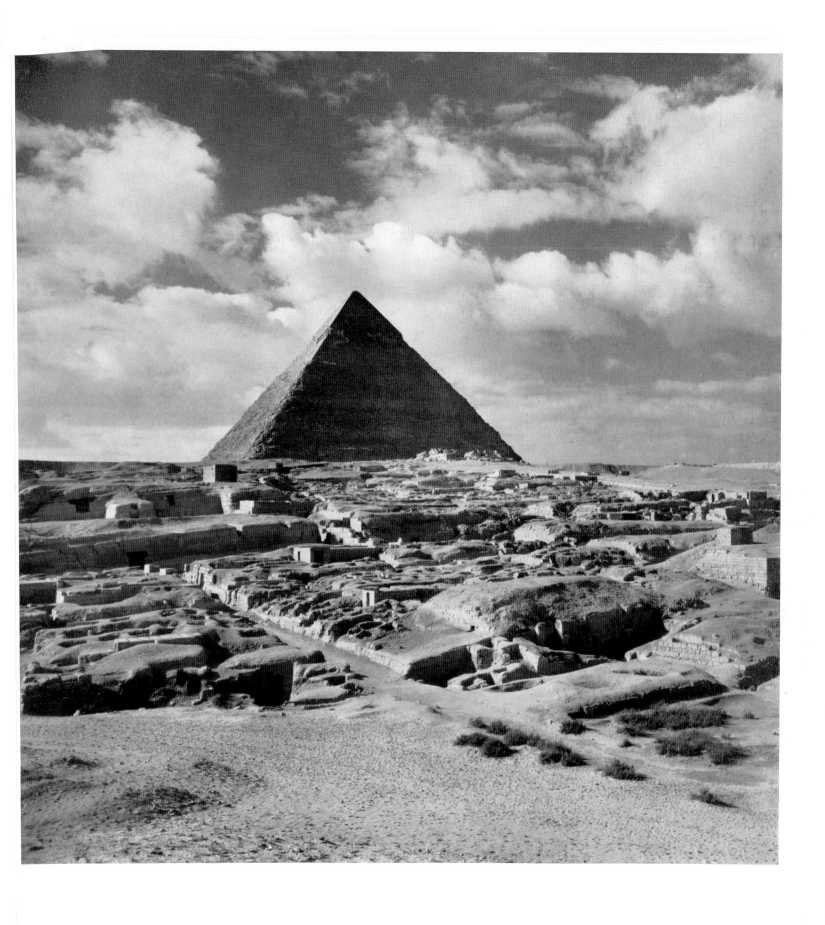

35 Mastaba cemetery near the pyramid of King Chephren

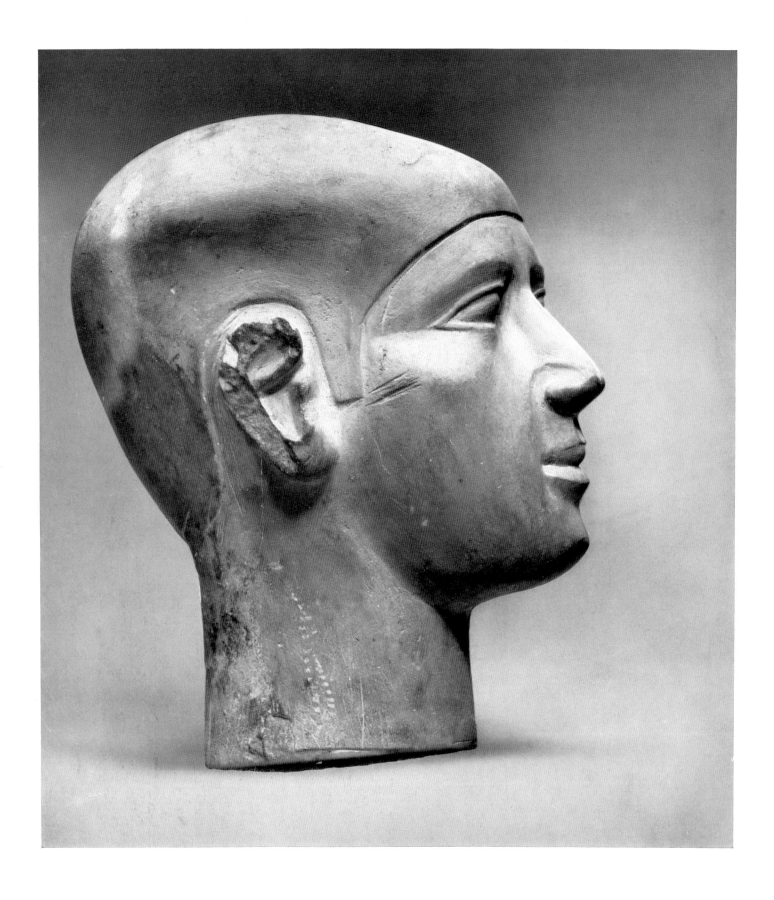

38 Portrait head from the royal cemetery at Giza. Cairo, Museum

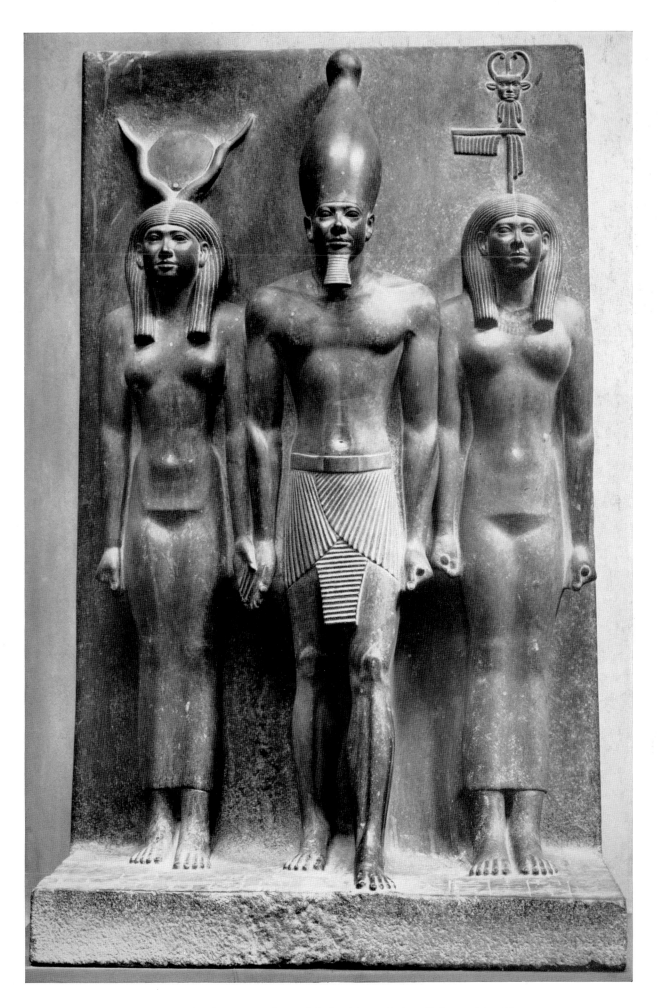

39 King Mycerinus between Hathor and the local deity of Diospolis Parva. Cairo, Museum

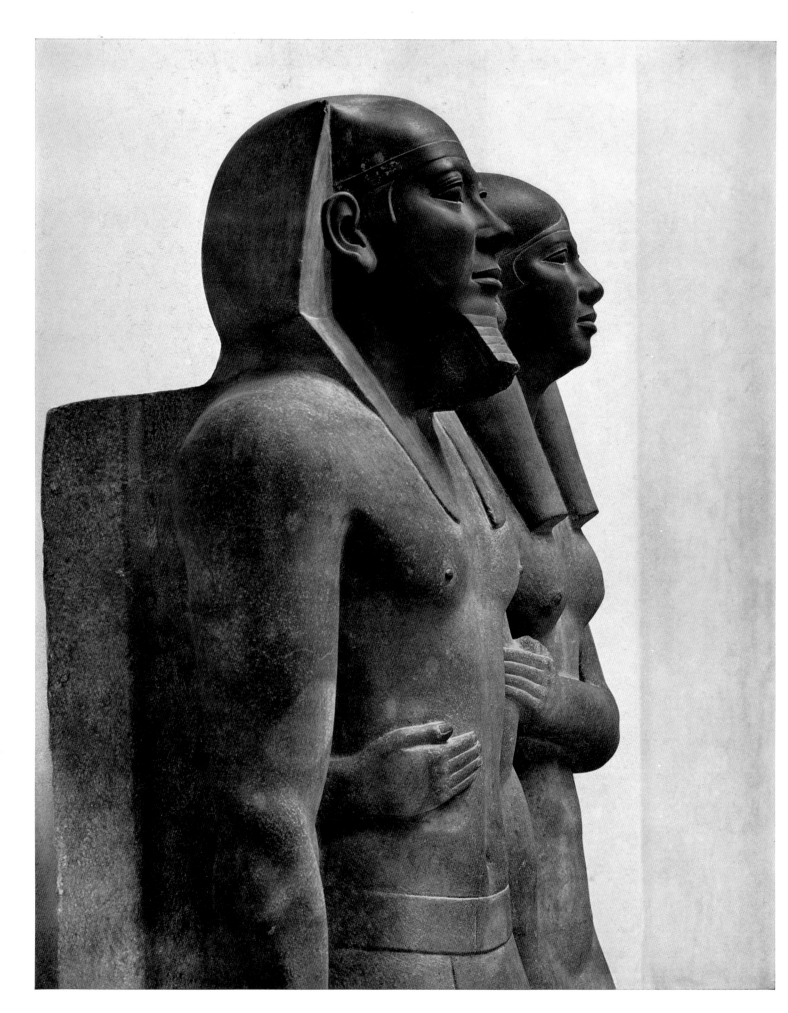

40 King Mycerinus and Queen Khamerernebti. Boston

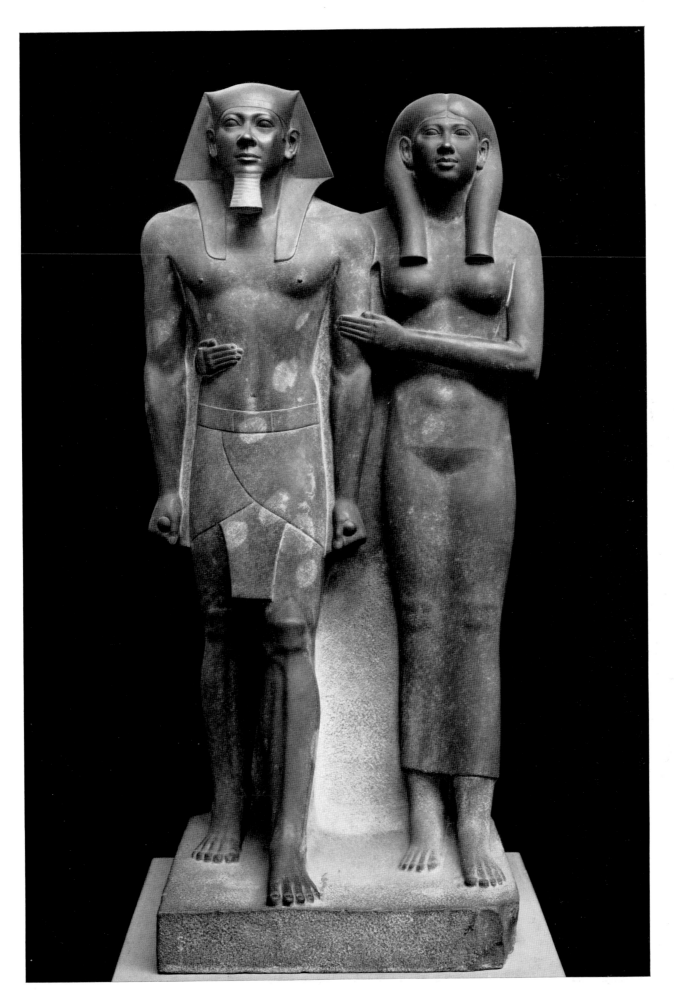

41 King Mycerinus and Queen Khamerernebti. Boston

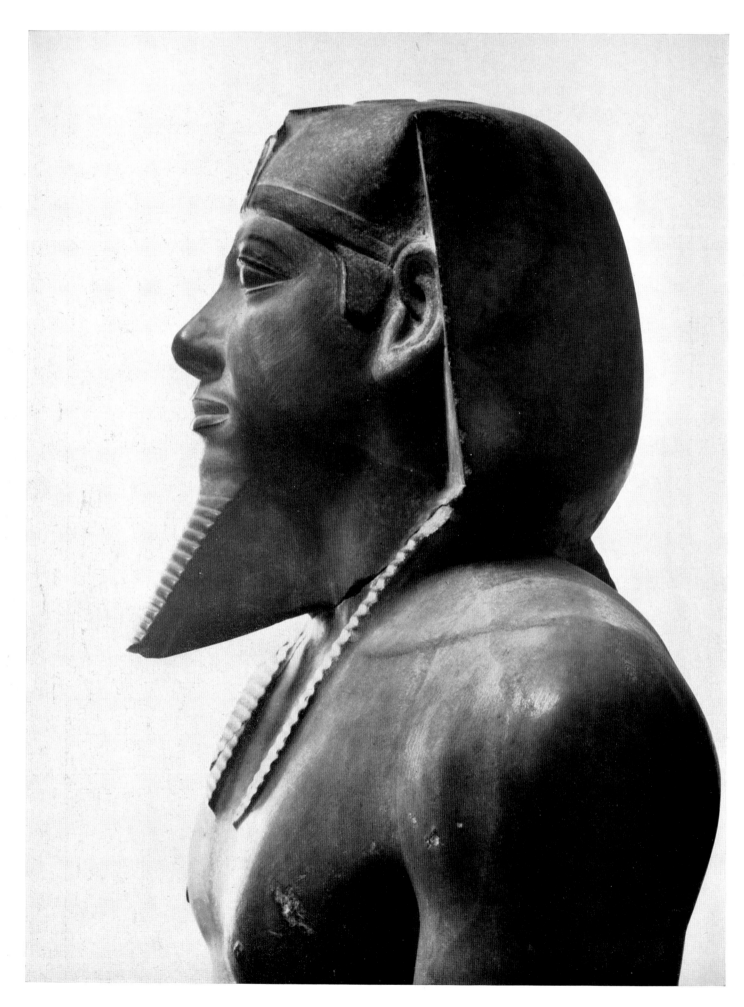

42 King Mycerinus. Cairo, Museum

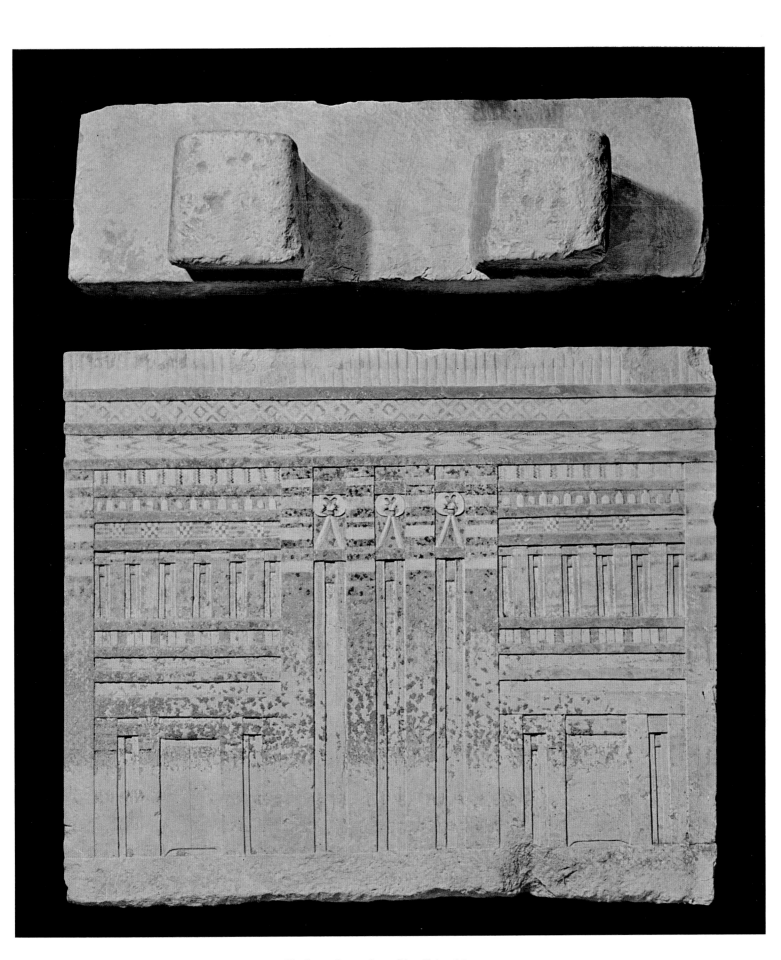

V Sarcophagus, from Giza. Cairo, Museum

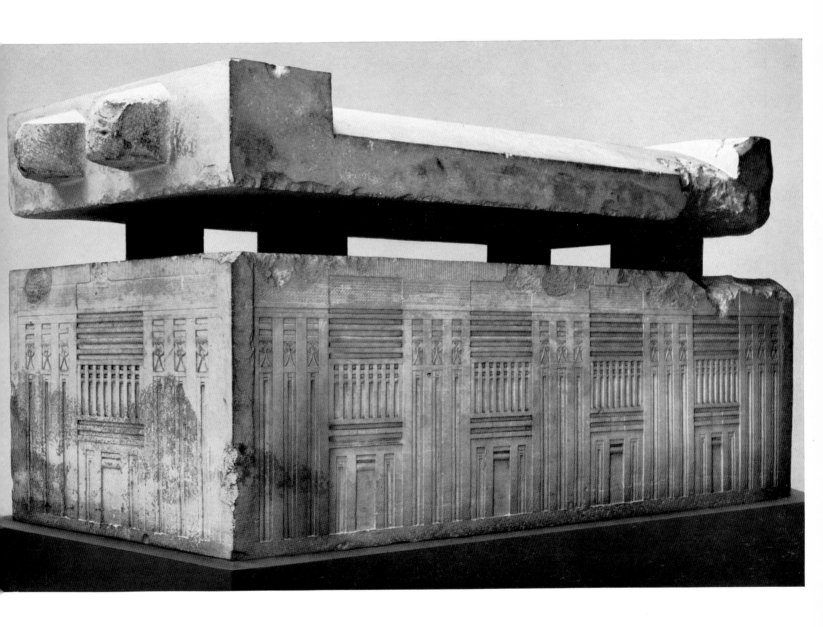

43 Sarcophagus of Rawer. Cairo, Museum

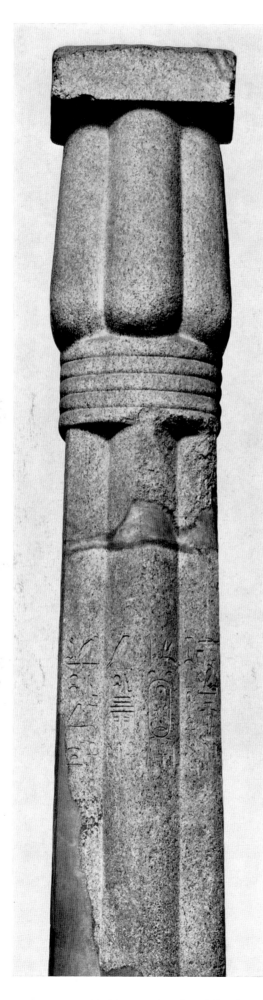
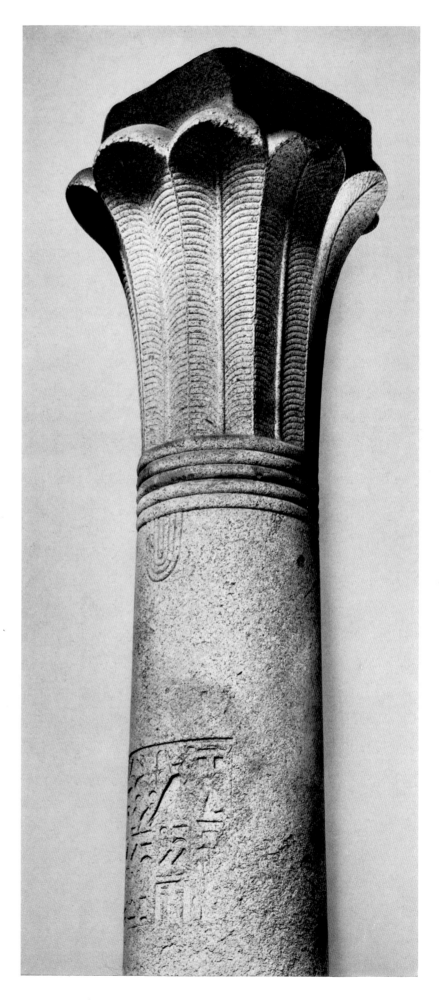

44 Two granite pillars: left in form of papyrus clusters from the funerary temple of King Neuserre near Abusir,
right with palm capital from the funerary temple of King Sahure at Abusir. Cairo, Museum

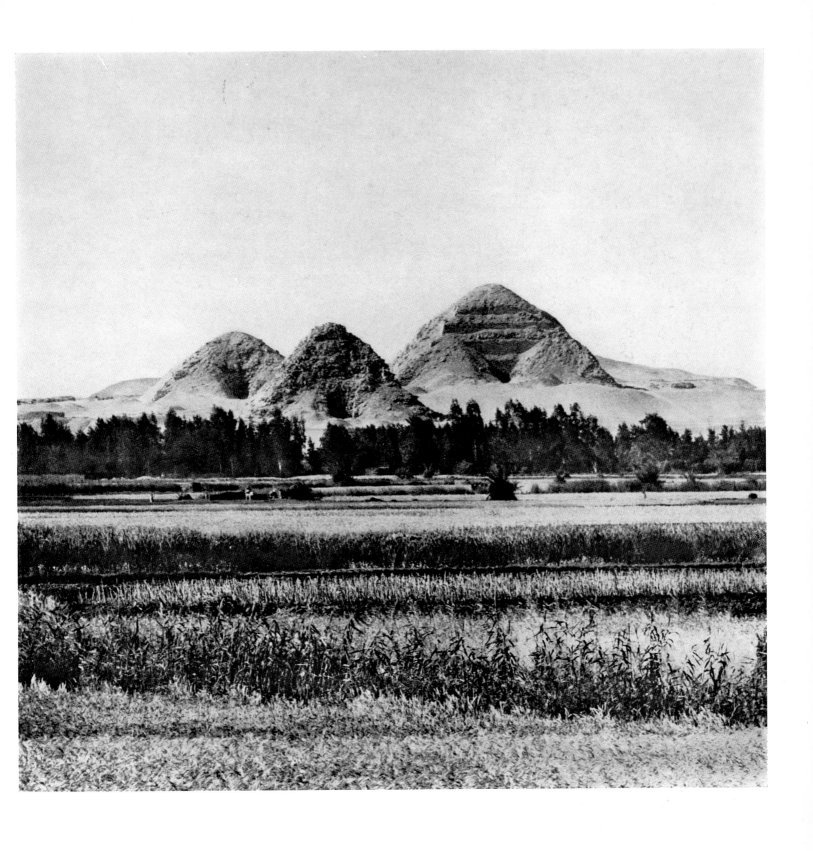

45 The Abusir pyramids, seen from the north

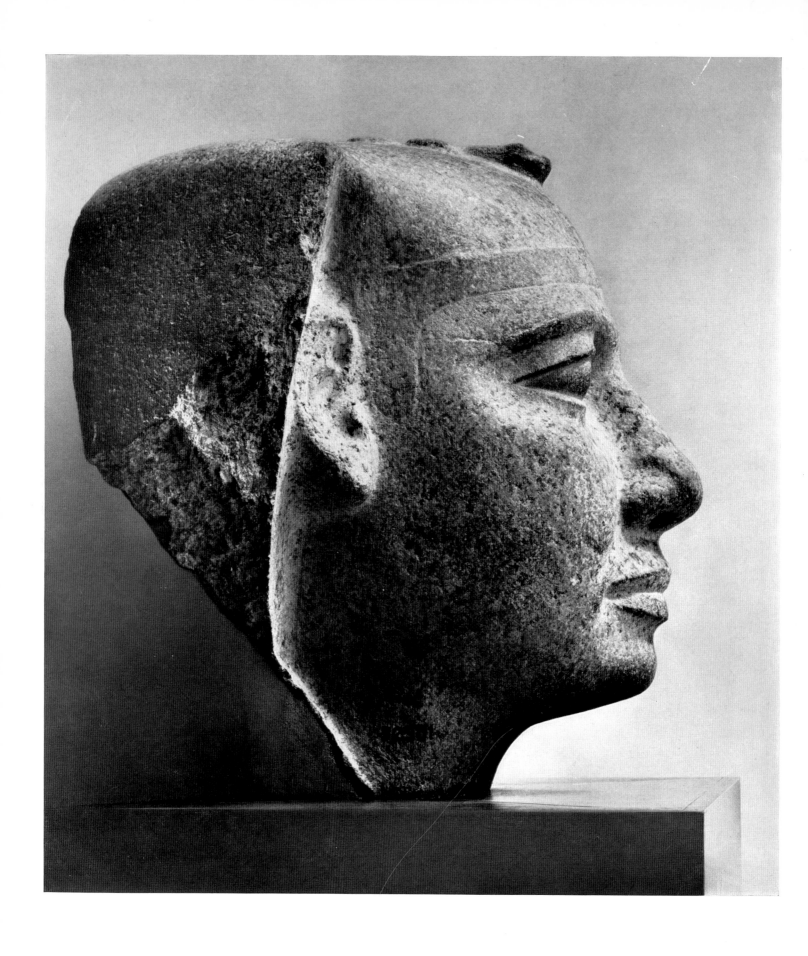

46 King Userkaf. Cairo, Museum

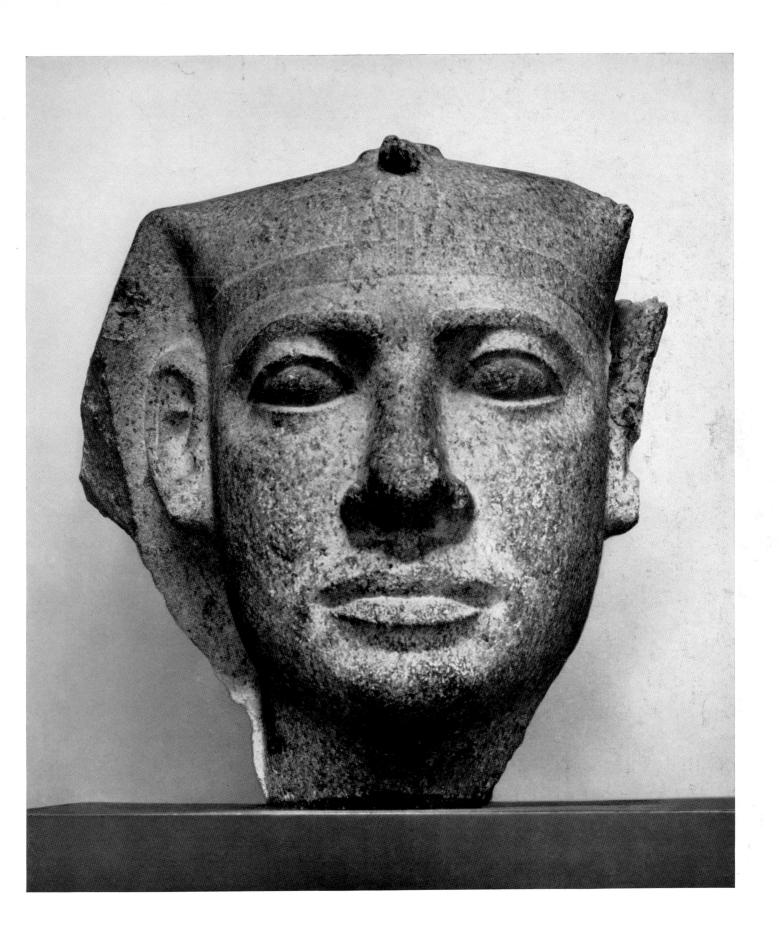

47 King Userkaf. Cairo, Museum

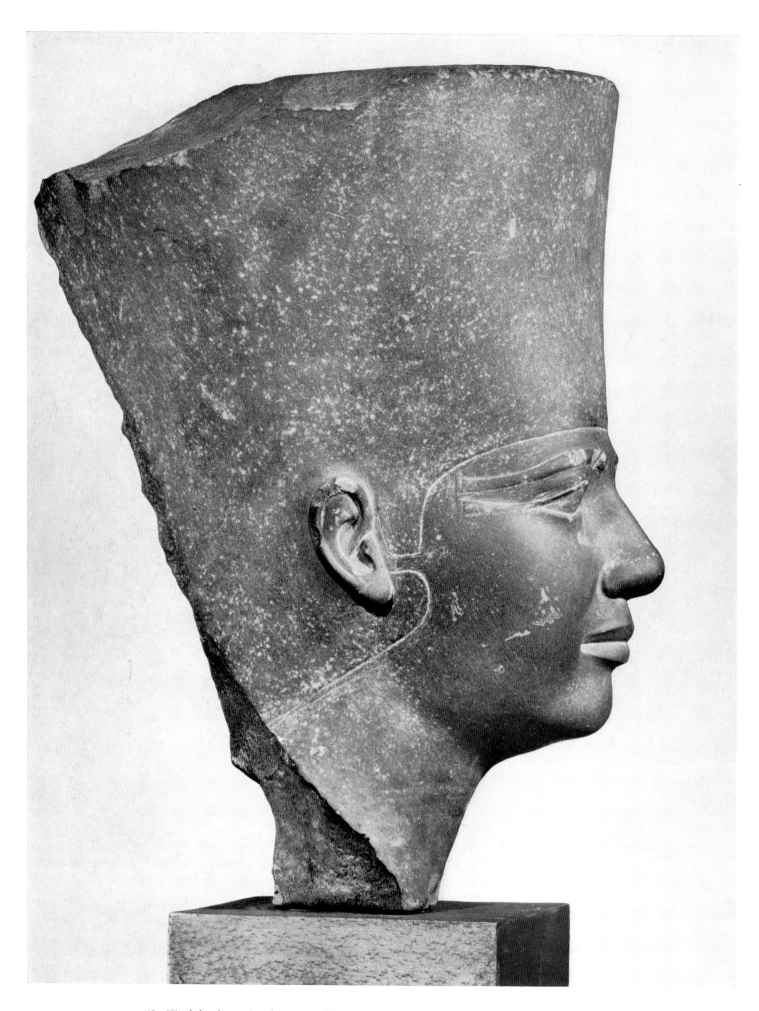

48 King's head, wearing the crown of Lower Egypt, probably Userkaf. From Abusir. Cairo, Museum

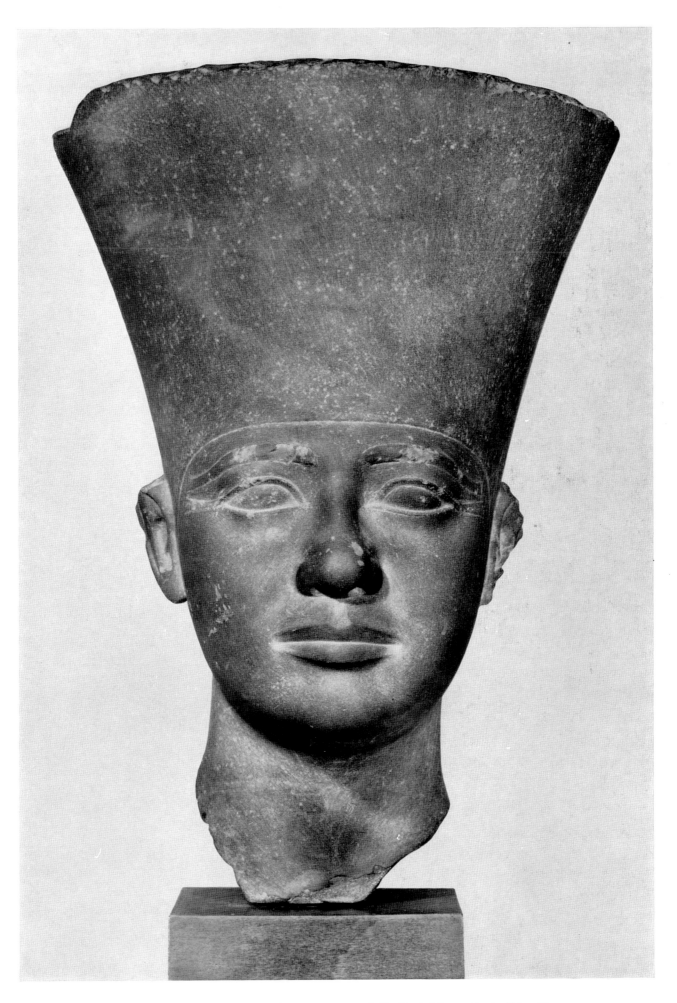

49 King's head, wearing the crown of Lower Egypt, probably Userkaf. From Abusir, Cairo. Museum

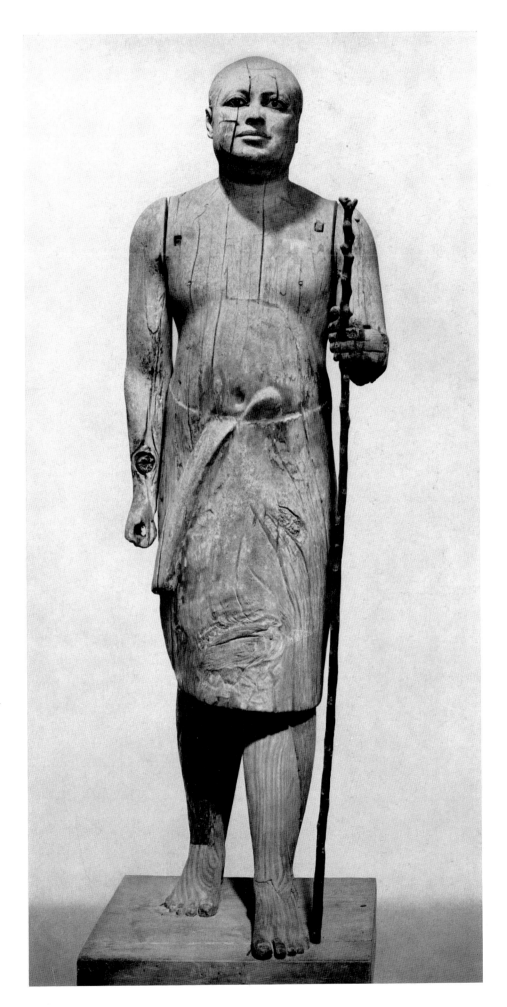

59 Ka-aper. Cairo, Museum

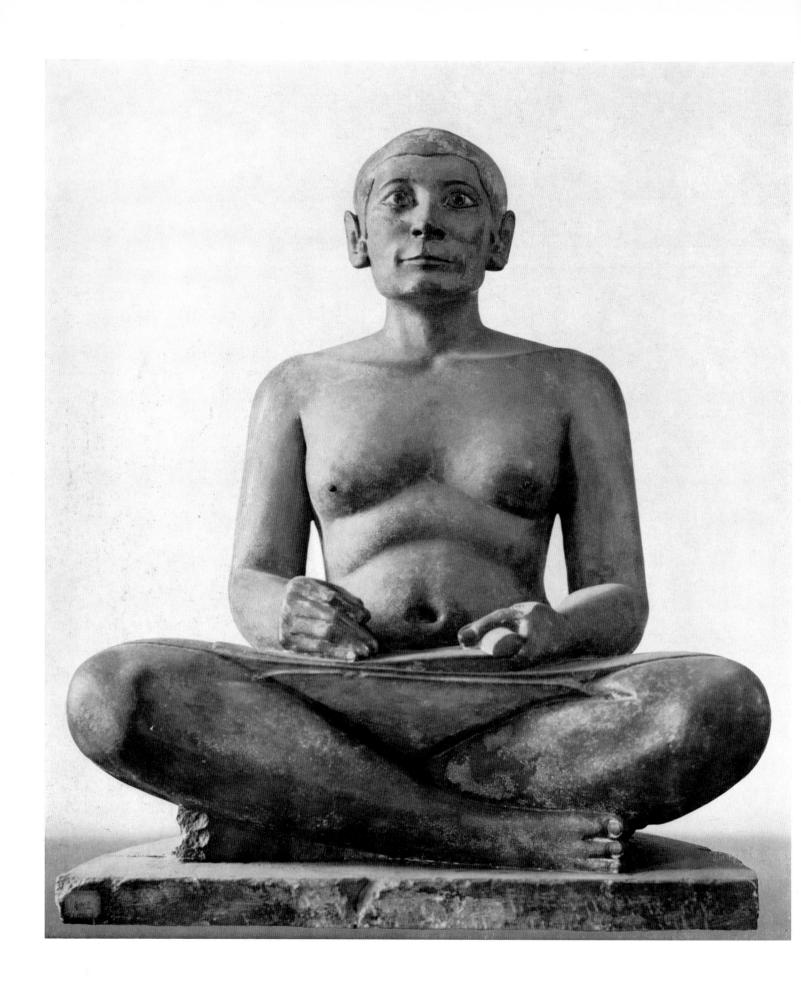

60 An official writing. Paris

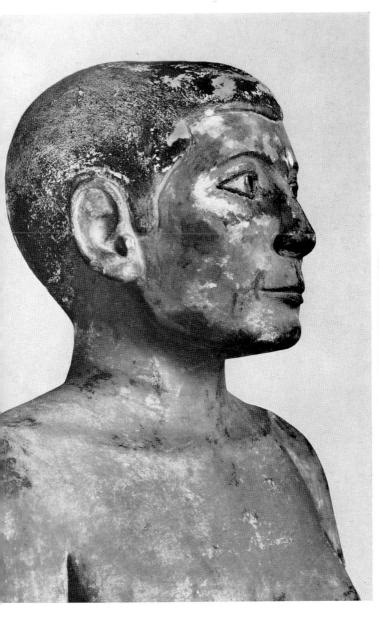

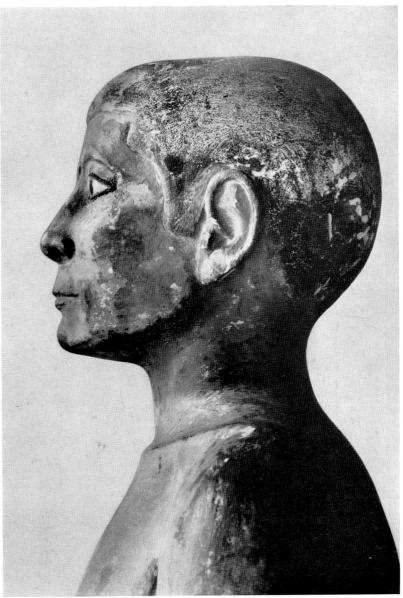

61 An official writing. Paris

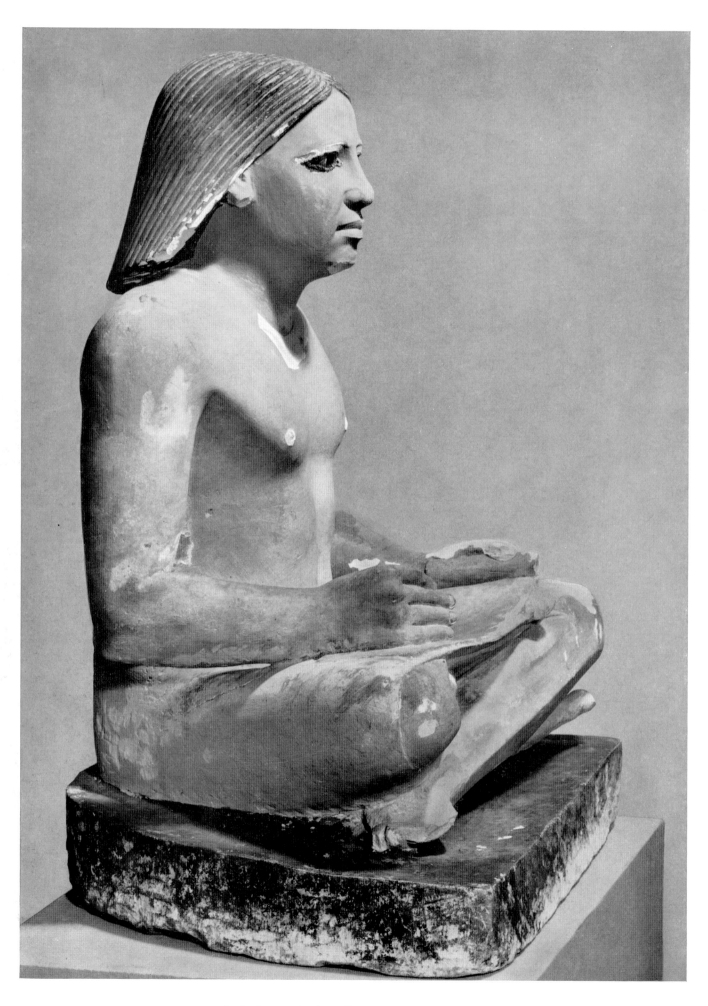

62 Scribe portrait of an unknown man. Cairo, Museum

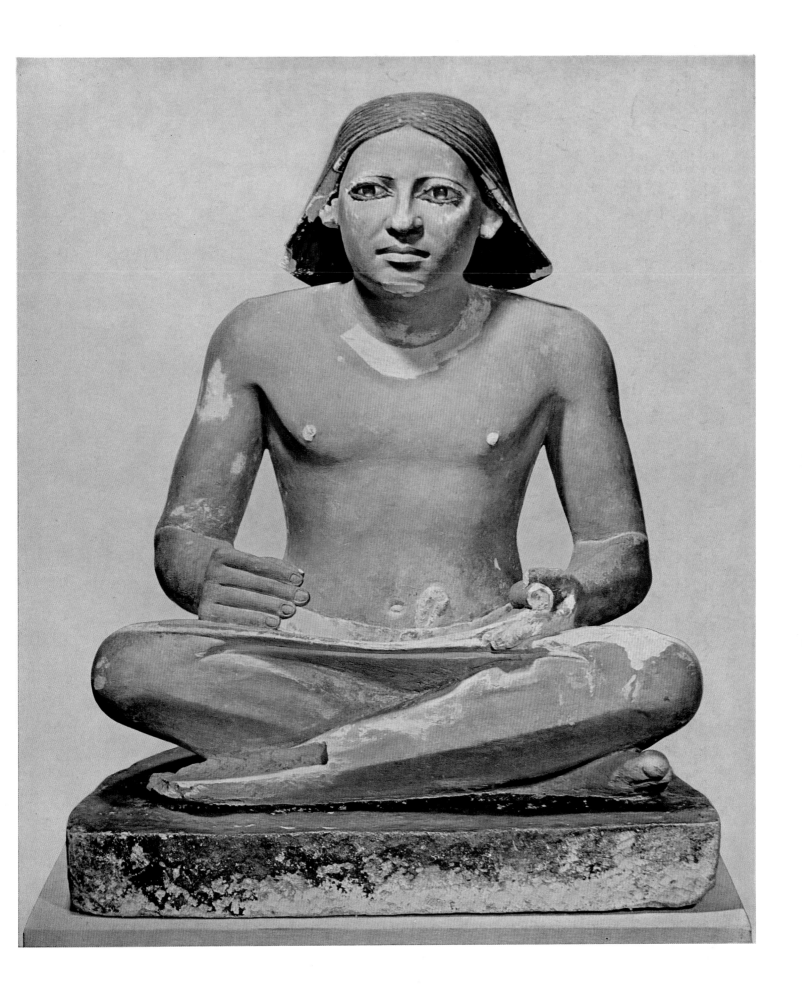

VI Scribe portrait of an unknown man. Cairo, Museum

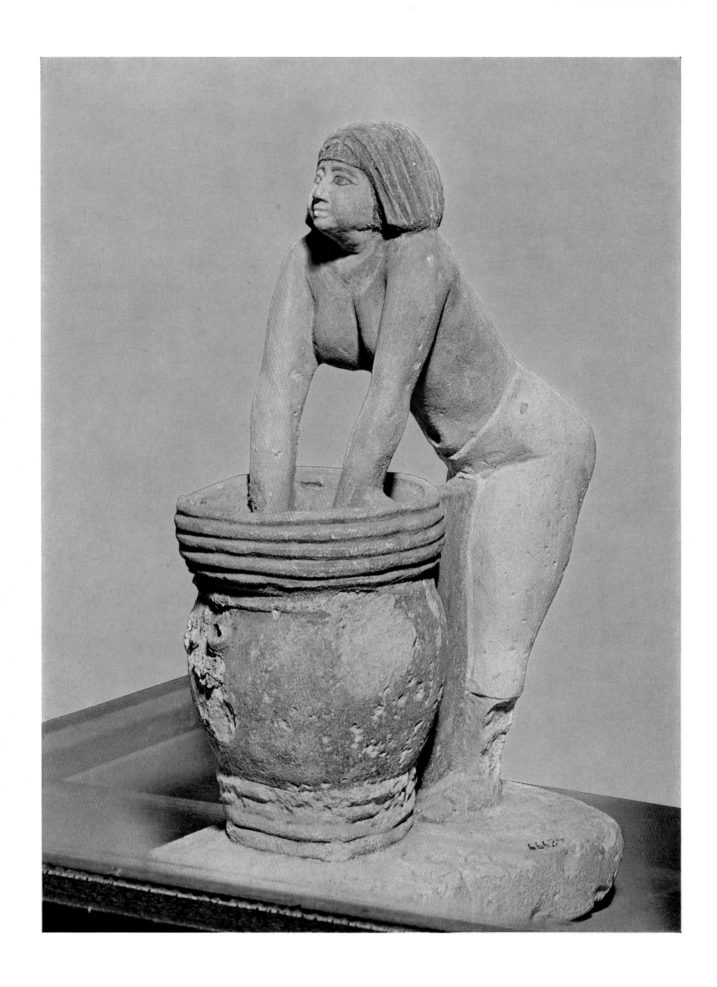

VII Girl preparing beer. Cairo, Museum

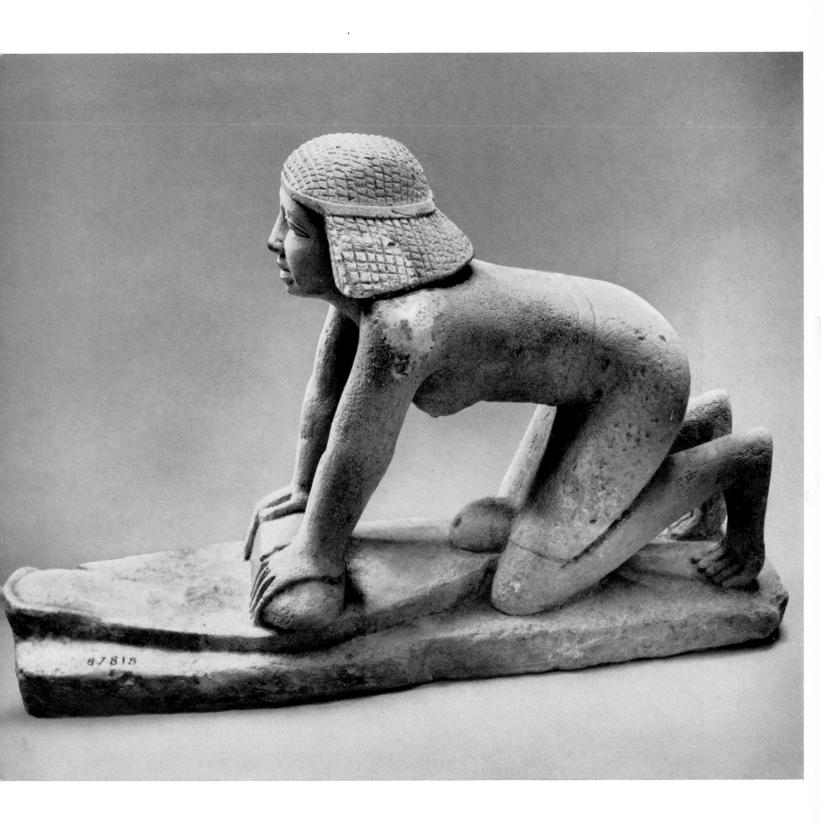

63　Girl grinding corn. Cairo, Museum

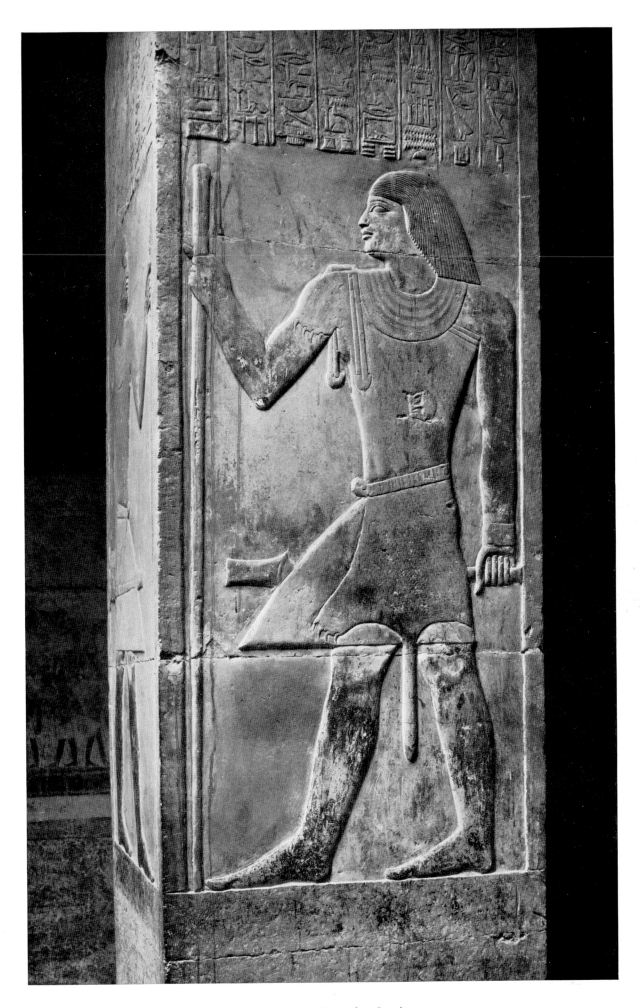

75 Mereruka. In his tomb at Saqqâra

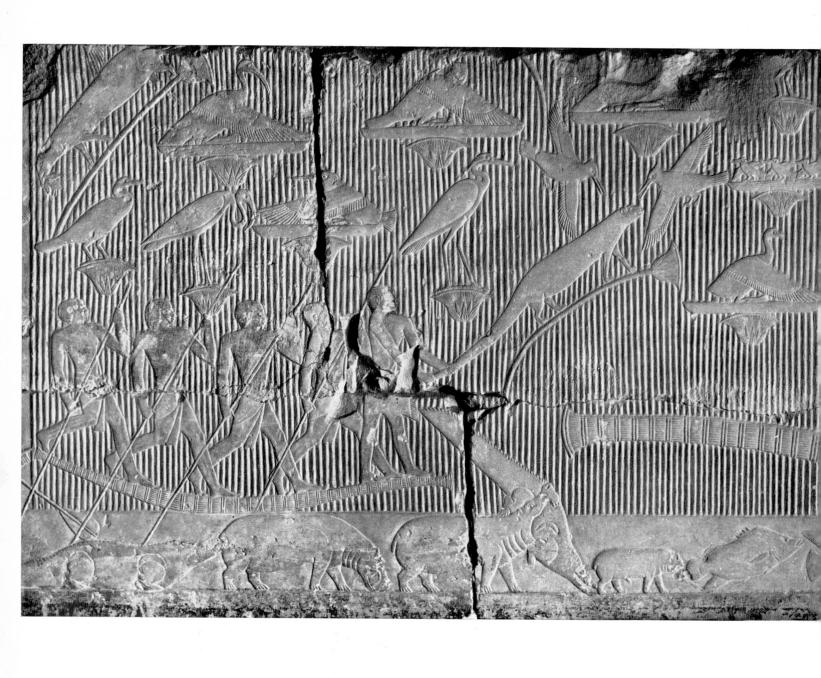

76 A drive in the papyrus thicket. In Mereruka's tomb at Saqqâra

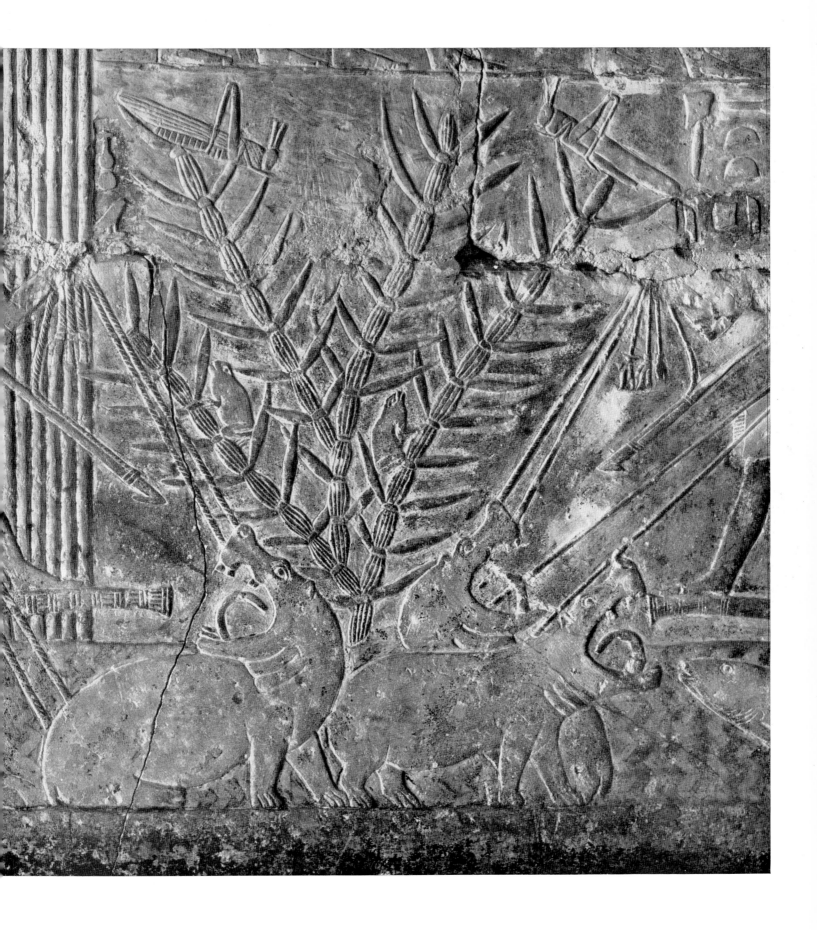

77 Harpooning of a hippopotamus. In Mereruka's tomb at Saqqâra

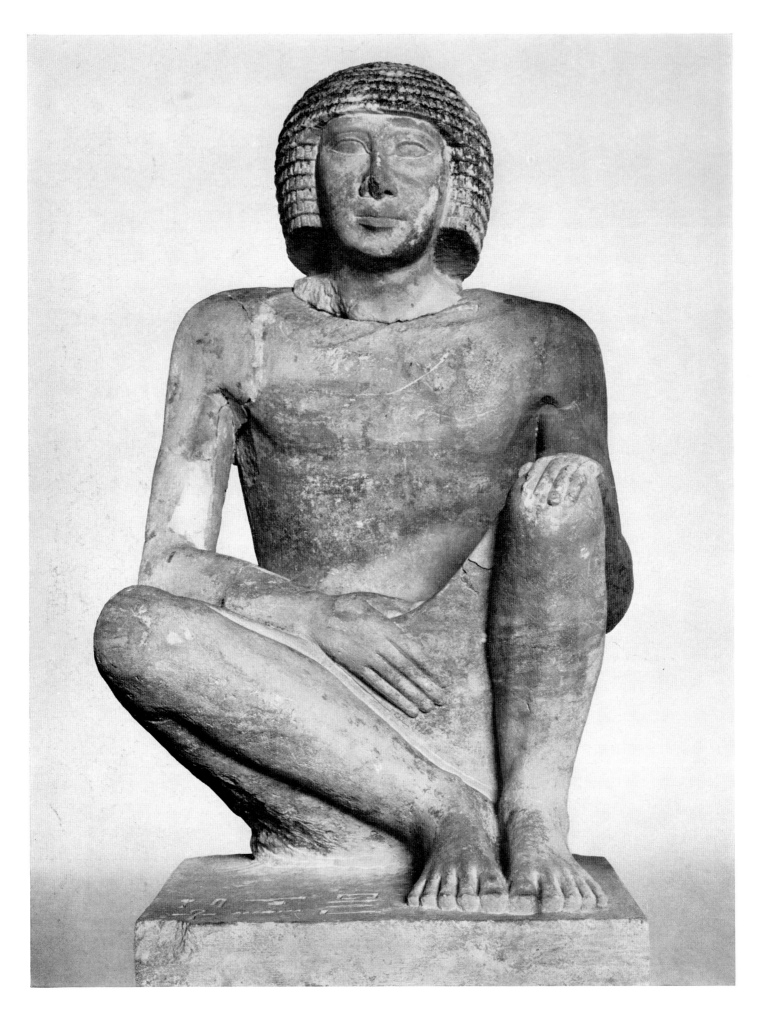

78 Ni'ankhre, the chief of the physicians. Cairo, Museum

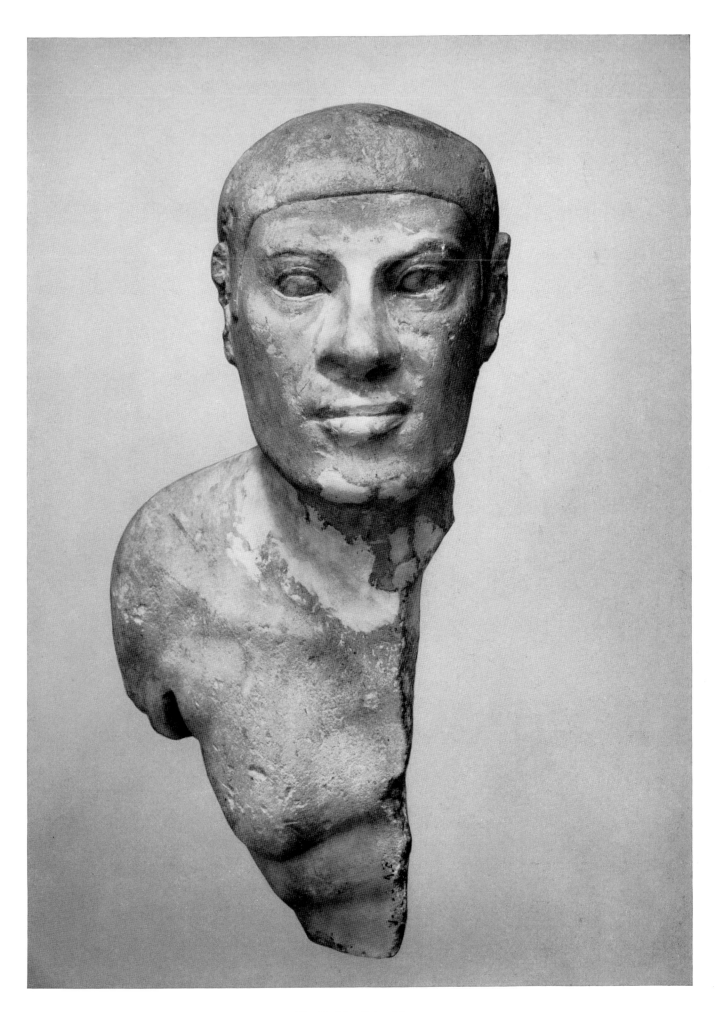

79 Urchûu. Cairo, Museum

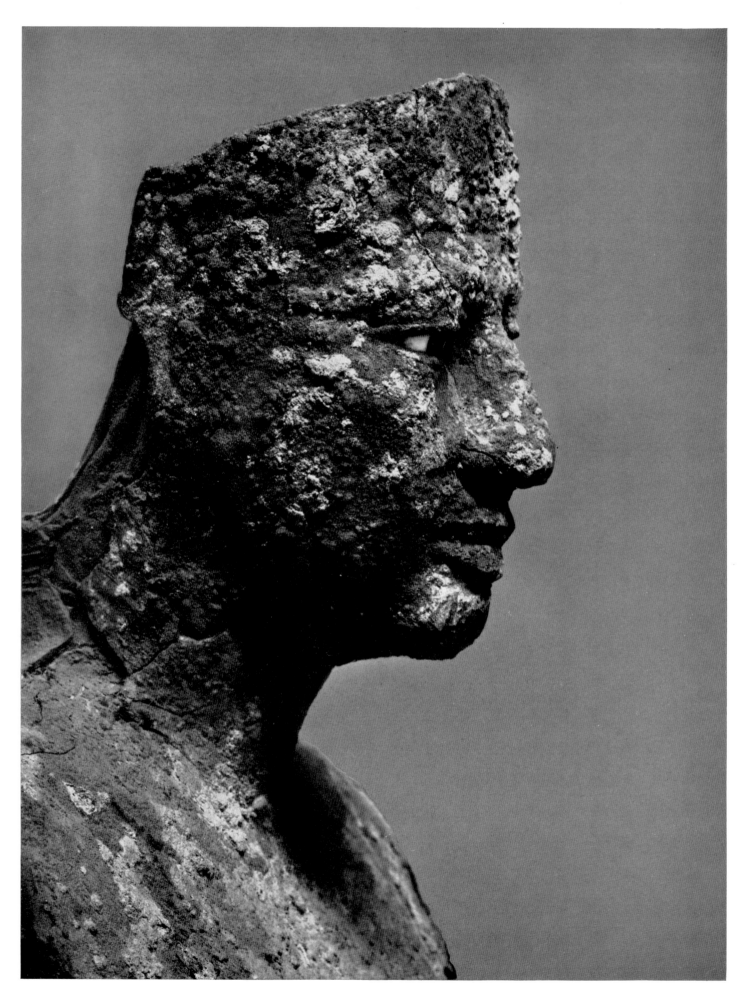

80 King Pepi I. Cairo, Museum

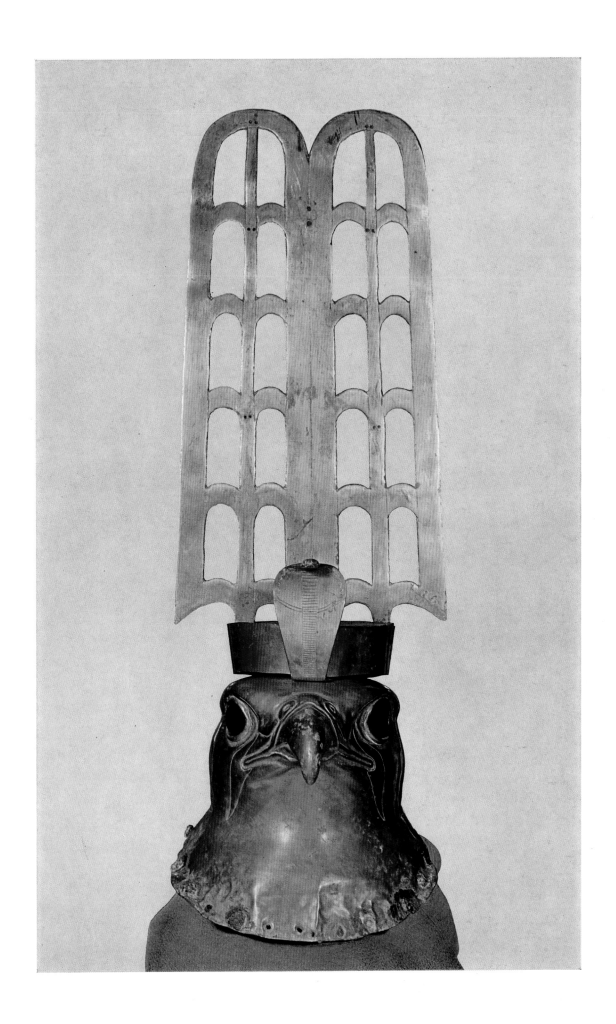

X Falcon from Hieraconpolis. Gold. Cairo, Museum

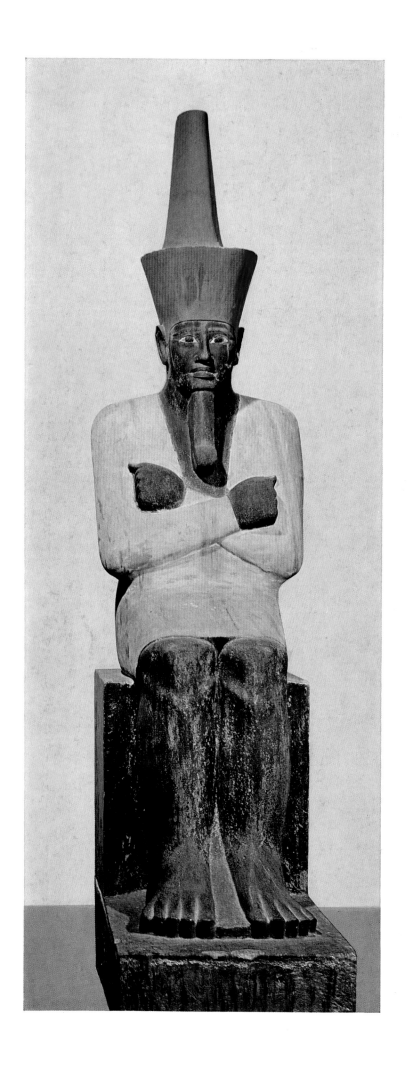

MIDDLE
KINGDOM
ELEVENTH DYNASTY
(2133-1992)

XI King Mentuhotep. Cairo, Museum

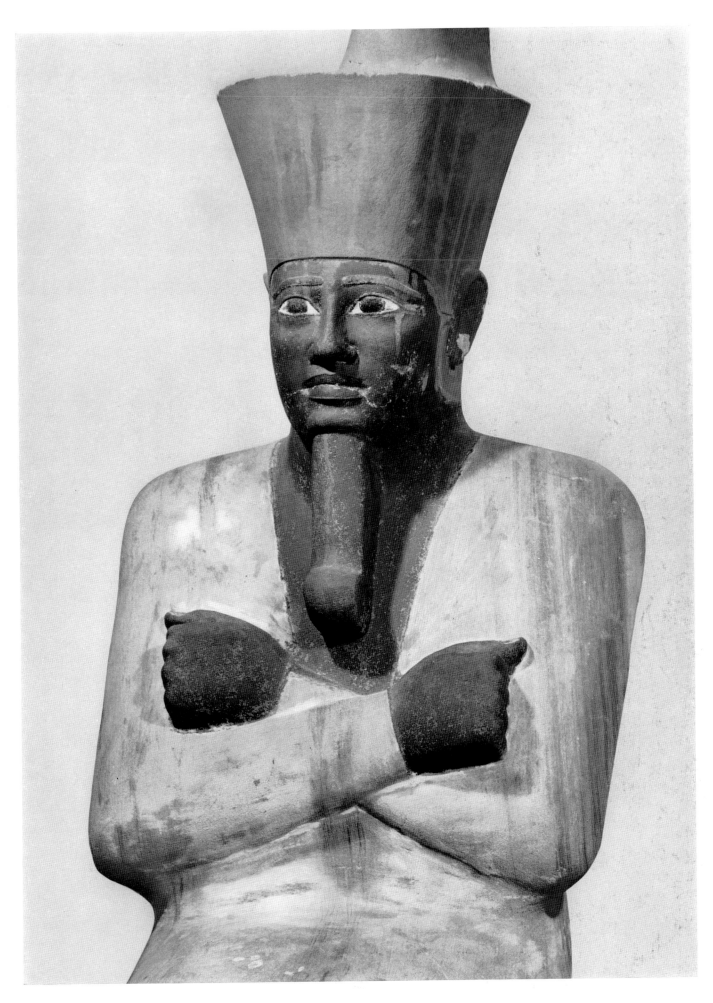

81 King Mentuhotep. Cairo, Museum

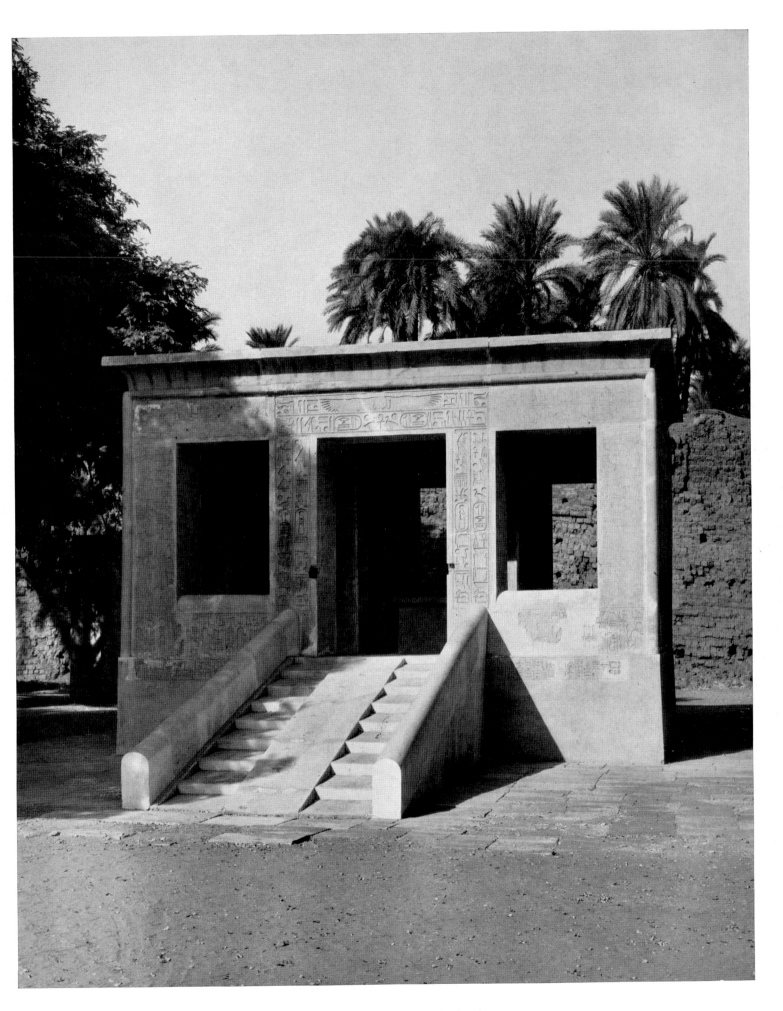

91 Chapel of King Sesostris I in Karnak

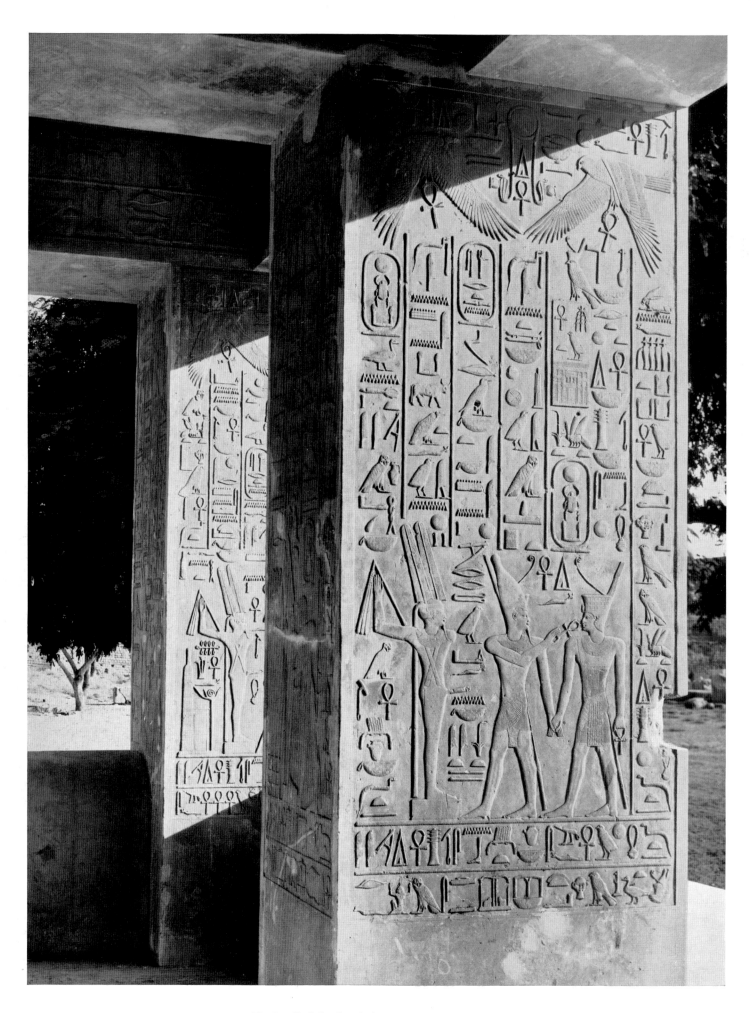

92 Detail of the chapel of King Sesostris I in Karnak

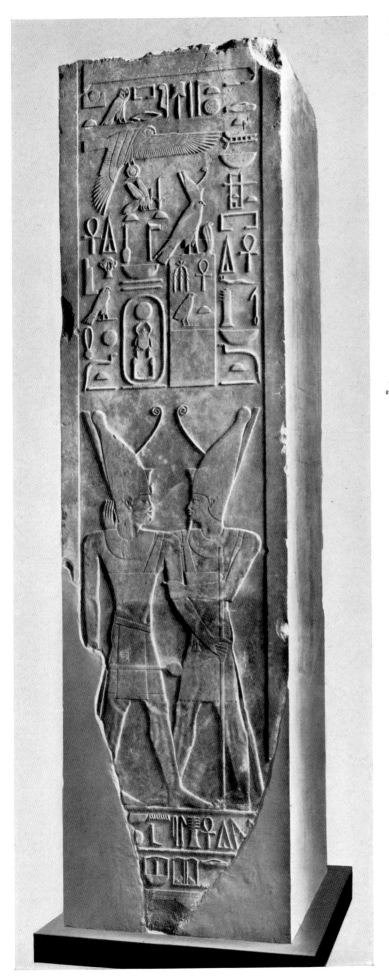
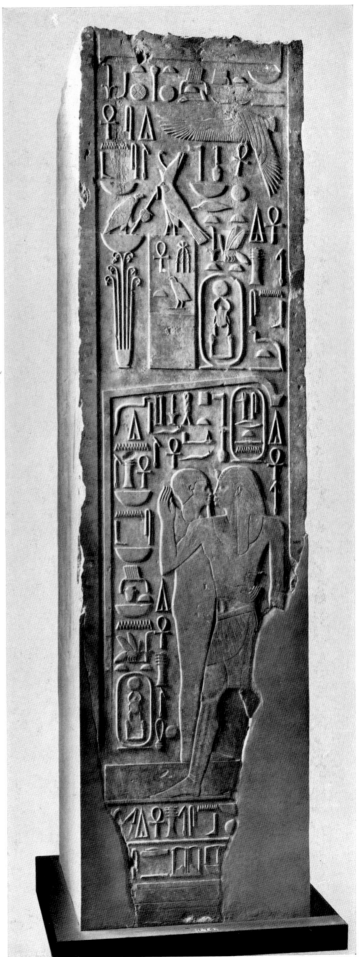

93 Pillar from a building of King Sesostris I, two sides. Cairo, Museum

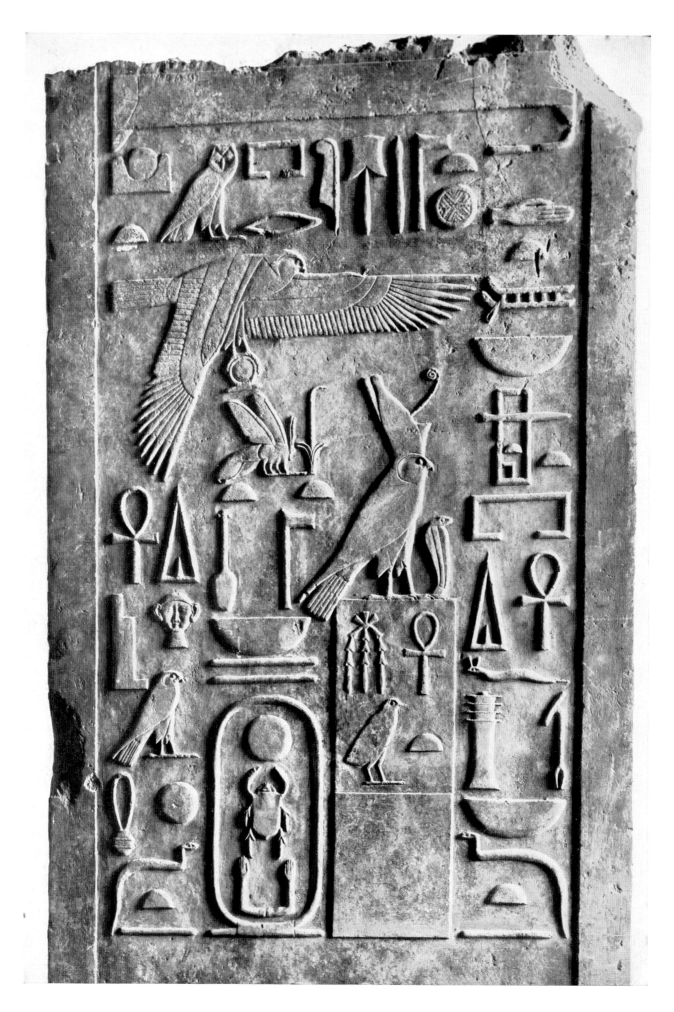

94 Upper portion of the pillar from a building of King Sesostris I from Karnak. Cairo, Museum

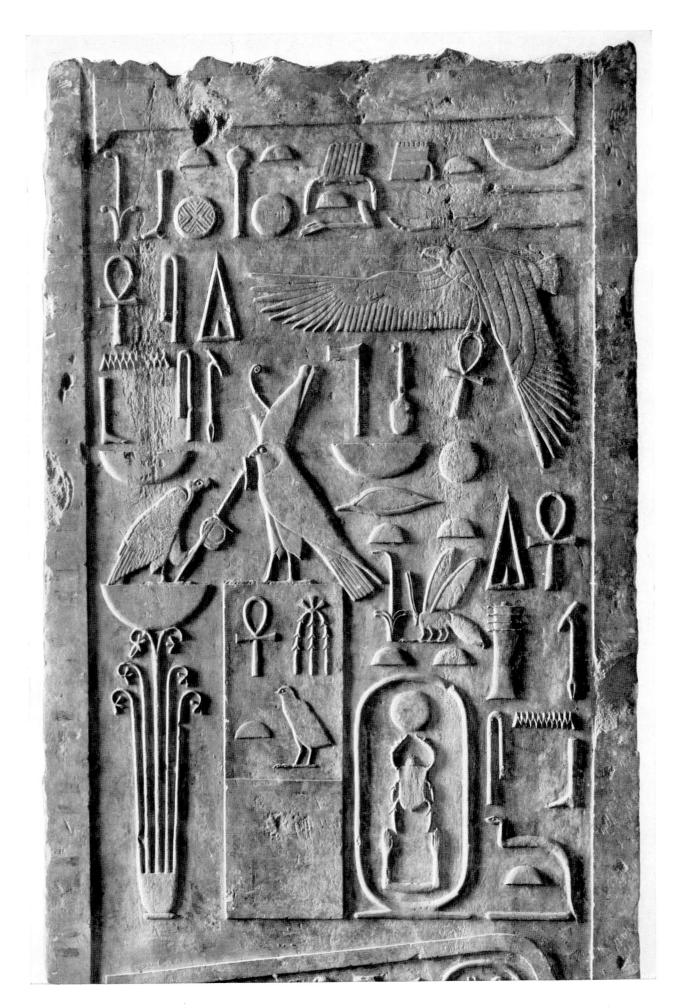

95 Upper portion of the pillar from a building of King Sesostris I from Karnak. Cairo, Museum

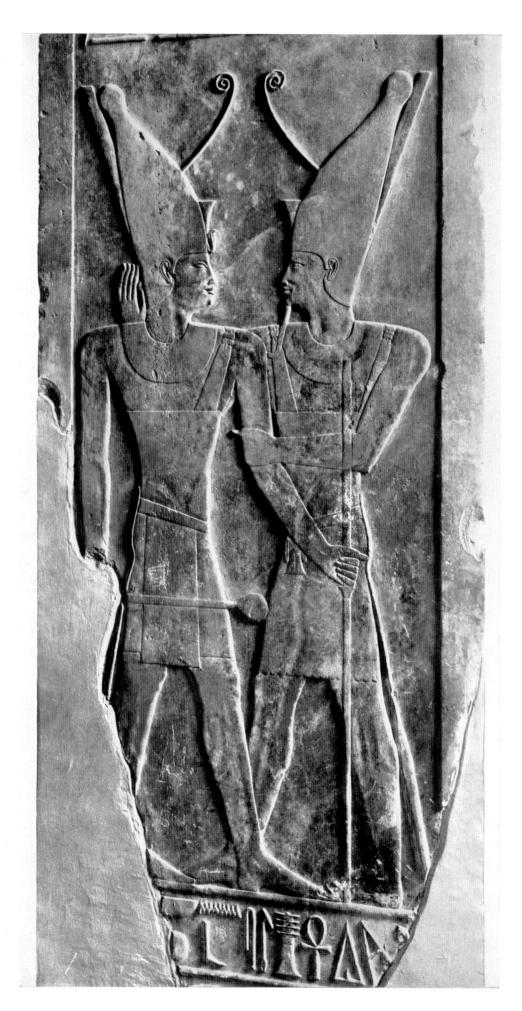

96　King Sesostris I and the god Atum. Pillar relief. Cairo, Museum

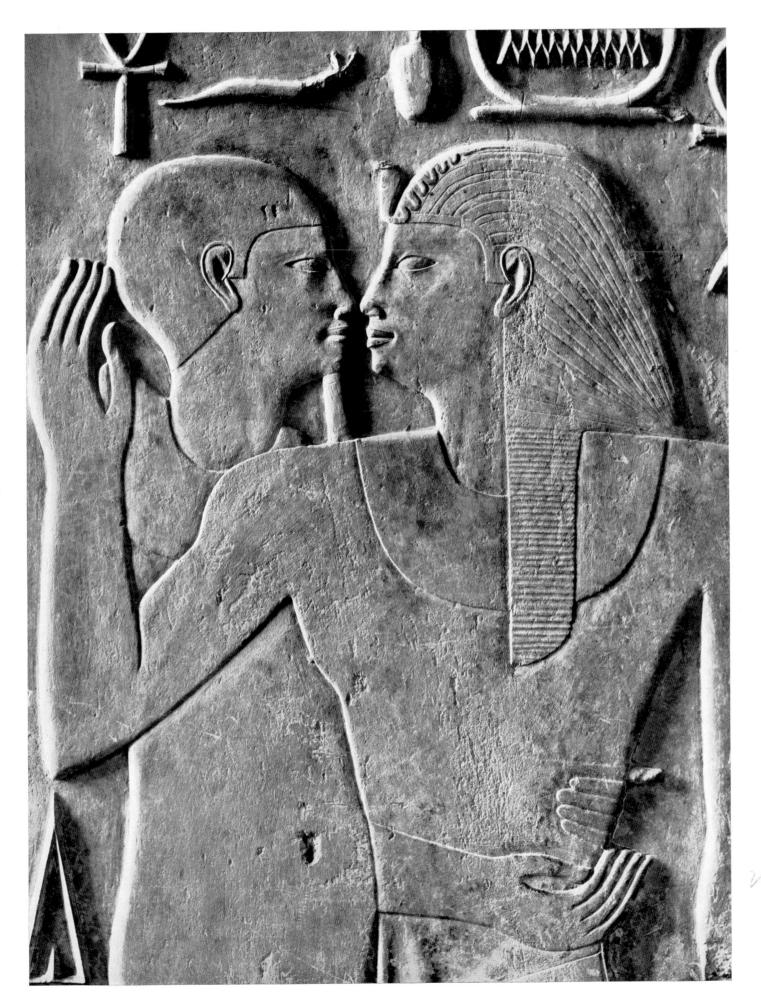

97 King Sesostris I and the god Ptah. Pillar relief. Cairo, Museum

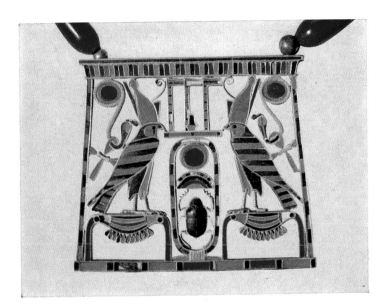

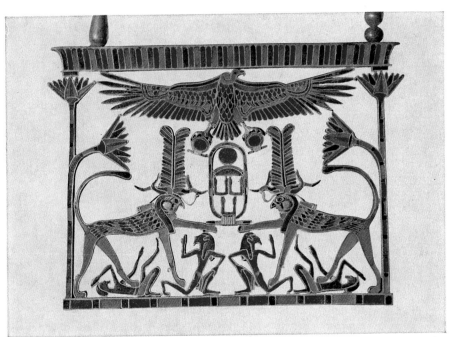

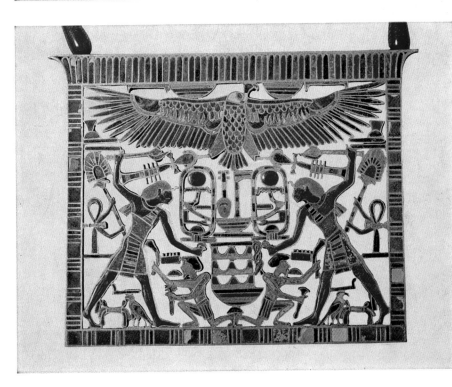

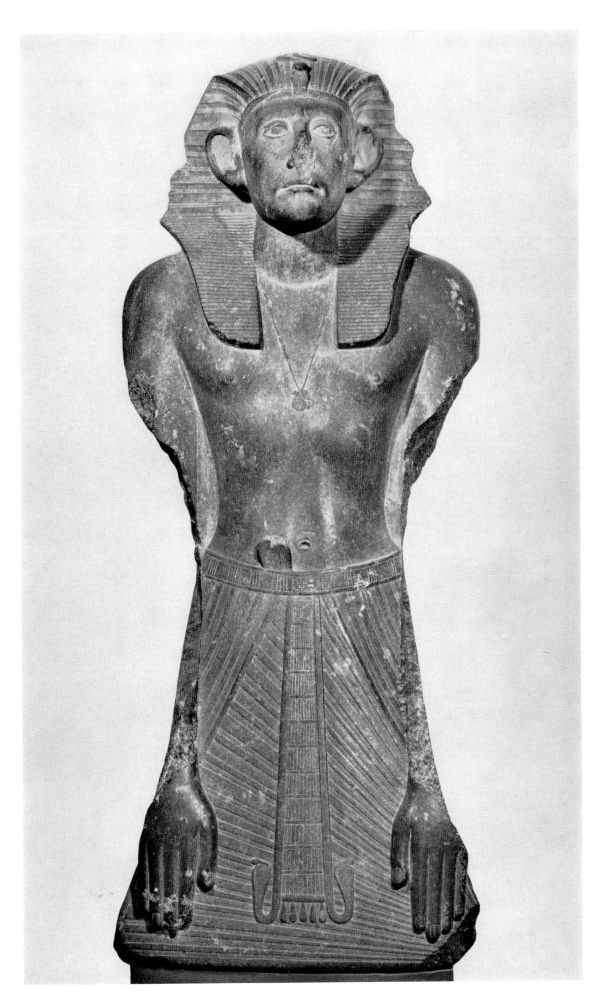

107 King Sesostris III in adoration. Cairo, Museum

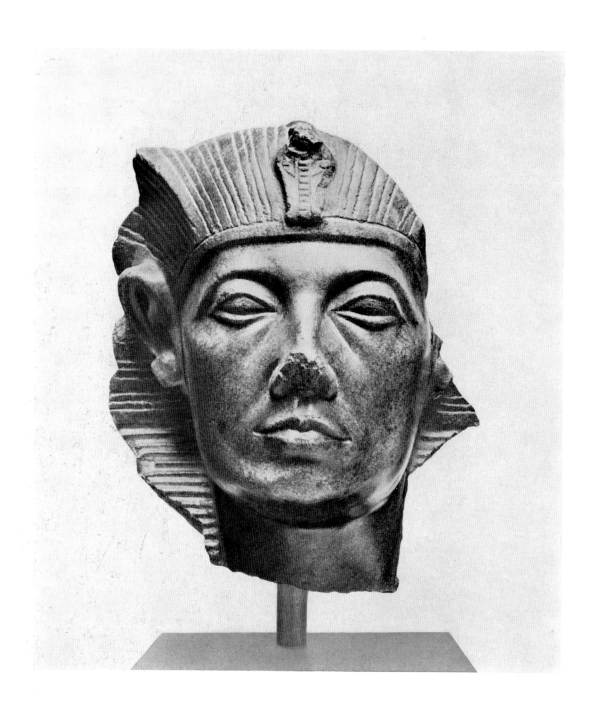

108 King Sesostris III. Berlin

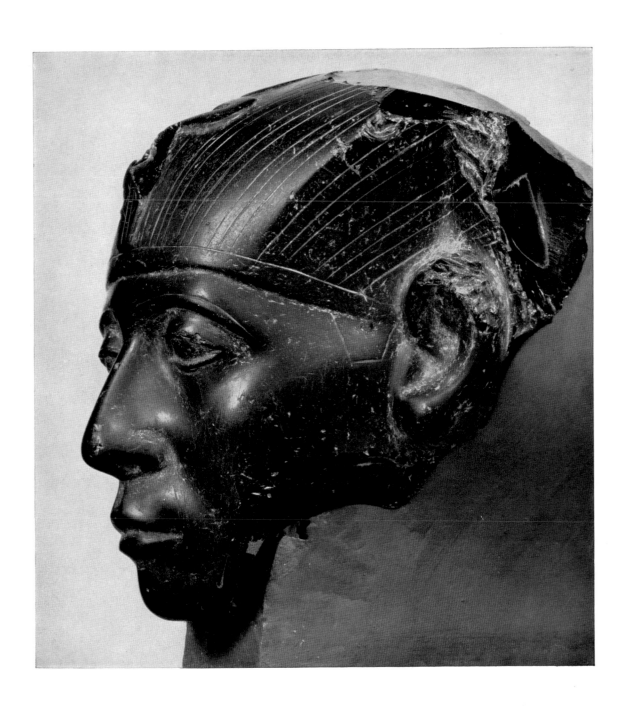

109 King Sesostris III. Washington

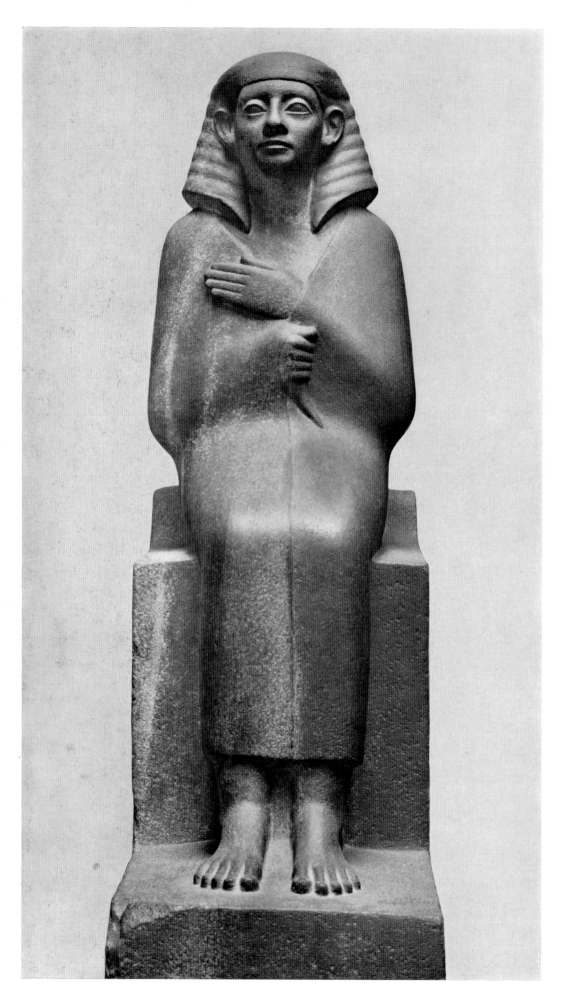

112 Chertihotep, superintendent. Berlin

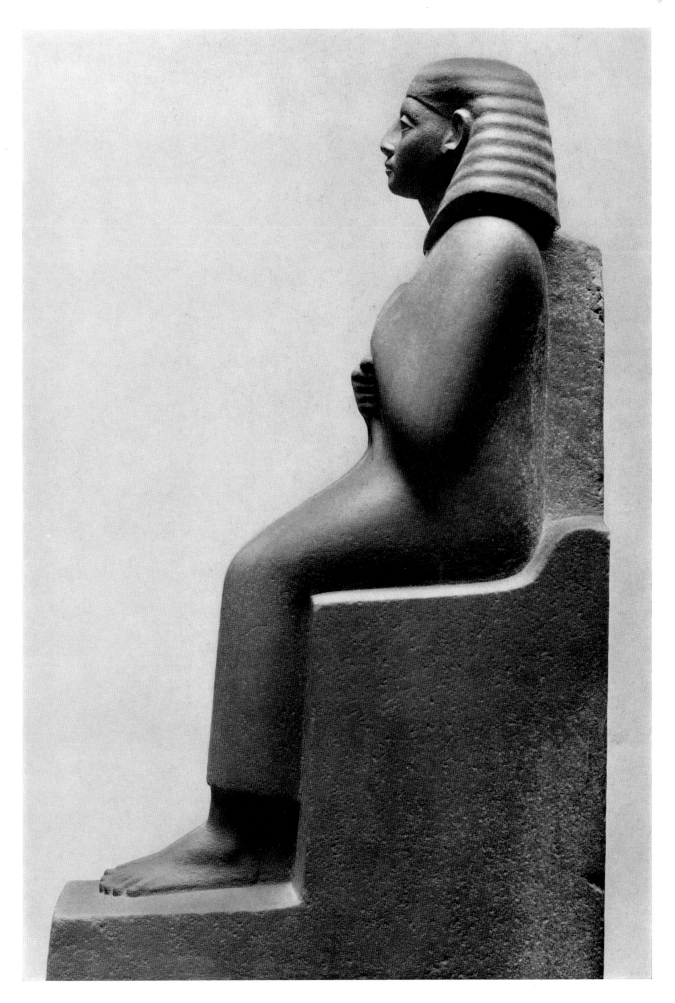

113 Chertihotep, superintendent. Berlin

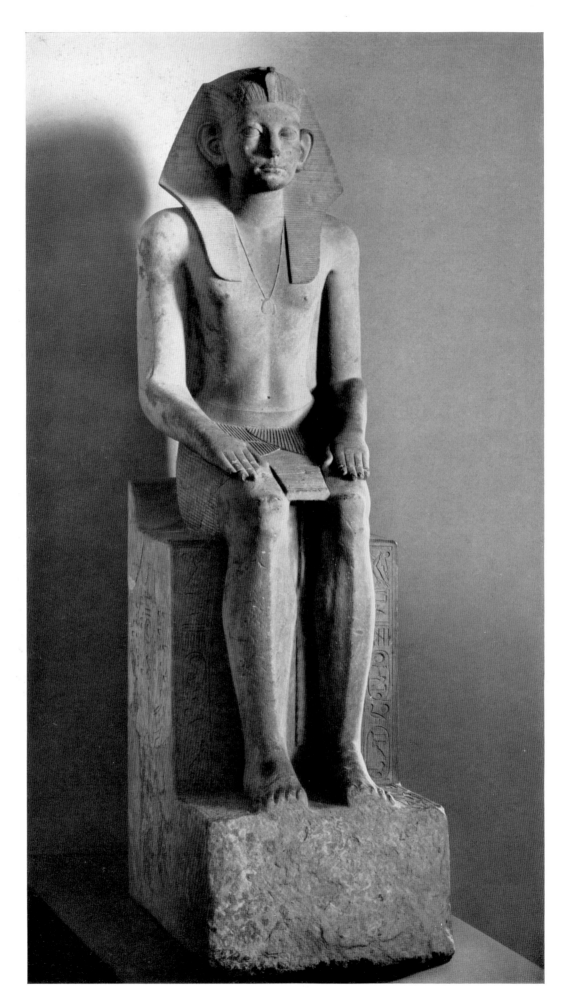

114 King Ammenemēs III. Cairo, Museum

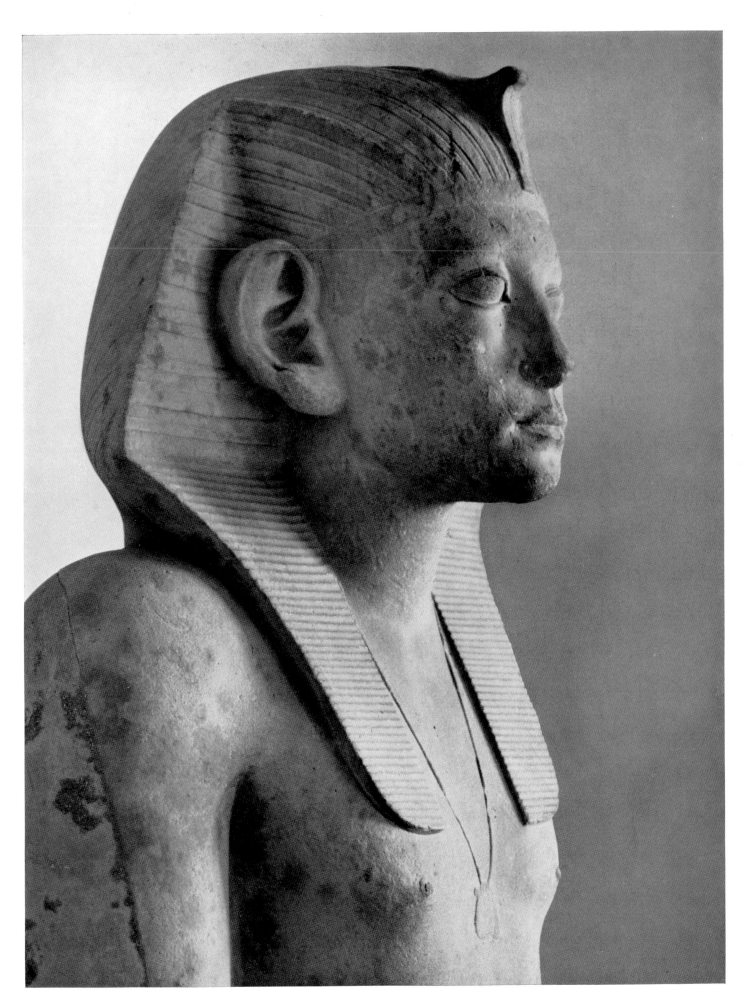

115 King Ammenemēs III. Cairo, Museum

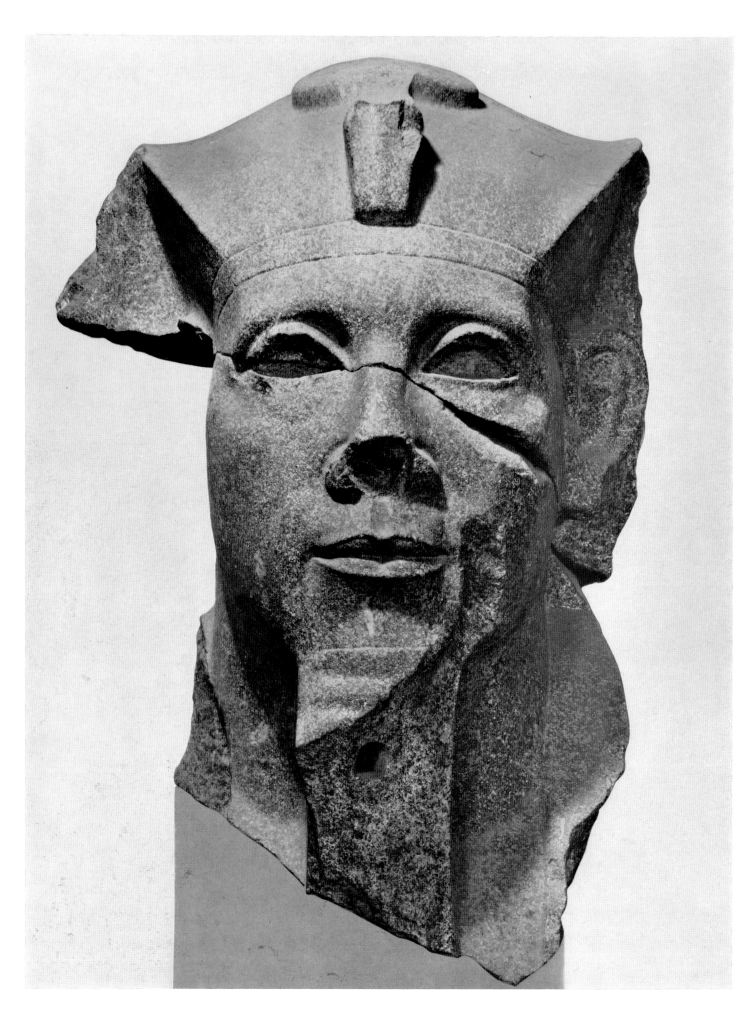

116 King Ammenemēs III. Cairo, Museum

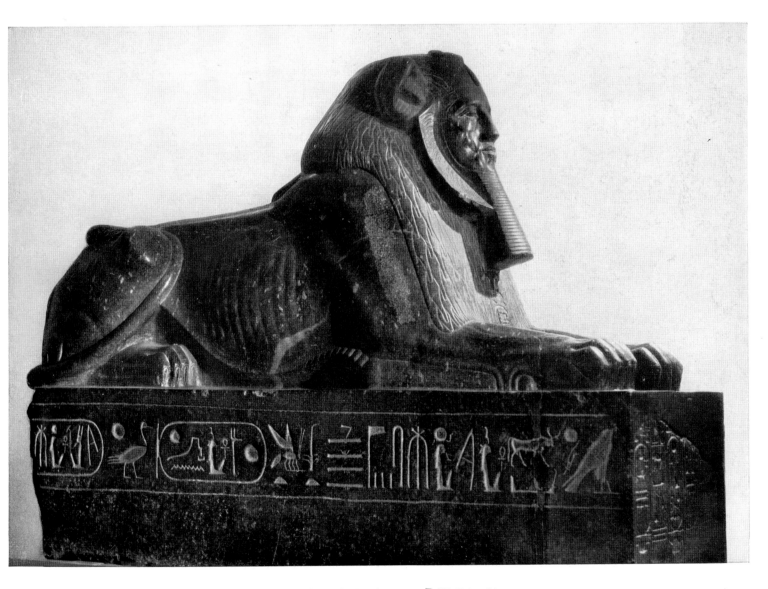

117 Maned sphinx of King Ammenemēs III. Cairo, Museum

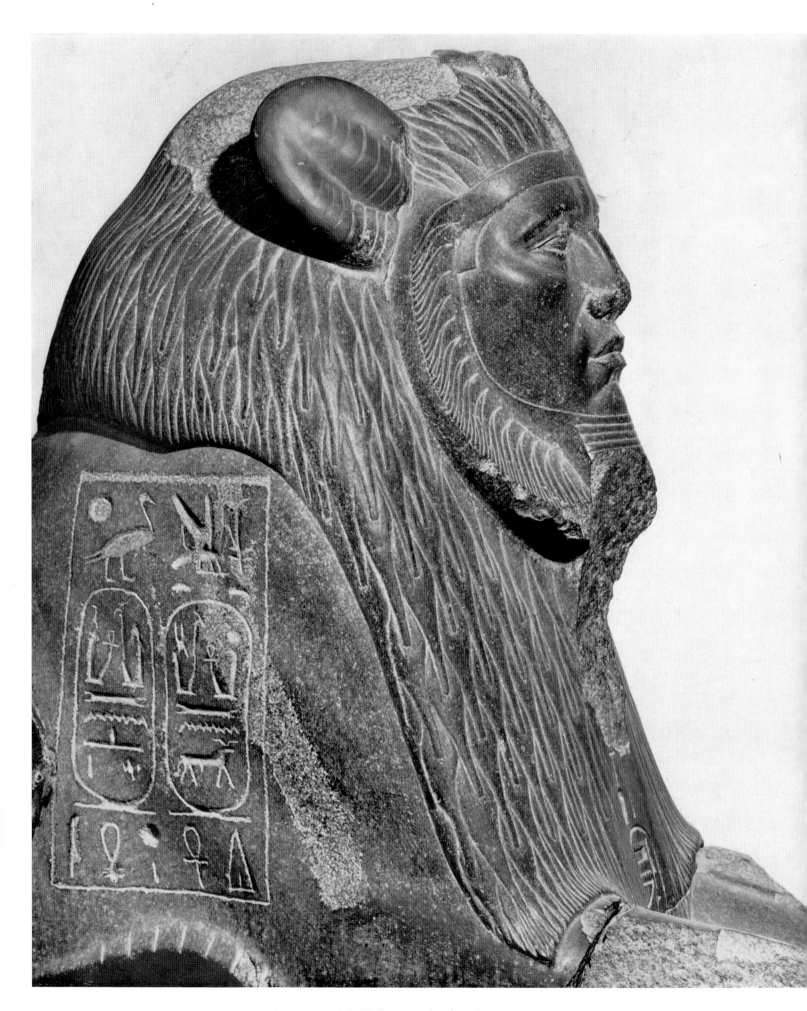

118/119 Maned sphinx of King Ammenemēs III. Cairo, Museum

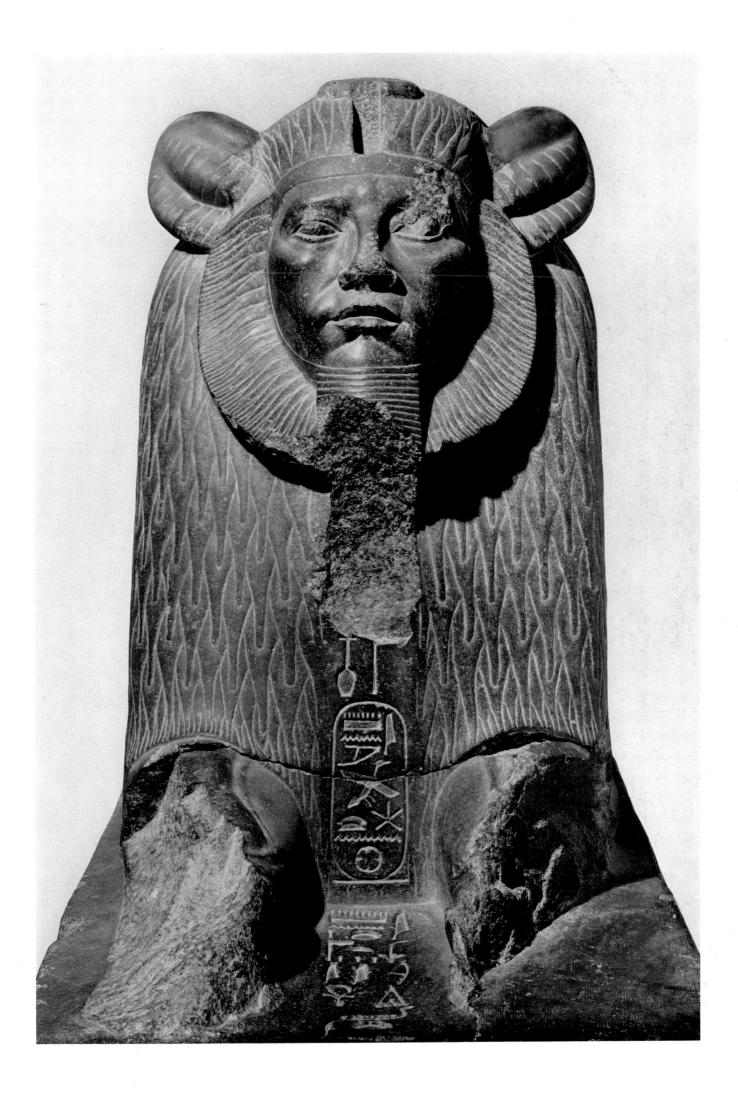

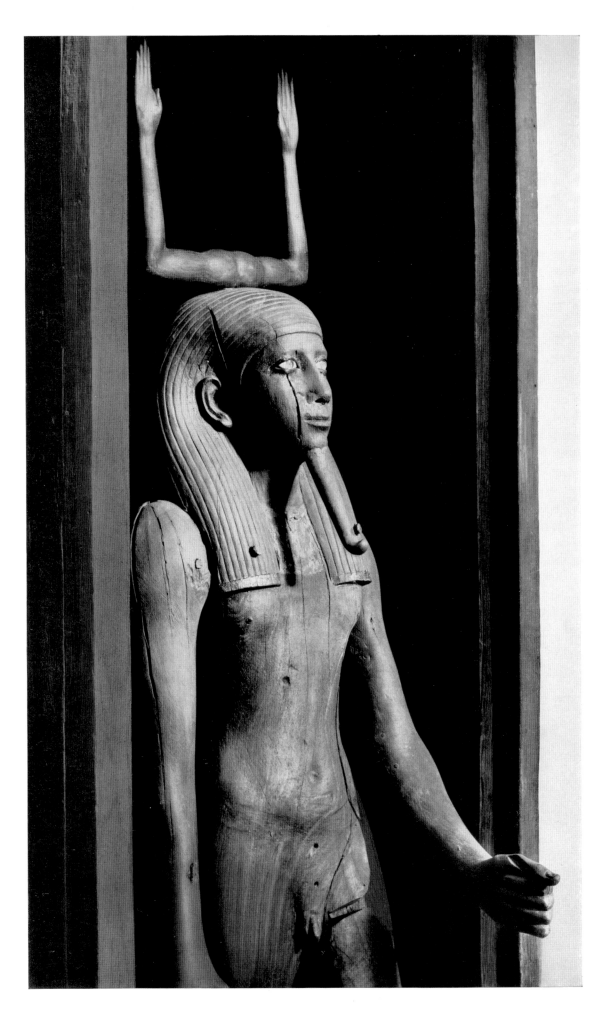

120 Ka statue of King Hor. Cairo, Museum

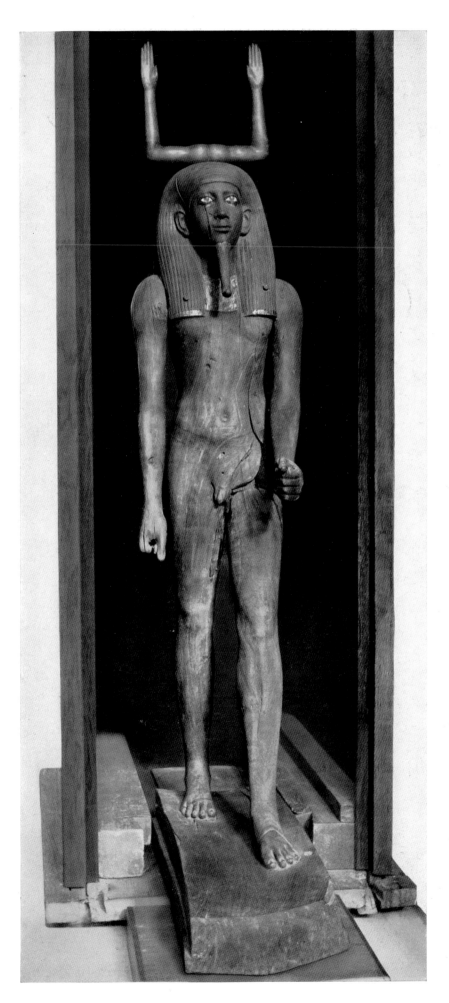

121 Ka statue of King Hor in his shrine. Cairo, Museum

NEW EMPIRE

EIGHTEENTH DYNASTY (1552–1306)

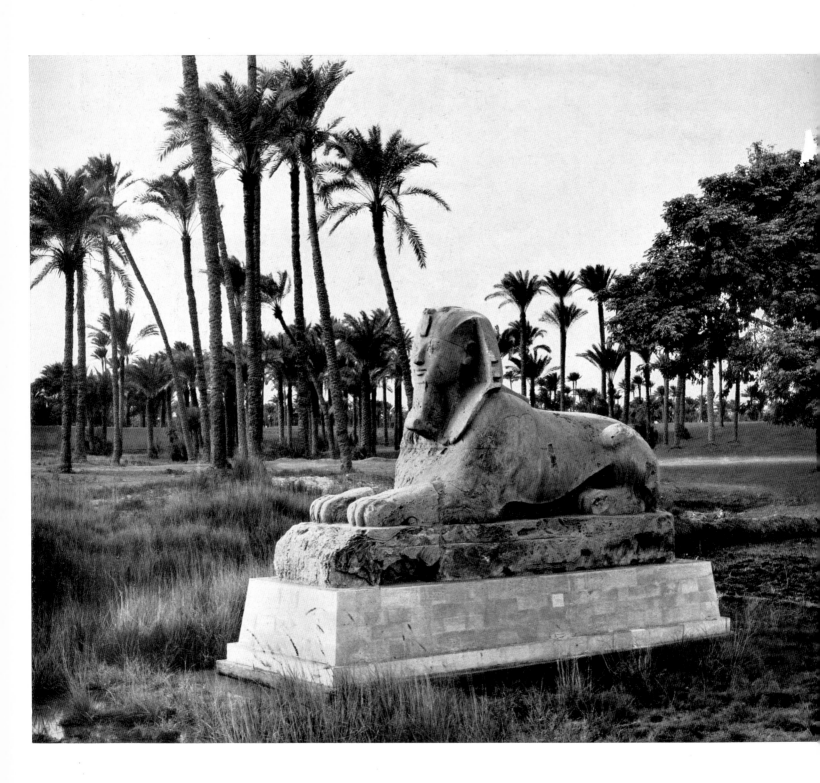

122 Alabaster Sphinx in the Memphis Temple Zone

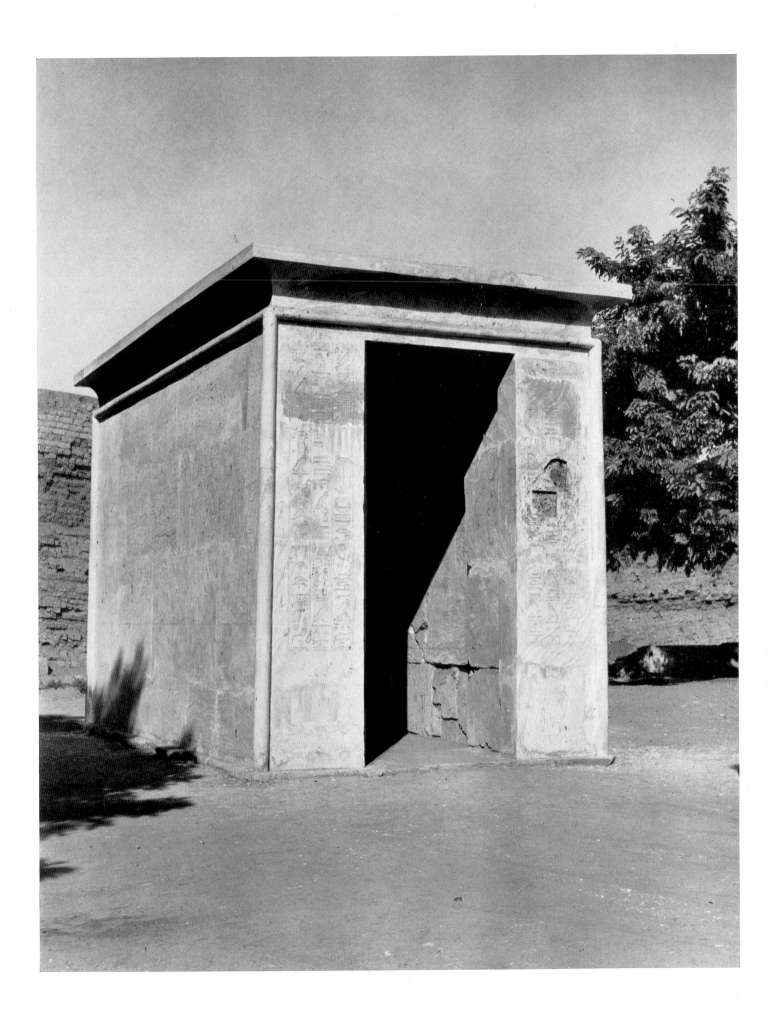

123 Karnak. Shrine for the Bark of Amun, erected by King Amenophis I

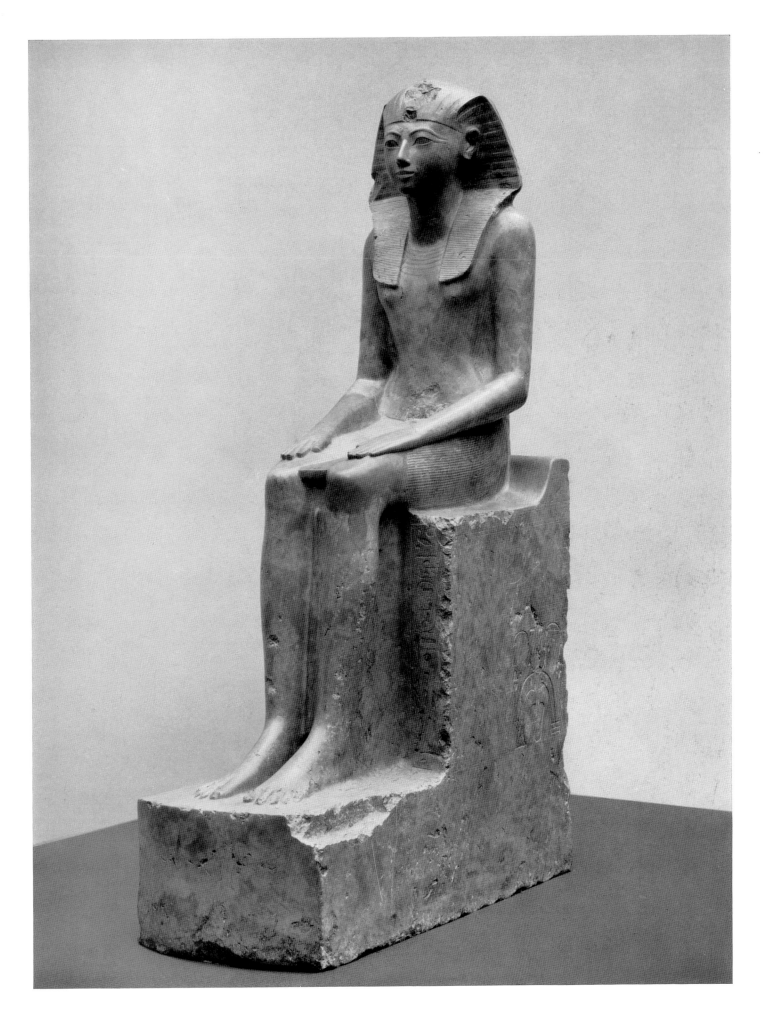

133 Queen Hatshepsut. New York

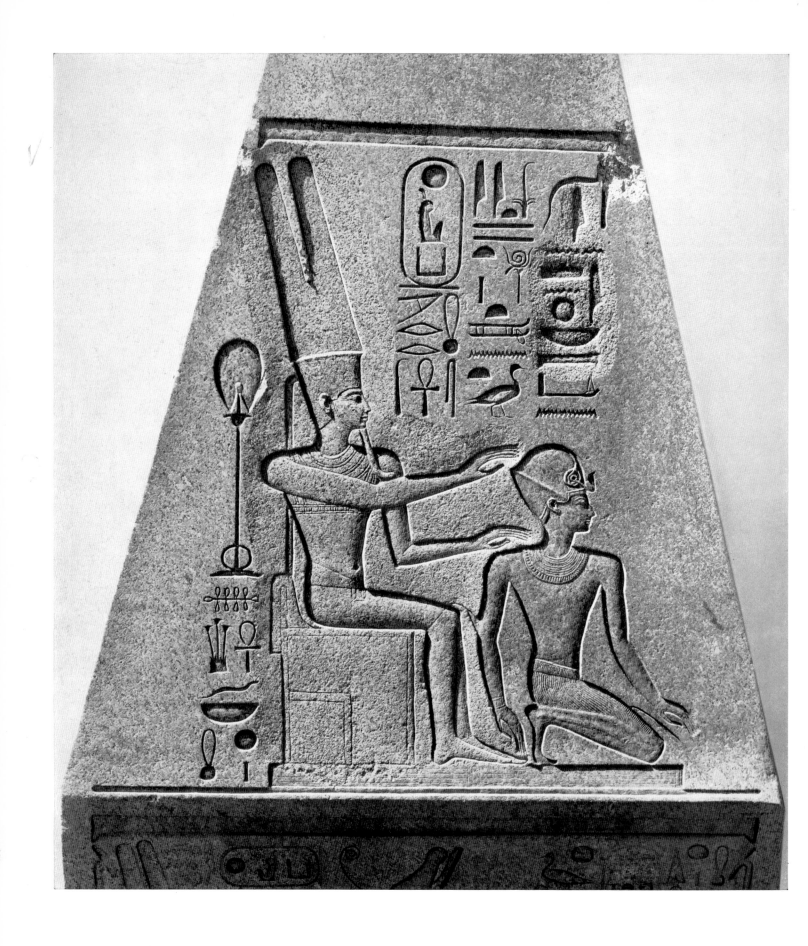

134 Karnak. Temple of the national god Amun: The god Amun-Rē and the Queen, from an obelisk of Queen Hatshepsut

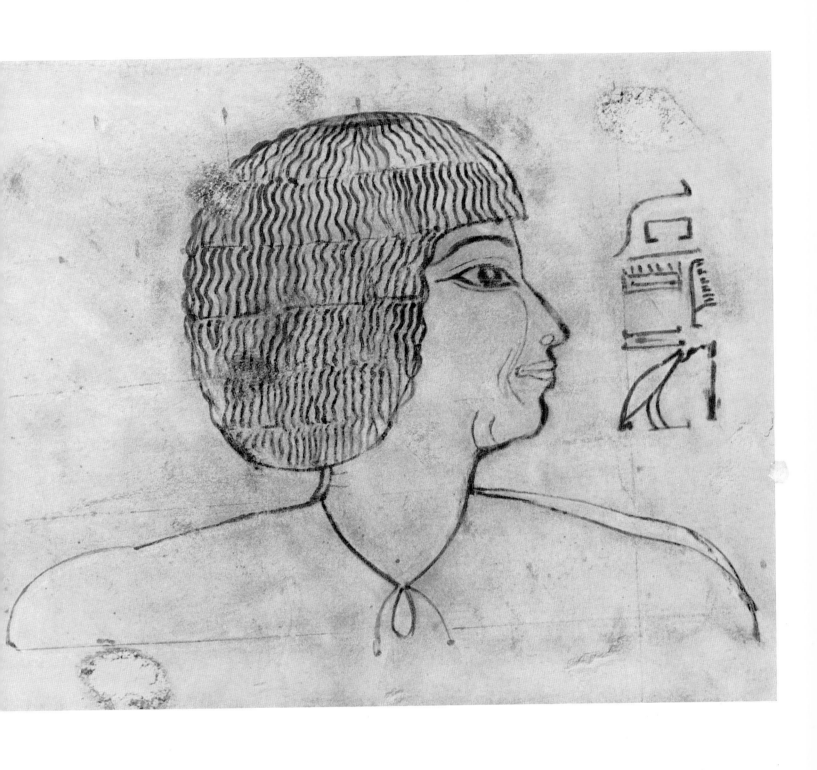

135 Senmut, chancellor during the reign of Queen Hatshepsut, in his tomb near the temple of Queen Hatshepsut at Thebes (Der-el-bahri)

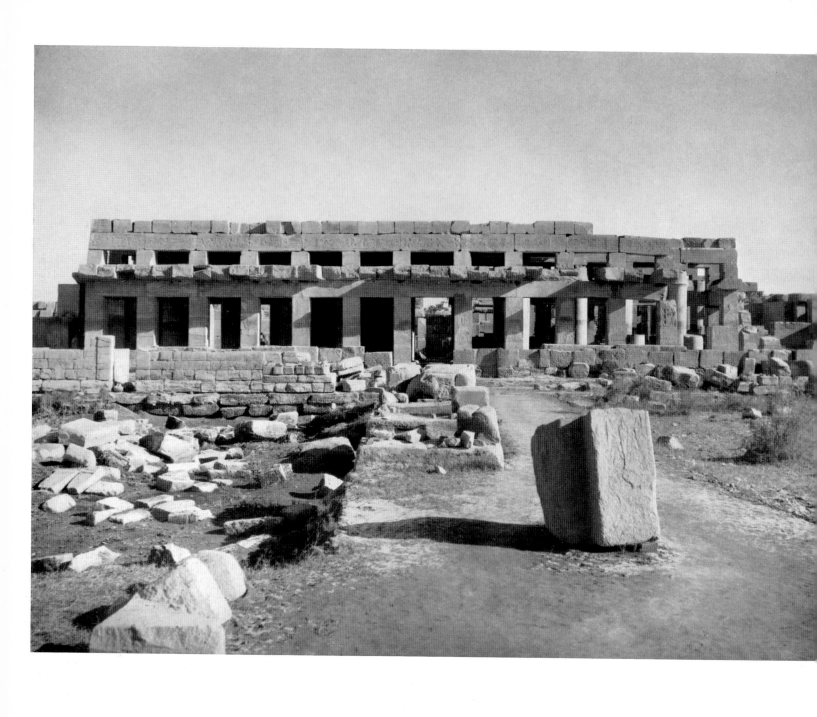

136 Karnak. Temple of Amun. Ceremonial temple of King Tuthmosis III, west front

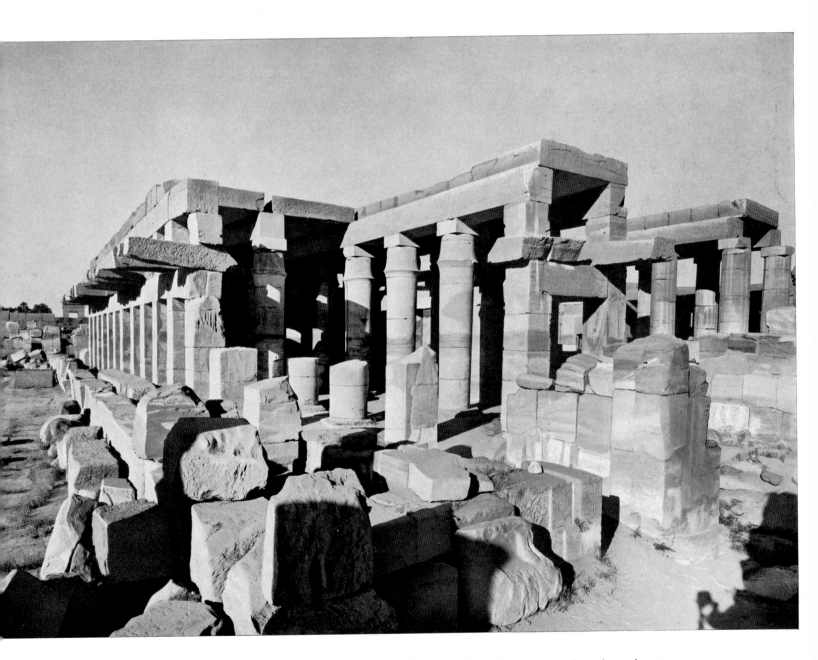

137　Karnak. Temple of Amun. Ceremonial temple of King Tuthmosis III, the three naves seen from the south-west

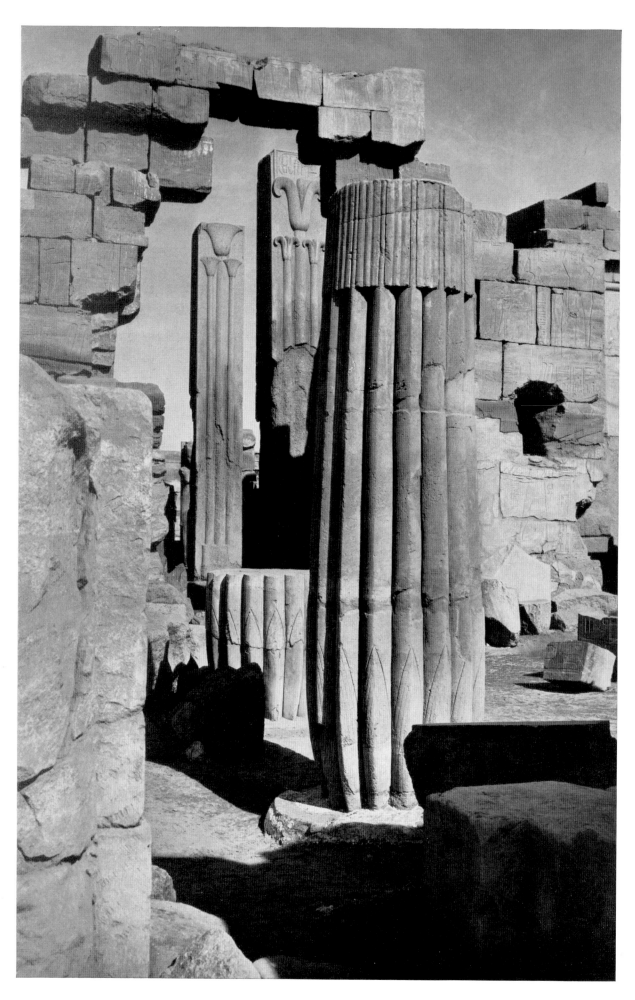

138 Karnak. Temple of Amun. Southern court and Hall of Annals of King Tuthmosis III

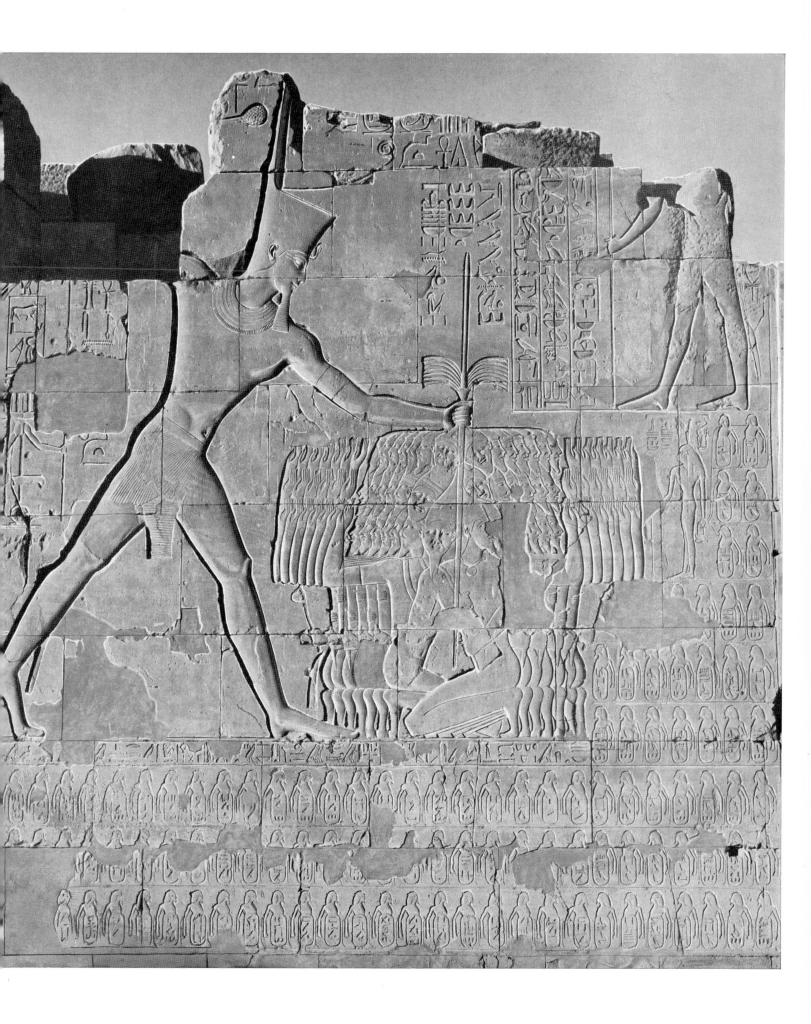

139 Karnak. Temple of Amun. Seventh pylon: King Tuthmosis III smiting the Asiatics

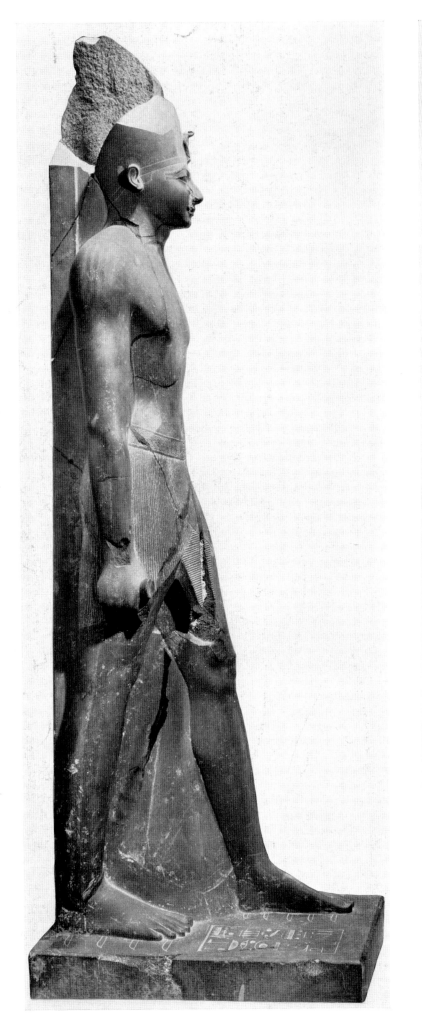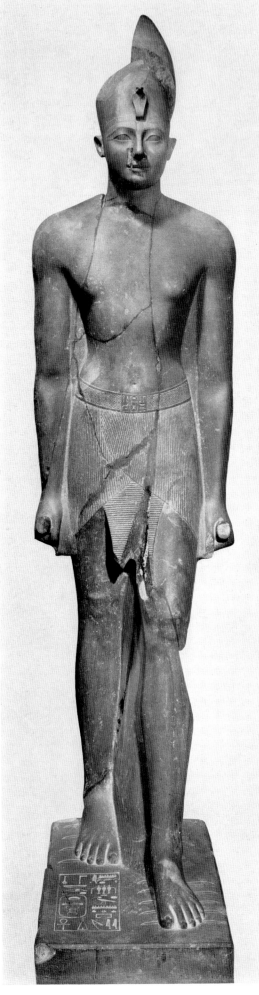

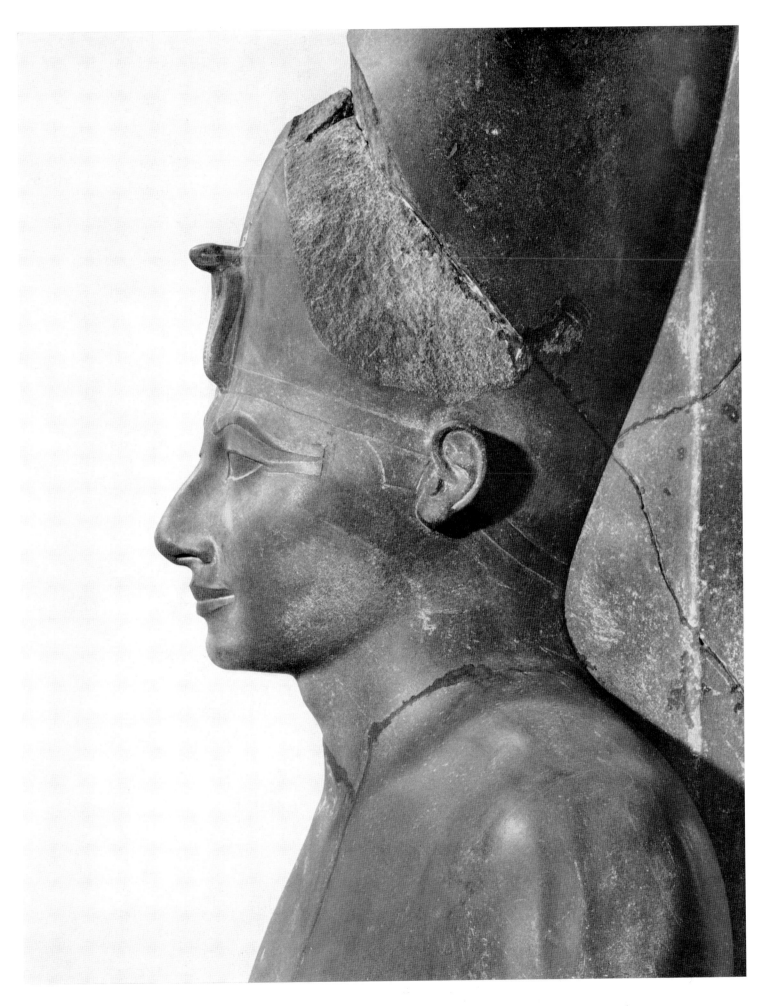

140/141 King Tuthmosis III. Cairo, Museum

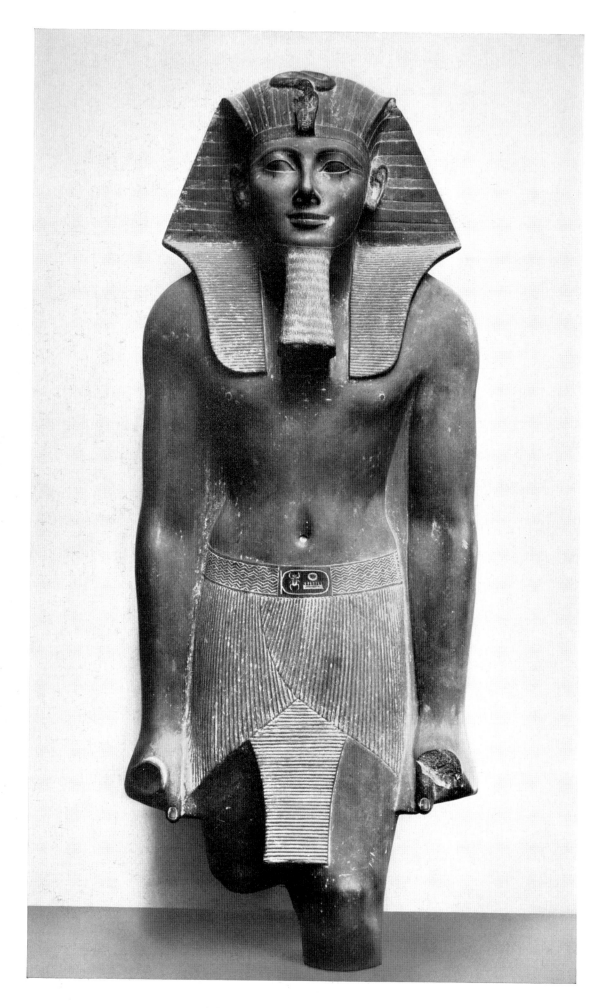

142 King Tuthmosis III. Cairo, Museum

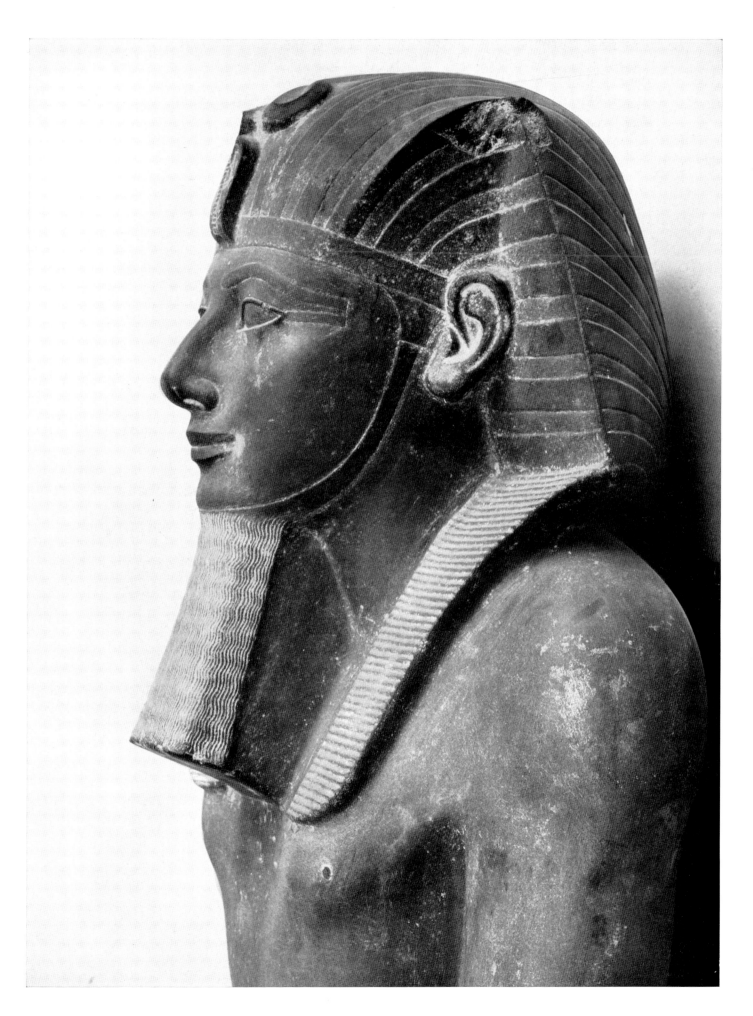

143 King Tuthmosis III. Cairo, Museum

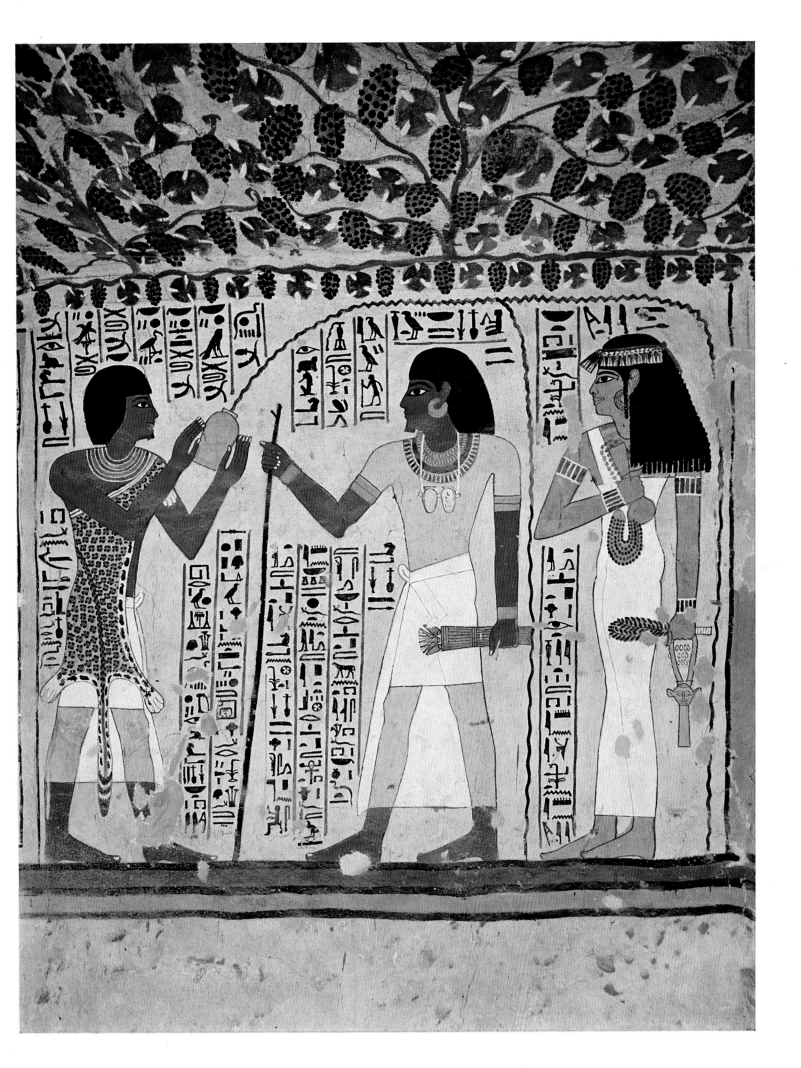

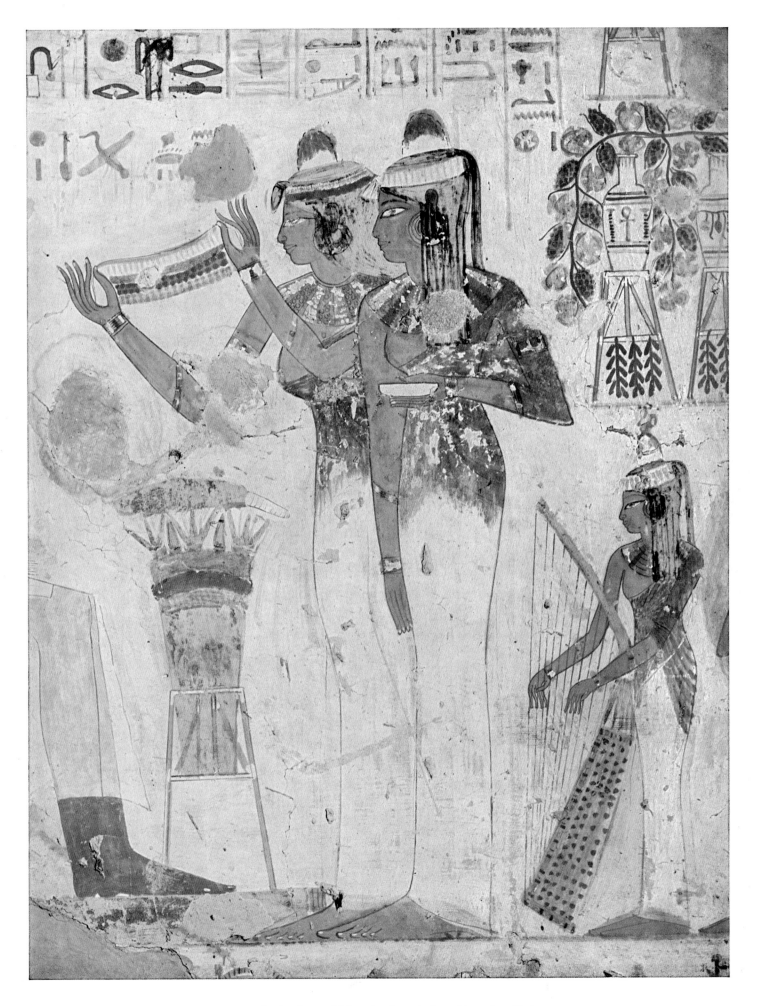

XXVI The daughters of Djeser-ka-rē-seneb, from his tomb at Thebes

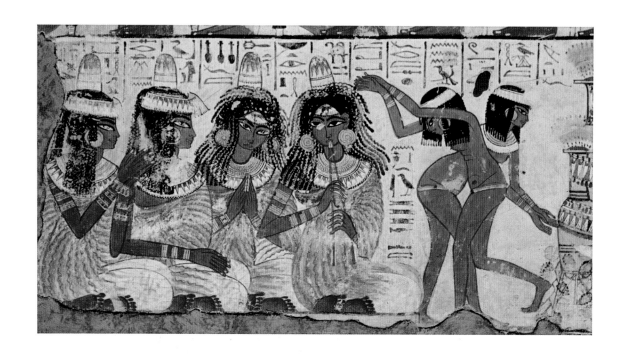

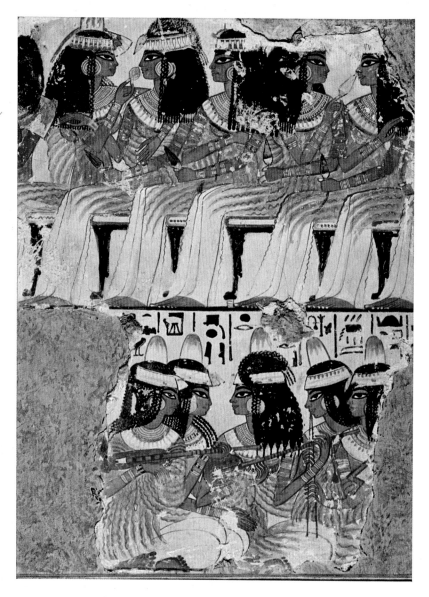

XXVII Festival scenes from an unknown tomb at Thebes. London, British Museum

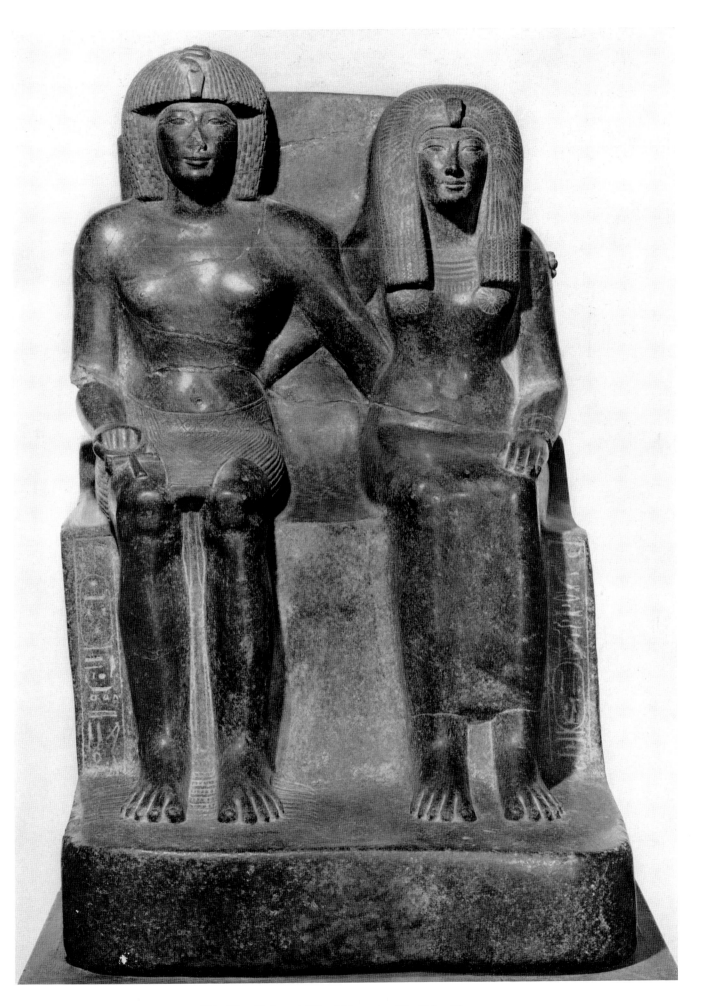

151 King Tuthmosis IV and his mother Tio. Cairo, Museum

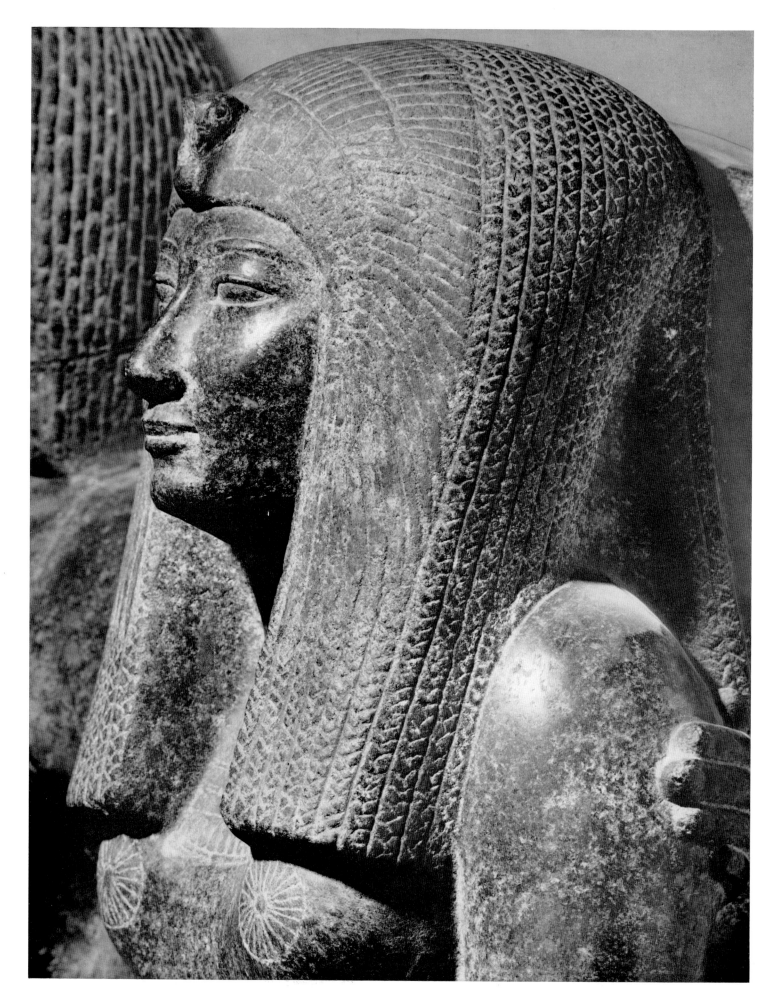

152 Queen Tio, from the portrait group in Plate 151

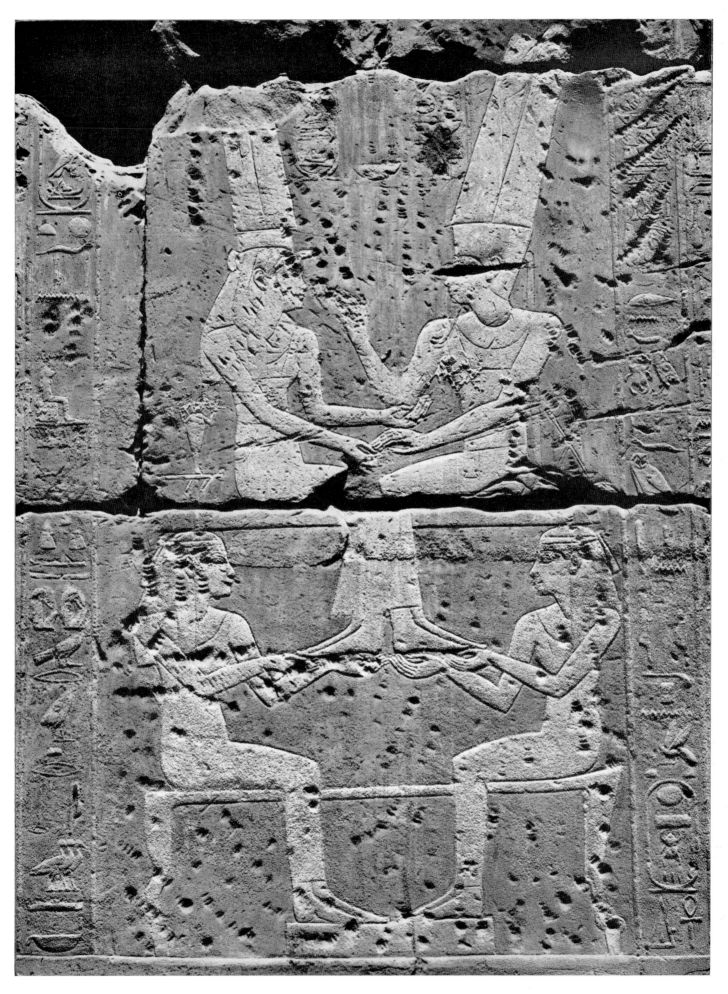

153 The marriage of Queen Mutemweja, the wife of King Tuthmosis IV, and the god Amun.
From the Hall of Birth in the temple of Amun-Mut-Khōns at Luxor

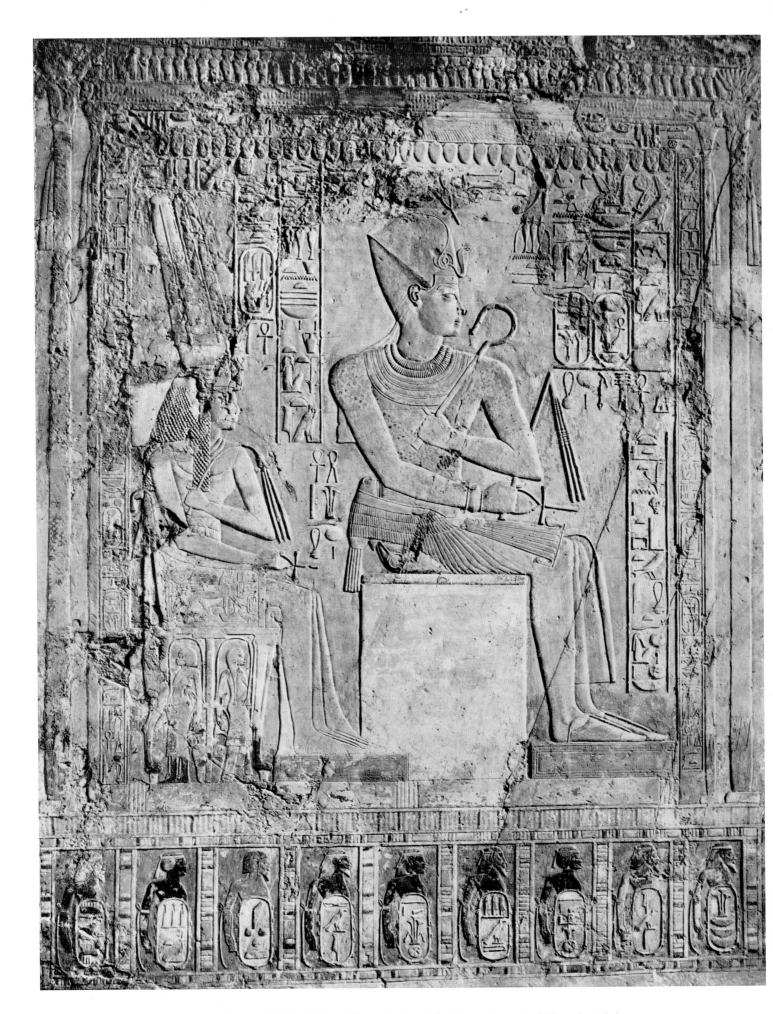

154 King Amenophis III and Queen Tiy at the feast of Sed, from the tomb of Kheruef at Thebes

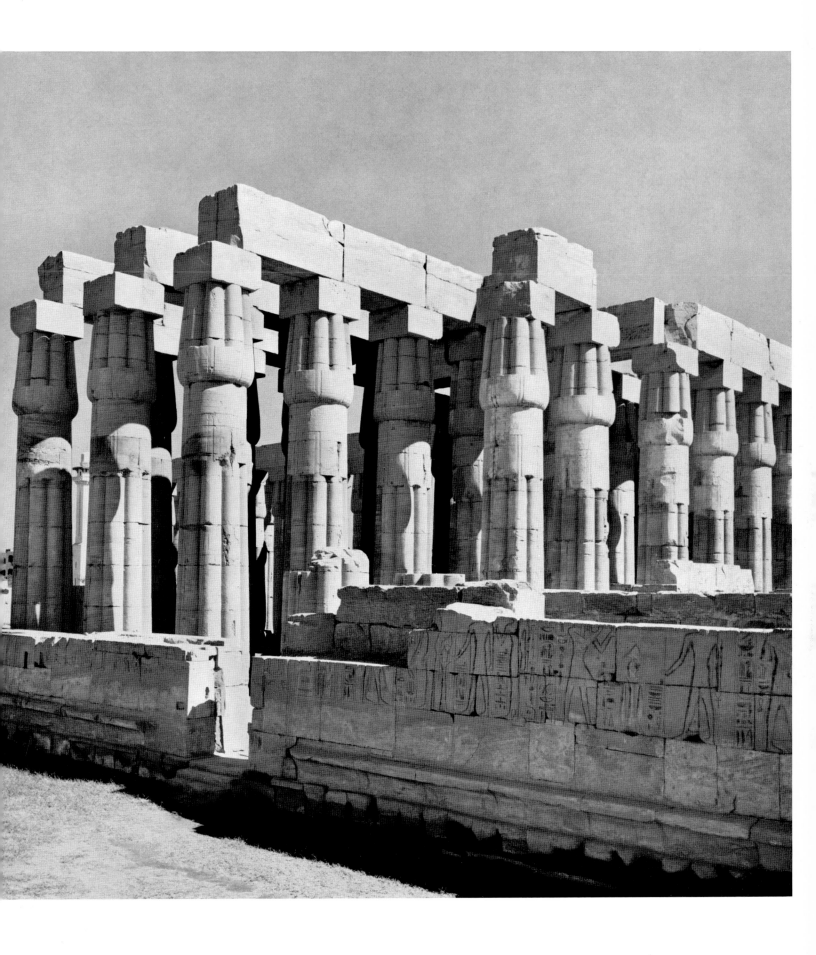

165 Luxor. Temple of Amun-Mut-Khōns. Porch of the temple house of King Amenophis III, seen from the west

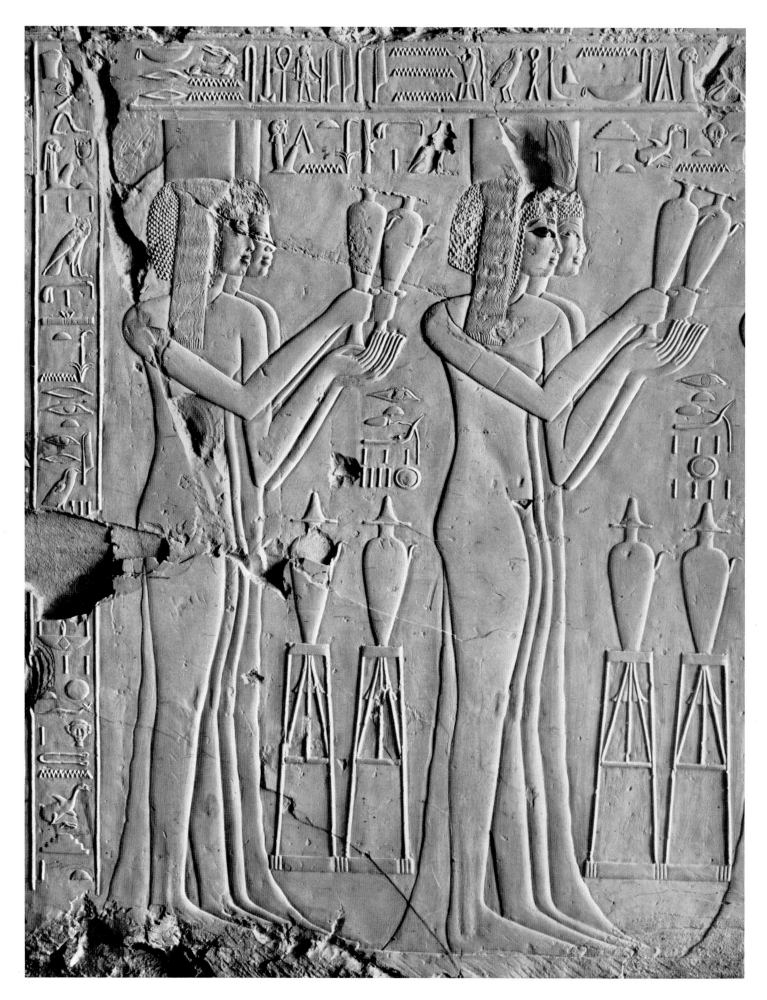

166 Procession of princesses carrying sacred vessels. Left half of the relief in the tomb of Kheruef at Thebes

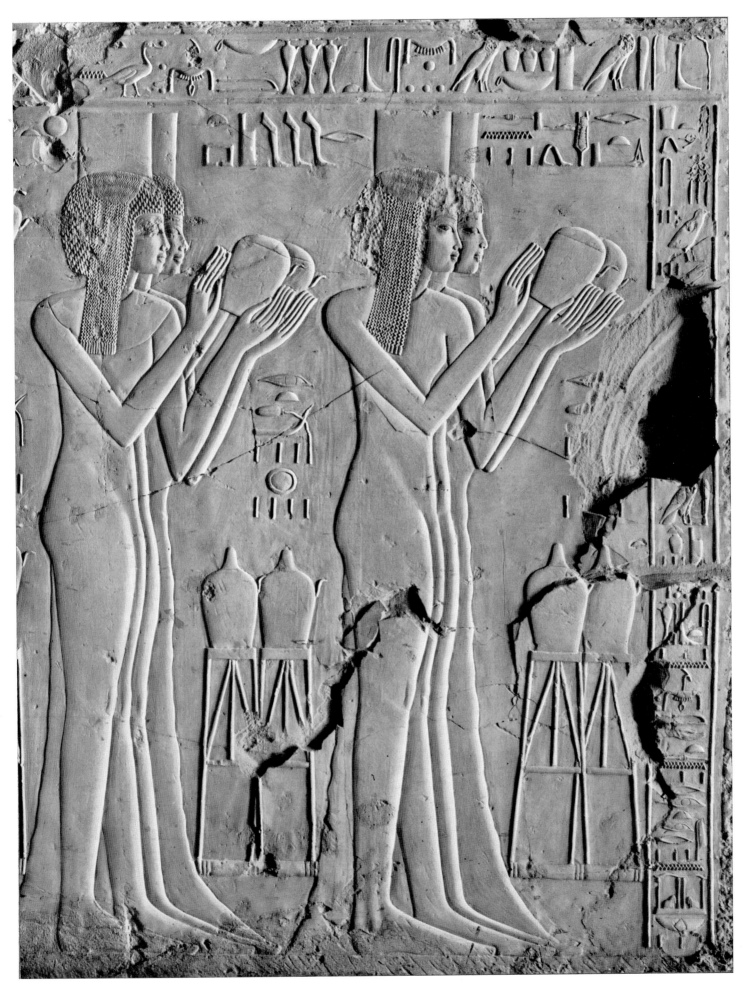

167 Procession of princesses carrying sacred vessels. Right half of the relief in the tomb of Kheruef at Thebes

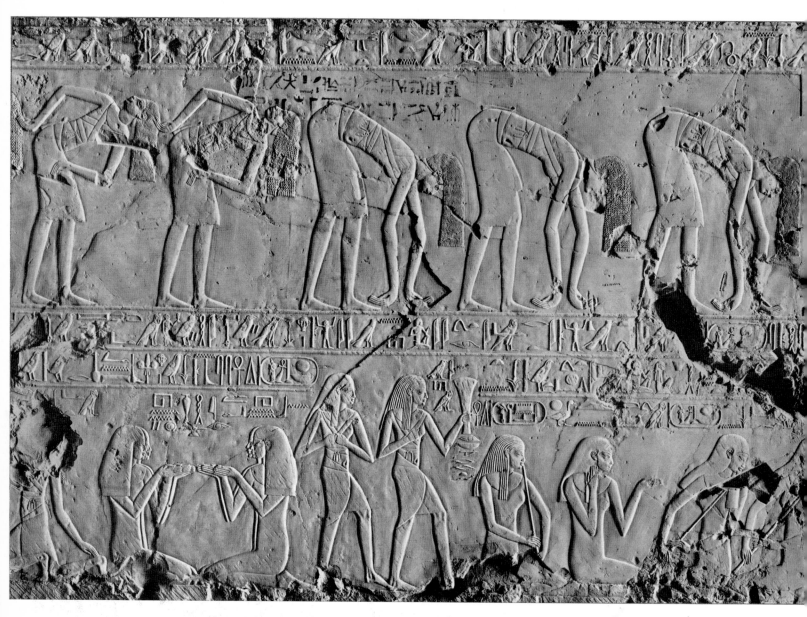

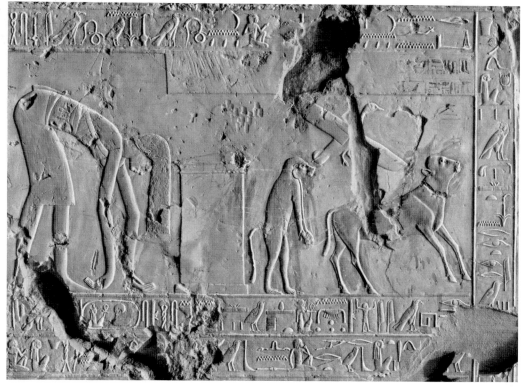

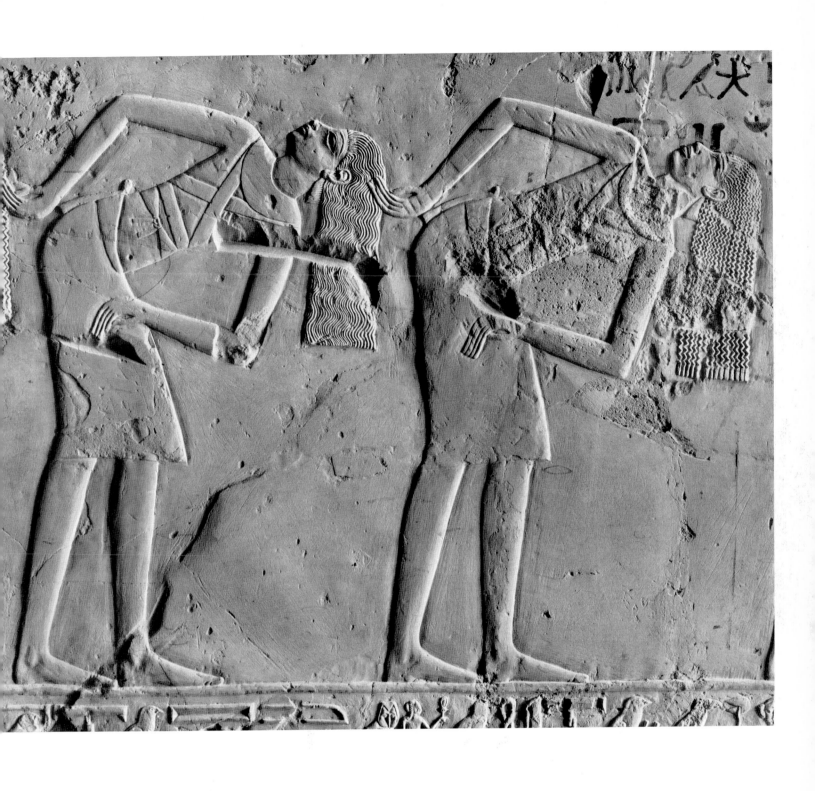

168/169 In the tomb of Kheruef at Thebes.

168 Above: Dancing girls and musicians from a festival scene. Below: Baboon and calf. Continuation of the upper frieze (cfr. above)

169 Two of the dancing girls from the upper frieze (cfr. Plate 168 above)

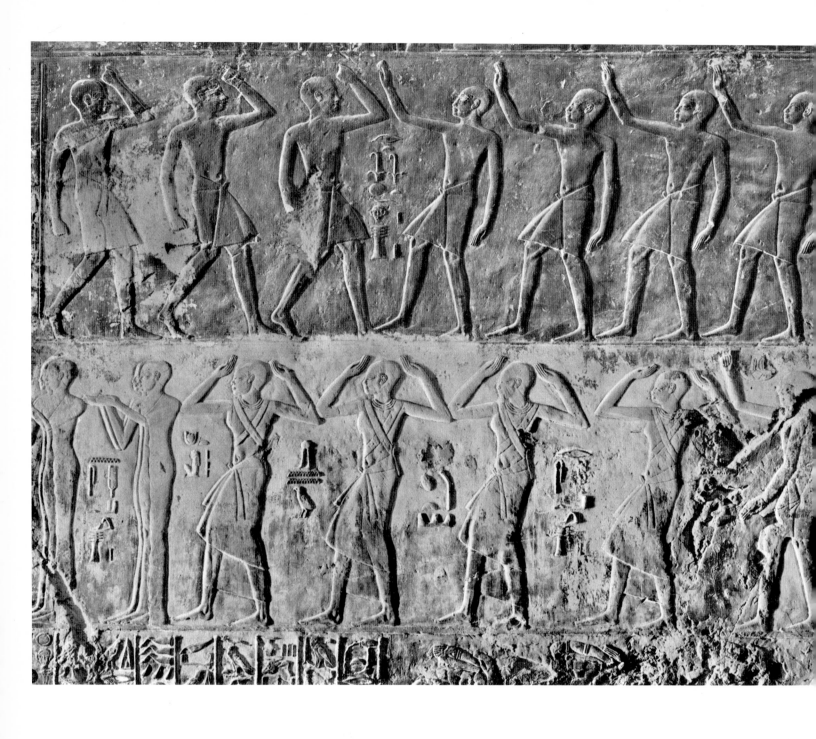

170 In the tomb of Kheruef at Thebes. Dancing men and girls from a festival scene

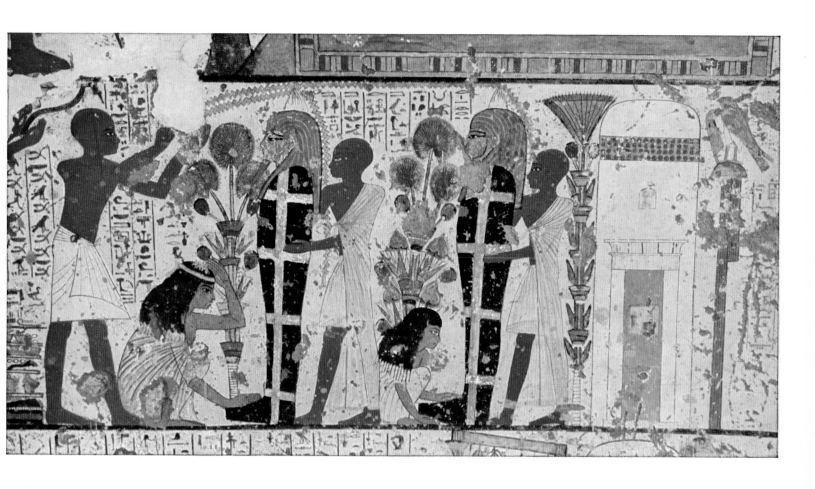

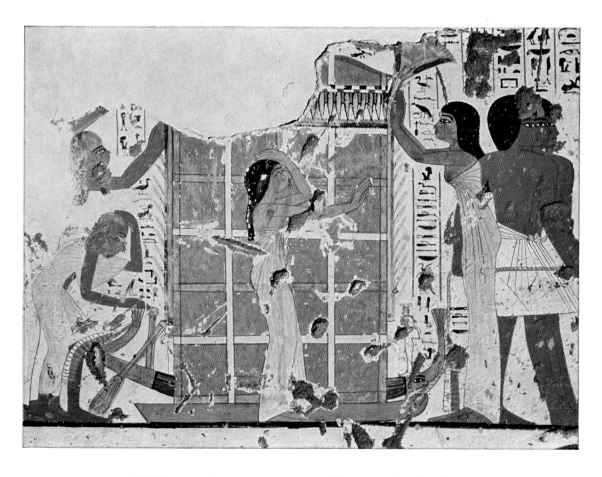

XXVIII From the tomb of the sculptors Nebamun and Ipuki at Thebes.
Above: Funeral ceremony at the entrance to the tomb. Below: Mourners at the funerary shrine

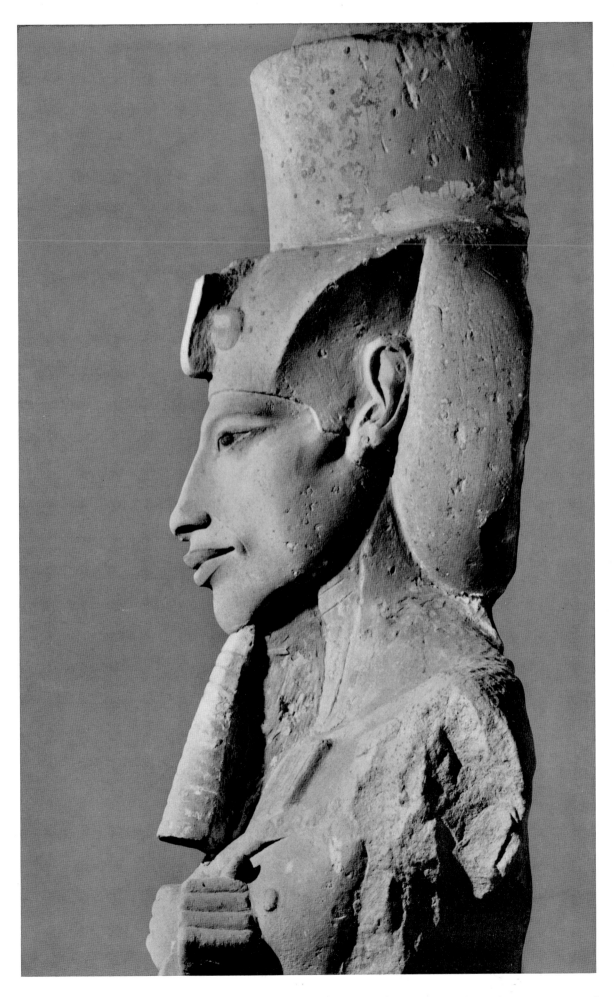

180/181 King Amenophis IV, later Akhnaton. From a pillar statue in the temple of Aton near the temple of Amun at Karnak.
Cairo, Museum

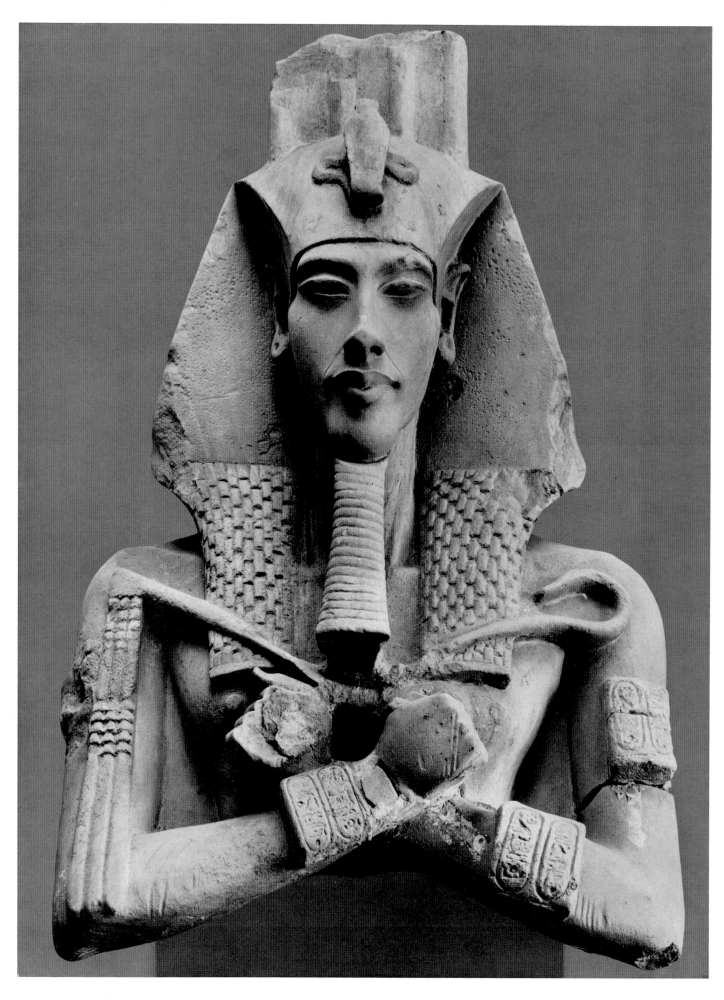

182 King Amenophis IV, later Akhnaton. From a pillar statue in the temple of Aton near the temple of Amun at Karnak.
Cairo, Museum

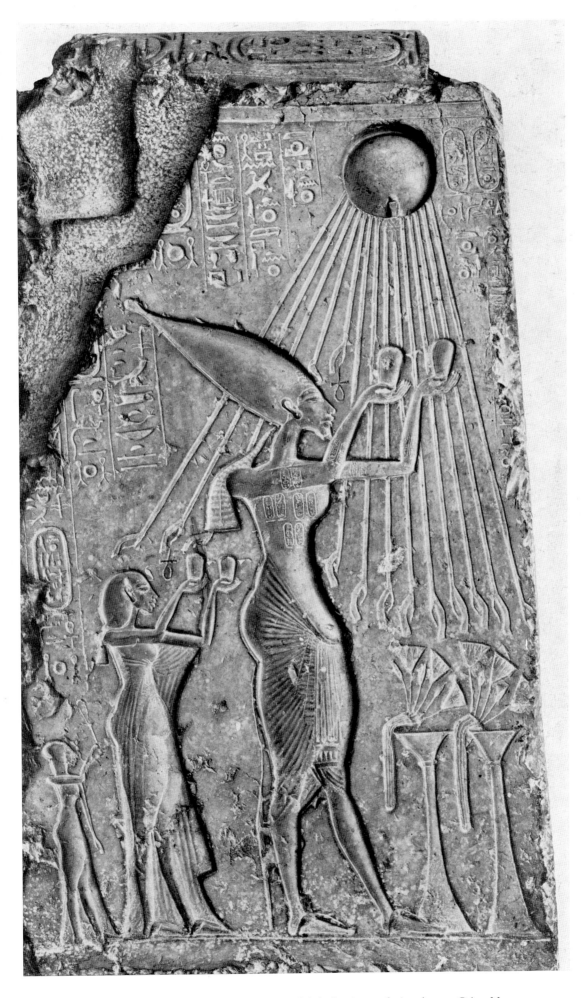

183 King Akhnaton, Queen Nefertiti and one of their daughters, adoring the sun. Cairo, Museum

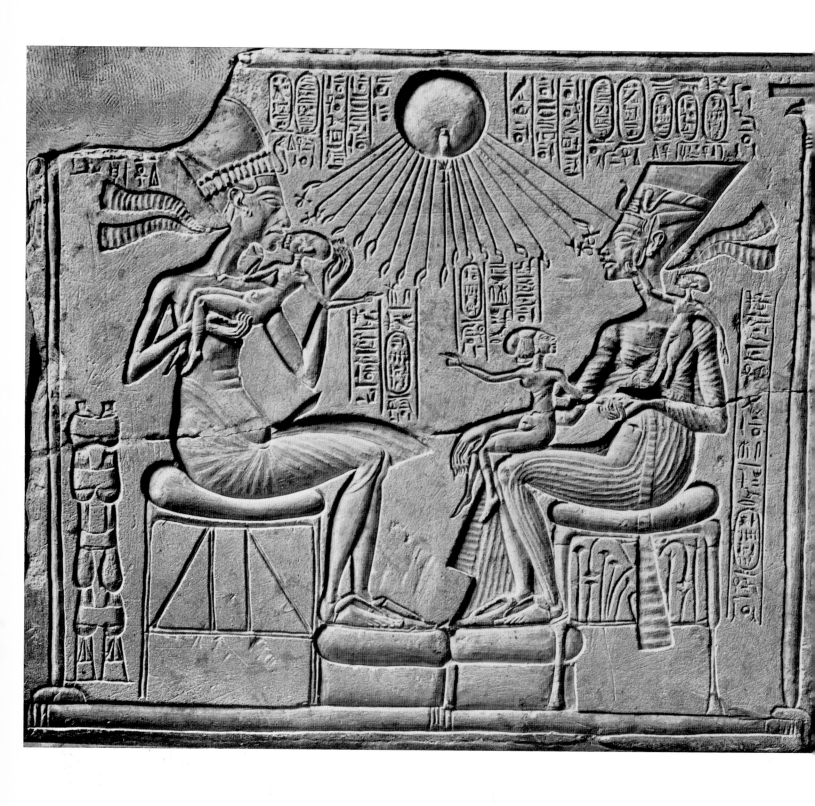

184 King Akhnaton and Queen Nefertiti with their children. Above god Aton as solar orb. Berlin

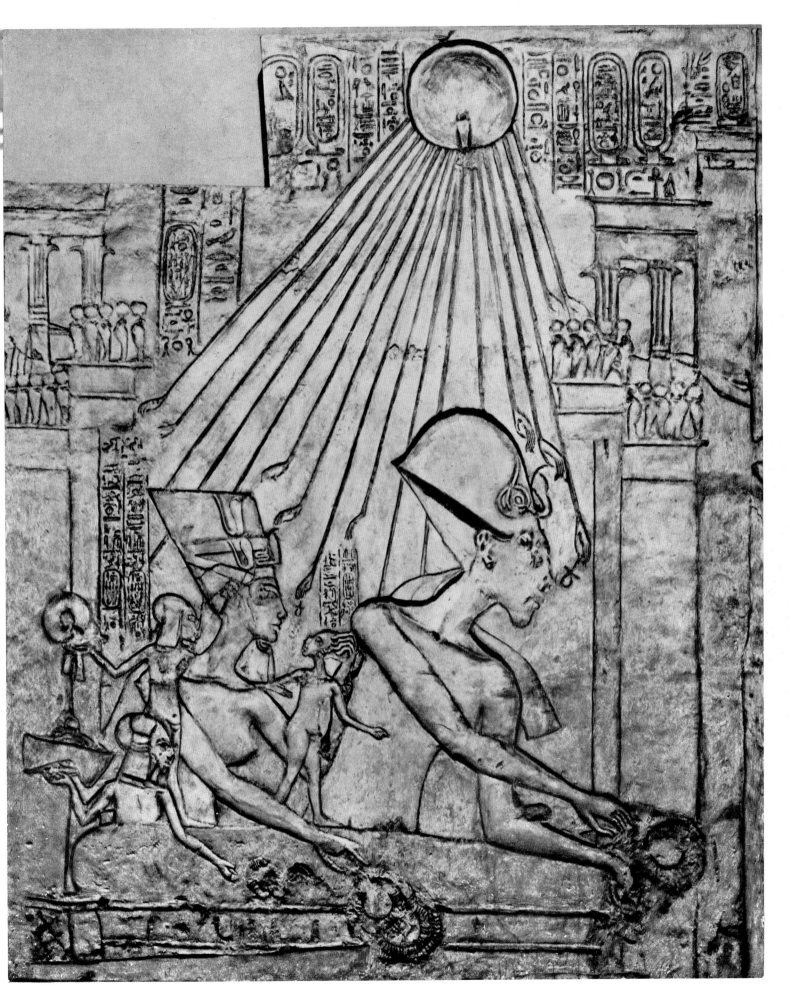

185 King Akhnaton with his family in the royal palace. Tomb of Eje at Amarna

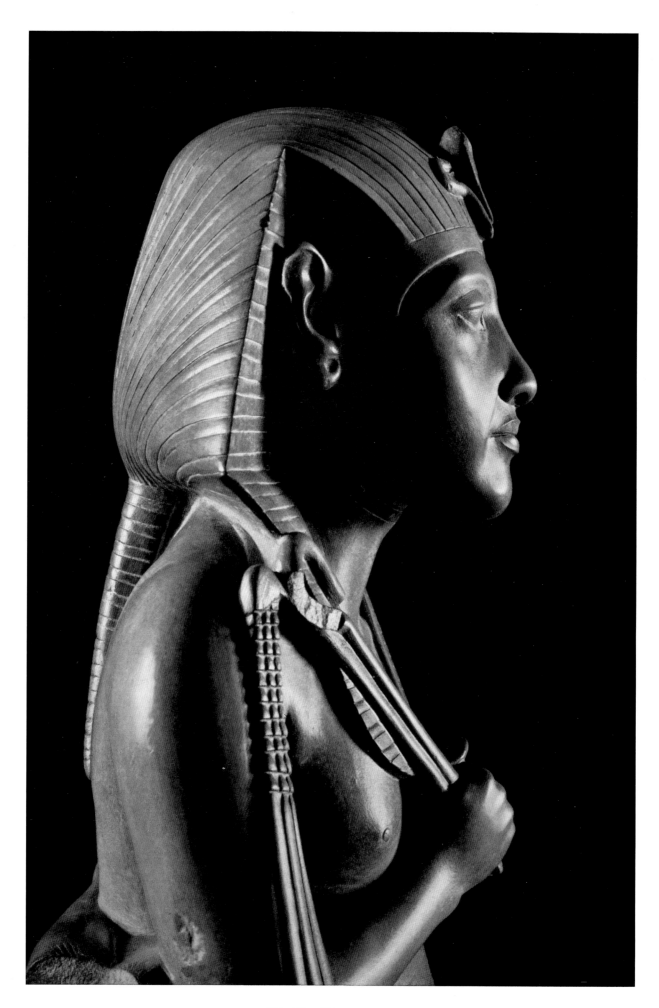

186 King Akhnaton. Paris

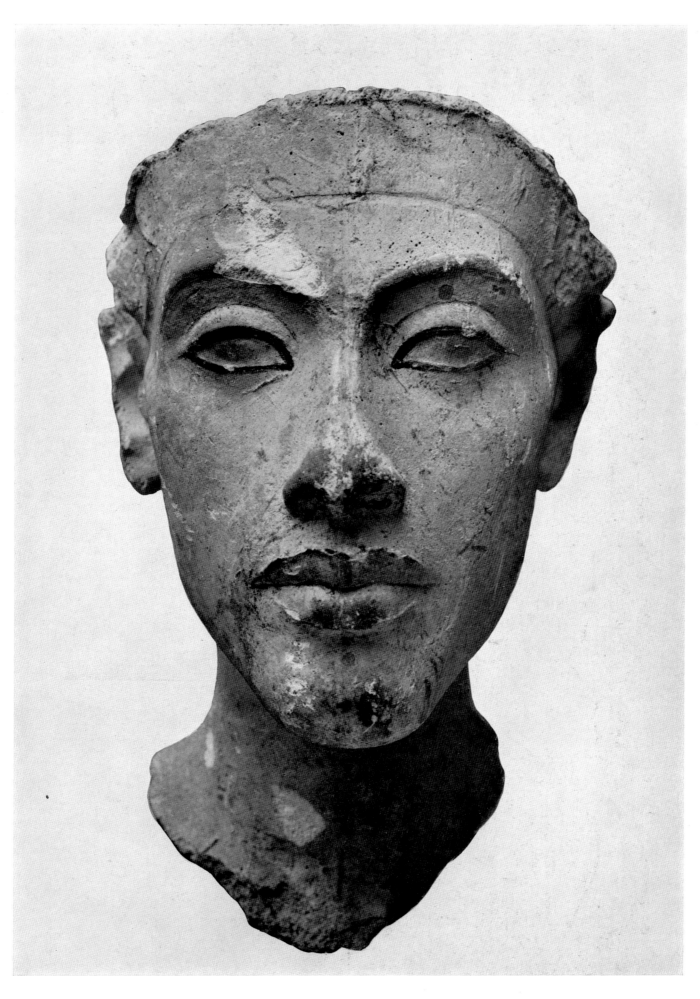

187 King Akhnaton. Gypsum model, from the atelier of the sculptor Tuthmosis at Amarna. Berlin

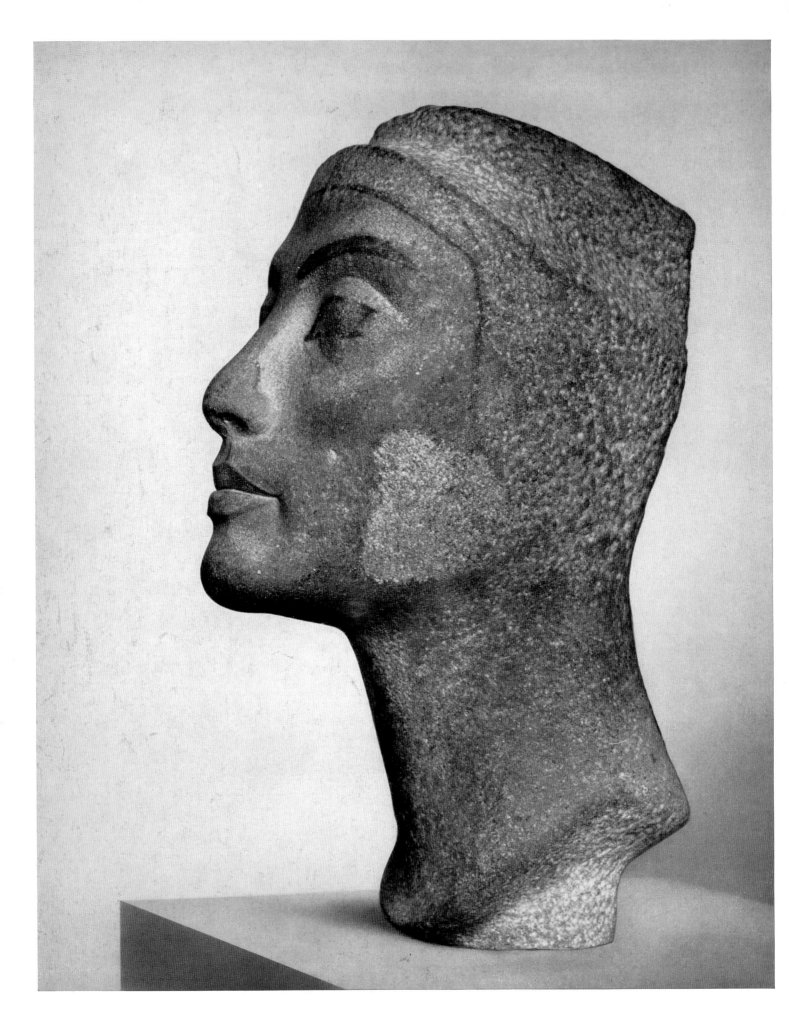

188 Queen Nefertiti. Cairo, Museum

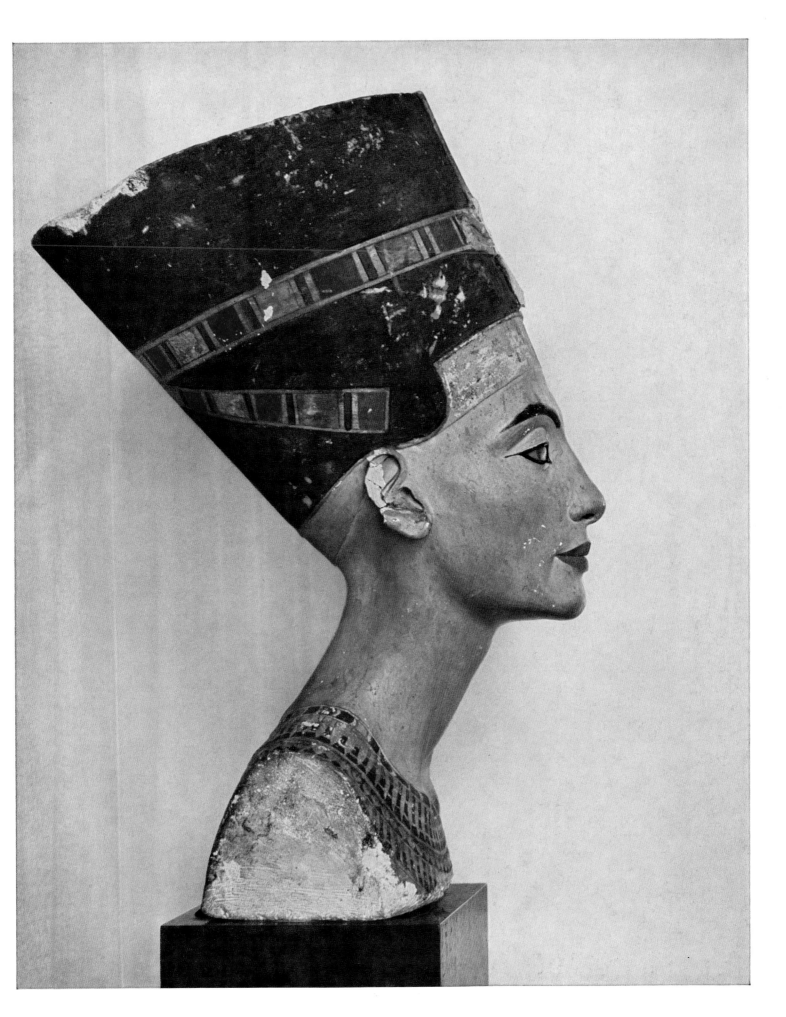

XXX Queen Nefertiti. Berlin

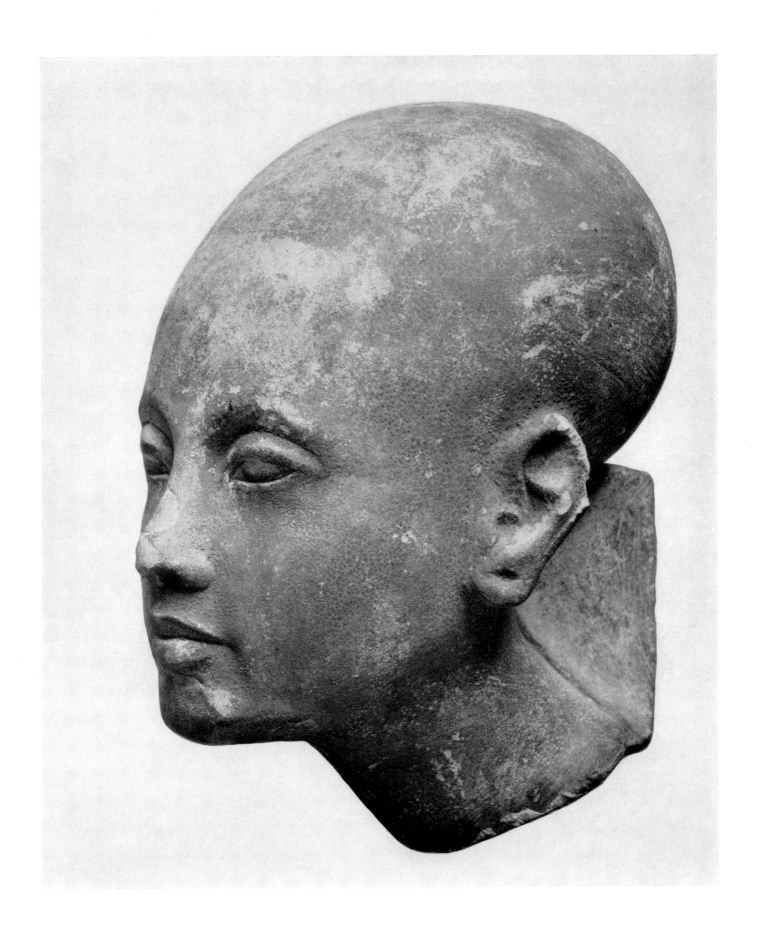

189 Head of an official, of the period of King Akhnaton. Berlin

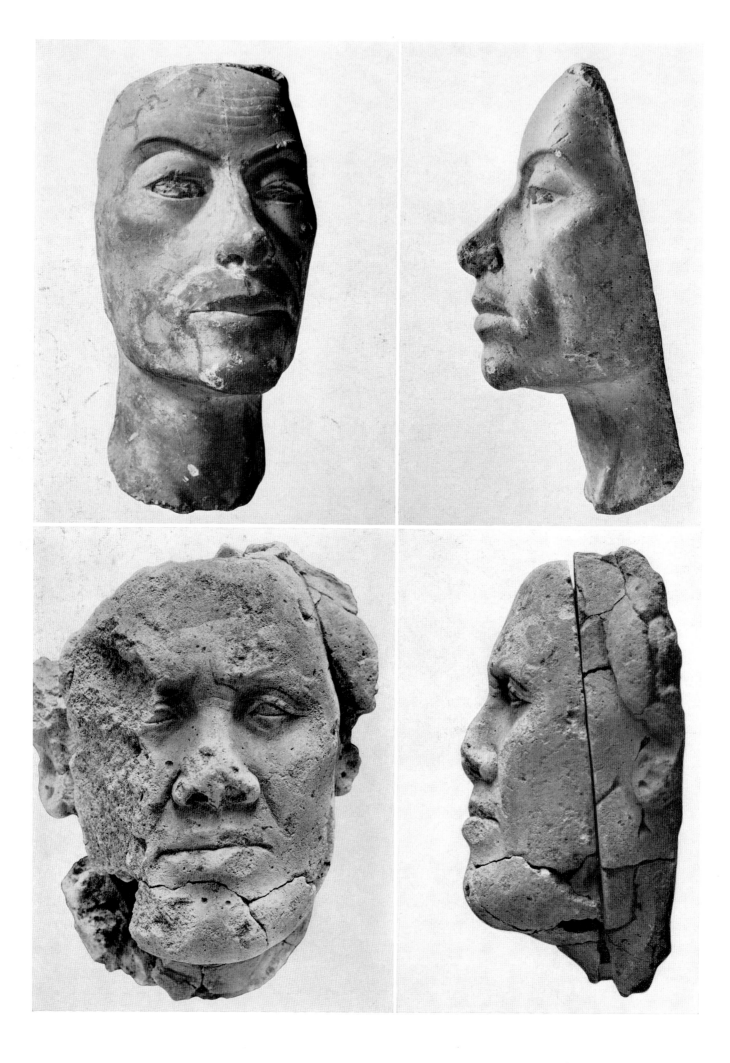

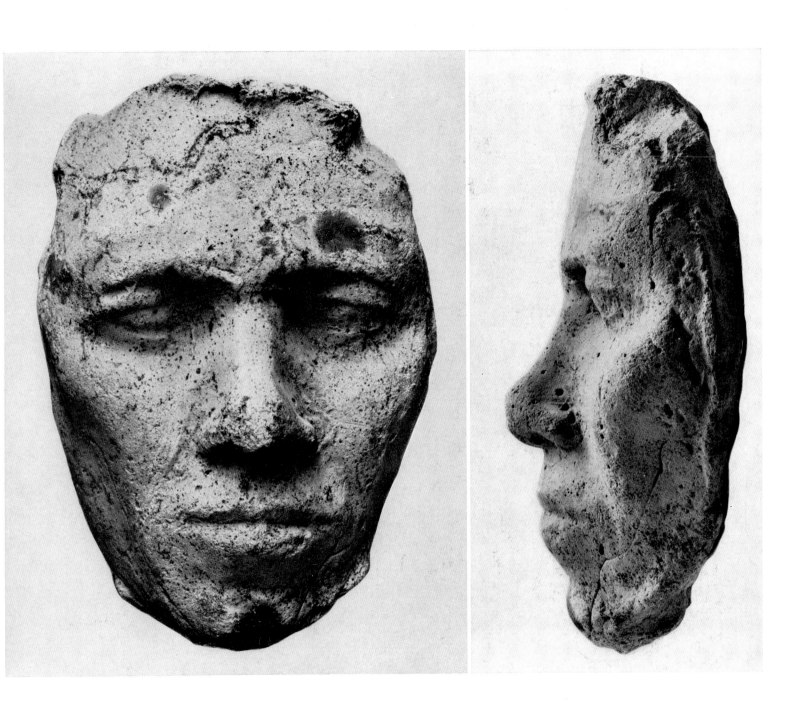

190 Gypsum masks of two men. From the atelier of the sculptor Tuthmosis at Amarna. Berlin

191 Gypsum masks of a man. From the atelier of the sculptor Tuthmosis at Amarna. Berlin

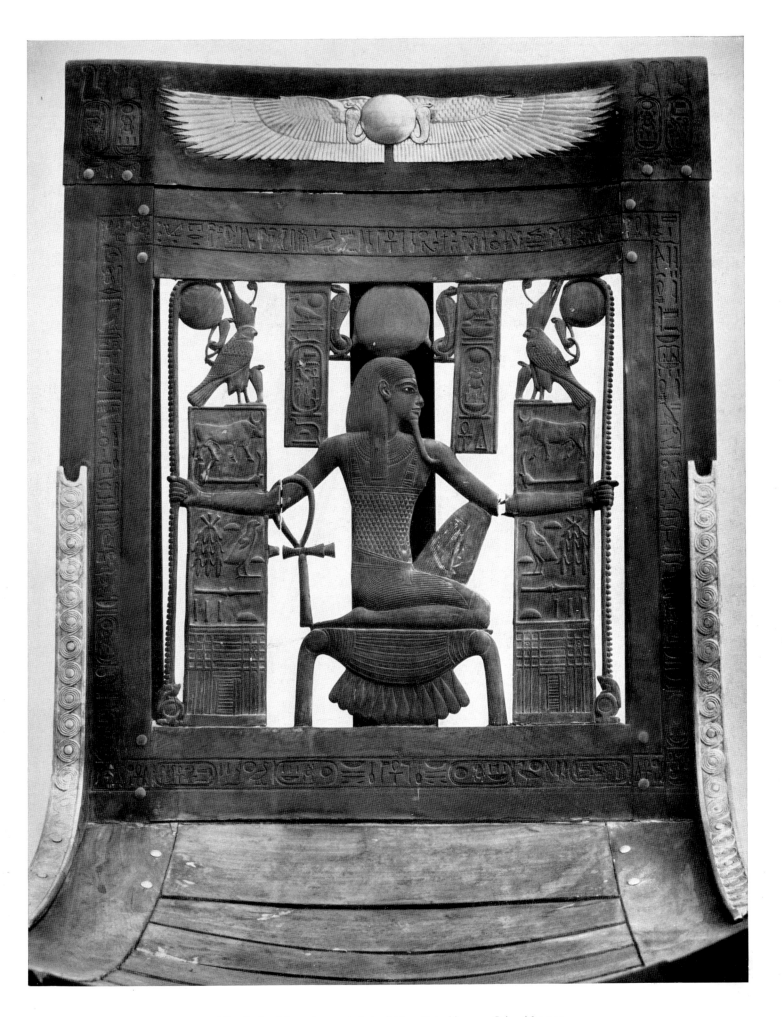

193　Back of the cedarwood chair of King Tutankhamun. Cairo, Museum

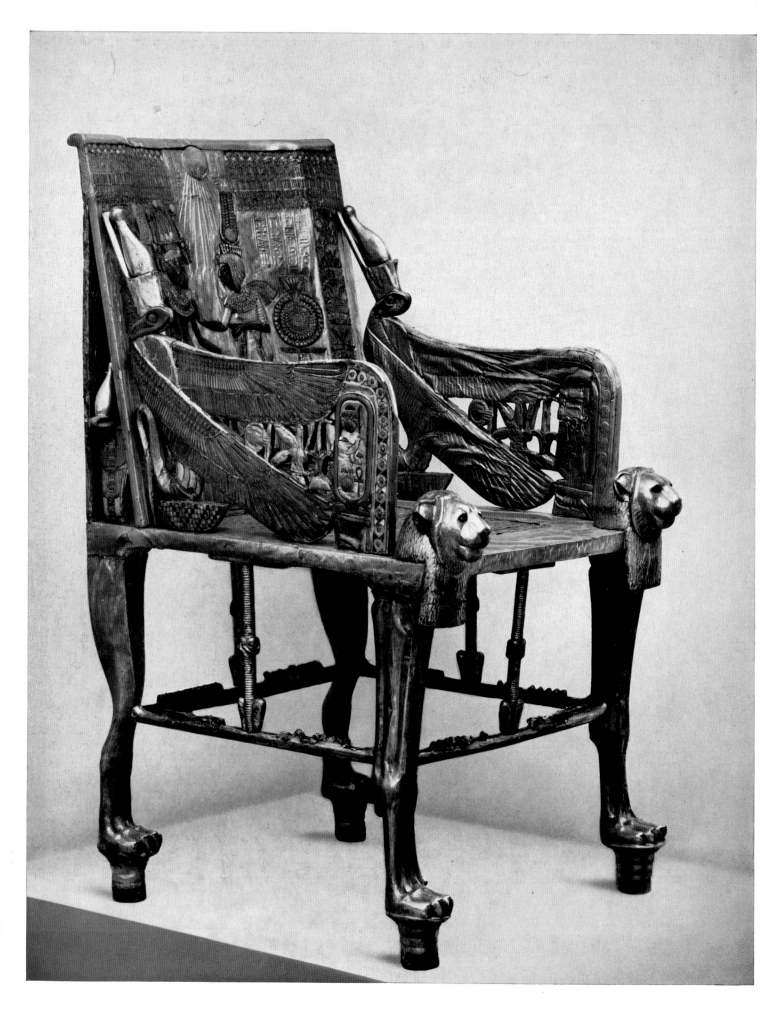

194 Throne of King Tutankhamun Cairo, Museum

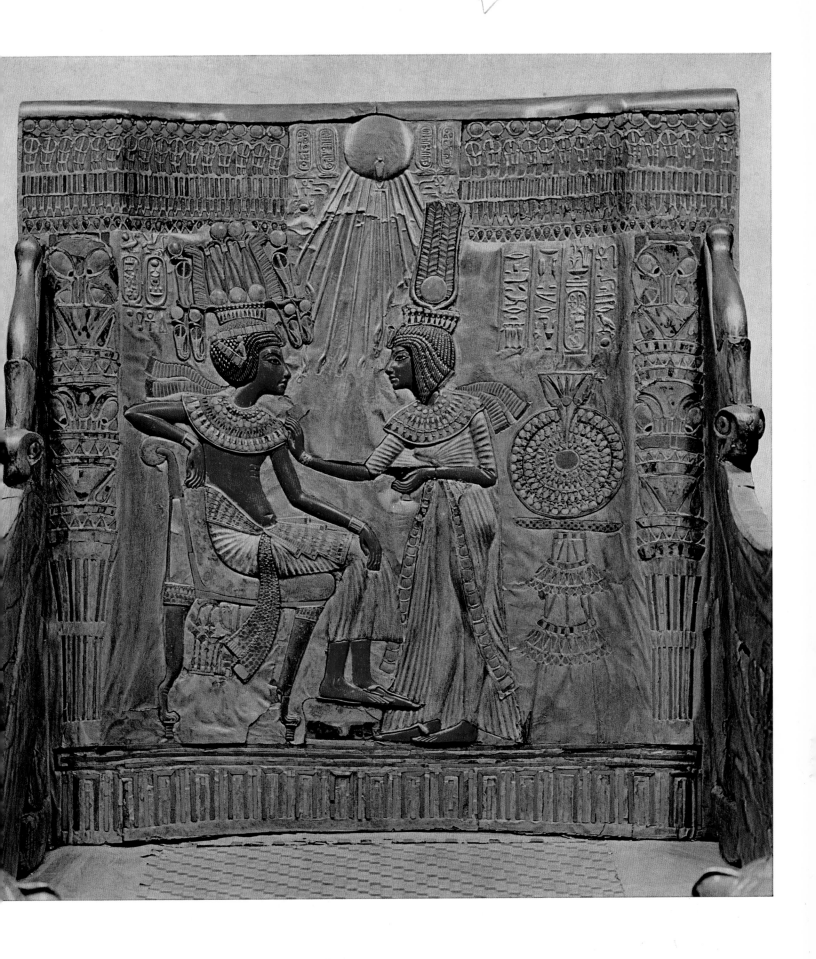

XXXV Back of the throne of King Tutankhamun. Cairo, Museum

XXXVI King Tutankhamun and his wife Ankhesenamun, from the lid of an ivory chest. From the tomb of King Tutankhamun. Cairo, Museum

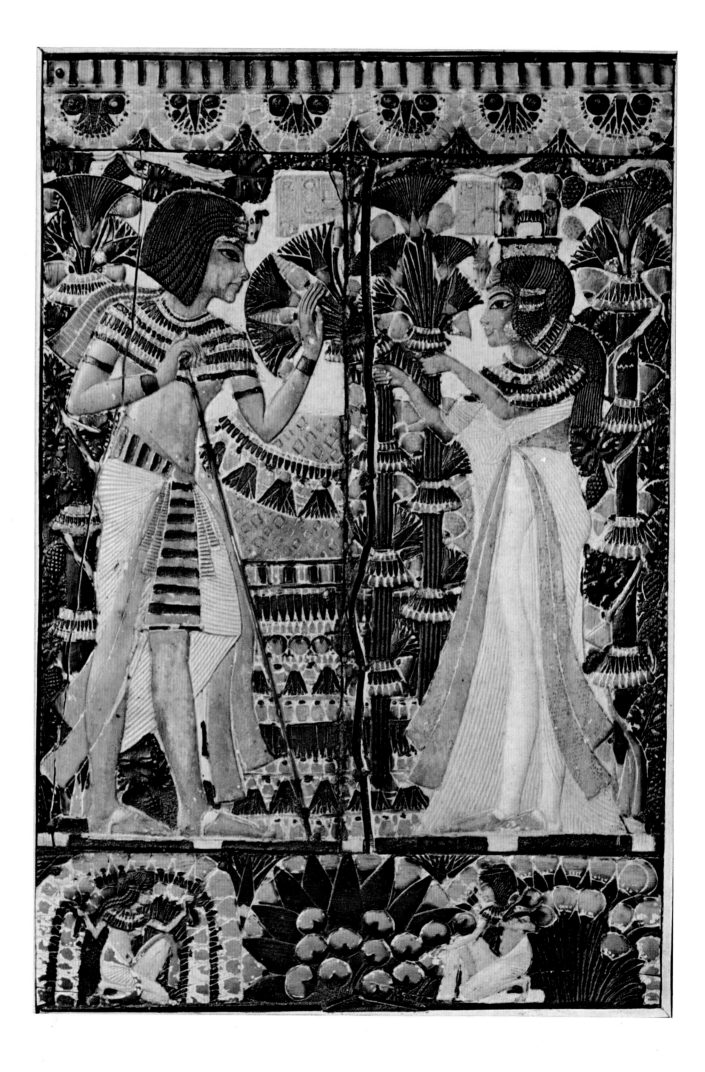

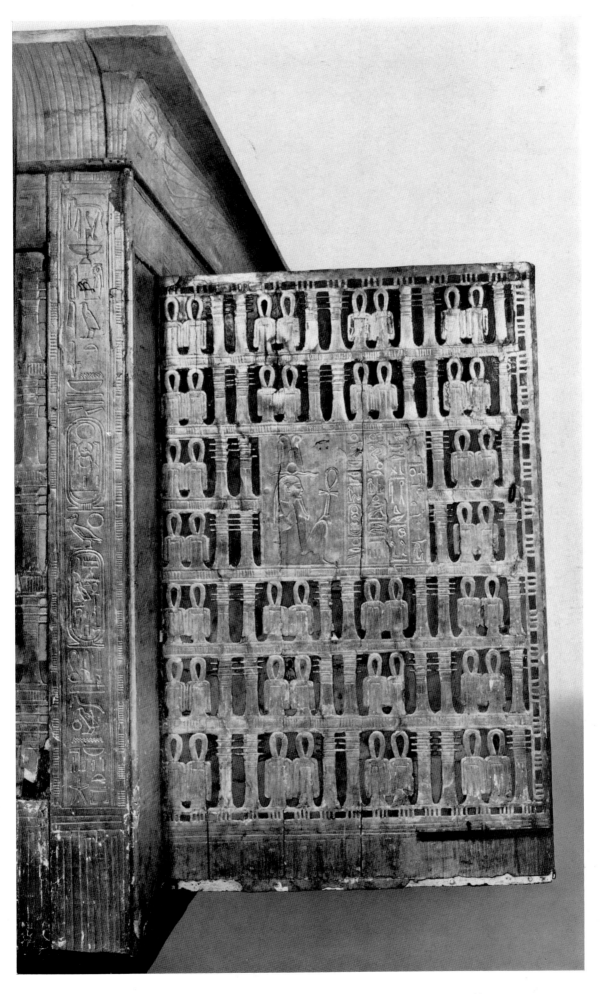

195 Front of the outermost of the four chests for the sarcophagus of King Tutankhamun.
On the open door the symbols of Djed and Isis blood. Cairo, Museum

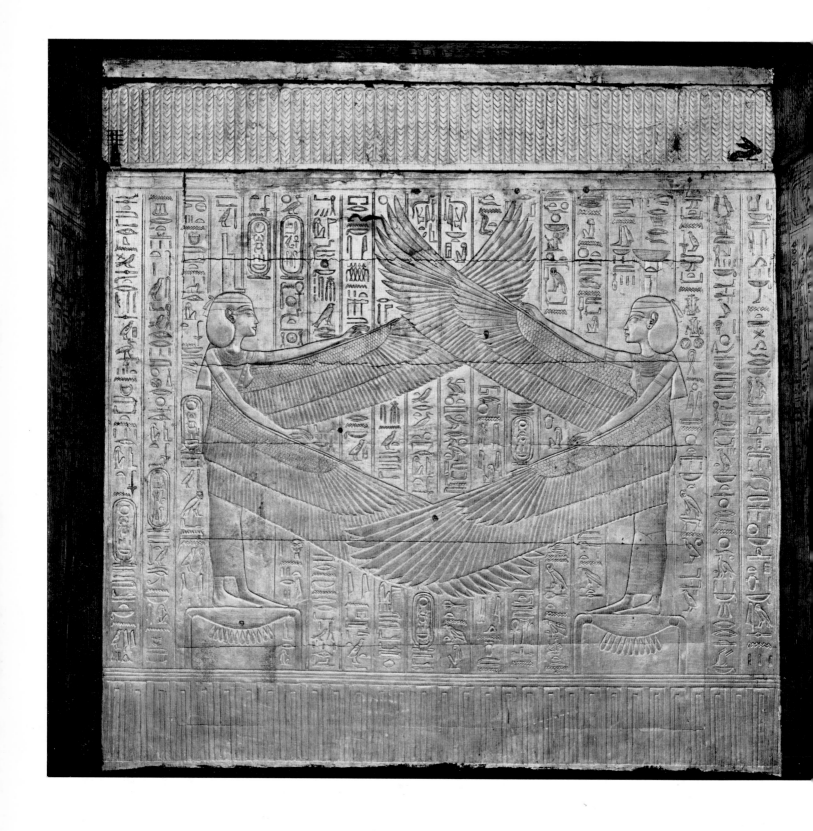

196 View to the interior back wall of the second chest from the sarcophagus of King Tutankhamun. Cairo, Museum

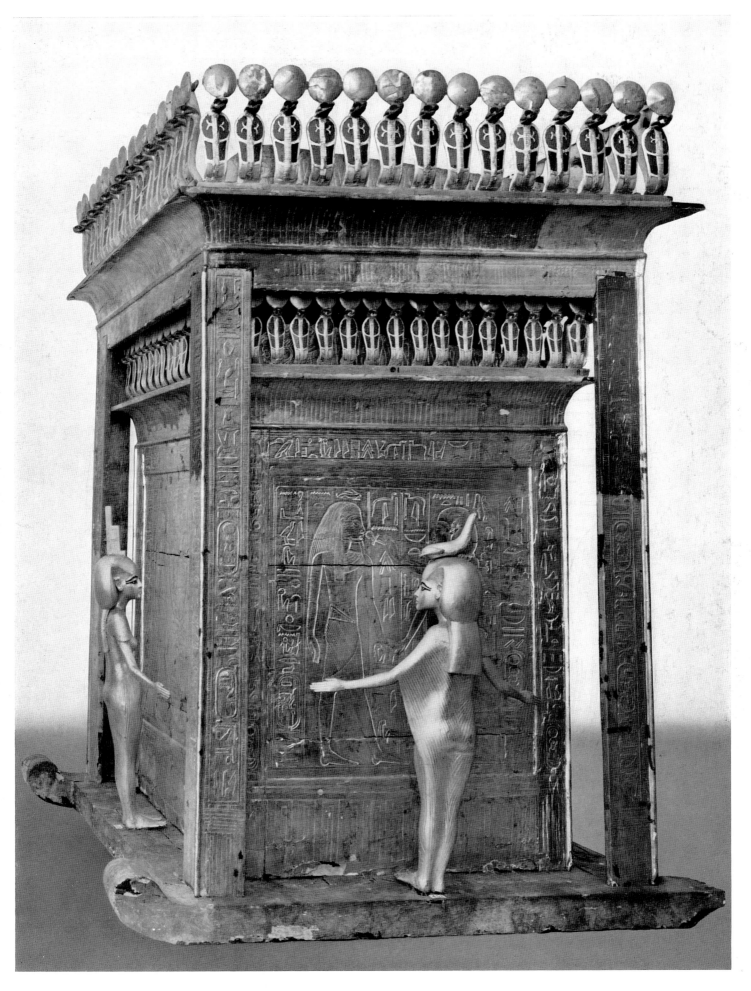

197 Canopic chest on gilt wooden sled for the alabaster canopic box, from the tomb of King Tutankhamun. Cairo, Museum

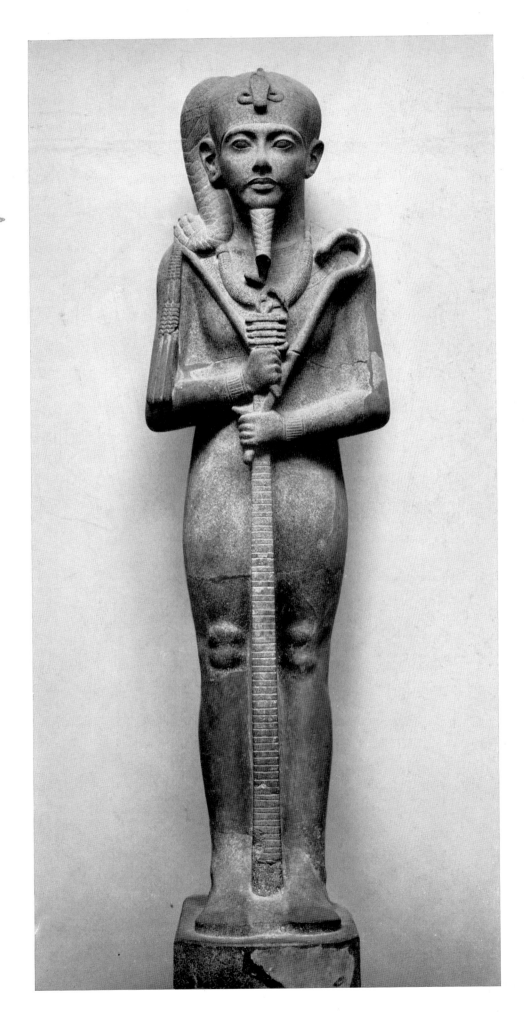

201 The moon god Khōns, son of Amun and Mut. Cairo, Museum

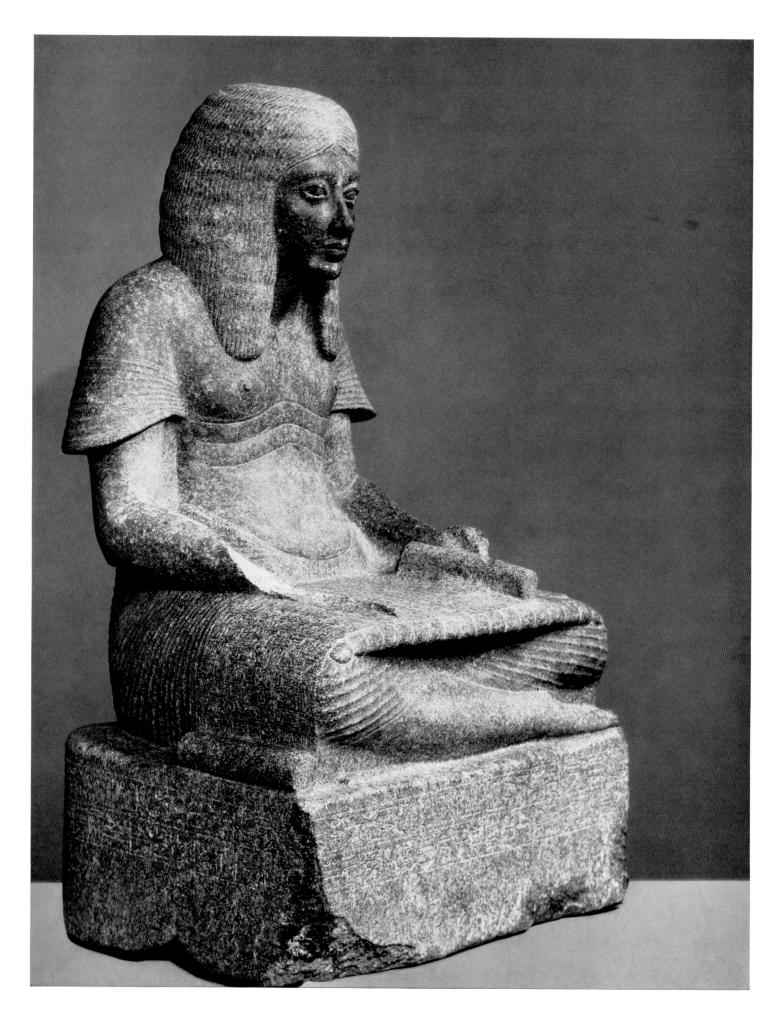

202 Haremhab as highest state official (cfr. Plate 203)

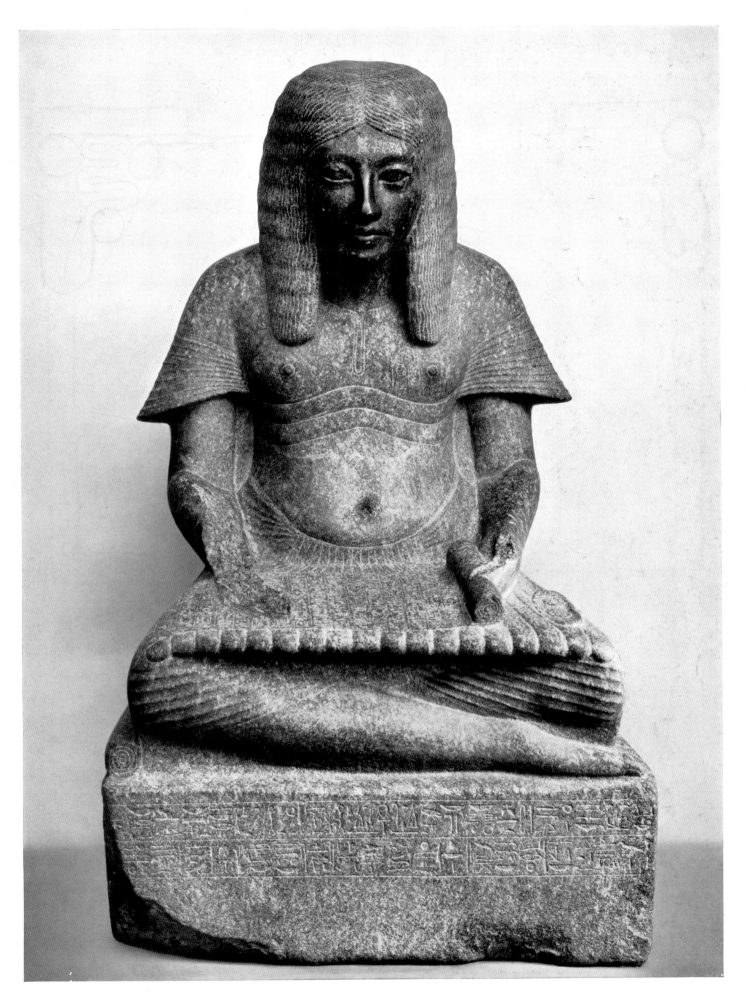

203 Haremhab as highest state official. New York

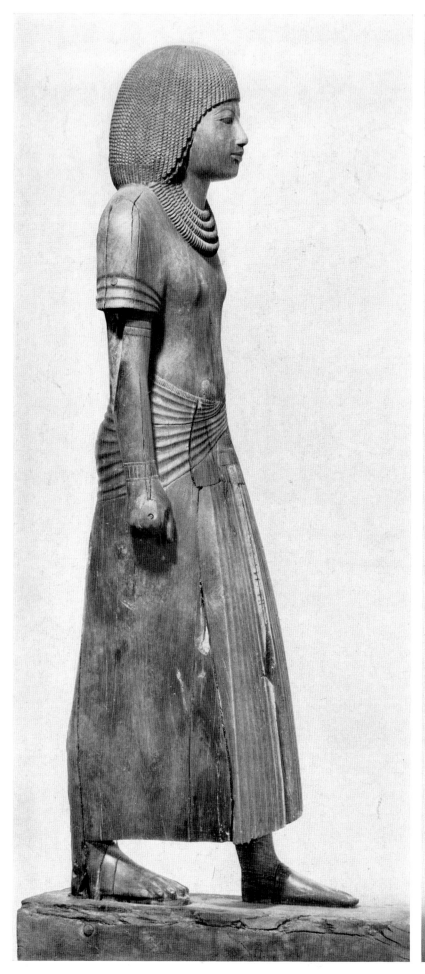
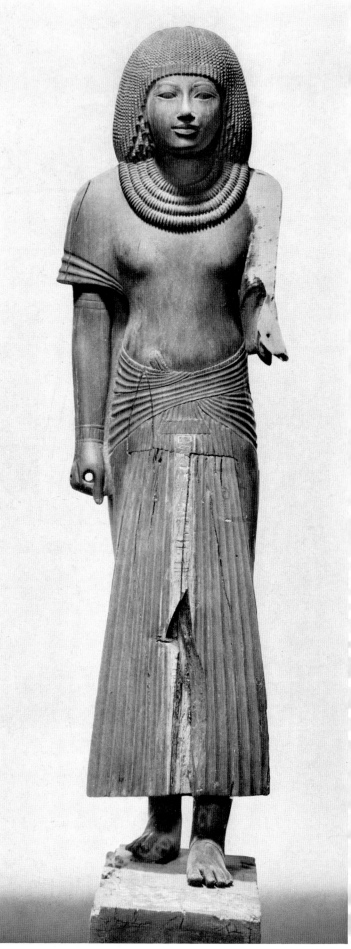

204 Ti, master of the horses of King Haremhab. Cairo, Museum

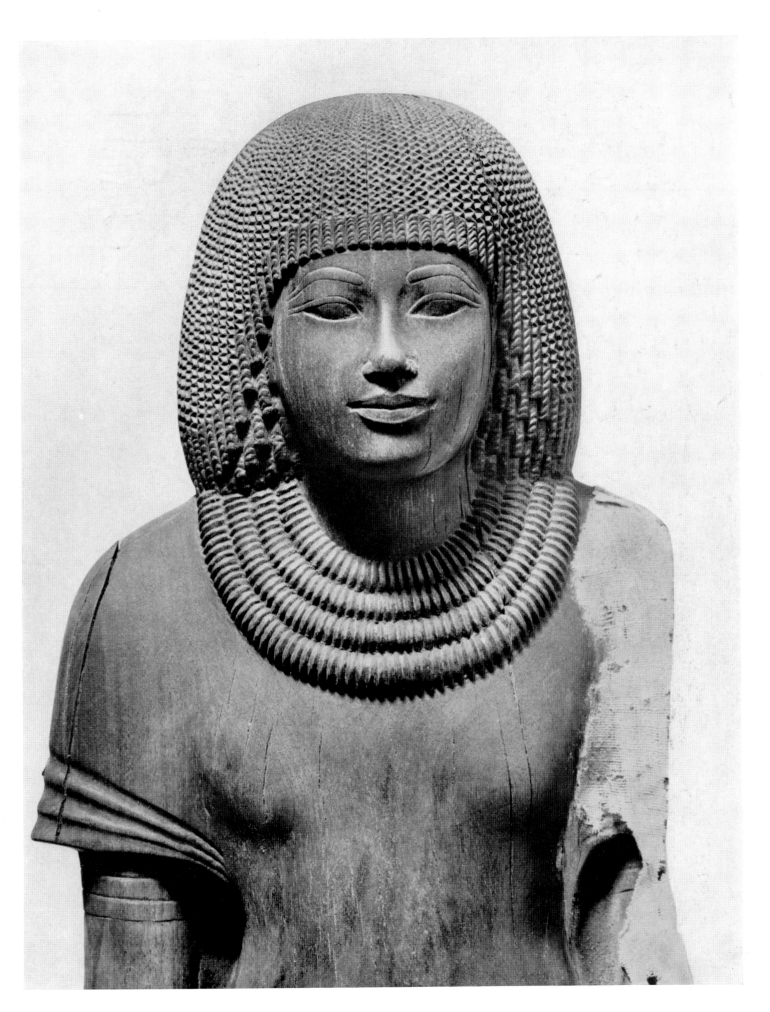

205　Ti, master of the horses of King Haremhab (cfr. Plate 204)

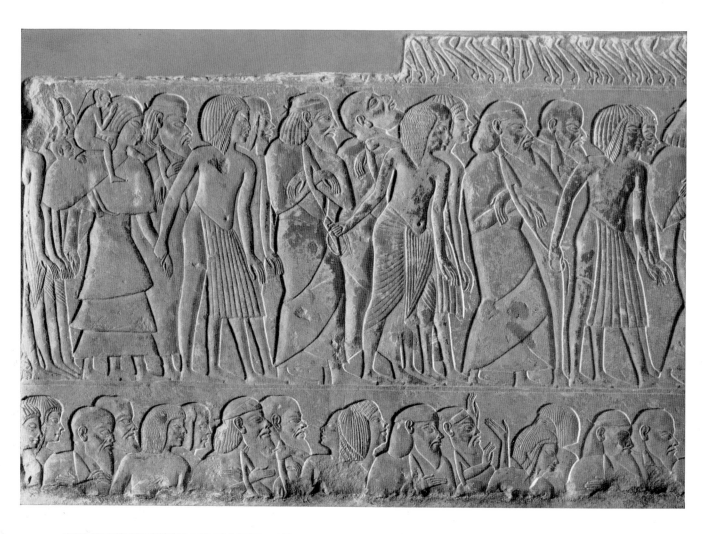

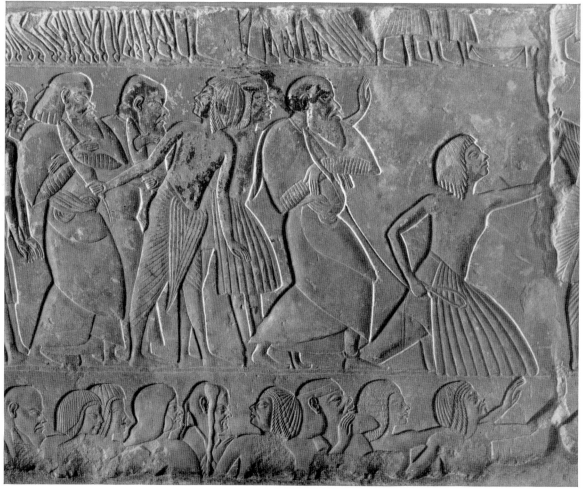

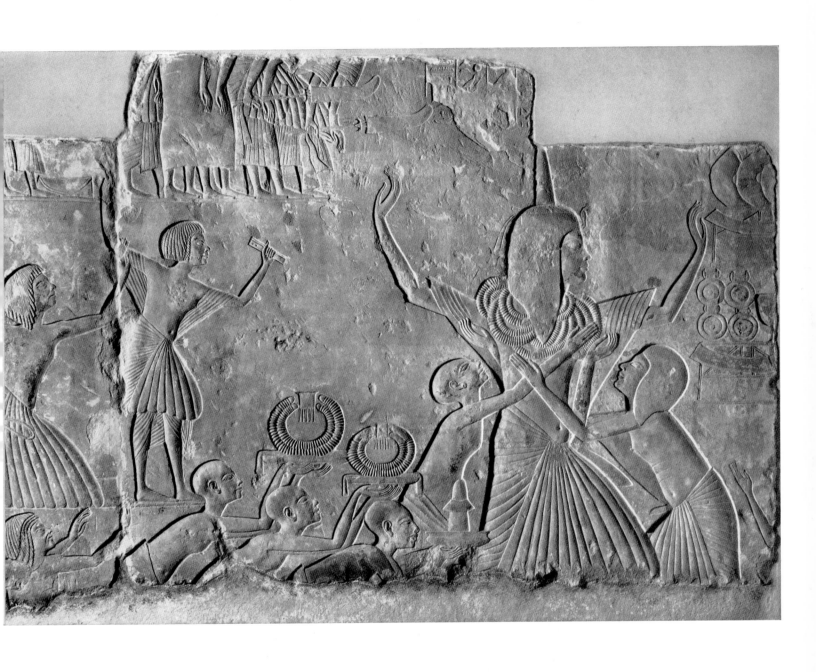

206/207 From the tomb of General (later King) Haremhab near Saqqāra. Procession of prisoners. Leiden

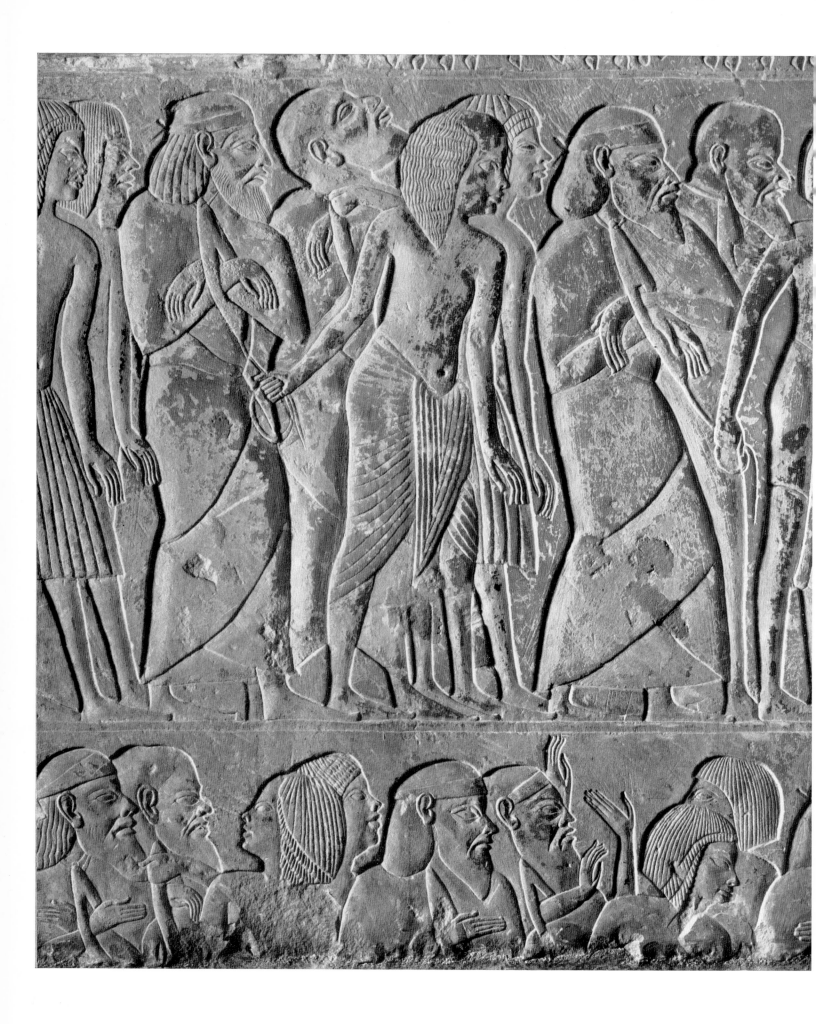

208 From the tomb of General (later King) Haremhab near Saqqāra. Procession of prisoners (cfr. Plate 206)

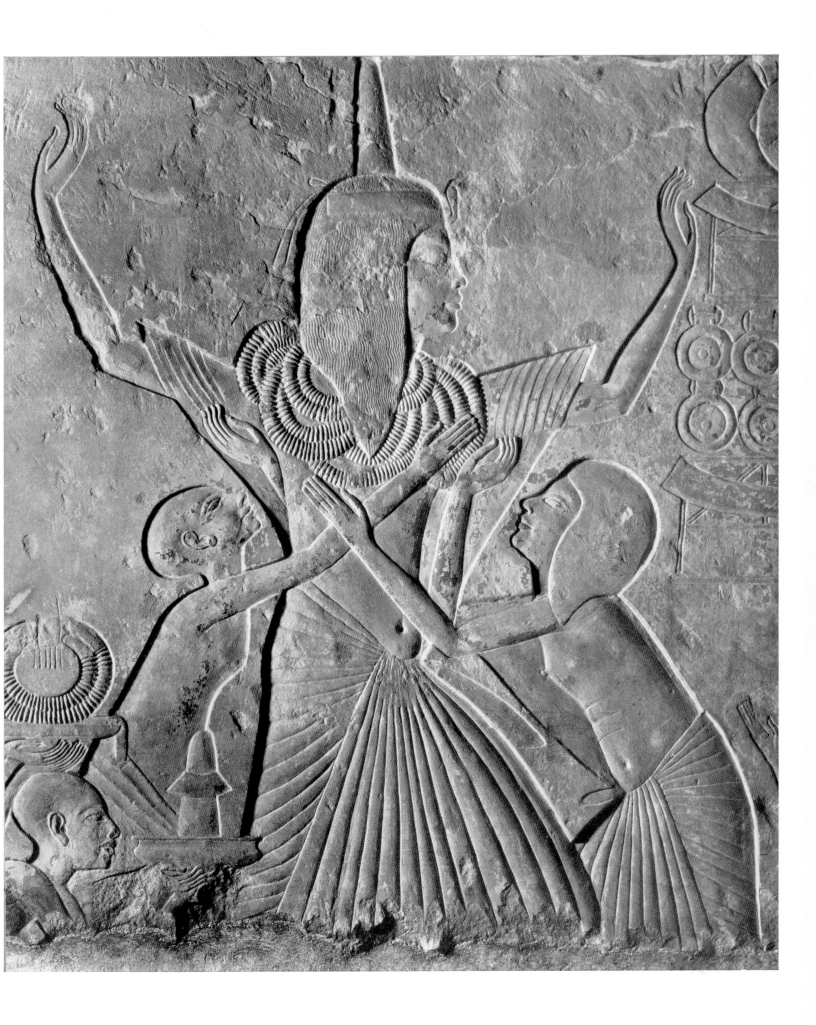

209　From the tomb of General (later King) Haremhab near Saqqāra. Haremhab (cfr. Plate 207)

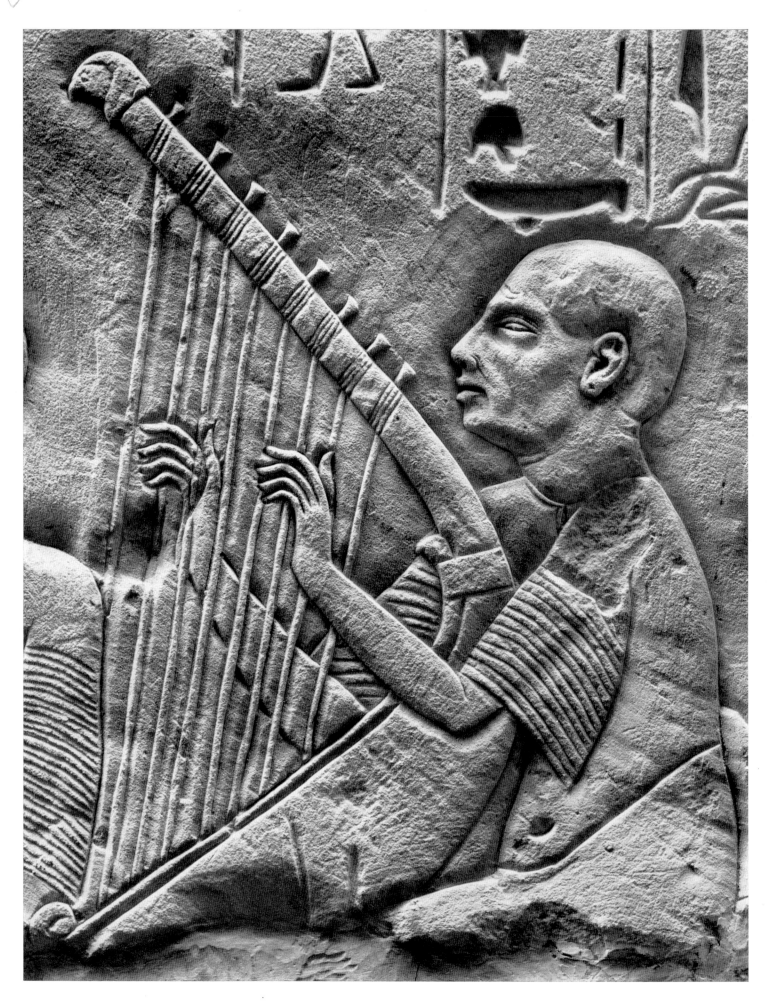

210 Blind harp-player. From the tomb of Paatenemheb near Saqqāra. Leiden

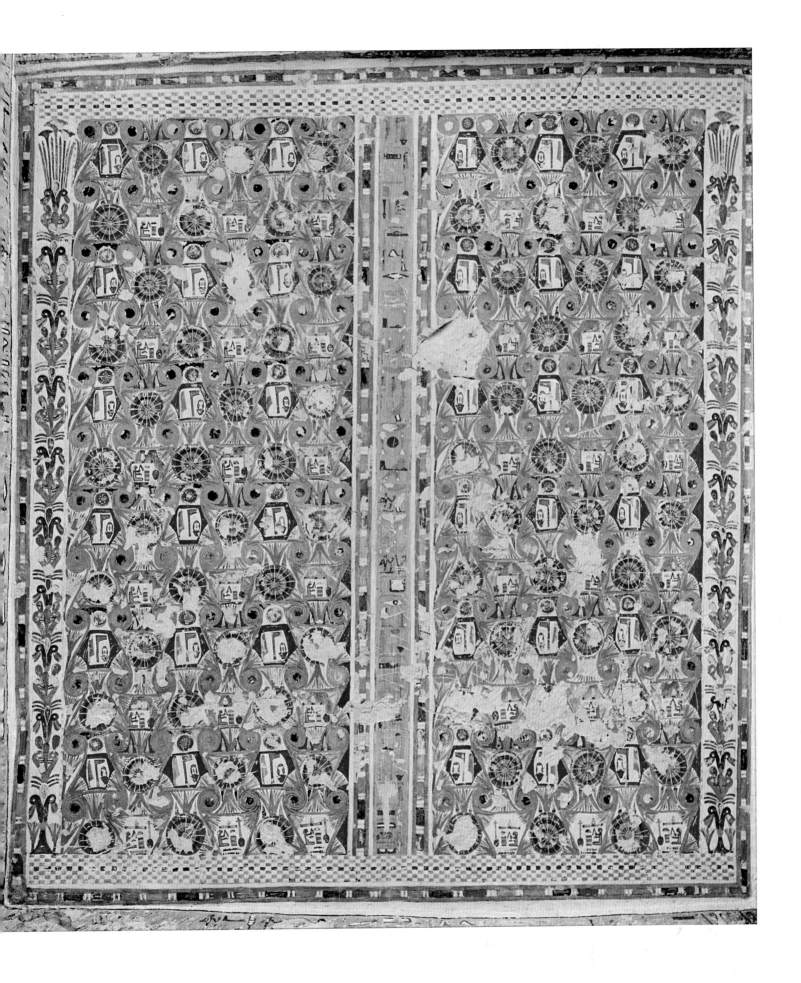

XLV Ceiling of the main room in the tomb of Neferhotep near Thebes

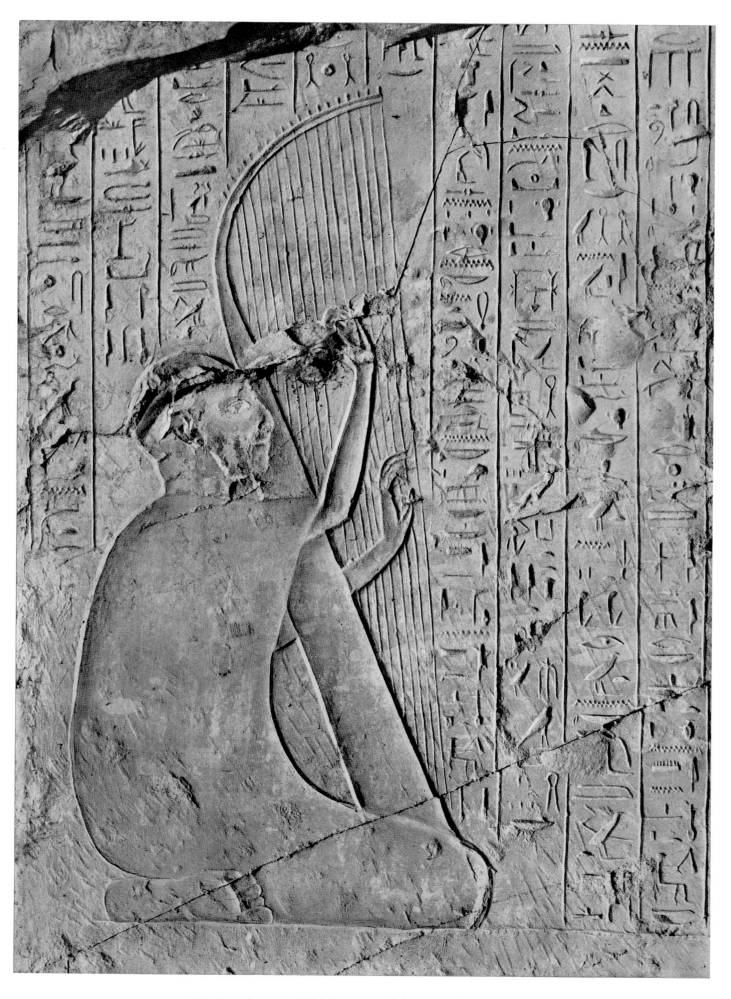

211 From the tomb of Neferhotep near Thebes. Harp-player at a festival

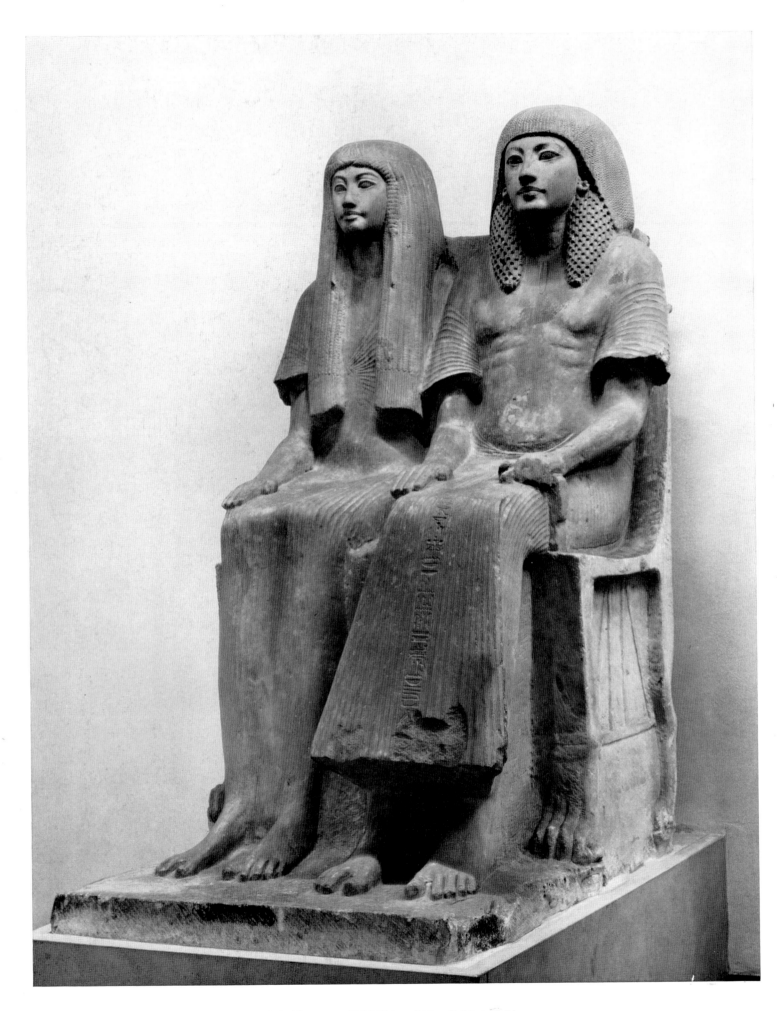

212 The court official Maia and his wife Merit. Leiden

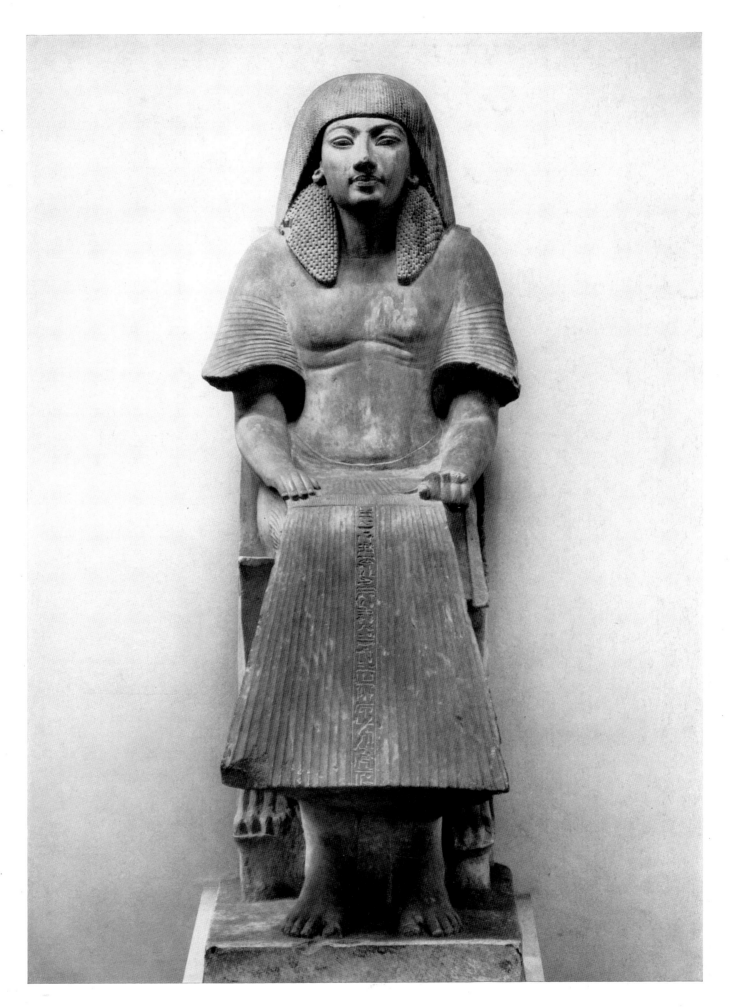

213 The court official Maia. Leiden

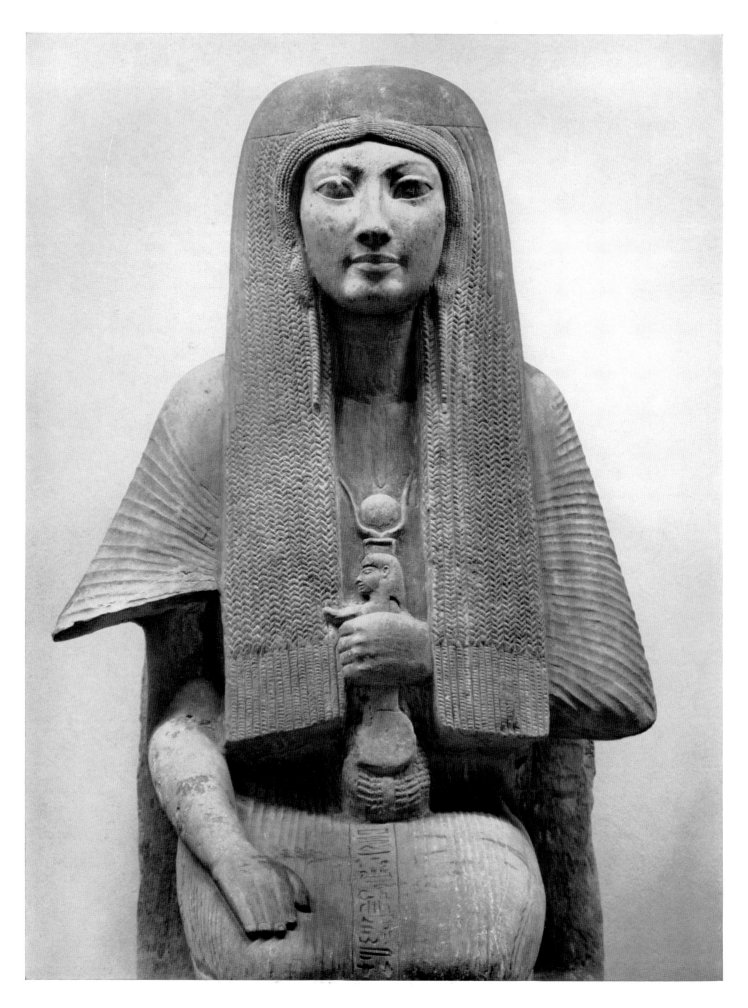

214 From the statue of Merit, wife of Maia. Leiden

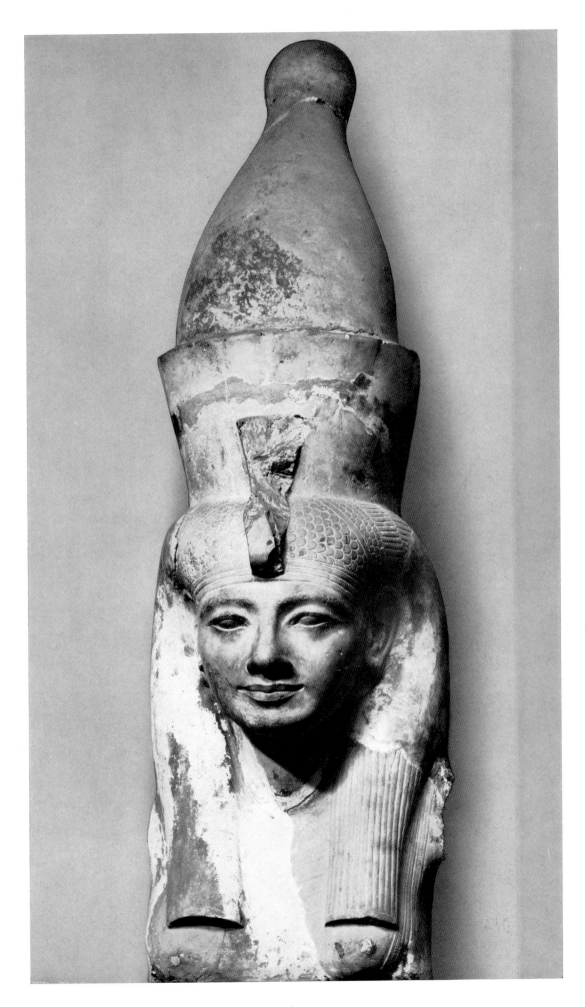

215 The goddess Mut, wife of Amun. Cairo, Museum

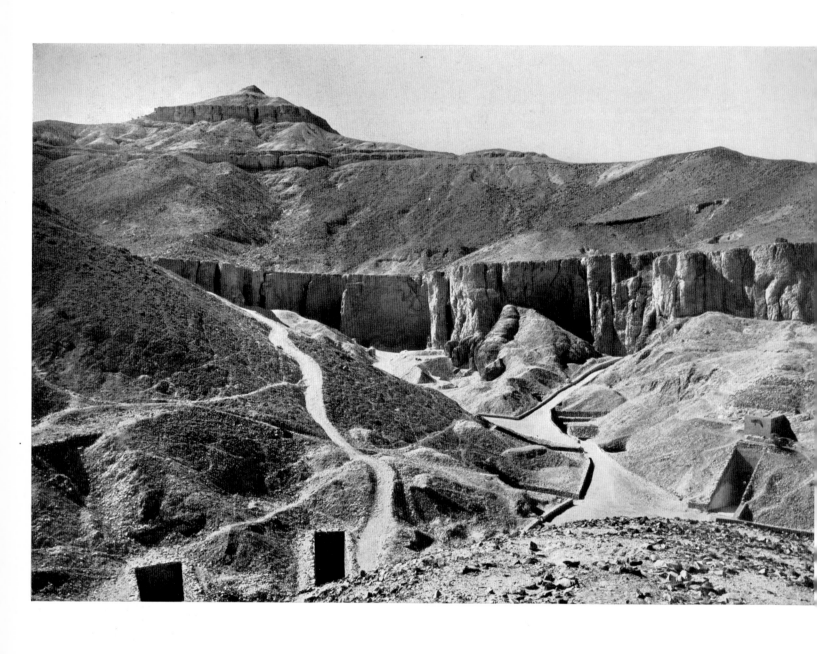

216 The Valley of the Kings' Tombs in the Western Theban mountains

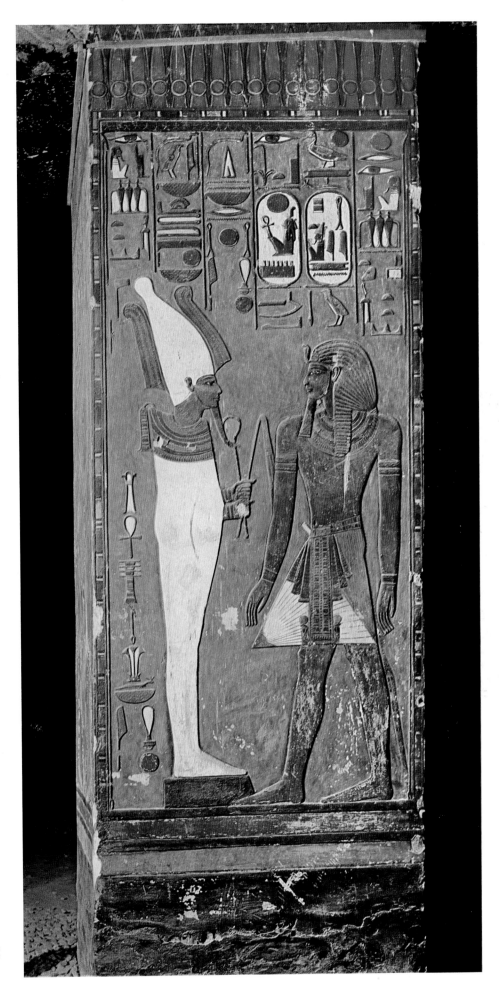

XLVI King Sethos I before the god Osiris,
from his tomb in the Valley of the Kings'
Tombs near Thebes

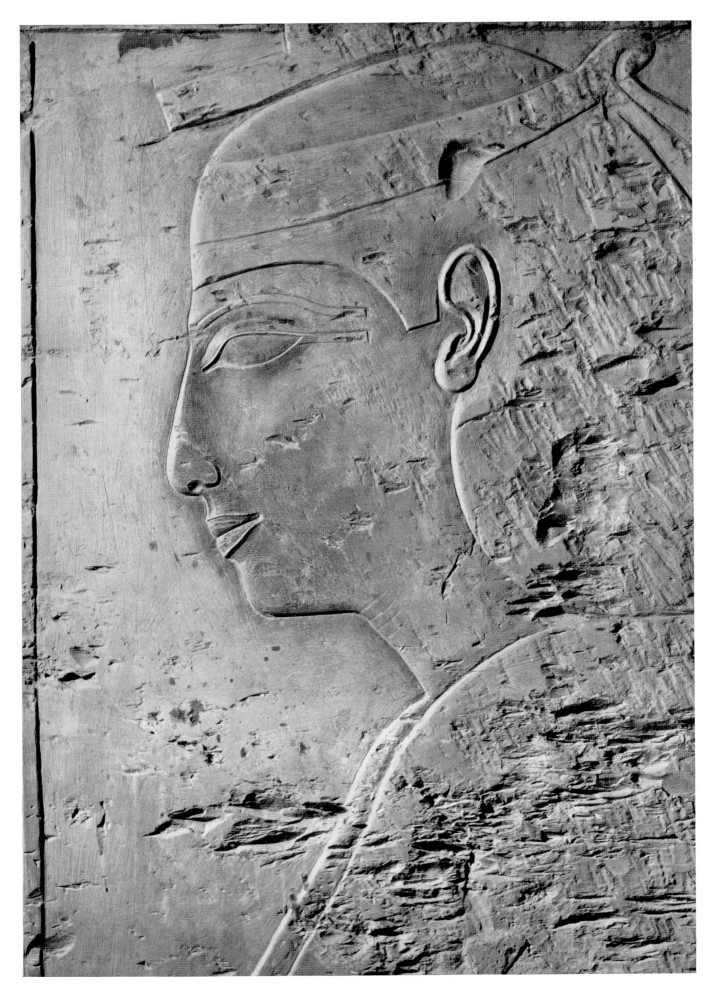

217 From the tomb of King Sethos I in the Valley of the Kings' Tombs: The goddess Isis

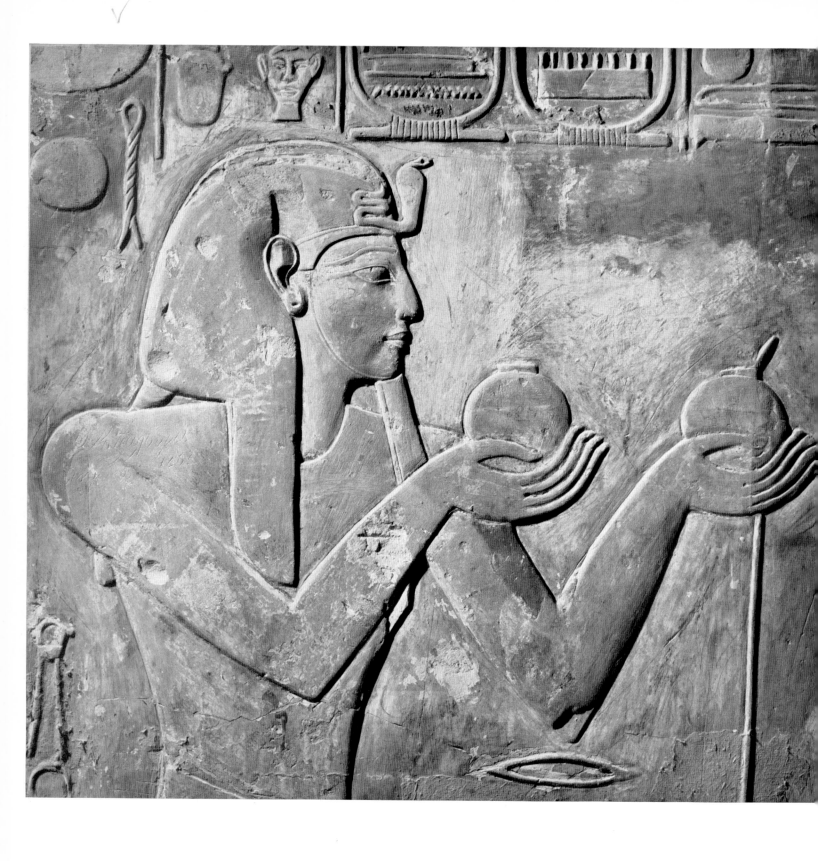

218 From the tomb of King Sethos I in the Valley of the Kings' Tombs: The King offering sacrifices

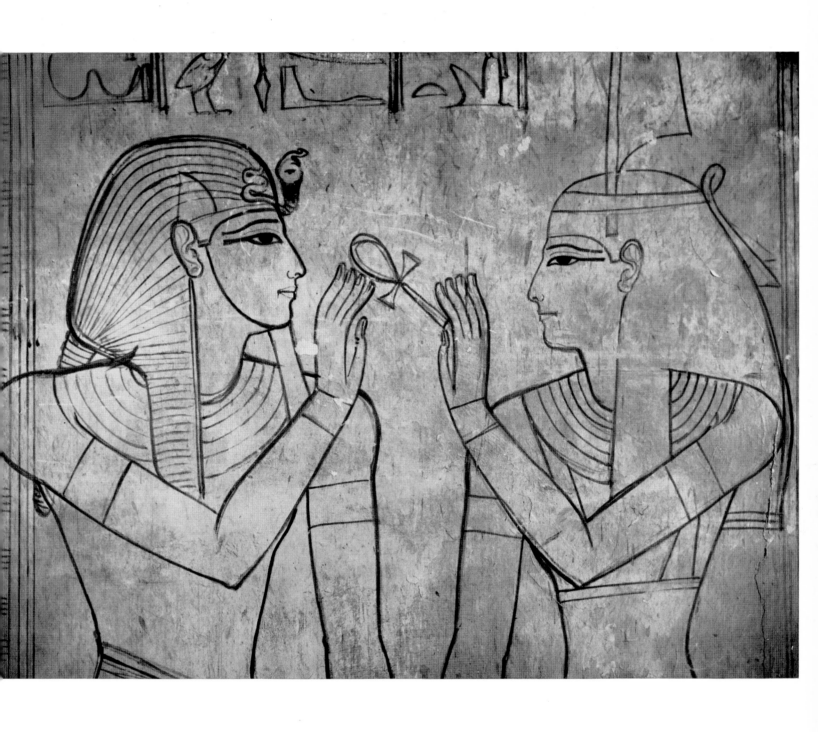

219　From the tomb of King Sethos I in the Valley of the Kings' Tombs: The King before Maat, goddess of truth and righteousness.
Preliminary drawing for a relief at one of the six pillars in the hall of pillars

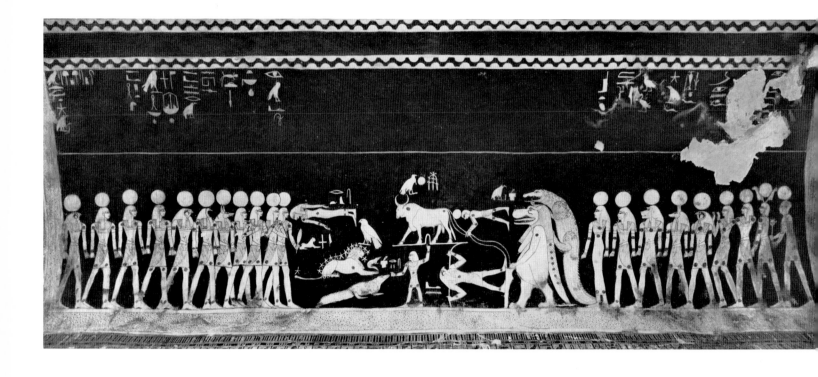

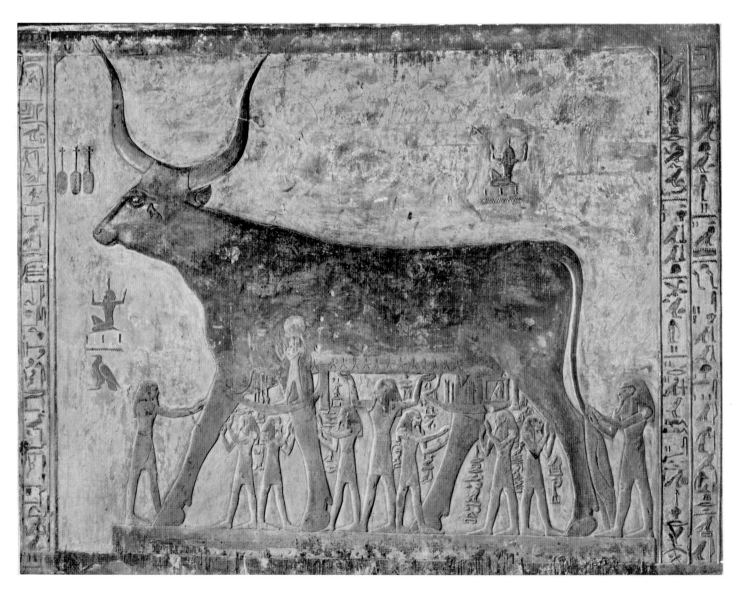

220 From the tomb of King Sethos I in the Valley of the Kings' Tombs. Above: Astronomical ceiling in the room of the sarcophagus behind the hall of pillars: The constellations between eleven gods on the left and nine gods on the right. – Below: The divine cow supported by the god Shou

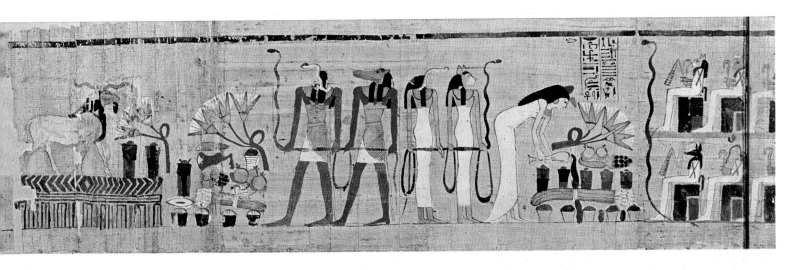

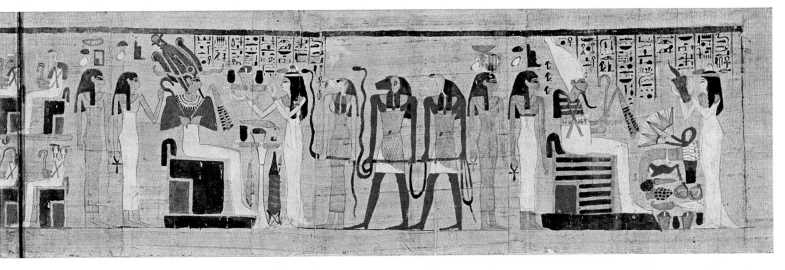

XLVII From the funerary papyrus of the deceased Djedmaatisanchin, illustrating the "Book of That Which is in the Underworld".
Cairo, Museum

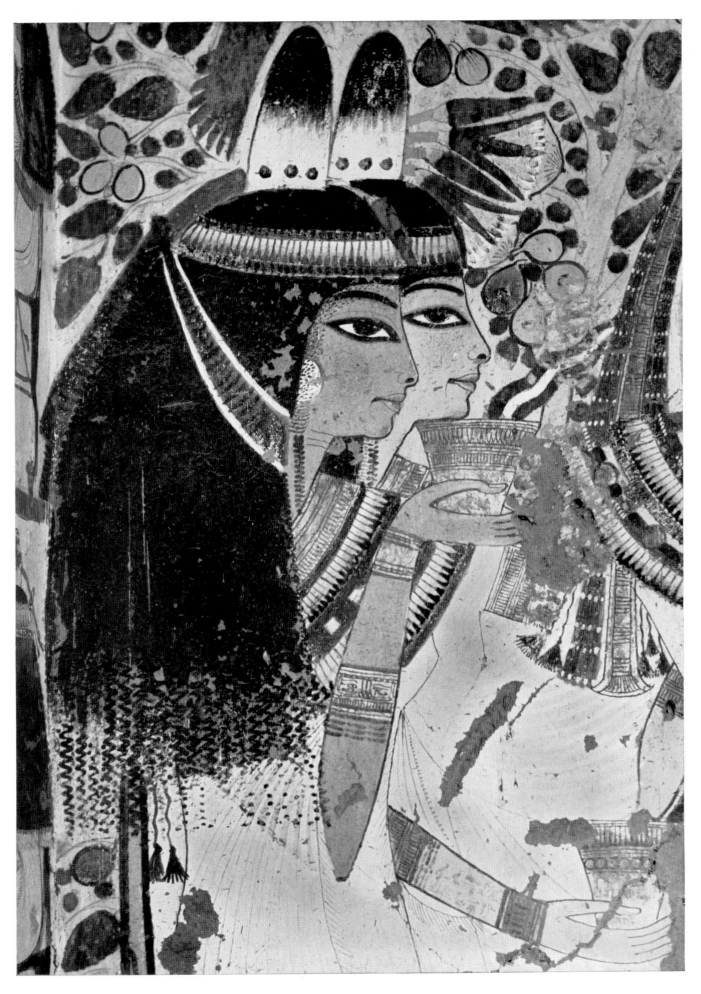

221 From the tomb of the high priest Userhēt at Thebes: The mother and the wife of the deceased

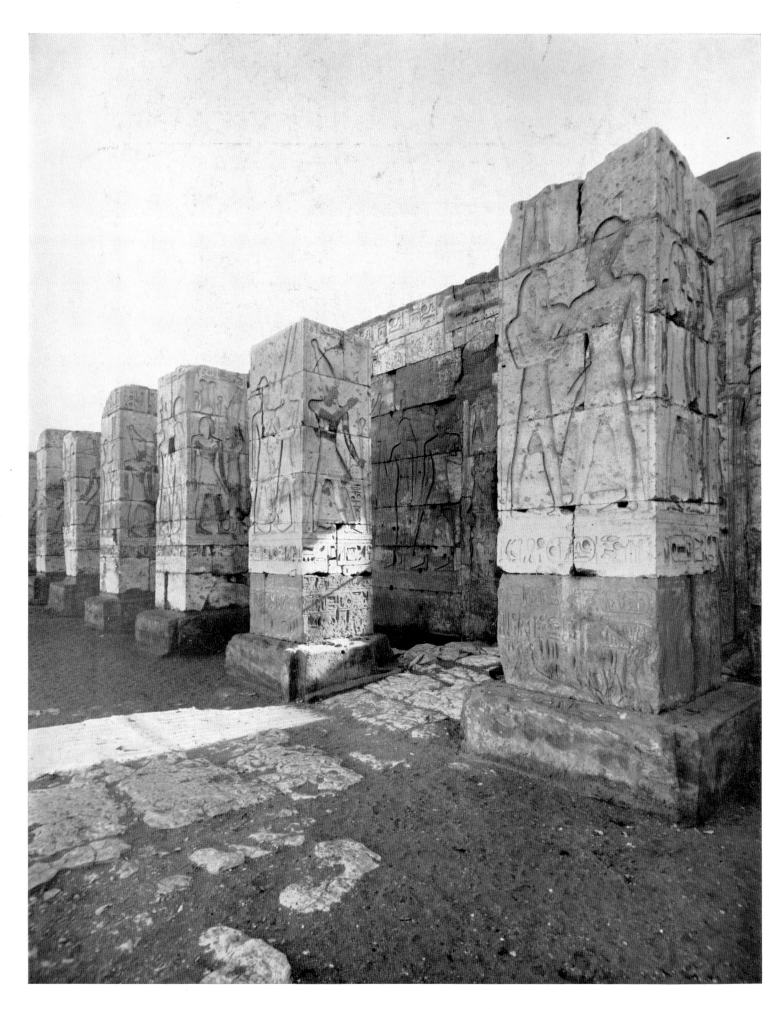

222 Temple of King Sethos I at Abydos. Hall of pillars of the second court

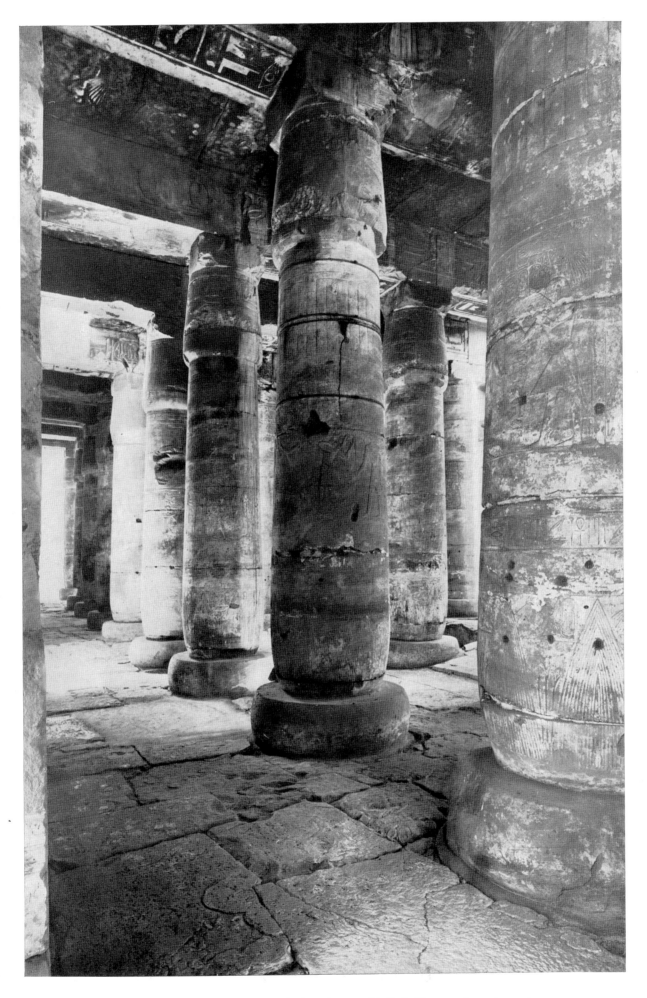

223 Temple of King Sethos I at Abydos. The second hall of pillars, seen from the north

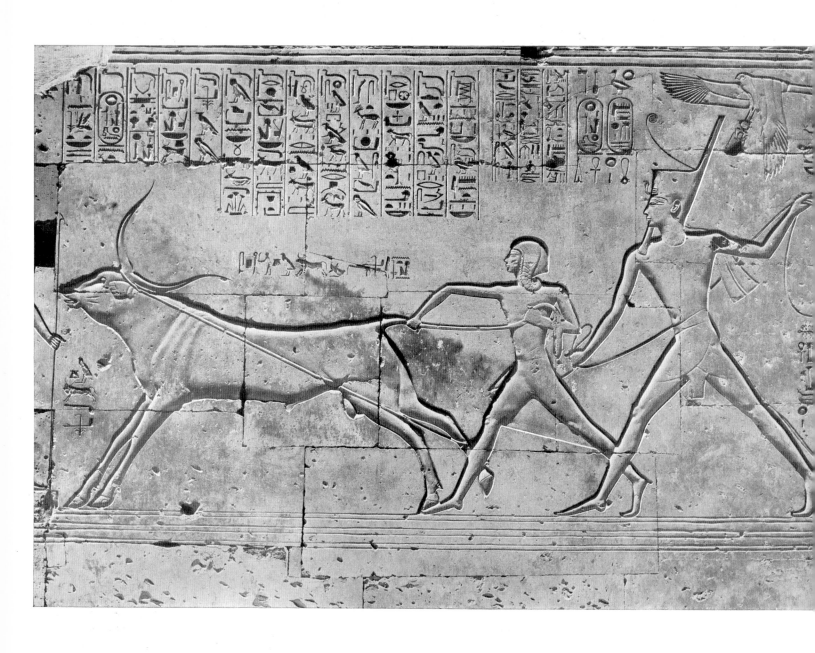

224 Temple of King Sethos I at Abydos. King Ramesses II and a prince capturing a bull

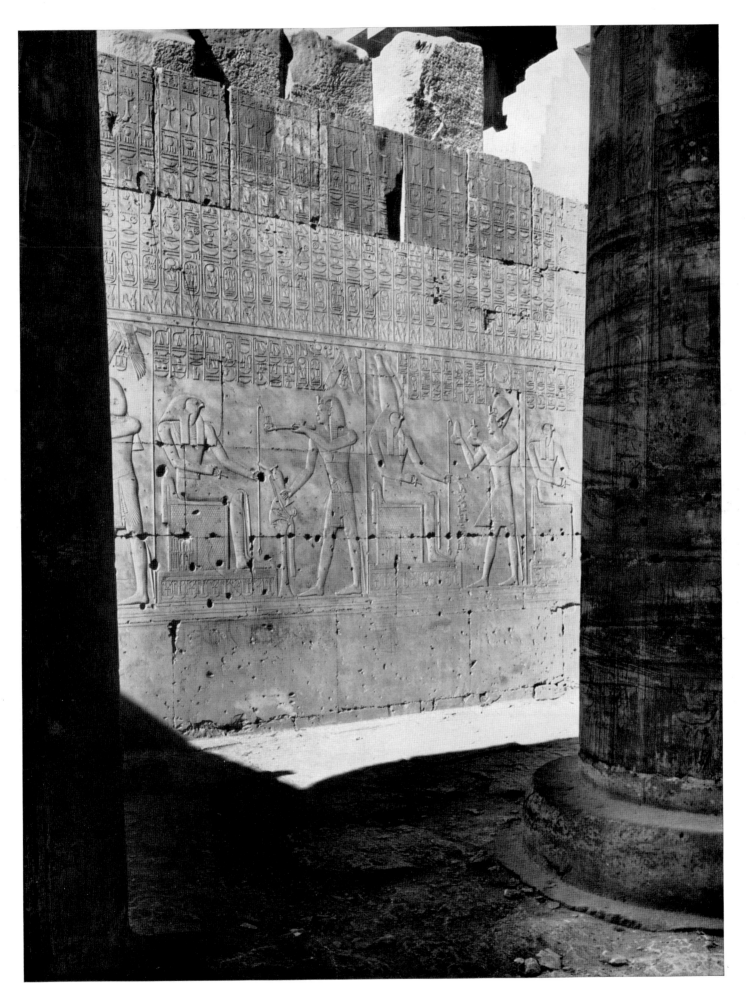

225 Temple of King Sethos I at Abydos. The hall of Nefer-tem and Ptah-Soker: View of the north-west wall

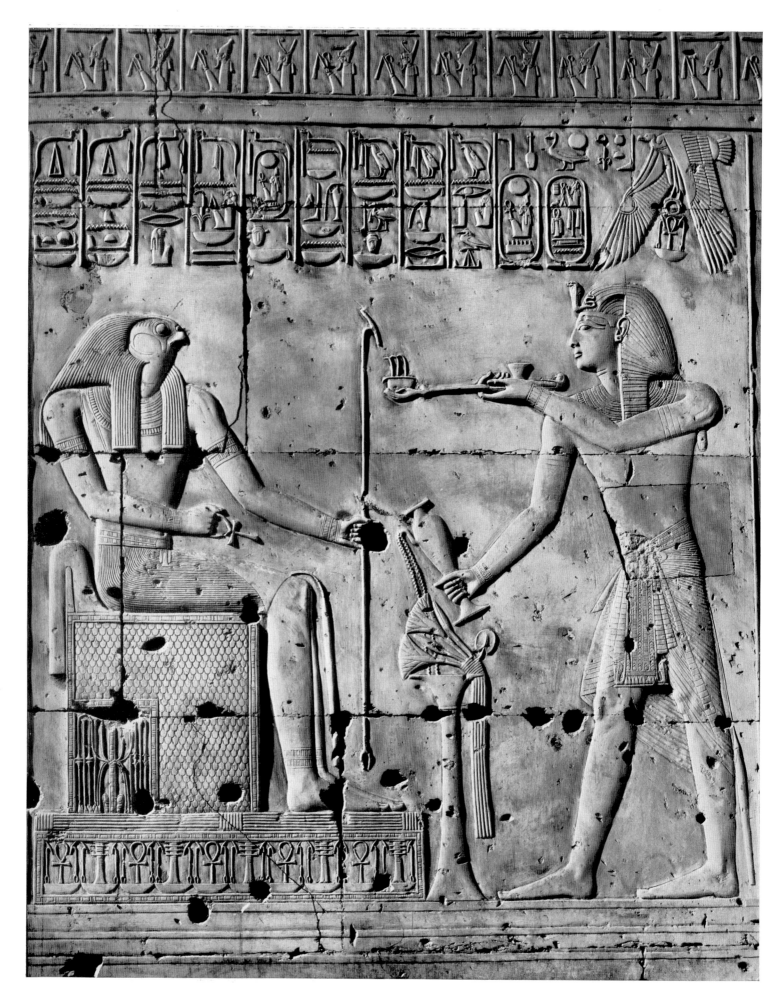

226 Temple of King Sethos I at Abydos. Hall of Nefer-tem and Ptah-Soker: King Sethos I before the death god Soker

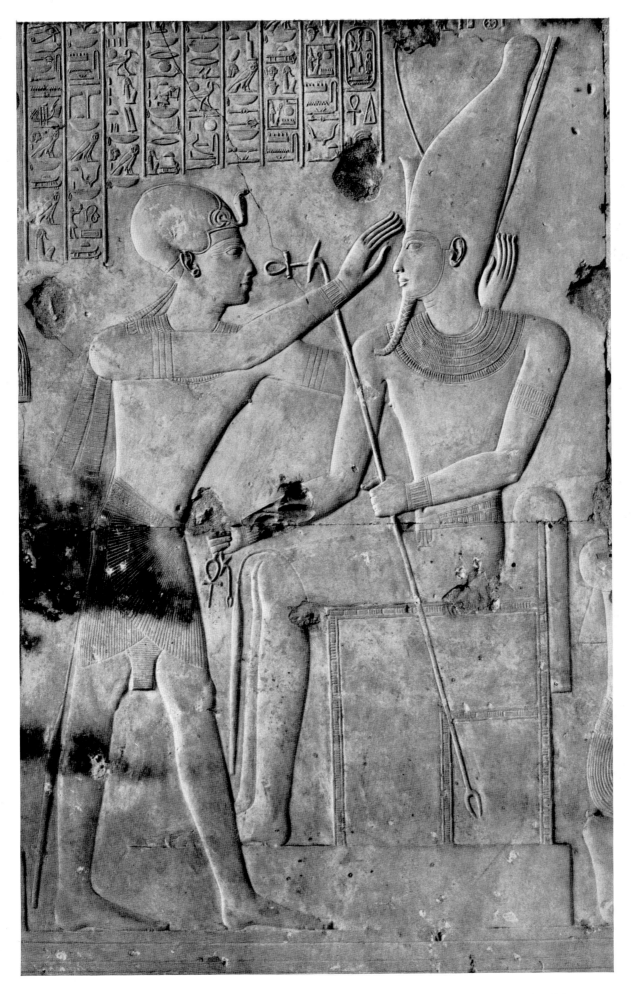

227 Temple of King Sethos I at Abydos. Sanctuary of Rē-Harakhte: King Sethos I before the universal god Atum

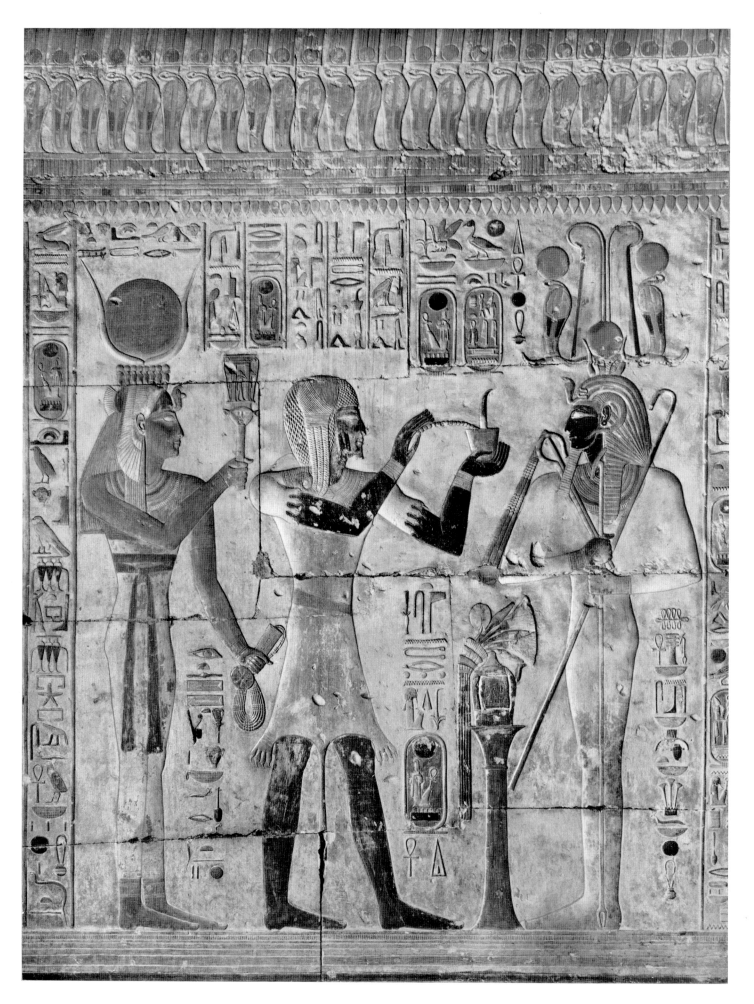

228 Temple of King Sethos I at Abydos. The Osiris chapel. The goddess Isis and the Jun-Mutef priest before Sethos-Osiris

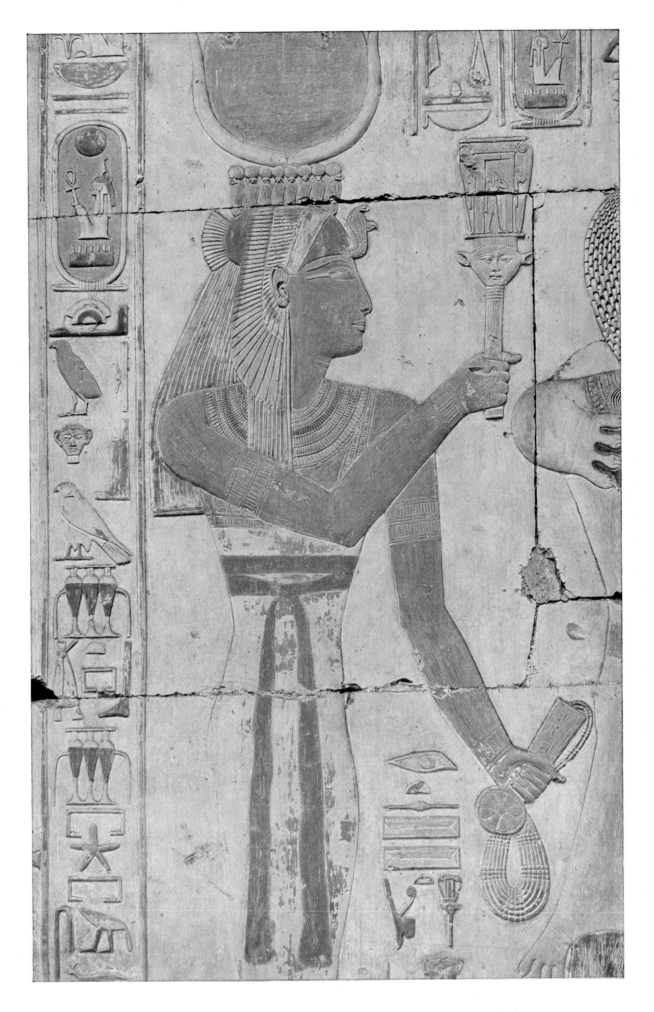

XLVIII Temple of King Sethos I at Abydos. Chapel of Osiris: The goddess Isis (cfr. Plate 228)

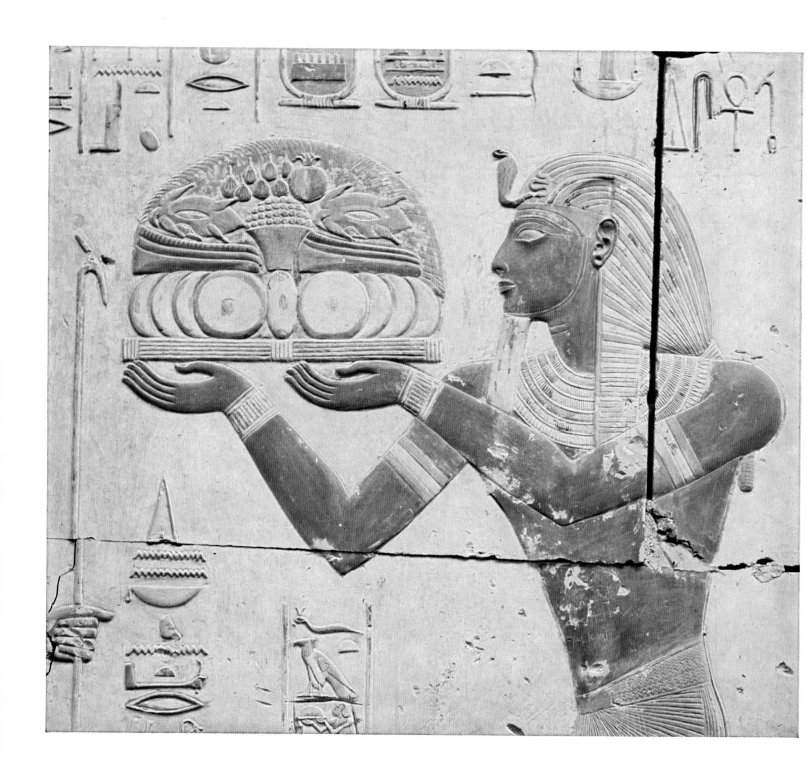

XLIX Temple of King Sethos I at Abydos. Chapel of Isis: King Sethos I offering sacrifices (cfr. Plate L)

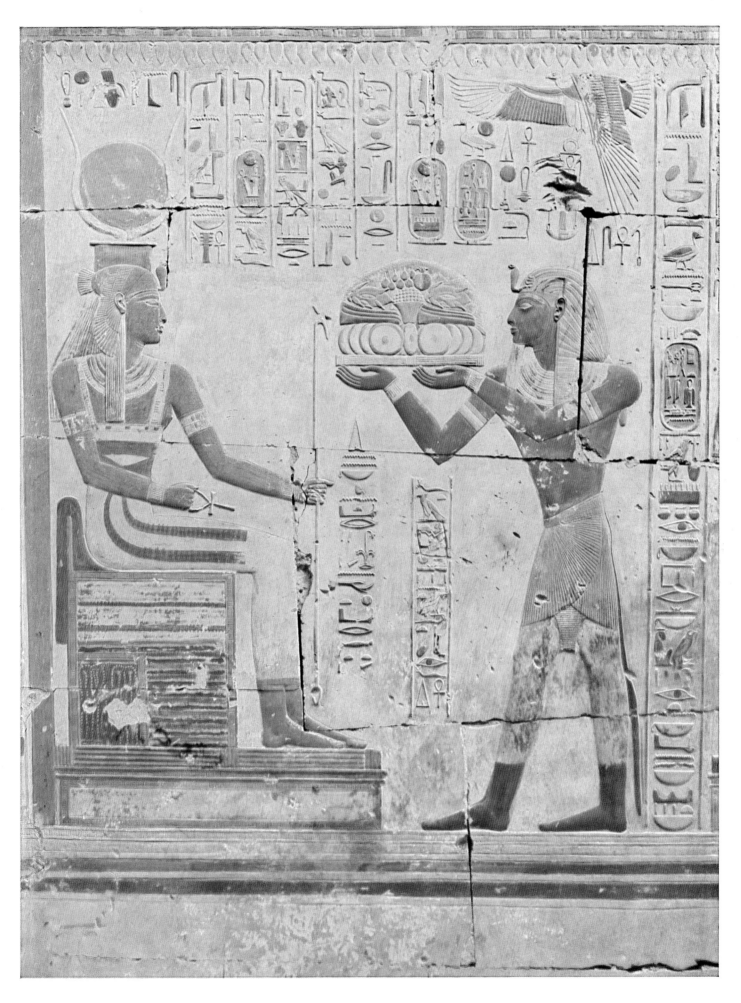

L Temple of King Sethos I at Abydos. Chapel of Isis: King Sethos I with offerings, before the goddess Isis

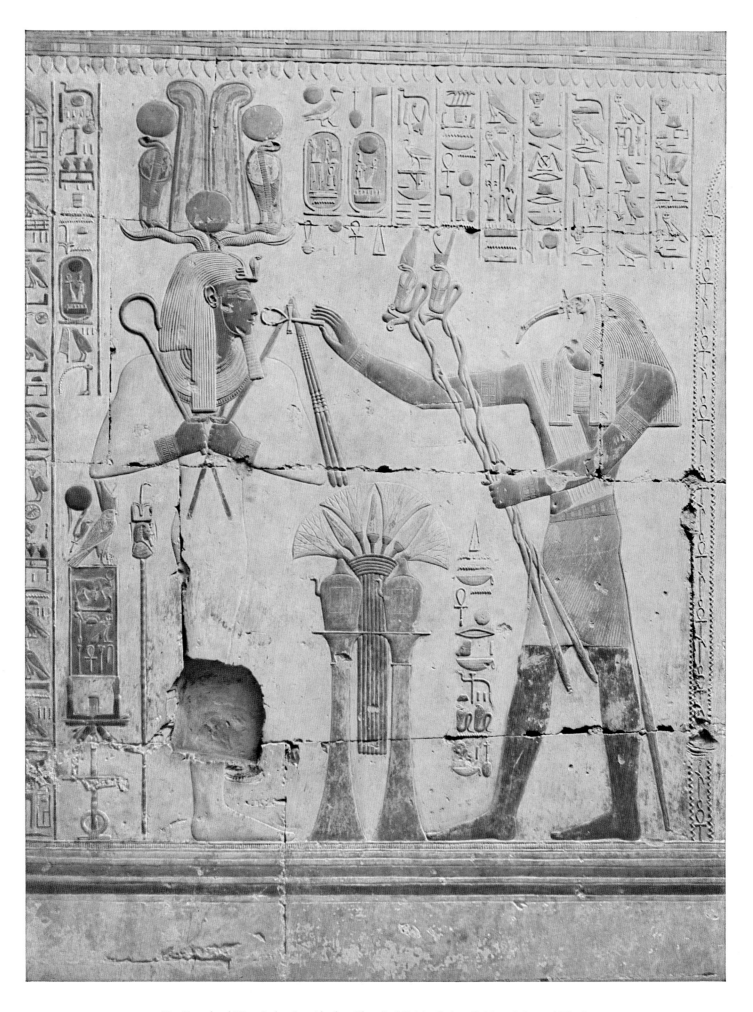

LI Temple of King Sethos I at Abydos. Chapel of Osiris: Sethos-Osiris and the god Thoth

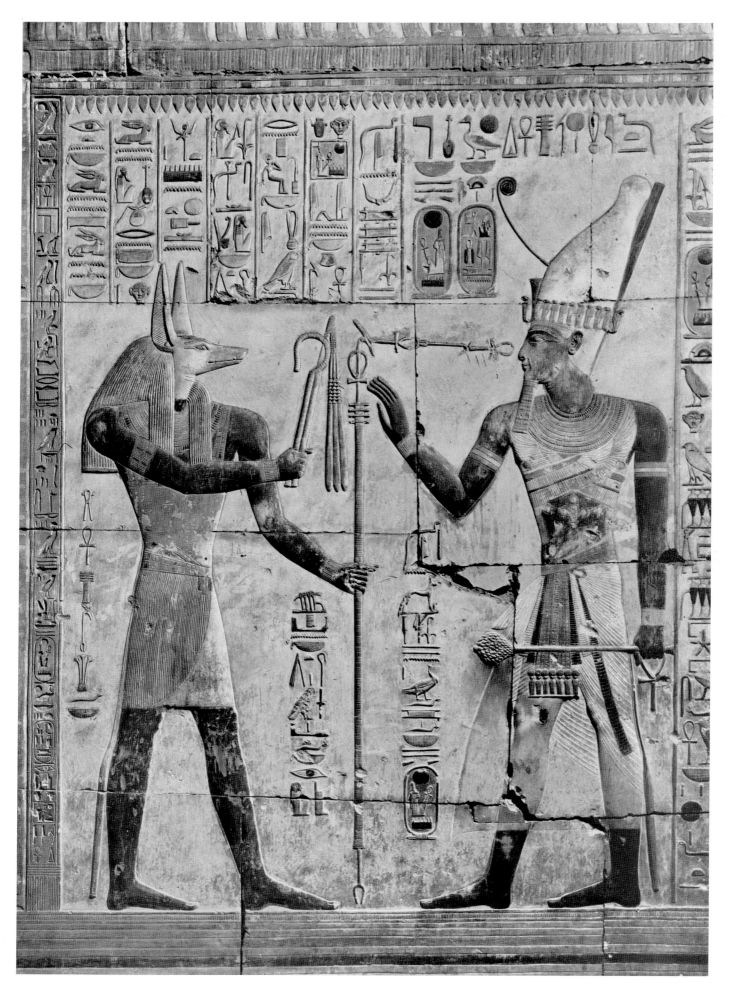

229 Temple of King Sethos I at Abydos. The Osiris chapel. King Sethos I before the god Opouat

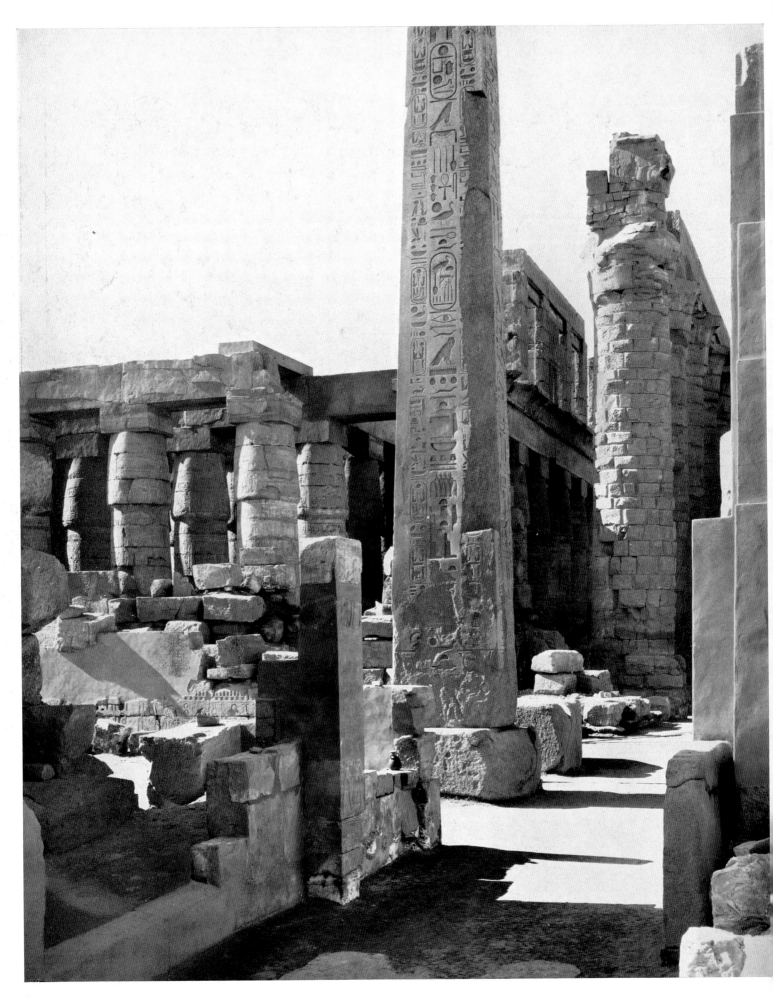

230 Karnak, Temple of Amun. The great hall of pillars of Kings Sethos I and Ramesses II. In the foreground the obelisk of King Tuthmosis I

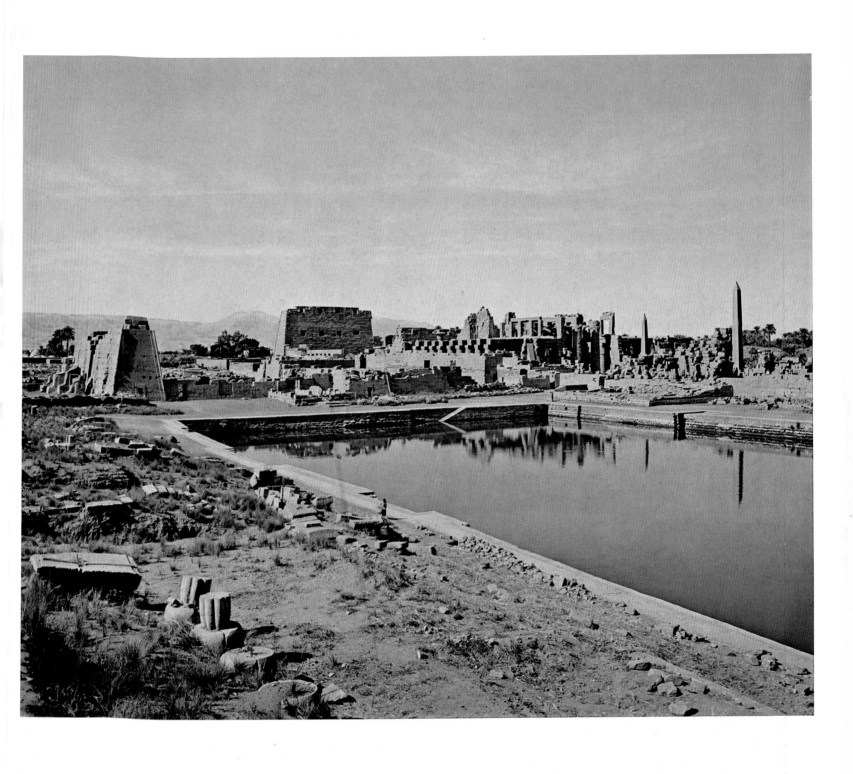

LII Karnak, Temple of Amun, seen from the Sacred Lake

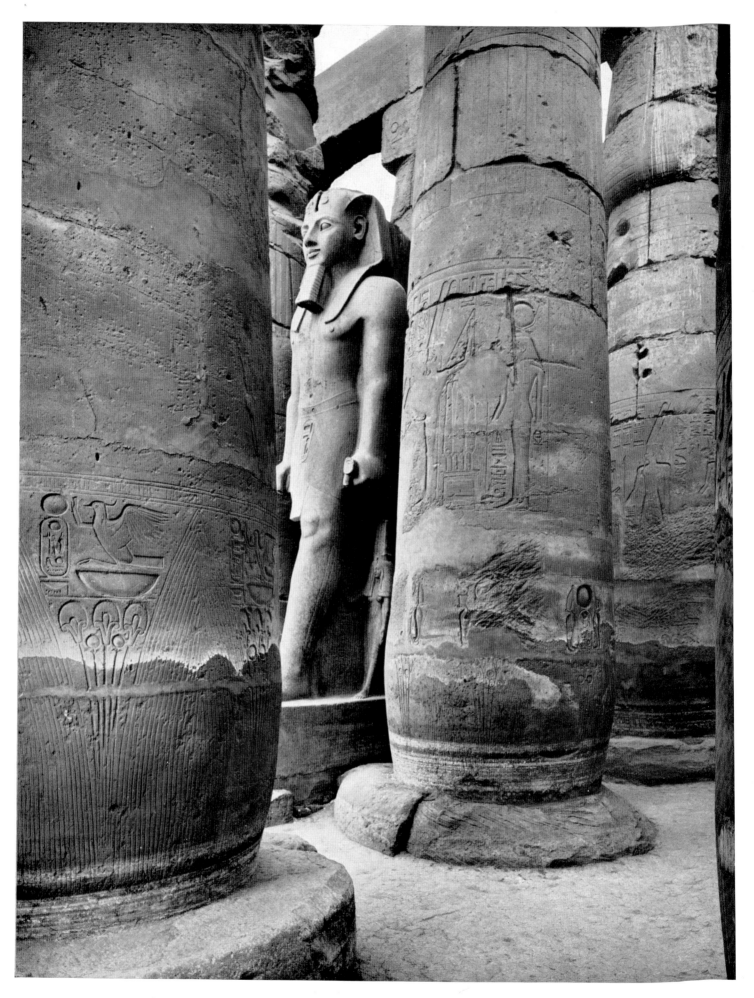

238 Luxor, Temple of Amun-Mut-Khōns.
Statue of King Ramesses II from the first court; beside it the little figure of his wife, Queen Nefertari

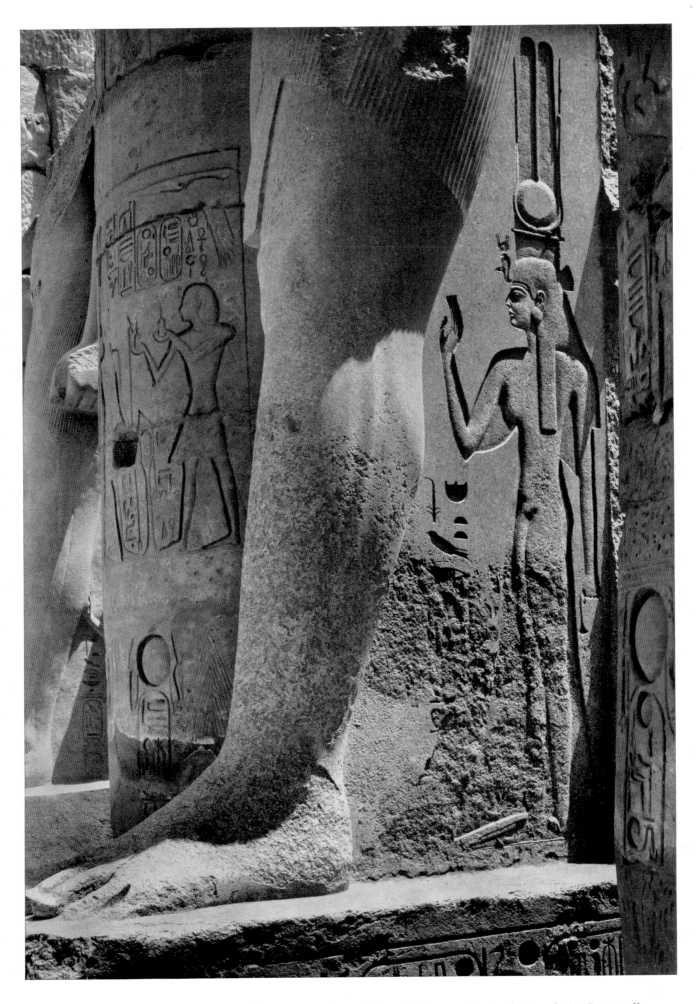

239 Luxor, Temple of Amun-Mut-Khōns. First court. Queen Nefertari beside one of the large statues of King Ramesses II

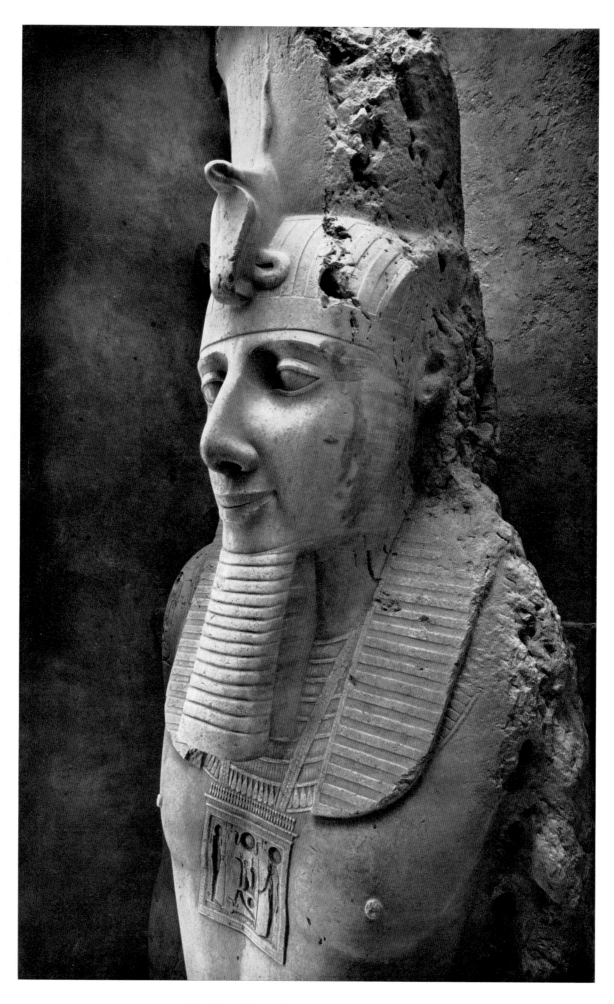

240 Mit-rahina. Colossal statue of King Ramesses II

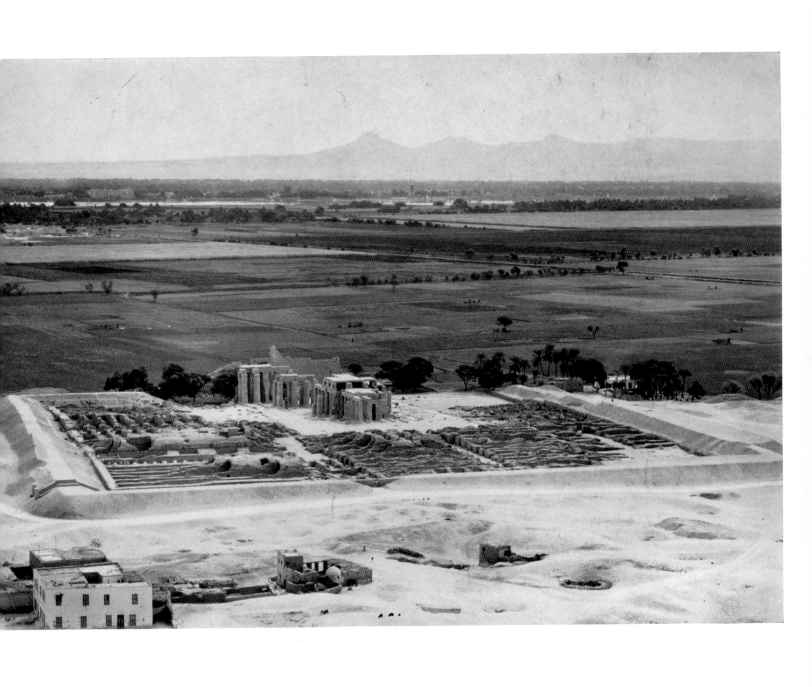

241 Funerary temple of King Ramesses II and landscape near Thebes and Luxor

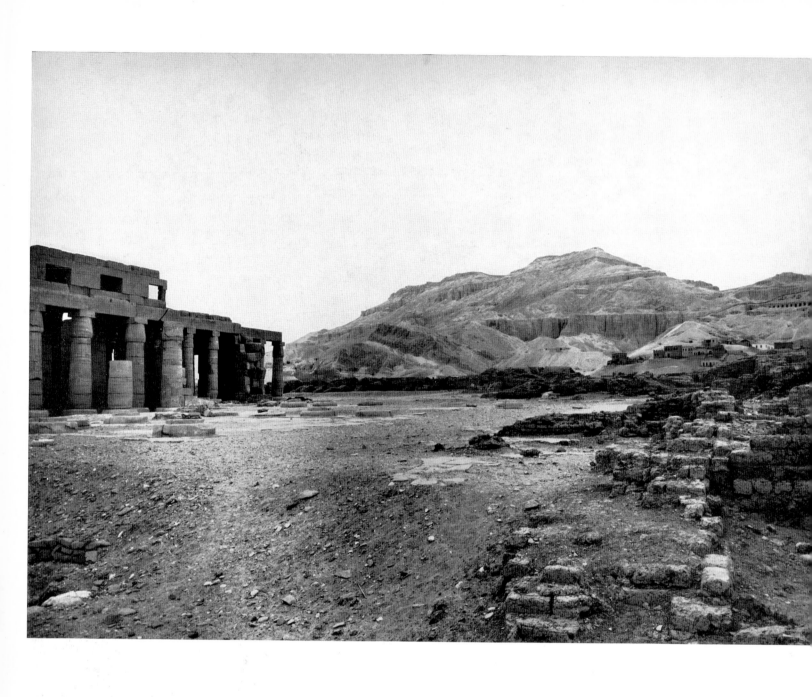

242 The Necropolis of Thebes, seen from the funerary temple of King Ramesses II. On the right, Middle Kingdom rock tombs

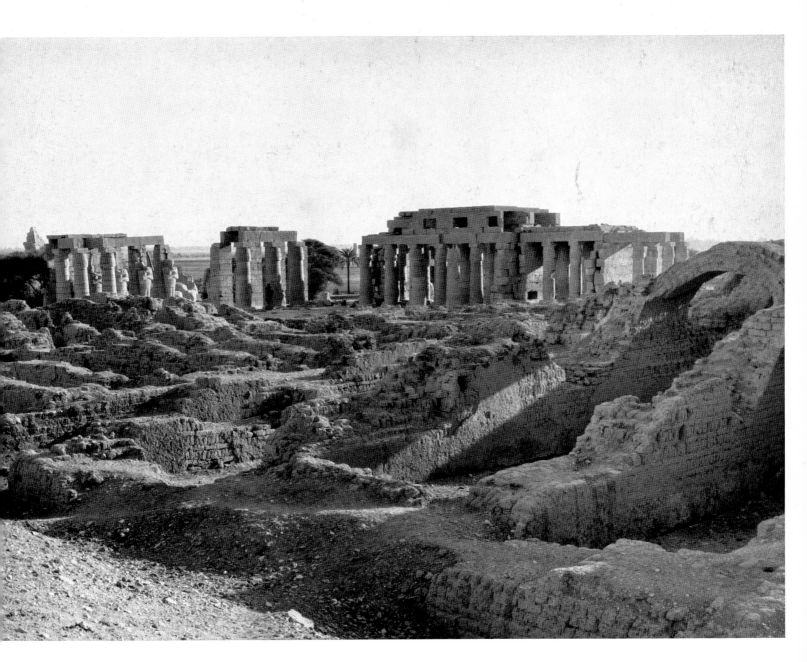

243 Thebes. Funerary temple of King Ramesses II, seen from the north. In the foreground the ruins of the store-rooms

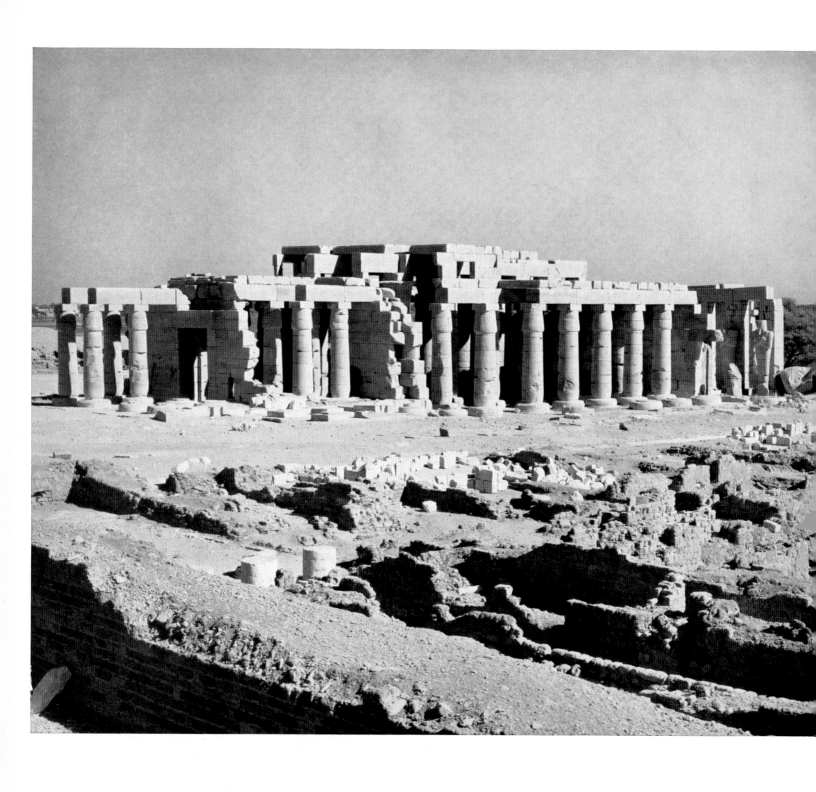

244 Thebes. Funerary temple of King Ramesses II, seen from the west,
with view of the three main naves and the two south-western lateral aisles of the hall of pillars

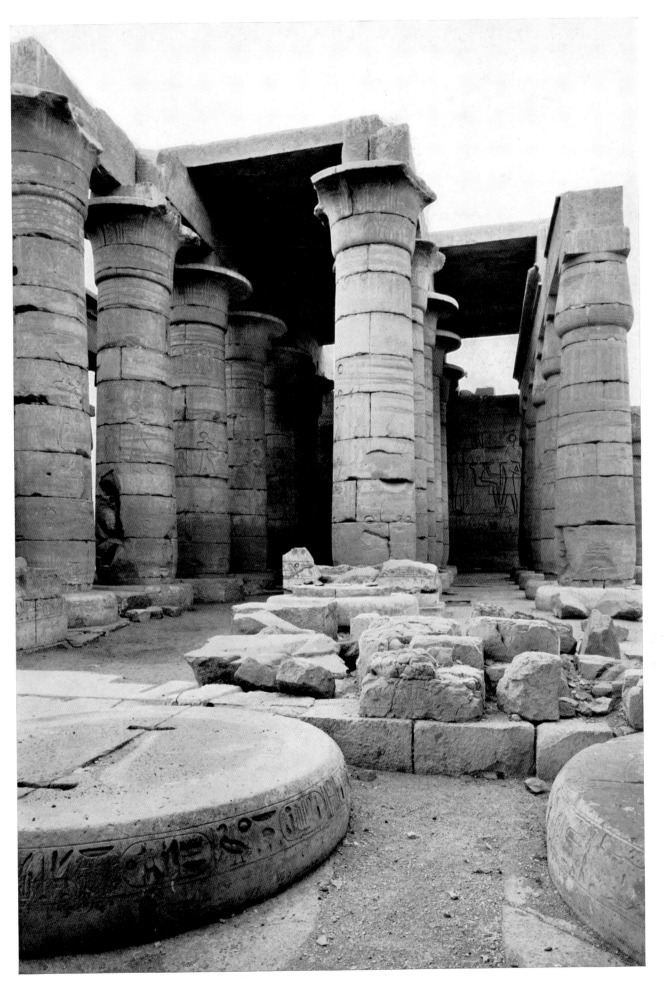

245 Funerary temple of King Ramesses II. View of the central and north-eastern main naves

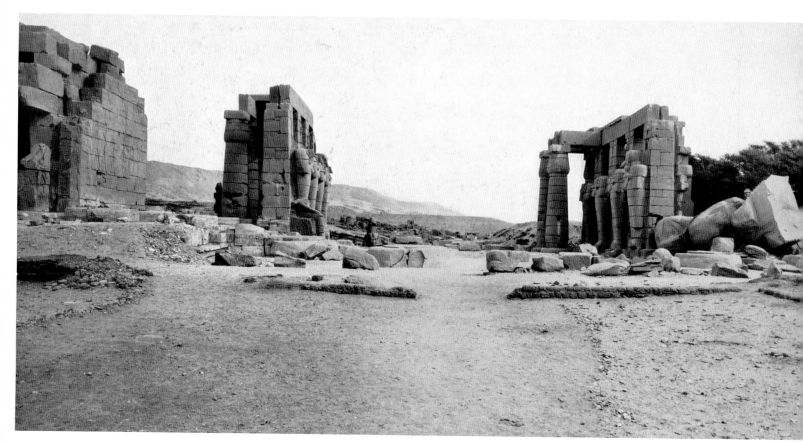

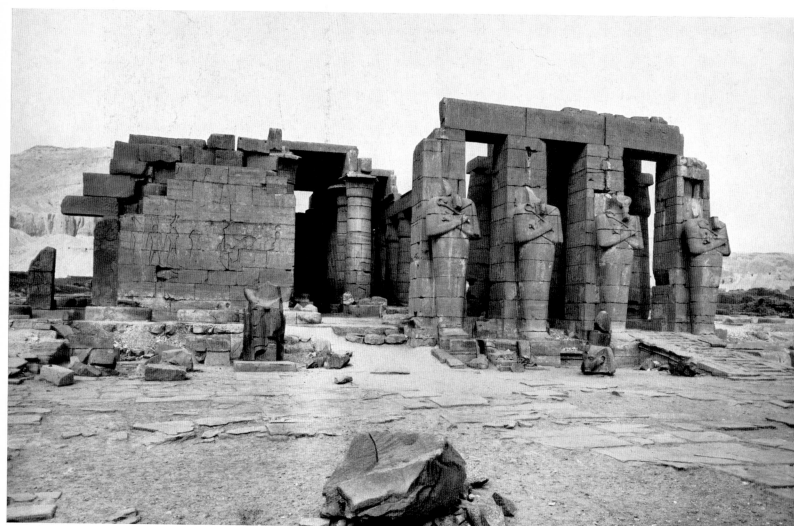

246 Funerary temple of King Ramesses II. Above: The second court seen from the south-west.
Below: The north-west side of the second court; behind it, the great hall of pillars

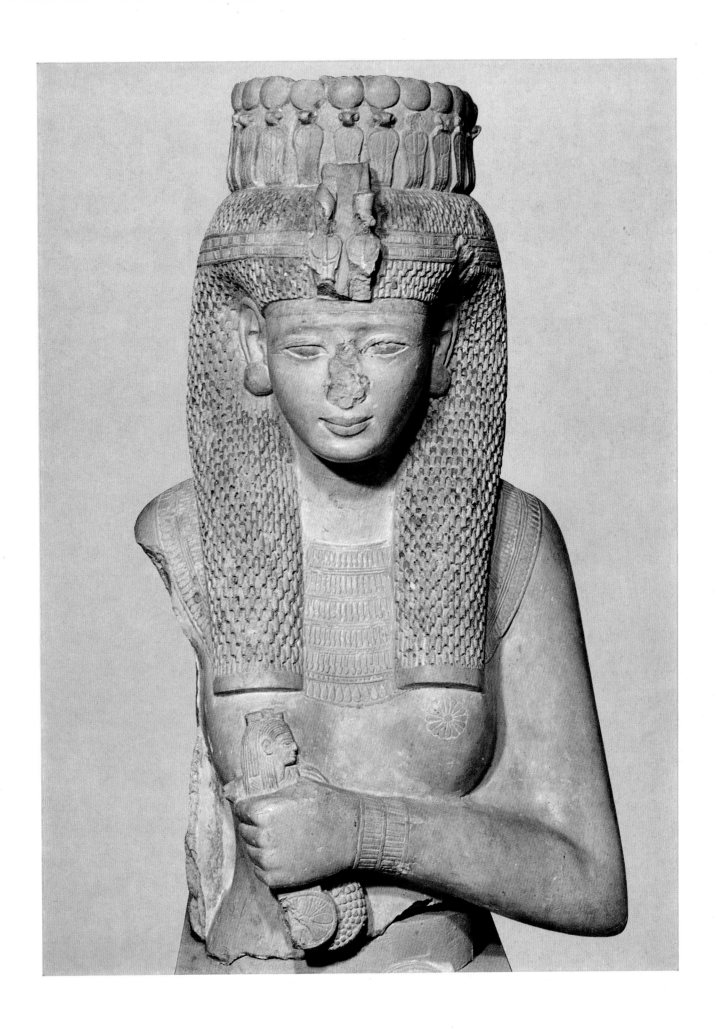

LIV Bust of a wife or daughter of Ramesses II, from the funerary temple of the king at Thebes. Cairo, Museum

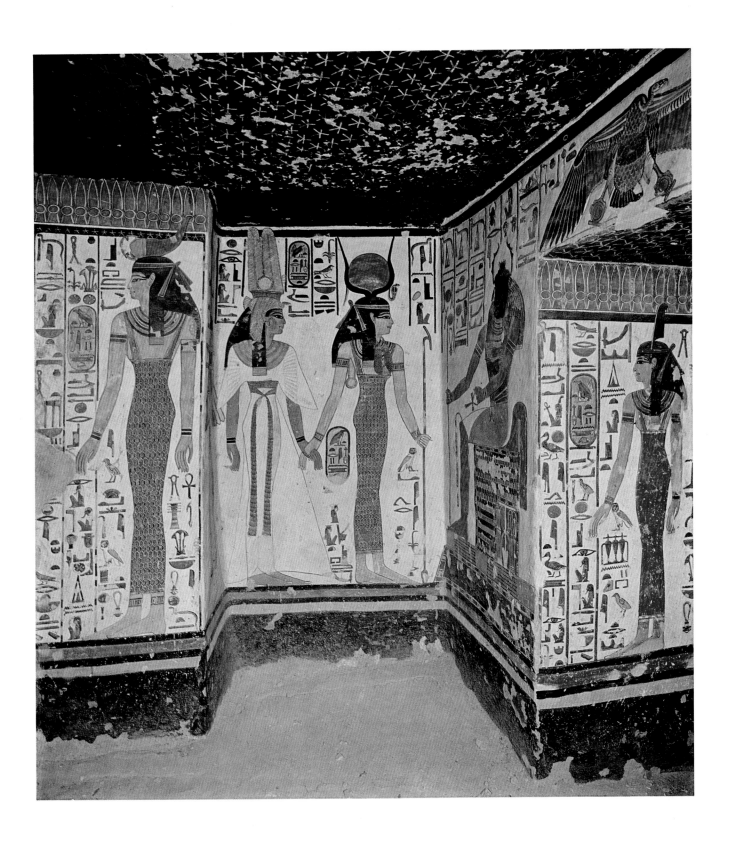

LV In the tomb of Queen Nefertari at Thebes: Queen Nefertari guided by Isis

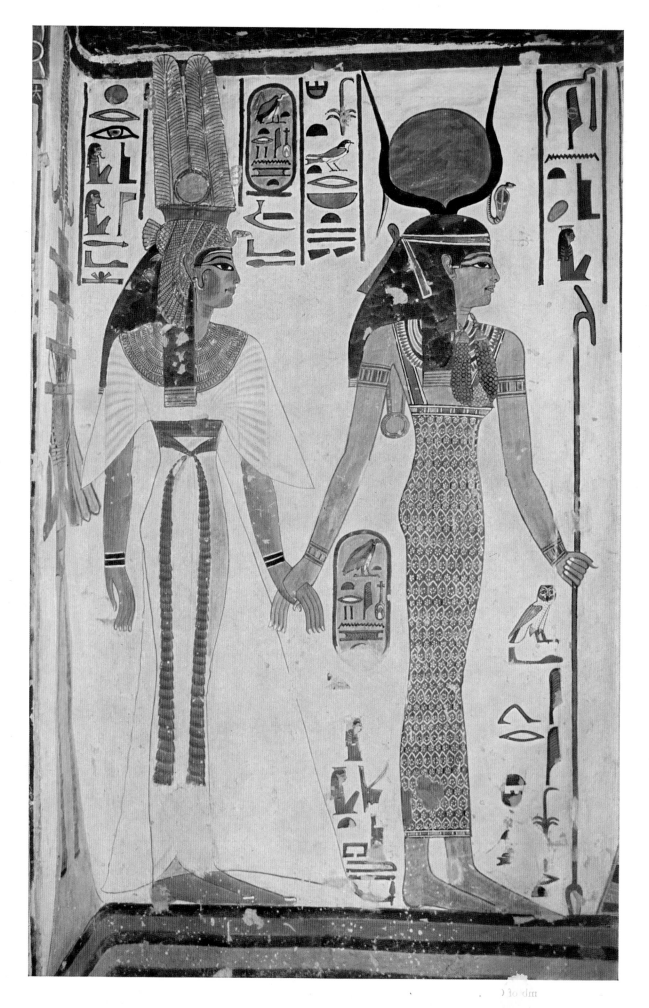

LVI Entrance room to the tomb of Queen Nefertari at Thebes. Queen Nefertari guided by Isis. Detail of Plate LV

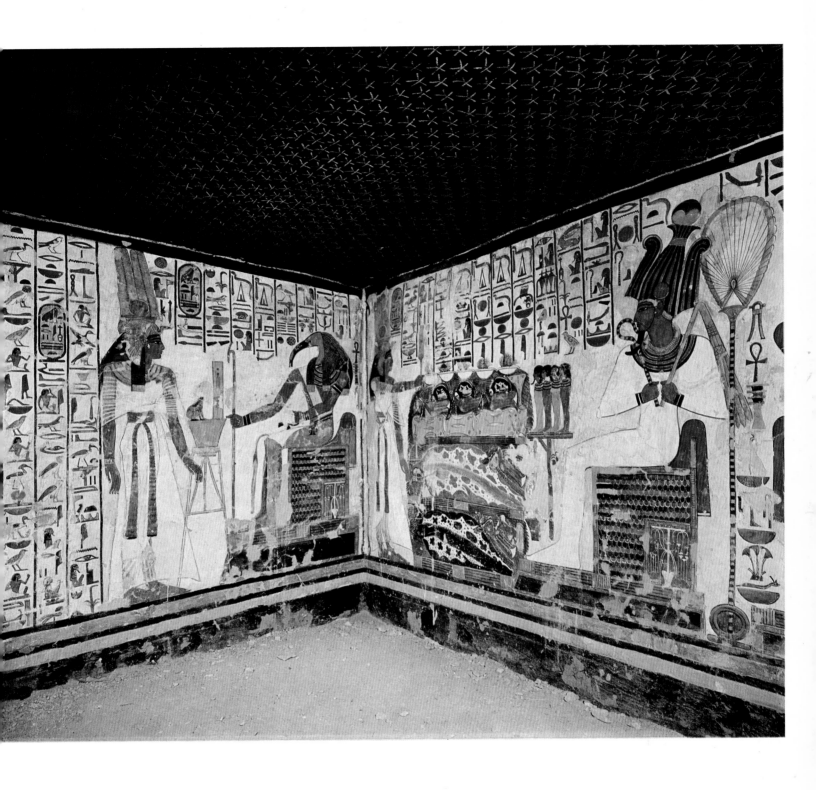

LVII In the　　　　　Queen Nefertari at Thebes. Main room. The Queen before the god Thoth (left) and the god Osiris (right)

LVIII In the tomb of Queen Nefertari at Thebes. Main room. The Queen in adoration

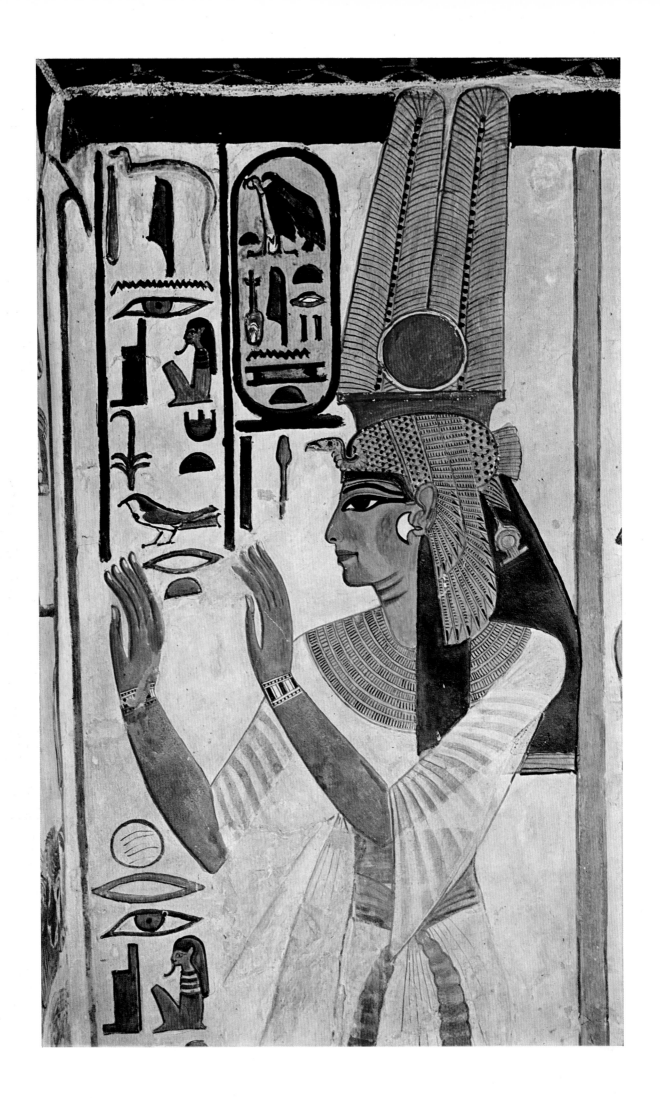

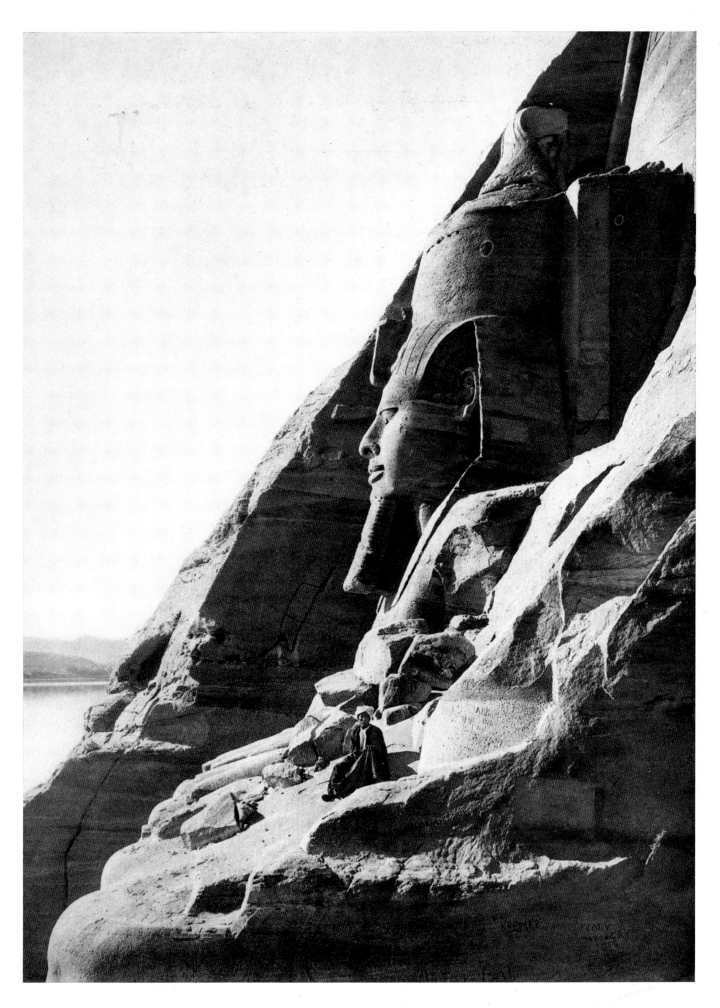

247 Abu Simbel. One of the four colossal statues of King Ramesses II in front of the entrance to the temple

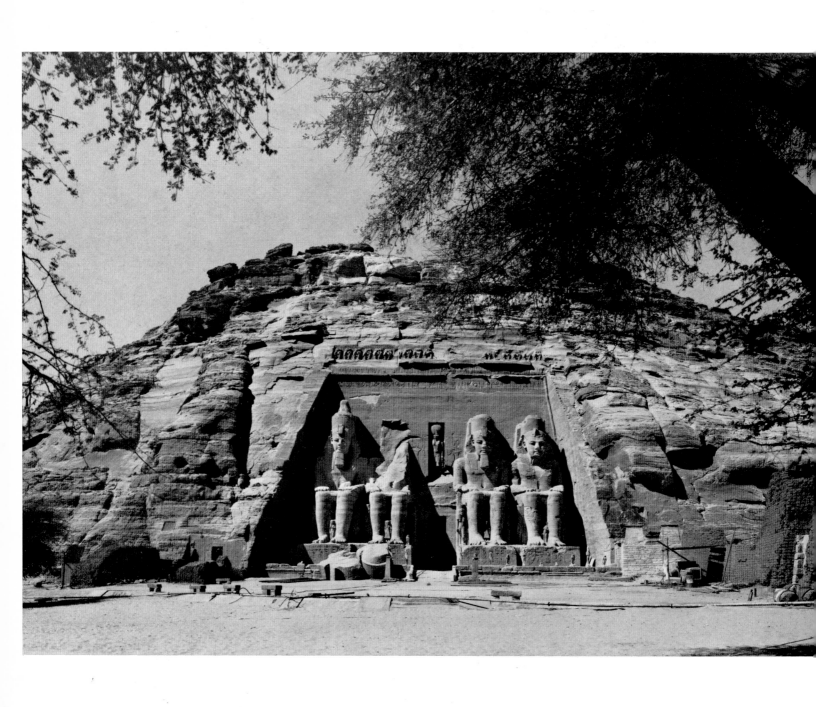

248 Abu Simbel. Front of the rock-temple erected by King Ramesses II with the four colossal seated statues of the king

249 Abu Simbel. Above: The two temples of King Ramesses II, seen from the north. Below: The front of the small northern temple

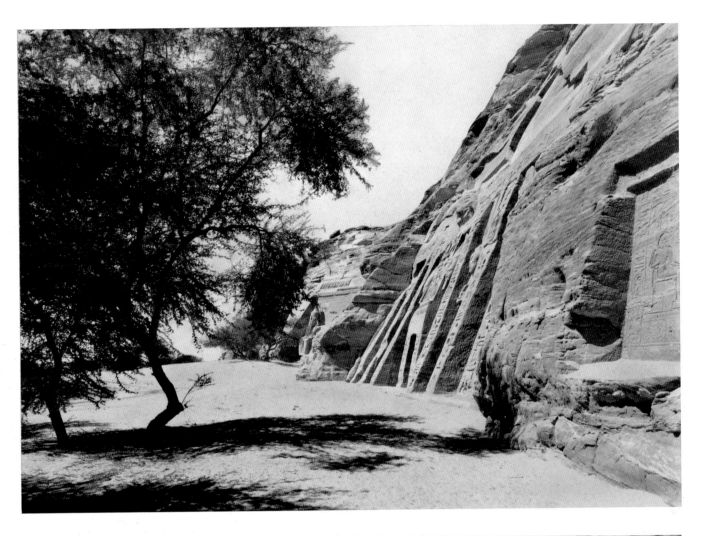

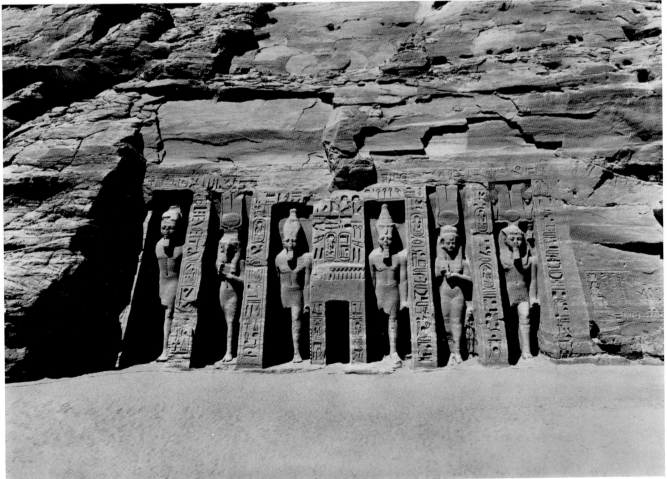

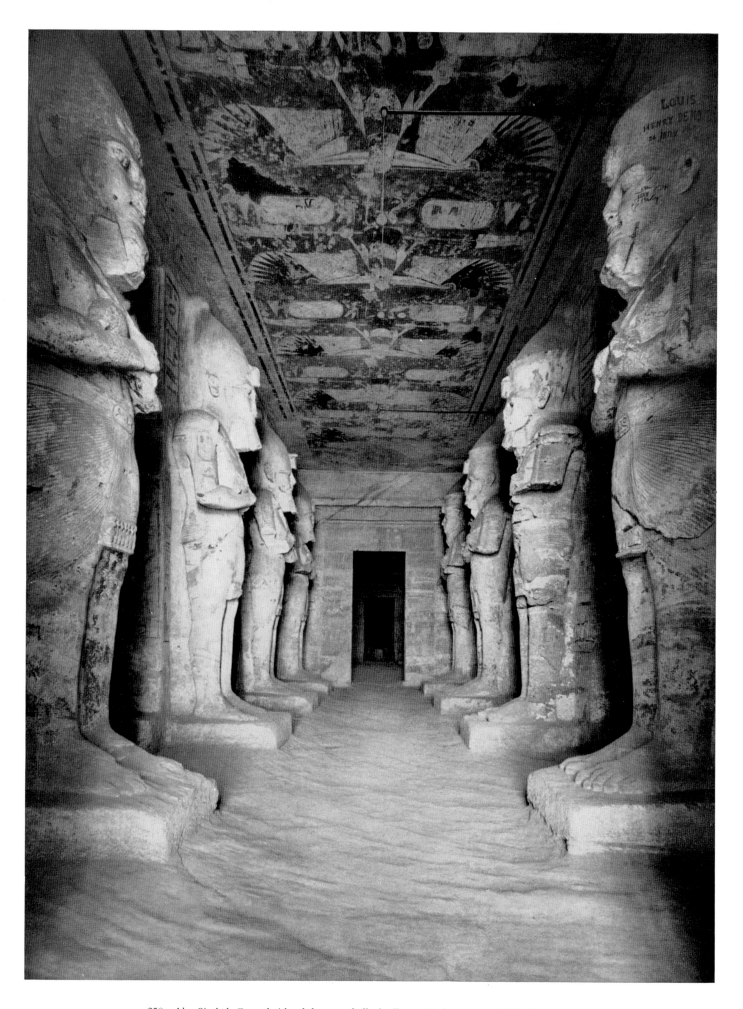

250 Abu Simbel. Central aisle of the great hall of pillars with the statues of King Ramesses II

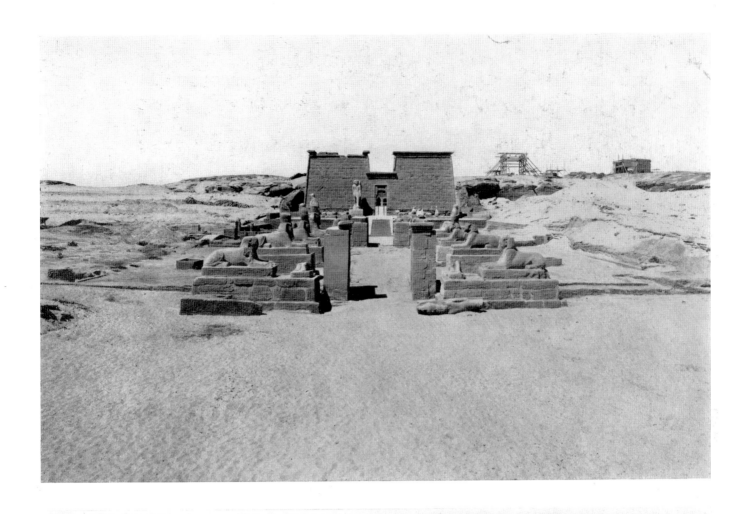

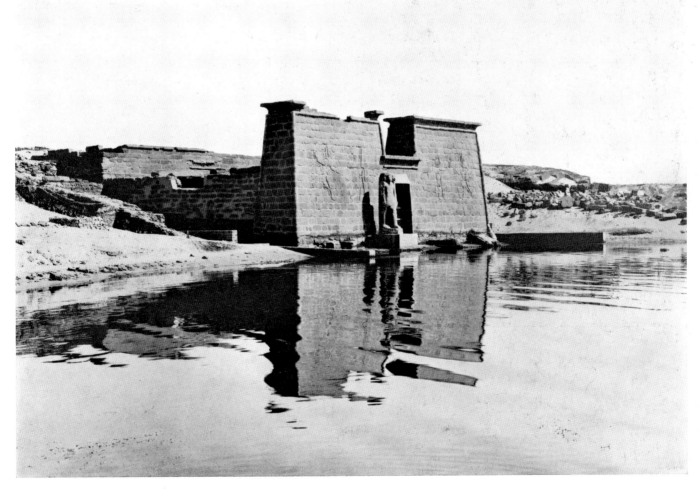

251 Quadi es-Seboua, Temple of King Ramesses II.
Above: During the dry period; below: In winter-time after the second elevation of the dam

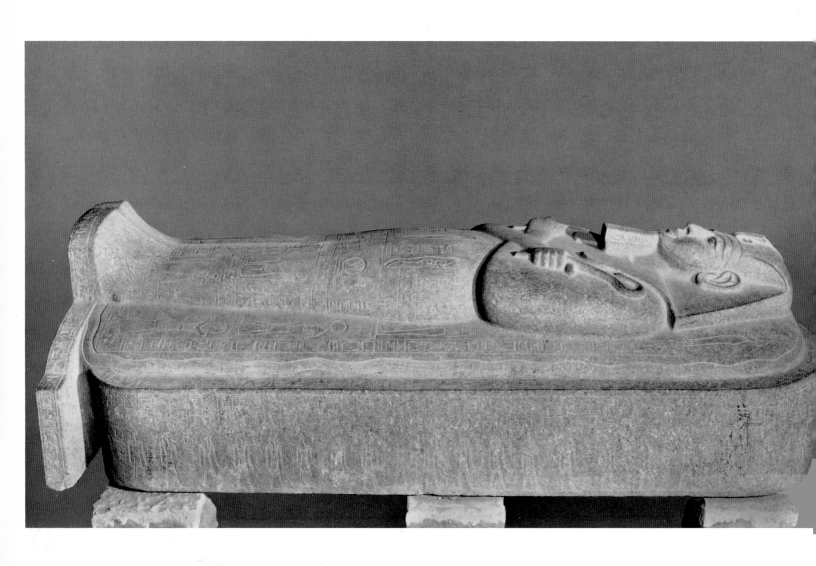

252 From the tomb of King Merenptah in the Valley of the King's Tombs: The lid of the King's sarcophagus with the representation of the deceased

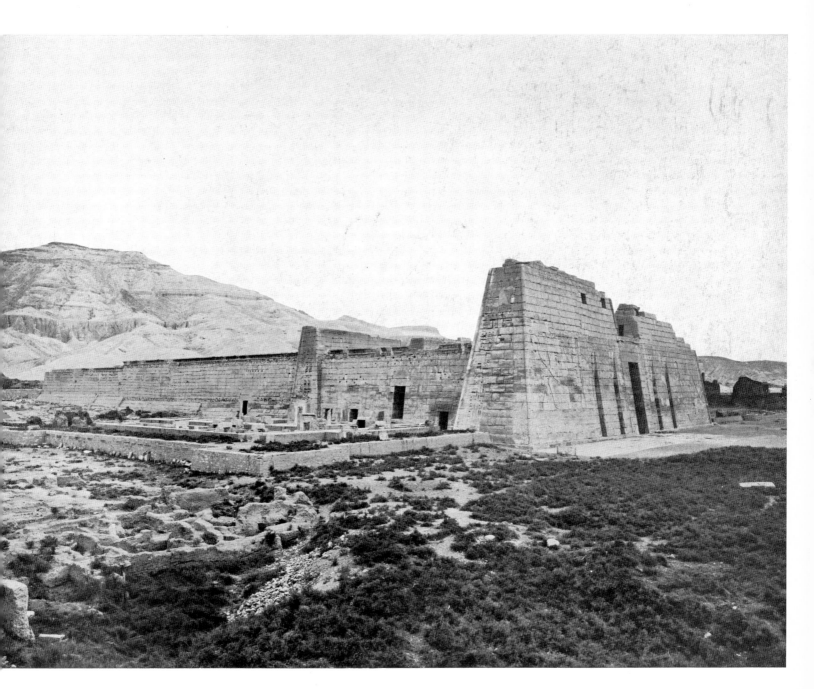

253 Thebes (Medinet Habu). Funerary temple of King Ramesses III, seen from the south

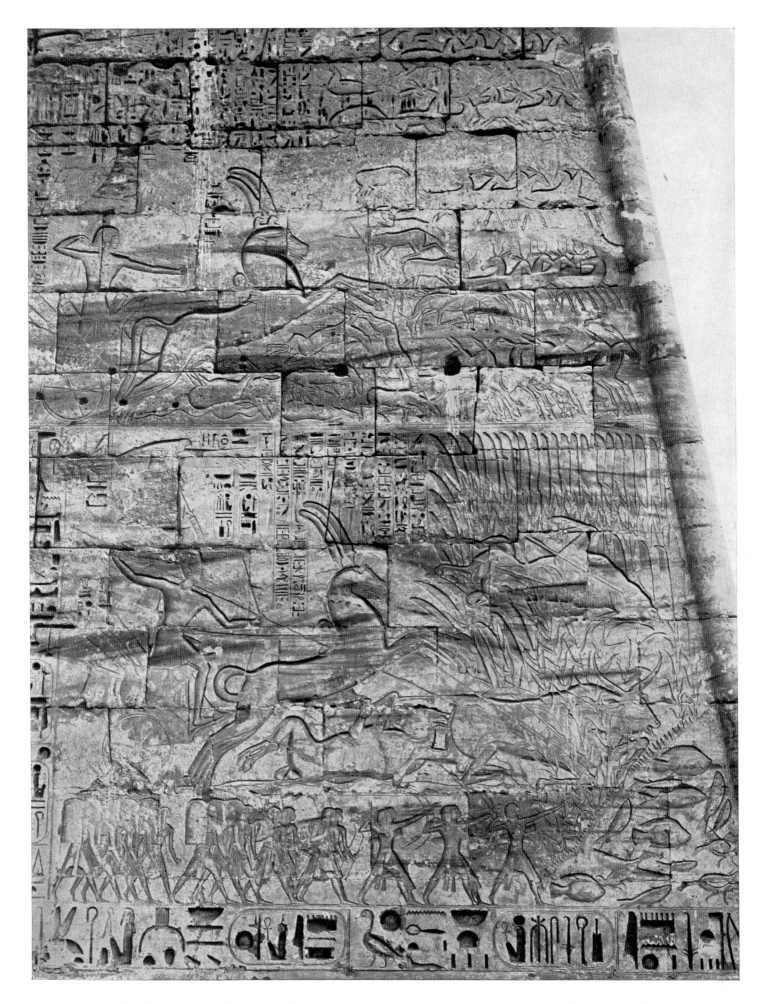

254 Thebes (Medinet Habu). The King hunting, from the first pylon of the funerary temple of King Ramesses III

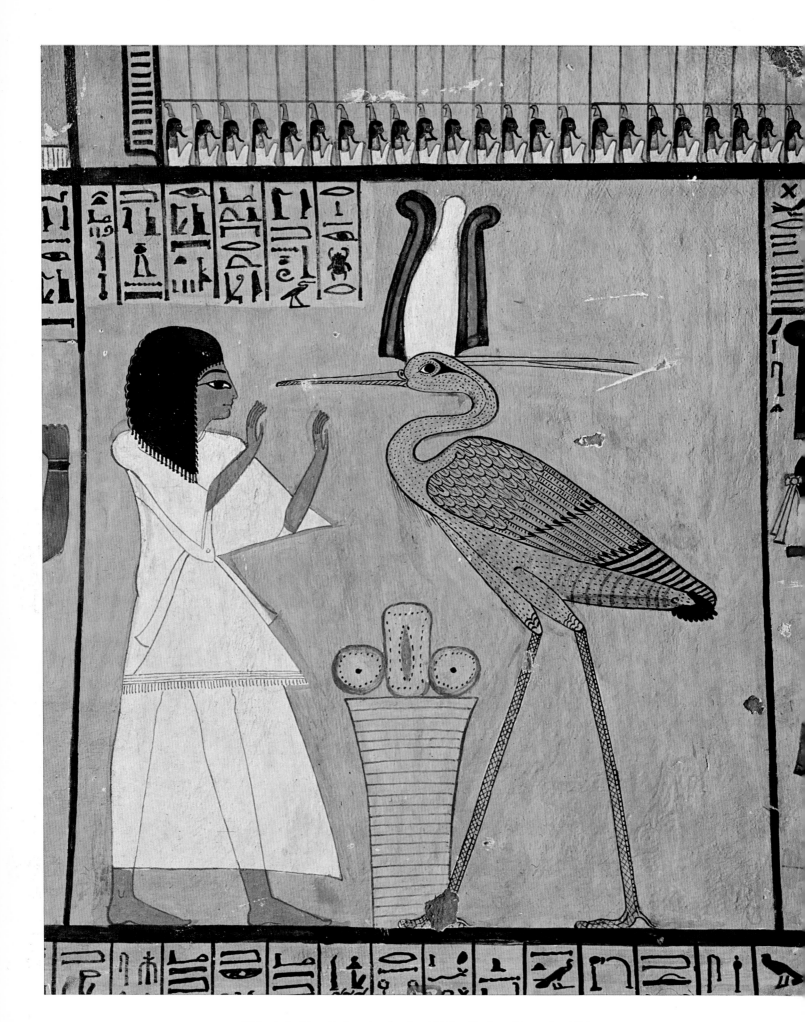

LIX Anhurkhawi before the phœnix of Heliopolis, from his tomb at Thebes

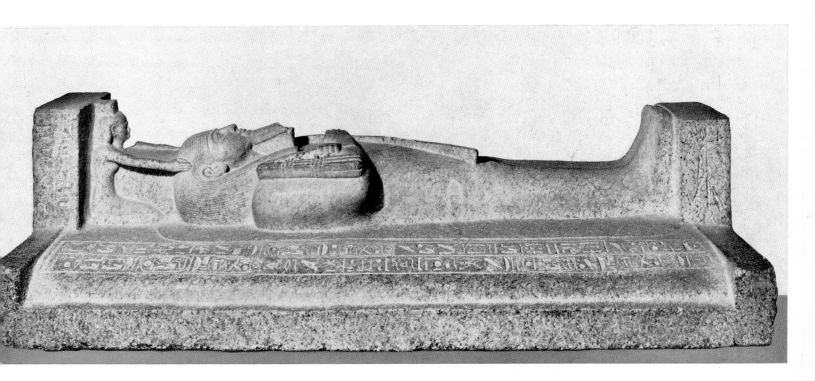

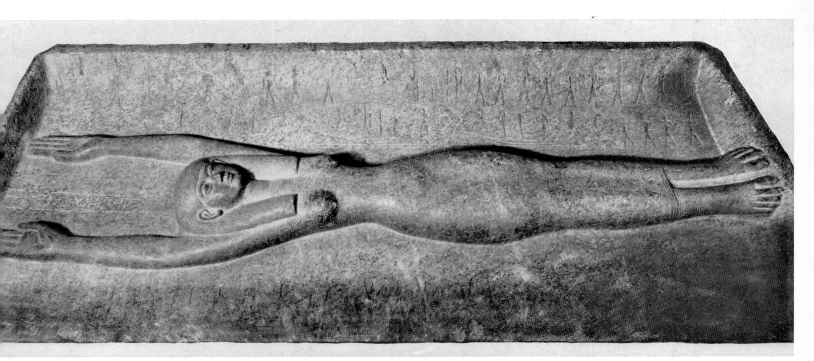

255 Sarcophagus of King Psusennes I (1054–1009) from Tanis.
Above: The lid representing the King as Osiris. Below: The goddess Nut on the bottom of the lid. Cairo, Museum

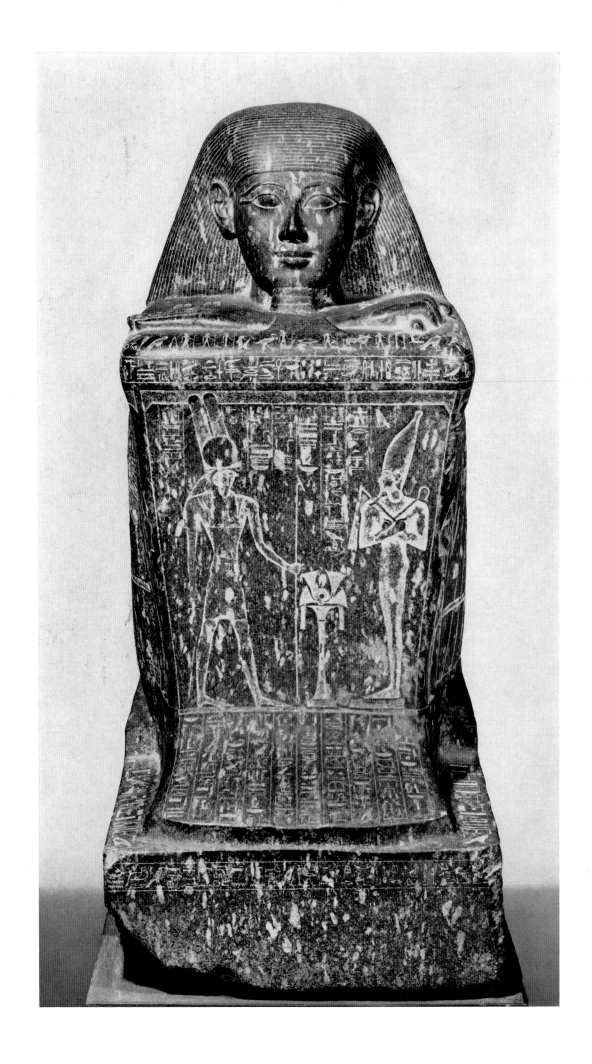

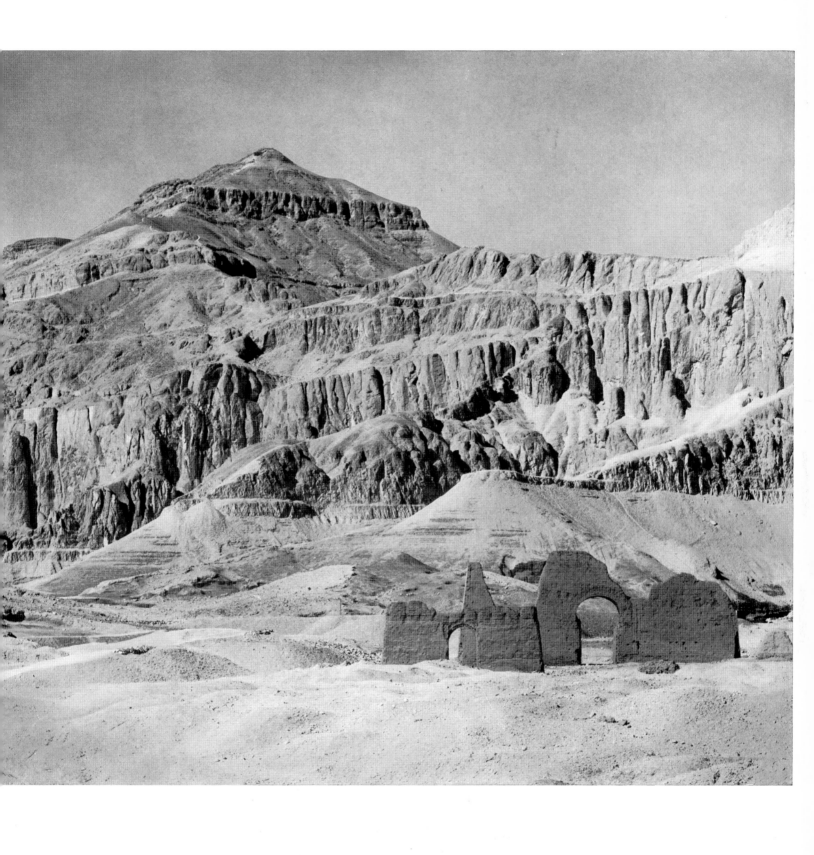

257 Upper portion of the tomb of the viceroy Mentuemhēt at Thebes. In the background the western mountains with El Qorn

256 Hor, son of Neseramun, so-called squatter. Cairo, Museum

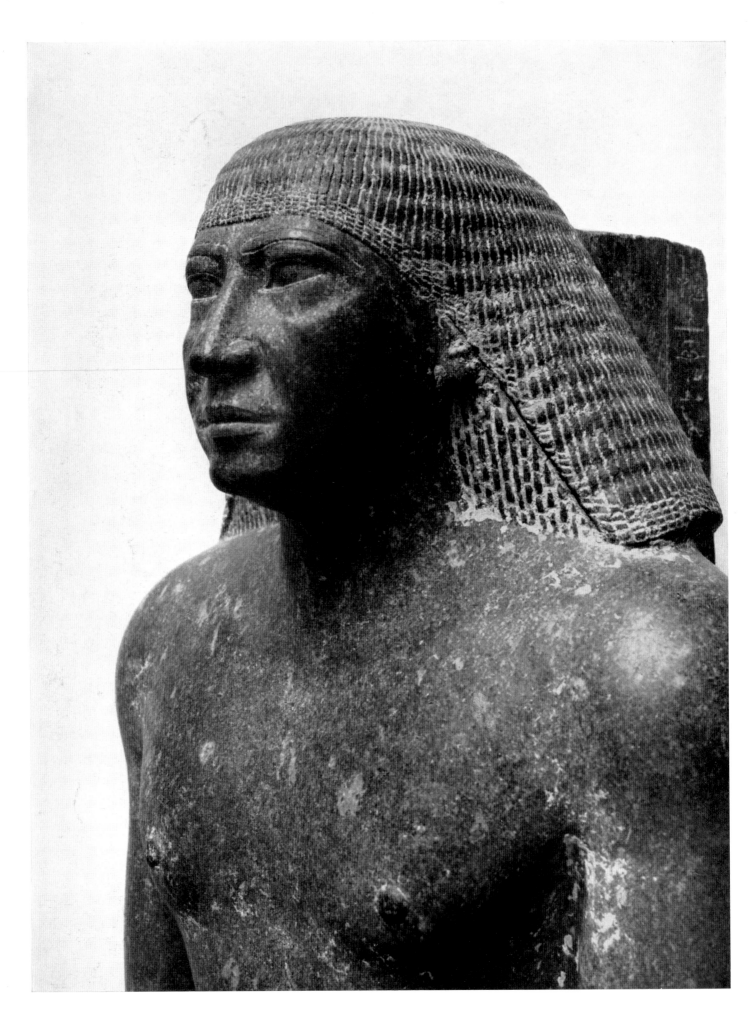

258 The viceroy Mentuemhēt. Cairo, Museum

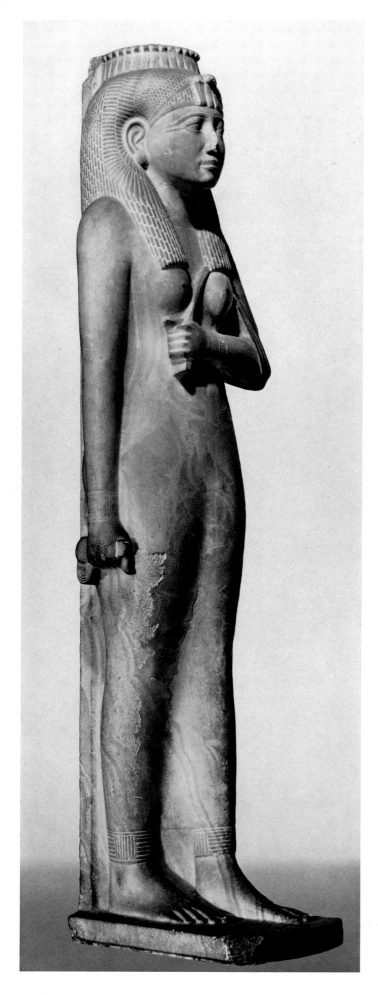
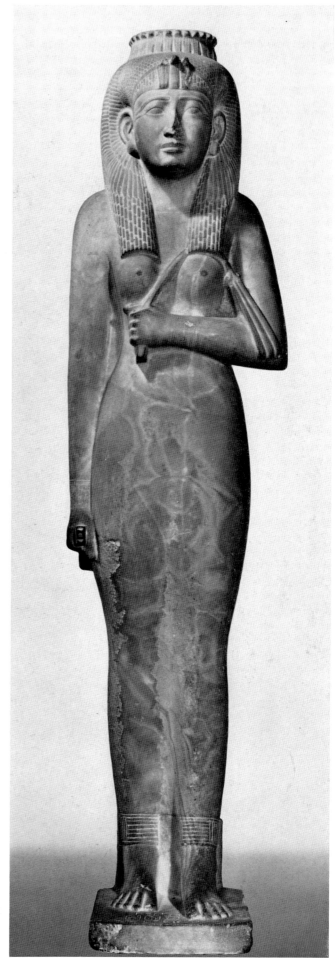

259 Alabaster statue of Amenartais, "divine wife of Amun", princess of Thebes and sister of King Shabaka. Cairo, Museum

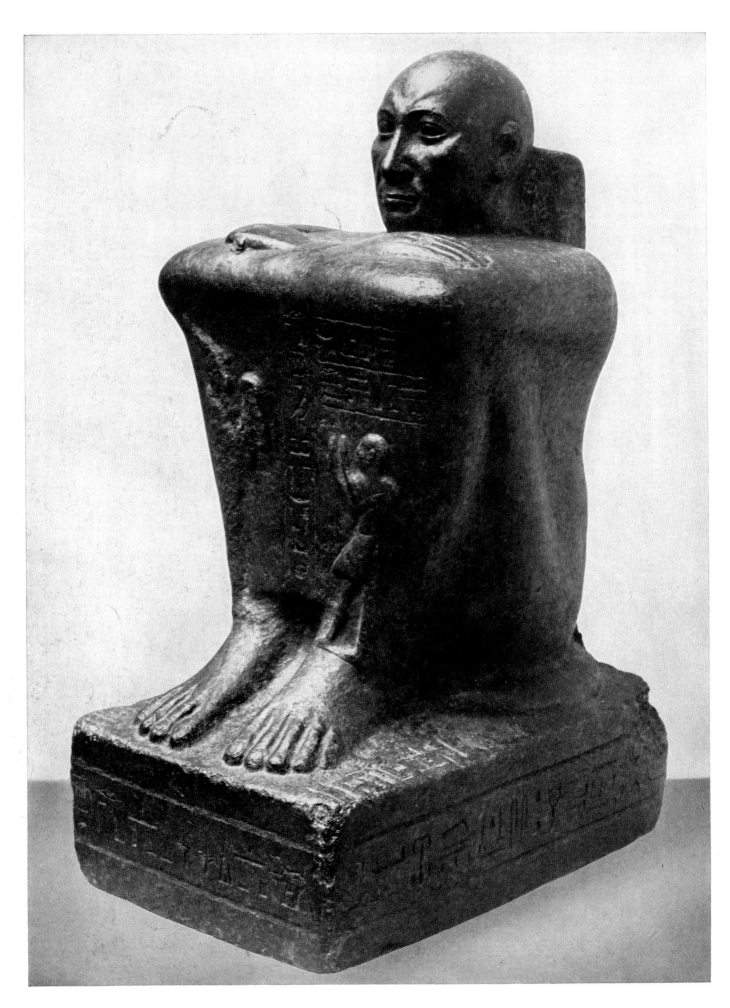

260 The priest Petamenophis, so-called squatter. Berlin, Museum

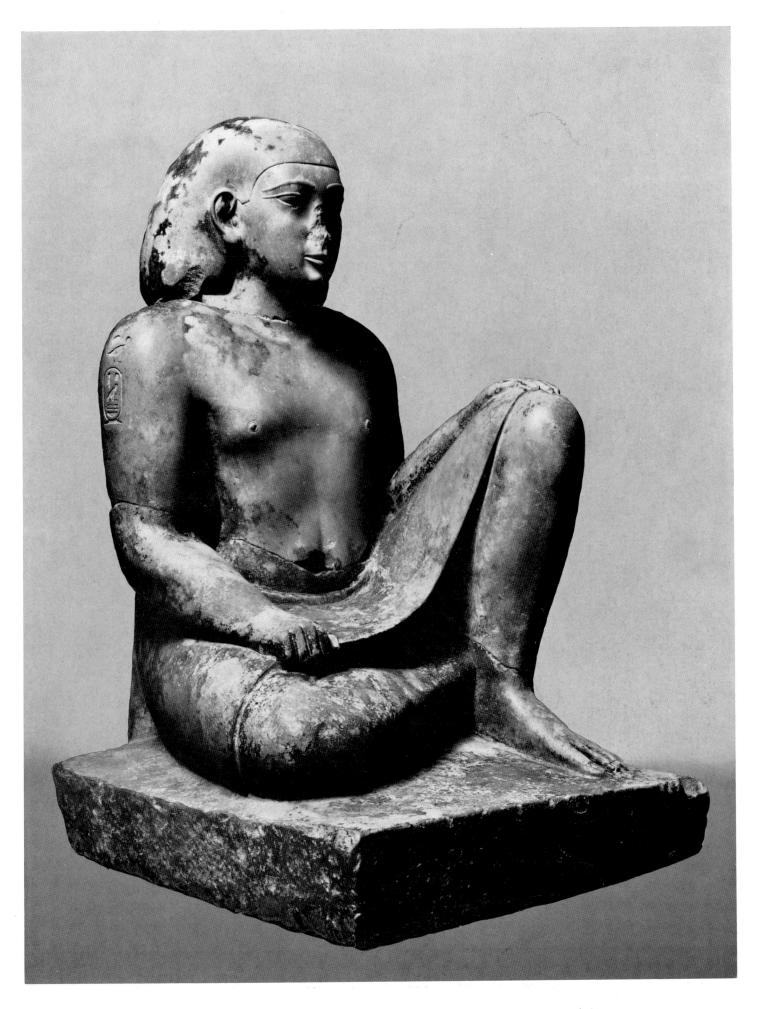

261 The courtier Bes. Time of King Psammetichus I. Lisbon, Calouste Gulbenkian Foundation

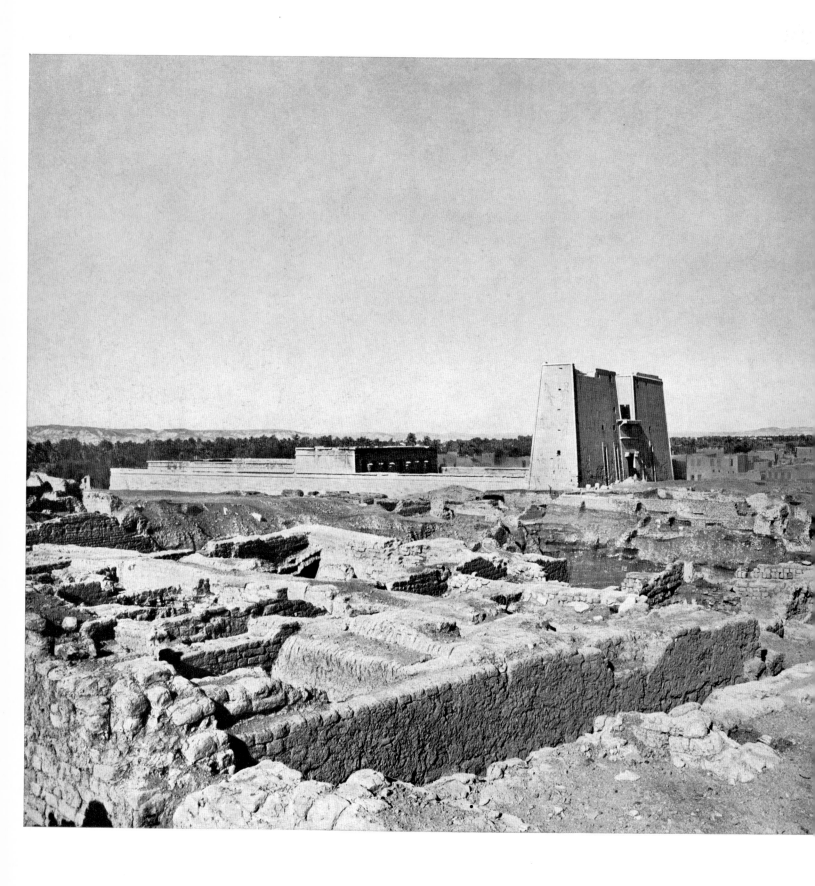

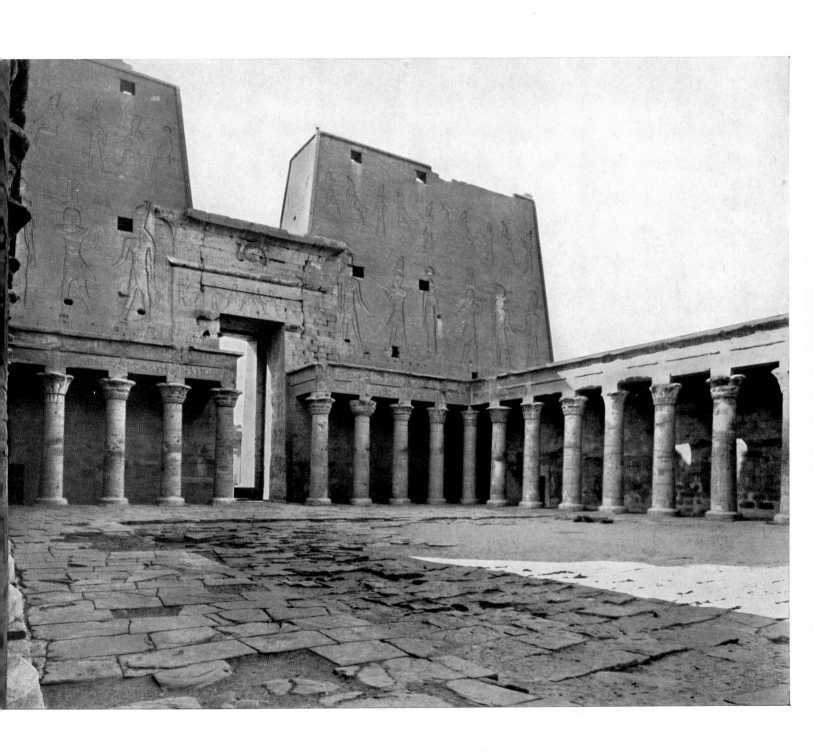

263 Edfu, Temple of Horus. View of the south side of the large court and the pylon

262 Edfu, Temple of Horus. General view from the west. In the foreground, the huge store-rooms

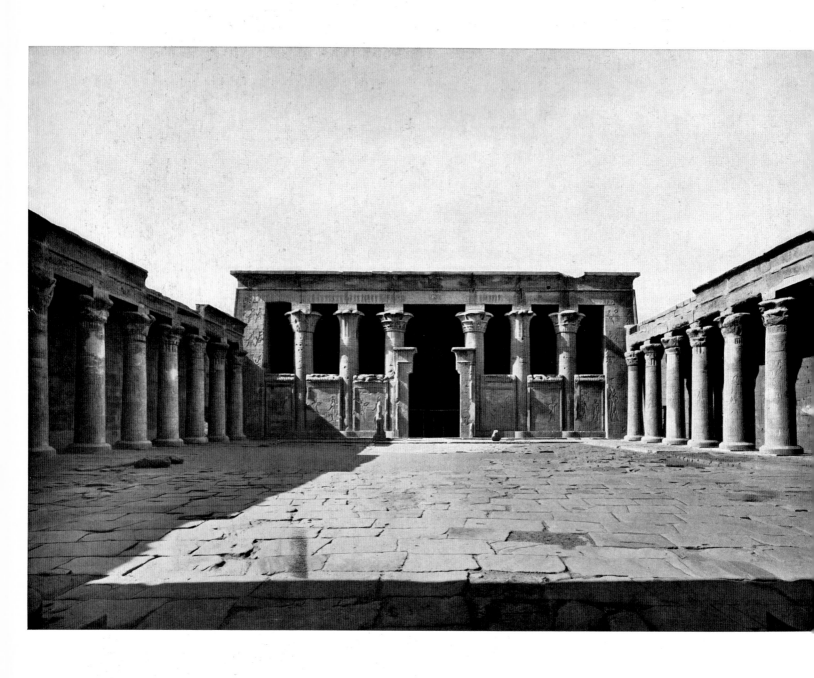

264 Edfu, Temple of Horus. The porch of the temple seen from across the court

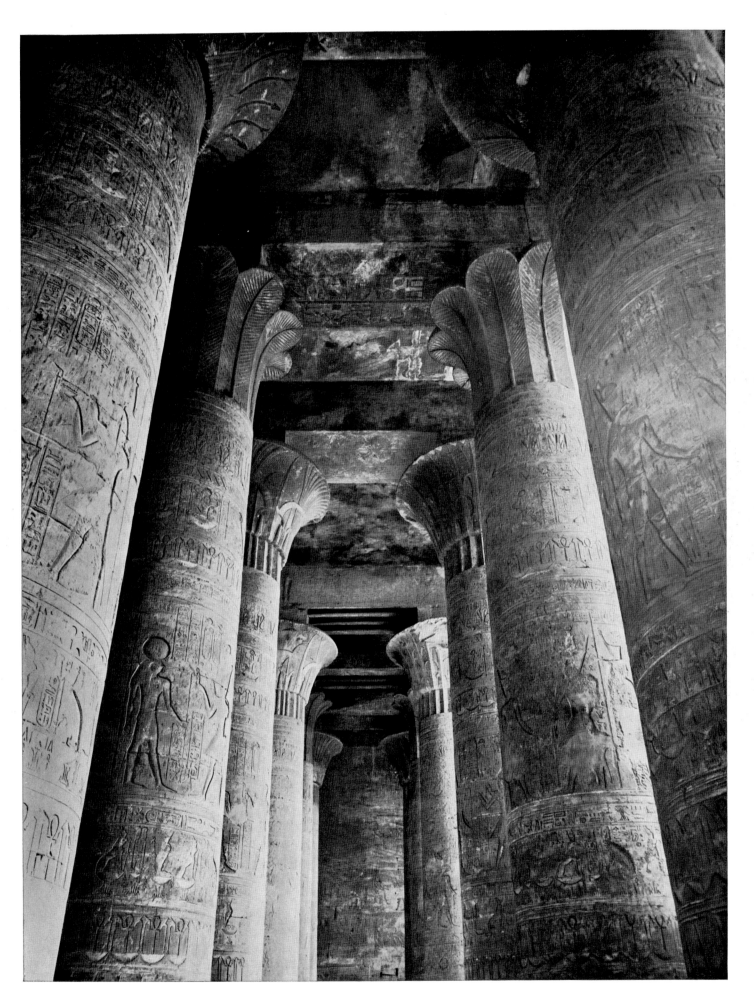

265 Edfu, Temple of Horus. Diagonal view of the temple porch

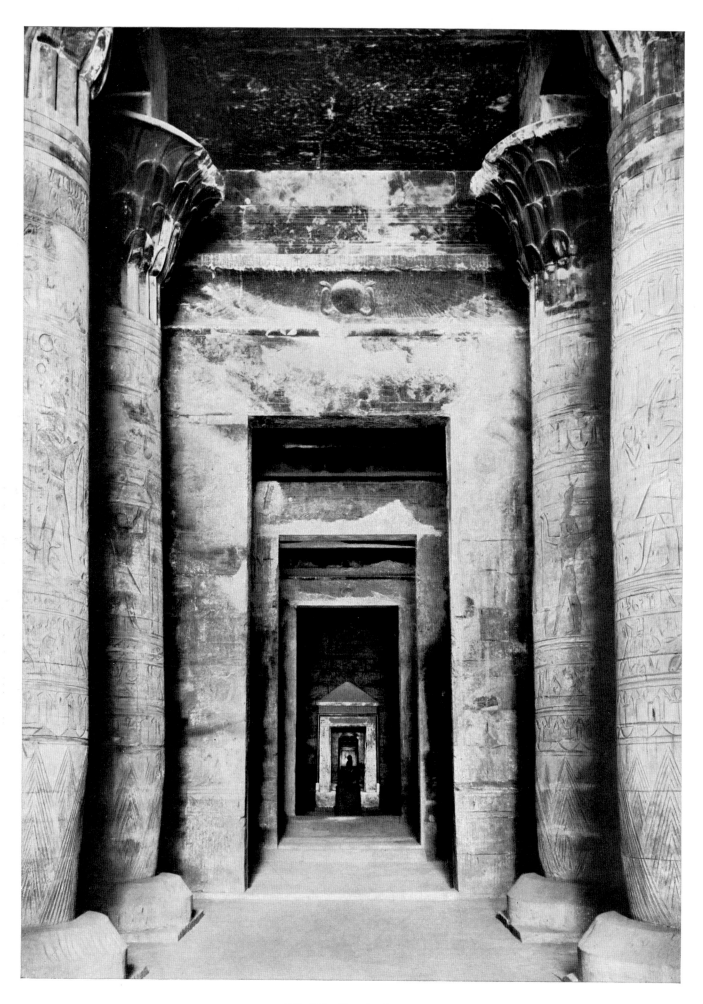

266 Edfu, Temple of Horus.
The hall of pillars and the holy of holies with the two antechambers. In the holy of holies, the granite chapel of Nektanebos II

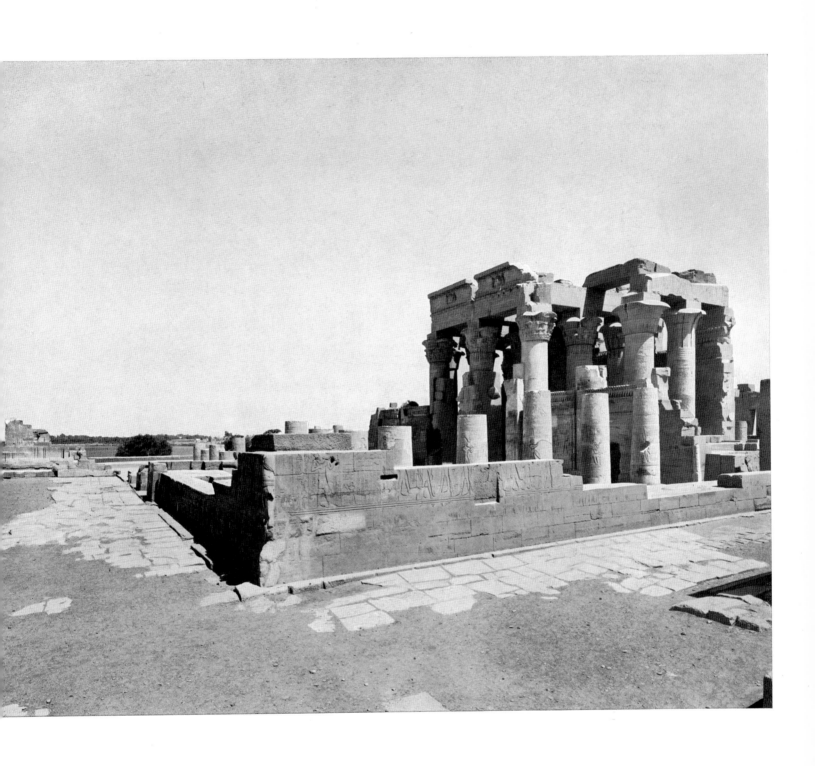

267 Kom Ombo. Twin sanctuary of Suchos and Haroēris

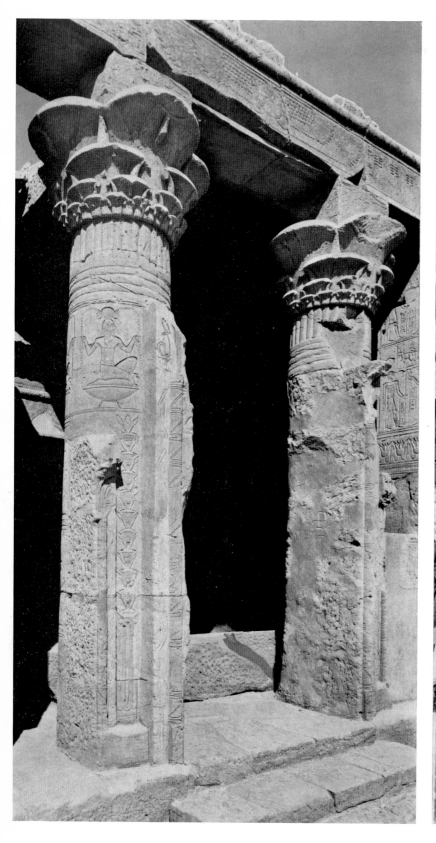

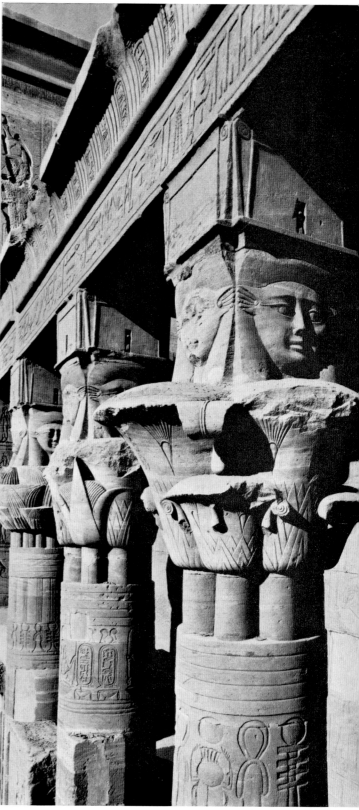

268 Left: Dandour. The temple. Flower bunch columns of the pronaos.
Right: Philae. The Temple of Isis. Columns from the House of Birth (cfr. Plate 296)

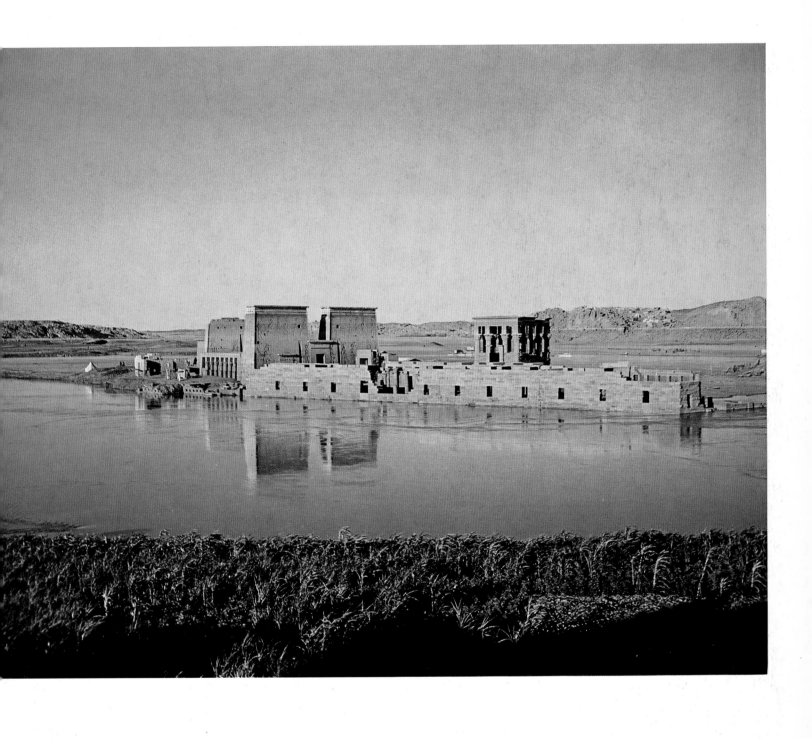

LX The temple of Isis at Philae

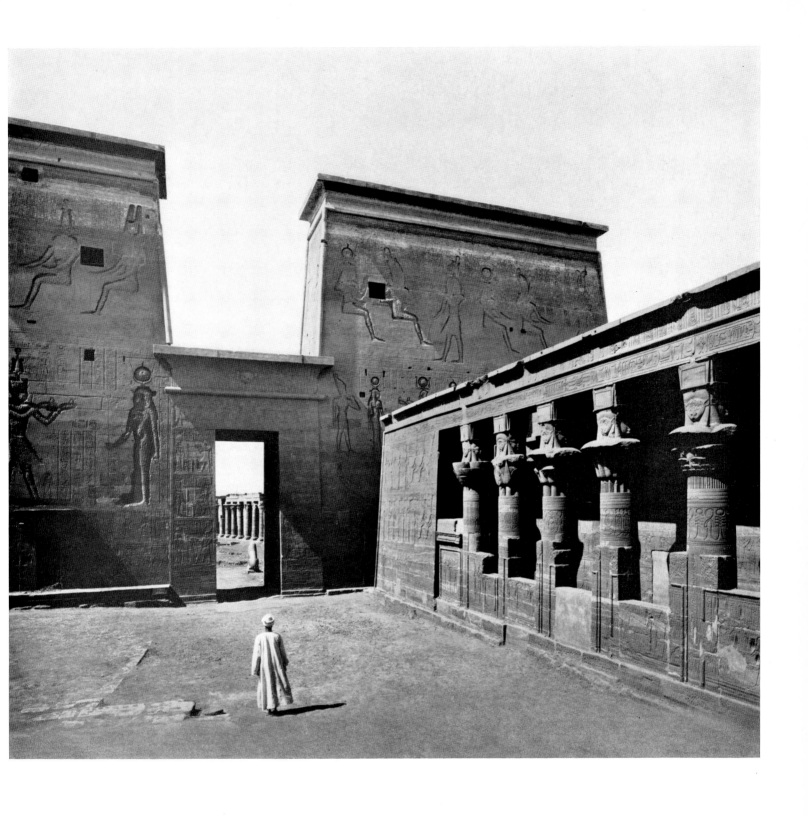

269 Philae. The Temple of Isis. The first pylon, the court, and eastern front of the House of Birth, seen from the north

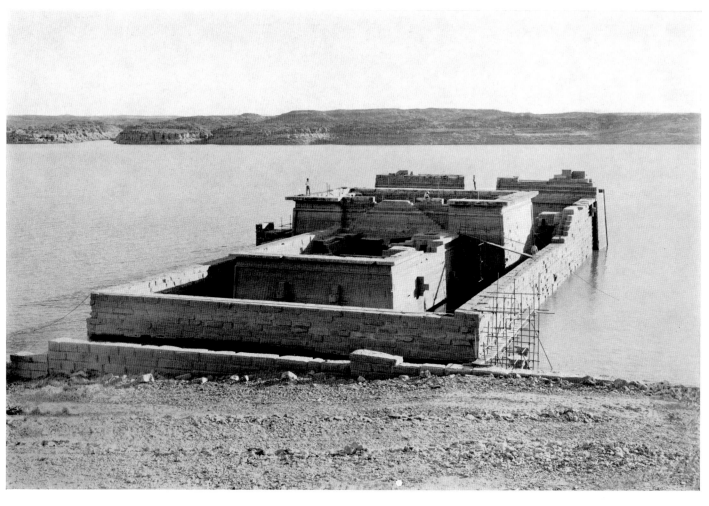

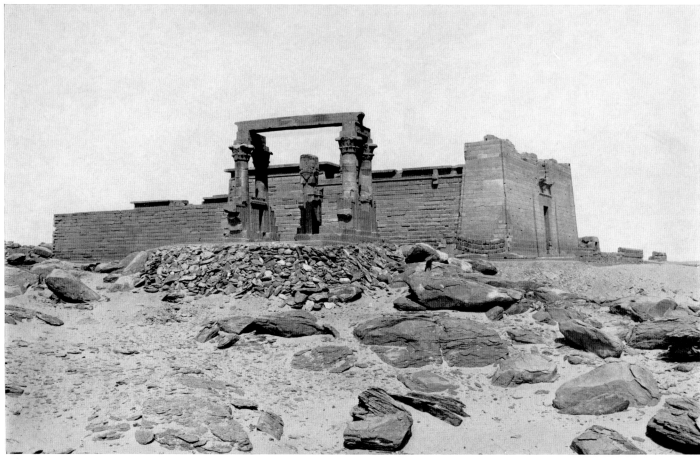

270 Kalabcha, Temple of Mandoules.
Above: The temple inundated as every winter for forty years until 1962.
Below: The temple rebuilt on its new site near Assuan. In the foreground the kiosk of Kertassi

GODS AND TEMPLES

by Eberhard Otto

DESCRIPTIVE SECTION
AND NOTES ON THE PLATES

by Max Hirmer, Kurt Lange and Eberhard Otto

THE NUBIAN TEMPLES

by Christiane Desroches-Noblecourt

GODS AND TEMPLES
by Eberhard Otto

ANYONE studying Egyptian art and the antiquities of all kinds which have survived from ancient Egypt, or anyone who has seen the monuments of the country itself, gains the impression that much of what remains from ancient Egypt has a direct connection with religion and the cults of the gods; representations of gods in relief and in the round, scenes of cult-ceremonies, offerings from tombs and temples form a large part of the relics of Egyptian civilization which have come down to us. If we consider buildings in particular it would indeed be difficult to find anything other than temples and tombs. In fact this impression is not one of chance, although it has undoubtedly to be corrected to some degree. There are only a few remains of dwelling-houses, palaces and towns, which for the most part were built and rebuilt on the same sites within the limits of the cultivated lands; their existence, however, must obviously be added to the general picture. Nevertheless, that first impression is justified in that life in Egypt, even everyday life, was more intimately bound up with religious ideas than was life in other times or in other cultures. Even the state, inasmuch as it was represented in the person of the god-like king, was a largely religious institution. The close connection between king and god was not only expressed by a kind of family resemblance between the two, so that it is sometimes almost impossible to decide whether a statue represents a god or a king, but it is also in effect a symbol. Furthermore, life was a preparation for death; if one thinks of the elaborate material arrangements made in readiness for death, including building tombs which were provided with lavish equipment, it clearly emerges that the shadow of death did not darken the joy of life, since the gaiety of life was directed towards the after life. This concept is best expressed in the world vividly portrayed in the painted scenes in the Theban tombs.

The manifestations of Egyptian religion which have been handed down to us in the form of works of art—to use 'art' in the widest meaning of the word—impress us not only by their richness, by the monumental size of some buildings like the pyramids and the great halls of the temples, and by their beauty, like that of the temple of Sethos I at Abydos, but also by their strangeness. Naturally this strangeness applies particularly to the mixed manner of representation used for the gods and to the many mythical scenes in the royal tombs, things which aroused mockery even in antiquity among Greek and Roman writers, and which also have been held to be expressions of hidden meanings.

The strangeness of appearance is further strengthened because the world of the Egyptian gods does not seem nearly as familiar to us as the divine world of classical antiquity. This lack of familiarity is not only due to the fact that knowledge about Egyptian religion is not a part of the general culture of the West, but also because its essence cannot be comprehended through occidental tradition and mythology. Similarly, a knowledge of western religious buildings, whether they are temples or churches, does not lead to an understanding of Egyptian temples.

So it seems justified, and indeed necessary, to consider Egyptian gods and their temples in relation to each other, and it is advisable when looking at the temples also to consider the temple-complexes which form parts of the tombs of the kings.

THE GODS

From an observation of the forms in which a deity could appear to an Egyptian one thing is clear: the human being was in no way the only, or even the preferred, form used by the deity. It was a prehistoric instinct to experience the deity in all natural forms: the list of divine beings included not only the firmament, the sun, moon and stars, but also the earth and the Nile, and so too the space between heaven and earth. The Egyptian invested animals, particularly those which were not domesticated, with divine powers, and made god appear in their forms. The

of Sethos I at Abydos has triple sanctuaries both on the north and on the south sides of the western part of the temple. A special case is the temple of Kom Ombo which was dedicated to Haroëris (a form of Horus) and to Sobk. Here not only the sanctuary but its approach rooms and corridors are duplicated; one side of the temple is for Haroëris and the other for Sobk. A different arrangement is found in the temple of Sethos at Abydos, where seven chapels are placed next to each other in a row. The construction of the sanctuary had changed by the Ptolemaic Period, as can be seen in the large temples at Edfu and Dendera. In each of these temples the sanctuary is shaped like a huge shrine set down within the structure of the temple and surrounded by a passage which separates it from the rest of the temple.

From what we know of the functions and the treatment of the cult-images, we should not in any circumstances consider them as divine images in the manner of the statues of Greek gods. They can only have been small, transportable, and therefore probably wooden statuettes, which were certainly embellished with gold and semiprecious stones, but were not necessarily great works of art. So we cannot regard any of the images of gods which have been preserved, such as those of Khons and Mut, as cult-images in the narrowest sense of the term. This reservation is important when we come to interpret the place of these divine images in the history of art. Furthermore, no-one has succeeded in establishing what were the prototypes of the great many divine images, made of plastic materials like glazed composition and bronze, which have survived from ancient times. When assessing the degree of respect which kings and gods commanded in the eyes of the Egyptians, it is worth noting that in temple reliefs which show the king engaged in cult-practices in the presence of a god the cult-image of the god is not shown. Although the actions shown in the reliefs were directed towards the god's image, the god himself is depicted in different attitudes and adorned in different ways.

Quite early in historic times the conception of the god living in his temple had ceased to be so simple that he could be identified with his image. Similarly it could no longer be said that the statue or statuette of a god in his shrine represented an embodiment of his majesty and of his diversity. What we have already said about religious practices excludes such a simple solution, even though it must represent the belief held by a large part of the ignorant populace. We ought rather to consider the god's statue as an image into which the god could descend to receive the offerings and honours presented to him. Our own conclusions on this point are supported by Egyptian texts and by convincing evidence from temple architecture. From the New Kingdom onwards we find false doors in the temples of the gods as well as in the royal funerary temples. These doors originated in tomb-architecture and the pyramid-temples. Unless we regard them as meaningless decorations, and this is a quite untenable view, we must conclude that their very presence indicates some ancient function which later fell into disuse. False doors are not by any means found in all temples of the gods dating from the New Kingdom, though it is still not clear why they are to be found in some temples and not in others. The fact that they were included in the funerary temples of Western Thebes, and indeed placed in the rooms dedicated to the cult of the dead king, can be explained by their original function. But we also find them for example in six of the seven chapels in the temple of Sethos I at Abydos. The only chapel without a false door, the one dedicated to Osiris, has a real door leading to the rooms behind, which were devoted to the cult of Osiris. At Karnak, in the small temple of Amenophis II, situated between Pylons IX and X, the false door isolates the centre room. A false door also forms part of the rear wall of the triple shrine in the great court (C in Fig. 35) of the Luxor temple where the barks of Amun, Mut and Khons were placed.

The sanctuary, as we have shown so far, served the cult of one or more special gods of the temple. Yet, other deities were sometimes associated with the principal cults, though the reason why is not always clear. In the Theban funerary temples the centre of the precinct was occupied by three chapels for the barks of Amun, Mut and Khons respectively. To the left were the rooms dedicated to the cult of the dead king, and they too contained a processional bark for the dead ruler. To the right was an open court with an altar dedicated to the cult of the sungod. In the rear rooms of Nineteenth Dynasty temples like that of Sethos I, and also that of Ramesses III, cults of Osiris and of Min, the god of fertility, seem to have been included. At Karnak, the largest temple-complex in Egypt, we find a conglomeration of shrines of widely differing types. The main temple is dedicated to Amun, 'Lord of the Thrones of the Two Lands' and 'King of the Gods'. In the open ground in front of the temple, on the right side of what ultimately became the first court of the temple, Ramesses III had another temple built where the barks of the three Theban gods could be laid up. To the north, that is on the left of this same open area, a

triple sanctuary was built by Sethos II for the same purpose, but on a smaller scale. Mut and Khons also had their own temples to the south of the main temple. To the east of the Amun temple Tuthmosis III caused his Festival Temple to be built, a structure lying across the axis of the main temple, with five transverse aisles and four rows of columns, the centre two rows being made up of pillars which reproduce in stone wooden tent-poles. Apparently the royal jubilee was originally celebrated in a tent-like structure. The central temple-complex at Karnak was surrounded by many small shrines occupied by lesser Theban and other gods. Next to the Khons temple was that of the hippopotamus-goddess, Ipet; to the north lay a temple of Ptah, the god of Memphis; in the north and to the north-east several shrines for Osiris were situated, and in the north-east corner of the whole complex, according to recent investigations by the French archaeologist Paul Barguet, there was possibly an Osiris grave. North of the enclosure-wall surrounding the complex of Amun, we find a temple dedicated to the falcon-god Month, which in turn was surrounded, like the main temple, by several smaller shrines, including one dedicated to the goddess Maat.

The gods worshipped in the temple of Sethos I at Abydos have already been discussed.

The great temples of the Ptolemaic Period provided homes for numerous subsidiary cults within their precincts. In the temple of Horus at Edfu, the central room behind the sanctuary was dedicated to a special form of the god; the double room adjoining this on the left was sacred to Sokaris of Memphis, the double room on the right to the moon and to relics of Osiris. Others among the side-chapels belonged to Re, Min and a number of other deities. The rooms assigned to the worship of subsidiary gods were arranged around the sanctuary and opened on the passage running around it. On the roof of the great temple at Dendera there is a series of rooms devoted to the cult of Osiris.

Another feature of the temples of this period is the 'birth-house' or mammisi. It was built in front of the main temple, facing the processional way into the temple. The typical birth-house consists of a sanctuary with one or more antechambers, surrounded by a colonnade, the capitals of the columns of which are richly decorated with plant designs. This type of building probably had its origin in a hut or pavilion made of mats and papyrus stems, which was erected outside dwelling-houses for the confinement and subsequent purification of Egyptian women. The fact that birth-houses became apparently regular adjuncts to temples of the Late Period further demonstrates the tendency towards conformity which is found in late Egyptian religion. A basic element in this conformity is the old concept of the divine triad, consisting of father, mother and child. These triads are found in all the larger temples, and since the differences between the gods became more and more blurred with the passage of time, it came to matter very little whether the mother-goddess in a triad was called Neith, Hathor, Isis, or something else, or whether the child-god was Re, Horus, Ihi or Harsomtus. They are all the same in this particular context, in so far as the former exemplify the maternal aspect of the goddesses and the latter the childlike aspect of the gods.

It has already been noted that the god might not be approached in his dwelling, the sanctuary. On those occasions when he needed to be accessible to all, he had to leave this sanctuary and appear in public. The need to provide for his 'goings forth' explains the processional nature of the lay-out of the temples. Temple-complexes extended forward from the sanctuary into a series of halls, courts and processional ways. During the New Kingdom in particular the 'going-forth' of the god on solemn occasions became associated with an important function—the oracular answering of questions addressed to the god. The god's activity in this respect was not confined to events and decisions of everyday life, to putting himself at the service of the ordinary man, although in the second half of the New Kingdom considerable use was made of divine oracles in this way. The consulting of the oracle was also made an occasion for the enunciation of political decisions. Several kings of the Eighteenth Dynasty declared that they had been chosen for their supreme positions by Amun on the occasion of his progress through the temple. It is noteworthy therefore that this important act was performed in public.

The 'dwelling' of the god necessarily included a number of chambers which were required for the service of his cult. A sacristy, or chapel of purification, was needed for the officiating priest who, during the New Kingdom, performed his duties as the representative of the king. Theoretically the king was always the officiating priest. The representations on the walls of these rooms show among other things the king being purified and then led into the temple by the gods Horus and Thoth. In the temple of Sethos I at Abydos the purification chapel is the small room 14 beside the Butcher's Hall. At Karnak there is one chapel in the central complex, south of the sanctuary, and another, belonging to the Festival Temple of Tuthmosis III, almost in the middle of the east

side of the pillared hall. In the funerary temple of Ramesses III at Medinet Habu the room used as a sacristy was the first on the right in section C (see Fig. 68), and there was clearly a second in the north-west corner of the second court. We find a similar room with basically the same subjects illustrated on its walls at Edfu, built into the space between two columns in the outer hypostyle or pronaos (1 in Fig. 80).

A room of particular importance in the service of the god was the hall of the offering-table, in which the previously prepared food-offerings were laid out and consecrated before being offered to the god. In temples of the New Kingdom the offering-table was situated in a central room just in front of the sanctuary; in Ptolemaic temples it was in the preceding hall. As well as the table it contained statues of the gods and kings who, as it were, participated as guests in the offerings to the gods of the temple.

Temples also contained rooms for the preparation of offerings, a butcher's hall, unguent chambers, storehouses for materials and vestments, a library and a treasury. At Edfu the library, called the 'house of books', is to the right of the pronaos, behind the screen-wall on the south side, and contains among other texts and scenes on its walls a catalogue of books—obviously of the inscribed papyrus-rolls which were kept there. The treasury was usually built in as unobtrusive and secure a position as possible. In the temple of Ramesses III at Medinet Habu it was in the four small rooms on the left of Hall C. The security of the narrow entrance-door was insured by its being flush with the outer walls, so that the reliefs on them continued across it. When the door was shut one had the impression that the wall continued without a break. At Edfu the treasury is a long, narrow room, to the right of the hypostyle hall (2). At Edfu also, and at Dendera, the functions of the treasury were fulfilled by crypts— narrow passages, either subterranean or in the thickness of the walls. At Edfu the crypts are subterranean and are reached through entrances in the floors of the corner rooms at the back of the temple. At Dendera there is a network of secret passages built on several levels; entrance to them can only be obtained through removable stone slabs in the walls or the floor. This way of concealing the secret rooms is very reminiscent of Herodotus's story about the treasury of King Rhampsinitus.

The 'dwelling of the god' thus emerges as a collection of rooms of many different functions. It not only served as an expression of the soul and nature of the deity, but it also had to satisfy all the practical demands of the cult. Even its decorations and ornamentation fulfil to a large extent a symbolic purpose, in so far as they indicate the original design and function of individual parts of the temple. Only when it has been shown how subject to tradition were the temple and its rooms, and how restricted they were by the functions they had to perform, can the problem of their artistic unity be discussed. Only then can one adequately assess how far the architects of the time succeeded in solving the problems which faced them. The multifarious pantheon of the Egyptians, with its traditional forms of worship and religious experience, is reflected in the no less complex character of their religious architecture, to which eventually many artistic traditions and developments contributed, from the courageous attempt of Zoser to reproduce permanent copies of flimsy festival tents and chapels in stone, through the mastery of technique in the pyramid-temples, to the monumental buildings of the Ramesside Period, and the solidly enclosed temple-precincts of the Ptolemaic Period.

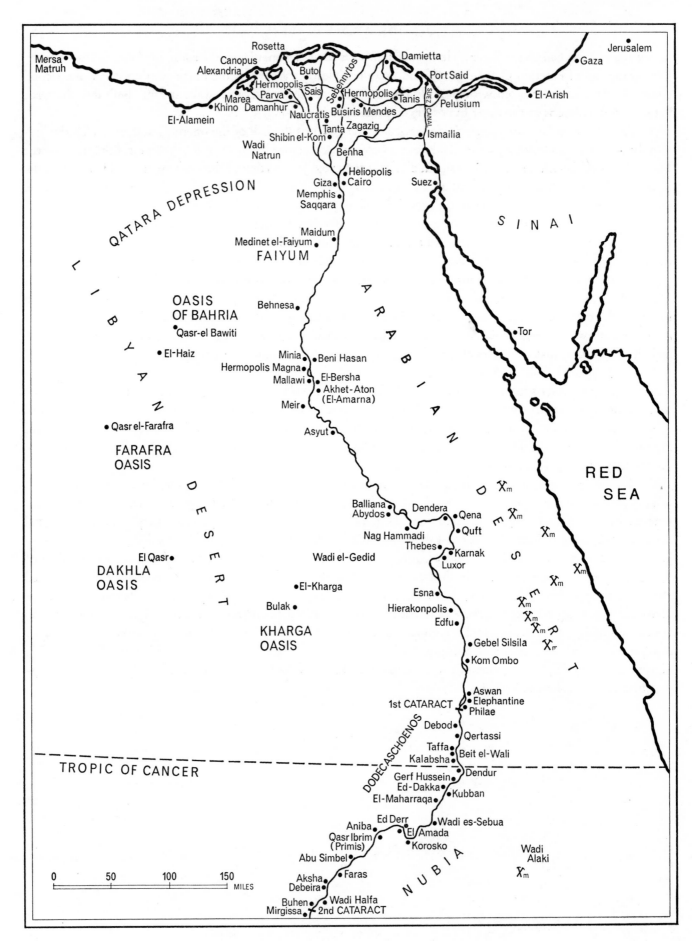

MAP I. Egypt from the Nile Delta to the Second Cataract.

DESCRIPTIVE SECTION
AND NOTES ON THE PLATES

by Max Hirmer, Kurt Lange and Eberhard Otto

INTRODUCTION

THE HISTORICAL monuments of Egypt, admired by travellers of ancient times as wonders of the world, can be divided into a number of principal groups which provide an impressive panorama of the golden age of the civilization of ancient Egypt. On the normal route between Alexandria or Port Said and Cairo and on through Middle and Upper Egypt, the visitor to the Nile Valley comes upon the ancient monuments in an order corresponding more or less to the historical process of development from the foundation of the kingdom to the time of the successive foreign dominations.

The extensive desert cemetery of the old northern capital, Memphis, about twenty miles south-west of Cairo near the present-day village of Saqqâra, and the impressive pyramid zone near the modern Giza, about five miles from Cairo, introduce us to the buildings and sculptures of the Early Dynastic Period (c. 3000–2778 B.C.) and of the Old Kingdom (c. 2778–2263 B.C.). In Middle Egypt we find the rock-tombs, adorned with sculptures, of the regional princes of the Middle Kingdom (c. 2133–1786 B.C.), the free-standing structures of which have unfortunately been as good as completely lost to posterity. In the neighbourhood of Luxor and in Nubia, when we see the huge temple ruins and statues of kings and penetrate into the royal tombs at Thebes, driven deep into the heart of the Western Mountain, we are able to form an idea of the grandeur and talents of the New Kingdom, that period during which Egypt became a world power (c. 1552–1085 B.C.). On the site of the old provincial capital of Dendera near Qena, and between Luxor and Aswan with its temple-island of Philae, we encounter finally the surprisingly well preserved sacred places of the Late Period, built under the domination of Graeco-Macedonian rulers and Roman Emperors. It is as if a kind of Ariadne's thread guided us through the monumental labyrinth of an immense historical development—monuments which have excited the admiration of all succeeding generations and which cannot fail to impress even the spoilt children of the twentieth century, accustomed to fantastic technical achievements of every kind. At almost every bend of the Nile there rise before our eyes towering stone witnesses to a proud past dating back many thousands of years—witnesses which challenge us to more profound historical study and, in their timeless majesty, leave a lasting imprint on the minds even of those who, before seeing them, have paid little attention to the heritage of antiquity.

In the well-known words of Herodotus, who traversed it about 445 B.C., the long valley of Egypt is a gift of the Nile. This mighty stream, in its 4000-mile course through half of Africa, gradually dug the valley out of the gravel-strewn desert plateau of north-eastern Africa, filling it year by year at the same season with rich, bluish-grey mud, fertilizing the soil from which sprang abundant harvests, in so far as the irrigation systems of the peasantry were capable of absorbing it.

Life and death are close neighbours in this peculiar landscape. Almost at every point it is possible to see from one side to the other of the cultivated zone, which, with its populous cities and often considerable villages, its palm groves and fields filled with luxuriant and glistening crops, is bordered on either side by the pale slopes of the Great Desert. Sometimes approaching, sometimes receding, during the whole of the long journey through the land they accompany the banks of the river, that slow-flowing, long-revered giver of life, whose course, like that of no other stream, is woven about with the glamour of legend. The sight of it awakens thoughts and

impressions of a peculiar kind. These waters coming from the tropical interior of the dark continent have glided over the backs of hippopotami and over the armour-plates of crocodiles; lions have drunk of them; up in the Sudan, wiry naked black hunters have piloted their reed canoes along the gentle stream of the young Nile. Curious outlines arise before the eyes of those endowed with a feeling for history: the god-kings of Pharaonic times are joined by the fascinating figures of an Alexander, a Caesar, an Antony, of the immortal Cleopatra, whose memory lives on in the realm of dreaming fantasy, by the figures of the coolly daring conqueror Octavian, of Hadrian, and finally the silhouette of Napoleon. All of them have left indelible traces of their lives on the soil of this ancient land of wonders.

The spiritual fruit of a journey to the Mediterranean, which for the thoughtful will always represent an apprenticeship to the comprehension of Europe, is incomplete without the experience of Egypt and it is no mere chance if the world of the Nile has a quite unusual attraction for the visitor from western Europe, thirsting for impressions.

THE EARLY DYNASTIC PERIOD AND THE OLD KINGDOM

The remains of settlements and cemeteries of the oldest Nile Valley cultures, scattered in groups over the foreland of the desert never reached by the waters of the Nile, though they may have escaped the notice of non-Egyptologists, have now been in the main systematically studied by scientists, but the traveller on his way along the western foot of the desert between Cairo and the oasis of Faiyum will constantly come across imposing structures dating from the earliest times. Here among drifting sand lie the cemeteries of Memphis, the 'balance of the lands'. The houses built of sun-dried mud bricks of this great city, founded according to tradition about 3000 B.C. by King Menes, the consolidator of the kingdom, have long since crumbled to dust; the Arab writer Abd-ul-Latif, who lived at the end of the twelfth century A.D., held the beauties of the city to be amazing and indescribable. Today the site is occupied by palm groves and the villages of Saqqâra, Mit Rahina and Abusîr, and only occasional masses of ruins and gigantic structures bear witness to the former glories. The extensive cemetery zone was used for burials at all periods of Egyptian history and it has yielded rich booty both to thieves hungry for gold, who sometimes appeared in organized bands, and to excavating scholars. With the exception of the large subterranean catacomb of the sacred Apis-bulls, all its most impressive monuments date from the Early Dynastic Period and the Old Kingdom. Here, during the last few decades, excavation has uncovered a number of important early tombs, the numerous accessories of which have revealed names of individual kings of the First Dynasty and give reason to suppose that tombs of these rulers exist here. During the reign of the outstanding King Zoser, the first monarch of the Third Dynasty, who is named on the monuments as the Horus (the falcon-headed deity) Netjer-khet, an enterprising generation erected at Saqqâra, about 2760 B.C., the first artistically planned monumental stone structures known to us—the imposing Step Pyramid of the king, rising amidst the silence of the desert and surrounded by government and religious buildings and storehouses, all enclosed within an organically constructed wall—an 'eternal dwelling' dating from the dawn of the pyramid period. Nearby under the veil of the desert sand are traces of other tombs of later kings. Among them is the recently explored base of the pyramid of Sekhemkhet, comprising numerous chambers and a mysterious alabaster coffin which, on being opened, was found to be empty.

The first of those mighty builders, the kings of the Fourth Dynasty, Snofru, erected, a little further to the south near Dahshûr, two square-based pyramids about 300 feet high; recent exploration of the gate temple of one of these has yielded rich finds in statues and reliefs. It has not yet been possible to ascertain who erected the pyramid near Maidum, three steps of which still remain.

Snofru's successors turned north and created the most famous of all pyramid groups: the majestic trio of such monuments at Giza, to which the great Sphinx, carved out of rock and completed in ancient times with layers of ashlar, also belongs. Of the temples pertaining to these pyramids, that of Cheops has unfortunately disappeared except for a few fragments; of the Chephren complex, considerable portions of the actual funerary temple and of the valley temple, deeply impressive in the severity of its architectural conception, have been preserved. The religious buildings in front of the pyramid of Mycerinus, also built of massive square blocks, and the valley temple belonging thereto were never completed.

In the neighbourhood of the royal pyramids, there are many smaller ones which were erected for the burial of queens, but in some cases they seem to have been used for other purposes. Adjoining them are often found tombs of princes and princesses, of high court functionaries and of favourite officials. At Giza they were designed in such a way as to form whole burial quarters, with straight passages running between the sloping superstructure.

The Pharaohs of the Fifth and Sixth Dynasties returned to the neighbourhood of King Zoser's step mastaba, where they built themselves much more modest tombs. The most important pyramids are those of Kings Sahure, Neferirkare and Nyuserre, near the village of Abusîr. Of the sanctuaries which these rulers erected to the memory of their father the sun-god, on the edge of the desert, that of Nyuserre near Abu Gurob, excavated by German archaeologists, with its large alabaster altar and the ruined pedestal which once bore a stumpy obelisk, is a fine

example of a temple of that period. In the interior of the pyramid of Unas, now reduced to a low mound of debris, to the south-west of the tomb of Zoser at Saqqâra, the oldest Egyptian religious texts known to us can be seen.

From the statue chambers of such tombs come the famous stone or wooden likenesses of the dead monarchs which surprise us with their artistic charm and the vivacity of effect when we see them in museums. These natural and dignified figures are the forerunners of the heroic statues of nude youths which Greek sculptors produced nearly two thousand years later.

The reliefs which decorate the walls of the tomb-chambers of this period present us with a truly inexhaustible conspectus of life in an ancient land. The subject-matter of the reliefs form, as it were, a magical provision for the dead; they provide a rich pictorial chronicle of all that lent interest and meaning to life on earth. This creative acknowledgement of the visual world of earthly existence, as it once was, was preserved unforgettably for each one who could allow it to operate directly for himself in the 'eternal dwelling' of the necropolis of Giza and Saqqâra.

Artistic achievement in the provinces during the Old Kingdom was far inferior to that of the capital, Memphis. The reliefs in some of the rock-tombs of princes near Elephantine opposite Aswan can compare with the productions of the Memphis workshops as regards composition and craftsmanship, but these form an exception. The fundamental first creative phase of ancient Egyptian culture reached perfection in the area between Abu Roâsh to the west of Cairo and Maidum to the south.

Egyptian chronology is based on the reigns of their kings (Pharaohs). Following the history of Egypt written by Manetho of Sebennytus in the Nile Delta during the reign of the Macedonian ruler Ptolemy II (285–246 B.C.) we divide the Pharaonic Period into dynasties. From the foundation of the State to the reign of the last native king before Alexander the Great, there were thirty dynasties.

THE THINITE PERIOD · ABOUT 3000–2778 B.C.

The fragment of a stone bearing Old Kingdom annals, now preserved in Palermo, and other inscriptions give us the names of certain rulers who are not mentioned in later lists of Egyptian kings, e.g. *Seka, Khaiu, Tjesh etc., Scorpion, Narmer.*

According to Egyptian tradition, history begins with King Menes. He is probably the same as a king named Hor-Aha. Only the latter name is found on monuments of the period. Egyptians considered the union of the Two Lands, i.e. Upper and Lower Egypt, as conclusive evidence of the foundation of the state of Egypt by Menes. This union is portrayed in different symbolic representations, as if each king repeated it. On the sides of the throne of Sesostris I, for instance, it is symbolized by two gods twining the heraldic plants of Upper and Lower Egypt around the sign meaning 'unite'. On one side the gods Horus and Seth perform this act and on the other two deities representing Upper and Lower Egypt. In fact, however, it can be proved that before King Hor-Aha there were several kings who ruled over the whole country. The formula 'Union of the Two Lands' was probably created at a later date to signify the end of what had been a long historical process.

FIRST DYNASTY

Kings: *Hor-Aha (Menes?), Djer, Wadji (Djet), Den (Udimu), Adjib, Semerkhet, Ka-a.*

SECOND DYNASTY

Kings: *Hetepsekhemui, Nebre (Neb-nefer), Nynetjer, Uneg* (position in dynasty uncertain), *Senedj, Peribsen, Khasekhem, Khasekhemui.*

Collateral Lower Egyptian dynasty during the reigns of the two last-named: *Neferkare, Neferkasokar, Hudjefa, Djadja* (identical with *Khasekhemui?*), *Nebka.*

The historical period of Egypt begins with the 'Union of the Two Lands', which took place about the year 3000 B.C. The first two dynasties are known as the Thinite period, for the earliest kings, according to tradition, came from Thinis in Upper Egypt and the tombs of the kings of the First Dynasty and of some of the Second Dynasty (Peribsen, Khasekhemui) have been found at Abydos near Thinis. These kings were Upper Egyptians who made themselves masters of the whole of Egypt. Although the differences between the two regions continued after the union and renewed struggles flared up until the end of the Thinite period, the Upper Egyptian kingdom remained victorious throughout. On the other hand—and that is the essential and decisive element of this union— no attempt was made to subjugate, let alone exterminate, the defeated Lower Egyptian population. This attitude is symbolized by the fact that the king sometimes wears the crown of Upper Egypt, sometimes that of Lower Egypt, and further that he is not only the 'victorious Horus falcon' of Upper Egypt, but calls himself also the 'Two Lords'. From the beginning a high political wisdom aimed at a levelling and fusion of the two populations and of their cultural peculiarities. As the monarchy gains in strength, so, from the early Thinite period onwards, the Egyptian world takes shape in its religion, statecraft, society, historiography and art. The invention and development of hieroglyphic writing and the establishment of the calendar are the two fundamental intellectual innovations of that time.

It is not known whether the idea of the double kingdom also involved a double burial, one grave and one cenotaph. Recently great tombs of the First Dynasty have been found at Saqqâra which their excavator, Walter B. Emery, considers to be royal tombs, and in part assigns to the same kings of whom tombs are known in Abydos. Some authorities claim that the archaic tombs at Saqqâra are not royal tombs, but the graves of high officials— a theory that fits only some of these tombs with certainty.

THE PALACES AND TOMB MONUMENTS IN ABYDOS AND SAQQÂRA

The palace architecture of the Thinite period can be visualized from the royal palace of Wadji (Djet) (Plate 6). These structures were built of bricks made from Nile mud and either were crowned by a continuous cornice above a façade divided by pillars or had defensive turrets projecting in front of the actual façade.

The brick tombs of the kings of Abydos, a compact group, are relatively small, some with a central room separated from the niche-like store rooms by pilasters, others being structures of many chambers with a larger burial chamber and a number of store rooms.

Much larger than the tombs at Abydos are the imposing royal tomb monuments which have been excavated in Saqqâra. Two of these have been identified by W. B. Emery, one being of the time of King Wadji (Djet) and the other of that of King Ka-a. Both of them are mastaba-tombs of the characteristic slab shape which is typical for the whole period of the Old Kingdom.

FIG. 1. Plan of mastaba-tomb No. 3504 at Saqqâra, built during the reign of King Wadji (Djet) of the First Dynasty. In the centre is the tomb chamber, surrounded by magazines containing goods for the use of the dead king.

FIG. 2. Plan of mastaba-tomb No. 3505 at Saqqâra dating from the reign of King Ka-a of the First Dynasty. Under the central core is the tomb chamber hewn out of the rock; the mortuary temple adjoins the mastaba on the north side.

The tomb of King Wadji (Djet) (Fig. 1) is a mastaba about 150 feet long and 63 feet wide with outer walls enlivened by projections and recesses. The interior follows the rustic tradition of the royal tomb-dwelling: in the centre the tomb chamber, surrounded by numerous store rooms of varying sizes, the whole with a flat roof. Around all four sides of this mastaba slab, which was about 24 feet high, there ran a low wall, on which were arranged bulls' heads made of sun-dried clay, but with real horns, in a row. Whether these referred to the number of the animals sacrificed or were magic apotropaic symbols is not clear. The whole complex was surrounded by an enclosure wall. Outside this there were on three sides rows of tomb chambers for the servants who probably died by poison and had to follow their master into the next world.

Compared to the mastaba of King Wadji (Djet), that of King Ka-a (Fig. 2), the last ruler of the First Dynasty, is more advanced in its arrangement, with a funerary temple adjoining the sepulchre, as later in the Step Pyramid of Zoser and the pyramids of the Fourth Dynasty. The mastaba of Ka-a, like that of Wadji (Djet), has the usual slab shape and an area of 107×74 feet and a height of 25 feet. Of the frontage, only three sides are panelled. Walls more than 15 feet thick enclose a central core which is made of rubble. Only below this lies the real tomb chamber, 30 feet long and accessible from the east by a descending corridor with a store-room on either side. Surrounding the mastaba is again a low wall which seems to have carried bulls' heads, and beyond this there is yet another wall, 9 feet thick, with an opening on the north side towards the precincts of the funerary temple. This consists of a ritual chamber in the south-west and of a number of rooms and passages. The mastaba and the funerary temple are again surrounded by an enclosure wall opening towards the east, and the entire complex is 117 feet wide and over 195 feet long. The frontages of the mastaba are surprisingly well preserved: on the projections and recesses there is the thick original stucco covering with geometrical paintings of still perfectly fresh colours, red, white, black, blue, green and yellow, imitating matting.

In the actual tomb chamber there was found the collapsed sarcophagus, and in the temple, plinths and feet of two wooden statues.

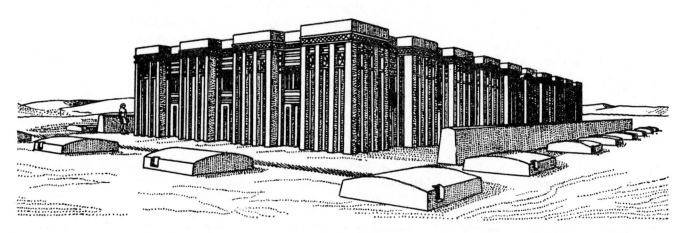

FIG. 3. Reconstruction of mastaba-tomb No. 3503, probably built for Queen Merneith of the First Dynasty.

THE SMALLER MONUMENTS

1. *Lion.* Speckled granite. Late Predynastic or Early Dynastic period. Length 12½ inches. Berlin, Staatliche Museen, No. 22,440.

This type of lion, with menacing open mouth and tail curving over on to its back, is also found in smaller sculptures in similar material. It has no base and reveals no typically Egyptian characteristics of style. This type was later replaced by a more temperate conception.

Drilling enabled the canine teeth and the lower incisors to be shown, thereby conveying a drastic impression of ferocity and bloodthirstiness, and thus giving the animal a character typical of the decades before and after the union of the Kingdom about 3000 B.C., but not seen again in later years.

2. *Cosmetic palette with desert animals and fabulous beings.*

Slate. End of the Predynastic Period. Height about 17 inches. Oxford, Ashmolean Museum, No. E.3924.

The most famous examples of the objects called cosmetic palettes, illustrated here, represent the most important evidence of the time of the union of the kingdoms. Their size excludes their use for practical purposes as palettes. Probably they were votive gifts in the temple at Hierakonpolis. It remains unclear why these objects were used as votive offerings, and why they were made the vehicles for historical representations.

From Hierakonpolis (*Kôm-el-Ahmar*). On the edges two slender, counterpoised beasts of prey with freely rendered heads. An instinctive fear of empty spaces has resulted in the filling of both sides of the palette with figures of animals. Of actually existing animals are represented the lion, leopard (?), hyena, buffalo, giraffe, steinbock, several species

of antelope, hunting dogs with collars and a grallatory bird. Among the imaginary animals are some short-jawed beasts of prey with exaggeratedly long necks, a four-footed griffin with the head of a bird of prey and wings opening like combs on its back, and an erect jackal-like animal with a double waist and genitals, which appears to be playing a flute (a magician?). In the centre of one side of the palette is a pan in which malachite and other materials were mixed to make eye-paint.

3. Above: *Cosmetic palette with giraffes and palm.* Slate. End of Predynastic Period. Height 12½ inches. Paris, Louvre.
On both sides enframed by four beasts of prey of similar species. In addition, on the side containing the pan, a long-necked fabulous animal, a lion and an ibis, and on the other side two giraffes and a palm. The eyes of the animals were at one time inlaid.

Below: *Victory tablet.* Fragment. Slate. Beginning of Early Dynastic Period. Height about 11 inches. Cairo Museum, No. 14238.
The tablet illustrated here commemorates the victory of a king, probably King 'Scorpion'. On one side of the tablet beneath a crosspiece, above which feet can be seen, are the names of seven conquered localities, symbolically represented by the hieroglyphs for owl, akh-bird, wrestler, beetle, Ka, casket and reed, and surrounded by walls and bastions which are being demolished by animal symbols of royalty—falcon, lion, Seth animal, scorpion, etc. On the other side of the tablet are oxen, donkeys and rams in rows (captured animals?); beneath, plants and a cipher.

4, 5. *Victory tablet of King Narmer.* Slate. Beginning of the Early Dynastic Period. Height 25 inches. Cairo Museum, No. 14716.
From Hierakonpolis (*Kôm-el-Ahmar*). As commemoration of a victory, this is related to the fragment reproduced in Plate 3.
4. Obverse. At the top, on either side, are heads of the heavenly goddess Hathor with ears and horns of a cow; between them in the centre, the name of the king. Beneath, on the side containing the pan, are three pictorial strips. Above: The king, wearing the crown of Lower Egypt, on his way to witness the execution of fettered enemies, whose heads are laid between their feet. Behind the monarch is a personal attendant with his master's salve box and sandals, in front of him an official with writing materials and four standard-bearers; the emblems on the standards raised on staffs symbolize the divine might of the king.
The king wears a coat supported by a band over his left shoulder, together with an ornamental apron divided in two; behind, on the girdle, is the traditional oxtail; in his raised right hand he holds the ceremonial flail, in his left hand the pear-shaped mace, with the Horus falcon on the lower part of the handle. In front of the monarch is his name, expressed by the hieroglyphs for sheath-fish and chisel. Below: two bearded men leading two fabulous animals whose long necks twine round the pan. Such animals appear not only on similar tablets (cf. Plates 2 and 3), but also on Old Babylonian cylinder-seals, and later we find them in the name of the Upper Egyptian town of Cusae. Here one may suppose that some political union is

symbolized and it is not improbable that it was a manner of expressing the union of Upper and Lower Egypt, since on both sides of the tablet Narmer is wearing the crowns of both countries. Beneath, the king in the shape of a wild ox batters down the wall of a fortified settlement, at the same time trampling on the arm of a conquered foe.

5. Reverse. The king, wearing the crown of Upper Egypt, strikes down an enemy held by the hair, a victory motive which persists throughout all the periods of Egyptian history. Behind the king is the sandal-bearer with his box. Above the kneeling victim, whose home is given as the Harpoon nome (?), is a symbolical representation: the king in the shape of a falcon god is holding by the lip the head of a captive rising out of the hieroglyph meaning 'land'. The six plants (papyrus?) nearby may symbolize six thousand captives, but perhaps also Lower Egypt. Below: Two naked fallen enemies with names of districts or tribes.

6. *Tombstone of King Wadji (Djet), 'Serpent'.* Limestone. First Dynasty. Width 25½ inches; original total height 98 inches. Paris, Louvre, No. E.11007.
From Abydos. Each tomb had two such stelae. The work shows a surprising artistic maturity together with a partially antiquated treatment of form. The Horus name of the king is rendered with a fine feeling for form and arrangement: a serpent with raised head against the background of the palace, the panelled façade of which comprises three towers and two lofty gates: above, the king-god in the shape of a falcon.

Colour Plate I. *Dogs hunting gazelles.* Disk of black steatite inlaid with coloured alabaster. From the tomb of Hemaka at Saqqâra. First Dynasty. Diameter 3½ inches. Cairo Museum, No. 70104.
In the tomb of Hemaka, chancellor of King Udimu, successor to King Wadji (Djet), were found numerous disks with drilled holes. It is not clear what their purpose was, but perhaps they were disks put on spindles for weaving. This particular disk is one of the most skilfully decorated. A raised rim with a criss-cross design encloses the surface area which contains representations of two groups of animals: two dogs hunting two gazelles. While one dog still chases one gazelle, the other dog has caught its victim, thrown it down and is shown biting through its neck. The theme is known also on palettes (see Plates 2 and 3). This small masterpiece deserves admiration not only because of its carefully detailed execution but also because of the harmony with which its decoration is fitted into its given area.

7. *Statue of Hetepdief squatting on his knees.* Granite. End of Second Dynasty. Height 15½ inches. Cairo Museum, No. 1.
Hetepdief is shown squatting on both knees with hands laid flat on his thighs. He wears a wig with short curls and a short loin-cloth. Compared with later representations of kneeling or crouching figures this early example suffers from a certain heaviness and stiffness which is emphasized by the relatively low position of the head. Nevertheless the carefully modelled face with its alert features shows the skill of the artist.

On the right shoulder of the statue the names of the first three kings of the Second Dynasty are engraved: Hetepsekhemui, Nebre and Nynetjer. Perhaps Hetepdief was a priest of their mortuary cult. It is therefore possible that the statue was carved only towards the end of the Second or even perhaps only at the beginning of the Third Dynasty; it comes from Mit Rahina, the site of ancient Memphis.

THE OLD KINGDOM

THIRD DYNASTY · 2778–2723 B.C.

Kings: *Zoser, Zoser-Atoti* (= *Sekhemkhet, Zeserti-ankh?*), *Sanakht, Khaba, Nebka, Huni.*

The centre of political life shifts to Memphis near the modern village of Saqqâra. Notable achievements in many fields. Development of building in stone: construction of King Zoser's Step Pyramid and of the residence-buildings belonging to it; also of the similar, unfinished monumental tomb complex of King Sekhemkhet and of others.

THE TOMB-COMPLEX OF KING ZOSER AT SAQQÂRA

The complex of edifices surrounding the Step Pyramid of King Zoser (Figs. 4 and 5) includes the king's funerary temple on the north side of the Step Pyramid and the southern tomb, and consists of a temple, palaces and chapels, which were used by the king on the occasion of the Jubilee festival. A spacious hall connects the only entrance at the south end of the east wall with the great court (between the pyramid and the southern tomb), in which the king's ceremonial race in honour of Apis took place. The whole complex—the achievement of the subsequently deified Imhotep—is the first great architectural work in stone. The architectural forms are still based on the custom, usual when building with bricks of Nile mud, of employing bundles of reeds as supports for the walls, or wooden logs trimmed with the adze, and ceilings consisting of closely-packed rows of round wooden beams. The facing with glazed composition tiles of the walls in three rooms underneath the pyramid, and of three rooms in the southern tomb, is merely a highly skilful imitation in stone and glazed composition of mats made of vegetable materials. The Step Pyramid itself was developed out of a mastaba, a kind of tomb originally of bench shape.

This mastaba stood over the 91-foot deep shaft (Figs. 6–8) leading to the royal burial chamber. From this shaft there ran numerous corridors (Fig. 7), originally filled with household utensils and stone jars, as well as three chambers with the above-mentioned glazed composition facing on their walls, and reliefs of the king, similar to those in the southern tomb (Plate 15).

The original mastaba, above which the Step Pyramid was subsequently erected, measured 205×205 feet and was 25 feet high. It was built of fragments of stone faced with blocks of masonry, which were afterwards strengthened to a thickness of 10 feet all round the mastaba.

Along the east side were shafts 104 feet deep, each leading to a gallery 97 feet long (Figs. 6 and 7). These contained

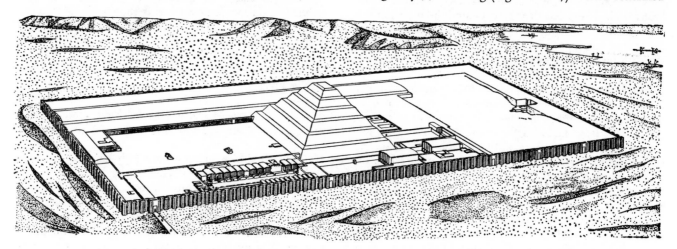

FIG. 4. Bird's eye view of the area of King Zoser's tomb at Saqqâra, showing his Step Pyramid.

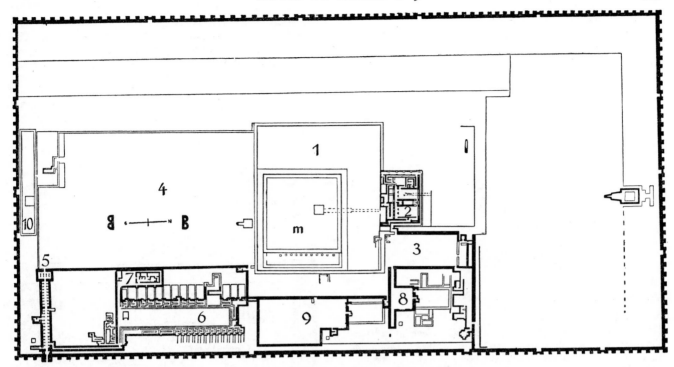

FIG. 5. Plan of the area of King Zoser's tomb.

1. The Step Pyramid (cf. Plates 8 and 13) arising out of the original square mastaba (m). 2. Adjoining it, to the north, the funerary temple of King Zoser. 3. The court, with the serdab in its SW corner, in which the statue of the king was found (cf. Plates 16 and 17). 4. The great court with the altar (near the southern edge of the pyramid) and the two B-shaped stones, which probably served as turning-points during the king's race in the course of the Jubilee festival (cf. Plate 15). 5. The entrance hall (cf. Plate 11). At its western end the portico (cf. Plate 10); at the eastern end, the only gate in the surrounding wall (cf. Plate 9). 6. The Jubilee court, with the false chapels of Upper Egypt on its western side and those of Lower Egypt on the east;

these accommodated the Gods of Upper and Lower Egypt when they attended the Jubilee festival. 7. The small temple (cf. Plate 13). 8. The court in front of the northern palace; on its east side the façade with papyrus half-columns shown in Plate 12. 9. The court of the southern palace. 10. The southern tomb (cf. Plate 14). Inside it, at a depth of 91 feet, rooms with walls faced with glazed composition tiles and in one of these three reliefs of the king during the ceremonial race (cf. Plate 15).—The western side of the tomb area is occupied by false terraces, the middle one containing galleries filled with thousands of jars and human bones. In the centre of the north side of the area was another large altar.

the tombs and offerings for the queens and prematurely deceased children of the royal family. As the original dimensions of the mastaba were not sufficient to contain all these, it was extended towards the east, its original square shape being thus converted into an oblong with a longer east-west axis (Figs. 4 and 8).

The fact that the flat top of the mastaba was lower than the surrounding wall and thus invisible from outside, must have persuaded the architect Imhotep to erect a tomb rising by steps, which would be visible from a distance, 'a gigantic flight of steps reaching up towards the sky, which would enable the soul of the dead king to ascend towards the sun, his father Re', as Lauer has described it.

The original four-step pyramid, after its north-south axis and also its east-west axis had been lengthened, became that east-west oblong, six-step, 195-foot high pyramid which still remains as a monument to a great king and a gifted architect of the early Old Kingdom, and of Egyptian culture.

8. *View from the Unas Pyramid towards the north-east*. In the foreground the southern part of the perimeter wall;

in front of it, a building of mud bricks; beyond, close to the wall, the southern tomb. In the background the great court, on the northern edge of which rises the Step Pyramid. To the east of the great court, remains of the temple and the Jubilee Court can be seen. In the distance, the dark strip is cultivated country; behind it, the pale cliffs of the eastern desert near Tura.

9. *Southern end of the east side of the perimeter wall with the only gate*.

Reconstructed by utilizing old blocks. The wall encircled the whole tomb area, with a length from north to south of about 610 yards (= 1000 Egyptian cubits) and 306 yards from east to west; the original height was 65 feet. It is built after the manner of archaic mastabas, with recesses. Along its four sides are 14 bastions. The only gate, at the southern end of the eastern portion, leads into the great hall (cf. Plate 11) and thence through the portico (cf. Plate 10) to the great court. The eight rows of holes on the upper portion of the wall correspond to the extremities of the wooden beams used to strengthen walls built of mud bricks; in this stone wall, they form an effective and

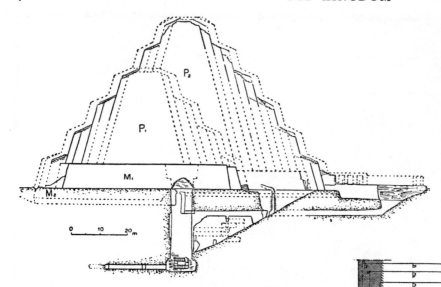

Fig. 6. Longitudinal section of the Step Pyramid in direction south-north. M: The original mastaba, of which the ground-plan was originally a square. P1: The original four-step pyramid. P2: The ultimate six-step pyramid. Beneath the original mastaba the 91-foot deep shaft and the granite burial chamber.

Fig. 7. Cross-section of the Step Pyramid at the level of its base, showing the 91-foot deep royal shaft and the galleries leading off it, with the three rooms with faience-covered walls (x). To the east of the pyramid are the shafts leading to the tombs of the queens and the royal children. To the north of the pyramid the funerary temple. From east to west the section reproduced covers only about three-quarters of the area of the ultimate base of the pyramid.

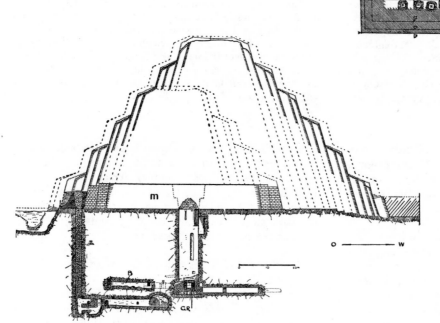

Fig. 8. Longitudinal section of the Step Pyramid in direction east-west. Beneath the original mastaba (m), the 91-foot deep shaft leading to the granite burial chamber (GR). To the left one of the rooms with walls covered with glazed composition tiles (B). On the east side of the mastaba one of the 104-feet deep shafts leading to the tombs of the queens and the royal children.

vivacious element. Like all the other buildings in the tomb area, the wall is built of Tura limestone from the mountain on the opposite, eastern bank of the Nile. This wall may well be considered a small-scale imitation of the 'White Wall' with which Menes, the founder of the city, encircled Memphis.

10, 11. *Portico of the hall of pillars and the hall of pillars seen from the eastern entrance.*
The 58-yard-long hall of pillars comprises two rows each of 20 three-quarter columns, in the shape of bundles of reeds, 19½ feet high, each pillar terminating the ends of short transverse walls. The two outside walls have window-

like openings in the top portion between the transverse walls. The ceiling was an imitation in stone of a wooden ceiling made of semicircular wooden beams, set close together and transversely (in the second picture, the modern ceiling is not yet in position). The portico consists of eight pillars, placed in pairs on either side of short connecting walls. The shape of the three-quarter columns in the hall is found here too: the pillars resting on cylindrical pedestals are in the form of 'reed-stems'; their tops are carved as if they were fitted with a protective covering. At the entrance to the portico is a wall with an open gate also constructed of stone.

12. *Façade on the east side of the court before the northern palace.*
Papyrus-shaped columns, papyrus being the plant symbol of the North. Wonderfully realistic representation.

13. *The temple.*
Rectangular shape, with rounded corners. Three of the walls terminate on the inner side in fluted three-quarter columns which, like those of the hall of pillars, were presumably crowned only with an abacus. On the eastern side of the temple we again find a half-open stone door, this time opening towards the inside.

14. *Corner of a wall at the southern tomb with frieze of serpents.*
This wall, rebuilt from fragments, formed part of the superstructure of the southern tomb, which was demolished during the Nineteenth Dynasty. The wall-surfaces are broken by false-door niches. The round staves are reminiscent of the wooden rollers by which the reed mats were lowered when doors were closed. The row of erect cobras crowning the wall is the primitive form of a symbolical ornament which lasted down to very late periods and probably points to Lower Egypt. There are good grounds for believing that the internal organs of the king were buried in the southern tomb. The enclosure contains a shaft 91 feet deep, which, as in the case of the pyramid, leads to a chamber faced with granite. From the bottom of the shaft a passage leads to three rooms, the walls of which, like those beneath the pyramid, are faced with turquoise-coloured glazed composition tiles. One of these rooms contains three slabs, designed to imitate doorways, with reliefs of the king (cf. Plate 15).

15. *King Zoser during the ceremonial race.*
One of the three mural reliefs in the southern tomb. The king, wearing the crown of Upper Egypt, is shown taking part in the ritual race which formed part of the celebrations during the periodical jubilee festivals. He is lifting the ritual flail and another object which cannot be identified with certainty. In front of the king is a long pole bearing the figure of a divinity in the shape of a jackal, before which a cobra stands erect. Above the monarch hovers the divine falcon with a symbol of life. To the right, symbols of health. In front of the king's head, his Horus name: Netjer-khet. The relief is surrounded by a frame of glazed tiles.

The sculptor has succeeded particularly well in showing the subject running. He depicts him with his legs wide apart, his feet apparently only just touching the ground. In view of the flatness of the relief, the modelling of the important parts of the anatomy is an outstanding achievement, in particular the collar bone, the knees, the whole muscular system, and especially the leg muscles, and last but not least the whole, beautifully upright body and the structure of the very lively face.

16, 17. *King Zoser.* Limestone. Traces of painting. Height 55 inches. Cairo Museum, No. 49158.
This life-size statue was found in the serdab on the north side of the Step Pyramid (Figs. 5, 6), a limestone chamber, in the sloping front wall of which were two peepholes. It is the oldest life-size royal statue known. The eyes, formerly inlaid, are now empty. The royal head-dress with pointed lappets, the wig of strands and the long holder for the beard are unusual and stress the antiquity of this statue with its strikingly individual features. On the pedestal are the title and name of the king, always called Netjer-khet on contemporary monuments; the name Zoser does not occur until later. Traces of colouring: white on the mantle, brown on the skin, black in the hair.

THE TOMB-COMPLEXES OF KINGS OF THE THIRD DYNASTY AFTER ZOSER

In addition to the imposing tomb-complex of King Zoser with its splendid Step Pyramid, the following Third Dynasty tomb-complexes may also be mentioned, some of which include pyramids: first of all the unfinished pyramid of Sekhemkhet, the presumed successor of Zoser, which was found by Zakaria Goneim in 1951–2 not far from the south-west corner of the Zoser enclosure-wall. Although unfinished, this pyramid also was surrounded by a carefully constructed enclosure-wall on one part of which was found, inscribed in red paint, the name and title of the same Imhotep who was architect of Zoser's tomb-complex. At Beit Khallaf, about 310 miles south of Memphis, is the rough brick mastaba-tomb built by King Sanakht. The structure known as the Layer Pyramid at Zawiyet el-Aryan (between Giza and Saqqâra) was probably intended as the tomb of Khaba, while King Nebka also began to erect a tomb in the same place.

Huni began at Maidum, about 30 miles south of Memphis, the great pyramid which was probably finished by Snofru, the first king of the Fourth Dynasty. When complete, this splendid pyramid was about 315 feet high, and each side was about 470 feet long; its angle of incline was 51° 52'. Yet for centuries this monument of the last king of the Third Dynasty has soared skywards like a great tower, stripped of its casing, with the steep walls of the inner core, which alone survives, sloping inwards only slightly from the perpendicular. Although it is now only a ruin, how splendidly still does the Maidum Pyramid exemplify the stupendous architectural achievement of the Old Kingdom!

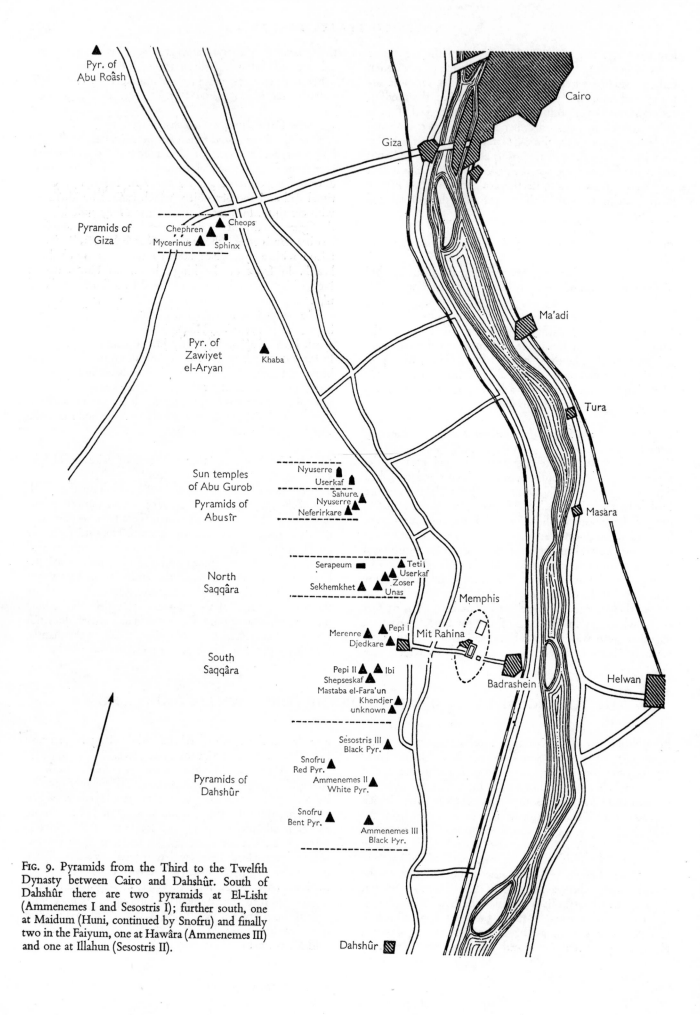

Pyr. of
Abu Roâsh

Cairo

Giza

Pyramids of
Giza

Chephren · Cheops
Mycerinus · Sphinx

Ma'adi

Pyr. of
Zawiyet
el-Aryan

Khaba

Tura

Sun temples
of Abu Gurob

Nyuserre
Userkaf

Masàra

Pyramids of
Abusîr

Sahure
Nyuserre
Neferirkare

North
Saqqâra

Serapeum

Teti
Userkaf
Zoser
Unas

Sekhemkhet

South
Saqqâra

Merenre · Pepi I
Djedkare

Memphis

Mit Rahina

Pepi II · Ibi
Shepseskaf
Mastaba el-Fara'un
Khendjer
unknown

Badrashein

Helwan

Sesostris III
Black Pyr.

Snofru
Red Pyr.

Ammenemes II
White Pyr.

Pyramids of
Dahshûr

Snofru
Bent Pyr.

Ammenemes III
Black Pyr.

Dahshûr

FIG. 9. Pyramids from the Third to the Twelfth
Dynasty between Cairo and Dahshûr. South of
Dahshûr there are two pyramids at El-Lisht
(Ammenemes I and Sesostris I); further south, one
at Maidum (Huni, continued by Snofru) and finally
two in the Faiyum, one at Hawâra (Ammenemes III)
and one at Illahun (Sesostris II).

MASTABA-TOMBS OF THE THIRD DYNASTY

The mastaba-tomb of Hesire, who, as 'King's acquaintance' and 'great one of the South', was one of the leading officials in Zoser's time, serves in its entirety as well as through its relief decoration, as an example of the architecture during this period.

18. *Wood reliefs from the tomb of Hesire at Saqqâra. Height 45 inches. Cairo Museum, Nos. 1426, 1427.*
Eleven wooden reliefs (in varying states of preservation), belonging to the eleven niches in the mastaba have been found; the six best-preserved of these are today in the Cairo Museum. Hesire is shown on one of the reliefs here reproduced, standing erect, with the staves of his rank and writing materials, and on the other seated before an offering-table. In the latter he is wearing a wig of ringlets, in the former the strand coiffure. Portraits and hieroglyphs are wonderfully fresh and delicate in their execution. Although the two relief figures already show the typical hieroglyphic character which prevailed from this time on, the features and certain details of the bodies are treated with a realism found only exceptionally in later Egyptian reliefs.

19. *Hesire at the offering-table.*
Detail of the relief shown on the left of Plate 18. Hesire holds in his left hand the long staff and the club-like sceptre of his rank. From his shoulder hang the writing materials, consisting of palette, rush-box and water-container. The chair has slender ungulate legs, the seat having the shape of a papyrus stem. Above the table, consisting of support and slab, with its half-loaves of bread, are various articles of food. The practice of depicting foodstuffs in front of the deceased in his tomb goes back to the ancient Egyptian idea that, so long as the dead man has food and drink at his disposal, even if only in a picture, his 'ka', i.e. the imperishable essence of his being, can continue to exist.

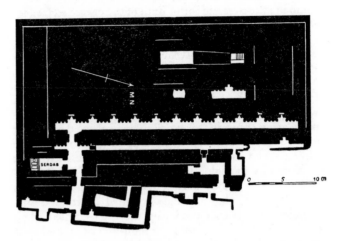

FIG. 10. Plan of the mastaba-tomb of Hesire at Saqqâra. The entrance is at the south end. While the east wall of the inner corridor is smooth and decorated with painted scenes, the west wall is interrupted by 11 niches each of which contained a wooden relief bearing a representation of the dead owner, approximately half life-size (Plate 18). The 'outer niche' is at the north-eastern corner of the mastaba. In the mass of the superstructure outside the burial chamber is a concealed niche.

FOURTH DYNASTY · 2723-2563 B.C.

Kings: *Snofru, Cheops (Khufu), Djedefre, Chephren (Khafre), Mycerinus (Menkaure), Shepseskaf.*
 One particular source names two other brothers of Chephren: *Hor-Dedef* and *Baf-Re*; according to Manetho, a historical writer of the Ptolemaic Period, *Shepseskaf* was succeeded by a king called *Tamphthys.*

 Deliberate concentration and direction of popular energies under the leadership of divine-royal supreme power. Construction of the great pyramids with their temple complexes. Reduction in the number of types and the abandoning of decorative imitation in favour of simple powerful forms. This change resulted in sacrificing the rich endowments of private tombs. That is why our knowledge of those times is very limited. Doubts about the succession of kings after the reign of Cheops lead to the assumption that a simultaneous or counter-dynasty existed. The fact that Shepseskaf had his tomb constructed at South Saqqâra and did not choose to build a pyramid but a mastaba leads to the conclusion that there was inner tension.
 The pyramids of the kings of the Fourth Dynasty lie on the eastern edge of the Western Desert, occupying an area with a north-south length of about 90 miles. Two of Snofru's pyramids are at Dahshûr (Plate 20), more than 25 miles to the south of Giza, and the third, probably finished during his reign, is at Maidum, nearly 80 miles south of Giza. The remains of the pyramid of Djedefre, successor to Cheops, are near the modern village of Abu Roâsh, 11 miles to the north-west of Giza. South of the modern Saqqâra, in the neighbourhood of the capital Memphis, there is only the tomb of Shepseskaf, the last king of the Fourth Dynasty.

MONUMENTS OF THE EARLY FOURTH DYNASTY

20. *The pyramid field of Dahshûr.*
View from the Unas pyramid at Saqqâra, looking south. In the middle distance, on the left, pyramids of the South Saqqâra group. In the centre of the background the so-called 'Bent Pyramid' (height 336 feet); on the right, the so-called 'Red Pyramid' (height 339 feet), the oldest royal tomb in pure pyramid form. Both of these were erected for the founder of the Fourth Dynasty, King Snofru.

21, 22, Colour Plate II. *Prince Rahotep and his wife Nofret.* Painted limestone. Height about 4 feet. Cairo Museum, Nos. 3, 4.
From the tomb of the prince—who was probably one of King Snofru's sons—at Maidum. As high-priest of Heliopolis, army commander, etc., Rahotep occupied a number of the highest offices. As a favourite of the king, his wife Nofret was a member of the court. The animated effect produced by the colouring gives these two figures a pre-eminent place among ancient Egyptian statues. The eyes are inlaid with dull and light-coloured quartz and surrounded by a border producing the black-painted edges of the lids. The left sides of the high-backed cube-shaped seats were hewn off with rough blows in ancient times. The prince is wearing a simple apron, with an amulet on his collar of tubular beads. Nofret—this favourite woman's name can mean either 'the good' or 'the beautiful'—is wrapped in a close-fitting mantle. The fillet in her hair shows a pattern of flowers. The customary difference between the colour of a man's skin and a woman's should be noticed. Whereas the woman's is in the main a sort of creamy yellow, that of the man varies in the different works from a light to a dark brown.

Even though there is still a touch of early archaism in Rahotep, he embodies clearly and realistically his time and the sturdy peasant race from which the kings of the Fourth Dynasty sprang. His broad shoulders, his arched chest and his muscular arms show his peasant origin. His alert and intelligent face are proof of the capacity of this race to build up a state with the political power of the Fourth Dynasty.

The portrait of Nofret is in contrast to that of Rahotep. Here for the first time in Egyptian art the beauty of a woman's body has been perceived and expressed. Her garment allows the shape of her body to be revealed, and with its open neck it all but exposes her gracious breasts. This is beautifully executed as is her lifelike head which bears an almost enigmatic expression. According to W. Wolf it expresses the voluptuous animal nature of woman in a universal manner.

Colour Plate III. *Grazing geese, from the mastaba of Nefermaat, a son of King Snofru, and his wife Atet at Maidum;* painting on plaster. Early Fourth Dynasty. Height of register 11.2 inches. Total length 68 inches. Cairo Museum, No. 1742.
These geese have a special place amongst the uncommonly lively representations of animals known from the early period. The severe, slightly dry symmetry of the register is relieved by the subtle shading and the many colours of the different species of geese represented. This has never been surpassed in Egyptian painting. The diverse rendering of the creatures and the depiction of the vegetation which suggests the landscape behind, create a genre-painting in spite of its composition in registers.

23. *King Cheops.* Ivory seated statuette. From Abydos. Fourth Dynasty. Height 3 inches. Cairo Museum.
This little figure is the only surviving three-dimensional representation of the builder of the Great Pyramid. Flinders Petrie found it in 1902 in the temple precincts of Khentamenty, with whom the god Osiris became identified from approximately the Sixth Dynasty onwards. The king wears the 'red crown', i.e. the crown of Lower Egypt. The upper part of the crown is broken off. He holds the whip in his right hand and his left hand is stretched out on his thigh. He is dressed in a short apron. His name is carved on the front of his seat, which is shaped like a cube. In spite of its small size, the statue expresses the energy and vigour which are commonly attributed to the ruler Cheops.

24. *Prince Ankhhaf.* Limestone faced with stucco, painted. Height 23 inches. Boston, Museum of Fine Arts, No. 27.442.
From the prince's tomb near Giza. As the third husband of Princess Hetepheres, the vizier Ankhhaf was the son-in-law of King Cheops. He was both vizier and superintendent of the royal buildings. This bust obviously had a religious purpose different from that of the damaged statues of the prince which have been found. The bust was modelled out of a layer of stucco spread in varying thicknesses over the limestone. The arms are cut off at the level of the armpits; the torso has been cut away beneath the breast. The overpainting is of a light reddish-brown. For unexplained reasons the ears have been trimmed like those of the so-called reserve heads, to which this work is closely related. The unusually realistic features, with their elaboration of individual details of form, give this bust a special place among the sculptures of the time.

THE PYRAMID AREA OF GIZA

This great tomb area contains, in addition to the three most celebrated pyramids, the burial places of the most important personages of the Fourth and also of the Fifth Dynasty. Each pyramid complex consists of four buildings lying one behind the other, the whole stretching from the edge of the cultivated zone towards the west as far as the cliffs of the desert plateau. The four buildings are: the gate or valley temple; the covered causeway, with openings to admit light; the funerary temple in front of the pyramid, in which the rites in memory of the deceased ruler were

celebrated; and lastly the pyramid itself as the monumental climax.

In the northern part of the area lies the oldest and at the same time the largest pyramid, that of Cheops, the son of Snofru and Hetepheres. At the base the sides are about 750 feet long (=440 Egyptians cubits) (north side 755 feet, south side 756 feet), and at an angle of 51° 52' the sides originally reached a height of 481 feet (present height 450 feet). Adjoining it on the west is the royal cemetery, with the mastaba roads running from north to south and from east to west, laid out according to a uniform plan in the Fourth Dynasty for the members of the royal family and the high state officials, and bounded on the south by a

wall. In front of the pyramid—as can still be seen in the case of the two later pyramids—lay the funerary temple, to which a causeway led from the valley temple on a branch of the Nile. Immediately adjoining the eastern side of the pyramid are two depressions for the ships. The two ships discovered in 1954 lie to the south of these. To the east, in front of the Cheops pyramid, are three smaller pyramids for close relatives, probably daughters of the king. Adjoining them is another mastaba area.

The pyramid shown in the centre of the plan, that of Chephren, the son of Cheops, originally had sides 707 feet long (present length 690 feet) and at an angle of 52° 20' reached a height of 471 feet (present height 447 feet); at

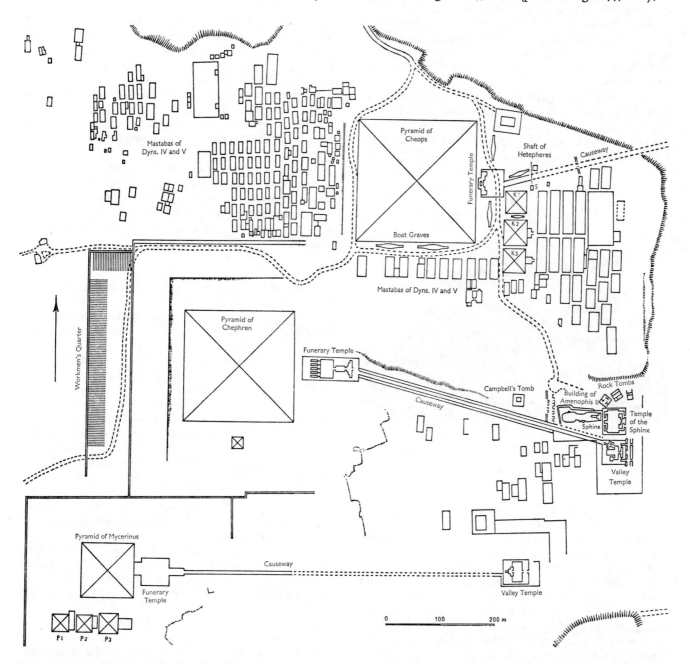

FIG. 11. The pyramid area of Giza with the three great pyramids of Cheops, Chephren and Mycerinus. To the south of the Cheops pyramid, the two ships discovered in 1954. On the eastern side of each pyramid is its funerary temple, to which the causeway from the valley temple leads; in the case of the Chephren and Mycerinus pyramids, these temples have been preserved, but that of the Cheops pyramid has to a large extent been destroyed. To the north-west of the Chephren valley temple is the Sphinx.

the top a considerable part of the casing remains, which originally covered the whole pyramid. The funerary temple, the approach causeway and especially the valley temple of this pyramid are very well preserved.

The southernmost and smallest of the three pyramids is that of Mycerinus. Its sides were once 356 feet long (now 340 feet) and its angle 51°. Its height was formerly 218 feet (now 204 feet). Clearly visible remains of the funerary temple, causeway and valley temple have been preserved. In front of it on the south there were also three small pyramids.

Between the causeways to the two last-named pyramids there is another large mastaba zone, with tombs mainly of prominent persons of the Fifth Dynasty.

Just to the north, on one side of the beginning of the causeway from the Chephren valley temple, lies the Sphinx. In front of it is the Sphinx temple (not to be confused with the Chephren valley temple, which writers often wrongly describe as the Sphinx temple).

The principles of pyramid construction, differing in their details from one pyramid to another, can best be illustrated by the pyramid of Cheops, which surpassed the others both in its main conception and in the construction of the inner chambers.

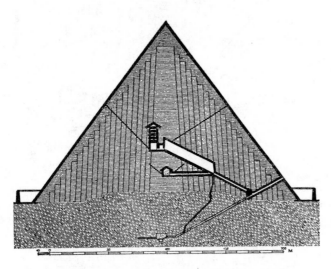

FIG. 12. Longitudinal section, direction south-north, of the Cheops pyramid.

The framework consists of irregularly placed, rough-hewn stone blocks, with an outside casing of carefully dressed limestone, 17 feet thick. The layout of the internal construction was changed three times.

As in all other pyramids, the entrance is on the north side. In this case it is at a height of 49 feet above ground level, the passage at first sloping downwards for 62 feet and then rising. At the point where it begins to rise, the passage was blocked by a number of large granite blocks, as a protection against tomb thieves. The passage then leads into the great chamber, rising with a gradient of 26·5°; it is 30 feet high and 153 feet long, with a maximum breadth of 7 feet 3 inches. Faced with polished Mokattam limestone, it is a masterpiece of masonry work. From it a short passage leads to an antechamber shut off by four

granite blocks. At a height of 137 feet above ground level is the royal funerary chamber, with a north-south length of 17 feet and an east-west width of 34 feet. The chamber is faced with Aswan granite. At the western extremity is the king's sarcophagus. From the funerary chamber two air-shafts lead towards the outside; they run at different gradients and measure 6 × 8 inches; one of them is 173 feet long, the other 231 feet; they probably had a religious significance. Above the funerary chamber are four horizontal stone ceilings separated by empty spaces, and a gable roof of blocks inclining towards one another, to protect the funerary chamber from the pressure of the top of the pyramid.

25. *The pyramids of Giza seen from the road to Saqqâra.*
The pyramid of Cheops shown in the picture on the right is still 450 feet high today. Nowhere can its imposing height be seen to better advantage than from this viewpoint on the road to Saqqâra. The road passes to the east of the pyramid-field of Giza. The three subsidiary pyramids of the Cheops pyramid can be clearly seen in the picture. The southernmost appears roughly in the middle of the Chephren pyramid, owing to the change in the perspective.

26. *The pyramid-field of Giza from the south.*
In the photograph the funerary temples in front of the two later pyramids can be clearly seen: that of Mycerinus (which in the illustration appears to be in front of the pyramid of Chephren), and that of Chephren (in the illustration, in front of the Cheops pyramid).

27, 28. *The Giza sphinx.*
This rock statue, a colossal couchant lion with a king's head wearing the royal *nemes* (head-dress), was carved out of the heart of a limestone quarry whence King Cheops obtained the blocks for his pyramid and the superstructures of the tombs of his high officials. This mighty work is generally ascribed to the reign of King Chephren, but certain details, such as the type of features and the receding lateral surfaces of the head-gear, point to an older origin. Under the New Kingdom this sphinx was believed to be a portrait of the sun-god Re-Herakhty of Heliopolis. The paws and the outer sides of the trunk are built up out of ashlar blocks. In 1925-6, when the huge monument was again completely cleared, cement supports to hold up the head were placed beneath the head-dress on either side. On the cheek, in front of the ear, are traces of reddish-brown colouring. The damage to the head dates from the iconoclastic disturbances about A.D. 1380 and further damage was later inflicted by the Mamelukes.

Despite the gigantic dimensions (height about 65 feet, length 238 feet) it harmonizes well with the surrounding landscape. Its size can be gauged by comparing it in Plate 28 with the Chephren valley temple, in the left background at its feet.

In Plate 27: In the background behind the sphinx, the pyramid of Cheops.

In Plate 28: Immediately in front of the sphinx, the remains of a temple which probably existed at the time of King Chephren; at an angle in the foreground, a monument dating from the New Kingdom. Behind the sphinx, the causeway running from the Chephren valley temple

to the pyramid temple. Above the head of the sphinx can be seen an Arab cemetery.

29. Southern portion of the Giza pyramid-field, from the east.

In front of the sphinx, ruins of a temple probably dedicated to him; adjoining it, the Chephren valley temple. From this the ancient causeway leads up to the funerary temple of the Chephren pyramid (on the right in the illustration). In the centre of the background, the pyramid of Mycerinus.

VALLEY TEMPLE AND FUNERARY TEMPLE OF KING CHEPHREN

The valley temple, often described as a 'gateway', lay on a branch of the Nile. This magnificently simple building is in shape almost a perfect square. It is distinguished by the beauty of its proportions and the brilliance of the materials, which even today is still striking; these are characteristic features of Fourth Dynasty buildings.

In front of each of the two entrances in the eastern façade there probably stood two sphinxes. Both entrances lead to a transverse corridor from the middle of which we gain access to the 'broad hall' (B). Adjoining this are the three aisles of the 'long hall' (L), with monolithic granite pillars 13 feet 6 inches high. Light entered this hall through oblique openings which still exist. Against the walls there once stood 23 statues of kings; holes in the plaster (Plate 32) still show the positions of their square pedestals. From the south-west corner of the 'broad hall' a corridor leads to a group of store-rooms, arranged in two rows of three each. At the north-west corner is the end of the corridor leading to the causeway.

The funerary temple, which adjoins the eastern flank of the pyramid, is likewise built of massive blocks of local limestone faced with granite, out of which the necessary rooms seem to have been fashioned as if they were hollowed out. In the great court (H), which likewise contained statues of the king, the sacrifices were made. It is the centre of the so-called 'public' part of the temple. Its columns were of Aswan granite, in front of which were

seated statues of the king. Adjoining the court to the west are five chapels (C), in each of which the king was worshipped under one of his five names. Each chapel contained a statue of the king and probably a bark as well. These may well have been the five barks excavated in the vicinity of the funerary temple. Behind the court was the 'intimate' part of the temple, with the alcove of the Sanctuary (S), to which only the officiating priests had access. In front of the great court, near the entrance, we again find the system of the 'long hall' (LH) with the 'broad hall' (BH) lying before it, as in the valley temple, but in this case the 'broad hall' is larger.

30, Colour Plate IV, 31. *King Chephren.* Diorite. Height 66 inches. Cairo Museum, No. 14.

This seated portrait statue, together with eight other more or less complete statues of the king, was found in the 'well shaft' of the valley temple. In this particular statue, to the figure of the king is added the royal god Horus in the shape of a falcon, which, sitting on the back of the throne, lends its protecting strength to the monarch. This powerful pictorial conception is not often found in statues of Egyptian kings and nowhere has it achieved more effective form than here. The throne has lion's legs; each pair of front legs is joined to the forepart of a lion by a maned lion's head. On the sides of the throne, the symbol of the union of the two Egypts, the hieroglyph 'sema' (='join'),

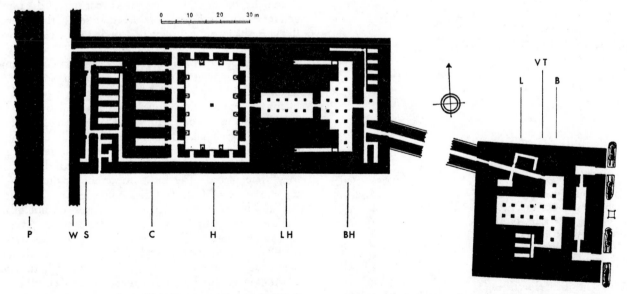

FIG. 13. Funerary temple and valley temple of King Chephren. On the right is the valley temple (VT), with its 'broad hall' (B) and 'long hall' (L). From there the 500-yard causeway leads north-west to the funerary temple in the centre of the eastern side of the Pyramid (P). Its western flank adjoins the inner enclosing

wall (W) of the pyramid. BH: A broad hall, narrowing in step-wise fashion from east to west. On either side are apartments believed to have been serdabs. LH: Long hall. H: The great court. Adjoining it, five chapels (C). S: Sanctuary with false door.

around which are wound the emblematic plants of Lower and Upper Egypt, the papyrus and the so-called 'lily'. On the base, to right and left in front, the name. The clenched fist of the king grasps a folded cloth with hanging ends of unequal length. Between the heels is a round depression, the purport of which has not been explained. Above the centre of the forehead, lying flat against the head-dress, is the erect forepart of the divine cobra which symbolized the royal power and threatened the enemies of the 'Great God' with destruction.

In the words of Walther Wolf, this statue 'demonstrates the victory of complete majesty over nature, and in its place, whatever is wholly valid, enduring and existing is set'. It is 'the timeless reality of a higher sphere of exist-

ence'. 'Therein lies the secret, that in this statue there is an indivisible union of most vital life and the appearance of eternity, and that it convincingly demonstrates divinity in its complete vitality. In this way the Egyptian of the Fourth Dynasty represented the divine king, the universal god made flesh, the pledge of world order, the support of trust.'

32. *Valley temple.* Oblique view from the 'broad hall' with its single row of columns into the 'long hall' with its three pillared aisles.

33. *Valley temple.* The middle aisle of the 'long hall', seen from the 'broad hall'.

PRIVATE TOMBS OF THE FOURTH DYNASTY

The table-shaped form of the mastaba, from which it gained its name (in Arabic 'mastaba' means 'bench'), is shown in the reconstruction in Fig. 14. The hall-mark of these tomb-structures is their simple monumental appearance; they are laid out in streets at right angles to the great pyramids of Cheops and Chephren. In conformity with the wishes of the great rulers, the mastabas of the Fourth Dynasty, constructed of great stone blocks, lack chapels decorated with reliefs and statues, although the Third Dynasty mastabas of the nobles of the kingdom at Saqqâra and Maidum already possessed such decorations (Plates 18, 19, 21, 22, 24 and Colour Plate II). Now only a small offering-place was allowed at the south end of the east side of the superstructure; it provided protection for the offering equipment and also served as a magazine. The cult-chapel together with the serdab and its statue was eliminated; only

the shaft and the burial chamber survived, the latter being lined with fine limestone slabs and containing the simple sarcophagus. After the burial, the shaft was filled up. In a small anteroom between the shaft and the sarcophagus-chamber was placed a portrait-head, known now as the 'reserve head' (Plates 36–38).

34. *Funerary temple of Mycerinus, seen from the south-east corner of the Mycerinus pyramid.*
In the background, the Chephren pyramid.

35. *Old Kingdom mastaba cemetery, with the Chephren pyramid in the background.*
To the south of the causeway leading to the funerary temple of the Chephren pyramid stand the numerous rows of superstructures of private graves of officials, mostly of the Fifth Dynasty. In their statue-chambers many statues have been found, representing the occupants of the tombs and their servants. In front of the eastern side of the pyramid (lying in shadow), the funerary temple can be clearly seen.

36–38. *Portrait heads from the royal cemetery at Giza.* Limestone. Life-size. Cairo Museum, Nos. 46216, 46215.
These individually carved heads belong to a particularly interesting group, which appears to be limited to statue-less tombs of members of Cheops' and Chephren's families at Giza, although similar heads have occasionally been found elsewhere. They come from the subterranean sarcophagus chambers, in the entrances to which—towards the shafts—they were placed. The most important examples are in the museums of Boston, Cairo and Vienna. The hair is depicted like a close-fitting cap, the eyes are not inlaid, and the broad, simple treatment of the features gives an effect of portraiture. The ears have been more or less hacked off. At the back of the head and neck are vertical notches; on the throat, just above the base, there are often light horizontal grooves. All this points to some local burial custom, perhaps going back to age-old conceptions, or connected with the passage in section 373 of the Pyramid Texts: 'Arise! Take thy head, pick up thy bones, gather together thy limbs!' According to H. Junker, these heads were intended to help the wandering soul on its way back to the tomb,

Fig. 14. Bird's-eye view of a group of Fourth Dynasty mastaba-tombs. On the left of the drawing the sides of two mastabas have been cut away to show the deep shafts leading to the funerary chambers.

Fig. 15. Longitudinal section of a shaft and funerary chamber in a Fourth Dynasty mastaba. The antechamber between the two shows the position of the 'reserve head'.

a kind of physiognomical signpost to the buried body to which it belonged. It may here be pointed out again that the bust of the Prince Ankhhaf (Plate 24), preserved in the Boston Museum, is clearly not a fragment of a full statue of the prince, but probably a forerunner of the later true reserve heads such as are shown on Plates 36–38.

STATUARY OF THE TIME OF KING MYCERINUS

39. *King Mycerinus between two goddesses*. Green slate. Height 38½ inches. Cairo Museum, No. 46499. From the king's valley temple at Giza.
In a recess in the king's valley temple, unfinished at the time of his death and completed in brick by his successor Shepseskaf, several similar triads have been found. They are now divided between the museums of Cairo and Boston.

On the right of the king, who is wearing the crown of Upper Egypt, is the goddess Hathor; on his left, the nome-goddess of Diospolis Parva, with the nome-symbol above her head.

The collocation of goddesses and the king in the first place expresses the idea of a family-group consisting of the three and, secondly, reveals a family likeness in the features of the three. Henceforth it becomes the rule for a god to be shown with the features of the ruling king.

The goddesses of these triads represent the first three-dimensional figures of deities in the Old Kingdom. The goddesses are, however, characterized only by their attributes, and not by individual likenesses. In type they are most similar to the figure of the wife of Mycerinus who is depicted in a pair-statue with the king (Plates 40, 41); this group was also placed in the king's valley temple.

40, 41. *King Mycerinus and Queen Khamerernebty*. Slate. Traces of painting. Height 56 inches. Boston, Museum of Fine Arts, No. 11.738.

From the king's valley temple in front of his pyramid at Giza. This unfinished, only partially polished work is the earliest known example of a type which later became very common in statues of private individuals and eventually developed into the family group. The difference between the robust, masculine features of the king with their expression of watchful expansiveness and the more placid expression of the woman's features, is striking and is proof of the fact that the art of this period was not dominated by any ideal pattern.

The determining factor of this group is that in the posture of the king and of his wife all expressive elements are suppressed. Both figures are quite independent and separate parts of a whole, without the man and woman fusing together psychologically to produce a unity. Without the expression of movement between the two, yet an impression of monumental and timeless peace is achieved by the delicate gesture of embrace used towards the king by his consort. Every expression of feeling is eliminated.

42. *King Mycerinus. Upper part of a seated statue in alabaster.* Life-size. Cairo Museum, No. 40704.
From the king's funerary temple in front of his pyramid at Giza. The material and the conception give this seated statue a peculiar charm. It is by no means established whether the alabaster statue represents Mycerinus or his son and successor Shepseskaf, for the latter completed the funerary monuments of his father.

THE SARCOPHAGUS AS AN IMAGE OF PALACE ARCHITECTURE

Colour Plate V. *Sarcophagus of an unknown person.* From Giza. Painted limestone. Fourth Dynasty. Height about 3 feet. Cairo Museum, No. 6170.
The picture shows the narrow side of this lavishly decorated sarcophagus. The design repeats the theme of the door, using it in various shapes and sizes. The centre is emphasized by imitating three rather exaggeratedly high doors, each of them crowned by a symbol of 'protection'. To the right and left of the centre two very much lower doors adjoin. Above these lower doors, half way up the

sarcophagus, runs a frieze with an outline of six windows on each side. We find the same designs slightly altered on the beautiful façade of the sarcophagus of Priest Rawer (Plate 43), itself an imitation of a palace, and also on tombs from the Early Dynastic Period (Fig. 3). Finally they also appear in the wall surrounding the tomb enclosure of King Zoser at Saqqâra (Plate 9). The painting of individual sections in different colours increases the plastic charm of the outside of the sarcophagus. These imitation palaces on sarcophagi give an excellent idea of the lost palace façades themselves.

FIFTH DYNASTY · 2563–2423 B.C.

Kings: *Userkaf, Sahure, Neferirkare, Shepseskare, Nyuserre, Menkauhor, Asosi, Unas (Onnos).*

The cult of Re, the sun religion of Heliopolis, became the state religion. Growing importance of high priests and state officials. Golden age of the art of sculpture.

The first monarchs of the brief Third Dynasty, Zoser and his successor Sekhemkhet, had their tombs erected in the immediate neighbourhood of the capital, Memphis, on the western edge of the desert near the modern Saqqâra; likewise the unfinished pyramid of Neferka lies only fifteen miles to the north near the modern Zawiyet-el-Aryan, while the tomb of the last Fourth Dynasty king is also close to Memphis. Similarly, it was in the neighbourhood of the capital Memphis that the kings of the Fifth and the following Dynasties built their pyramids. These monuments, however, were not built with the same care for their survival as those of Zoser, Snofru, Cheops, Chephren and Mycerinus. All that is left of them today consists of pyramid-shaped heaps of stones, without that crystalline nobility which distinguished the pyramids of the Fourth Dynasty.

Close to Zoser's step pyramid lie the pyramids of Kings Userkaf and Unas, while a little further south rises that of Asosi. Some six miles to the north, near the modern Abusîr, we find the three pyramids of Kings Sahure, Neferirkare and Nyuserre (Plate 45). Slightly north of this, near Abu Gurob, are the sun-sanctuaries of Userkaf and Nyuserre, the only two of which considerable portions have been preserved among those mighty sanctuaries with obelisks, dedicated to the sun, which made their appearance during the Fifth Dynasty and the form of which has fortunately been preserved in a hieroglyph.

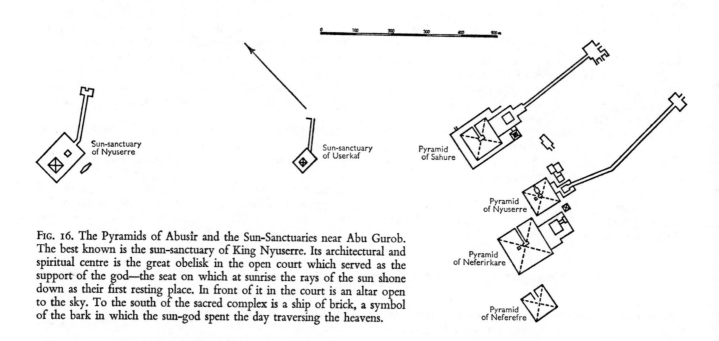

FIG. 16. The Pyramids of Abusîr and the Sun-Sanctuaries near Abu Gurob. The best known is the sun-sanctuary of King Nyuserre. Its architectural and spiritual centre is the great obelisk in the open court which served as the support of the god—the seat on which at sunrise the rays of the sun shone down as their first resting place. In front of it in the court is an altar open to the sky. To the south of the sacred complex is a ship of brick, a symbol of the bark in which the sun-god spent the day traversing the heavens.

SARCOPHAGUS ARCHITECTURE AND BUILDINGS

43. *Sarcophagus of Rawer.* Limestone. Cairo Museum.
From the tomb of Rawer at Giza. The sarcophagus has been carefully designed to represent a palace with doors, windows and niches. It gives a good idea of the arrangement and ornamentation of a palace built of sun-dried bricks of Nile mud.

44. *Two columns each with a different type of capital from the funerary temples of two pyramids at Abusîr.*
Left: Papyrus-bundle column from the funerary temple of King Nyuserre at Abusîr. Cairo Museum, No. 221.

The diameter of this column is about the same as that of the column with palm capital from the funerary temple of King Sahure pictured on the right. This papyrus column is one of the earliest examples of that type of column which has a capital in the form of a number of unopened papyrus umbels, while the column itself is fashioned as if made from an equal number of papyrus shafts. This design of column and capital was retained—though modified and made more complex—into the Late Period.

Right: Pillar with palm-capital from the hall of pillars in the funerary temple of King Sahure at Abusîr. Height of the capital (from the lowest ring to the upper surface of the abacus): 78 inches. Aswan granite. Cairo Museum.

The palm fronds rise from the supporting capital as if bound round with several coils of cord. On the lowest cord there is a manifold loop; on the shaft of the column, the name and title of the monarch. The palm columns from Abusîr are the oldest so far discovered and at the same time the most beautiful examples of this long-lived type, which occurs two thousand years later in temples of the Ptolemaic period.

45. *Pyramids of the Fifth Dynasty at Abusîr.*
The picture shows three of the four best-preserved pyramids near Abusîr. The pyramid of King Nyuserre is in the foreground; to the left of it at the rear is that of King Neferirkare and to the right that of King Sahure. These pyramids of the Fifth Dynasty reached by no means the height of those of the kings of the Fourth Dynasty; the highest is that of Neferirkare and it only measures 228 feet. Here too the original facing has gone. These pyramids and the temple precincts belonging to them were examined by Ludwig Borchardt from 1902 to 1908, on behalf of the German Oriental Society, who published the results of his investigations.

About 550 yards to the north-west of the pyramid of King Sahure lies the sun-sanctuary of King Userkaf, who built his pyramid at Saqqâra. The royal head pictured on Plates 48 and 49 was found near the lower temple of King Userkaf's sun-sanctuary. Further on, about 800 yards to the north-west, near Abu Gurob, the sun-sanctuary of King Nyuserre has been discovered.

STATUARY

46, 47. *King Userkaf.* Aswan granite. Height 26 inches. Cairo Museum, No. 52501.
From the funerary temple of this king's pyramid at Saqqâra. The body belonging to this severe, truly monumental head has not been preserved. Among the colossal statues of ancient Egyptian kings, this is, according to the present state of our knowledge, the oldest. The pupils of the eyes were indicated by colouring, traces of which remain.

48, 49. *Life-size head of a king (Userkaf?) of the Fifth Dynasty.* Metamorphic limestone. Discovered in 1957 during Swiss-German excavations at the lower temple of the sun-sanctuary of King Userkaf at Abusîr. Cairo Museum.
The subject wears the crown of Lower Egypt, the Red Crown of the North; the upper part of the crown is broken off. The king is depicted without a beard. The eyebrows and the elongated line of union of the eyelids are much more ornamental than those on the head of King Userkaf (Plates 46, 47), and the face of this sculpture appears gentler and more youthful than the other. It has therefore been suggested that it is not the head of a king but that of a goddess, perhaps the goddess Neith.

50. *Alabaster stele with figure of Rawer in relief.* Cairo Museum.
From Rawer's tomb at Giza. At the top are the titles and name of the subject, who was a high-ranking man in his time. The inscription reads as follows: 'Sem-priest, lector priest, keeper of the secrets of the books of the god (of the temple archives), follower of the god Min, Rawer.' Traces of colouring have been preserved. The body and draperies are indicated only by chiselled contours. The material, with its softly shimmering transparence, produces a particularly fine effect.

51. *Rawer.* Limestone. Height 10 inches. Cairo Museum, No. 66625.
From Rawer's tomb at Giza. Fragment of a life-size statue. The spiritualized face is formalistically related to the granite head of King Userkaf (Plates 46, 47).

52–57. *Ranufer, high priest of Ptah in Memphis.* Limestone, with traces of painting. Height of the figures: 73 and 70 inches. Cairo Museum, Nos. 18 and 19.
From his tomb at Saqqâra. Colour of the body, light orange-brown, of the hair, black. Collar above shoulders painted. Inscriptions on the bases. The short hair of the statue on Plates 52, 53 left, 54 and 55 makes Ranufer appear older than in the other figure with its strands falling on the shoulders (Plates 53 right, 56 and 57). But the impression of a difference in age is obviously only caused by the variation in hair-styles; both statues, certainly, represent the High Priest in the prime of life.

This variety of hair-styles in tomb statues on one and the same person is not unique, just as the depiction of the whole body of one person varies, as a rule, in many of the statues placed in a mastaba-tomb. That is obviously the case too with the statues of Ranufer. The more slender figure is the idealized one and this idealization is further emphasized by a wig.

On one of the statues which show Ranufer in a standing position he is wearing an ordinary loin-cloth which is folded back at the edge; on the other statue he is shown wearing a wig and a shorter festive loin-cloth, part of which is pleated for embellishment, and his belt is decorated with a decorative knot.

In his capacity as high priest of the temple of Ptah, who as the great creator-god in early times became the patron of craftsmen, Ranufer was also chief of the craftsmen. As such he had no doubt the best stonemasons at his disposal to create the statues for his own mastaba-tomb. In fact both these statues belong to the most outstanding achievements in sculpture of their time. They embody the outlook of the feudal times beginning with the Fifth Dynasty, when elegant deportment and manly seriousness were the ideals and principles of aristocratic men. If the idealized statue of Ranufer wearing a wig is effective only because of its height and proportions, so the other appears most masterful and self-conscious—not least because of the posture and expression of the face.

58, 59. *Ka-aper, priest and high state official.* Wood. Height 43 inches. Cairo Museum, No. 34.
From Ka-aper's mastaba-tomb at Saqqâra. The nickname 'Sheikh-el-Beled', i.e. 'village magistrate', has stuck to this famous sculpture since the native workers who were employed at the time of its excavation spontaneously named it so because of Ka-aper's resemblance to their own village magistrate. This statue was found together with a second also of wood which is only preserved from the thighs upwards; it shows Ka-aper as a slim man with a wig of short curls. The statue of a woman preserved down to her hips was also found in the mastaba. The

original surfaces of the statues were covered with a thin layer of stucco and paint; this has perished on all three statues. The eyes are made of quartz and other materials; they are embedded in a copper frame which surrounds the lids.

The statues representing Ka-aper and his wife are the oldest examples of wood being used in Egypt for private portraits of a large size. Yet it must be remembered that the stucco with which these works were originally covered, and also the painting, did not let the original material show through. On the statue shown here, the right foot and the left leg up to the knee have been replaced. The knobbled stick with which the statue is nowadays adorned in place of the staff of his rank does not really belong. The right hand once held the short sceptre of his rank.

If the statue, which dates from the early part of the Fifth Dynasty, still shows the subject in a somewhat stiff posture, this only enhances the expression of dignity given to the priest. His slight plumpness has no repulsive effect.

60, 61. *An official writing.* Limestone, painted. Height, 1 foot 9 inches. Paris, Louvre, No. N.2290. From a mastaba-tomb at Saqqâra.
The skin is painted reddish-brown and the hair black. The eyes are, as usual, embedded in a copper frame, and are made of alabaster, black stone and silver (pupil).

The official represented is the judge and provincial governor Kai. This is undoubtedly the most important scribal statue of the time. The sculpture is clearly connected closely with the living model which is specially emphasized by the lifelike reproduction of details of the body as well as of the head. Yet, in spite of all its apparent naturalism, this statue must be considered only as the ideal picture of a scribe in general and not as a portrait of Kai himself. The profession as such is symbolized and not the individual into whose mastaba-tomb the sculpture was to be put.

62, Colour Plate VI. *Statue of an unknown scribe.* Limestone, painted. Height 19½ inches. Cairo Museum, No. 36. From Saqqâra.
The left hand is holding the papyrus scroll, and the right hand is ready to write. The colour of the body is orange-brown, that of the hair black. The eyes are inlaid in copper lids, which have now corroded green; the eyeballs are of crystal, the whites of alabaster, a copper nail serving as pupil. The restrained, questioning expression is of great psychological charm, and the work of high artistic value. Works of this kind do not represent domestic scribes waiting on the orders of their master, but high officials conscious of their highly appreciated knowledge and skill, who desired to be thus immortalized.

Compared with the scribe in the Louvre the Cairo statue of the unknown scribe is basically more idealistic, and is provided in addition with wig and collar. The theme of the whole statue is its pyramidal composition which considerably restricts the natural posture of the scribe, a restriction not found in the Louvre scribe. The bending of the right wrist, which results from the pyramidal construction, is really astounding.

Colour Plate VII. *Girl working at mash-tub.* Limestone, painted. Fifth Dynasty. Height 10½ inches. Cairo Museum, No. 66624. From Saqqâra.
Plastic representations in the round of servants and craftsmen (cf. Plate 63) supplement to a certain extent the scenes from life, depicted in relief in the mastaba-tombs. Sometimes it is easier to recognize the craftsman at work when he is depicted in a statue, rather than in a relief or a painting. The simplicity and realism of the servants and craftsmen are in pleasant contrast to the solemnity of their masters.

63. *Girl grinding corn.* Limestone, painted. Height 12½ inches. Cairo Museum, No. 87818.
The type is coarse, but the conception fresh and vivacious. One is reminded of the saying of a sage of the time: 'Good speech is more hidden than the green gem, yet one finds it in maids among the millstones.'

Similar figures of servants are frequently found surrounding the statue of their master in the statue chamber or serdab, providing him after death with the things he needed in life. They adhere less strictly to rule than the statues of their masters, the pose and draperies of which were governed by social conventions.

TOMBS OF THE FIFTH AND EARLY SIXTH DYNASTIES

The portraits reproduced in Plates 52–62, 64, 65 and Colour Plate VI—all of high functionaries and, in some cases, at the same time, priests—come from their tombs, or mastabas, at Giza or Saqqâra. As explained above, under the Fourth Dynasty there was no room in the mastabas for statues or reliefs of the deceased, since the practice of building offering chambers and serdabs was abandoned. At the beginning of the Fifth Dynasty there was a change. The tombs of prominent personages became many-roomed buildings, though the external form of the traditional mastabas was retained. Amidst the massiveness of the undecorated and windowless whole, resembling a gigantic stone slab, the rooms necessary for rites and worship seem as if they had been hollowed out. The dominant element is not so much the room as the whole mass of solid stone.

In the serdab, which usually adjoins the offering-chamber, we find the statue, or several portraits of the deceased.

Only a small peep-slit links the serdab with the world of the living, and allows the offering prayers to enter it. To understand Egyptian sculpture properly, especially that of the Old Kingdom, it should always be borne in mind that at least as far as tomb-sculpture is concerned, it was not in general intended to be seen. It was not even made with an observer in mind. This was the case already with the statue of Zoser (Plates 16, 17). In the remaining rooms of the mastaba, selected scenes in relief showed the life of the important owner. It should be noted that these scenes aim only to a small extent to establish the individual life, and that a whole series of themes were avoided by a sort of taboo, including birth, marriage, death and burial; also

the king and the palace, religious ceremonies and the gods.

The following scenes from reliefs in three of the most important tombs at Saqqâra, belonging partly to the Fifth and partly to the early Sixth Dynasty, show examples of these varied pictures of human existence. Ground-plans of these three mastabas—all three on the same scale of reduction—will be found in Figs. 17–19. In the tomb of Ti, who was overseer of the pyramids of Neferirkare and Nyuserre and of the sun-temples of Sahure and his successors, the entrance consists of a spacious pillared hall. From this a subterranean passage leads to the burial chamber, while a long corridor gives access to the offering-chamber, adjoining which to the south is the serdab, which formerly contained three statues (that on Plates 64 and 65 were on its eastern side). The mastaba of Ptahhotep, the first of the priests of the pyramids of Asosi, Nyuserre and Menkauhor, also contains the rooms dedicated to his son Akhethotep. The mastaba of the vizier Mereruka, with its 31 rooms, includes the burial chambers of his wife Wadjet-khet-hor and their son Meriteti.

64, 65. *Ti.* Limestone with traces of painting. Height 78½ inches. Cairo Museum, No. 20.

From his tomb at Saqqâra. A fresh and youthful nobility distinguishes this slightly over-life-size portrait of the estate-owner and court official Ti. Traces of black colouring on the hair; the body was painted reddish-brown. Inscriptions on the base. The nose has been (not very skilfully) restored. Parts of the wig of small ringlets are not in their original state.

66–69. *Reliefs from the tomb of Ti at Saqqâra.*

These mural reliefs are of carved limestone and come from the offering-chamber. They show to a greater or lesser degree traces of ancient painting.

66. *Ti watching a hippopotamus hunt.*

On the north wall. Ti is in a boat which is traversing a papyrus thicket on the bank of an arm of the Nile. Amidst the foliage, a number of young birds in their nests, being fed by their parents or protected against ichneumons or genets. Some of the birds are sitting on their eggs. In front of Ti's boat is another, the crew of which are harpooning hippopotami; a male hippopotamus turns round with open jaws, another is biting a crocodile. A young hippo is trying to climb on to its mother's back. In the small boat on the left, behind Ti's steersman with his pole, a man is angling for sheath-fish.

67. *Ti and his wife Neferhotpes.*

On the south wall. Ti, leaning on his long staff of office, and his wife Neferhotpes are watching game and cattle being brought in for sacrifice. The antelopes in the two upper rows are tethered to short stakes. The cattle are wearing ceremonial collars and their leads are attached to the under jaw. In front of Ti (on a level with his forearm) is a steward with an unrolled inventory scroll.

68, 69. *Herds of donkeys, rams and cattle.*

Above: A herd of donkeys being driven over sheaves of wheat on the threshing-floor (eastern wall).

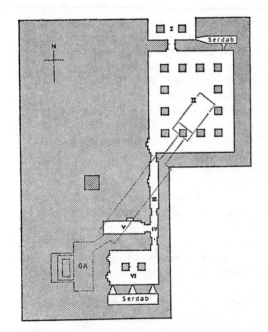
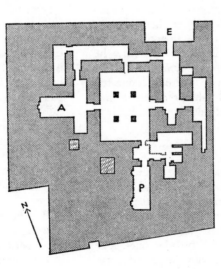
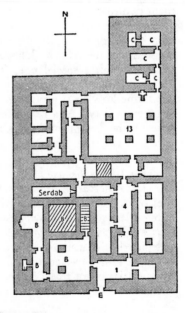

FIGS. 17–19. Mastaba tombs of the Fifth and early Sixth Dynasties. —Fig. 17. Mastaba of Ti (width 110 feet, depth 143 feet). I: Entrance. II: Pillared hall; from this a subterranean passage leads to the burial chamber. VI: Offering-chamber containing the most celebrated reliefs (cf. Plates 66–69); adjoining it, the serdab, with the three peep-slits for the original three statues (cf. Plates 64 and 65).—Fig. 18. Mastaba of Ptahhotep (width 86 feet). Opening off the hall with its four pillars, to the south, is the offering-chamber of Ptahhotep (P); to the west, that of his son Akhethotep

(A).—Fig. 19. Mastaba of Mereruka (width 68 feet). E: Entrance. In room 1, together with others, are the reliefs shown in Plates 76 and 77; in room 4, the relief showing Wadjet-khet-hor (Plate 74); in the pillared hall (13), on the surfaces of the pillars, reliefs showing the figure of the deceased (Plate 75). On the north side is a false door with a statue of the deceased. The rooms marked B are the portion of the tomb reserved for Mereruka's wife Wadjet-khet-hor; those marked C, the portion reserved for his son Meriteti.

Below: Upper register: Rams being driven over the seed to tread it into the soil; behind the drovers, a man with a seed-bag. Lower register: Cattle crossing a ford in the Nile marshes. One of the naked drovers is carrying on his shoulders, to prevent it from drowning, a new-born calf, which is lowing and looking round at its mother who follows anxiously behind (north wall).

70–72 upper. *Reliefs from the tomb of Ptahhotep at Saqqâra.* Limestone reliefs from the offering-chamber.

70. *Ptahhotep at offering-table.* On the north wall. Painted. Life-size.
This illustration shows the priest Ptahhotep seated on a chair with lion's legs. He stretches out his right hand towards the food on his table, while with his left he raises an ointment pot, on which is written 'Finest festival oil', to his nose. In addition to the usual shoulder-collar and knee-length apron, he is wearing a leopard-skin, which is a symbol of one of his priestly offices. Under the chair an almost obliterated figure can be discerned. The obliteration of figures of relatives in consequence of quarrels is frequently found. Above the table, with its rows of peculiarly shaped objects, which might be loaves or cakes, an abundance of dead birds and other foodstuffs is depicted.

71. *Presentation of cattle and poultry.* On the east wall.
The owner of the tomb is not shown here; his figure occurs to the right of the scene; the cattle and other creatures of his estates are being presented to him. At the bottom of the picture are cranes and geese, and above them two rows of cattle. In the upper register, not reproduced on the plate, are scenes of animal husbandry including the birth of a calf. The division of the wall into registers and the relative dullness of the theme presented the artist with a special task. It is noteworthy how he groups together everything he wants to depict, and at the same time how these groups are very skilfully connected in different ways. As a result, individual registers do not appear to be disconnected strips, nor do they dissolve into unrelated tableaux.

72 upper. *Water-lilies and bird.*
The close observation of nature is noticeable in the water-lilies on the right below the table at which Ptahhotep is sitting (Plate 70). It is shown how the two Egyptian native species differ widely. The blue water-lily (*nymphaea caerulea*) is depicted with a more slender calyx and petals and the Egyptian lotus (*nymphaea lotus*) with broader ones. The latter species is not to be confused with the *genuine* lotus of India and East Asia (*nelumbo nucifera*).

———

72 lower. *In the mastaba-tomb of Princess Idut at Saqqâra.*
Representation of a ritual slaughter. The animal has been thrown down and the shank of one of his front legs is being severed. The servant who is performing this act, calls to the man holding the shank: 'Grip it tightly'. To the right another servant is carrying away a leg which has already been severed and another joint. The man on the left is in the process of sharpening a knife.

Colour Plates VIII, IX. *From the mastaba-tomb of the vizier Mehu at Saqqâra.* Fifth Dynasty.

The mastaba-tomb of Mehu, who was one of King Unas' viziers, lies very near the pyramid of his king. This mastaba is distinguished not only by the beauty of its reliefs, but particularly by the exceptionally well-preserved colours in many places. Those given here were chosen from the many varied scenes in the tomb which show, among other activities, goldsmiths at work. As a large part of the wall-paintings in this tomb are very well preserved they could serve as *the* example for demonstrating the painted style peculiar to Egyptian wall-painting (the tomb is actually closed to the public). These polychromatic paintings are not in any way to be considered as realistic; there has been no attempt at all to capture nature in all its colourfulness, though the temptation to the Egyptian artist would have been very great in the Nile Valley with the brilliancy and iridescence of its landscape and its light. Colours are not used for purely optical effect; neither is the blending of colours employed; the aim is not to achieve an effect of illusion. On the contrary, colour is only used to distinguish the figures from the background and from each other and as such to make them easily perceptible. The background is thus often greyish-blue, not to give the illusion of the colour of the sky, but only to create for the eye a clear and peaceful background for the figures which move in front of it. The colour of the water is conventionalized where it is reproduced in the paintings. It is symbolically blue, black or green, no attempt ever being made to imitate the water of the Nile, which can shine with a thousand colours and harmonies. With regard to the human figures themselves, the body of the man is a brownish-red and that of the woman varies from a light yellow to yellow-white, though the colour of the skins of men and women in Egypt is generally the same, as is the case with us and all other races. What is always important is the tangible singling out and the reproduction of human beings and all objects in relation to the whole area of the painting. And it is just this way of thinking polychromatically, which is remote from any kind of realism and indeed would seem out of place, that characterizes the Egyptian style of painting. In later centuries artistically more refined paintings are served by a wider range of colours than in the more austere times of the Old and Middle Kingdoms, but the principle always remains the same.

VIII. The representation of whole registers of offering-bearers belongs to those scenes which reappear in tombs of all periods. Though the theme is dull, its attraction lies in the variation of the detail. Here we see in the bottom register of the painting that the number and posture of the birds carried by the bearers change. Furthermore, the creatures confined in the plaited boxes hardly resemble each other either in species or in composition. The bearers in the upper register are clearly different from one another. The almost unrelated juxtaposition of the figures, the lack of any depth in the scenes, and the rarity of overlapping, emphasized by the well-preserved colours, here exemplify the style of the Old Kingdom as against the compactness of individual figures and the grouping of figures in echelon in paintings of the same themes in later periods.

IX. *Girls dancing.* Here we see the so-called 'Hathor dance' done by harem-girls; in the lower part of the picture a 'leader' and a 'deputy leader' are taking part in the dancing. The costume of the dancers consists of a short loin-cloth, jewellery and a scarf round the neck. Their hair-style is strange, with a bobble plaited in at the end. The two girls standing to the left of each register are clapping out the rhythm.

SIXTH DYNASTY · 2423–2263 B.C.

Kings: *Teti, Phiops (Pepi) I, Merenre I, Phiops (Pepi) II, Merenre II, Queen Nitokris (Neit-aqer).*

Increasing power of the local feudal families resulted in the weakening of the central government. A feeling of greater self-consciousness is expressed in the length and detail of biographies and in the richness of their tombs.

Building took place all over the country. The temple of Pepi II can be regarded as a forerunner of the great Hathor temple at Dendera. The pyramids of this dynasty at Saqqâra are built on a smaller scale than those of the Fourth Dynasty. The kings of the Sixth Dynasty, like those of the Fifth, had their pyramids built at the edge of the desert near Memphis. To the west of modern Saqqâra the pyramids of Teti, Pepi I, Pepi II and Merenre lie close together; not far away are the remains of pyramids dating from the Seventh Dynasty (e.g. that of Ibi) and also from the Eighth Dynasty, e.g. Djedkare (see Fig. 9). At this period nobles were more often buried in their own provinces.

After the protracted reign of Pepi II, who was succeeded by Merenre II and Queen Nitokris, a crisis resulted from the accelerated disintegration of all that was formerly considered sacred and binding; this in turn led to a total regrouping of society and the culture of Egypt reverted to its former primitive level.

TOMB SCULPTURE AND SCULPTURE IN THE ROUND

73. *False door from the tomb of Iteti at Saqqâra.* Limestone, painted. Cairo Museum.
Unusually elaborate false doors with statues in the round of the deceased, are characteristic of private tombs during the Sixth Dynasty.

Iteti, known as Ankhires, is standing in the doorway leading to the kingdom of the dead, which, like the doors of real houses, is fitted with a lintel and drum for rolling up the mat used to close the door. Above, in the niche, we see him on a relief tablet sitting at table, with texts naming the offerings he wished to receive. On either side of the false door he is shown in sunk relief wearing a wig of strands and a projecting apron, whereas the statue shows him with a wig of ringlets and ceremonial apron.

74–77. *Reliefs from the tomb of Mereruka at Saqqâra.* Limestone, with traces of painting.

74. *Wadjet-khet-hor, wife of Mereruka.*
East wall of Room 4. To the left of Wadjet-khet-hor we see the leg and the lower part of the apron of the over-life-size figure of her husband. She is wearing the simple dress of the period, supported by straps. On her shoulders is a broad collar. The head is surrounded by an ornamental fillet and on her right wrist she has an ornament of bands one above the other. She is enjoying the perfume of a blue water-lily.

75. *Pillar relief of Mereruka.* About life-size; in the pillared hall forming the offering-chamber.
As a priest, Mereruka is wearing a leopard-skin, with apron and shoulder collar. In his right hand he is holding the long staff of rank, in his left the club-shaped sceptre.

76. *A trip through the papyrus thicket.*
Entrance hall, south wall. Standing in a light boat made of bundles of reeds, which is being propelled by four men, Mereruka seizes by the tail an ichneumon which is endeavouring to reach a nest of young kingfishers while their anxious parents flutter around. On the extreme left, another ichneumon (which in reality does not climb in this way) with its prey, a young bird. On the stems of the papyrus plants many kinds of birds are standing or sitting in nests. In the water are fish and hippopotami, one of the latter biting a crocodile.

77. *Harpooned hippopotami.*
Entrance hall, north wall. Three hippopotami, to whose heads ropes are already attached, turn with open jaws towards the hunters approaching from either side in their boats and threatening them with other harpoons. From the mouths of the pachyderms project huge curved tusks, which as material for carvings were trophies much sought after. To the left the wall of papyrus stems in regular rows. In the centre, spawn-weeds, with frogs and locusts upon them, one of them erased.

78. *Statue of the chief court physician Niankhre. From his mastaba-tomb at Giza.* Limestone. Early Sixth Dynasty. Height, 25¼ inches. Cairo Museum, No. 6138.

This seated statue is an interesting example of the relaxation of the strict convention of the Old Kingdom. By placing the right leg in a diagonal position and letting the right forearm follow the line of the shank, an asymmetry is established which is otherwise, as a rule, avoided. The left leg being upright and the right leg slanting, creates the impression that the subject was just about to take up the usual squatting position. It looks as if a movement is consciously sought, as was formerly not the case in the plastic representation of squatting and sitting subjects in the Old Kingdom. It is not the quiet attitude of being seated that is reproduced now, but the actual transitory moment of settling down. The perfection of details, in particular the lively, composed expression of the learned doctor, make this a masterpiece of its time; tradition has very consciously been deserted. The obvious change in conception and form signifies the deliberate abandonment of the static in favour of the dynamic.

79. *Werkhuu.* Upper part of a limestone statue with traces of colouring. Height of the fragment about 14 inches. Cairo Museum.
The surprisingly realistic and vivacious conception, which seems to rise above the hitherto prevailing convention, gives an idea of the tension and changes to which the Egyptian of the Sixth Dynasty—and perforce his sculpture as well—was exposed. Instead of the timeless dignity of expression found in the older works of sculpture, a novel class-consciousness becomes clearly evident.

80. *King Pepi I.* Copper and other materials. Total height of the statue 70 inches. Cairo Museum, No. 33034.
From Hierakonpolis (Kôm el-Ahmar). The life-size statue, like the smaller one of his son Merenre found with it, is beaten out of copper plate; some of the parts have been cast. The pieces were riveted together and attached by copper nails to a wooden core. So far no other equally imposing metal statue dating from the Old Kingdom has been found, though there is proof that copper statues were already being made during the Second Dynasty. The crown on this statue is missing. The expression of the face is, in contrast to those of the Fifth Dynasty, considerably more human and individual. The inlaid eyes give the face a fascinating vivacity.

Colour Plate X. *Head of a falcon.* Gold and obsidian. From Heirakonpolis. Height 4 inches. Cairo Museum, No. 52701.
This is one of the most important pieces of goldsmiths' work preserved from the Old Kingdom. It was found under the flooring of the temple at Hierakonpolis. It is not possible to assign it a very exact date. The head made of gold with eyes of obsidian was put on a wooden body, now decayed, covered with copper plates, which had the shape of a falcon lying down; in its beak was a tiny figure of a king also made of copper. The high feather-crown which decorates the falcon's head, and which is the attribute of divinity, is cut from gold plate; the other parts are hammered and engraved. In its simplicity and grandeur of style this work of art creates an unusual impression.

FIRST INTERMEDIATE PERIOD

SEVENTH TO TENTH DYNASTIES · 2263–2133 B.C.

The crisis which overcame Egypt at the end of the Sixth Dynasty has already been touched upon in the discussion of the history of that dynasty. It signified the collapse of the religious and political systems of the Old Kingdom with which Egypt had been dominated since the unification of the country around 3000 B.C. and especially during the Fourth and Fifth Dynasties. The arts too were overtaken in a catastrophic manner by this collapse.

The loss of the noble style in art indicates the depth of the break. This is manifest in sculpture and in relief, as well as in inscriptions which also formed part of the arts.

The collapse of the state authority brought about a remarkable strengthening of self-confidence and independent achievements of individuals.

A number of ephemeral nobles ruled for a few generations at Memphis during the Seventh and Eighth Dynasties. The princes of Herakleopolis followed them during the Ninth and Tenth Dynasties. Their dominion included the Delta which they tried to protect from Asiatic influences; however, their authority over the southern part of Upper Egypt was merely nominal, if it existed at all. In practice local nomarchs ruled there and continually fought one another. One of these nomarchs founded the line which subsequently became the Eleventh Dynasty, the beginnings of which were contemporary with the Herakleopolitan dynasty. From this period, which comprises the Seventh to the Tenth Dynasties, there survive few works of art either from Upper or from Lower Egypt. On the other hand, literature flourished in Lower Egypt; its form and subject-matter also influenced that of the Middle Kingdom.

THE MIDDLE KINGDOM

In the Nile Valley the traveller will seek in vain for well-preserved buildings from the Middle Kingdom period on their original sites. We know that there were plenty of them, for from the Delta to distant Upper Nubia traces of provincial capitals, temples and fortifications can be found, and like the rulers of the Old Kingdom the mighty Kings of the Twelfth Dynasty were buried in pyramids. But the condition of the pyramids at Dahshûr, Lisht, Hawâra and Illahun is typical of the fate which overtook the monuments of that memorable period, so important for the understanding of spiritual and historical development, not only in ancient Egypt. Built of bricks of modest dimensions, covered only on the outside with a facing of stone which nearly everywhere has crumbled away, they have been reduced to ruins and become shapeless mounds. The funerary temples belonging to them have been destroyed to such an extent that their sites are marked only by areas of ground strewn with debris.

We can measure the gravity of this loss when we read the descriptions of them written by those who visited them in ancient times or when we come across occasional fragments of buildings covered with beautiful bas-reliefs or decorative inscriptions. What the subsequent rulers, foreign oppressors known as the Hyksos kings, did not destroy, was plundered by the later generations of the New Kingdom period, who in their fury to build and their ignorance looked upon existing structures as being no more than convenient stone-quarries. In the neighbourhood of Karnak, near the modern Luxor, which as the centre of the then flourishing cult of Amun contained many a royal monument dating from the Middle Kingdom, archaeologists have been able, after exhaustive labours, to reconstruct a little limestone chapel of Sesostris I, and other decorated portions of buildings, out of the stone structures into which at a later period they had been incorporated. In the neighbouring temple zone of Medamûd, French excavations have brought to light various architectural components decorated with beautiful reliefs, from a group of buildings of the reign of Sesostris III. At Medinet Maadi, on the south-west edge of the Faiyum, the desert sand has yielded up a much-damaged shrine of Ammenemes III, which was the focal point of a much later temple complex, while on the site of Iun, the ancient city of the sun (the modern Heliopolis, north-east of Cairo), a lofty obelisk erected to the glory of Sesostris I still stands—the oldest of the characteristic type that has hitherto been found. But all these are poor compensation for the loss of the great sanctuaries of that period at Tanis, Heliopolis, Crocodilopolis, Coptos, Thebes and elsewhere, and the extensive funerary temple of Ammenemes III—the famous 'Labyrinth' described by classical travellers—in front of his pyramid at Hawâra. Even the funerary temple of Mentuhotep Nebhepetre in the bay of the cliffs at Deir el-Bahri, at Thebes, is now only recognizable in its ground-plan.

We can form a better idea of the spatial conceptions of the period from the rock-tombs of provincial princes. In Middle Egypt, and especially at Beni Hasan, El-Bersha, Meir, Asyut, and on the southern frontier near Aswan, high in the cliffs running parallel to the river, we are impressed by the beauty and proportions of the façades and chambers hewn out of the rock.

Formerly the tombs at Beni Hasan offered the most famous examples of wall-paintings of the period, but now they are very faded. The latest group of such tombs, built by local rulers, is at Qau el-Kebir, near El-Badari. These were particularly grandiose architecturally, but are now badly ruined.

The sculptural works of this period are scattered all over the world in famous museums, of which they are among the most treasured possessions—royal portraits of pure, severe design; heads of rulers full of lonely courage and disillusioned perception; sculptures revealing an understanding for the anatomical foundations of facial expression, hardly ever surpassed by earlier works and practically never by those of later periods of Egyptian art. From gigantic figures to tiny statuettes, every conceivable dimension is to be found, and almost invariably the artist's solution, whether it tends towards the typical or the individual, preserves its value even under the unfavourable conditions inevitable when such works are exhibited in the museums of large modern cities. The portraits of private individuals found in graves likewise surpass, with the simple grandiosity of their conception and their plastic treatment, the works of this kind produced in such surprising quantity during the following

period of the New Kingdom. In the history of ancient oriental sculpture, no period has succeeded so well as the golden age of the Twelfth Dynasty in Egypt in the production of portraits which awaken the interest of mankind—an interest to which we of the present day feel ourselves intimately attracted, as if in them a part of our own problems had already been experienced and overcome.

ELEVENTH DYNASTY · 2133–1992 B.C.

A princely family from the neighbourhood of Thebes begins the reorganization of political affairs. After a struggle with the local princes of Herakleopolis, unification of various parts of the country is achieved, without at first eliminating the privileges of the feudal families.

The first rulers are the princes *Antef, Antef Sehertaui, Antef Wah-ankh*, and *Antef Nebtepnefer*. Starting from their provincial principality, they begin the work of 'unification of the kingdom'. This was completed by *Mentuhotep Nebhepetre* (2060–2010 B.C.), who changed his name twice, so that for a long time it was believed that there were three monarchs named Mentuhotep. His three different names can be explained by the fact that the reign of this monarch comprised different phases, from the inherited principality to his rule over reunited Egypt. The final victory of this first Mentuhotep over Herakleopolis was achieved in 2040 B.C., so that the latter year really marks the beginning of the Middle Kingdom. With his successors *Mentuhotep Seankhkare* and *Mentuhotep Nebtauire* the Eleventh Dynasty comes to an end.

FUNERARY TEMPLE OF KING MENTUHOTEP NEBHEPETRE

With the building of the funerary temple of Mentuhotep Nebhepetre in the rock basin of Deir el-Bahri near Thebes a new era begins in architecture and the formative arts. This funerary temple, built close up against the rock wall behind it, is a combination of the rock-tomb and the pyramid-tomb. In its dimensions and the manner of its construction in stone it is the only royal tomb of its kind.

The temple itself is built round a square base of stone. It was crowned by a comparatively small pyramid rising over 65 feet above base level. The whole plan was that of a rising pyramid. In front of the lower floor of the temple, which probably consisted only of rock, there was, on the south-east side, a colonnade. A sloping ramp led up to the next level, that of the actual temple. Colonnades like that on the lower level were built on the south-east, north-east and south-west sides of the temple. Its roof was supported by three rows (on the north-west side, only two) of octagonal, so-called protodoric columns. Six small chapels lay along the north-west side. Adjoining the temple was a smaller pillared hall, from which a shaft led to the burial chamber. The last room of all, with the holy of holies, was hewn out of the rock. Its roof was supported

by eight rows of eleven columns each. A second burial chamber was built into the pyramid itself.

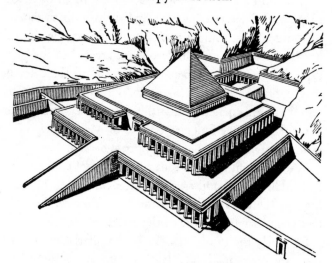

FIG. 20. Reconstruction of the funerary temple of Mentuhotep Nebhepetre at Deir el-Bahri. For its plan, see Fig. 27 (page 432).

SCULPTURE IN THE ROUND AND IN RELIEF

Colour Plate XI and 81. *King Mentuhotep Nebhepetre* (2060–2010 B.C.). Sandstone, painted. Height 72 inches. Cairo Museum, No. 36195.
Found in a recess of the shaft known as Bab el-hosân, forming part of the funerary temple of this king at Deir el-Bahri near Thebes. This undamaged massive seated figure is like a mummy wrapped in its bandages. The king, wearing

the crown of Lower Egypt, is sitting enthroned in the attitude of Osiris, dressed in jubilee robes, on a plain cube-shaped seat with a high pedestal. The skin is olive-black, the robe whitish, the crown dull red. On the same site other seated and standing statues of the king, coarser in their execution, were found. As the second consolidator of the kingdom, this monarch enjoyed considerable fame in the

following periods and his tomb was the scene of one of the great Theban festivals, the 'beautiful festival of the desert valley'.

82. *King Mentuhotep slaying an enemy.* Limestone, with traces of colouring. Height 10½ inches; width of the whole relief, 20½ inches. Cairo Museum.
From Gebelên, seventeen miles south of Thebes. The plate shows the right half of the relief. The king is shown slaying a Libyan chieftain in the traditional manner. The fallen captive, held by his hair, has a feather symbolizing his nationality in his right hand. A fish is attached to the back of his girdle in the manner of a royal 'tail'. This could be interpreted in the sense that the activities of this mighty ruler and his great Twelfth Dynasty successors were directed towards foreign conquests to a greater extent than was the case under the Old Kingdom.

83. *From sarcophagi of two wives of King Nebhepetre Mentuhotep.*
Above: *Detail from the sarcophagus of Queen Kawit.* Limestone with traces of colouring. Cairo Museum, No. 623.

Seated on a chair, Queen Kawit raises a drinking cup to her mouth while holding a mirror in her left hand. A lady's maid is tidying the ringlets in her hair, while a manservant standing in front of her is pouring liquid into another cup.
Below: *Sarcophagus of Queen Ashait shown in full length.*

Limestone with traces of colouring. Cairo Museum, No. 6033.
Queen Ashait watching the activities on her estates.
Both sarcophagi were found at Deir el-Bahri. In them were buried, in wooden coffins, Kawit and Ashait, wives of King Nebhepetre Mentuhotep. The reliefs on the sides are of a brittle delicacy somewhat coarsely expressive.
The confrontation between the massive compact figure of the king (Plates XI and 81) on the one hand, and the very slim figures on the sarcophagi on the other, point to the difficulties of finding a new style in which human beings could be depicted. It is, perhaps, not merely chance that the contemporary ideal of beauty was the same after the Second Intermediate Period during the Seventeenth and early Eighteenth Dynasties, when we find a similar 'elongation' of the human body.

Colour Plate XII. *Offering-bearer. From the tomb of Meketre at Thebes (Deir el-Bahri).* Painted wood. Eleventh Dynasty. Height 44 inches. Cairo Museum, No. 46725.
From the end of the Old Kingdom, representations in the round of offering-bearers were placed in the nobles' tombs as well as figures of servants and craftsmen. The colours of the wooden statue shown here are very well preserved. The figure is of a girl in a long garment holding a small goose in her right hand and supporting the basket on her head with the left. The objects in the basket are probably pottery vessels with stoppers of Nile mud.

THE ROCK-TOMBS AT BENI HASAN

To the south of Abu Qurqas, on the east bank of the Nile, lies the row of rock-cut tombs of Beni Hasan. There are altogether thirty-nine, and they belonged to princes and nobles of the old town of Menat-Khufu. They date mostly from the Eleventh Dynasty. Many of them are noteworthy, both for their architectural structure as a whole and also for their important inscriptions and excellent, even if badly preserved, paintings. Besides simple rock-cut tombs which

have several chambers but no columns, there are others with papyrus-bundle pillars and lotus-shaped capitals. Amongst the latter there are several in which the main chamber is preceded by a vestibule embellished with columns supporting a portico.

84 upper. *In the rock-cut tomb (No. 15) of the nomarch Baqet at Beni Hasan.* Eleventh Dynasty. Part of the painting on

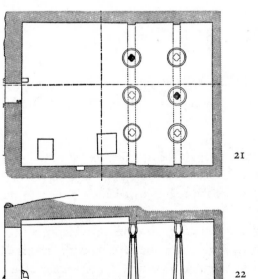

21

22

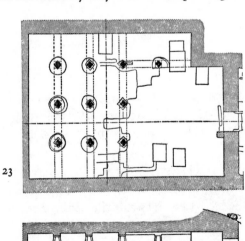

23

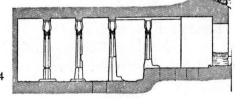

24

FIGS. 21-24. Beni Hasan. Ground-plan and section (west/east) of tomb No. 17 of the nomarch Khety (21, 22) and of tomb No. 18 (section east/west) owner unknown (23, 24). Scale 1:300.

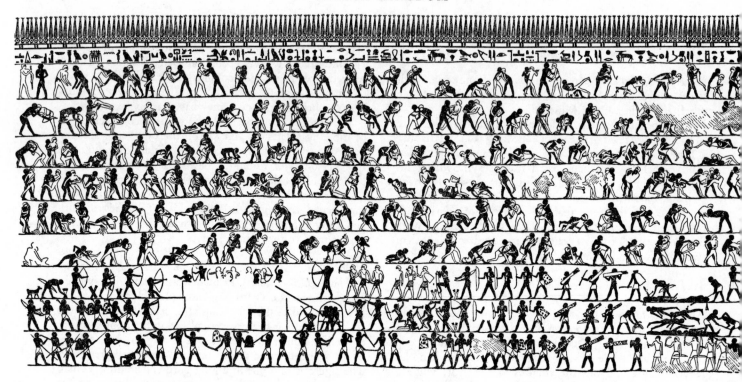

FIG. 25. Beni Hasan. Wall-painting on the east wall of tomb No. 15 of the nomarch Baqet (cf. Plate 84 upper).

the east wall. Two columns, now broken away, supported the ceiling of this oblong room. Register after register show wrestling scenes. The lowest register of the scene can be seen in the drawing in Fig. 25. This theme, which occurs very rarely in tombs dating from the Old Kingdom, only became popular at the end of that period and during the Middle Kingdom (see also Plate 84 lower). These scenes do not show a contest from beginning to end but rather they reproduce with great care single poses and holds. To clarify the picture the wrestlers are drawn in black and white respectively. Within the limits of this subject, what is shown here of postures and overlapping bodies, borders on the best that Egypt could produce in this style. Only

battle-scenes dating from the New Kingdom can be compared with them in this respect.

84 lower. *In the rock-cut tomb (No. 17) of the nomarch Khety at Beni Hasan.* Eleventh Dynasty. View from the entrance towards the west wall. The hall, cut out of the rock, was supported by two rows of bundle-pillars whose bases and entablatures were similarly hewn out of the rock. Apart from the offering-list for the dead person which is recognizable at the bottom right, the back wall is decorated with eight registers of paintings depicting scenes from life. The five upper registers show wrestling matches, troops and the storming of a fortress.

TWELFTH DYNASTY · 1991–1786 B.C.

Kings: *Ammenemes I* (1991–1962 B.C.), *Sesostris I* (1971–1928 B.C.), *Ammenemes II* (1929–1895 B.C.), *Sesostris II* (1897–1879 B.C.), *Sesostris III* (1878–1843 B.C.), *Ammenemes III* (1842–1797 B.C.), *Ammenemes IV* (1798–1790 B.C.), *Queen Sebekneferure* (1789–1786 B.C.).

This dynasty, whose founders were not of royal blood, had apparently to fight for its existence up to the time of Sesostris III. For this reason, the rulers often appointed the crown prince early in their reign as a co-ruler. A feudal system was still rife at this time in Middle Egypt. Yet, in practice, the nobles owed their power to the King. They were eliminated during the reign of Sesostris III.

Evidence of the social upheaval of the preceding period is provided by towns with citizens, which gave the newly developed social classes work and livelihood; furthermore, in their role as nome capitals with an official mayor, they undermined the remainder of the nomarch's territorial domain. At that time Nubia as far as the Second Cataract was established like a colony firmly under Egyptian rule. Sesostris III built a frontier post there

which strictly controlled all transit traffic. Relations with Asian countries seem to have been peaceful and far-reaching up to the time of Sesostris III and trade took place under definite diplomatic protocol. We hear for the first time during this reign of military campaigns. It has been established that towards the end of the dynasty and during the following hundred years a surprisingly large number of Asiatic workers and craftsmen settled in Egypt. Even though it is probably not appropriate to talk of a 'migration', the fact is that it paved the way for the rule of the Hyksos (see page 425).

Civilization flourishes anew under powerful, conscientious monarchs. Great activity in architecture under Sesostris I; re-attainment of full mastery in sculpture; notable achievements of craftsmen. The earnest ethical ideas of the time are reflected in the facial expression of the strikingly spiritualized statues of kings, as well as in the best private portraits. Warlike enterprises in Nubia and Western Asia, especially during the reign of Sesostris III. The court is transferred to the neighbourhood of the Middle Egyptian oasis, the Faiyum. Royal pyramids are built between Memphis and the approaches to the Faiyum on the edge of the western desert plateau, e.g. those of Ammenemes II and Sesostris III at Dahshûr, of Ammenemes I and Sesostris I at Lisht, of Sesostris II and Ammenemes III at Illahun and Hawâra in the Faiyum area. At Heliopolis an obelisk of Sesostris I has been preserved, the oldest known example of this slender form of monument which afterwards became common.

MONUMENTS FROM THE TIME OF KING SESOSTRIS I AND HIS IMMEDIATE SUCCESSORS

85. *Head of an unknown woman.* Wood and other materials. Height 3½ inches. Cairo Museum.
Found at Lisht, near the pyramid of Sesostris I. The eyes were inlaid. The hair of the head, now incomplete, was carved from a type of wood different from that of the head and covered with a black paste in which little gold plates were stuck as ornaments. In execution and expression the face bears witness to a delicate artistic sensibility and in this respect may be compared with the beautiful, spiritualized portraits of women dating from the New Kingdom.

86, 87. *King Sesostris I.* Three of the ten seated statues of the king found at Lisht. Limestone with traces of painting. Height 75½ inches. Cairo Museum, Nos. 411–420 (411 on Plate 87).
Found together with seven other very similar seated statues of King Sesostris I in a hidden recess of the burial chamber in this king's pyramid at Lisht. The statues shown here are noteworthy for their fine detail: see in particular the head shown on Plate 87. The clenched right hand is holding a rolled-up cloth. The beard is delicately grooved and the raised eyebrows extended to the roots of the nose give the face a curiously tense expression.

88, 89. *Reliefs on the thrones of two statues of Sesostris I from Lisht.*
88. The falcon-headed Horus, and Seth, with his characteristic head of a long-eared animal, as national gods are tying papyrus and lily, the plant emblems of Upper and Lower Egypt, round the hieroglyph meaning 'unite', on which the name of the king is shown between texts of benediction.
89. The national gods (often called Nile gods), with robust limbs and pendant breasts, on their heads the plant symbols of Lower Egypt (papyrus) and Upper Egypt (lily), as representatives of Horus and Seth tie the respective plants round the hieroglyph meaning 'unite'. On the top of the latter the name of the king.

90–92. *Shrine of King Sesostris I at Karnak.* Limestone.
By utilizing the old, relief-covered limestone blocks which were subsequently used as filling in the pylon of King Amenophis III at Karnak, it was possible to reconstruct this processional temple. It was dedicated to the god Amun, identified with the ithyphallic god of fertility Min, and formed part of the sanctuary erected in honour of this god at Karnak. Flights of shallow steps on either side lead up to the interior, in which the sacred bark with the figure of the god was deposited. This building was probably erected on the occasion of the king's jubilee. Among the interesting texts on the walls are lists of the nomes of Egypt with details of their areas, towns and gods; these lists are on the north and south sides of the base. The disappearance of almost all Twelfth Dynasty religious buildings makes this reconstruction, carried out by Henri Chevrier after careful research, all the more valuable.
92. Sesostris I Kheperkare is conducted by Atum, the ancient god of the universe, who turns back towards the king to present him with life, into the presence of the ithyphallic chief god of ancient Thebes—Amen-Kamutef, the 'bull of his mother'. Above, as protecting divinities of Egypt, hover the vulture and the falcon, with symbols of life in their talons. The hieroglyphic inscriptions, beautifully carved in high relief, comprise, in addition to the description of the chief subject, the titles and names of the king and prayers for his well-being.

93–97. *Pillar from the jubilee-building of Sesostris I at Karnak.* Height 132 inches. Cairo Museum.

This damaged pillar, of which two sides are here reproduced, comes from a temple erected on the occasion of a jubilee by Sesostris I in the sacred zone of Karnak. Fragments of its blocks were later utilized by Tuthmosis I to fill in the ground in one of his courts at Karnak. In quality of relief-work and beauty of execution these figured reliefs are on a par with those in the king's shrine (Plates 90–92).

94, 95. *Hieroglyphs on the upper part of the pillar.*
In the rectangle beneath the falcon and the erect head and neck of the snake, the king's Horus name: 'Ankh-mesut' ('Life of births'), then, reading from top to bottom, other titles such as: 'Nesu bity' ('King of Upper and Lower Egypt'), 'Nuter Nefer' ('The good god'), 'Neb taui' ('Lord of the two lands'), and, placed as usual in a cartouche, his throne name 'Kheper-ka-re', which means more or less: 'Created (Kheper = to become, to come into existence) is the essential force (Ka) of the sun god (Re)'. Above, falcon and vulture hover as protecting divinities of the two countries. Other inscriptions express the hope that the ruler will be blessed with life (Ankh), endurance (Djed), good fortune (Uas) and health (Seneb), like the sun-god for all eternity.

96. *King Sesostris I and the god Atum.*

97. *King Sesostris I and the god Ptah.*
The features of the king and of the god are identical. Ptah, who was originally a Memphite god but was also revered throughout the country, together with the local divinities, as the creator of all things and god of the arts, has the compact shape characteristic not only of him, but also of the gods Osiris, Min and Khons. The king grasps his head and shares with him the breath of life. This silent, proud companionship of god and king, as expressed by Egyptian art, has a noteworthy dignity.

———

98, 99. *Princess Senui.* Grey granite. Height 66 inches. Boston, Museum of Fine Arts, No. 14.720.
From Kerma, in Nubia, where Senui's husband, Prince Hepdjefai of Siut, was governor during the reign of Sesostris I. This princess of an old and respected family is clad in a simple long robe and is holding a flower in her right hand. The high quality of the sculpture points to its having been carved in the court workshops in the capital, whence it must have been sent to the governor of this important southern outpost as a mark of special favour.

100, 101, Colour Plate XIII. *Rock-tombs of the nomarchs of the Twelfth Dynasty in Aswan.*

100. *Rock-tomb of Prince Sirenput I, son of Sat-tjeni, at Aswan.*
The prince governed Elephantine during the reign of Sesostris I. The photograph shows the court and the façade of the tomb. On six columns supporting the roof of a hall, there were inscriptions and portraits of the occupant of the tomb. To the left of the door, on the back wall, a large figure of the deceased, followed by his servant carrying his

sandals, and two dogs; next, cattle being led before the prince, who is spearing fish from a boat. On the right of the door, the deceased seen from behind, with his three sons behind him; above, women with flowers in a small pillared court.

101, Colour Plate XIII. *In the tomb of Prince Sirenput II, son of Satet-hotep, at Aswan.*
The occupant of the tomb was a contemporary of King Ammenemes II. In the foreground of the tomb was an undecorated pillared court, in which, on the right, stood the granite sacrificial altar. Further on there was a corridor with three niches on each side, in each of which, hewn out of the rock, was a statue of the deceased in the form of the mummified Osiris. At the end of the corridor, a small room with four columns and a niche, each of the back and side walls containing family scenes (in the middle, the deceased with his son (XIII); on the right, with his mother, Satet-hotep; on the left, with his son and wife).

XIII. Middle scene of the niche: Sirenput is sitting on a chair with lion's legs and stretches out his left hand towards the offerings which have been brought to him. Opposite him, his son with flowers. In the inscription, the name of the king enclosed within a cartouche.

———

102. *Nofret, wife of King Sesostris II* (1897–1879 B.C.). From Tanis. Dark granite. Twelfth Dynasty. Height 63½ inches. Cairo Museum, No. 382.
The queen is sitting on a block-shaped throne with a low back. On her breast she is wearing a very lightly engraved piece of jewellery. The tightly fitting long garment, held up by shoulder-straps, makes the upper part of the body appear almost naked; but it envelops the legs in such a way that the lower part of the body becomes integrated into the block-like structure of the statue and the contours of that part of the body are barely perceptible. The heavy wig with the head of the uraeus-serpent creates an almost too bulky frame for the delicate features of the face. The eyes were inlaid. The inscriptions down the side of the throne and on its base give the title and name of the queen.

103. *Statue of the governor Khema.* Granite. Twelfth Dynasty. Height 45 inches. Aswan, Museum on Elephantine Island.
The picture shows the prince sitting authoritatively on his simple, antique stool. His wig is of medium length and he is wearing a long loin-cloth. The artistic perfection of this statue puts it in a class with those of the contemporary kings. Engraved on the side of the stool is a prayer for the dead addressed to Anubis and also a statement that the statue is a gift from Khema's son, Sirenput.

MONUMENTS FROM THE TIME OF KING SESOSTRIS III

104–106. *King Sesostris III at the feast of jubilee.* Limestone with traces of colouring. Cairo Museum, No. 56497.
From Medamûd near Karnak. Door-lintel from a building erected in the area of the temple of the god Month for a jubilee festival (Egyptian: Heb-sed). The king, clad in jubilee robes—wearing, on the right, the crown of Upper

Egypt, on the left, that of Lower Egypt—is seated on his throne in a lightly-built chapel (Plate 106), while the symbols, with human arms, of the ancient capitals of Upper and Lower Egypt—on the left, Behdet (Damanhur); on the right, Nubt (Ombos)—offer him signs signifying countless years of rule. From the bent arms of the symbols

for the capitals hang hieroglyphic numerals, the values of which increase according to their height, thus giving exaggerated expression to the wishes for the length of the monarch's reign. Below, on the left, the god Amun of Thebes; on the right, the falcon-headed god Month of Hermonthis, but here described as 'lord of Thebes, visiting Medamûd', bringing wishes for 'all life and good fortune' to the newly enthroned king. Above, beneath the star-spangled sky, the disk of the sun, encircled with snakes, spreads its wings. Enframed in cartouches, the actual name of the king, Sesostris (=man of the goddess Usret—'the strong'), and his throne name, Khakaure ('Rising of the essential forces of the sun god').

Colour Plate XIV. *Three Twelfth Dynasty pectorals.*

These pectorals are amongst the most beautiful and valuable examples of goldsmiths' work dating from the Twelfth Dynasty. They were discovered in the tombs of the Princesses Sit-Hathor and Meret in Dahshûr, near the pyramids of King Sesostris III.

XIV upper. *Pectoral with cartouche and the name of King Sesostris II (Khakheperre).* From the tomb of Princess Sit-Hathor. Height 2 inches. Cairo Museum, No. 52001.

The gold base shows small pieces of coloured semi-precious stones inlaid in cloisons soldered on. On both sides of the name of King Sesostris II stand two royal falcons above the sign for 'gold'. Above the king's cartouche the symbol for God appears three times on the offering-mat sign. This row of signs which forms the centre of the piece may be read as 'May the Gods be satisfied with King Khakheperre'. Artistic clarity and simplicity distinguish this noble piece of jewellery.

XIV middle and lower. *Two pectorals from the tomb of Princess Meret.* Found by J. de Morgan in 1894. Heights 2½ and 2¾ inches respectively. Cairo Museum, Nos. 52002, 52003.

XIV middle. *Pectoral with the name of King Sesostris III.* Small, coloured, semi-precious stones are again set in the cloisons which are soldered on to the gold base. This pectoral was worn—as were the others shown here—on a necklace made of semi-precious stones. Taken as a whole the pectoral represents a chapel, the top of which is in the form of a cavetto cornice. This cornice is supported at each end by the flower of a water-lily; from each stem arises a second bloom which is turned towards the centre. As in the piece above, the centre of the pectoral is taken up by the cartouche containing the king's name, in this case Khakaure Sesostris III; above it hovers the vulture-goddess Nekhbet with her wings spread out. The cartouche with the king's name is carried by the front paws of two royal griffins; their heads are those of the God Horus bearing tall feather-crowns. Each griffin crushes a conquered opponent under foot.

XIV below. *Pectoral with the name of King Ammenemes III.* The goldsmith's work and the inlaid precious stones are the same as in the two pieces above. The pectoral as a whole again depicts a chapel. As in the middle pectoral the vulture goddess Nekhbet hovers with out-spread wings above the name of the King Nymare Ammenemes III.

Additional hieroglyphs disturb the clarity of the arrangement. The goddess has the adjuncts 'lady of heaven, mistress of the Two Lands', and the king's name is supplemented with the title 'the good god, lord of the Two Lands, who smites all foreign lands'. The symbolism of victory is also supplemented by words. Taking the place of the griffins in the pectoral of King Sesostris III, the ruler himself is depicted here conquering the foe. The names of the hostile nations are inserted into the free spaces.

107–110. *Statues of King Sesostris III.*

There are over 30 heads of King Sesostris which have come down to us in various states of preservation. They represent the fundamental change in style which took place in the period of approximately 120 years between the early part of the Twelfth Dynasty and the reign of King Sesostris III. An excellent portrait from the early period is that of Sesostris I (Plate 87). We can see how the change of spirit during that time influenced the people, their thinking and their artistic outlook. In place of the solid cubic structures of the heads of the early Twelfth Dynasty kings, we now find in the statue of Sesostris III a face with movement in all parts. This change shows how near the artists had got to nature, and how they were trying to express spirit and life in their portraits. Finally, light and shadow are used to illuminate the soul of the subject. No other collection of royal portraits from ancient Egypt reflects, as these of King Sesostris III do, the human element, the full weight of a kings' dignity and even his innermost feelings.

107. *King Sesostris III.* Black granite. From Deir el-Bahri. Temple of Mentuhotep Nebhepetre. Height of part still preserved, about 58 inches. Cairo Museum, No. 18/4/22/4. The king, with signs of ageing round the eyes and wrinkles above the root of his nose, lays his hands flat on his royal kilt which is narrowly pleated. On his chest the king wears a talisman hanging on a chain made of tube-shaped beads. Amulets were often shown worn by kings of the Twelfth Dynasty and this custom persisted into the Thirteenth Dynasty. This statue is the oldest example of its kind effectively executed in the round; the attitude is generally assumed to be one of prayer, as W. Wolf has pointed out: 'This is an attitude of prayer in which the king, even if not without being self-conscious, submits humbly to the will of the gods, entrusting himself and the State to their care. The gods stand above the kings and the State they represent; they can withdraw their good will from both. God, king and State are no longer an entity, and the kingdom had become in practice, if not in theory, a temporal institution. Having lost its religious hold it required a heroic effort from all the kings' supporters to make good this loss with increasing political power. This monumental sculpture serves not only to testify to this change and to make the nation aware of it, but also to give the State an air of reality which could be established in the minds of the people. Hence its significance was transferred from the religious to the political plane.'

This work was found together with five other statues of King Sesostris III (two of them without heads) at Deir el-Bahri. There Sesostris III had erected a temple for the

cult of Nebhepetre Mentuhotep II, the uniter of the two kingdoms, and also set up monuments to himself.

108. *King Sesostris III*. Brown slate. Height 3¾ inches. Berlin, Staatliche Museen, No. 20175.
The upper part of the uraeus-serpent's body reaches down to the king's headband. This also applies to a small head of Aswan granite (Berlin, No. 9526) which depicts Sesostris III with the crown of Upper Egypt; a further example is a head in the Kunsthistorisches Museum in Vienna (No. 5813). This characteristic feature links together these three magnificent sculptures which perhaps originated in the same workshop.

109. *King Sesostris III*. Fragment of a head. Obsidian. Height 4 inches. Lisbon, C. S. Gulbenkian Collection.
Original provenance unknown. This deservedly famous head represents, I feel sure, Sesostris III and not, as is generally assumed, his son and successor Ammenemes III. The expression of the face cannot be adequately described. If the royal head-dress with the series of triple lines typical of the mature Twelfth Dynasty did not prove that this is an Egyptian king, one might well believe that it was the head of a Renaissance pope. In the sculptural mastery of the material, this little head of volcanic glass is also an outstanding masterpiece.

110. *King Sesostris III*. Dark-grey granite. Height of whole statue, 66 inches. Cairo Museum, No. 32639.
From Medamûd near Karnak. On the breast is an amulet, hanging from a necklace of beads of various shapes. The arms and parts of the legs have been restored.

———

111. *Sphinx of King Sesostris III*. Diorite. Height 17 inches, length 29 inches. New York, Metropolitan Museum of Art. No. 17.9.2.
On the chest is the king's name. The lion's body is of the characteristic shape, but the face of the ruler is surprising in its highly individual effect as portraiture.

112, 113. *The official Khertihotep*. Brown, crystalline sandstone. From the neighbourhood of Asyut. Height 30 inches. Berlin, Staatliche Museen, No. 15700.
This seated statue, which is completely undamaged, is one of the best examples in Egyptian art of a private sculpture. It is certainly the most important example of a seated statute of a subject wearing a cloak; it dates from the Middle Kingdom. There are no inscriptions either on the base or on the seat. The subject is wrapped in a long cloak as was the fashion at that time. The right hand holding the coat gives the impression that the subject wishes to withdraw within himself. Down to the feet a bold, firm rhythm determines the composition: here is the zenith of the sculpture of a whole culture. The head shows great plastic liveliness which is underlined by the clarity of the look in his eyes under the heavy lids and by the nose and mouth with its lips drooping at the corners. W. Wolf has remarked: 'An ethically humane trait has entered the face, a trait which we have also met in the royal sculpture (in the case of Sesostris III), and which represents the really decisive change from the artistic representations of the Old Kingdom.'
The date of the statue has been given by some authorities as the early Twelfth Dynasty, but it really belongs to the late Twelfth Dynasty and was probably executed towards the end of the reign of King Sesostris III.

MONUMENTS FROM THE TIME OF KING AMMENEMES III

114–116. *Statues of King Ammenemes III.*

114, 115. *King Ammenemes III*. Hard, yellowish limestone. Height 63 inches. Cairo Museum, No. 385.
This statue, which must certainly come from the funerary temple of this king, was found during the construction of a canal at Hawâra—the site of the 'Labyrinth' mentioned by old writers and of the royal pyramids pertaining thereto —in the Faiyum. With its refined, quietly severe solemnity, this wonderful life-size statue is one of the most important portraits of kings that ancient Egypt has bequeathed to us. On the breast, an amulet peculiar to this period hangs from a bead necklace. The size of the ears is noteworthy and probably due to deliberate artistic intention.

116. *Gigantic head*. Grey granite. From Bubastis. Height 30 inches. Cairo Museum, No. 383.
Monumental but equally impressive are the two grey coarse-grained 'colossal heads' from Bubastis; one of these is in Cairo and the other in London (No. 1063). They may have belonged to two 'colossal statues' of King Ammenemes III—that is to say to monuments like the over life-size statues from Tanis, of which good examples are the two black granite statues showing the Thirteenth

Dynasty King Mermesha seated, which are now in the museum at Cairo (Nos. 37466–7); they are nearly twelve feet high.
The eyes in the Cairo head were inlaid and had lashes made of metal. This important head like its counterpart in London, in its tendency towards stylization, foreshadows the characteristic style of the Thirteenth Dynasty.

———

117. *Maned sphinx of King Ammenemes III*. Black granite. Length 72 inches. Cairo Museum, No. 393.
From Tanis. This is the only one out of a total of four sphinxes of similar type found at the same place, of which the body is undamaged. The upper part of the head, the ears and parts of the face have been restored (cf. Plate 118 for properly restored ears). The strikingly large inscription on the high pedestal dates from the time of Ramesses II and gives his royal title and name. On the shoulder are traces of an obliterated king's name of the Hyksos period. The tense, concentrated strength of the body-lines is in conformity with the spirit of the time in which this sphinx was created.

118, 119. *Maned sphinx of King Ammenemes III*. Greyish-

black granite. Height of the sphinx about 39 inches, length nearly 80 inches. Cairo Museum, No. 394.

From Tanis. Of the four sphinxes found there this has the best-preserved features. In this special kind of sphinx, the face of the monarch is not, as is usual, enframed in the royal hood, but in the actual hair, formally stylized, of the lion's mane. According to Heinrich Schäfer 'only an artist of the first rank could have taken such a risk and, by combining a lion-framed human face with an actual lion body, successfully achieved such a monumental, unforgettable result'. Towards the end of the New Kingdom, a monarch had his title and name carved on the breast.

120, 121. *Ka-statue of King Hor in its shrine*. Wood. Height 70 inches. Cairo Museum, No. 259.

From the tomb of this otherwise unknown king in the southern brick pyramid at Dahshûr. As the pair of arms on the top of the head shows, the statue represents the immortal essence (Ka) of the ruler incorporated in his body. The now naked body formerly wore a girdle and apron of a different material. The eyes are of quartz, alabaster and other substances and, as usual, are embedded in a bronze surround. The hands once clasped great sceptre staffs. This impressive statue now lacks the layer of painted stucco which once covered it.

SECOND INTERMEDIATE PERIOD

THIRTEENTH TO SEVENTEENTH DYNASTIES · 1786–1552 B.C.

In the Thirteenth Dynasty (1786–1633 B.C.) innumerable kings reigned: the more prominent, who are also immortalized by large and impressive statues, include *Sobkhotep*, *Mermeshau* (=General) and *Neferhotep*. In both parts of the country, buildings too are ascribed to them. Monarchs changed so often that at this juncture continuity of the State depended on the administration rather than on the ruling house. Side by side with the Thirteenth Dynasty, a so-called Fourteenth Dynasty was ruling in the western part of the Delta.

The designation 'Hyksos Period' given to the following epoch originates in the assumed 'invasion' of peoples called Hyksos at that time. The name means 'princes of foreign countries', and was used in Egypt from the Twelfth Dynasty onwards for Asian rulers. Their rule was probably not a result of a powerful invasion of the country, but the breakdown of Egypt's unity and the decline of central political power gave the opportunity to the racially mixed tribes who had been driven from their original settlements to occupy the Delta and to establish separate states.

There were two Hyksos dynasties; the Fifteenth Dynasty embraces the so-called Great Hyksos: Seuserenre Khyan, Auserre, Apophis, Nebkhepeshre Apophis, Asehre and Aqenenre Apophis. They resided at Avaris in the north-east Delta. Side by side with them ruled the dynasty of the so-called Lesser Hyksos which is regarded as the Sixteenth Dynasty. In fact it is probable that, at some stage, all four dynasties (i.e. the Thirteenth to the Sixteenth) ruled side by side. Under the sovereignty of the Hyksos at Avaris, Egypt consisted of several vassal states. One of these states was at Thebes, and its rulers were the precursors of the subsequent Seventeenth Dynasty. After 1600 B.C. they began the fight against the Hyksos and their Egyptian and foreign vassals. Their last king, Kamose, penetrated to the Hyksos residence at Avaris. His brother and successor, Amosis, links the Seventeenth with the Eighteenth Dynasty.

THE NEW KINGDOM

Despite all the destruction of its ancient monuments, the landscape once dominated by Thebes of the hundred gates—its ancient Egyptian name was Weset—is nevertheless the real scene of the achievements of those generations who, after driving out the foreign rulers, extended the boundaries of the country and thus made Egypt a world power, and inaugurated a third golden age of their national civilization. Just as the Giza pyramid cemetery to us today represents the Old Kingdom, so does the world of monuments in and around Thebes conjure up before our eyes the New Kingdom: the age of enterprising, warlike kings, of the extension of Egyptian territory as far as the upper Euphrates, of the development in many directions of all the native creative forces. It was not until the Egyptians, by their conquests of Middle Eastern countries which had already reached the stage of a highly developed, conscious urban civilization and by the resulting need to enter world politics, had gained experience that their talents came to full maturity and to the highest possible degree of realization. Nowhere in the Nile Valley does the student of history see this so clearly as among the pillared halls, the temple courts and the cemeteries of Thebes, once a world-famous city full of pomp and glitter, whose ultimate fate the prophet Nahum predicted would also be that of the hated Assyrian city of Nineveh:

'Art thou better than populous No, that was situate among the rivers, that had the waters round about it, whose rampart was the sea, and her wall was from the sea? Ethiopia and Egypt were her strength, and it was infinite, Put and Lubim were thy helpers. Yet was she carried away, she went into captivity; her young children also were dashed in pieces at the top of all the streets; and they cast lots for her honourable men, and all her great men were bound in chains.'

As we wander through the immense ruins, we are reminded on every side not only of the conquest and sacking of Thebes by the cruel hordes of Assurbanipal, but also of later tribulations at the hands of Roman soldiers sent to suppress risings or of the fanatical followers of new faiths. Indeed, at times we cannot help thinking that the forces employed to achieve this mighty work of destruction were as great as those which contrived to erect this gigantic stone world, almost oppressive in its massiveness and power of effect, to the glory of their gods and kings.

From the early days of religious architecture under the New Kingdom, there has been preserved a small temple, restored in modern times, from the reign of Amenophis I, in the precincts of the Amun temple near the modern village of Karnak. The earliest large structure of the Eighteenth Dynasty is the terrace temple which Queen Hatshepsut, about 1490 B.C., had built by her gifted favourite Senenmut, in the Theban necropolis at the foot of the western cliffs of the rocky bay at Deir el-Bahri. This grandly conceived structure, with its direct appeal to modern taste, and the sculptured ornamentation, fascinating in the play of its sparkling colours, produce upon the modern beholder an impression of uplifting and gay harmony, such as is revealed only very exceptionally by architectural monuments of the New Kingdom. In its musical charm there is a regal feminine element, the fascination of which was not dispelled by the destructive efforts of the queen's bitter rival, Tuthmosis III.

This doughty conqueror and surprisingly able practical politician among the Pharaohs of the New Kingdom left numerous monuments to his triumphs in the older part of the Karnak temple area. The mighty transverse structure of his stone festival pavilion near the old sanctuary bears witness to his military and diplomatic successes in Palestine and Syria as eloquently as do the walls and columns of his halls of annals and the sweeping contours showing the monarch slaying his arch-enemies on the walls of his two pylons. A still greater tribute than the buildings commemorating victories or conquests are the sober and factual descriptions of his campaigns carved on the stone walls of the chambers.

The fruitful age of Amenophis III is commemorated not only by the colossal 'Memnon statues', which are the only relics of his funerary temple, but also, and in a far more noble manner, by that most solemn of all Theban temples which stands in the middle of Luxor on the Nile promenade. The nobility of its lofty columns, the solemnity of its broad second court and of the sacred chambers decorated with reliefs, leaves a lasting impression on the

mind and makes us regret even more the destruction of the funerary temple and palace of this splendour-loving monarch, which once stood on the west side of Thebes, close to the edge of the cultivated zone.

Where relics of that time are still found, they impress us with the dignity of their conception and the skill of their execution. Though they may lack the energy and freshness of early Tuthmosid works, they nevertheless reveal the assurance and self-confidence of a proud and socially progressive community. Nowhere is this more convincingly expressed than in the rock-tombs of the great men of the time—for example in the tombs of Khaemhet, Kheruef and Ramose.

From the reign of Amenophis IV, the later Akhnaton, the wanderer through the ruins of Thebes will find no monumental relics. The remains of his sun-sanctuary to the east of Karnak can barely be traced amidst the sand; after the fall of the Aton rulers, King Horemheb used most of the masonry for his own two pylons, which have partially collapsed, on the way from the great Amun temple to the temple of the goddess Mut. Of the gigantic statues of the heretic king, the best preserved have been removed from the ruined court of the temple to the Museum of Antiquities in Cairo.

With the exception of the terrace sanctuary at Deir el-Bahri, the festival temple of Tuthmosis III and the Luxor temple, the most notable large buildings in Thebes date in almost every case from the Nineteenth and Twentieth Dynasties. Lovers of ancient Egypt cannot help regretting that in particular the celebrated Ramesses II, in his zeal for building, never lost an opportunity of imprinting his own image on older sacred buildings by adding a court in front of them, or at least by covering them with his own inscriptions and statues. His exaggerated self-consciousness of his status as god-king frequently pushes into the background, in a most uncalled-for way, the more delicate and tranquil elements, even if it does not completely suppress them. Many of those who pay

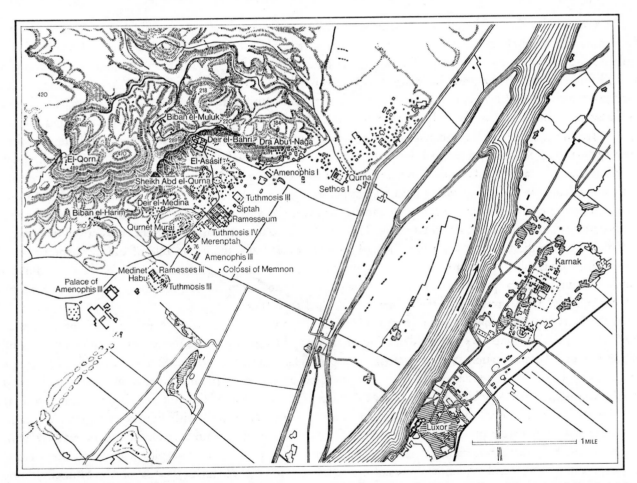

FIG. 26. Plan of Thebes. On the east bank of the Nile, Karnak and the modern town of Luxor; on the west bank, bordering on the cultivated zone, the necropolis. For the sake of clarity, only the names of the monarchs are shown alongside their funerary temples; Biban el-Harim=Valley of the Queens' Tombs; Biban el-Muluk=Valley of the Kings' Tombs. Near the modern villages of Qurnet Murai, Deir el-Medina, Sheikh Abd el-Qurna, El-Asasif and Dra Abu'l-Naga lie the most important cemeteries.

a flying visit to the so-called chief sights of the Nile Valley will carry home with them the wrong impression that in the achievements of the Ramesside epoch, with its squandering of material and labour, they have seen the most notable relics of the New Kingdom.

The will of the ruler—however popular the figure of the ruler may be—cannot put too great a strain on the national labour potential without paying the penalty. Nevertheless, however unsatisfactory the proportions of the various architectural components, however discordant the colossal statues of kings reduced to decorative elements empty of content, we must not let ourselves be blind to the grandiose effects produced by this exaggeration of will and achievement. The very obviousness of the presentation has a peculiar pathos. Whatever misgivings we may nourish in our hearts, it is a thrilling, unforgettable experience to penetrate into the forest of columns in the enormous hall of the Karnak basilica, to find ourselves face to face with the mighty pillar statues of the deified pharaoh in the Ramesseum on the west bank, to feel, when we examine the walls of the well-preserved temple at Medinet Habu, in the building of which Ramesses III sought to rival his predecessor of the same name, whose influence was still strong, the reflexes of a historical period which has retained its greatness, or to find, preserved in the tomb of Sethos I, an abundance of coloured representations, in which the badly restored walls of the funerary temple near Qurna are lacking. The image of ancient Thebes would be incomplete without this extreme realization of all that was materially possible, under the sway of those strong-willed co-ordinators and consummators who are so often granted to great civilizations in the evening of their national history. But we must not take their world of monuments—still strikingly noble under Sethos I, but aiming rather at external effect and exaggerated demonstration of power under Ramesses II and III—as a yardstick for measuring the values of the artistic achievement of Ancient Egypt which in reality underwent constant transformation over three thousand years.

The visitor who tires of temple halls, pillared corridors and gigantic statues, should betake himself alone to the tombs in the lonely cemeteries at the foot of the western hills. There, where the painter's brush so often replaced the sculptor's chisel, because the unsuitable nature of the limestone made sculptural relief impossible, he will find that which the great buildings could not offer him and that which alone makes the ancient world lovable—the charm and fascination of private existence, the intimacy of the family circle, festive social gatherings to the accompaniment of songs and the music of lutes, delicately limbed girls with antelope eyes and budding breasts beneath the folds of their semi-transparent robes, dancers, sowers, reapers, worshippers offering thanks to their god—expressed like a prayer with intimate and often very personal piety—and finally all that which, despite the contrast, is also a part of life—the funeral procession to the site of the 'eternal dwellings', the age-old lamentations and solemn rites of the mummy placed erect before the entrance to the tomb. And then the visitor should go to the lower end of the royal necropolis and let his eye rove over that site of which the history has at times been stranger than poetical fancy could imagine. He can enter the gates and corridors of that mysterious underworld in which the mightiest rulers of the New Kingdom were buried and finally, in one of the most modest of all these tombs once filled with treasures, gaze upon the peaceful image, glittering with gold, of the Pharaoh Tutankhamun, as he was just after he died—that magnificent outer coffin, which, the last treasure left in his tomb, still contains the mortal remains of the monarch who died so young.

Of the New Kingdom buildings and tombs scattered about in the Nile Valley between north of Thebes and the Sudan, some are rightly considered deserving of attention in view of their effectiveness or the unusual beauty of their artistic ornamentation. Two sanctuaries are particularly interesting: the temple erected by Sethos I on an ancient holy site at Abydos and subsequently completed by Ramesses II, and the equally famous rock temple at Abu Simbel in Nubia, which Ramesses II's stonemasons carved out of the cliff fringing the valley near the bank of the Nile. The cycle of reliefs at Abydos, covering wall after wall with figures of which the original colouring has been partly preserved, is somewhat formal in character, with a coolness and objectivity which might almost be called academic, but one can never agree with those eminent critics who count them among the best created by ancient Egyptian sculptors of bas-reliefs. On the other hand, in the case of Abu Simbel, although masses of natural rock were removed by herculean labour in the carving of the seated giants on the temple façade and the colossal statues in the hypostyle hall, yet our reservations regarding this questionable attempt to rival the natural scenery of mountains disappear and give way to an emotion evoked by more than a sense of

history when we pass in front of each of the giants and go through the lofty portal, dominated by the falcon-headed sun-god in his niche. That which in other Nubian temples of Ramesses II, some of them likewise hewn out of the rock—Beit el-Wali, Gerf Husein, Es-Sebua and Ed-Derr—needs the support of the landscape and often disappoints because it is the work of provincial craftsmen, has here in the extreme south achieved a grandiose effectiveness, grandiose down to the sweep of the flowing contours of the reliefs.

EIGHTEENTH DYNASTY · 1552–1306 B.C.

EIGHTEENTH DYNASTY: FIRST PHASE · 1552–1436 B.C.

Kings: *Amosis* (1552–1527 B.C.), *Amenophis* (*Amenhotep*) *I* (1527–1506 B.C.), *Tuthmosis I* (1506–1494 B.C.), *Tuthmosis II* (1494–1490 B.C.), *Hatshepsut* (1490–1468 B.C.), *Tuthmosis III* (1490–1436 B.C.).

Under the last rulers of the Theban Seventeenth Dynasty (Seqenenre Tao I and II, Kamose, Amosis) began the struggle for freedom which ended with the expulsion and pursuit of the Hyksos and the re-establishment of the kingdom of Egypt. The consequences of this for the country, its policies and culture were immense. Kingship presents us with a new image, strongly personal in colour.

In the last phase of the expulsion of the Hyksos it was King Amosis (1552–1527 B.C.), the brother of Kamose, last ruler of the Seventeenth Dynasty, who succeeded in seizing Avaris, the stronghold of the Hyksos in the lower Nile Delta. After his death his son Amenophis I (1527–1506 B.C.) crossed the Egyptian borders as far as southern Palestine. Even by the beginning of his reign, the country he had inherited was united and strong. His father had already extended the borders of Egypt to the south and north. Like his mother, Ahmes Nefertari, Amenophis too was later deified. It was he, moreover, who was the first king to separate the mortuary chapel from the tomb and build the first funerary temple in the region of the Theban necropolis; but his tomb itself lay hidden in the mountains beyond, though not in the actual Valley of the Tombs of the Kings. His son Tuthmosis I (1506–1494 B.C.) in his campaigns reached the Third Cataract in the south and, in the north, was the first Egyptian Pharaoh to reach the Euphrates. By his marriage with Mutnofret he had a son, Tuthmosis II (1494–1490 B.C.), and, by a later marriage with Ahmes, a daughter, Hatshepsut (1490–1468 B.C.).

The kingdom in the early part of the Eighteenth Dynasty had in the meantime grown more powerful and larger. Two personalities emerged now on the scene: Queen Hatshepsut and King Tuthmosis III. Completely opposed to each other in their political outlook, both pursued their aims with equally tireless energy, even though in opposite directions, inspired by their belief in a high vocation through their divinity and from a feeling of the deepest dedication to their state.

The struggle for power between Hatshepsut and Tuthmosis III must be attributed not only to the self-assertion of the two rulers (which was characteristic of the period), but also to the personal differences between them. Hatshepsut had been sister and wife of Tuthmosis II, but her short marriage to him had produced no male heir. Tuthmosis III was a son of the same king, but only by a lesser wife; though indeed later he married the only daughter of the marriage of Tuthmosis II with Hatshepsut. After the death of Tuthmosis II the widowed Queen Hatshepsut acted as regent for her stepson and nephew, later Tuthmosis III, as he was still under age, but she pursued her own political aims. In contrast to the 'expansionist' policy of her time, she endeavoured to follow a comparatively conservative course, modelling herself on the pattern of the great kings of the Middle Kingdom. In order to realize her intention to rule, she declared herself Pharaoh, and used her advisers, in particular the Chancellor Senenmut, who, however, fell out of favour towards the end of her reign. Whether Tuthmosis III waited for her death, or caused it, is uncertain. In any event after her death he destroyed memorials to her everywhere, and added her years of ruling to his own reign.

Tuthmosis III now proceeded to carry out the so-called expansionist policy with great vigour. In fact, he was now forced to react to the world political situation; since the time of the Hyksos Egypt, Palestine, Syria,

Mesopotamia and Asia Minor had formed a single, politically interrelated world, from which no country could any longer withdraw. The conquests—to the south as far as the Fourth Cataract, and to the north, where the Euphrates had been reached and crossed repeatedly—had resulted in the creation of a fixed political position for the Egyptian kingdom in this world. In seventeen campaigns Tuthmosis III, as brave a general as he was a tenacious one, laid the foundations of Egypt's supremacy for a century. In internal affairs the new situation had far-reaching consequences: chariot troops and a standing army created a new social class. Along with foreign soldiers, workers and women, strange material and, no less important, new ideas were introduced and assimilated, leading to a new blossoming of Egyptian culture.

Of buildings of the early Eighteenth Dynasty, there have been preserved from the time of Amenophis I only the remains of his funerary temple at Thebes (near Dra Abu'l-Naga) and the alabaster sanctuary at Karnak (Plates 123–125), while from the time of Tuthmosis I we have only the remains of his buildings at Karnak (Plate 126 and note). A first great flowering of architecture and the formative arts began under Queen Hatshepsut, among whose buildings the terrace temple in Thebes (Deir el-Bahri) (Colour Plates XV, XVI, Plates 127–131) takes first place. Under Tuthmosis III the artistic decoration of this temple was completed (though it is true that this was accompanied by the destruction of pictures and statues of Hatshepsut). We shall return to this king's buildings at Karnak (Plates 136–139), when we discuss the temple zone in that city. Of particular interest in the history of architecture are the small, peripteral temples of Hatshepsut and Tuthmosis III at Medinet Habu (Figs. 29, 68) and that of Tuthmosis III at Karnak (Fig. 57), as they anticipate to a certain extent the usual form of the Greek temple.

MONUMENTS FROM THE TIME OF KING AMENOPHIS I (1527–1506 B.C.) AND KING TUTHMOSIS I (1506–1494 B.C.)

122. *Alabaster sphinx on the site of the Ptah Temple at Memphis.* Height 13 feet, length 26 feet.
Erected where it was discovered, in the palm-grove near the village of Mit Rahina; in 1953 it was provided with a new base. The work was long held to date from the time of Ramesses II, but stylistic features justify its attribution to the early Eighteenth Dynasty.

123–125. *Karnak. Shrine for the bark of Amun, erected by Amenophis I.*
Of the many colonnades and pillared halls which the kings of the early Eighteenth Dynasty built at Karnak, it is fortunate that the little alabaster chapel, dating from the time of King Amenophis I, has survived. It is 23 feet long, and is decorated with reliefs on the outside and inside.

123. This alabaster chapel with its severe lines was re-erected by utilizing fragments which had been built into the third pylon and stands near the similarly re-erected bark sanctuary of Sesostris I (Plates 90–92), to the north of the great court of the temple of Amun.

124, 125. Mural relief from the interior of the shrine of Amenophis I. The royal founder of the shrine is standing before the god Amun, who bestows everlasting life upon him with a sceptre. To the right, we see Amenophis again, here wearing (for the first time in works so far dis-

covered) the so-called Blue Crown (khepresh, often incorrectly described as a 'war helmet'). The individual traits of the king's features are striking, especially the un-Egyptian, slightly hooked nose.

126. *Karnak. Temple of the imperial god Amun. Fourth pylon and obelisks of Tuthmosis I and Queen Hatshepsut.*
View towards the east from the ruined (third) pylon of Amenophis III adjoining the great hall of pillars on the east. On the right, the obelisk of Tuthmosis I, which alone has remained standing of the two in Aswan granite that he placed in front of what was then the entrance to the temple. It is over 70 feet high, its base being 6 feet square. In the centre, the dedicatory inscription of Tuthmosis I; the lateral inscriptions were added by Ramesses IV and VI, the effect being spoiled by overcrowding of the surfaces. On the left, the remains of the (fourth) pylon erected by Tuthmosis I. Behind, the one obelisk still standing of the two erected by Queen Hatshepsut, 96 feet high, base 5 feet 4 inches square. It is adorned on each of its four sides with a vertical inscription containing figured representations in the upper part, showing Hatshepsut, Tuthmosis I and III sacrificing to the god Amun. The weight of the obelisk has been calculated to be 325 tons, whereas that of Tuthmosis I weighs only about 143 tons.

MONUMENTS FROM THE TIME OF QUEEN HATSHEPSUT (1490–1468 B.C.)

Colour Plates XV, XVI, 127–131.
Terrace temple at Deir el-Bahri.

The temple of Queen Hatshepsut was dedicated to the

supreme god Amun, though parts of it were also dedicated to Hathor, Anubis and the sun-god Re-Herakhty. Last but not least, it also served for the funerary rites of the queen and her parents, Tuthmosis I and his second wife Ahmes.

In his hatred for his rival of many years' standing to the royal throne, Tuthmosis III caused portraits of Hatshepsut to be obliterated or destroyed in this temple (and also in buildings erected by the queen at Karnak and elsewhere), but there were also political reasons for this act, namely the diametrically opposed attitudes of the two rulers. The twenty-two years of Hatshepsut's regency were a time of tranquil internal development and peaceful commercial missions, but at the same time it was during these two decades that the fruits of Tuthmosis I's successes abroad, which had done so much to strengthen Egypt's position as a future world power, were lost.

An avenue of sphinxes led from the borders of the cultivated land up to the temple, which lies close to the steep cliff of the western mountain (Plate XV); it seemed to link the life of the former city of Thebes in front of it with the mysterious world of death, slumbering in the hills behind it. The avenue led to the gate of the Lower Terrace of the temple (Figs. 27, 28), which was planted with palm trees and vines. From the terrace a ramp leads up to the Middle Terrace. At the end of the ramp a colonnade stretches in both directions in front of the supporting wall of the terrace. An unfinished colonnade with chapels built in the cliff completes its north-eastern side. This is joined to the front group of colonnades, built in front of the supporting wall of a small Upper Terrace, and reached by another ramp. On both sides of this ramp lie the colonnades, which bound the Middle Terrace in the north-west. The left of these colonnades is devoted to the description of the expedition to Punt, the land of myrrh and incense (on the southern coast of the Gulf of Aden), while in the colonnade on the right (Plate 127) the reliefs have as their subject the divine procreation by Amun and the birth of the Queen Hatshepsut: these latter reliefs describe how Amun, led by Thoth, the God of Wisdom, approached the Queen Ahmes, who conceived the divine child by him; how the royal mother Ahmes (Plate 129) was led to the Birth Colonnade by the ram-headed Khnum and the frog-headed Heqet, female helper of the birth; the presentation of the divine royal child by Hathor to Amun as the supreme God; in addition there are more reliefs, which were, however, restored in the Ramesside Period.

On either side of the colonnades mentioned lie those parts of the temple dedicated to Anubis and Hathor—to the north-east, adjoining the Birth Colonnade, the chapel of Anubis hewn out of the rock (Plate 127), with a vestibule consisting of twelve sixteen-sided columns; to the south-west, adjoining the Punt Colonnade, the sanctuary of Hathor, with two oblong rooms, in which some of the round columns have capitals in the form of the head of Hathor, and beyond these the chapel itself, which consists of three rooms containing reliefs of exceptional beauty (Plate 131).

The upper terrace once had, above its supporting wall, a colonnade, now almost completely destroyed, the ceiling of which was supported by an inner row of sixteen-sided columns and an outer row of colossal statues of Hatshepsut. A granite doorway led to the adjoining great hall, with two rows of columns round its centre. Along its north-west wall were alternately larger and smaller niches, the former once containing further statues of the queen. The

holy of holies is driven deep into the rock. Adjoining the south-west corner of the great hall is the queen's funerary chapel, also driven into the rock, as are its annexes.

No better picture of the nobility of this temple can be given than that contained in the inscription on the relief showing Amun being led by Thoth to Ahmes, in the colonnade dedicated to the birth of Queen Hatshepsut:

> Then came the glorious god
> Amun himself, lord of the thrones of both lands,
> when he had taken the form of her husband,
> they found her resting in the beauty of her palace.
>
> She awoke at the perfume of the god
> and laughed in the face of his majesty.
> Enflamed with love, he hastened toward her,
> he had lost his heart to her.
>
> She could behold him
> in the shape of a god,
> when he had come near to her.
> She exulted at the sight of his beauty.
>
> His love entered into all her limbs.
> The palace was filled
> with the sweet perfumes of the god,
> all of them from the land of incense, Punt.
>
> The majesty of this god
> did to her all that he wished.
> She gladdened him with her self
> and kissed him.

Colour Plate XV. *The terrace temple of Queen Hatshepsut from the south-east.*
The temple, dedicated to the imperial god Amun, which now has been comprehensively restored, contains, as has been shown, chapels for the goddess Hathor and the god of the dead, Anubis. Other rooms were provided for the funerary rites of the ruler and of her parents, Tuthmosis I and Ahmes. The imposing group of buildings at the foot of the bare cliffs of the valley include part of the funerary temple of King Mentuhotep Nebhepetre (visible on the left of the photograph).

Colour Plate XVI. *Painted mural-relief in the colonnade in front of the Anubis chapel.*
The vulture-goddess Mut, described in the inscription as mistress of the star-spangled heaven depicted above her, holds in her talons a signet-ring, the symbol of 'countless years'. Above, in a kind of puzzle of hieroglyphs, the name of Queen Hatshepsut; above the Ka-symbols a frieze of cobras standing erect, supporting on their heads the sun's disk enframed by cows' horns. In front of the horns, alternately, the symbol of 'endurance' and that of 'life'. The pictures beneath on this part of the wall were obliterated under Tuthmosis III by blows of the chisel.

127. *Porch of the Anubis chapel and Birth Colonnade.*
View, from the northern (unfinished) colonnade, of the porch of the Anubis chapel, with its four rows each consisting of four sixteen-sided (protodoric) columns, and the Birth Colonnade, showing the first of its two rows of eleven columns.

Colour Plate XXVII. *Banqueting scenes.*
From a tomb of Nebamun (possibly No. 146) in Thebes. British Museum, Nos. 37984, 37981. Period of King Tuthmosis III or Amenophis II.

A feast is one of the subjects recorded in most of the Theban tombs of the Eighteenth Dynasty. This is a memorial meal, completely secular in its treatment, in honour of the dead at the 'Beautiful Festival of the Desert Valley'. The upper, horizontal, scene presents a detail showing four musicians, of whom one is playing a double-reed pipe, while the other three are beating time by clapping with their hands. In front of them two naked girls are dancing. The lower picture has in its upper register ladies feasting at the banquet, dressed in rich festival clothes and adorned with expensive jewellery and flowers. The lower register shows more musicians, this time with lutes, and again one with a double reed pipe. The wall-painting, only parts of which have survived, is one of the most beautiful on this subject because of the charm of its figures. The artist has made striking use of the possibilities of group composition by overlapping and arranging the figures in formation. Two of the girls are shown full face, which is exceedingly rare in Egyptian art even in this mature period. A few lines of the song sung at the dance have survived:

[Flowers of sweet] perfume given by Ptah and produced by Geb.
His beauty is in every body.
Ptah has done this with his own hands, to rejoice his heart.
The pools are freshly filled with water,
The earth brims over with love for him.

THE REIGN OF KING TUTHMOSIS IV (1412–1402 B.C.).

151, 152. *King Tuthmosis IV and his mother Queen Tio.*
Granite. Height 43 ins. Cairo Museum, No. 42080.
From Karnak. This is an unusual representation of the king, who is shown here with a roundish wig of ringlets adorned with the uraeus, and holding a symbol of life in his right hand. His left arm is round his mother, whose hair, hanging down to her breast, is covered by a vulture hood. The group as a whole has a strange appearance, with the two figures far apart from each other, compared with the closely knit groups of earlier times, particularly of the early phase.

Evidently the trend now was to focus everything on a more individual and realistic approach to design in general and to people in particular.

SCULPTURE FROM THE TIME OF KING AMENOPHIS III (1402–1364 B.C.).

153. *Queen Mutemuia chosen as wife of King Tuthmosis IV receives their first son Amenophis III from the god Amun.*
The relief is a poetic rendering of the procreation of the divine son Amenophis III by the supreme god Amun with the bride Mutemuia, the daughter of Artatama, king of the Mitanni, still a virgin, and chosen as wife of King Tuthmosis IV.

The picture shows the bridal pair, with the god Amun on the right and the future mother of the king, Mutemuia, on the left. They are seated on a couch held up by the 'protector' goddesses Selkis and Neith. The relief, better preserved than the others of the same cycle, is in the Hall of Birth of the temple of Amun-Mut-Khons at Luxor. The nineteen reliefs of the complete cycle, which are dedicated to the conception and birth of King Amenophis III and continue until his recognition as son by the divine father Amun, take up the concept of the king as the divine son, an idea which can be traced back as far even as the Old Kingdom, and which had been portrayed already in the reliefs, so important artistically, in the Birth Colonnade of the temple of Hatshepsut in Deir el-Bahri (cf. page 431 and the description of Plate 129).

The nineteen successive scenes from the reliefs, placed one above the other in three rows on the west wall of the room, portray these details:

Bottom row: Amun; Hathor embraces Mutemuia; Amun and the king; Amun in conversation with Thoth; the union of Amun with Mutemuia (Plate 153); Amun and the ram-headed god of creation Khnum; Khnum fashioning the two boys Amenophis III and his ka on the potter's wheel in the presence of Hathor.

Middle row: Thoth announcing to Mutemuia that she is to be the mother of the king; Mutemuia, very pregnant, is helped by Hathor and Khnum into the Hall of Birth; birth of the king and his ka with the aid of the divine helpers of childbirth; Amun, standing by Hathor and Mut, holds the child Amenophis III in his arms.

Top row: Two divine wet-nurses suckle the child and his ka in the presence of his mother Mutemuia and the goddess Selkis; nine goddesses hold the royal child; Heqet holds the child and his ka in her arms, the Nile god behind them; Amun receives the royal child and his ka from Horus; Khnum and Anubis; the child and his ka before Amun; the child and his ka before Seshat, the goddess of writing.

These reliefs, a good part of which is enchanting, are unfortunately not at all well preserved, nor is any attempt being made to rescue them by putting them in a protected place or at least by making good plaster casts to preserve their present condition for posterity. Yet they are of outstanding interest, artistic as well as iconographic. Through them comes the idea, widespread throughout the whole ancient world down to Alexander the Great, of the divine son of the supreme Lord—a concept which found its ultimate expression in Christian times when it was transferred to the figure of Christ.

154. *King Amenophis III and Queen Tiy* at the Third Jubilee Festival in 1366 B.C. to celebrate the 36 years of the king's reign. From the tomb of Kheruef (No. 192).

Amenophis III, on the occasion of his third jubilee festival (Heb-sed), is sitting holding a crook-shaped

sceptre and a flail, with the Blue Crown on his head, enthroned on the raised seat of a flimsy chapel, of which the roof is supported by little pillars with flower capitals. Queen Tiy, his principal wife, is sitting behind him holding a pliant queen's flail and a symbol of life, with a diadem on her head and the high feathered crown of a goddess. Her throne is richly adorned with figures: on the panel beneath the arm-rest pharaoh is shown as a lion trampling on an enemy, and between the lion-shaped legs of the throne are the conquered arch-enemies of Egypt, the Asian and the Negro, bound together by the hieroglyph meaning 'unite'. In comparison, the king's throne seems simple. The back consists of a Horus falcon embracing the ruler with its wings. On the roof is a frieze of cobras and rows of pendent grapes. The feet of the royal couple rest on box-like hassocks. Below, enframed in ovals, are the names of conquered localities; out of each oval rises the head and shoulders of a prisoner, with his hands tied behind his back. Here and there are traces of colouring.

155. *Amenophis III.* Limestone relief, almost life-size. Berlin, No. 22439.

This head, now in the possession of Berlin Museum, belongs to a relief in the tomb of Khaemhet in Thebes (No. 57), who was the overseer of the royal granaries under King Amenophis III—or, as we should say now, his Minister of Food. Like that in the tomb of Kheruef (Plate 154), this relief depicts in very delicate detail the king on his throne under a canopy. On the king's head is the beribboned Blue Crown with its uraeus snake. A double chain of gold lies over the collar on his shoulders.

156. *Amenophis III.* Gypsum. Height about 8 inches. Berlin, No. 21299.

This head would appear to be a cast, in sections, from the head of a large sculptured figure of King Amenophis III, of which we know many like this were erected in Akhetaton. The top of the head has been fashioned to take a crown. This copy, owing to its realism (although this is clearly somewhat subdued), and its original, which is no longer preserved, date back to the last years of the reign of King Akhnaton. Indeed, a quantity of works from this period have been discovered in the workshop of the sculptor Tuthmosis (cf. Plates 186–189 and the portrait-masks of Plates 190, 191).

The full shape of the head with its short neck corresponds well with other surviving likenesses of the king, who was thickset and, in his later years, obese and ponderous.

When considering the person of King Amenophis III as a whole, it may be noted in this connexion that his figure as a ruler scarcely conforms with what one might expect from the evidence of the splendid regal portraits in the tombs of Khaemhet (Plate 155) and Kheruef (Plate 154) and from the artistic brilliance of his 38 years' reign. Nevertheless his reign, after the years of Queen Hatshepsut and King Tuthmosis III, was a second peak in the development of art in the Eighteenth Dynasty and was enormously productive, especially in the field of temple and palace building, even though a large part of this has by now been completely lost.

Born in 1415 B.C., Amenophis III became king as early as 1402 B.C. on the death of his father, Tuthmosis IV, who only reigned ten years. In the second year of his reign, that is in 1401/1400 B.C., came his marriage with Tiy. She was not of royal birth, but in spite of the five Asiatic princesses whom Amenophis III had also taken as subsidiary wives, in addition to his large harem, she was always of prime importance to him in his life as a man and as a ruler.

Though Amenophis III had, as an eighteen-year-old boy, taken part in a military punitive expedition in Nubia, he was, however, in no way of a military disposition and, in contrast to his grandfather Amenophis II and his great-grandfather Tuthmosis III, he had never gone on a campaign to Asia at the head of his army. Already by the age of 25 he was withdrawing himself as much as possible from political life, in order to devote himself to building and to the enjoyment of life in general. He was able to celebrate jubilee feasts (the Sed Festival) in the thirtieth, thirty-first and thirty-sixth years of his reign, before he died in the thirty-eighth year of his reign, in 1364 B.C., aged 51.

At first his marriage with Tiy produced only daughters, of whom eight are shown in the wonderful relief in the tomb of Kheruef, dating from the year 1366 B.C., the year of the third Sed feast of King Amenophis III, where they appear celebrating this festival. At last after more than 15 years of marriage with Tiy, in about 1385 B.C., the only son, Amenophis IV, later called Akhnaton, was born. After his birth came another daughter, Baketaton ('Aton's servant'). In contrast with the names of the older princesses, which incorporate the name of Amun, the name of the youngest daughter contains reference to Aton, which shows—and there are several pointers to this—that the cult of Aton had already been celebrated before Amenophis IV (although not as the only god of the land), and that by the end of the reign of Amenophis III this cult had already taken on a more important role.

157. *Queen Tiy.*
Above: Small head in ebony and other materials. Height 4¼ inches. Berlin, No. 21834.

This small head comes from a palace at Medinet Ghurab in the Faiyum, where the old queen lived as a widow. The top and back of the head are covered by a smooth bag-shaped cap made from a whitish precious metal. Over this metal cap is laid a thin layer of stucco and linen, which was embroidered with blue pearls, of which a few still remain, representing the curls of a wig. A broad band of gold surrounds her forehead and temples. Over this there was fastened the front part of the two royal snakes, now missing, their bodies reaching down from the crown of the head. Disk-shaped ornaments of gold and lapis lazuli are in her ears. The eyeballs are inlaid black and white, the eyebrows and eyelids are made of black wood. Remnants of red colouring survive on the face. There is a spike on her head to which a feather ornament would have been fastened. The piece cut out of the neck would have fitted the upper border of a shoulder collar; the little head was in all probability fitted to a body made of some other wood. The acuteness of its characterization makes this small work a speaking witness to the artistic achievement in portraiture of the New Kingdom, particularly during

the period of the last part of Akhnaton's reign, that is during the time shortly before 1347 B.C. Comparison with authenticated busts of the queen prove this to be beyond doubt the mother of Akhnaton.

Below: Small head in steatite. Height about 2⅞ inches. Cairo Museum, No. 38257.

This little head, found in a temple in Sinai, is made from grey-green steatite and looks rather like slate. The head has two uraeus snakes, with their heads twining in the hair, and above them, set in the middle of a diadem, the name of Queen Tiy is inscribed in a cartouche. The face, with its sharply cut cheekbones, its narrow eyes and protuberant mouth, bears an unmistakable resemblance as a portrait to the very similar ebony head from Berlin described above. This face too makes an unfavourable impression because of the way in which the mouth turns down at the corners, creating a rather arrogant expression of dismissal.

As already mentioned when considering the facts relating to the character of King Amenophis III, Tiy was in no way of royal blood. Her mother Thuiu was certainly of pure Egyptian stock. Her father Yuya, about whose ancestors and place of birth nothing certain is known, under King Tuthmosis IV held the priestly office of a Prophet of Min, the God of Fertility, who was held in great respect in Upper Egypt, particularly in Coptos, modern Quft, and further afield as far as the Red Sea. After the death of King Tuthmosis IV he appears to have succeeded in becoming adviser to the Queen Regent Mutemuia, mother of the heir to the throne, Amenophis III. After the marriage of the young king, scarcely 15 years of age, in the year 1401/1400 B.C. to Tiy, who was herself barely more than ten, Yuya achieved the high post of Overseer of the King's Horses and Charioteers, or, as we should call it today, General of the Cavalry. His title of 'Mouth and Ear of the King' indicates that he was the most highly trusted adviser of the young king. Thuiu for her part is called 'the Royal Body Servant', 'She who is honoured by Hathor' and 'Royal Mother of the Great Royal Spouse'.

The position of Queen Tiy was an unusual one, which had never arisen until her day. She was the first queen whose name was included in the royal titles, even in the official documents. Her name appears even in the deeds sealing the marriage of her husband Amenophis III with the foreign princesses from Babylon and Mitanni (see page 439 above), also with a daughter of King Tarkhunda-radu of Arzawa, in Upper Cilicia. It is not known what part these Asiatic princesses played in relation to Tiy, as the premier consort of the pharaoh. They may have been highly ranking secondary wives of the king, but they are scarcely mentioned again in the official records after the festivities (important for reasons of state), which marked their reception and their marriage ceremonies. The silence of the harem seems to have embraced them, like the many hundreds of other women.

158, 159. *Amenhotep the Wise, son of Hapu.*

158. *In his youth.* Grey granite. Height 51 inches. Cairo Museum, No. 44861.
From Karnak. This sage, later revered as a god, had his own temple area in the Theban necropolis and was one of the highest officials under Amenophis III and his Overseer of Buildings. He is shown here writing, with his head bent in thought.

159. *As an old man.* Grey granite. Height 56 inches. Cairo Museum, No. 42127.
This work is modelled on a type of figure representing wise men dating from the end of the Middle Kingdom, and revived on this occasion for reasons which are not known. The features of this high-ranking adviser to the king produce a striking effect in the way they show the traits of old age.

If, as indicated above, Amenhotep the Wise was worshipped as a god, if his funerary temple in Thebes was fully comparable with the royal funerary temples, and if his statues were placed in Theban temples to serve as intercessor between god and men, this was because the Egyptians regarded persons like the wise Amenhotep as the divine personification of their ideal human. Otto explains that: 'The whole key to the Egyptian personality cult is made clear in this great man, whose life is fully authenticated in history. During the Ptolemaic Period Amenhotep the Wise, together with Imhotep the High Priest of Heliopolis and Royal Architect of Djoser, and the Greek goddess Hygieia, was worshipped as god of healing in Deir el-Bahri. The Apis-bull of Memphis, whose name in Egyptian sounds almost the same as that of Hapu, was counted as his father. This instance of deification deserves mention as a historical example, for it shows more clearly than words can, how strongly even nowadays the Egyptian feels for his old cultural ideal of the sage, the administrator and official: in the historical self-assessment of the Egyptian this ideal has always come before that of the priest or warrior.'

ARCHITECTURAL MONUMENTS FROM THE TIME OF KING AMENOPHIS III

160, 161. *Thebes, the Memnon colossi.*
The two colossi, which as now preserved are 63 feet high, against an original height (including the crowns which are no longer there) of 68 feet, represent Amenophis III. They formerly adorned the entrance to the king's funerary temple. This temple was almost completely demolished under the later pharaohs and erected elsewhere in another form. Each colossus is hewn out of a single block of stone from the neighbourhood of Heliopolis. Amenophis III is sitting in each case on a cube-shaped throne. On the sides of the thrones, beneath the king's names and titles, are figures of the two national gods, with the plant emblems of Lower and Upper Egypt encircling the hieroglyph meaning 'unite'. On the northern colossus (on the right of the picture) on the king's left stands his mother, Mutemuia; on the right, his wife Tiy. A third figure, between the legs,

has been destroyed. This northern colossus is the famous 'singing colossus' of the ancients, visited at the time of the Roman emperors by numerous travellers, among them the Emperor Hadrian and his wife Sabina. On certain days, shortly after sunrise, a sharp ringing noise could be heard. As a result of restoration in the reign of Emperor Septimius Severus, the colossus lost the ability to emit sounds.

According to legend, the singing sound was the lament of Memnon, the Ethiopian killed by Achilles during the Trojan war, who at sunrise greeted his mother Eos.

162–165. *The Amun-Mut-Khons temple at Luxor.*

The conception of this temple, dedicated to the imperial god Amun as well as to his wife Mut and their son Khons, the moon-god, goes back to Amenophis III. The most beautiful parts of it were built during his reign.

In view of the fact that the north-eastern sections of the temple belong to a later period, this description will begin with the part built by Amenophis III in accordance with his original plan, even though the official entrance to the completed temple is at the other end, through the pylon built by Ramesses II, and continues on the wider path through the great court (C), also built by Ramesses II. Only then is that part built by Amenophis III reached, beginning with the hall of pillars (B). The original plan, conceived during the reign of Amenophis III, included the large 'second' court (A) and the temple building itself, adjoining it on the south-west—the House of Amun.

In the north-eastern section of the temple-building, first came a pillared hall (with side rooms off its end walls), which was turned into a church during the Early Christian Period. Next to it came two smaller halls, each with a ceiling supported on four pillars. The second of these (S) was later converted into the Sanctuary of Alexander the Great. Next came a fourth hall, a transverse rectangle in shape, containing two rows each of six columns, and finally, the holy of holies, its ceiling being supported by four columns. On both sides of this central row of pillared halls there were chapels, of which the first on the east side, the hall of birth (H), contained wall-reliefs depicting the marriage of Queen Mutemuia with Amun (Plate 153) and the birth of King Amenophis III. Cell-like rooms on the north-west and south-east sides of the whole building were used for storing ceremonial robes and equipment.

A pronaos with four rows of eight pillars led to the first hall of the temple from the second court (A). The remaining three sides of the second court had colonnades with two rows of pillars. According to the original plan, the court was to have been closed at its north-east end by a pylon. Before this had been completed, the royal architect changed his mind and began to build a vast hall of pillars (B). However, the only parts of this that were finished were the seven pairs of central pillars, almost 52 feet high, with capitals shaped like open papyrus umbels. It is not certain whether this hall of pillars was meant to have other equally tall pillars all over it, or whether by raising the height of the middle nave, it would have had the form of a basilica, like the later large pillared hall at Karnak.

The building of the temple was not resumed until the reigns of Kings Horemheb and Ramesses II. Under the latter the large 'first' court (C) and the pylon, the colossal statues and the obelisks were completed. To conform with the direction of the Nile, the axis of this court had to be at an angle of 7° east, as is the case with the axis of the small temple from the time of Tuthmosis III near the northern end of the court. Colonnades, each of two rows of pillars, surround all four sides of the court.

An avenue of ram-sphinxes led from the door of the pylon to the imperial sanctuary at Karnak, ending at the triumphal (tenth) pylon of Horemheb.

162. *The temple area seen from the roof of the new Winter Palace Hotel.*

The pylon is shown in the background, and consists of two towers made of stone blocks, flanking a lofty doorway. Their sloping walls are edged with a torus-moulding, their top is finished by a cavetto cornice. Of the two obelisks originally placed in front of the doorway, only one is still standing and it can be seen in the picture. Of the two obelisks which once stood before the gateway, only one remains and this can be seen in the picture; the other has, since 1836, adorned the Place de la Concorde in Paris. In front of the pylon towers were colossal royal statues. Adjoining the pylon came the 'first' court, built by Ramesses II, with double rows of columns; then the large hall of pillars with seven pairs of 52-foot high columns, occupying the centre of the picture, with capitals in the form of open papyrus umbels. The abacus and architrave on top of each of these have been preserved. The walls

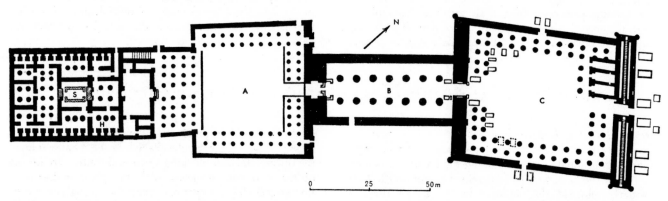

FIG. 35. Amun-Mut-Khons Temple, East Thebes (Luxor). Ground-plan. Left (on the south-west of the whole layout) the temple building, in which there is the Sanctuary (S) and the Hall of

Birth (H). A: Great Court of Pillars of Amenophis III. B: Hall of Pillars of Amenophis III. C: Great Court and, completing it on the north-east side, the Great Pylon, built by Ramesses II.

of this pillared hall, now to a large extent destroyed, were decorated with reliefs by King Tutankhamun, showing the celebration of the great New Year festival in Thebes. His name in the inscriptions, however, was later replaced by that of Horemheb.

163. Large 'second' court (A) *and hall of pillars from the east.*
In the foreground on the right, part of the wall surrounding the first court.

164. View of the large 'second' court (A) *from the north.*
On the left and extreme right of the picture, the colonnades of the south-east and north-west sides. At the end of the court, the pronaos or vestibule of the actual temple.

165. Porch of the temple from the west.
The columns are in the form of papyrus clusters, the capitals consisting of clusters of papyrus umbels in bud form (cf. Plate 44 left).

TOMBS FROM THE TIME OF KING AMENOPHIS III

166–170. Thebes. From the tomb of Kheruef, the chamberlain of Queen Tiy (No. 192).

Scenes from the tomb, which was made at the end of the reign of Amenophis III, and of which many of the reliefs show scenes from the king's third Sed Festival on the occasion of the 36th year of his reign. Its central theme, showing the royal couple on their thrones, has already been reproduced in Plate 154. Because of the delicate execution of these reliefs, their complete clarity, and the beauty of their line, and also because all the details have been so carefully observed and recorded, this tomb is one of the most masterly creations of its period, not forgetting the magnificent splendour of the reliefs from the almost contemporary tomb of the Vizier Ramose (No. 55).

166, 167. Procession of eight royal princesses.
These slender, truly regal maidens, in their close-fitting, but at the same time flowing, robes, are daughters of King Amenophis III; they are about to consecrate the scene of their father's jubilee by pouring water from sacrificial vessels. On their curled hair, from which a wide strand of hair hangs down at the side, they wear a curious, undecorative head-dress. Between the four pairs and in front of the leading pair are other libation jars on wooden stands.

The picture of the eight princesses, who are shown here all in the bloom of their early childhood, is completely idealized. Since the marriage of Amenophis III and Tiy took place in 1401/1400 B.C., and as only daughters were born from the marriage before the year 1385 B.C., which was about the time of the birth of the long-expected heir, and since after 1385 B.C. only the daughter called Baketaton was born, it follows that in the year 1366 B.C. the age of the princesses shown here would in reality have been between 33 and about 18.

168, 169. Dancing girls and musicians at the Sed Festival of the king.
The upper register of the frieze contains a scene, not quite clear in all its details, of foreign girls, doubtless Libyans, dancing a mime full of movement, while the lower section shows more dancers together with musicians. As a continuation of the upper section there are shown, behind a shrine, a leaping calf, a monkey and a flying duck.

170. Dancing men and girls in various dance movements.

———

Colour Plate XXVIII. Thebes. In the tomb of the sculptors Nebamun and Ipuki (No. 181), *active during the reigns of Amenophis IV/Akhnaton and Tutankhamun. Transverse hall, left wall.*

Above: *Funeral ceremony at the entrance to the tomb.*
In front of the tomb, the upright, decorated mummy is being purified by priests who sprinkle water upon it and also perform the ritual of the 'opening of the mouth'. In front of the mummies, the heads and shoulders of which, in accordance with custom, are covered with portrait masks, while tall bunches of flowers stand before them, crouch mourning women, who stroke the bandaged feet of the deceased. The larger of the two figures has scratched her breast and is strewing earth over her head.

Below: *Mourners at the funerary shrine.*
Women and menservants are bewailing their loss, by laying their hands gently on the funerary shrine, adorned with papyrus stems and standing on a wooden sledge, which men are waiting to draw to the tomb by means of the rope attached to it. From the shrine protrude the prow and stern of a funerary bark, on which are small figures of Isis and Nephthys, the tutelary goddesses of the dead.

171, Colour Plate XXIX, 172–178. In the tomb of the Vizier Ramose at Thebes (No. 55).

Ramose was the vizier and overseer of the capital during the last years of the reign of Amenophis III and the first years of the reign of Amenophis IV, later called Akhnaton, and he followed his young king for a few years to his new capital of Akhetaton. His extensive tomb at Thebes was begun during the last years of Amenophis III and at the same time received its finest decorations, including the wall-paintings on the south-west wall of the great hall of pillars, and the noble reliefs on the south-east wall of the same room. These decorations represent the final expression of the art of the last years of Amenophis III. From the first years after the death of Amenophis III date the reliefs on the north-west wall of the great hall of pillars, the last to be undertaken, for after the removal of the court from Thebes to the newly founded Akhetaton, the tomb was left unfinished.

In front of the tomb (Figs. 36, 37) is a courtyard, the irregular shape of which is due to the presence of other, earlier tombs nearby. A short and narrow corridor leads from this courtyard to the principal hall, the roof of

which is supported by four rows each of eight papyrus-cluster columns (now for the most part destroyed, but in part replaced by imitations). From the westernmost corner of the main hall, a long underground corridor leads down to the burial chamber, at a depth of 55 feet, which consists of a vestibule and other rooms, never used. Adjoining the main hall and on the same level, is a smaller, long hall with eight papyrus-cluster columns, and after this a small room with niches. These last two rooms, like the north-east wall of the principal hall, were left without fine decorations.

On the south-west wall of the tomb, in two super-imposed registers (Plate 171, Colour Plate XXIX) are mural-paintings depicting the funeral procession of the inmate of the tomb.

The south-east, or entrance, wall is covered with the celebrated reliefs, of which the most important are repro-duced in Plates 172–178.

171, Colour Plate XXIX. *Wall-painting from the south-west wall: The funerary procession of Ramose.*
One can see from the top photograph on Plate 171 that the funerary procession, which extends the whole width of the wall, is divided into two registers arranged one above the other. Of the two lower photographs on Plate 171, the upper one repeats at larger scale the rear half of both the registers between which the procession is split up. The bottom photograph, shows only the front half of the lower processional scene. Colour Plate XXIX shows two parts of the lower scene. The following description begins at the head of the processions and continues from right to left.

Of the two registers, the upper one with its larger figures is the less well preserved: bearers of offerings, men march-ing with ceremonial solemnity, draught oxen before a symbol which is being carried on a sledge, the funerary shrines with the signs of Osiris and Isis, also drawn on sledges and with projecting parts of funerary barks, on which stand the goddesses of death, Isis and Nephthys, with priests and mourners behind them. Lower register: the rites at the moment when the mummy is placed erect at the entrance to the tomb, standing and crouching female mourners (Colour Plate XXIX lower), bearers of offerings with papyrus stems, a group of standing women whose laments rise to the funerary shrine (Colour Plate XXIX upper), men carrying tomb accessories, symbols of rank and jugs, and lastly a number of distinguished mourners in white robes reaching to below their knees.

172–178. *The reliefs on the entrance wall, that is the south-east wall.*
On either side of the entrance in this east wall, Ramose is shown offering sacrifices. On the left, he is making gifts to the gods in the presence of his wife and members of his household; on the right, he is making an offering to the sun and is followed by twelve youthful assistants, in three rows; the three young men in the middle row are note-worthy for the beauty and delicacy of execution (Plate 178).

The remainder of the north part of the entrance wall shows the use of consecrated oil and salves and the purifi-cation of Ramose (Plate 172), while the southern half, in

addition to Ramose's offering to the sun, shows, in two rows, the 'festival in the house of bliss, built in the city of the dead'. This is a sacred, ceremonial banquet, in which Ramose and his wife Merit-ptah take part, together with their nearest relatives. In these reliefs, most of the person-ages seen in the upper row are repeated in the lower. Plates 173–177 show the left and middle portion of the lower row of reliefs, the two parts which have been best preserved.

Let us first consider the relief in Plate 173. On the left is Keshy, chief huntsman of Amun, with an unnamed personage behind him; then comes May, a cavalry officer, with his wife Werel behind him. May and the unidentified

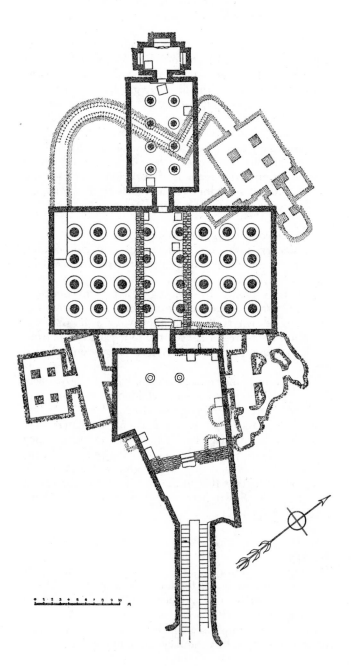

FIG. 36. Tomb of the Vizier Ramose at Thebes (No. 55). Ground-plan (about 1:400).

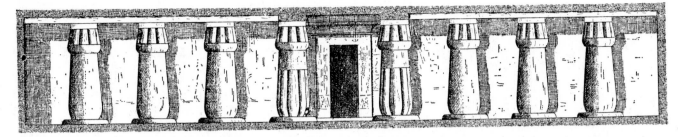

FIG. 37. Tomb of the Vizier Ramose at Thebes (No. 55). Section through the main hall of the tomb-chapel.

figure hold bunches of water-lilies in their hands. Next come the parents of Ramose (Plate 174), first his mother Apuya, 'the darling of the gods,' and then his father Neby, chief herdsman of Amun in the northern zone and superintendent of the granaries in the Delta. Separated from him by a pile of foodstuffs and water-lilies, some representations of Ramose's brother Amenhotep, one of the highest officials and chamberlain of the king's court in Memphis with his sceptre of rank, the double row of gold disks round his neck, i.e. the gold of honour, and behind him his wife May, first lady of the court and favourite of the queen (Plate 175-177). These two were the parents of Ramose's wife Merit-ptah (Ramose's brother was thus his father-in-law as well). At the right end of the lower row of reliefs is the less well preserved (and for this reason not reproduced) relief showing Ramose blessing the meal and his wife Merit-ptah. There follow Ramose's brother and his wife and their daughter Merit-ptah between them. The relief in the upper row is similar.

173-177. Reliefs showing guests at the feast.

In each of these figures type and personality are wonderfully balanced. The faces, cut as sharply as gems, filled with a latent sensuousness which is nevertheless in none of them lacking in spirituality, stand out against the incomparable wealth of the framework and ornamentation. In the sublime beauty of these noble couples the perfection of a civilization is proclaimed. The enchantingly expressive world which we have here before our eyes represents the achievement of a goal. Later, Akhnaton's artistic revolution took a completely different road. But those who have a feeling for art will always consider this achievement as one of the most perfect artistic realizations of humanity.

173. *Keshy and an unnamed personage, May and his wife Werel.*

174. *The parents of Ramose, Neby and Apuya.*

175. *Ramose's brother Amenhotep with his wife May.*

176. *May, wife of Ramose's brother.*

177. *Ramose's brother Amenhotep.*

178. *One of the youthful assistants of Ramose as he offers gifts to the sun.*

The youth here reproduced and his two companions (who form the middle row in the group of twelve youths) reveal an unusual beauty in the treatment of line and modelling. Robust virility is combined with all the charm and lovableness of youth.

The artistic quality of the reliefs on the south-east wall of the tomb of Ramose can best be characterized in the following words of Walther Wolf: 'The excessively refined relief is richly modelled. The delicately harmonious faces, the vibrating exquisite wigs, the gossamer-like, richly pleated garments, belong to a metropolitan society of extreme refinement and ethereality, to the delicate, even slightly morbid, supporters of an over-ripe decadent culture. These people live a life in perfect beauty and dignity, they celebrate a perpetual festival. The fine, softly rounded line expresses completely their attitude to life; it is a far cry from the austere severity of the Tuthmoside period. At this time people must have felt that they stood at a *fin de siècle*, that behind their luxury and elegance lurked the *taedium vitae;* from the symmetry of these exquisite faces ennui threatens to burst forth. It is unthinkable that a style like this could be enhanced.'

The north-west wall of the great hall of pillars has reliefs dating from the years immediately following the death of Amenophis III on both sides of the doorway leading to the narrow hall with eight papyrus-bundle pillars. Of these reliefs, those on the left of the door clearly belong to the earliest period of the reign of Amenophis IV, certainly no later than the third regnal year. The king is shown seated on a throne beneath a canopy with the goddess Maat similarly seated behind him; they receive Ramose who comes before them. The whole of this scene is executed in the style of the reign of Amenophis III. Quite the opposite is the case with the other reliefs, to the right of the door, which were carved in the fourth year of Amenophis IV (Fig. 38). On the extreme left are shown in two registers men of the royal bodyguard (not in the figure) in attendance on the king and his royal wife Nefertiti, who are represented at the window of appearance in their palace on the point of honouring Ramose. Above the royal pair is the Aton-disk with its rays ending in hands. In spite of the severe damage which the relief suffered during the persecution of the Akhnaton heresy after the return to Theban orthodoxy, the spare, almost old, face of the king can still be recognized. The scene is stamped with the style, in fully developed form, which became so characteristic of the first nine years or so of the period spent by Akhnaton in Akhetaton. The same is the case with the next relief. While in the reliefs on the left of the door Ramose presents a stout appearance with an upright, noble bearing, in the relief on the right of the door (Fig. 38, right) he has become a slender, deeply

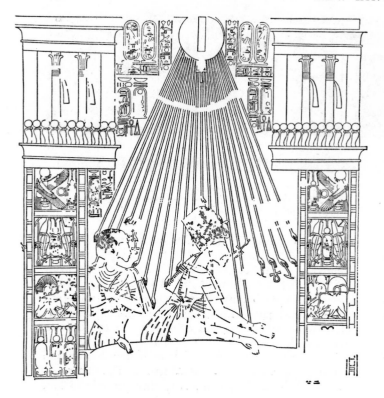

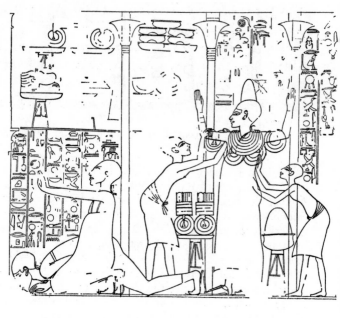

FIG. 38. From the sequence of reliefs to the right of the door in the north-west wall of the great hall of columns in the Tomb of the Vizier Ramose at Thebes (No. 55).

On the left: King Amenophis IV and Queen Nefertiti at the Window of Appearance in their palace from which they honour the Vizier Ramose with the 'gold of honour', consisting of gold chains and other gold ornaments. On the right, in an adjoining scene (not to be seen in the figure here) are shown courtiers with a delegation of foreign envoys, some Nubians and some Asiatics.

bowing courtier with the elongated head which was so characteristic of the new style. The same style is exhibited in the adjoining scene on the right (not shown in Fig. 38) in which Ramose distributes to attendants the 'gold of honour' presented to him by the king. Likewise, the scene in the register below the last is executed in the same style, although not in relief, but in black painted outline only; it shows the reception of the foreign envoys, but it too is not included in Fig. 38.

179. *In the tomb of Khaemhet at Thebes* (No. 57) who was 'overseer of the granaries' under Amenophis III, a high office equivalent to a modern Minister of Agriculture. In the entrance doorway.

Khaemhet with raised hands speaks a prayer to the sun-god. The reliefs in this tomb exhibit a courtly tradition, an avoidance of all strong expressions of feeling and a marked precision in execution which place it in the middle years of the reign of King Amenophis III, about 1390–1380 B.C. Khaemhet is shown wearing on top of his wide collar a double gold chain with elements shaped like lentils; this ornament is the 'gold of honour' which the king presented to serving officers and officials.

EIGHTEENTH DYNASTY: THIRD PHASE · 1364-1306 B.C.

Kings: *Amenophis IV/Akhnaton* (1364–1347 B.C.), *Tutankhamun* (1347–1338 B.C.), *Ay* (1338–1334 B.C.), *Horemheb* (1334–1306 B.C.).

Amenophis IV or Akhnaton, the son of King Amenophis III and of his wife Tiy, outbid his father in the cult of the individual and brought into the open a latent but existing trend in religious belief, the belief in the sun-disk Aton as the sole divine spirit. At the same time he claimed a position similar to that of a prophet as the only competent preacher of his doctrine. Religious and political tensions caused him to remove his residence to Akhetaton

(now called El-Amarna) in Middle Egypt. His followers moved there after him. The old powers, particularly Amun and his priesthood, were persecuted. Neglect of the essential tasks of a ruler led to a break-down in foreign and economic affairs.

After the downfall of Akhnaton the kings who succeeded him returned to live in Thebes and recognized Amun again, as well as the other gods. They were Akhnaton's son-in-law, Tutankhamun, and, after his brief reign of barely nine years, Ay, who reigned for four years; the latter had been a close supporter of Akhnaton, and was originally called the 'Divine Father', 'The Fan Bearer on the right-hand of the King' and 'Overseer of the King's horses'.

The man who saved the state was Horemheb, at first commander-in-chief and then, after Ay's death in 1334 B.C., king. Under him foreign relations were re-established and an attempt made to win back Egyptian influence. In internal affairs, the rehabilitation of the cults of the old gods and of the temples was completed and the heretic Akhnaton and his teaching outlawed, and his residence at Akhetaton destroyed. After a drastic purge of all traces of events from the period of Akhnaton, there followed the rebuilding of the administration and the re-creation of the State on a new basis.

Nothing remains of the buildings from the period of Akhnaton in his residence at Akhetaton. It is only from the evidence revealed by excavation that anything can be learnt of the layout of the great Aton temple or indeed of the royal palace: representations in the tombs cut in the mountain cliffs at the edge of the town show in part villas and gardens.

The history and person of King Amenophis IV, later Akhnaton, still calls for special consideration. The years of his reign mark the turning point in the history of Egypt as a world power. At the beginning of the thirty-six years during which his father Amenophis III ruled, the Egyptian State was at the zenith of its expansion and at the highest peak in the development of its power in the political as well as the military sphere. Even Amenophis III scarcely contemplated extending Egypt's position further in the framework of the ancient world. A passion for hunting, an excessive urge to build and an ever-increasing search to free his personality and his personal wishes and by no means least a frankly enormous harem, largely diverted the king from his highest political duty as a ruler. In his whole being an important and ever more fixed trend showed itself in the direction of an absolute rule, very closely bound up with his personality. The picture we have of him contrasts sharply with that of his great, truly royal predecessors on the throne, because of his love of luxury and an exaggerated desire for the monumental in building: one need only think of his gigantic mortuary temple in Western Thebes of which the only surviving witnesses are the Colossi of Memnon—the great seated statues of the king, over 70 feet high, which stood in front of the pylons; equally vast was his palace city on the banks of the pleasure lake, also in West Thebes.

An almost despotic arbitrariness, and an emphasis on his private life unparalleled in earlier times, were combined in this monarch with the desire for personal deification even in his own lifetime, and this was clearly expressed particularly by the temple at Soleb in Nubia, which he built as his personal symbol on earth, and by the temple built for his wife Tiy at Sedeinga in Nubia. It was such a world as this that Amenophis IV entered. Nature did not afford this ailing prince, born late in his parents' life, the opportunity to express his marked ambition and urge to dominate in the deeds of war which had brought fame to his great ancestors Tuthmosis III, Amenophis II and Tuthmosis IV. Decidedly egocentric and despotic, but also non-political, he became obsessed with the idea of creating a new universal ideology during his reign. This culminated in the displacement of all the gods of Egypt, even of the imperial god Amun, by Aton, the sun-disk, who alone was to be regarded as possessing value.

But it should be stressed that the young king's worship of the sun in no way need have brought on the schism which unfortunately followed. Otto has observed that 'That which made Aton an opponent of Amun was not his name and position as a "new" god, but the religious temperament of his followers'. The religious worship of the sun had already by the Fifth Dynasty assumed a definite shape in the belief in Re. It achieved at that time its most easily understood expression in the building of the sun-sanctuary, with which the king 'fulfilled an obligation to his divine father'. The worship of the sun-god continued throughout all the subsequent periods, and then flared up anew in the Eighteenth Dynasty. Tuthmosis IV considered himself to have been chosen as Pharaoh by the sun-god Re, the age-old sun- and creator-god and not by Amun. And this same Tuthmosis IV had expressly stressed in one of his scarab inscriptions that he overthrew the Asiatic countries in the name of Aton. Was this

already a first sign of the division which at the end of the Eighteenth Dynasty was to shake the very being of Egypt so deeply? We also meet the upsurge in the significance of Aton in the reign of Amenophis III. It should be remembered, for example, that his youngest daughter bore the name Baketaton ('Aton's servant'), while the princesses born earlier had names compounded with that of Amun; furthermore, that a company of the royal bodyguard was named after Aton, and that the gold bark of the royal couple on the pleasure lake in Western Thebes was named 'Aton gleams'.

Though the conflict between Amun and Aton may have reflected the tension between the priesthood of Amun and the monarchy, yet the primary cause was surely the special religious interest of the period. The Egyptian during the expansion of his empire through Asia had learnt to understand the concept of sun worship on a broader basis. For all the people and religions, with which the Egyptians now had contact, participated to some extent in the worship of the sun. 'The new (Egyptian) world clearly sought a new god, unfettered by religious doctrines and comprehensible, with an appearance which could be grasped by everyone. For indeed the Egyptian was in general inclined to place each new form of his world under a new god; and we have enough witnesses from the time of Amenophis IV who let a new concept of god be seen, a god who as lord of all life, all growth and prosperity, could really be experienced not only within the borders of Egypt but over the earth by all peoples. To express the conflict between Amun and Aton in a formula, perhaps one may make the definition: Amun was the Egyptian national god, Aton a world god.' It would be a mistake to see in the figure of the god Aton a new creation of the king.

But it is clear that the unfortunate division, which actually happened during the reign of Amenophis IV/Akhnaton cannot have come about solely from religious causes. Its roots lie far rather in the transformation of the figure of the king into a temporal, personal figure, a transformation expressed most extremely by Akhnaton; they lie also in the tension between the monarchy and the priesthood. This conflict, from the point of view of economics, had arisen through the growth in the size of temple-properties while from the political point of view it was grounded in the marked spread of influence over the king's court by the prophets of Amun; finally, it was rooted in the very close association between god and monarch.

It is not known precisely how the complete break with the past came about in the sixth year of the reign of

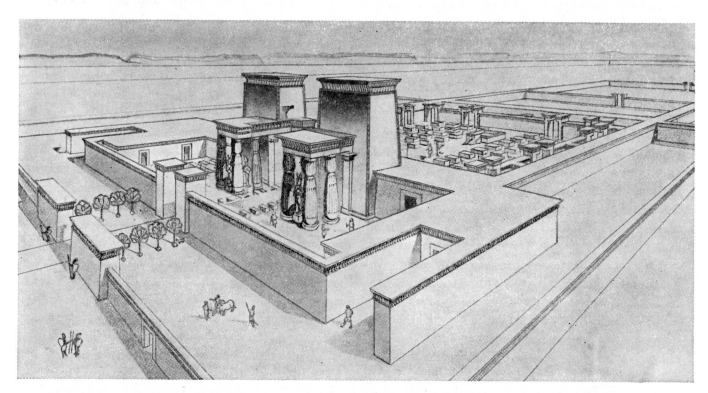

FIG. 39. The sanctuary of the great Aton-temple in Akhetaton. A reconstruction based on the relief representation in the tomb of Merire I (No. 4), at Akhetaton.

Amenophis IV, nor whether, as seems likely, it happened as a consequence of a sharpening of the opposition to the priests of Amun. Nevertheless the king changed the name he had held hitherto, Amenophis (i.e. 'Amun is satisfied') into Akhnaton (i.e. 'Aton is favourable'), left Thebes and settled in the new residence Akhetaton (modern El-Amarna), founded in Middle Egypt. Within the area enclosed by fourteen boundary-stelae palaces, administrative buildings, dwelling houses and temples literally sprang out of the ground.

By its nature the Temple of Aton differed from the earlier Egyptian temples. As an open temple it was comparable to the sun-sanctuaries of the Fifth Dynasty. Its sanctuary, which possibly resembled the sun-temple of Heliopolis, of which nothing is now known, basically consisted of four open courts. The sacrifice to Aton took place in the open air on a very large altar, which stood in its own court, the second from the east. About 175 offering tables filled both the courts lying behind the altar court, in the most westerly of which rose a portico with its two wings on each side, each supported by four pillars. Two statues of the king were placed in between these pillars, of which the one in the northern half of the portico wore the Red Crown, the one in the southern half the White Crown. It is especially remarkably that outside the actual temple building there were approximately another 800 offering tables, as though many people in Akhetaton had had their own individual offering tables. A cordon of gardens and trees, with ponds, surrounded the dwelling houses—all apparently created for a small circle of favoured and high ranking followers of the king.

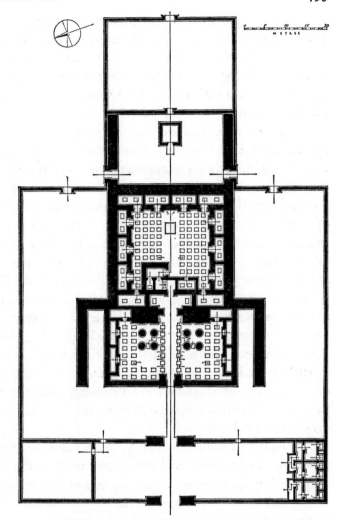

FIG. 40. The Sanctuary of the great Aton-temple in Akhetaton. Ground-plan (1:800).

The sanctuary was situated in a temenos called the *Perhai* ('House of Jubilation'), measuring 875 × 300 yds. In this, some 325 yds. away from the sanctuary, was the *Gem Aton* ('Aton has been found') with six courts divided by pylons containing many offering tables, as there were also in the *Perhai*.

Who these high ranking people were is not quite clear: certainly the old, trusted people of the king had either left him or had been dismissed by him, as the example of the Vizier Ramose shows. That there were adventurers in the train of the king is suggested by contemporary biographies which contain words like 'I was a nothing, the son of no-one: the king made me something'. It would, however, be going too far to draw conclusions about the nationalities and antecedents of the people placed in high positions round the king from the twenty or so portrait-masks found in the workshop of the sculptor Tuthmosis in Akhetaton. Scholarly interpretations which attribute particular characteristics to them are far too divergent to provide any basis for a lasting judgement.

The economic and cultural consequences for Thebes arising from the removal of the capital to Akhetaton are virtually impossible to assess but they were certainly immense. With the suppression of all the other gods and particularly of Amun, the imperial god, royal subsidies would have been withdrawn from the temples themselves and from the holders of temple offices at that time, also from the holders of state posts in the whole administrative system of the vast business of the State. The larger part of the ruling classes was, overnight as it were, thrown into insignificance, need and poverty. All these people must have hated the king very greatly. To a devastating extent, the country was thrown into complete disorder accompanied by demoralization of the administration and the economy.

The political position of Egypt had become catastrophic a few years after the removal of the capital to Akhetaton. The king, quite unpolitical by disposition, was also without any feeling of duty towards the conduct of foreign policy, and saw the religious reformation as his one and only task. In foreign affairs Egypt already by the time of Akhnaton's reign had reached a stage when only a very strong ruler concentrating on the problem with all his energies could have mastered the situation. Only Nubia remained faithful, fortunately so because of its gold and the reserves of men and material vital to the State. Except for Nubia, however, Egypt lost in a few years all her possessions and influence in the north. Even by the time of Amenophis III King Tushratta of the Mitanni had asked for help against the Hittite Kingdom, which was growing ever more powerful. He was later killed fighting the Hittite King Shuppiluliumash I, and his son was obliged to recognize the Hittite overlordship. With the defeat of the Mitannian kingdom, however, the Assyrians under Ashur-Uballit began to invade, although they first turned against the Hittites. No longer was there any trace left of an Egyptian overlordship in the direction of North Syria and the Euphrates. The North Syrian towns, beleaguered by Itakama of Kadesh on the one side and by Aziru of Amurru on the other, appealed to Akhnaton in vain; the Phoenician ports and finally Byblos fell to Aziru, who then, however, was himself overthrown by the overlord Shuppiluliumash I, without Egypt moving in any way against Aziru or, later, against the Hittites. Affairs in Palestine went equally badly.

Within half a man's lifetime was lost all that it had taken generations of vigorous, methodically planning rulers to build up. Neither the statesmanlike talent of the commander-in-chief, later the King Horemheb, in the closing years of the Eighteenth Dynasty, nor the Ramesside Period, though that was outwardly so brilliant, could remedy the death-wound which Akhnaton dealt the Egyptian kingdom. If—and this cannot be too strongly stressed— Egypt collapsed as a state at the end of the Ramesside Period in spite of the tremendous efforts made by the very great rulers of the Nineteenth and Twentieth Dynasties, then it is true that the internal political intrigues of that period, which can no longer be disentangled, were very largely to blame for it: Akhnaton, however, was the real originator of the collapse.

The 'Hymn to Aton' found in Ay's tomb at Akhetaton is a witness to the thinker and poet in Akhnaton: the fervour of his prophetic soul calls out to us from the hymn, which resembles—wittingly or unwittingly—the 104th psalm; the latter is of later origin, and falls far below the hymn in warmth and purity of feeling and in beauty and simplicity of language. However prejudiced one may be against Akhnaton, his 'Hymn to Aton' belongs to the great creations in the world of literature.

You arise beautiful in the horizon of heaven,
O living Aten, the initiator of life,
When you shine forth in the eastern horizon
And fill the whole earth with your beauty.
You are beauteous, great, shining and high above every land.
Your rays encompass the lands to the limits of all that you have made;

You are the sun, and reach their limits, subduing them to your beloved son.
Although you are afar, your rays are upon earth;
You are in their sight, and yet your goings are not seen.
When you set in the western horizon, the earth is in darkness as if in death.

One passes the night in the bedroom with head covered;
The eye does not see its fellow.
All one's property is stolen, although it was under one's head and is not to be seen.
All lions come forth from their lairs; all snakes bite.
Darkness is the only light, the earth is in silence.
Man's creator is at rest in his horizon.
The earth is lit up when you arise in the horizon, shining as the Aton in the daytime.

You dispel darkness and offer your rays;
The Two Lands are in festival, awake and standing on their feet;
You have raised them up; their limbs are purified, clothes are put on, their hands are raised in praise of your appearing.
The whole land sets about its work.

All cattle are at peace in their pastures; all trees and meadows are green.
The birds fly forth from their nests, their wings giving praise to your spirit.
All small animals gambol upon their feet.
All creatures that fly and alight live when you appear for them.

Boats sail north, and south likewise; all roads are open when you appear.
Fish in the river leap before your face; your rays are in the midst of the sea.

You are he who makes the foetus grow in woman, who makes the water in mankind;
Who makes the son live in the body of his mother, quieting him by ending his tears.

(You are) nurse even in the body, giving breath to enliven all
you make.
You descend from the body to breathe on the day of his birth.
You open his mouth completely and you provide his nourish-
ment.

The chick in the egg chirps in the shell; you give it air within
it to make it live; you have endowed it with fulfilment to
break it, that is the egg; it comes forth from the egg to speak
of its fulfilment; it walks about on its two legs when it has
come forth from it.

How manifold are your acts; they are mysterious in the sight
of men, you sole god, of whom there is no like.
You have fashioned the earth according to your desire, quite by
yourself, including all men, cattle, flocks, whatever is on earth,
what walks on feet, what flies up soaring upon wings, the lands
of Khor and Kush and the country of Egypt.
You set every man in his place and arrange his requirements,
each one having his food and with his lifetime reckoned; tongues
made different in speech and their natures likewise; their skins
being diverse, for you have made diverse the peoples of countries.

You create the Nile in flood in the underworld, and bring it
as you wish to make the common people live, even as you make
them for yourself, you, the lord of them all, who grow weary
with them; the lord of every land who shines for them, the Aton
of the daytime, great of majesty.

All distant lands, you make them live. You have set a Nile in
flood in the heaven; it descends for them and it makes waves
upon the hills like the sea to irrigate their fields in their villages.
How efficient are your plans, O lord of eternity! A Nile in
flood in the heaven—your gift for the foreign peoples and for
the flocks of all foreign lands that walk upon feet.
But the Nile flood for Egypt comes forth from the underworld.

Your rays nourish every meadow. When you shine, they live
and they flourish for you.

You make the seasons in order to foster all that you have made,
the winter to cool them, the heat so that they should taste you.
You have made the sky far away to shine in it and see all that
you have made, being all alone and shining in your forms as
the living Aton, appearing in glory and gleaming, being far
away and coming close.

You make millions of forms from yourself—towns, villages,
fields, roads, the river.
Every eye sees you directly in front of it, for you are the Aton
of the daytime upon the places where you have gone (?).
There is no eye for which you have created sight that does not
see what you have created; for you are in the heart of man (?).
There is no-one else who knows you except your son Nefer-
kheperu-re-wa-en-re (Akhnaton). You have made him adept in
your skills and in your strength.

The earth comes into being upon your hand, just as you made
them.
You have shone forth and they live; you set and they die.
You are lifetime yourself, and one lives by you.
Eyes are fixed on beauty until you set; all work is suspended
when you set on the right.

When you rise you make all go well for the king. Hurrying is
in every leg since you created the earth.
You raise them up for your son who issued from your body, the
King of Upper and Lower Egypt, living in Truth, Lord of the
Two Lands, Nefer-kheperu-re-wa-en-re, the son of Re, living
in Truth, lord of appearances, Akhnaton, great in his lifetime,
and the great king's wife, his beloved, lady of the Two Lands,
Nefer-neferu-aton-Nefertiti, living and flourishing for ever and
ever.

It would, however, be right to object that the possibility, initiated in this period, of forming a personal relation-
ship with god was then frustrated by the despotic egocentricity of Akhnaton. For the route to Aton was solely
through the person of the king, and Aton was the god only of this king, whose orders only the king understood
and could accomplish. Moreover, Akhnaton's doctrine denied the totality of life: it overlooked, or more correctly,
wished to overlook, as Otto has pointed out, 'that next to the world of light, of beauty and of life stands the
world of night, of need and danger, that the necessary complement of life is death'. 'Reduced to a formula: Aton
—as Akhnaton saw him—dethroned not only the imperial god Amun but also Osiris.'

We know nothing about the end of Akhnaton or of his residence Akhetaton either. We only know that
Nefertiti suddenly left her husband and went to live in her own palace in the northern part of Akhetaton. Like
Tiy, the old mother of the king, who came from her widow's residence in Medinet-Ghurab in the Faiyum, to
visit her son in Akhetaton, she must have realized the disaster conjured up by Akhnaton. Smenkhkare, husband
of Meritaton, Akhnaton's eldest daughter, seems to have been co-regent with the king in the last three years
before the fall of Akhetaton, and to have negotiated with Thebes. His wife's name was changed to Meritamun.
His death, like that of Akhnaton, is shrouded in mystery. Tutankhamun, probably a son of Akhnaton and of a
daughter of the Babylonian King Burraburiash II, and at the same time son-in-law of Akhnaton as the husband
of his third daughter Ankhsenpaaton, returned to Thebes and in the name of the past and of the imperial god
Amun of Karnak formally introduced the 'restoration'. Akhetaton was destroyed, the name Akhnaton extinguished.
Tutankhaton, in view of the circumstances, altered his name to Tutankhamun, and that of his wife to Ankhsenamun.

The outstanding figure of the late period of the Eighteenth Dynasty was the commander-in-chief, Horemheb,

who from at least the end of Akhnaton's reign, and certainly in the reigns of Tutankhamun (1347–1338 B.C.) and Ay (1338–1334 B.C.), had taken all the important decisions. He lived in Memphis as 'Guardian of the borders of the Kingdom' and it was due to his defensive wars in South Palestine that at least this area was held as a military outpost for Egypt.

When Horemheb declared himself king on the death of Ay in 1334 B.C., he legitimized his accession by divine judgement: Horus, the God of his home region, was said to have determined his rule and Amun chose him. Following the example of Tuthmosis III in the way he reckoned the years of his reign, he dated his reign from the year of the death of the King Amenophis III, that is from 1364 B.C. By this device the last trace of the past unlucky era seemed on the surface to have been extinguished; literally the period of King Horemheb meant the absolute obliteration of the era covering the period from the accession of Akhnaton to the death of Ay.

It is exclusively Horemheb's achievement to have warded off the immediate threat to Egypt from external attacks and by his successful campaigns in South Palestine to have created again an operational base for future undertakings. The list of conquered towns set up by him in the Temple of Karnak is to be regarded not so much as a mark of triumph but far rather as the 'expression of conscious recognition of a tradition of obligation'. The deterioration in the internal affairs of the state was halted finally by Horemheb. At Karnak the edict is preserved which recapitulates the ordinances actually issued by Horemheb to remedy finally the abuses existing in the country.

By the time of his death in 1306 B.C., twenty-eight years after his accession as pharaoh, Horemheb had achieved enough to ensure that his kingdom of Egypt, although it had lost its old splendour for ever, was yet so firmly united again internally, so strengthened again militarily, that it seemed poised for a surge forward to a new position of power.

WORKS OF ART FROM THE TIME OF KING AMENOPHIS IV/AKHNATON
(1364–1347 B.C.)

Though the reign of King Amenophis IV, the later King Akhnaton, was so unfortunate for Egypt as a state— it was only through the energy and generalship of Horemheb, commander-in-chief under Tutankhamun and Ay, and king after the latter's death, that a political catastrophe was averted—yet the period of Akhnaton was of great importance for the development of art in Egypt. A complete revolutionary change took place shortly after his accession to the throne. But it would be a mistake to see in this change a general artistic development confined only to a change of style. Far rather the development was conditioned by Akhnaton's spiritual attitude which inspired completely new feeling for life, and especially by the new prophetic and autocratic relationship of the king to the world around him, even to the leading figures in his entourage. It was, in Walther Wolf's words, a 'revolution from outside represented in the figure of Amenophis IV and the converted circle of his followers': the new art was 'the result of a revolutionary act of force and a radical break with tradition'.

Fundamentally, art in the period of King Amenophis IV, later Akhnaton, was an instrument of propaganda, which the king 'methodically employed in order to foster belief in himself and in his doctrine'. It is evident that the king in so doing intervened himself in the shaping of the art of his period, and such intervention is also suggested by an inscription of his sculptor Bak at Aswan, who described himself as one 'of His Majesty's personally taught assistants'.

The beginning of this metamorphosis in art can be dated to the fourth year of the reign of King Amenophis IV, the year 1360 B.C. This fact is borne out by the late reliefs on the north-west wall (just to the right of the door) of the great pillared hall in the tomb of the Vizier Ramose in Thebes (No. 55), a sequence of scenes in which the new style can be observed already fully formed. This sequence presents one of the most generally noteworthy examples of this art, although it was made quite two years before the move of the king to the new palace at Akhetaton (modern El-Amarna) took place. The autocracy of the king, his claim to be son of god, his idea, shown clearly in the 'Hymn to Aton', that he was the only prophet of a new god, and the belief that only his favour would

provide for his subjects' bodily well-being in their lifetime as well as the light of the sun after their death—these factors in the last resort determined both the nature of the king as well as the cringing subservience of all his subjects, even the highest.

Even in the area of the Temple of Amun at Karnak, during the last years before the move to the new capital, Amenophis IV built a temple to Aton, from which four of his statues, about 17 feet high, are still preserved. Here already he showed a special relationship to Aton, which in itself did not appear completely unusual since tendencies towards a special worship of Aton had already been shown under Amenophis III and even under Tuthmosis IV. The great statues from Karnak are reminiscent of the old Osiris-pillars, in which the king and the god Osiris are shown intermingled as though in one form. They suggest the idea that Amenophis IV has shown himself in them intermingled with the god Aton; the pectoral ornaments and armbands bear the name Aton, but the face has borrowed the features of the king, just as Osiris was customarily shown with the features of the reigning monarch. The method of representing the king is unusual. To his subjects, who traditionally had seen their king represented as a noble and strong figure of a man, it must have seemed 'degenerate' and an insult to an old and hallowed tradition. However, it seems certain that these portraits of the king were not made like this because Amenophis IV was so wedded to the absolute truth that he allowed his own face, for the sake of truth, to be copied in the form of a common human. It is more probable that these statues represent in their very strong stylization the clear expression of the king's fanatically inspired prophecy and a spiritual tension which amounted nearly to madness. And in truth these figures of the king in the Temple of Aton at Karnak do seem to deliver a revolutionary blow against all that had come previously in Egyptian art.

This break with tradition had its natural sequel in the foundation of the new capital Akhetaton and the transference of the royal residence there in the sixth year of the king's reign.

Nothing has survived of what may have been created in the field of sculpture during the years immediately after the removal to the new capital until just before the fall and death of Akhnaton. The furious fanaticism of the opponents of the heretic Akhnaton, after the collapse of his régime, completely and ruthlessly destroyed all images erected in public places, together with the buildings in Akhetaton.

All that has survived from the bare eight years before the final years of the collapse, and which provides us with a guide to style in Akhetaton, are the reliefs, both large and small in size, found particularly in the private tombs of the great nobles of the court. These are closely related stylistically to the scenes in the Tomb of Ramose at Thebes, already mentioned. Further examples of the style are provided by scenes like the Adoration before Aton (Plate 183), the picture of the royal family sitting under the sun's rays of Aton (Plate 184), and the scenes on the fourteen boundary-stelae around Akhetaton, marking the limits of the town's area, which are related in subject to the Adoration of Aton referred to above; in addition there are the reliefs, similar to that in Plate 184, on limestone altars, like those preserved in Cairo and elsewhere. As indicated above, the best examples are in the rock-tombs, of which there are twenty-five in all, still unfinished, in the western cliff of the hills east of Akhetaton: notable amongst these is the great tomb of the later King Ay, which, in spite of destruction, affords us the best insight into the art of relief carving in Akhetaton (Fig. 41 and Plate 185).

In contrast to the Theban tombs the position of the person for whom the tomb was made is consistently made less important in the tombs of Akhetaton. Significant and systematic emphasis is focused on the king and his family under the rays of the Aton-disk. There is a continual stressing of the idea that Akhnaton as the only 'Son of Aton' is the intermediary between God and Man, and likewise that this one God has 'created the earth' for his 'Son' (Akhnaton) and the 'Great Royal Spouse' (Nefertiti). So it is understandable why Nefertiti and her children are present at all activities concerning the king. The relief in Ay's tomb in Akhetaton underlines this point very noticeably when it shows the king standing with his family at the Window of Appearance of his palace, together with his wife and daughters throwing gold chains as rewards to the high dignitary Ay.

The nakedness of the bodies in the relief just described, and in many others—for example, in the relief from the tomb of Ahmose (No. 3) showing the royal couple kissing in the chariot on the way to the temple, or at the banquet depicted in the tomb of Huy (No. 1)—is proof of the emphasis on realism, sensibility and immediacy, and the recording of intimacies so carefully avoided until that period. It should be noticed that an attempt is made in many reliefs, more than ever before, to achieve a feeling of spatial depth, suggesting a third dimension, and

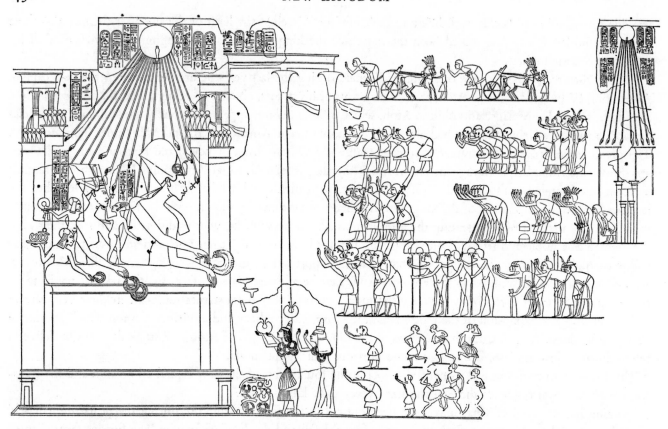

FIG. 41. From the Tomb of Ay at Akhetaton (El-Amarna) (No. 25). Detail drawn from the relief, showing the presentation to Ay of the gold of honour by King Akhnaton and the royal family (cf. Plate 185).

thus to portray the real world, either by means of the marked overlapping of the figures, the converging of sides or by views through actual door openings, as in the relief showing the Nile-lands at Akhetaton in the tomb of Mey (No. 14). Nowhere else in Egyptian art was the rendering of perspective so nearly achieved.

It is noteworthy that Akhnaton, when he had scarcely reached the age of forty-one, appreciated in the last years of his life the threat of political disintegration. Under the pressure of political considerations he abandoned the exaggerated worship of Aton alone with its related over-emphasized monotheism, and attempted to come to an agreement with the priests of Amun and with the old capital at Thebes. For this reason he got his son-in-law Smenkhkare (who was probably also his half-brother) to resume relations with Thebes.

Once more a change in style followed. Just as he had evolved and used 'his art consciously as a means of religious propaganda' soon after the beginning of his reign, 'so now', as Wolf says, 'he recorded his changed spiritual position to the old ways by an artistic volte-face'. The style became again more moderate, free from distortions and over-lapping of figures, and the basic, legitimate style of vigorous Egyptian art found new expression.

A style evolved which approached near to that of the period of King Amenophis III again, and carried on its charm. This is the style which is generally labelled as the 'Amarna style', although it really only applies to work of the last period of the eleven years during which Akhetaton was occupied; it had hardly anything to do with the art actually instigated by King Akhnaton as part of his programme. It is this style to which the important works of the late period of Akhnaton's reign belong, of which the majority came from the workshop of the sculptor Tuthmosis. These include the world famous bust of Queen Nefertiti in Berlin (Colour Plate XXX) and the busts in quartzite of the queen in Cairo (Plate 188) and Berlin, the heads in gypsum of King Amenophis III (Plate 156) and of King Akhnaton (Plate 187), the little heads in quartzite of the royal princesses and of a high official (Plate 189), the exceptionally important statue of a seated figure of Akhnaton in the Louvre (Plate 186) and, not least, the highly interesting stucco masks of which over twenty have survived. The fact that they survived intact in spite of the general devastation of Akhetaton by Akhnaton's opponents is doubtless due to the fact that they were still lying as unfinished works in the sculptor's workshop and thus escaped the wrath of the mob.

They all, and this cannot be sufficiently stressed, exhibit practically nothing of the artistic style systematically planned by Akhnaton in Karnak at the beginning and preached by him in about the first eight years of his period at Akhetaton.

This artistic style from the last years of Akhnaton in Akhetaton formed also the basis of the works of art made during the period of the young King Tutankhamun and of the works which his commander-in-chief Horemheb had made in the neighbourhood of his residence at Memphis. From all these works an essentially direct path led to those executed in the reign of King Sethos I.

180–182. *King Amenophis IV, later Akhnaton.*
Red-brown sandstone, with traces of the blue and red of the original paint. Height of statue, when complete, about 13 feet. The two reproduced are the best preserved of these standing figures remaining to us. Cairo Museum, Nos. 49528, 49529.

From the pillared court of the temple of Aton, which the king had built on the eastern edge of the Karnak area shortly after the beginning of his reign. Fragments of about thirty square pillars have been preserved, but only of some of the statues of the king placed in front of the pillars. They bear the name Amenophis. The crowns of the various statues differ. They are all holding the crook-shaped sceptre and the ceremonial flail in their hands, their arms being crossed over the breast. The profile in Plate 181 clearly shows that the long trimmed beard was in this case an artificial beard fastened under the chin. The king's *nemes* head-dress on the statue in Plate 182 (Cairo Museum, No. 49529) has on either side pieces hanging down in front of the breast which, like one at the back (not visible in the picture), represent plaited locks of hair hanging down like pigtails. The uraeus is set in the middle of the front surface of the head-dress. There are block-shaped plaques on the breast and arms, with the name Aton enclosed in cartouches.

The statue shown in Plates 180, 181 (Cairo Museum, No. 49528) is dressed in a royal apron, the cut of which frankly emphasizes the protuberant belly. Below the navel there is a girdle inscribed with the title and the king's name Amenophis, and these were not changed to Akhnaton even after the complete religious reversal of the year 1358 B.C.

183. *King Akhnaton, Queen Nefertiti and one of their daughters worshipping Aton.*
From the balustrade of the ramp of the temple of Aton in Akhetaton (El-Amarna). White limestone. Height, 3 feet 6 inches. Cairo Museum (unnumbered).

Akhnaton, the beribboned crown of Upper Egypt on his head, and the queen, from whose head a bag-shaped wig is hanging, are holding up offering vessels in each hand. Behind them a princess with braided hair shakes a sistrum. The god Aton in the form of a sun-disk is above them; its rays shine down, ending in hands with which they direct the symbol of 'life' towards the king and queen. In front of the offerers are two offering tables, on which bouquets of water-lilies are lying. These too bend towards the rays of Aton, as described in a hymn to the sun: 'They (the flowers) turn towards his (God's) eye the sun'. The inscriptions give the titles of the royal couple. The costumes are of the period and ignore ritual tradition.

The king carries on his chest and arms the name of the god Aton written in cartouches.

184. *The Royal Family under the rays of the sun.*
Limestone. Height about 1 foot. Berlin, No. 14145.

Scenes like this are portrayed on the middle panels of altars, of the kind set up usually in the dwelling houses of the capital. King Akhnaton and Queen Nefertiti are seated opposite each other on stools covered with cushions, their feet in sandals resting on foot cushions. On his head the king wears the Blue Crown, which on this occasion is surrounded by a diadem of uraei. Queen Nefertiti wears her own high crown, which she almost alone used. A fillet with entwined uraei surrounds it. Three naked princesses accompany their parents; one is caressed by her father, and the smallest plays with the uraei hanging down from the fillet on her mother's crown. Above them the god Aton, as the sun-disk, sends out hands as rays, which hold the symbol 'life' towards the heads of the royal pair. The hood ribbons flutter, as though the family were in the open air in a wind. There is a pile of garlanded wine flagons behind the king.

185. *King Akhnaton with his family at the Window of Appearances of the royal palace.*
From the tomb of Ay (No. 25) in Akhetaton (El-Amarna). Left entrance wall of the Great Hall, which according to the plan was supported by twenty-four papyrus-cluster pillars. Limestone. Height of detail illustrated, about 5 feet 3 inches; that of complete relief (Fig. 41), 7 feet 4 inches by 12 feet 6 inches wide.

Above the lintel of the balcony is the sun's disk, with its rays again ending in hands which hold the symbol 'life' towards the king and queen. The royal pair seem to be completely naked, which allows us to marvel at the lifelike softness in the rendering of the queen's breast. From the cushion-covered window the king and queen with three of their daughters throw down to Ay and his wife, standing below the window, the 'gold of honour' in the form of golden necklaces, vessels and rings, as the reward for Ay's services. The childish, eager gestures of the little princesses behind the queen have been charmingly recorded. The owner of the tomb, the 'Divine Father, Fan Bearer on the right hand of the King and Commander of the King's Stables', despite the high honours he holds, stands submissively, bowing obsequiously before the royal couple—in complete contrast to scenes from the Theban tombs of the times before and after Amenophis IV, when the occupant of the tomb himself was portrayed as the free and great man which he was on earth. Five registers of people at the side of the main scene echo

eloquently the servility of the central theme. In a smooth line, twisting like an S-curve, everyone bows towards the royal couple; the bows get deeper as the rank of the individual gets lower. The topmost register consists of charioteers, then follow scribes, office holders and other important courtiers, behind them the palace guards and the soldiers. Directly level with the royal pair stand a high priest of the temple of Aton, a vizier and the highest-ranking fan bearers. Below in two registers, actually arranged one above the other, but conceived as being one behind the other, come the servants, jumping in the air like small boys in their excitement over the gifts of their master. The pylon of the temple of Aton completes the picture on the right.

186. *King Akhnaton.*
Part of a group. Steatite. Height 2 feet. Probably from the workshop of the sculptor Tuthmosis at Akhetaton. Paris, Louvre Museum, No. N.831.

This is a part of a group of the king with his wife Nefertiti. The queen's figure may well have been removed by royal command in view of the separation of the royal couple, which took place in the last years of Akhnaton's reign. After the quarrel the queen went to live in a palace of her own at Akhnaton, the so-called North Palace.

In many ways the face recalls that of the statues at Karnak, everything is so subdued and ennobled. We see here not a fervent spirit but rather a man whom life has rescued from the abyss into which his religious fanaticism had driven him, a face which a great artist during the very last years of the Akhetaton period has endowed with nobility and the goodness of a prophetic sage.

187. *King Akhnaton.*
Gypsum, partly painted. Height, about 10 inches. The edges of the eyelids and eyebrows are marked with black colouring. Thin black lines have been drawn round the eyes and from the nostrils to the corners of the mouth. From the studio of the sculptor Tuthmosis at Akhetaton. Berlin, No. 21351.

This excellently preserved head of the king is a simple portrait, but ennobled, peaceful, free from the fervour of a fanatic, showing rather a simple man amongst men. This makes a complete contrast to the 'Prophet's Head', which is also in the Berlin collection (No. 21348) and which comes from the same workshop: the latter captures the 'essence of the religious thinker and the enthusiastic prophet'. But the artistic achievement shown in the head illustrated here is due to the fact that by each approach nearer lifelike reality this head is raised to a significant and immortal vital form, a form which had already found its expression in the best works from the period before Amenophis IV, and which comes to life again here.

188. *Queen Nefertiti.*
Brown quartzite, with traces of colouring. Height 13 inches. Cairo Museum, No. 59286.

Found in 1933 in a house at Akhetaton during excavations carried out by the Egypt Exploration Society. Undoubtedly a work dating from the last years of artistic activity in Akhetaton. Clearly the back of the head would have been covered by a head-dress of some other material.

Marks of a chisel can be seen all over the unfinished work, and many of these have not been fully removed. The brows, edges of the eyelids and headband are marked in black colouring.

This comparatively late addition to the known portraits of the queen is another fascinating one, which is quite unsurpassed in the nobility of its appearance and character; it belongs to the greatest achievements of Egyptian art.

Colour Plate XXX. *Queen Nefertiti.*
Limestone, painted. Height about 20 inches. Berlin, No. 21300.

This bust, famous throughout the world for its beauty, comes from the studio of the sculptor Tuthmosis at El-Amarna. It is in fact a workshop model but made with the very greatest skill. That it was only meant for a workshop model explains why only the right eye of the head was fully inlaid. The inlay of the eye consists of a flake of rock crystal over a flat paste of black wax colouring. The crown is blue, the head band yellow, the ribbons round the crown and shoulders are multi-coloured. The eyebrows and edges of the eyelids are black, the lips very red. There is a fine wrinkle on the upper lids. The crown is one seen almost only on Nefertiti.

The erect posture of the head is perfectly balanced by the angle of the profile. In this the powerful, stiff crown, thrown far back, makes a bold contrast to the slender, astonishingly delicately arched neck, which leads up to the noble profile of the face. In a face which is equally fascinating from every point of view, the spectator is captured not so much by its grace as by the interplay between the rather bold symmetry of its shape and the nervous tension of the expression, which seems to vary from moment to moment.

189. *Head of statuette of an official.*
Painted limestone. Height 5¼ inches. Berlin, No. 14113.

This delicate little head, with its youthful, gentle expression, rests on a neck stretched forward in a striking manner, which is strengthened by a filling above the neck. The eyes are painted black and white, the lips red, the skin reddish brown. Previously considered to be the portrait of a princess, this charming, noble work has recently been classified as a fragment from a statuette of an official. The rounded back of the head, jutting far out, was a favourite device of portrait artists down to the Late Period in Egypt. This feature is very striking in works of art from Akhetaton, particularly in portraits of the royal princesses, both in heads sculptured in the round and in reliefs (cf. Plates 184, 185). The head of the young official lacks the strange bulges and hollows which make the best representations of the princesses seem so true to life.

190, 191. *Gypsum masks from the studio of the sculptor Tuthmosis in Akhetaton (El-Amarna).*

Concerning masks in general it seems that they were produced when a model was made in clay from life. As clay in the dry air of Egypt crumbled in a very short time, a plaster mould was prepared from the clay model, while the clay model was still damp. This gypsum mould, or negative, was then used in its turn to create a gypsum

Theban plain, on the boundary line between the cultivated zone and the desert mountains, from the time of King Amenophis I (see Fig. 26, page 427).

At the extreme western end of the Theban necropolis, almost diametrically opposite the Valley of the Kings and lying at the foot of the steep towering cliffs which surround it, is the dramatic—one might almost say menacing —valley cul-de-sac 'Biban el-Harim', the Valley of the Queens' Tombs. It does not only contain the tombs of queens, as its name implies, but also the tombs of royal princes, like the four sons of Ramesses III. Of these that of

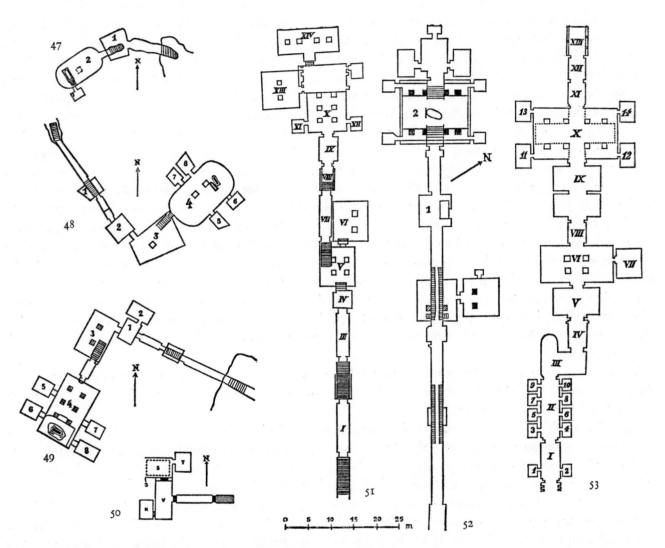

FIGS. 47-50. Kings' Tombs from the Eighteenth Dynasty.—
Fig. 47. Tomb of King Tuthmosis I (No. 38). 1: Antechamber. 2: Sarcophagus chamber.—Fig. 48. Tomb of King Tuthmosis III (No. 34). The tomb, which lies in a steep ravine, has its entrance very high up. A steeply sloping corridor and connecting stairway lead down to a shaft which is 16 feet deep. 3: Antechamber, containing a list of 741 divinities and demons. 4: Sarcophagus chamber with two pillars. 5-8: Side rooms.—Fig. 49. Tomb of King Amenophis II (No. 35). Steep stairs and corridors which go deep down. 1: Shaft, and at its bottom, a room (2). 3: Antechamber. 4: Burial chamber with a deep-lying crypt (Plate 150 upper), in which the sarcophagus was placed (Plates 150 lower, XVIII). 5-8: Side rooms.—Fig. 50. Tomb of King Tutankhamun (No. 62), drawn to scale like the other tombs in order to emphasize its smallness. Cf. Fig. 42, page 462. Scale 1:800.

FIGS. 51-53. Kings' Tombs from the Nineteenth and Twentieth Dynasties.—Fig. 51. Tomb of King Sethos I (No. 17). The finest

of the kings' tombs with important reliefs and paintings. I-III: Corridors and flights of steps. On the walls of II: Isis (Plate 217) and Nephthys. IV-VI: Antechambers. In VI the two pillars with the preliminary sketches drawn on stucco (Plate 219). VII and VIII: Corridors. In VIII a representation of the ceremony of 'opening the mouth'. IX: Antechamber. Reliefs of Sethos I in front of various gods of the dead (Plate 218). X: Hall of Pillars. On the walls, pictures of the kingdom of the dead from the Book of the Gates (cf. page 475). On the six pillars, reliefs of King Sethos I before Osiris-Khentamenty. In the background the alabaster sarcophagus, now in the Soane Museum in London, stood in a somewhat lower part (cf. Plate 220 upper). XI and XII: Side rooms (cf. Plate 220 lower). XIII: Offering chamber. XIV: Unfinished room.—Fig. 52. Tomb of King Merenptah (No. 8). 1: Antechamber. 2: Pillared hall, with its middle nave roofed by a barrel-vault.—Fig. 53. Tomb of King Ramesses III (No. 9). X: Pillared hall with the royal sarcophagus, which is now in the Louvre in Paris, its lid at Cambridge. Scale 1:800.

Prince Kha-em-weset (No. 44) and of Prince Amen-her-khopeshef (No. 55) deserve to be mentioned for their unusually well preserved and extensive tomb paintings. Then there are the tombs of unknown princesses (Nos. 36 and 40), that of the mother of King Sethos I, Sitre (No. 39), and of the mother of King Ramesses VI, Ese, and also that of Queen Titi, the wife of one of the later kings named Ramesses. The best of all the tombs is No. 66, that of Queen Nefertari, which was built for the most favoured of the four main wives of King Ramesses II (see Colour Plates LV–LVIII).

The construction of royal tombs varies considerably in details, but as regards the generality, certain rules can be observed. From the entrance, three corridors normally lead one after the other to the lower level. Small rooms are sometimes found leading off these corridors, or niches for the articles needed by the deceased. Often in the middle of the corridors we find deep shafts, the primary purpose of which was to prevent the entry of tomb thieves, but which also served to catch water that had seeped down. In the simplest kind of tomb there is then one antechamber leading to the main chamber of the tomb. In more elaborate tombs, however, several rooms lead into each other until the main chamber is reached, the roof of which is generally supported by pillars. The royal sarcophagus is placed in this, generally in a slight depression in the floor. There are often side rooms leading off this main room. Figures 47–50 and 51–53, all drawn to scale, show the various dimensions of the tombs.

The shape of the room containing the sarcophagus is in very many instances a transverse oblong. Its shape in plan in many tombs is reminiscent of the royal cartouche, as in the tomb of Tuthmosis I (Fig. 47) and of Tuthmosis III (Fig. 48). The change of direction of the axis in the older tombs is interesting: for example, in the tomb of Tuthmosis I (Fig. 47), Tuthmosis III (Fig. 48) and of Amenophis II (Fig. 49). The ground plan of the tomb of King Amenophis III and the unfinished tomb of King Tuthmosis IV even show a double change of direction, the former being shaped like an S, while the second turns back in the same direction as it started. The tomb with the greatest length is that of Queen Hatshepsut (Tomb No. 20). It is 693 feet long and its series of corridors go down 315 feet deep. Its length is largely made up by the corridors, twice interrupted by stairways. They run more or less in the shape of a half-oval, and they end in the antechamber. From this room another stairway leads to the burial chamber, the roof of which is supported by three pillars, and which is connected with three side rooms.

With the beginning of the Nineteenth Dynasty it became customary for the axis to run in a straight line from the tomb-entrance to the burial chamber as can be seen in the plans of the tombs of Sethos I (Fig. 51), Merenptah (Fig. 52) and Ramesses III (Fig. 53).

According to the ancient Egyptian idea, during the night the dead king travelled through the underworld in a boat together with the sun-god. The walls of the burial chambers were accordingly decorated with pictures and texts intended to describe this voyage and to help the king on his way. These pictures and texts in the tombs are based on works of the ecclesiastical literature dealing with the world to come.

The tombs provide a generalized image of the hereafter, where the dead man is now waiting, in which the subject of the underworld is treated in accordance with a specific dogma. E. Otto, in his book *Osiris and Amun*, has described it thus: 'It is the journey of the sun through the twelve hours of the night, which correspond to the twelve regions of the underworld. The sun-god enters the underworld in the west in the shape of a ram. He stands on his bark in a shrine, which is surrounded by the protecting "entwining" serpents. Spirits draw the bark from region to region. On his journey the sun-god brings light and life for the duration of one hour to the dead men waiting in that particular region. At times he settles the apportionment of offerings and receives homage. Directly he leaves a region, its inhabitants sink down again into darkness and slumber. By morning at the twelfth hour he reaches the eastern horizon, which he crosses triumphantly—changing himself into the shape of a scarab beetle—in order to rise again as the sun of the new day.'

The pictures and texts in the tombs are based on the books of priestly literature, which are as follows:

The *Book of what is in the Underworld* or *Amduat* consists of twelve parts, the underworld being conceived as divided into twelve caverns corresponding to the twelve hours of the night. In each of these is a river, along which the ram-headed sun-god and his attendants travel in the sun-ship, bestowing light and life on all around for a short while. Monsters, demons and spirits, crowding on the banks, greet the sun-god as he passes and hold off his enemies.

The journey of the sun-god through the twelve parts of the underworld is similarly described in the *Book of the Gates*. Between the various parts of the underworld were fortified gateways, the guardians of which were gigantic serpents, whose name the dead king had to know. Two serpents vomiting fire and two gods protected the entrance and greeted the sun-god.

The hymn in praise of the sun-god occurs originally in the *Hymn to Re*. On entering into the underworld the deceased had to call the sun-god by his seventy-five names. The hymn is found only in the first two corridors of the tomb.

The manner in which the sun-god speaks in the presence of the spirits and monsters of the underworld is explained in the book of *The Sun-God's Journey through Hell*.

Also relevant to the representations of the hereafter described above are the scenes of ceremonial rites, which, like the 'Opening of the Mouth', concern the rebirth of the dead man; also scenes illustrating ancient legends of the gods, as, for example, the one in the tomb of King Sethos I.

The group of books, somewhat didactic in purpose, which describe the topography of the hereafter, such as the first two books mentioned above, includes also the so-called *Book of Two Ways* and the funerary papyrus of the singer of Amun Djed-maat-is-ankh, dated to the Late Period, the contents of which are linked with the first of the books mentioned, and from which the beautiful and well preserved vignette reproduced in Colour Plate XLVII is taken.

NINETEENTH AND TWENTIETH DYNASTIES

NINETEENTH DYNASTY (1306–1186 B.C.)

Kings: *Ramesses I* (1306–1304 B.C.), *Sethos I* (1304–1290 B.C.), *Ramesses II* (1290–1224 B.C.), *Merenptah* (1224–about 1204 B.C.), *Sethos II*, *Siptah*, *Queen Twosre*.

TWENTIETH DYNASTY (1186–1085 B.C.)

Kings: *Sethnakhte* (1186–1184 B.C.), *Ramesses III* (1184–1153 B.C.), *Ramesses IV–Ramesses X*, *Ramesses XI* (at the latest 1112–1085 B.C.).

The new ruling line, which covered the entire Nineteenth and Twentieth Dynasties, was descended from an officer's family of Lower Egypt. At the beginning of the Nineteenth Dynasty the capital of the kingdom was transferred finally to the north, actually to the site of Avaris, the former stronghold of the Hyksos, in the eastern Nile Delta, south of the lake of Menzalah; it was named Piramesse, 'the House of Ramesses'.

Efforts to re-establish Egyptian hegemony over Syria led to an outbreak of hostilities with the kingdom of the Hittites, which stretched over the centre and south of Asia Minor, and which for its part was trying to expand ever further southwards in the direction of Syria. The subsequent outbreak of war between the young King Ramesses II and the Hittite King Muwatallish, which culminated in the Battle of Qadesh on the Orontes, was brought to an end in 1269 by a treaty between the two kingdoms, signed by Ramesses II and Khattushilish III.

From the period from King Merenptah to Ramesses III Egypt had to fight to survive against the Libyans in the west and the so-called Sea Peoples, who were pressing in on Egypt from the north-east and from the sea. Though the kingdom managed to survive intact through these wars, the heavy fighting completely drained its economic strength.

Owing to these campaigns it became necessary to use foreign mercenaries and to settle them on the land. Lower Egypt in particular, where the new royal residence was situated, was especially affected by this, with two consequences, the results of which came to light much later, and which characterized the period at the end of the

Twentieth Dynasty: these were the secularization of the kingdom and the reactionary attitude of the former residence, Thebes.

As early as the reign of the art-loving King Sethos I an enormous outburst of building activity took place. Thus at Karnak the Great Hypostyle Hall was erected in the temple area of the imperial God Amun (cf. Figs. 56–59) and at Abydos the construction of the temple of the king (Plates 222–229, Colour Plates XLVIII–LI) was undertaken. This latter temple contains a celebrated series of reliefs, which are perfectly preserved; in their beauty they rival those in the same king's tomb at Thebes (Plates 217–220, Colour Plate XLVI). A completely unprecedented spate of building activity, both in the number of monuments and in their size, followed during the reign of Ramesses II. The most striking works of this king, whose reign lasted 66 years, are: the completion of the Great Hypostyle Hall at Karnak (Plates 230, 231, Colour Plates LII, LII), and of the Amun-Mut-Khons temple at Luxor (Plates 236–239), the buildings at Tanis and Memphis (which included the recumbent colossal statue of Mit Rahina, part only of which has been preserved, Plate 240), the funerary temple at Thebes, generally known as the Ramesseum (Plates 241–246) and the rock temple at Abu Simbel (Plates 247–250). From the reign of Ramesses III it is only possible to mention here his splendid funerary temple, remarkably well preserved, which is at Medinet Habu at Thebes (Plates 253, 254).

To supplement the very bare outline given above, further consideration should be given to details of parts of the history of the Nineteenth and Twentieth Dynasties and to some of the facts and problems which were of very great consequence during this period.

Disregarding all tradition, Horemheb selected as his successor to the throne of the pharaohs a man named Paramessu, who came from Lower Egypt, probably from Avaris, the old Hyksos stronghold in the north-eastern Delta; he was the son of Sethos, a commander of the archers, and hence a high-ranking officer. Horemheb did this because this active man was completely independent of the intriguing cliques of the Theban priestly hierarchy and of the relations of the old royal house. He would certainly be able to assume the leadership of the state and to rebuild its foreign policy, which had collapsed. Even while Horemheb was still ruling, Paramessu was appointed commander of the archers, charioteers and infantry, overseer of all the foreign countries, and simultaneously vizier and overseer of the prophets of all the gods, thus combining all the highest military, political and financial offices of state in his own person. Thus on Horemheb's death he ascended the throne as Ramesses I with no opposition. Under him, in the form of a new era, were accomplished the plans, already conceived by Horemheb as the basis of a successful foreign policy, to loosen the ties with Thebes, and to transfer the imperial capital to the northern half of the country, to Avaris, which now entered history as the 'House of Ramesses'. After the collapse of the Ramesside kingdom the town was known as Tanis. Now Lower Egypt could become the operational base for all foreign policy and strategic decisions, all matters which were the business of the capital of the kingdom. Only from here, even on a path beset by war, could connexions again be resumed with the world of the eastern Mediterranean and with the Near Eastern peoples of the north-west.

The removal of the political capital to the north was in no way intended to reduce the existing cultural importance of Thebes as the city of the King of the Gods, of the imperial god Amun, or as the necropolis of the pharaohs; it was not to forget its 'past that had become sacred'. On the contrary, Thebes remained the cultural centre of the kingdom.

When Ramesses I died, after a reign lasting one and a half years, the throne was transferred to his son, Sethos I, by the usual method of succession. The kingdom was stable. But Phoenicia was still not in Egyptian hands. Syria itself never again came under Egypt's overlordship, and still less did the area of the Euphrates, although in the past the Euphrates had been reached by Tuthmosis I, and Tuthmosis III had been even more successful in that area.

The 66 years' reign of the son of Sethos I, Ramesses II, together with the reign of the latter's son, Merenptah, marked the political as well as the cultural peak of the new era. Yet it seems as if these highly energetic, active monarchs pursued their aims so relentlessly that the strength of the Nineteenth Dynasty was exhausted and,

with it, that of the kingdom too, though indeed only temporarily. Not until Ramesses III, the second pharaoh of the Twentieth Dynasty, did a ruler of any great stature appear again on the scene. The kingdom finally collapsed under Ramesses XI, the last ruler of the dynasty, in spite of his vigour and political acumen.

The problems and dangers encountered in foreign affairs during the span of both dynasties were numerous and difficult; they were to increase further, as will be shown, in the course of the long period of more than 200 years covered by these two dynasties. The problems in internal affairs were no less grave and threatening, in spite of the brilliance of the reigns of Sethos I, Ramesses II and Ramesses III.

Taking a somewhat closer look at the problems of foreign policy, it can be seen that though Sethos I had succeeded with three campaigns in bringing back Palestine and Phoenicia into Egypt's grasp, yet Syria remained as before within the sphere of influence of the Hittite Kingdom. It was just this state of affairs that constituted the next really threatening danger for Egypt.

In 1285 B.C. the two sides confronted each other before Qadesh on the Orontes. On one side was Muwatallish, the Hittite king, with a coalition of princes from Syria and Asia Minor, and on the other King Ramesses II, from whom the initiative of the campaign had come, at the head of his four armies, named after the gods Amun, Re, Ptah and Seth, together with mercenaries from the ranks of the Amorites and the Sherden. At the beginning of the battle the Hittites succeeded in cutting off Ramesses II from three of his armies, and the battle is no tribute to the generalship of the young king, though it brought him great fame for the courage he displayed which enabled him to avoid defeat. Both armies withdrew undefeated from the battlefield. Although Ramesses II soon afterwards returned to the Orontes and took Tunip, the limits of the overlordship of both kingdoms still remained the river Nahr el-Kelb, the mouth of which lies just north of present-day Beirut.

In 1269 B.C., the twenty-first year of his reign, Ramesses II made an Egypto-Hittite peace treaty with the young Hittite king Khattushilish III. The original text was engraved in cuneiform on a silver tablet. Two monumental copies exist, one in the Amun temple at Karnak and the other in the royal funerary temple at Thebes. Several clay copies have been preserved in the archives of the Hittite capital Khattusha (the modern Boğazkoy). This 'eternal' peace treaty drawn up between the two kings was a measure actuated by common-sense, though it is also a tribute to the clear political thinking and very statesmanlike feeling of responsibility on the part of the two signatories to the treaty. From the Egyptian point of view, however, the distance of the central territory of the Hittite Kingdom from Egypt was too great to carry out a war really effectively; and on the Hittite side, ever since the accession of Khattushilish III, the Assyrians had threatened the flank of his kingdom on the east, while the Peoples of the Sea, breaking in on ceaseless forays from the area of the Black Sea, threatened his kingdom from the north. And it was these same Sea Peoples who unleashed the threat to Egypt on the west of the Nile Delta through the Libyans, a tribe related to the Berbers. This threat was made even more dangerous by the social and economic difficulties which at that time were brewing inside the kingdom. Everything seemed to call for the whole strength of the next generation to be retained for defence against incalculable dangers. 'Witnesses and guarantors of the peace treaty are the Gods of Egypt and of the Hittite kingdom, who guard the promise of eternal friendship and will punish whoever breaks the treaty.'

In the thirty-fourth year of his reign King Ramesses II sealed the peace treaty by his marriage to Naptera, a daughter of Khattushilish III. The event is recorded on several commemorative stelae: the text dwells at length on Egyptian superiority over the Hittites, but then records that the dispatch of the daughter of the Hittite king was regarded as a miracle, performed by the creator god Ptah for Ramesses II. The position in Egypt accorded to the young Hittite girl was much higher than that of the 'Great Royal Spouse', and she seems to have held equal rank with the king himself.

The text quoted below is from the commemorative stelae at Karnak, at Elephantine near Aswan and at Abu Simbel. First it records the decision of the Hittite king to marry his daughter to Ramesses II, then the honouring of the embassy from the Hittites by the dispatch of an Egyptian escort for the convoy bringing the bride, and the prayer of King Ramesses to Seth, the god of the foreigners, for good weather. Then comes a description of the procession of the combined Hittite and Egyptian escort through Syria, and finally of the arrival of the princess in Egypt, and the concluding lines, again somewhat bombastic in style.

Then the great chief of Khatti wrote appeasingly to his Majesty year after year.

But the King Ramesses paid no attention to them. And when they saw that their land was in that wretched state under the great power of the Lord of the Two Lands, Ramesses, then spoke the great chief of Khatti to his army and to his lords:

'What is this? Our land is devastated. Our lord Seth is angry with us. The sky gives us no rain since we have been fighting. Let us then strip ourselves of all our property; and first of all my daughter. Let us bear gifts to the good god, that he may give us peace, so that we may live.'

Then he sent his eldest daughter, and precious tribute before her: gold and silver and many strange wonderful things, innumerable spans of horses, bulls, goats, sheep by the ten thousand, the products of their land without end.

It was announced to his majesty:

'See what the great chief of Khatti does. His eldest daughter has been brought with many gifts of all kinds which grace the place where they are. The daughter of the chief of Khatti and the nobles of Khatti bring them. They have passed many mountains and difficult passes, and have reached the borders of his Majesty. Send an army and nobles to receive them.'

His Majesty rejoiced; the Lord of the Palace was in joy when he heard this unusual report, such as had never been heard before in all Egypt, and he sent an army and nobles to receive them quickly.

Then his Majesty took counsel with his heart: 'What is the position with those whom I sent to go on a mission to Syria on those days of rain and snow which happened in the winter?' Then he made a great offering to his father Seth, and besought him as follows: 'The heavens are in your hands, the earth is beneath your feet, what you command happens. Can you stop the rain and the wind of the north and the snow, until the wonders that you have commanded for me reach me?'

Then his father Seth heard all that he said. The heavens were at peace again and days of summer came. His army went forward, their limbs released and their hearts rejoicing. The daughter of the great chief of Khatti marched on towards Egypt. The army, chariotry and nobles of his Majesty conducted her,

mingling with the army, chariotry and nobles of Khatti, Syrian troops, infantrymen, his chariotry and all the people of the land of Khatti, mixed up with the Egyptians. They ate and drank together, and were of one mind like brothers who are not opposed to each other; peace lay between them, in accordance with the plan of the god himself.

The chiefs of every land through which they passed, turned aside, turned their backs, or fainted when they saw all the people of Khatti mixed with the army of the king Ramesses. These chiefs said, one to another: 'It is true what his Majesty has said How great is this which our own eyes have seen! All lands are with him, serving him, in one accord with Egypt. What was the land of Khatti? See! It has become his like Egypt. And even the heavens, they are under his seal and do whatever he wants.'

(After some days) they reached the Residence of Ramesses bearing great wonders, the fruits of valour and might, in the thirty-fourth regnal year, in the third month of winter. Then the daughter of the great chief of Khatti who had journeyed to Egypt was brought into the presence of his Majesty. Very great presents without number came after her.

Then his Majesty saw that she was as beautiful of face as a goddess. And it was a great, mysterious happening, a perfect wonder, very strange, such as never had been mentioned from mouth to mouth, and never called to mind in the writings of the forefathers.

The daughter of the great chief of Khatti was beautiful in the heart of his Majesty; he loved her more than anything, as something lovely he had received from his father Ptah. He made her name Queen Maatneferure (that which the beauty of Re sees)—the daughter of the great chief of Khatti, daughter of the great chief of Khatti.

It was an unusual and unknown wonder that happened to Egypt through his father Ptah, who granted it to him as a sign of victory. The land of Khatti lay pacified beneath the feet of his Majesty. Now when a man or a woman went on business o Syria and arrived in the land of Khatti, there was no fear in their heart, since the power of his Majesty was so great.

The threat to the Egyptian borders, on the one side from the Libyans in the west and on the other from the so-called Sea Peoples from the north, has already been referred to.

The danger from the Libyans first showed itself as early as the reign of Sethos I, and it forced him to wage a campaign in the second year of his reign. This threat flared up anew during the reign of Ramesses II, when forts were made over a distance of 250 miles from Alexandria to Umm el-Rakham. This great king seems already to have appreciated the danger fully. It was in fact a migration of the race from whom the Berbers are doubtless descended. This explosion of the Sea Peoples caused one group of them to pour from the departure point on the Black Sea, and part of this group went through Asia Minor and on into Phoenicia, but another part went into the Balkans and from there across the Aegean into the area of Libya. Meanwhile the other group, which will be mentioned again later, had marched directly to Asia Minor and had overrun and destroyed the Hittite kingdom shortly before 1185 B.C., and from there, pressing on across Phoenicia, threatened Egypt from the north.

Their first battle of any importance did not take place until 1219 B.C., the fifth year of Merenptah's reign. The Libyans, after heavy losses, suffered a complete defeat north-west of Memphis. By the time Ramesses III was ruling, new Libyan coalitions were being built up, and in 1179 B.C., the fifth year of his reign, the king was forced

to undertake a great defensive battle not far from Memphis, and then again, but conclusively this time, in 1173 B.C., the eleventh year of his reign. This battle broke the strength of the Libyans. In the temple of Ramesses III at Karnak, on the south side of the Great Court (between Pylons I and II) and in his temple at Medinet Habu in Western Thebes, on the façade of the tower of the First Pylon as well as on the south-west wall of the Second Court, there are written accounts and monumental reliefs of these victories which, together with the victory of Merenptah, had saved the Egyptian Kingdom from the danger of being invaded and destroyed. If there was still a Libyan infiltration after that, from 1173 B.C. onwards the character of their penetration had altered. It speaks much for the political insight of the king that from that time onwards the conquered people were drawn into the Egyptian tradition and assimilated into the Egyptian way of life. It is not surprising that with Sheshonq I a member of a Libyan princely family ascended the throne of the pharaohs in 950 B.C. and founded the Twenty-second Dynasty (the so-called Bubastite dynasty).

This same monarch, Ramesses III, who had finally beaten the Libyans in 1173 B.C., also gained the decisive victory over the Sea Peoples. Though he suffered the loss of Phoenicia, which was useful as a frontier area, Ramesses III, in 1176 B.C. by means of a land victory together with a victorious sea battle just off the mouth of the Nile, was able to overthrow the coalition of Sea Peoples composed of Philistines and several other races, and to save Egypt from the very real danger of being completely swamped by the movement of the people from the sea. There are also reliefs recording this sea victory at Medinet Habu. In spite of the victories of Ramesses III, any possibility of pushing back the borders of the kingdom even gradually to the north faded away. Evidently the offensive strength of the country was utterly exhausted by the defensive battles, even though these had been successful. Furthermore their opponents, by the use of iron weapons, possessed a superiority of arms which could no longer be equalled. To that must be added the factor that internal conditions had already become so difficult that from then on the stability of the kingdom was in grave danger. It is tragic that Ramesses III, who had saved Egypt several times on the battle-field, in the last peaceful years of his reign fell a victim to a harem intrigue over the succession to the throne, and was murdered in 1153 B.C.

A word should now be said about Nubia. However violent and threatening the defensive wars had been under Sethos I, and even more under Ramesses II, Merenptah and Ramesses III, against the Hittites, the Libyans and the Sea Peoples, conditions remained peaceful to the south of the kingdom, in the Nubian colonial empire where its final conqueror, Tuthmosis III, had advanced as far as Napata near the Fourth Cataract (see Map 2, page 436). Since the beginning of the Eighteenth Dynasty Nubia had been organized systematically into a colonial empire. It was given an excellent governor, largely independent, of high military rank and bearing a high-ranking title, the equivalent of a viceroy, the 'King's son of Kush', who depended on his own troops and who had his own administrative machinery. Divided into two regions, the Land of Wawat and the Land of Kush, the former covered the northern area southwards as far as the Second Cataract and corresponded roughly to the area colonized during the time of the Middle Kingdom; the southern area was added by the pharaohs of the early Eighteenth Dynasty: by Tuthmosis I as far as the Third Cataract and, as already said, by Tuthmosis III as far as the Fourth Cataract. Thanks to its loyalty Nubia served as the real source of gold for the kingdom, with rich gold mines in the neighbourhood of the Wadi Alaki in the Land of Wawat. Its peoples and its riches formed a reserve of men and materials, and in the vast defensive wars of the Nineteenth and Twentieth Dynasties it was one of the most important assets of the kingdom.

As a highly intelligent move in colonial government Egypt had brought its elaborate culture into the Nubian colonial empire. From the cultural domination of Nubia by Egypt was evolved that curious Egyptian-Nubian mixed culture of the Ethiopians. From their ranks, after the decline of Egypt, came the founder of the Twenty-fifth Dynasty which, even if only temporarily, was for the last time to unite once again the whole Nile Valley including the Nubian empire under one pharaoh.

Social and economic conditions still remain to be considered briefly. The internal political problems of the two centuries of the Ramesside period are manifold, but they can only be touched upon here.

Owing to the reluctance of the Egyptian to be a soldier the army was largely composed of mercenaries, even

in the earlier centuries. Now, its ever-increasing need for troops led to the danger of an ever-increasing growth in the number of mercenaries; as the mercenaries settled in Egypt with their wives and families, a complete change in the balance between the races resulted. While on the Egyptian side organizational and administrative activity was rated far higher than fighting as a mercenary, an internal conflict inevitably developed during and after the period of the continuous victorious wars described above, when those men who had guarded the kingdom from destruction found their achievements insufficiently valued. The conflict arising in this way was all the more tragic for the entire kingdom, because the militarily active element, who especially by the reign of Ramesses III were largely of Libyan extraction, had by then begun to prosper, in marked contrast to the classes in the state engaged in internal politics and economic affairs, especially the class of priests.

As a large proportion of the economic resources of the country was owned by the temples, and as moreover the Ramesside period in particular saw a marked increase in the temples' property, the relationship between the monarchy, the state and the priesthood should now be considered.

As far back as the period of the Middle Kingdom, and even more by the beginning of the New Kingdom, there were significant ties between the kings born in Thebes and their 'Father', the god Amun of Karnak, the King of the Gods. These ties between the ruling house and the deity—or rather his priests—may have been strengthened still further because the ancestors of King Seqenenre Tao II and his wife Queen Ahhotep, who ruled towards the end of the Seventeenth Dynasty, seem to have been descended from the circle of the Amun priesthood. Ahmes-Nefertari, wife of Ahmose, the first king of the Eighteenth Dynasty, was already 'Second Prophetess of Amun'; and from the time of Queen Ahhotep referred to above, the mother of the Kings Kamose and Ahmose, the princess of the highest rank at any period was accorded the title and rank of a 'Divine Spouse of Amun', a custom that was revived again with special significance during the Late Period, in the Twenty-fifth, the so-called Ethiopian, Dynasty.

As in all likelihood the highest ranking princess was also the queen (as the wife of her brother, the king), the image of the king as the divine son of God took on a completely terrestrial form. The god Amun, in the shape of the king, begot by the queen, his divine spouse, the future heir to the throne, who thus was also of divine birth. Representations of this scene include the reliefs in the Birth Colonnade in the temple of Hatshepsut at Deir el-Bahri and those in the Hall of Birth in the sanctuary of the Amun-Mut-Khons temple at Luxor (cf. pages 431 and 446, and the note to Plate 153 on page 443).

It is obvious that in a period when the prosperity of the state coincided with the religious importance of the god Amun, the political position as well as the economic scope of the temple of Amun grew increasingly important, as did the number of the temple's possessions and its administrative machinery. Otto has described the situation as follows: 'The "Imperial Temple" at Karnak, with its associated temples and the royal memorial temples in Western Thebes, increasing from one generation to another, each equipped with priests and servants, and each possessing land and property in different parts of the country, constituted a religious, political and economic power factor, which it had not possessed to this extent in earlier periods.'

The High Priest of Amun, who stood at the head of this power complex, was, owing to his position, a person of the greatest importance and power. But it should be clearly understood that the high priest was not a priest in the ecclesiastical sense, only an extremely powerful administrative official. It seems very doubtful whether, at any rate by the Eighteenth Dynasty, a difference can be made between 'priest' and 'layman' in Egypt. Anyhow it is certain that in the days of Queen Hatshepsut the High Priest Hapuseneb was simultaneously vizier, and was thus the man who stood at the head of the administration of the Egyptian state and held all the reins of power in his hands.

Again at the beginning of the Late Period the same situation can more or less be observed, namely that there was no practical or theoretical division between the spiritual and the temporal power. Herihor, the first king of Upper Egypt after the break-up of the unified state, was originally the 'Fan bearer on the right of the king', and hence a high-ranking officer. After the death of Ramesses XI, the last Ramesside king, Herihor, was in control of the military power as viceroy of Kush, then obtained the political key post of vizier and the title of High Priest of Amun; and his career reached its peak when he became king.

To return to the Ramesside period, which is our primary consideration now, we find that the temple as the hub of the economic life at this time had more significance than ever before. The temples were no longer exclusively spiritual institutions; instead they were owners and administrators of large estates, as well as managers of the revenues accruing from them and also from the foreign provinces.

Although during the whole of the Eighteenth Dynasty, and even more during the Nineteenth and Twentieth Dynasties, the temples increased from one generation to another their ownership of land by means of royal gifts, of gold and silver by the assignment to them of tribute money, and of men through their allocation as prisoners, yet it was only the Amun temple at Karnak, with its estates, income, precious metals and manpower that resembled a state in miniature.

In addition there were the Theban royal funerary temples, the size and endowment of which increased from one dynasty to another—also the building activities throughout the whole country, such as those of Sethos I at Abydos, and of Ramesses II in Thebes, in Nubia, and elsewhere.

Thus it is clear that the temples formed the centre of economic life, and that less than before were they only spiritual organizations but rather—as it were—purely 'temporal' landowners, receiving incomes from the land and also from the provinces.

Although the imperial capital was situated in Lower Egypt from the beginning of the Nineteenth Dynasty, yet a disproportionately large part of the royal bequests and foundations went to Thebes and not to Avaris, the 'House of Ramesses'. Thus, according to the famous Harris Papyrus, during the period of Ramesses III, out of 107,617 men 86,486, or 80 per cent., went to Thebes, and out of 722,532 acres of land 583,313 acres—again 80 per cent. Only the quantity of gold which Thebes received was noticeably smaller, being in the region of 5 per cent, with about 75 lb. from the total of about 1,500 lb. (=3,648·1 deben). A dangerously large proportion of the entire national wealth came under the direct administration of the temple as the property of the divinity.

Too much attention cannot be paid to the many-sided combination of temporal and spiritual affairs that were united under the temple. As Otto says: 'Religion and cult, land and men, industry and commerce, craftsman and technician, all were combined under the hand of god, the sole owner.'

Owing to the lack of precise data it cannot be stated exactly how large a proportion of the national resources was, as it were, owned by the god and administered by the temples. But the inescapable conclusion remains that really this immense wealth must indirectly have been of use to the king, if only because otherwise the enormous increase in the temples' possessions would have meant an unbearable diminution of the 'royal possessions'. Again Otto has pointed out: 'Both elements, monarchy and temple, had a share in what we call the state, and they both can be considered as being, in the same way, fundamentally religious: behind the economic relationship between the monarchy and the temple stands the religious relationship between the king and god.'

How this carefully balanced system was destroyed when one of the two components achieved supremacy, either as an absolute monarchy or as a theocracy, was demonstrated on the one hand by the heretical despotism of Akhnaton and on the other during the Late Period when the kingdom was disintegrating, in the theocracy which could already be seen emerging during the Twenty-first Dynasty in the concept of the divine state of Amun.

MONUMENTS FROM THE TIME OF KING SETHOS I (1304–1290 B.C.)

Colour Plate XLVI, 217–220. *From the tomb of King Sethos I (No. 17) in the Valley of the Kings.* Cf. Fig. 51, page 473.

In the preceding pages there have already been several references to this tomb. Owing to its size, with a length (to Room XIV) of 325 feet, and to the splendour of its decoration, with its wall-reliefs and wall-paintings mostly in a very good state of preservation, this is one of the most outstanding tombs in the area of the Valley of Biban el-Muluk. From the last of its pillared halls (Room XIV), which is not decorated with paintings like the others, leads a corridor 150 feet long, which doubtless was intended to lead to more rooms, the building of which was never undertaken.

As long ago as October 1817, the tomb was discovered by the Italian archaeologist Giovanni Battista Belzoni from Padua. After a varied career in London, he went to Egypt

in 1815 as an engineer and soon became employed as an excavator. By 1817 he had already opened the temple of Abu Simbel, penetrating the sand dunes which covered the entrance, and in 1818 he excavated the Chephren Pyramid at Giza.

The numerous representations in the tomb of King Sethos I are very striking and follow a continuous theme throughout the tomb; close study reveals the meaning of this theme. The reliefs and paintings illustrate the texts of the most important books, listed on pages 474-5, about the Kingdom of the Dead, particularly the *Book of what is in the Underworld* (the *Amduat*) and the *Book of the Gates*. In other scenes of the highest artistic value, the king is shown in front of various deities. Finally, there are scenes from a very ancient myth of the gods, and a picture of the divine cow.

Below, the thirteen rooms and connecting corridors of the tomb (cf. Fig. 51) are described individually:

Corridor I:

On the ceiling, hovering vultures; on both walls, scenes from the book *Hymn to Re* (cf. page 475).

Flight of Steps II:

In the alcove of the left wall, thirty-seven different scenes of the sun-god taken from the same book, also texts from the *Book of what is in the Underworld*, and on both walls delicately worked reliefs of Isis (Plate 217) and Nephthys.

Corridor III:

Left and right, journey of the sun through the Fourth and Fifth Hours of the Night, from Chapters 4 and 5 of the *Book of what is in the Underworld*.

Antechamber IV:

Sethos I, in front of various gods.

Hall of Pillars V:

On the left and right-hand walls, striking scenes from the Kingdom of the Dead: on the left, the Journey of the Sun through the Fourth region of the underworld, on the right through the Fifth region, from Chapters 4 and 5 of the *Book of the Gates:* with Sethos I on the rear wall with Horus before Osiris on his throne, and nearby Hathor and other gods. On the bottom of the left wall there is also the interesting scene of Horus with each of the four representatives of the 'four human races': Egyptian, Asiatic (with pointed beard and colourful apron), Negro and Libyan (tattooed and with feathers on his head).

Hall with Two Pillars VI:

On the pillars the preliminary drawings, interesting technically as well as first class artistically, for reliefs which were not carved, showing the king in front of various gods (Plate 219). On the walls, Journey of the Sun through the Ninth, Tenth and Eleventh Hours of the Night according to Chapters 9-11 of the *Book of what is in the Underworld*.

Corridors VII and VIII:

Scenes showing the 'Opening of the Mouth' (cf. the description on page 462).

Antechamber IX:

The style of these well preserved reliefs is especially distinguished: they are still coloured in places, and show the king in front of various gods such as Osiris, Hathor, Horus-Harsiesis, Isis, Anubis and others (cf. Plate 218).

Hall of Pillars X:

First the hall of pillars itself: on the six pillars King Sethos I in front of Osiris-Khentamenty (Colour Plate XLVI) and similar scenes in delicately coloured reliefs. On the walls, scenes of the Kingdom of the Dead taken from the *Book of the Gates*.

Behind, the sarcophagus chamber at a lower level. Originally the alabaster sarcophagus of the king was in this room, but it is now in the Soane Museum in London. The mummy of the monarch with its marvellously preserved and delicate head is now in the Cairo Museum, as is also the lid of the mummiform coffin (No. 61019).

On the left wall of the sarcophagus chamber: Sethos I making an offering to Herakhty, and above this (in four rows one above the other) the Journey of the Sun in the First Hour of the Night according to Chapter 1 in the *Book of what is in the Underworld*. In addition, at the end of the wall the scene of the 'Opening of the Mouth' of Sethos I as Osiris by Anubis.

On the rear wall and on the right hand wall the Journey of the Sun in the Second or Third Hour of the Night, according to Chapters 2 or 3 of the *Book of what is in the Underworld*.

On the vaulted ceiling an illustration of the constellations of the stars, accompanied by two groups of gods on each side, one of eleven gods and one of nine (Plate 220 upper).

Side room XI:

Gates and Journey of the Sun in the Third region of the Underworld according to Chapter 3 of the *Book of Gates*.

Side room XII:

Relating an ancient myth of the gods, this shows the rebellion of the human race against the sun-god, their punishment and deliverance. On the rear wall the divine cow supported by the god of the air Shu (Plate 220 lower).

Side room XIII (offering-chamber):

On the entrance wall and on the right wall, also on the left wall and the rear wall, the Journey of the Sun during the Sixth, Seventh and Eighth Hours of the Night according to Chapters 6, 7 and 8 of the *Book of what is in the Underworld*.

Room XIV:

Inaccessible, and with no decorations. From here an entrance leads into the corridor, 150 feet long and not completed, as mentioned above.

Colour Plate XLVI, 217-220.
Individual scenes from the tomb.

Colour Plate XLVI. From the Hall of Pillars. X. From the left-hand pillar of the hindmost pair of the six pillars. King Sethos I in front of the mummiform Osiris-Khentamenty. Limestone relief, painted.

The six pillars in Room X have all four of their sides decorated with coloured reliefs, showing the reception of the dead king by the gods who will watch and guard over his life in the other world. Actually the king always appears in the form of a living being, but is shown to be dead by the appellation 'justified' added after his name.

The relief illustrated here, on which the colour is particularly well preserved, shows the king in front of Osiris-Khentamenty (see page 486 regarding the latter). In the scenes on the other pillars in Room X the gods are shown holding the king's hand in greeting; here this is not possible because of the enclosed form of Osiris. Only the texts written above the figures indicate the relationship of god and king. These read: *The Osiris King Sethos I, justified before Osiris-Khentamenty.* Osiris says: *I give you eternity like Re, that you may appear in the Heavens daily.* Behind the god is a protective form of blessing: *All protection, life, endurance, welfare is behind him, as it is (behind) Re.*

217. *The goddess Isis*, sister and wife of Osiris. On the over life-size head of the goddess is the symbol denoting her, a throne, of which the lower part is visible. Opposite Isis, on the right wall, is her sister Nephthys, goddess of the dead. From the left wall of the second flight of steps (II). Limestone with traces of colouring.

218. *King Sethos I offering wine in spherical jugs to a divinity.* From the antechamber (IX), at the entrance to the third hall of pillars. Limestone with traces of painting.

219. *King Sethos I before Maat*, goddess of truth and righteousness. Maat, the embodiment of that law and order which it was the king's duty to ensure, is holding up to the ruler the symbol of 'life'. The large feather projecting from the band round her hair is her attribute and symbol. Design and draughtsmanship, in their sureness and nobility of conception, reveal the hand of a master. From the first pillar of the hall with two pillars (VI).

220 upper.
From the ceiling of the sarcophagus chamber behind the Hall of Pillars X. Astronomical scenes of constellations, which are flanked on the right side by nine, and on the left by eleven gods. The row on the right side is led by Isis. She is followed by the four sons of Horus—Amsety, Hapi, Duamutef and Qebhsenuef—who both represent the four quarters of the heavens and are the protective spirits of the four Canopic jars containing the viscera of the mummified dead man (cf. page 467). The bull shown in the centre of the celestial scene represents the constellation of the Great Bear. The flat stand supporting the bull is joined to a rope held tautly by the falcon-headed deity Dun-anuy. This rope is meant to represent the axis of the world. In all probability Dun-anuy is intended to represent the constellation of the Swan. The remaining figures, amongst whom the hippopotamus-goddess Hesamut and the lion-shaped Neter-enty-imiuny are particularly striking, have not as yet been identified as particular constellations.

220 lower.
From Room XII. The divine celestial cow with her body covered with stars, and between her front and back legs the two barks of the sun, of which the front one is carrying the god Re. Shu, the god of the air, is supporting the belly of the celestial cow. Eight spirits as symbols of the pillars of heaven surround her legs. This scene first appeared in the tomb of King Tutankhamun (cf. page

466) and is found again in the period of Ramesses II and Ramesses III.

———

Although it belongs to a later period, the following work is included now as it is connected with funerary literature and therefore may well be considered in conjunction with the scenes from the king's tomb.

Colour Plate XLVII. *From the funerary papyrus of the female singer of Amun, Djed-Maat-is-ankh.* Cairo Museum. Late Period.
Since early times Egyptians had been preoccupied by speculation concerning the nature of the hereafter, and their image of it evolved and became more concrete as time went on. Funerary literature forms a considerable part of Egyptian writing. It does not consist only of sayings which were meant to afford the dead man protection from every danger, but also of books of a primarily instructive nature, which describe the topography of the hereafter: these have been mentioned several times already (see pages 474-5 and 482). The funerary papyrus reproduced here is very characteristic, though it comes from a later period, and contains several scenes showing the dead woman making offerings to different deities.

In the top portion, on the left, standing on a balustrade in front of a pile of offerings, is the ram-god, a form frequently used to present the sun when it is being drawn through the underworld. Two demons carrying a serpent are shown moving towards him. The scene on the right shows the dead woman herself, pouring a libation over a mound of offerings in front of six unknown divinities who have animal heads. In the bottom portion, which is the continuation of the part above, there are two scenes of the dead woman making offerings in front of two different representations of Osiris. Behind Osiris in each scene Isis and Nephthys are standing. The space in between the scenes is again filled by demons. The Osiris figure on the right wears the White Crown of Upper Egypt and is described as 'Osiris, Lord of Eternity, Ruler of the Living'. On the left he is shown wearing ram horns and a composite crown, and is described as 'Osiris-Khentamenty, Ruler of Life'. This is the god Khentamenty, worshipped from early times in Abydos, who had been identified with Osiris from the Sixth Dynasty (see also page 486).

———

Earlier when the Theban rock-tombs of the Eighteenth Dynasty were discussed (page 441), a reference was made to the fact that there were also in Thebes a large number of rock-tombs dating from the period of the Nineteenth and Twentieth Dynasties, and decorated with paintings. Two tombs may be selected from these, dating from the beginning of the Nineteenth Dynasty, in which the paintings are thought to have been the most beautiful in the necropolis before they were damaged.

221. *Thebes, from the tomb of Userhet* (No. 51), who under Sethos I was High Priest of the Ka (essential strength) of King Tuthmosis I.
On the west wall of the tomb the dead man and his sisters

The Christians had turned this temple into a church but fortunately not all the magnificent reliefs were destroyed and they still to-day show something of their former charm and colour. Ramesses II, surrounded by the deities of the cataract, can be seen in the sanctuary situated underground, and in its antechamber. One of the most charming of the goddesses in all Nubia is without doubt the aristocratic Anukis, wife of the god Khnum, graceful and wild like the gazelle of the desert. She is shown here wearing the head-dress of tropical Africa, in the role of the divine wet-nurse, with Ramesses II at her breast (Plate 235). By virtue of the immortalizing rejuvenation which the ruler experiences in this way he enters into the eternal cycle. The text accompanying the scene describes the goddess: it calls her here *Mother of the King, Anukis, Lady of Elephantine, who feeds at her breast the Lord of the Two Lands, User-Maat-Re* (i.e. Ramesses II).

234. *Beit el-Wali* in Egyptian Nubia. Beginning of the reign of Ramesses II. Façade of the speos.

Three doors can be seen at the end of the court which is bounded on the north and the south sides by two walls decorated with historical reliefs, illustrating the campaigns of the young Ramesses in Nubia (south wall, on left) and in Asia (north wall, on right). Alterations made when the temple was transformed into a Christian church can also be seen. Originally there was probably one main central entrance, flanked on each side by a small side entrance. When these side entrances were enlarged in Christian times the figures of Amun at the left door, and of Re at the right door, were damaged. The central doorway no longer has its original cornice, but now has an arch cut in the rock by the first Nubian Christians.

235. *The goddess Anukis* offering her breast to Ramesses II.

236-239. *Amun-Mut-Khons temple at Luxor. The great court built by King Ramesses II.*

Earlier, when describing those parts of the Amun-Mut-Khons temple at Luxor built under King Amenophis III (page 446), it was pointed out that the sanctuary complex, together with the actual temple building itself, the great court of pillars in the south-west and the hall of pillars all date from this king, while another great court had been added to the north-east by Ramesses II. A vast pylon, with two obelisks in front of it, was built as the termination of this court, which is the largest in the whole temple area. From this pylon an avenue of ram-headed sphinxes, several miles long, formerly led to the imperial sanctuary at Karnak. Now there are still some of these left in front of the pylon mentioned above at the Amun-Mut-Khons temple, and also in front of the imperial temple at Karnak; they give some idea of this imposing processional avenue. The pylon of the Amun-Mut-Khons temple is still in a very good state of preservation, and it has monumental reliefs on the north-west façades of both its towers illustrating scenes from the Battle of Qadesh (see pages 477 and 493).

The relief on the west wing of the south-west wall of the great court built by Ramesses II shows how this pylon

small temple, which had already been built by the time of Amenophis III, but which is of particular interest owing to the reliefs dating from the later Ramesside period, depicting the birth, circumcision and childhood of the divine child Khons—scenes which touch on a subject that later, in the Ptolemaic Period, occurred in the Mammisi (Houses of Birth).

The temple of Khons, the child of Amun and Mut, has already been referred to on page 490. Like the small temple of Opet nearby, it dates from the Ptolemaic Period, when the imperial temple area was enclosed, but undoubtedly in origin it was part of a self-contained temple complex going back as far as the Middle Kingdom. The design of the present temple, of which the core dates from Tuthmosis III, was made under Ramesses III. His successor, Ramesses IV, together with Ramesses XI and Herihor, the Theban priest-king of the Twenty-first Dynasty, completed it and decorated it with reliefs.

The entrance is formed by a large pylon, where the avenue of sphinxes leading to the temple from the gateway of Ptolemy III Euergetes I (246-221 B.C.) ends (as mentioned on page 494). Next to this comes the great court (A on Fig. 61) with a colonnade, surrounding it on three sides, of papyrus pillars with bud capitals. Adjoining it is the hypostyle hall (B) of basilica-type, in which the pillars of both the middle rows, which have papyrus-umbel capitals, are about 5 feet higher than those of the other two rows, which have papyrus-bud capitals. In the middle of the next room, an enclosed hall (D), is the Holy of Holies (C), with the bark of the god in it. Then comes a small hall with four pillars (E) surrounded by chapels, seven in all. Throughout the building, the heavy, massive pillars are reminiscent of the temple of Amun in the great temple, situated on the south side of the great court between the First and Second Pylons, which was also constructed by Ramesses III.

The place where the temple stands bore the name Benenet, a name which is connected with the Egyptian concept of the primeval hill, and suggests that at the creation of the world the place on which later the temenos of Khons was erected emerged from the primeval ocean as the first piece of land. Put into anthropomorphic terms, it represents the birth of the youthful god; but little is known about the actual significance of the god Khons himself, who was also regarded as a moon-god and the 'wanderer', apart from the fact that he was considered the child of Amun and Mut. Though late Ptolemaic-Roman in its origin, the little Temple of Opet situated nearby, which also bore the name 'House of Birth', is also concerned with ideas about the divine birth. The essence of this syncretism, which is difficult to understand, has been explained thus by Otto: 'A pregnant goddess came here and begged Amun to be allowed to stay here for her confinement; and she bore the divine child at this place. The core of this legend is clearly so riddled with mythological ideas that it can no longer be established which mythical figure it was originally intended to represent. The divine child is called simultaneously Osiris, Horus, Amun and many other names. The crucial point is, however, the theme of this legend, not its theological interpretation.'

Of the buildings on the north of the great temple of

Amun, practically all of which have been very largely destroyed, it is only necessary to mention the temple of Ptah, which is situated close to the perimeter wall surrounding the temple area. Here a small temple was dedicated to human-headed Ptah, the chief god of Memphis, by Tuthmosis III; the Ethiopian Shabaka (716-701 B.C.) and some of the Ptolemaic kings may have restored and enlarged it. Six gateways, ranged one behind the other, some dating only from the Ptolemaic Period, lead the way into the temple with its small court and hall, the roof of which is supported by two columns. At the very end comes the sanctuary, surrounded by three chapels. The middle one of these still contains the old cult statue of the god (of which the head is missing now), while the right-hand one contains the statue of Sakhmet, the consort of Ptah.

230. *Southern portion of the great hypostyle hall seen from the gateway of the Fourth Pylon,* i.e. from roughly east-south-east.

On the right-hand side of the photograph can be seen the southern row of six pillars, with capitals in the shape of open papyrus umbels, from the central aisle of the great hypostyle hall. Beside them is the most southerly of the three high naves; it is flanked on the south by the first row of smaller pillars with bud capitals, and as there is an upper clerestory wall with stone lattice windows running above their architrave and cavetto cornice, the same nave level is reached as that of the middle aisle (cf. Fig. 59). To the left are the southern side aisles completed under Ramesses II, which are separated from one another by rows of pillars with bud capitals, of which seven can be seen in the photograph. In the foreground of the picture is the obelisk which is still standing from the pair erected by Tuthmosis I.

Colour Plate LII. *View across the sacred lake towards the central area of the temple of Amun.*

On the left the Seventh Pylon, built by King Tuthmosis III, is just visible. It is the most northerly one on the processional route between the temple of Amun and the temple of Mut. In the background of the temple area is the First Pylon, its south tower rising high up. In front of this the great hypostyle hall of Kings Sethos I and Ramesses II stands out, clearly distinguishable in the middle of the picture. In front of it fragments, only low now, of the Third Pylon, before which the processional route coming from the temple of Mut turned in. Above the north-west corner of the edge of the sacred lake the memorial stone dedicated to Amenophis III can be seen, with its giant scarab representing the god Khepri, the ancient god identified with Amun and Re. On the right towers the obelisk still standing from the pair erected by King Tuthmosis I, and that of Queen Hatshepsut (the last fairly far right in the photograph). In the background the mountains of Western Thebes can be seen lying beyond the Nile.

231. *In the great hypostyle hall.* View through, taken from the transept which runs from the northern to the southern side doors of the hypostyle hall.

Right at the edge of the picture can be seen the pillars

with bud capitals belonging to the innermost r...
seven northern side aisles. Then come the simi...
which form the outside edge of the most no...
the three main aisles. Above the architrave an...
resting on these pillars is the northern clerestor...
windows (not in plate). The photograph also...
each side two of the pillars which form the cer...
with their capitals shaped like papyrus umbels. I...
the back of the photograph, are the architrave...
and clerestory with its latticed windows from...
row bordering the southernmost of the three mai...

Though the reliefs on the pillars in the main...
the northern side aisles mostly date from the reig...
Sethos I, later Ramesside monarchs also had th...
inscribed here.

INDIVIDUAL MONUMENTS FRO...

232, 233. *King Ramesses II.* From Karnak. Granit...
6 feet 4 inches. Turin, Museo di Antichità, No. ...
This statue has been assembled from fragments...
major additions. Fragments of a second, simi...
from the same site are in the Cairo Museum...

The king is seated on a throne with an espec...
base. A finely pleated dress covers his body and...
upper part of his arms. He is carrying the cro...
sceptre in his right hand, the left is lying wit...
clenched on his thigh. He has sandals on his...
wears the 'Blue Crown' on his head. Little figures...
only to his calves stand on each side of the thi...
of his wife Nefertari and the other of one of th...
the royal pair. Beneath the soles of the king's...
nine bows are carved on the base, symbolizing...
ainty over the traditional nine enemy nations. ...
noted that: 'The problem of giving form to the c...
kingship, rescued from the confusion of the A...
period, and to its renewed significance, is resolv...
most masterly way in the magnificent seated stat...

There is clearly an affinity, even in the style,...
this and the seated figure of the imperial co...
Horemheb, shown as a scribe, from the temple...
at Memphis (Plates 202, 203), but the stylistic...
which had already been initiated in that work...
carried far further. The crown looks as if made...
the pleats of the dress underline the razor-edged...
of the linen, even the face, despite the softness of i...
treatment, is drawn noticeably sharper and c...
outline than that in the statue of Horemheb. A...
of details have been treated differently in order...
up the massiveness of the whole figure here a...
For instance, the right arm, and even more, t...
surrounding the upper arm, protrude from the c...
the whole work, the forearm of the hand hol...
crook is deliberately stressed, and the crook itself i...
the shoulder line and breaks the contour—al...
directed towards a conspicuous but clearly very in...
contrast between the massiveness of the whole fi...
the elements which lessen it. This creates a tensi...
royal statue which, in spite of the youthful, th...
pleasing sweetness of the expression, makes it...

with one of the 'Beautiful Festivals' in the Amun-Mut-Khons temple of Luxor:

The princess, rich in grace, Lady of affection,
Sweet with love, Mistress of the Two Lands,
Beautiful with sistrums in hand,
Whom your father Amun has blessed.

You who are much loved with the Crown,
Songstress of the beautiful countenance, noble with the
 feathers,
Greatest in the harem of the lord of the palace,
By whose utterances one is set at peace.

All that you say, will be done for you,
Everything beautiful according to your wish.
All your words bring contentment to the face,
Wherefore men love to hear your voice.

236. *View of the great court of Ramesses II from the north.*
The first court, 185 feet long and 166 feet wide, has not yet been completely cleared because, built into its north-eastern part, is the mosque of the holy Abu'l-Haggag revered by the Mohammedans. Before this mosque was built the court was surrounded on all four sides alike by colonnades. Between the pillars, which have capitals shaped like closed papyrus umbels, there are the colossal standing statues of the king made of granite: these, as shown in the illustration and in the ground plan (Fig. 35, on page 446), are placed on the south-west side of the court and at the ends of the north-western and south-eastern sides which join on to it. One of the two sitting statues at the entrance to the hall of pillars of Amenophis III is still preserved.

237. *Fragment of a head from one of the colossal sculptured figures of King Ramesses II in the great court.*
It is possible that the head belonged to the ruined one of the pair of colossal seated figures of the king which were placed at the entrance to the hall of pillars of Amenophis III. The head now rests on a base, the complete width of which is barely visible in the illustration, but which is 6 feet 9 inches wide.

238. *Colossal statue of King Ramesses II in the right half of the south-east colonnade.*
On the king's head there was formerly a crown, hewn out of a separate block, which has not been preserved. The 'staffs of plenty' in his hands have ends like circular seals. On the front of the girdle and apron, the king's names. Close to the king's advancing left leg, stands his wife, Queen Nefertari-mi-en-Mut, with an ornamental wig reaching to her breast and a lofty crown of feathers; her right hand is laid gently on her husband's calf. On the lower part of the pillar on the left (belonging to the south-western colonnade) above the stylized plant symbols of Egypt, the king's subjects symbolized by a crouching lap-wing with human arms raised in prayer, worshipping the name of the king placed above the symbol for 'gold' and enframed in the royal cartouche, with the solar disk above it. On the pillar in the centre of the photograph is Amun Kamutef, identified with Min, and behind him Isis. On the column to the right, a figure of Amun in relief can be seen.

239. *Lower portion of a colossal statue of King Ramesses II in the right-hand portion of the south-eastern colonnade.*
Aswan granite. Just as in her statue in the round on the base behind the leg of the colossal statue of Ramesses in Plate 238, the 'great king's wife', Nefertari-mi-en-Mut, is here seen in deep relief on the connecting wall joining the thrust-out leg of the statue to the rear column. Here, in addition to the vulture hood on her head, she also has the crown of feathers with horns and the sun's disk. On the pillar to the left, also shown in the plate, King Ramesses II can be seen offering a sacrifice to Amun.

————

240. *Mit Rahina. Colossal statue of King Ramesses II from the site of the Ptah temple in Memphis.*
This limestone statue was 42 feet long before the loss of its legs. The delicately but at the same time firmly treated features, with the long, finely-balanced nose and smiling mouth, have the characteristics of portraiture. They radiate some of that personal charm of the 'Good God', who once again directed the strength of Egypt to the achievement of a great aim and covered the Nile valley, from the Delta as far as Nubia, with enormous buildings and sculptures. Over the collar, there hangs, from ornamental ribbons, a pectoral in the form of a shrine, bordered at the top by a frieze of cobras. In the middle of this, beneath the solar disk entwined by two cobras, is the king's throne name: User-maat-re Setep-en-re: 'Strong is the just régime of the sun-god; the chosen one of the sun-god'. Turning towards the name within the framework of the chapel are Ptah and Sakhmet, the great divinities of Memphis.

241–246. *Funerary temple of King Ramesses II, known as the Ramesseum. Western Thebes.*

Before describing the funerary temple of King Ramesses II itself a little ought to be said about the Theban funerary temples of the Eighteenth to the Twentieth Dynasties in general, and their religious significance assessed.

As has been indicated already on page 429, a change took place at the beginning of the Eighteenth Dynasty in the form of the funerary cult, which for centuries was to determine the character of the Theban necropolis. This was the separation, carried through under Amenophis I, of the tomb of the king from the place of the funerary cult. Though this king of the early Eighteenth Dynasty was the only one who did not put his tomb in the Valley of Kings but near his mortuary temple in the mountains behind the modern village of Dra Abu'l-Naga, and though this funerary temple, compared with the large buildings of later kings was only modest, yet it was through Amenophis I that the physical separation of tomb and funerary temple was instituted. In this way began that series of splendid funerary temples, becoming with each reign ever larger and more magnificent, which stretched in front of the steep cliffs of the mountains of Western Thebes, beginning in the north and spreading with every successive generation further to the south.

A general comment on the funerary temples of the kings of the Eighteenth to Twentieth Dynasties as a whole, and their relationship to the temples of the gods, has

already been made in the introductory chapter 'Gods and Temples' (page 386). Here it need only be noted that the funerary temples of the kings in Western Thebes were in the first instance temples of Amun, but they present, on account of the cult practices observed in them, 'a complicated mixture of traditional elements and theological speculations'. Because they were primarily temples of the god Amun, the centre of the temple complex naturally belonged to this king of the gods. Already by the time of the Twelfth Dynasty it had become established that Amun came over the river, carried in his bark from Karnak to the Theban necropolis, during the temple festival—the 'Beautiful Feast of the Desert Valley'—described above on page 490; also that both his divine wife Mut and their son Khons should accompany him in their barks and form with him the 'kernel of the procession'. From the Eighteenth Dynasty onwards the arrangements of the rooms in the interiors of the royal funerary temples were ordered with this procession in mind. It is easiest to follow their plans in the funerary temple of King Sethos I at Qurna to the north of the necropolis of Western Thebes (Fig. 62). The centre of this temple is formed by three narrow rooms, one for each of the three divine barks, and by two side rooms running parallel. This division into three is also clearly recognizable in the funerary temple of Ramesses II, the Ramesseum, discussed below: and no less in the funerary temple of Ramesses III at Medinet Habu, which is similar to these two, except that the room for the bark of Amun, as the central point, receives greater emphasis than do the rooms on its right and left for the barks of Mut and Khons.

The cult of the dead king's ancestors, the second important constituent in the arrangement of the funerary temple, had to be given special prominence. The rooms connected with this were generally located on the left— viewed from the entrance—in front of the area occupied

by the divine triad Amun, Mut and Khons. For this, see Fig. 62 again. Moreover the dead king himself was assigned a processional bark—it is not clear from what period or whether it was always so—which, carrying his statue, accompanied the three divine barks in the procession of the Valley Festival.

A final cult element was the cult place for the sun-god Re. The god visible in the heavens had an altar as the place for his worship in an open court of the funerary temple. His cult did not conflict with worship of the imperial god Amun nor with that of the deified father and king. For Re and Amun counted as *one* god, as indeed was indicated by the union of their two names into Amon-Re, practised since as early as the Middle Kingdom. In the same way the dead king at his death returned again to the divine father Amun from whom he had come, and was re-united in him.

The 'false door', the primeval cult element, remains to be considered. This monumental copy of a door was a necessary part of the equipment of tombs even by the time of the Old Kingdom, as it was also in the pyramid temples. Otto has explained: 'It is symbolic, in the fullest meaning of the word. Through it leads the way into another world: the offering placed before it and the prayers brought there are at once transformed through its intervention. Now in the same way this feature plays here (in the royal funerary temple) a mediating role for the dead king, whose corpse rests far away in the Valley of the King, and whose transfigured form waits in the Hereafter.'

It is worth noting that the kings of the later New Kingdom did not hesitate to build their palaces in the immediate vicinity of their mortuary temples. This was the case with Horemheb, and even more for Ramesses II and Ramesses III, whose palaces, still recognizable, were built in particularly close proximity to the first court of their temples.

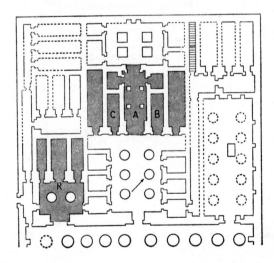

FIG. 62. Funerary temple of King Sethos I at Qurna, Western Thebes. Ground-plan of the western half of the temple; scale 1:800. In the middle (shaded) the three rooms for the cult of the Bark of Amun (A)—in which the supports for the bark have been preserved—of Mut (B) and of Khons (C), also both the side rooms adjoining these on each side. In the southern corner of the western part of the temple (shaded) are the rooms for the cult of his father, Ramesses I, also the Sanctuary (R).

There is not space in this book to examine here all the Theban funerary temples. But at least the funerary temples of Ramesses II and Ramesses III, as examples of temples in the grander style, must be described, especially as both were built to a uniform plan and both have been very well preserved, so that they provide an excellent picture of the whole arrangement of a large Theban funerary temple of the Nineteenth and early Twentieth Dynasties.

Today the ruins of the funerary temple of King Ramesses II are still surrounded by extensive brick buildings (Plates 241–243), which supported a platform on vaults, and clearly were used as dwelling-houses, stables and warehouses. The cartouche stamp on their bricks shows that they too were built in the time of Ramesses II.

The layout of the temple itself (Fig. 63) began in the south-east with a vast pylon 217 feet wide. Its outside is now quite in ruins, its inner façade facing the adjoining first court is decorated with reliefs. These reliefs relate particularly to the campaign against the Hittites in 1285 B.C., waged in the fifth year of the king's reign, and to the Battle of Qadesh. The scenes of the Hittite campaign shown here are extremely vivid: life in the camp with the whole rabble of the soldiery, chatting and brawling

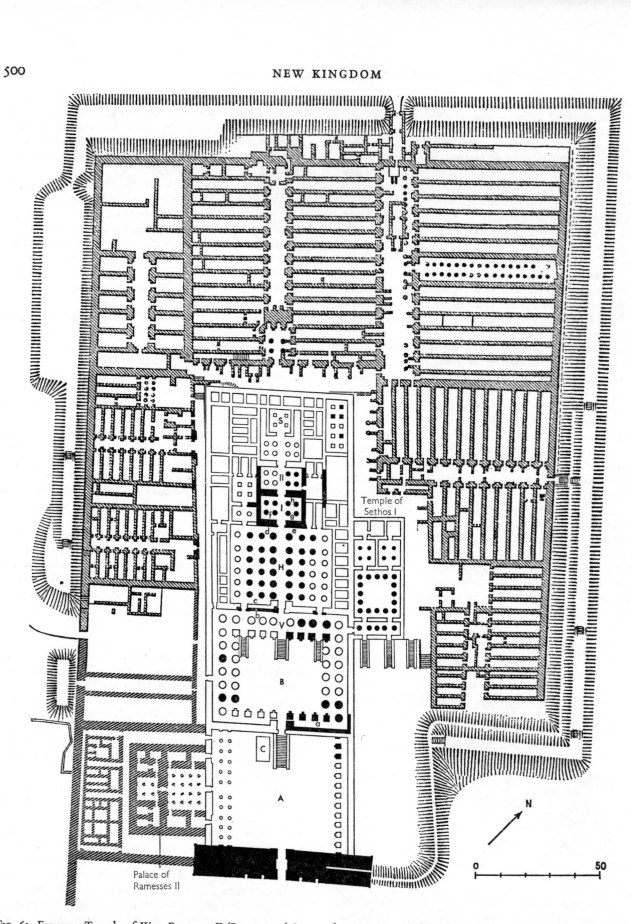

Temple of
Sethos I

N

0 50

Palace of
Ramesses II

FIG. 63. Funerary Temple of King Ramesses II (Ramesseum) in Western Thebes. Scale, about 1:1,500. Within the whole enclosure, the actual funerary temple. A: First Court with remains of colossal statue of king (C). B: Second Court. H: Large Hypostyle Hall. I and II: the two foremost of the three communicating small halls of pillars, and the Sanctuary (S). The latter was intended for the cult and the bark of Amun; the rooms next to it, left and right, served for the barks of Mut and Khons. To the south-west of the temple is the royal palace, to the north-west the Temple of King Sethos I. Surrounding the temple complex the brick buildings for dwelling-houses, store-rooms and stables.

amongst themselves, their donkeys and horses stretching their legs, unharnessed and glad of their freedom; the king's council of war, and the beating of captured spies; and suddenly—paralysingly—the Hittites storming into the camp.

In the first court (A) only parts of its pylon-shaped north-west wall have been preserved. The colonnade which once lay in front of the south-west wall acted also as the front of the adjoining royal palace. On the façade of the north-west wall facing the court there are reliefs of which the lower register shows scenes of the Battle of Qadesh, and the upper register portrays the festival of the harvest god Min, which was celebrated on the king's accession to the throne. This first court still has fragments of what must once have been an unusually large free-standing colossal statue of the king. Its height must have been about 57 feet, its weight about a thousand tons. The chest expanse from shoulder to shoulder measures 23 feet; round the arm at the elbow, 17½ feet; diameter of the upper arm, 4 feet 10 inches; length of the forefinger, 3½ feet; width of the foot, 4½ feet. In spite of its gigantic scale the statue had been fashioned and polished extremely carefully. The saddest loss is that its face has been destroyed. This immense and impressive piece of work was commemorated in a sonnet 'Ozymandias' in 1817 by Percy Bysshe Shelley, who, though he had not seen it himself, had heard of the nobility of the work achieved here and had been deeply impressed by it.

I met a traveller from an antique land
Who said: Two vast and trunkless legs of stone
Stand in the desert. Near them on the sand,
Half sunk, a shatter'd visage lies, whose frown
And wrinkled lip and sneer of cold command
Tell that its sculptor well those passions read
Which yet survive, stamp'd on these lifeless things,
The hand that mock'd them, and the heart that fed;
And on the pedestal these words appear:
'My name is Ozymandias, king of kings:
Look on my works, ye Mighty, and despair!'
Nothing beside remains. Round the decay
Of that colossal wreck, boundless and bare,
The lone and level sands stretch far away.

The second court (B) (Plate 246 upper), which comes next, has colonnades on both sides, left and right. On its front and rear sides there were pillars with statues of the king as Osiris, of which four are still standing, and remain an impressive sight. In addition, on the north-western side of the court, there were two more colossal seated statues of the king made from black granite (Plate 246 lower).

A row of pillars next to the north-west end of the court, together with the Osiris-pillars just described, supported the roof of a hall (V), which can be regarded as the pronaos or portico of the adjoining large hypostyle hall, to which three ramps led. Behind this there rose the front wall of this large hall of pillars or hypostyle hall (H). The temple halls and rooms which follow next were used for the cult of Amun, and his processional bark, with those of Mut and Khons, was placed there.

The great hypostyle hall is built in the manner of a basilica like that at Karnak. The taller pillars of the two central rows have capitals in the shape of open papyrus umbels, while the shorter pillars of all the other rows have bud capitals. On both sides the architraves on the innermost rows of shorter pillars support a clerestory (with window openings). Thus, in a similar way to the construction of the great hypostyle hall at Karnak, it was made possible for the two naves lying to the left and right of the central nave to reach the same height as it (Plate 245), thereby forming three high naves in all. However, here, in the Ramesseum, there are only another three lower lateral aisles on each side (Plate 244). The hypostyle hall has eight pillars in each transverse row and is six pillars deep; it is therefore, like the hypostyle hall at Karnak, longer on its transverse axis than on its main processional axis.

Following on the central line of the hypostyle hall come three smaller halls, each four pillars wide and only two pillars deep. The first of these three rooms has a ceiling with astronomical scenes. A fourth room, with only four pillars, the sanctuary (S), is the last of the series of rooms along the central axis. The last two of these rooms, together with the chambers lying to their left and right, are largely in ruins.

On the front wall of the great hypostyle hall (at c) the king is shown in his war-chariot, and in front of him the enemy fleeing on horse, by chariot and on foot. In addition there is a scene showing the storming of the Hittite stronghold Dapur, at which the monarch's sons, identified by their names, are shown taking part in the battle. Finally, on the north-west wall (at d and e) the royal sons and the ruler himself are shown in the presence of several gods.

The first small hall with eight pillars (I), lying next to the large hypostyle hall, has reliefs on its south-eastern wall (at f and g). They show the procession of barks of the divine triad Amun, Mut and Khons, while on the north-west wall (at h) the king is seen sitting under the Holy Tree of Heliopolis with the gods Seshat and Thoth writing his name on the leaves of the tree.

The royal palace was connected to the south-west wall of the temple: it will be shown that this arrangement was also followed for the palace of Ramesses III at Medinet Habu. It opened on to the first court (A) through three doors. Built of bricks, it is now largely in ruins.

It was discovered very recently that a temple already built by King Sethos I lay to the side of the north-east wall of the temple, in line with the large hypostyle hall (H). Clearly Ramesses II kept up and no doubt continued the funerary cult of his father.

241. *General view of the funerary temple and environs of Thebes and Luxor*, seen from the high-lying tomb of Horemheb (No. 78), one of King Tuthmosis IV's generals. The photograph shows the whole of the walled area of the temple, most of the space being occupied by store-rooms. In the middle distance the cultivated zone with the houses of Luxor on the banks of the glistening Nile; on the horizon, the mountains of the eastern desert.

242. *The Theban necropolis seen from the funerary temple of King Ramesses II.*
At the foot of the mountain range culminating in the

long-revered peak of El-Qorn, lie sand-covered tomb mounds and the villages of Qurnet Murai and Sheikh Abd el-Qurna. On the extreme right, high up on the slope, can be seen the openings in the façades of Middle Kingdom tombs.

243. *The temple and ruins of the store-rooms from the north.* On the extreme left of the photograph the pylon, originally 217 feet wide, forming the monumental gateway can be identified, but only its lower part remains. Much of the first court (A) has also been destroyed. The second court (B) can be seen running from the left of the picture almost to its centre. All but a few pillars from the double colonnades formerly on its north-east and south-west sides have been destroyed, while both on its south-east side as well as its north-west side there are four of the pillars with the Osiris statues (cf. also Plate 246). Separated by a destroyed section, which corresponds to the pronaos or portico (V) of the large hypostyle hall, there follows the hypostyle hall itself (H), most of which is still standing and which has the form of a basilica (cf. Plates 244, 245). Adjoining this there are lastly the little pillared halls (I/II: cf. also Plate 244). The store-rooms visible in the foreground were built with sun-dried mud bricks.

244. *General view of the temple from the west.* On the extreme right the ruins of the fallen colossal statue of Ramesses II (C) (see page 501) at the north-west end of the first court (A), as well as the second court (B) with its Osiris-pillars. To the left of this, stretching right across the photograph, the actual temple buildings with the three main naves of the great hypostyle hall (H) rising above everything, and, in front of these, the south-western side aisles (of which the innermost pillars are still standing). Lastly come the small pillared halls (I and II) and, in the foreground, ruins of store-rooms.

245. *The great hypostyle hall,* middle and north-eastern main naves. The original roof-slabs are still on the architraves. In the foreground, the bases of two pillars inscribed with the name of Ramesses III.

246. *The second court (B).*

246 upper. *View from the south-west,* showing two rows each with four pillars with Osiris statues. On the right of the picture the ruins of the colossal statue of King Ramesses II made of Aswan granite, which lie at the north-west end of the first court.

246 lower. *View from the south-east.* In the foreground on the right, on a slightly raised terrace, stand the row of pillars at the back which have the Osiris statues in front of them. Together with the row of pillars following them to the north-west they formed the pronaos or portico (V) of the great hypostyle hall. It opened on to the great hypostyle hall, of which one can glimpse the middle and north-eastern main naves, though on the left the original south-east wall of the hall bars the view of the two south-western side aisles. On the south-eastern façade of this wall there are reliefs at three levels. Below: the king's eleven sons. Left centre: the king is led to the temple by

Atum and Month. Right centre: the king kneeling before the three principal Theban divinities; behind him, Thoth. Above: the king making offerings to Ptah (left) and incense to Min (right).

In the court can be seen the head and lower parts of one of the two colossal seated statues of the king made of black granite. Much of the original pavement has been preserved.

———

Colour Plate LIV. *Bust of a princess from the court of Ramesses II.*

Limestone. Height 29 inches. From the funerary temple of the king in Western Thebes. Cairo Museum, No. 600.

Owing to its delicacy of execution and sweetness of expression this wonderful bust of a woman, whose face still has the features of a girl, ranks amongst the best works of the period of Ramesses II and the spirit of the late Eighteenth Dynasty is still preserved in its gracious bearing. The face, with its expressive and beautifully tender mouth, is surrounded by a heavy wig of curls painted blue. A golden circlet with two uraei holds it together. Above this the princess wears a crown formed out of uraeus snakes with sun-disks. The wide, golden collar is made up of *nefer* signs, a hieroglyph which means 'beauty, perfection'. Her left arm is lying under her breast and she is holding the counterpoise from a necklace, which is crowned at the top with a Hathor-head.

Colour Plates LV–LVIII. *The tomb of Queen Nefertari-mi-en-Mut (No. 66), one of the principal wives of King Ramesses II. Western Thebes, Valley of the Queens.*

The tomb of this favourite of the four principal wives of King Ramesses II is the greatest jewel in the Valley of the Queens and is situated under the precipitous cliff walls at the end of the gloomy valley of Biban el-Harim. It was first discovered in 1904 by an expedition of Italian excavators. The paintings in the tomb, which is not very large in size, are executed in low relief on a stucco base. They are of exceptionally great artistic value. Despite their funerary subject matter, they show very great charm, though they also possess very great dignity.

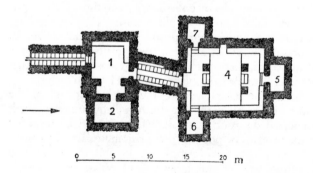

FIG. 64. Tomb of Queen Nefertari-mi-en-Mut (No. 66) in the Valley of the Queens in Western Thebes. Ground-plan 1:500. 1: First Room. 2: Main Room, lying to the south (Offering-Chamber). 4: Hall of Pillars (Sarcophagus Chamber) with the sarcophagus of the queen. 5–7: Side rooms.

Colour Plate LV. *In the first room of the tomb. View towards the north-east.*
On the face of the wall to the left of the small north recess of the room, the goddess Selkis is shown standing, with a scorpion on her head, while the goddess Maat appears at the extreme right of the photograph, at the entrance to the main room. She has her written symbol, the feather, on her head. On the rear wall of the recess there is a picture of the queen in a long, pleated robe, led by the hand by Isis towards the beetle-headed Khepri, a form assumed by the sun-god which personified his everlasting resurrection.

Over the entrance to the main room, on the right, the vulture-goddess Nekhbet of El-Kab is shown with both claws holding the *shen*-sign, the symbol of eternity and all-embracing sovereignty.

Colour Plate LVI. *Queen Nefertari led by the goddess Isis to the sun-god Khepri.*
On the crown of her head the goddess Isis is wearing the horns of a cow, surrounding the sun-disk, from which a cobra is hanging down. She is wearing a rolled chain on her breast, and its counterpoise amulet (*menat*) can be seen between her arm and back. In her left hand she is carrying the divine sceptre. Queen Nefertari is dressed according to the fashion of her period and is wearing over the vulture hood the tall feathered crown of the Divine Consort.

The text written in hieroglyphs is as follows: *Words spoken by Isis: Come, great king's wife Nefertari, beloved of Mut, justified* (i.e. with her speech found to be true), *so that I may allot thee a place in the holy land* (the Hereafter), *and the great king's wife and lady of the Two Lands, justified before Osiris, the great god.*

Colour Plate LVII. *Main room (offering-chamber). View towards the north wall and the northern half of the east wall.*
Beneath the ceiling, which—like that in the first room—is painted with golden stars, the glowing colours show up strongly against the white background of the walls. The part of the east wall visible in the photograph shows the queen, with a special sceptre in her hand, as she dedicates a rich offering. It is for Osiris-Khentamenty-Unnefer, *the King of the Living, the great God, the Lord of the Necropolis, the Lord until Eternity, the Lord of Infinity,* who sits with flail and crosier (crook-sceptre) on the throne. In front of him on a sort of standard are the figures of the four sons of Horus—Hapi, Duamutef, Qebhsenuef and Amsety. The god promises the queen, in return for her offerings, immortality and good fortune in his kingdom.

In the half of the north wall, which is shown on the left of the photograph, the queen is standing in front of Thoth, the Lord of Hermopolis, the god of writing, of wisdom and of judgement. On the stand between the pair are a writing palette and an ink-pot, on the edge of which a frog is sitting. Behind the queen are inscribed the words she speaks to the god, as well as the title she bears: *Words asking for the ink-pot and writing palette from Thoth in the Underworld, spoken by the great Royal Wife, the Lady of the Two Lands, Nefertari, beloved of Mut, true of voice.*

Colour Plate LVIII. *From the south-west corner of the main room. Queen Nefertari.*
A detail of the scene in which the queen is worshipping in front of the holy bull and the seven holy cows.

247-250. Abu Simbel.
The rock-temples built by King Ramesses II.

166 miles south of the first cataract Ramesses II had excavated the two famous rock-temples of Abu Simbel.

We do not know why Ramesses II decided to have these hewn out of the rock at this place in southern Nubia, not far from the second cataract—a large temple for the service of Amon-Re, Re-Herakhty and Ptah and for his own cult, and in addition a second sanctuary for the goddess Hathor and his deified wife Nefertari. There was no lack of suitable building land in the neighbourhood which would have been available for building the sanctuaries free-standing in the traditional manner. If it was just for the pleasure he took in carrying out this daring, self-imposed task, then we must admire the way in which this was carried through so impressively. The usual complex of rooms was more or less inserted into the rock.

The larger southern temple, with its unique façade, was dedicated to the imperial god Amon-Re of Thebes and to Re-Herakhty of Heliopolis, that is to say to the two principal gods of Egypt. In addition the god Ptah of Memphis and King Ramesses II had their cults here. The entrance to the larger temple is framed on each side of its gateway by two of the four colossal seated statues of the king, one of which collapsed long ago so that the upper part of its body now lies on the ground. These four colossal statues show Ramesses wearing the royal head-dress, the *nemes*, and over that the *pschent*, the double crown of the north and south, with the uraeus serpent; he is also wearing the usual beard. The seated statues, over 65 feet high, are almost as big as the Colossi of Memnon at Western Thebes (page 445) and in spite of a resemblance to each other have different expressions on their faces. The one on the extreme left, the best known of them, radiates a supernatural magic to an extraordinary degree; it is also one of the best portraits of King Ramesses II (Plate 247). Round the feet of the giant statues, in the form of little statuettes reaching barely halfway to the king's knees, are portraits of his favourite wife Nefertari as well as of his mother Queen Tuy and of several of his sons and daughters, born to him by his first two wives, Isisnofret and Nefertari. But only Nefertari, and not Isisnofret, is depicted at Abu Simbel.

The temple façade faces east. Over the entrance portal of the temple there is a standing statue in a tall, narrow niche of the falcon-headed sun-god, Re-Herakhty, who is resting his hands on symbols shaped like the hieroglyphs for *user* and *maat*. Both symbols are part of the throne name of King Ramesses II: User-Maat-Re. The royal name, and therefore Ramesses II himself, thus faces the rising of the sun, whose reflection the king himself is. On the outside of the two end colossi the slope of the rock wall is used in such a way that there is room for a chapel at each end. Their rear walls were decorated with a stele, their north walls dedicated to Re-Herakhty and their south walls to Amon-Re. At the northern end of the

terrace, hidden behind a pylon-shaped wall, there is a
sun-temple with a sun-altar, one of the few remaining
sun-altars in Egypt. At the south end of the façade there
is a small side temple built in the rocks, which was reserved
primarily for Thoth and Amun of Napata. It should be
regarded mainly as a shrine for the holy bark. On the
southern wall, at right angles to the temple, a great stone
inscription was cut by special orders of Ramesses II thirty
years after the famous Battle of Qadesh in the year 1285
B.C. (see pages 477, 493). It reports how Ramesses II,
after signing the peace treaty with the Hittites, married
the daughter of their king Khattushilish III and gave her
the name of Maatneferure when she arrived in late summer
at the Egyptian border. This stele, called the marriage
stele (see pages 477–8), of which the top part shows the
king of the Hittites, Khattushilish III, at the moment when
he is presenting his daughter Naptera to King Ramesses II,
was saved, together with the huge temple, from the flood
water which threatened them.

At sunrise the temple is illuminated: the colossal figures
on the façade seem to move in the light; the little statuettes
of the royal family gain substance; the two carved symbols
of the king's name are touched by the sun's rays, the source
of all life; and the sacred baboons, the genii of the depths of
the earth, adore the rising sun from the mountain peak.
The clear light forces its way deeper and deeper into the
sanctuary.

A frieze of sacred baboons forms the crown and upper
border of the temple front. The first dawn light falls on
them and they seem to greet the rising sun with their
hands raised in prayer. As one goes through the entrance
door, one reaches the hypostyle hall (H in Fig. 65), 58 feet
long and 54 feet wide, with its eight pillars, against
which, facing the central aisle, stand statues of the king.
These are 32 feet high and in the form of the god Osiris,
with flail and crook. The statues on the north side are
wearing the double crown and those on the south side
the crown of Upper Egypt. At dawn the faces of the
statues are lit by the general brightness. This phenomenon
lasts for more than an hour, and then the whole room is
gradually filled with light, and on the walls the scenes
recalling the great deeds of the king appear. The ceiling
of the central aisle has paintings of flying vultures, and
those of the side aisles, stars. The main military event of
the king's reign was the Battle of Qadesh, which he fought
in the fifth year of his rule, in 1285 B.C., on the banks of
the Orontes. This event is commemorated many times on
the buildings of Ramesses II, for instance in the Ramesseum
in West Thebes, at Karnak (see page 493), on the pylon
of the Amun-Mut-Khons temple at Luxor and in the
temple of Ramesses II in Abydos. But the report on the
north wall of the hypostyle hall of the temple of Abu
Simbel is perhaps the most factual one. It is displayed in
two registers, one above the other. The lower register
shows, from west to east, the Egyptian troops marching
to battle: the Egyptian camp protected by shields: vivid
scenes of life in the camp: the council of war, with the
king and his princes, and the beating of two enemy spies:
finally, the chariot fight between the Hittites and the
Egyptians. The top register shows, from west to east, the
king leaping to attack the enemy, who have surrounded

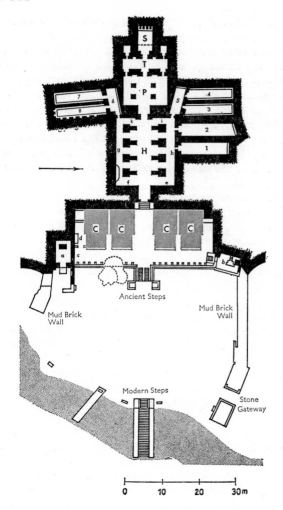

FIG. 65. Abu Simbel. The rock-temple of King Ramesses II.
Ground-plan 1:1,000.

On both sides of the ancient steps there is a pool, perhaps for
washing before entering the temple. In front of the terrace are
rows of captives, on the balustrade Horus-falcons of Re-
Herakhty and statuettes of the king. Under them are commemo-
rative inscriptions in honour of Ramesses II.

C: The four colossal statues of the king on each side of the
entrance portal. H: Hypostyle Hall, with eight Osiris-pillars. The
following reliefs are round its walls: on the entrance wall on
both sides of the door Ramesses II striking enemies in front of
Re-Herakhty (north wing) or Amon-Re (south wing): under
that, princesses or princes. On the north wall, in two registers,
scenes before and during the Battle of Qadesh against the Hittites.
On the south wall, in two registers: above—the king in front of
various deities; below—three scenes from the wars with the
Syrians, the Libyans, and the Negroes. On the rear wall:
Ramesses II brings captured Hittites (north wing) and negroes
(south wing) before the divinities.

P: Pillared Hall with four pillars with processions of barks.
T: Transverse Hall, in front of the Sanctuary which contains
the support for the Holy Bark hewn out of the rock. In the
Sanctuary (S) the statues of the king and the three gods Amon-Re,
Re-Herakhty and Ptah.

3, 4, 7, 8 and 1, 2: Six side chambers for storing ceremonial
equipment.

Outside the temple front: a chapel with reliefs, b court shaped
like a chapel with a sun-altar, c site of the inscription about the
king's marriage with Naptera, daughter of the Hittite king, later
called Maatneferure. On both sides the terrace in front was
enclosed by brick walls with stone gateways through them.

his chariot with their own: the fortress of Qadesh, the river Orontes flowing round it, with its defenders: the parade of prisoners in front of Ramesses II and the counting of the hands and limbs cut off the dead enemy.

The room next to this on the west (P), 25 feet deep and 36 feet wide, the ceiling of which is supported by four square pillars, leads into a transverse hall (T), from which three rooms open. The middle one of these is the sanctuary, with the support for the holy bark hewn out of the rock. In front of its rear wall are statues of Re-Herakhty, King Ramesses II, Amon-Re and Ptah. Except for the entrance door, there is no other opening to let in the daylight.

Twice a year, at the time of the equinox (21st March and 23rd September)—and the temple axis is constructed precisely in accordance with the position of the rising sun at the equinox—the four statues in front of the rear wall of the sanctuary are also lit up. Gradually, from north to south, the brightening light reaches them and enables all their details to emerge from the darkness. First Re-Herakhty appears, then the statue of King Ramesses II and finally the figure of Amon-Re. Only the statue of Ptah remains almost completely veiled in the gloom of the earth's depths, imprisoned by the chthonic world which the god personifies.

The two small rooms, situated one on each side of the sanctuary, with access from the transverse hall (T), are of no importance compared with the four corridor-like long rooms (3, 4 and 7, 8) which themselves are accessible only through two antechambers (5 and 6). These antechambers in their turn can only be reached from the north-west and south-west corners of the rear wall of the hypostyle hall (H). Probably the ritual objects needed for the ceremonies were kept in these long rooms. They correspond clearly to the crypts of the Ptolemaic temples. The southern group (7 and 8) of the two pairs of slightly asymmetrical long rooms is the more important; not only because their

walls, like those of all the other side-rooms, are decorated with reliefs, showing the king or his image in prayer before various deities, but also because the eastern one (8) of these two south rooms has a number of niches, above which there is the dedication inscription of the temple treasure. In addition to these four corridor-like long rooms there are two more (1, 2) which, seemingly cut at a later period, are reached directly through the north wall of the hypostyle hall by entrances underneath the relief of the Battle of Qadesh.

In front of the whole length of the temple a broad terrace is laid out, reaching down to the Nile. A rough brick wall with a cornice was built round the terrace to prevent it from being buried by sand, and stone gateways were added at both north and south.

The smaller temple of Abu Simbel, also cut into the rock, rises above the Nile with a façade 92 feet long and 39 feet high. In contrast to the large temple it had no surrounding buildings. It lies over 100 yards north of the large temple and it, too, is built into a projecting curve of the cliff. One can see at a glance that the two façades are made in an entirely different way. A golden-yellow stretch of sandstone divides the two sanctuaries, of which the main axes do not run parallel with each other but converge on the Nile. The level of the smaller temple is 17 feet lower than that of the larger one. With no buildings in front, the temple rises direct and abrupt from the Nile.

This smaller temple was dedicated to the royal consort Nefertari, who was here merged with the goddess Hathor. It should be noticed that only in Nubia did Ramesses venture to build a temple exclusively dedicated to his wife.

The front of the smaller temple is decorated in an alternating rhythm of pilasters in the form of buttresses, hewn from the rock, with between them statues of the king and Queen Nefertari as Hathor larger than life, three

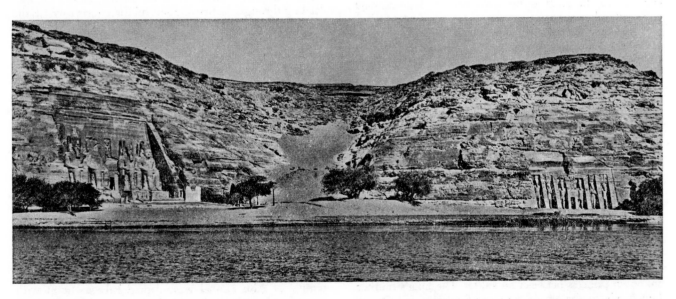

FIG. 66. Abu Simbel. The cliff wall falls steeply down towards the Nile, and the fronts of the two rock-temples are built where the cliff sweeps forward in two slightly projecting curves. On the left of the photograph, to the south, is the Great Temple dedicated to the gods Amon-Re, Re-Herakhty and Ptah, as well

as to the deified King Ramesses II. On the right is the northern smaller temple, dedicated to the king's wife Nefertari-mi-en-Mut united with the goddess Hathor.

From the middle of the rock-face a stream of golden-yellow sand pours down to the Nile.

on each side. They fill the façade on each side. The sculpture, inscriptions and the broken cornice above were certainly originally covered with painted stucco. The six standing figures are more or less of equal height, except that the most southerly of them is bigger than the rest, with a height of over 33 feet. Again there are little statues, this time of the children of the royal couple.

The smaller temple also differs from the large one inside. Each of the six pillars which support the roof of its main hall has carved on its front side a huge sistrum with the head of Hathor; it was usual for all sanctuaries dedicated to this divinity to have pillars with Hathor-capitals. On the three other sides of the pillars the royal pair or various gods are shown. The reliefs on the walls of the hall are arranged in a single register only. On both halves of the entrance wall the king is shown with his wife, and again smiting a negro in front of Amon-Re and a Libyan in front of Re-Herakhty. The reliefs on the long walls, equally carefully executed, depict the king or the queen in front of various deities, amongst them Anukis (see page 497). The remains of paint on the reliefs show that only the colours red, yellow, white and black were used. The whole temple interior, with its elegant slim figures, radiates an atmosphere which is full of grace, charm and the beauty of youth. It is as though amongst these men immortalized in the reliefs and their gods the sound of the sistrum and the scent of the flowers and blossom offered in sacrifice still linger on.

In the sanctuary which adjoins the hall of pillars the figure of the Hathor Cow springs from the rock and directly in front of her and under her protecting head is the figure of the king, looking as though he were stepping towards her and had suddenly appeared from the womb of the mountain, inside which the temple itself has been fashioned.

To the north and south of the two temples there are several inscriptions and stelae in honour of the king, chiselled in the rock at the command of high-ranking court officials.

Apparently the two cliff tops which Ramesses II chose as the site for his two religious foundations had already been given names in ancient times; thus the southern one was called Meha and the northern Ibshek. Though the religious buildings of King Ramesses II in Abu Simbel have neither precursors nor imitators yet the inscriptions scratched in the rocks, the so-called grafitti, bear witness that the place itself was a place of worship as far back as the Middle Kingdom, and possibly even during the period of the Old Kingdom.

247, 248. *The great rock-temple of Abu Simbel, and the left-most colossal seated statue of King Ramesses II.*
Little statuettes of the royal family stand on the right and left of the four colossi, and between their legs. Thus on each side of the colossus on the left of the row were the princesses, Nebet-tawy (left) and Bintanat (right), and an unknown princess between his ankles. The king's mother Tuy stands on the left of the second colossus and Queen Nefertari on its right, with Prince Amen-her-khopeshef between his legs. The figures of the royal family are repeated at the sides of the two northern colossi and between their legs. Between the second and third colossi,

in front of the entrance, the Nile gods are shown in relief with the heraldic plants of Lower and Upper Egypt, and prisoners. Reliefs on the door-frame of the portal show Ramesses II laying the foundation stone of the temple in front of Amon-Re and Mut, as well as in front of Re-Herakhty and the lion-headed Wert-hekau. Over the portal the name of the king User-Maat-Re is inscribed in large characters in relief, with the falcon-headed Re-Herakhty as the main figure: on each side the king presents to Re-Herakhty and to his own deified name an image of Maat. In the cornice under the frieze of baboons the name User-Maat-Re is flanked by royal serpents, with Amon-Re on the left and Re-Herakhty on the right.

249 above. *The great rock-temple, in the background, and the smaller one seen from the north.*

249 below. *The façade of the smaller of the two rock-temples.*

250. *Middle aisle of the great hall of pillars, or hypostyle hall, of the large rock-temple of Abu Simbel.*

251. *Temple of the deities Amon-Re and Re-Herakhty at Wadi es-Sebua.*

This religious foundation of Ramesses II, situated 97 miles south of the first cataract, was dedicated chiefly to the god Amon-Re, worshipped in this district for many years, and to the sun-god Re-Herakhty as well. It is laid out as a half-grotto (semispeos). Only the transverse room (14) and the sanctuary (15) are built completely in the rock. This important religious complex was annexed later by the Christians. The different periods during which this beautiful temple was built are still to be determined, except for the pylon. The temple is the only one where a sphinx avenue has been preserved almost intact. Six sphinxes with human heads and four with falcon heads border the central way leading through the first and second forecourts towards the final terrace. Four monumental statues of the king in a standing position are in front of the stone pylon of the actual temple building, those on the north side carrying the falcon-standards and those on the left the standard of Amon-Re. At the foot of the pharaoh another of his wives is shown: his own daughter Bintanat, who was his daughter by Queen Nefertari and whom he made one of the Great King's wives.

The presence of Bintanat as a wife and the portrayal of the king on the walls of the antechamber of the sanctuary, deified in the company of other gods, and also as the temporal ruler offering to them and to himself, make it possible to fix the date of the foundation of the temple at Wadi es-Sebua. It is certain that this semispeos was built later than the great temple of Abu Simbel, for we can establish that the image of the king in the sanctuary of Abu Simbel was added subsequently to the group of gods there. It is evident that the original decoration of the temple of Abu Simbel was adapted later to fit in with new ideas—ideas which were already accepted by the time the temple of Wadi es-Sebua was built.

251 upper. *The temple of Wadi es-Sebua in summer when the Nile is at its lowest level. The first court can be seen*

Fig. 67. Temple of the Gods Amon-Re and Re-Herakhty at Wadi es-Sebua. Ground-plan 1:800.

1: Stone portal with a statue of King Ramesses II and a royal sphinx on both sides.
2: First Forecourt. On each side of its central path three lion-sphinxes wearing the Double Crown of Lower and Upper Egypt (hence the name—es-Sebua=the lions).
3: Brick pylon. 4: Second Forecourt, with a pair of falcon-headed sphinxes, the symbol of Re-Herakhty, on each side of the central path. 5: Adjoining side forecourt with altar dedicated to Amon-Re and Re-Herakhty. 6: Store-rooms used in connexion with them. 7: Steps to 8. 8: Terrace with the actual temple building. 9: The latter's stone pylon; in front of it four statues of King Ramesses II, the one on the left (still standing) is holding a staff with a ram's head (symbol of Amon-Re), the one on the right (lying on the ground) is holding a staff with a falcon-head (symbol of Re-Herakhty): the other two are destroyed. There are reliefs on both towers of the pylon: Ramesses II striking enemies in front of Amon-Re and Re-Herakhty. 10: Court, with colonnades on each side, each with five pillars supporting the roof: in front of the pillars the colossal statues of the king. 11: The slaughterhouse running beside it. 12: Narrow terrace, reached by a staircase from court (10). 13: Large hall, partly constructed in the rock, with six pillars with royal statues and six plain pillars. 14: Transverse room (in the rock), with reliefs of different gods as well as of Ramesses II offering to his own image, together with three chapels adjoining it. The middle one of these (15) is the Sanctuary with reliefs on the walls; right: Ramesses II putting flowers on the Bark of Re-Herakhty decorated with falcon-heads, left: offering by the king in front of the Bark of Amon-Re. Rear wall: The Bark of the Sun with the ram-headed sun-god Re-Herakhty under a canopy, worshipped on the left by Ramesses II and on the right by three baboons. Under this a niche with figures carved from the living rock of the three deities worshipped in the temple: Amon-Re, Ramesses II and Re-Herakhty. Shading with dots: sandstone; black: bricks; diagonal hatching: living rock.

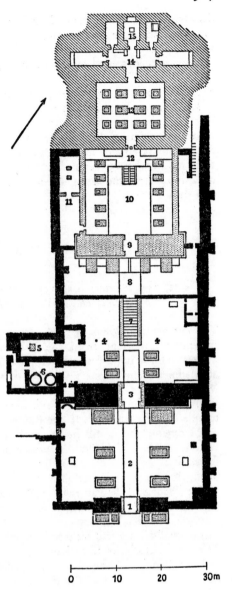

with the two lots of three lion-sphinxes, also the second court, with the falcon-headed sphinxes, and finally the stone pylon which has the colossal statues of the king in front of it.

251 lower. *The temple during flooding from the waters of the reservoir dam.* The first and second courts are completely under water, together with their sphinxes with lion and falcon heads respectively. The stone pylon is the first building to show above the water, with the colossal statue of the king, and, lying behind it, the court and that part of the temple which is cut into the rock.

THE REIGN OF KING MERENPTAH (1224 B.C.—c. 1204 B.C.)

The figure of Merenptah as a ruler has already been mentioned on pages 478-9 in connexion with his great victory over the Libyans north-west of Memphis in the year 1219 B.C. His great service to Egypt was that through this victory he gave the country a temporary respite from the threat of catastrophe in military and foreign affairs—even though it was achieved with very great sacrifice which was not easily made good again. The established régime, although clearly threatened by inner dissensions and the constantly recurring danger of war, was able to survive until the death of King Ramesses III.

It can be presumed that it was Merenptah who re-established Egyptian suzerainty over Palestine, and in this connexion it should be mentioned that a stele from the period of his reign exists, on which for the first time the name Israel appears in an Egyptian text, and already as the name of a country.

Though by general consent Merenptah is considered to be the Pharaoh of the Exodus of the Jews from Egypt, it should be pointed out, as Otto has said, that 'actual historical evidence for the stay of the children of Israel in Egypt is not forthcoming from Egyptian sources'. Also that 'actually it is a scholarly convention and no more' to associate Merenptah with the Exodus. 'The Biblical reports fit in with this period inasmuch as the general historical framework and a few isolated facts (like the compulsory labour on the building of the City of Ramesses) correspond with conditions in Egypt at that time ... As we have no evidence concerning the stay of a Canaanite race in Egypt either from the period of the Hyksos or from that of the Ramessides which would confirm the details of the Biblical story, the question whether their stay in Egypt has been sufficiently proved must be left open as far as Egyptologists are concerned.'

Concerning Merenptah's relations with the Hittites, it is probable that he supported the Hittite kingdom by

dispatching consignments of wheat during a famine. Nothing is known about Merenptah's end. It is possible that he was murdered or deposed. In any case a usurper called Amenmesses succeeded him as ruler.

252. *The tomb of King Merenptah (No. 8) in the Valley of the Kings at Thebes.* From the hall of pillars.
The lid of the pink granite sarcophagus bears a well-made, recumbent figure of the king as Osiris. The whole sarcophagus lid resembles in shape the cartouche. The dead man, his outward appearance like that of Osiris, wears the royal head-dress, the *nemes*, and holds the crooked sceptre and flail.

Some of the scenes incised on the sarcophagus depict demons of the underworld, and some are based on the theme of the journey of the sun through the underworld during the night. On the upper side of the sarcophagus a coiled snake bites its tail behind the king's head, a symbol of eternity originating in Egypt which spread far afield. The tomb of King Merenptah (illustrated by its groundplan in Fig. 52, page 473) contains only the sarcophagus lid in the hall of pillars. There are scenes only in the entrance corridor. Here there is a relief showing the king in front of Re-Herakhty, and texts from the *Hymn to Re* and scenes of the kingdom of the dead from the *Book of Gates*, with reliefs of the gods.

THE REIGN OF KING RAMESSES III (1184–1153 B.C.)

253, 254. *Funerary temple of King Ramesses III at Medinet Habu, Western Thebes.*

The last great building from the Ramesside period, and the most important from the Twentieth Dynasty, is preserved for us in the funerary temple of King Ramesses III at Medinet Habu at the south end of the necropolis of Western Thebes.

In the main the plan of this temple resembles the funerary temple of King Ramesses II, the Ramesseum. The temple of Medinet Habu is still in an excellent state of preservation: its two pylons and the whole of its front part as far back as beyond the great hypostyle hall are almost intact; it is of great importance as a temple building as a whole (Plate 253). Its vast reliefs and relief-cycles are very striking examples of the artistic skill of the period, which was still considerable, but even more they constitute an exceptionally important historical and ethnological record. The great victories of King Ramesses III over the Libyans and the Peoples of the Sea and, equally important, his decisive sea victory near the mouth of the Nile (cf. the reference on page 479) are illustrated in the reliefs on the temple walls on a vast scale and with an artistic conception of great importance. Included amongst these reliefs are representations of the racial groups threatening Egypt at that period, which are of enormous value to anthropological historians. And no less valuable are those relief-cycles depicting ritual ceremonies, such as the feast of the harvest god Min, the procession of the holy bark of the Theban divine triad and similar scenes, which present a clear picture of the course of these important religious events. Finally, an extensive calendar of the festivals provides us with an insight into the sequence of the festivals and the offerings prescribed for them.

If we examine the temple building as a whole (Figs. 68 to 73), we find that in the south-east the first pylon, still standing and with monumental reliefs on all its faces, gives access to the first court (A). On the north-eastern side of this court seven Osiris-pillars support the roof of a colonnade which is balanced by another of the same size, on the south-west side, of which the roof is supported by eight pillars with capitals in the shape of open papyrus umbels (Fig. 70). A second pylon, also with reliefs on both sides of its towers, leads into the second court (B). The

roofs of the colonnades which line its sides are supported by square pillars on the south-east, and by pillars with bud capitals on the north-east and south-west sides. On the north-west side of this second court, and lying on a somewhat higher level, there is a pronaos, very enclosed in appearance, which has broad Osiris-pillars in front, facing the second court, and another row of pillars behind, with bud capitals (Fig. 71). The pronaos leads into the great hypostyle hall (C), which again is formed like a basilica, with three tall middle naves and, on each side of these, two lower lateral aisles. Once more, as at Karnak and in the Ramesseum, the outer rows of pillars on each side of the three middle naves achieve their height through the addition of a clerestory with stone lattice windows built above their architrave, since the pillars themselves are only as tall as those in the lateral aisles (Fig. 72).

After the great hypostyle hall, first come two transverse rectangular halls (I and II), each with its roof supported by eight pillars (Fig. 73). Then, behind these small rooms and stretching across their whole width, is the group of three rooms dedicated to the Theban divine triad Amun, Mut and Khons. Once more this differs, as it did in the Ramesseum, from the equivalent group in the funerary temple of King Sethos I, in that the three rooms for the barks are no longer of roughly the same size, since the middle room (S), created for the bark of Amun, is appreciably larger than the two side ones for the barks of Mut and Khons. At the side of these rooms are some chapels dedicated to Osiris, of which one has astronomical scenes on its vaulted ceiling.

Of the remaining rooms, we need only mention the groups formed by the six chambers on the left, and five on the right, on both sides of the hypostyle hall. Their informative reliefs show that these served as store-rooms for the temple treasure.

So much for the temple building as such. A multitude of rooms surrounds the temple, chiefly on its north-east and south-west sides, which were used to house the priests and temple staff, as well as the officers and royal bodyguard and for the necessary stables, and finally for offices and so on. The whole complex was surrounded by a strong wall, 14 feet high, crowned with a crenellated battlement, joining on to the first pylon.

Modern excavations have been able to establish that

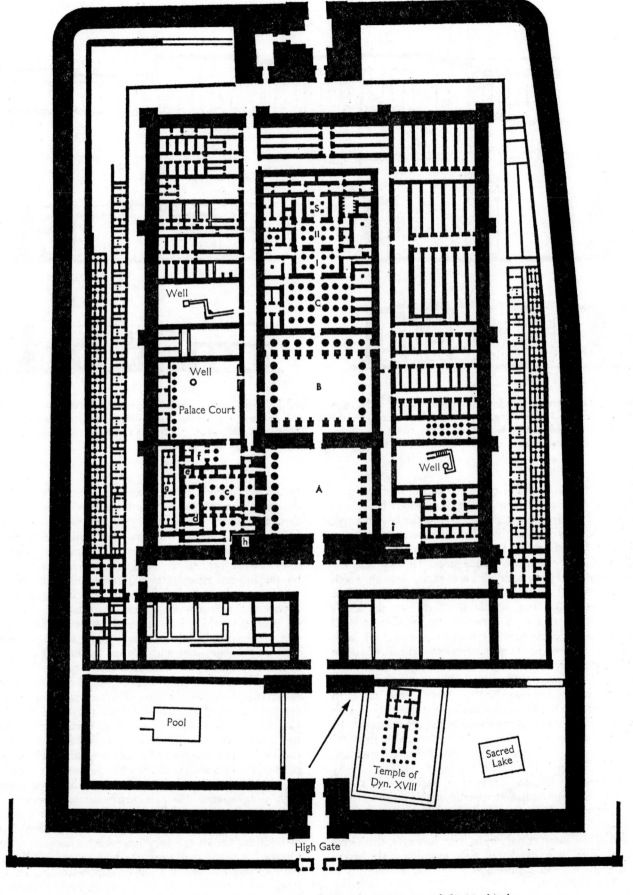

FIG. 68. Funerary temple of King Ramesses III at Medinet Habu at Western Thebes. Scale, about 1:1,450.

255. *Lid of the sarcophagus of King Psusennes I* (1054–1009 B.C.). Twenty-first Dynasty. From Tanis. Pink granite. Cairo Museum.

The sarcophagus was apparently made at the end of the Nineteenth Dynasty, possibly for King Merenptah, and then usurped by Psusennes I for his own use and altered. It enclosed an inner anthropoid sarcophagus. The top of the lid has a figure of the dead king, almost completely modelled in the round, represented as Osiris, with the divine beard and flail. A protective goddess kneels behind his head reaching out and touching it with her arms. The interior of the sarcophagus has shallow, incised reliefs round the edges and on the inside flat surfaces, depicting gods and the barks of the underworld. The centre of the interior of the lid is taken up by a figure of Nut, the goddess of the sky, modelled almost in the round. Her girlishly slim figure is emphasized by the fact that her arms are stretched high above her head. A dress decorated with stars is wrapped round her, but allows the utterly bewitching nature of her shape to be seen. The goddess is here representing in a way the personification of the lid of the sarcophagus: it is spread over the dead man just as the sky is spread over the earth.

This beautiful and thoughtfully made sarcophagus was, as has been said, certainly not carved originally in the Late Period but at the end of the Nineteenth Dynasty. It serves as an example of the way in which the Egyptians of the Late Period—by this time greatly lacking in artistic initiative—returned without thinking to earlier works, either by taking over an existing work and 'usurping' it, or by imitating things from the past in their own creations, or indeed just by straightforward copying.

256. *Block-statue of Hor, son of Nes(er)Amun, prophet of Amun.* Period of King Petubastis (817 B.C. and subsequent years) of the Twenty-third Dynasty. From Karnak. Dark granite. Height 43 inches. Cairo Museum, No. 42226.

The portrayal of people in the form of the block-statue was favoured with growing popularity from the time of the Middle Kingdom. This somewhat abstract form, avoiding incidentals, was in accord with Egyptian sentiment in general and with its preference for massive shapes in particular. In addition the flat sides of the block provided space for inscriptions of a biographical nature, religious scenes and prayers. In this way the potential of the sculpture as a vehicle for conveying meaning was increased. On the figure under consideration here, the front surface of the block is decorated with figures of Osiris (right) and Month (left), both participating in prayers for the grace and welfare of the man whose portrait it is.

It should not be forgotten that much of the sculpture surviving from the Late Period originates, like the figure which is described here, from the area of the temple of Karnak. Furthermore the fact that the statues known to us from the Late Period exhibit only a few types, so that for instance there are several versions of the block-statue, may be connected with the fact that they are temple statues, for which only a few models were, so to speak, permitted. Though the execution of this work is good and the whole piece is striking, yet a certain emptiness of expression must be admitted; the sphinx-like look of the man only holds one's attention for a short instant.

257, 258. *Mentuemhet, governor of the Theban district.* Twenty-fifth Dynasty.

257. *The pylon,* built from bricks of Nile mud, from the superstructure of his tomb in Thebes, near Deir el-Bahri. In the background, the sacred mountain of El-Qorn.

258. *Detail from the statue of Mentuemhet.* Granite. Height of whole statue, 53 inches. Cairo Museum, No. 42236.

Mentuemhet, mayor of Thebes and governor of the whole Theban district, came from a family of Theban priests, but as a priest held only the office of fourth prophet of Amun. He belonged to the period when Shepenwepet II as the divine consort of Amun was at the head of the divine state. She was the daughter of King Piankhi (751–716 B.C.) and sister of the latter's subsequent successor Taharqa (689–663 B.C.). However control, as far as politics were concerned, lay in Mentuemhet's hands because of his position as governor of the Theban district. It was owing to his ability as a statesman, combined with his energy, that the Theban Divine State was able to maintain itself unaltered, at that time, later during the Ethiopian period and throughout the terror of the Assyrian invasion and the sack of Thebes by Ashurbanipal down to the beginning of the Twenty-sixth Dynasty.

The statue of Mentuemhet, of which not much more than the head is illustrated here, is somewhat reminiscent of the statues of the feudal lords of the Fifth Dynasty, examples of which have been found in their mastabas; but this statue is only an imitation in a style prompted by the fashion of the period. A lot seems to have been put into it by the individual skill of the artist. In the modelling of the head, much more than of the statue as a whole, credit should be given to the individuality of the artist, for it anticipates a new attitude to portraiture, with the 'opening-up of new possibilities for the expression of individuality'; indeed the era after the end of the New Kingdom stipulated just this. In the words of W. Wolf, 'With this work we are standing before the very great achievement which the Late Period contributed to the history of Egyptian art.'

259. *Amenirdis, divine consort of Amun.* Twenty-fifth Dynasty, Ethiopian period. Alabaster. Height 66 inches. Cairo Museum, No. 565.

The princess was a daughter of the first Ethiopian king, Kashta, and was chosen for the office of divine consort, the first Ethiopian woman to be such, by adoption on the part of her predecessor, the Divine Consort Shepenwepet I, the daughter of Osorkon III, king during the middle of the Twenty-third Dynasty.

The statue, about life-size, of the princess is remarkable for its great beauty and the delicacy of its modelling. Above a long wig of curls with three uraei, the divine consort wears a crown fashioned out of uraeus snakes, which was probably completed on top by the sun-disk, the horns of the Hathor cow and the double feathers of Amun. Dressed in a tightly fitting robe, the princess is holding a bent flail with her left hand, which lies under her breast, and in the hand of her right arm, which hangs down loosely, she holds a bead collar with a counterpoise. Wide ornamental bracelets decorate her wrists and ankles.

Though the somewhat weak, heavy lines of the statue indicate the Ethiopian origin of the princess, yet the tall slim figure still recalls the charm of the female statues from the Eighteenth Dynasty, and it is filled with great nobility, very much in contrast to later statues of Ethiopian women known to us, such as the Takushet in the National Museum at Athens and even more the smaller female figures of wood and ivory that have survived. These display—in great contrast to the grace of the Amenirdis and the youthful delicacy of her breasts—an increasingly stressed voluptuousness of breast and hips, doubtless in line with Nubian ideals of beauty. On the other hand in this statue of Amenirdis the Nubian type of physiognomy has probably still been consciously avoided.

260. *The priest Petamenophis.* End of the Twenty-fifth Dynasty. Granite. Height 12 inches. Berlin.
This statue represents a late example of the series of block-statues. There is a raised relief of Petamenophis on the front of his robe, in which he is shown wearing the apron kilt of the Old Kingdom, and praying to Osiris. Like the earlier examples of this type, the man is shown sitting on the ground in his robe, which tightly surrounds the upper part of his body and his thighs; it gives the impression that he is enclosed in a cube. Even his arms and hands crossed over his knees are drawn into the block, as if fused into a whole with the rest. It is all the more remarkable therefore that the head is rendered with emphasized naturalism, and with features displaying individuality.

261. *Bes*, '*Count, Prince and Companion of His Majesty*' of King Psammetichus I (663–609 B.C.) of the Twenty-sixth Dynasty. From Lower Egypt but the exact site is not known. Limestone. Height 13 inches. Lisbon. Museum of the Gulbenkian Foundation, No. 158.

Of the postures in which the seated statues of Late Period sculpture are found, the most easily identified type is the squat and asymmetrical figure, a good example of which is the masterly statue of Bes. This seated statue of Bes, in its archaic style, in the shape of a seated man, with one leg tucked under him and the other raised high up, reminds one of the Sixth Dynasty statue of the doctor Niankhre (Plate 78), except that the earlier statue gave a far more immediate and vivid impression than does that of Bes, who seems to be almost completely withdrawn into himself in meditation.

The statue is fashioned out of fine-grained limestone with the appearance of marble, and it reveals a sharpness and precision of workmanship that is generally only found in sculpture executed in far harder stone.

Bes is wearing a bag-wig over his receding forehead. His long eyebrows and upper lip are slightly curved, the eyes themselves have clearly been made slanting. The corners of the mouth, turned up slightly, give an impression of faint irony.

The short neck under the small, square chin is noticeably full.

The carefully modelled body, very true to nature, is evidence of a fine sensitivity on the part of the artist and displays delicate, yet very certain, mastery of line. It indicates a quite conscious feeling for the organic and for spatial effect.

As is usual with these squatting figures, the lap is covered by a loin-cloth with an inscription on it. A customary inscription in three columns is carved on the back support behind the figure and it is completed on the base.

From the way the statue is made it can be surmised that it came from a royal workshop, although at that time there were also excellent ateliers in many parts of the kingdom which were independent of the king's court.

THE PTOLEMAIC PERIOD

Kings: *Ptolemy I Soter* (305–283 B.C.), *Ptolemy II Philadelphus* (285–246 B.C.), *Ptolemy III Euergetes I* (246–221 B.C.), *Ptolemy IV Philopator* (221–204? B.C.), *Ptolemy V Epiphanes* (203–180 B.C.), *Ptolemy VI Philometor* (180–145 B.C.), *Ptolemy VII Neos Philopator* (145–144 B.C.), *Ptolemy VIII Euergetes II* (*Physkon*) (145–116 B.C.), *Ptolemy IX Soter II* (116–107 and 88–80 B.C.), *Ptolemy X Alexander I* (107–88 B.C.), *Ptolemy XI Alexander II* (80 B.C.), *Ptolemy XII Neos Dionysos* (*Auletes*) (80–51 B.C.), *Ptolemy XIII/Cleopatra VII* (51–48 B.C.), *Ptolemy XIV/Cleopatra VII* (47–44 B.C.), *Cleopatra VII* (44–30 B.C.).

Egypt was freed from the Persian yoke by the invasion of Alexander the Great in the late autumn of 332 B.C.; his victory ushered in a new era, yet the effects of this overwhelming event were first felt a few decades later. The fierce battles of Alexander the Great for world sovereignty, the complete achievement of which occupied the monarch until his death, did indeed allow oppressed Egypt as soon as 332 B.C. to begin to enjoy a time of greater freedom. But it was not until after the death of Alexander the Great in 323 B.C. that Egypt, which had flourished for thousands of years, again blossomed in a period of prosperity. It followed the appointment of one of the foremost men of the army, from Alexander's personal circle of confidential friends, to the satrapy of Egypt. This was Ptolemy, the son of the Macedonian Lagus and of the Macedonian princess Arsinoë.

Ptolemy, who was to excel as a statesman as well as a soldier, at first only administered Egypt as satrap and custodian for the prospective ruler, Alexander IV, the son of Alexander the Great, born after his father's death. It was not until 305 B.C., nearly five years after the murder of the child Alexander IV by Cassander, then the leading man of the Alexandrian empire, that Ptolemy assumed the title of king. As Ptolemy I Soter he founded the line of seventeen Ptolemaic rulers of Egypt which was to come to an end in the year 30 B.C. with the reign of Cleopatra VII the Great, who displayed once again the statesmanlike power and grandeur of the first Lagid rulers.

Under the far-seeing Ptolemy I Soter, who died in 283 B.C., and also under his two successors, Egypt again achieved great prosperity and recognition in world affairs. Under Ptolemy II Philadelphus (285–246 B.C.) and his second wife and sister Arsinoë II, the state of Egypt as well as being strong politically and economically became a treasure house of the arts and learning. The father, Ptolemy I Soter, rebuilt the entire state militarily and economically, and refashioned its administration and state law, and by ruling with unusual ability and intelligence made Egypt one of the most fortunate kingdoms in the world of his day. Equally Ptolemy II Philadelphus and his sister-wife Arsinoë II made Alexandria, founded by Alexander the Great as the new capital of the country, the intellectual centre of the ancient world. The greatest spirits of the civilized world assembled in the Court of the Muses, the Museion, founded by Arsinoë II; the Alexandrian Library attached to the Museion was by far the most important library of antiquity, and it was equipped with scholarly care.

Ptolemy III Euergetes I (246–221 B.C.), following a lively foreign policy, enlarged the kingdom further—to the west (with Cyrene) and to the east (in Asia Minor and Thrace)—and in internal affairs again consolidated the state through important reforms. Then however a decline set in inexorably. The perpetual family dissensions, which did not stop at murder, weakened their position in foreign affairs more and more. Rome's watching eyes began to turn towards Egypt.

It should be emphasized that the Ptolemies during the whole period of their rule—from the time when Ptolemy I ruled Egypt as a satrapy—treated the land and people of Egypt with a completely conscious policy of Hellenization, and, in Bengtson's words, 'in the political field drew a barrier between Macedonians and Greeks on the one hand and Egyptians on the other'. On the other hand the concessions made to the Egyptians in religious matters by the Lagid dynasty were considerable. Allowing for political reserve for reasons of state, the Ptolemies' inclination towards Egyptian religion can be understood. The attractions of oriental religions had always been great since first the Greek world encountered the orient. It was not therefore surprising that just at a time when the traditional

religion of the Olympic gods threatened to become ever emptier, the spell of the mystic religions of the east, and in Egypt of the Egyptian religion in particular, should possess an irresistible attraction. Promoted by the ruling house of the Ptolemies, the cult of the ancient and venerable gods of the land continued. Thus there was a revival and extension of the ancient sacred sites of worship, venerated often from very early days, under the orders of the Ptolemaic kings, who developed a close spiritual relationship with the Egyptian religion. How could this fail to increase the approval of the still influential priesthood, and the affection of orthodox Egypt for the new ruling house?

As mentioned above, Alexandria, situated on the coast, had already been made the capital and residence of the Ptolemaic kingdom, and the city radiated the splendour and riches of the new kingdom, as its political, commercial and intellectual centre. Yet the building activity in Upper Egypt is proof how much attention was still paid to this part of the country, which for over a thousand years had been the hub of the pharaonic kingdom. Subsequent destruction in the area of the huge northern cities and districts, such as Memphis, Crocodilopolis (Arsinoë), the capital of the Faiyum, as well as in the Delta, has been too great for us to be able to gain more than an approximate picture of the buildings from this period. What has still been preserved in Upper Egypt, however, serves as a testimony to the building ability shown during these last two centuries before the Christian era. Names like Philae, Edfu, Kom Ombo, Esna and Dendera evoke the days of the final period of Egyptian splendour. Alexander Scharff has rightly said: 'Though this later period no longer produced any really new architectural ideas, yet these later architects should be honoured for having cherished and strengthened the ancient traditional forms with great understanding and a feeling for beauty.'

Although based on older sanctuaries, the temples of Philae, Edfu, Kom Ombo, Esna and Dendera were new creations of the Ptolemaic kings. But apart from Philae, where building began first under Ptolemy II Philadelphus, the new buildings at Edfu and Kom Ombo were only begun under Ptolemy III Euergetes I, at Esna under Ptolemy VI Philometor (180–145 B.C.) and indeed at Dendera not until the period of the last Ptolemies, so that the temple at Dendera was not finished until the time of the first Roman Emperor.

The Ptolemaic temples—and particularly those at Edfu, Kom Ombo and Dendera—rise imposingly above their surroundings, and the temple of Edfu in particular seems to be a mighty symbol of the building achievement of the Ptolemaic period. Yet, on the other hand, the building achievement of the Ptolemies, when compared with what might be called their potential, should not be overestimated. It can in no way be compared with that of the New Kingdom, if one takes into consideration their actual performance in relation to the length of time during which they were building. We should remember that the terrace temple of Deir el-Bahri was built in barely more than two decades of Queen Hatshepsut's reign (1490–1468 B.C.). Furthermore consider the building activities of the thirty-eight years of the reign of King Amenophis III (1402–1364 B.C.). Among the more important are three-quarters of the Amun-Mut-Khons temple at Luxor; in Western Thebes the mighty funerary temple of this king together with the Colossi of Memnon; the huge royal palace at Malkata; also the temple of Mut and its whole complex at Karnak; and finally the temple at Soleb in Nubia, which was dedicated to his memory. To carry the comparison further with reference to the Ramesside period, we find that under Sethos I (1304–1290 B.C.) in addition to the smaller funerary temple at Qurna in Western Thebes the great funerary temple at Abydos was built, even though it was completed by Ramesses II, and also a large part of the great hypostyle hall in the temple of Amun at Karnak—all this in scarcely fifteen years. The building activity of Ramesses II was simply gigantic, as the majority of his buildings must have been completed by the thirty-fourth year of his reign, i.e. at the time of his marriage with Naptera, the daughter of the Hittite king Khattushilish III; several more buildings can be identified as having been built after that time. Of the most important of his works, first come two early monuments: his funerary temple at Abydos and the rock-temple of Beit el-Wali in Nubia. Then he completed the temple of Sethos I at Abydos, the great hypostyle hall at Karnak and, by adding the first court, the Amun-Mut-Khons temple at Luxor. Later came the building of his funerary temple, the Ramesseum in Western Thebes, and—as his crowning achievement—the rock-temple of Abu Simbel, and later still the Amon-Re/Re-Herakhty temple of Wadi es-Sebua, also in Nubia. Finally, consider Ramesses III (1184–1153 B.C.). In spite of the heavy burden of war, which lay on this king's shoulders as a consequence of his decisive defensive wars against the Libyans and Peoples of the Sea, the thirty-one years of his monarchy were sufficient to build his vast and resplendent

funerary temple at Medinet Habu in Western Thebes. Moreover it should not be overlooked that at the beginning of the Nineteenth Dynasty the city of Ramesses was founded near the former city of Avaris, in the area of the Eastern Delta, to be the capital city of the Ramesside Dynasty, and there was a vast amount of building activity there. Though many architectural features for the new buildings were adopted and applied unthinkingly from the monuments of the Middle Kingdom, yet during the Ramesside period the completion of public buildings in the new capital certainly called for and absorbed considerable energy.

ARCHITECTURAL MONUMENTS FROM THE PTOLEMAIC PERIOD

262–266. *Edfu, the temple of Horus.*

Mention has already been made on pages 382-3 of Edfu, the ancient Tbot, which was one of the oldest cult centres of Horus, and of the ancient story of the quarrel between Horus and Seth. According to the myth, it was precisely here at Edfu that Horus, the son of Osiris and his sister-wife Isis, had one of his greatest fights with Seth, the brother and murderer of Osiris. Here it need only be repeated that Horus, who appears as a falcon, as a falcon-headed god and in human form, was considered to be the husband of Hathor of Dendera (pages 528-9), and that just as the goddess sought him out in Edfu, he visited her at Dendera. One of their two sons is Harsamtawy (Harsomtus), the uniter of the two lands. The sanctuary of Edfu was dedicated to these three gods, though primarily to Horus himself.

The ground-plan (Fig. 80) shows the huge dimensions of the pylon compared with the temple as a whole. The view of the temple from the south-west (Plate 262) gives an idea of its proportions. Behind the pylon is the court (H), with pillared colonnades on its eastern, southern and western sides (Plate 263). Here, as in the two halls beyond the court, the pronaos (1) and the hypostyle hall (2), the pillars have capitals showing numerous variants based on leaf and flower patterns. Owing to the restless detail of the capitals, the tranquillity of the older pillared courts and halls has been lost. Movement and richness of form take its place. A low wall between the front pillars of the pronaos, scarcely half their height, allows a view in from the court (Plate 264) and combines with the colonnades on the three other sides to enliven its general appearance.

The pronaos (1), inside which are two more rows of six pillars each, is divided from the actual hypostyle hall (2) by means of a disproportionately large wall. As in the pronaos a wider aisle has been left in the hypostyle hall between the pillars on the left and right wings to enable processions to pass through to the sanctuary. There are two antechambers between the hypostyle hall and the sanctuary. In the sanctuary itself (S) is the granite chapel, taken over from the pre-Ptolemaic temple for the god Horus, which was dedicated by King Nectanebes II (359-341 B.C.). In front of this is the support for the holy bark of the god, made of black granite. Surrounding the sanctuary is a passage, from which there is access to the chapels lying on its north, east and west sides.

A disproportionately narrow temple passage surrounds all of the rooms mentioned so far. Reliefs cover all its surfaces, giving useful information about cult practices as well as about the appearance of the Ptolemaic kings.

The narrow space, mentioned above, between the temple itself and the temple wall surrounding the whole, contrasts with the arrangement of temples in the Ramesside period, such as the Ramesseum (Fig. 63) and the temple of

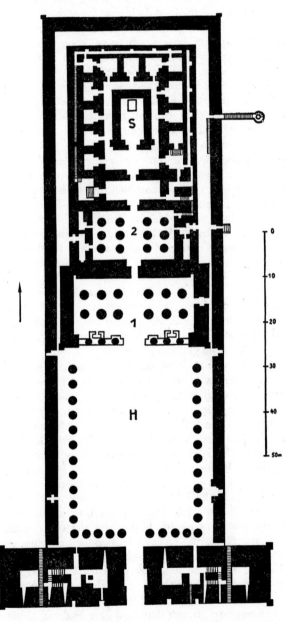

FIG. 80. Edfu. Plan of the Temple of Horus. At the southern end, the great pylon. H: Court. 1: Pronaos. 2: Hypostyle Hall. S: Sanctuary. Scale 1:850.

Ramesses III at Medinet Habu (Fig. 68). Whereas in these Ramesside temples the rampart or wall surrounding them was placed at a considerable distance, and separated from the temple by the royal palace and numerous other buildings designed for utilitarian purposes, at the temple of Edfu the perimeter wall surrounds the actual temple complex quite closely. At the level of the court it really only acts as the rear wall of its eastern and western colonnades and is incorporated in front (here to the south) in the pylon itself.

The temple of Horus at Edfu must count as the best preserved temple that has come down to us from antiquity. Practically no other temple gives us such a good idea of the general layout, and the spatial effects which were achieved when the roof is intact. We can see for ourselves how the light of the sub-tropical sky shines brightly down into the court, and from there floods into the pronaos, becoming more subdued as it penetrates from there into the hypostyle hall, getting dimmer and dimmer through the antechambers of the sanctuary until finally in the sanctuary itself it gives scarcely more than a mystic light. At Edfu one can still experience what space, light and shadow once meant for the worshippers in the temple.

Of the reliefs, the following have been chosen for description as they are of historical importance and provide information about cult practices.

The reliefs on the southern surfaces of the architraves over the doors leading into the hypostyle hall show scenes that are amongst the earliest and most interesting: the sun is worshipped by Thoth and Neith in the bark of the sun, which is accompanied by two falcon-headed Horus figures, while at the sides in attitudes of prayer we can make out Ptolemy IV Philopator and the four senses, sight, hearing, taste and understanding. Further on, in the lower row of reliefs on the right-hand wall of the sanctuary: Ptolemy IV Philopator unlocks the Horus chapel and opens its doors. He stands reverently, his arms hanging down, in front of the god Horus, burns incense in front of his deified parents Ptolemy III Euergetes I and Berenice II and again burns incense in front of the holy bark of the goddess Hathor.

On the west wall of the inner temple passage there are seven scenes of the battle of the god Horus with his enemies, who make an appearance in the forms of crocodiles and hippopotami. From these scenes mention may be made of the following: we see how Horus and the king (judging by the relief probably Ptolemy IX Soter II or Ptolemy X Alexander I) stab at a hippopotamus from the shore; Horus holding a chain to the left, a spear on the right of the picture; near him, his mother Isis. Next, Horus stabs the head of the hippopotamus, which he holds with the chain, while the king on land stands in front of two boats, one with Horus and the other with his assistants. Next, the chained hippopotamus lying on its back. Finally, from a sailing boat Horus stabs at a hippopotamus, which he holds by the back leg while Isis, at the prow of the boat, holds it by the head with a rope, and from the shore the king stabs at the animal's head.

The other reliefs, not described here in detail, show the usual scenes; for example, how the king smites his enemies in front of the gods, and so on. One should perhaps also mention that in the 'kiosk' accessible through a small court off the second antechamber in front of the sanctuary, there is a representation of the sky goddess Nut on the ceiling, which is unlike the scene of Nut at Dendera (see page 529) in that under her body the different figures of the sun are seen travelling in barks.

Near the temple is the 'House of Birth', the Mammisi, itself built in the form of a small temple. Here the 'ceremony of the confinement of the mother goddess' was celebrated. It is an addition which became a necessity in all large temples as a result of the spread of the cult of Isis in the Late Period and under the Roman Emperors.

These houses of birth are interesting from the architectural stand-point because as a rule (though there are variations) they recall the arrangement of the peripteral temples which had already been conceived by the time of Queen Hatshepsut and Tuthmosis III (Fig. 29, page 434 and Fig. 68, page 509). In any event, the actual building housing the cult rooms and their annexes is surrounded by a peripteral gallery. This has a roof supported by pillars above the actual capitals of which are placed additional special architectural elements. At Edfu the capitals are in the shape of bunches of plants, and above them the special elements are like dice, on which are shown the figures of Bes, the protector god of women during confinement. It should perhaps be mentioned here that in other houses of birth in place of the figure of Bes there are sometimes heads of Hathor.

The house of birth at Edfu consists basically of an antechamber, and a main room with two annexes. There are reliefs on its walls, the scenes of which reflect the significance of the house of birth. Thus amongst others there are scenes showing Hathor of Dendera, the relationship between whom and Horus of Edfu has already been explained on page 525. She is shown suckling the god Horus, while in front of her the 'seven Hathors', resembling the fates of the Greeks, are playing music and her young son Ihi is standing behind her with the sistrum in his hand. Next: the confinement of Hathor. Then there follow scenes of the birth of Harsomtus; under this, Khnum fashioning the child on the potter's wheel. The scenes of Hathor suckling Horus and the seven Hathor goddesses playing music are repeated on the pillars of the pronaos.

The individual dates of the building of the temple can be listed briefly: building began under Ptolemy III Euergetes I (246–221 B.C.); rough brick-work finished under Ptolemy IV Philopator (221–204? B.C.); suspended under Ptolemy V Epiphanes (203–180 B.C.); started again, and decorations begun, under Ptolemy VI Philometor (180–145 B.C.); the completion of reliefs and other decorations in the actual temple under his younger brother Ptolemy VIII Euergetes II (145–116 B.C.). Under this last king the house of birth was also built and in the year 122 B.C. the pronaos was completed. The court with its colonnades, the perimeter wall and the pylon were built in the two reigns of Ptolemy IX Soter II (116–107 B.C. and 88–80 B.C.) as well as in the period between by Ptolemy X Alexander I (107–88 B.C.). The reliefs were not completed until Ptolemy XII Neos Dionysos, the father of Cleopatra VII—that is twelve years after the birth of the last ruler of the Lagid house, in the year 69 B.C. Thus the total building time was 180 years.

262. *The temple of Horus. General view from the south-west.*
The photograph of the temple was taken from the high mound of rubble on top of the ancient city. The pylon is 115 feet high and 250 feet wide. Its proportions are only exceeded by the incomplete first pylon at Karnak, dating from the Ethiopian Period, which is 142 feet high, 370 feet wide and 49 feet thick.

263. *The court of the temple.*
Looking back from the north-eastern corner towards the colonnades to the south and west, and at the interior face of the pylon with its incised reliefs of Ptolemy XIII Neos Dionysos and various gods.

264. *View of the temple court from the south.*
On its north side the court is bounded by the front of the pronaos, which has a nobly proportioned cavetto cornice and six pillars which are joined together by a screen wall half their height. On the outside surfaces of the screen there are reliefs of Ptolemy VIII Euergetes II; on the two outer pairs of panels he is shown in front of the falcon-headed god Horus and on the two central ones in front of the goddess Hathor. There is a colossal statue of a falcon with the double crown on the left in front of the entrance to the pronaos. Its companion on the right is badly damaged. Both the eastern and western colonnades have twelve pillars: in the photograph one can see the most northerly of these, seven on each side, with their rich capitals in the shape of flowers or palms. In the east and west colonnades there are three series of reliefs on the walls, arranged one over the other, and showing Ptolemy IX Soter II or Ptolemy X Alexander I, sometimes with gods and sometimes as the victorious god Horus. In the centre of the court there used to be a great altar, on which offerings were made in the presence of the people of Edfu to Horus and the other gods worshipped in the sanctuary.

265. *View from west to east across the pronaos, between the two inner rows of pillars.*
The pillars, with capitals of palm fronds or umbel-shaped flowers, support the stone joists of the roof. King Ptolemy VIII Euergetes II is depicted in front of the Edfu deities on the walls and shafts of the pillars.

266. *View along the middle aisle,* of the hypostyle hall with its richly decorated pillars with flower capitals, through the two antechambers of the sanctuary and into the sanctuary itself. In this last room can be seen the granite chapel, covered with a pyramidal roof. This shrine is beautifully carved from fine material and was the gift of King Nectanebes II (359–341 B.C.) of the Thirtieth Dynasty to the pre-Ptolemaic temple; it was later incorporated into the Ptolemaic temple. The cult image of the god Horus used to be kept in the shrine. In front of it there is now a modern replica of the bark of the god Horus, standing on the old granite support.

267. *Kom Ombo,*
the temple of Suchos and Haroëris.

The gods to whom this temple was dedicated had already been worshipped in this place in sanctuaries dating from an older period. They were the crocodile-headed god Suchos and the falcon-headed god Haroëris. In association with Suchos, the goddess Hathor and the youthful moon god Khons-Hor were also worshipped, and in association with Haroëris, Tsent-nofret, 'the good sister', a special manifestation of Hathor, and P-neb-tawy, the 'Lord of the Two Lands'.

The ground-plan of the temple (Fig. 81) is basically similar to that of the temple of Horus at Edfu. Its length is not so great, only 270 feet against the 420 feet of the temple of Horus at Edfu. The pylon can scarcely be distinguished on the ground-plan and the court is barely half as deep as the one at Edfu. On the other hand this temple is somewhat wider (200 feet against 190 feet), because the temple of Kom Ombo had to serve for the separate cults of two gods, that of Suchos and that of Haroëris. Even in the pronaos (1) this pronounced division into two can be seen from the ground-plan. Here, as in the hypostyle hall (2), instead of a wide central aisle between two rows of pillars, there is a central row of pillars on the longitudinal axis. On each side of this central row of pillars there is a wider passage-like aisle and then, on both sides, two more rows of pillars in the longitudinal direction.

The division of the temple into two parallel parts, situated side by side along the long axis of the building and forming a single architectural unit, is carried through

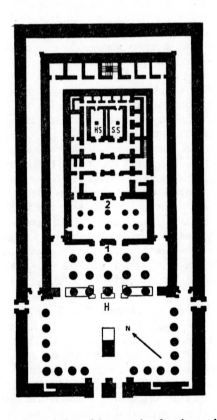

FIG. 81. Kom Ombo. Plan of the Temple of Suchos and Haroëris. At the south-western end, the pylon, which on the ground-plan can scarcely be distinguished from the thick perimeter wall of the temple. H: Court. 1: Pronaos, with two portals leading into it from the court, and two doorways into the Hypostyle Hall (2). SS: Sanctuary of Suchos. HS: Sanctuary of Haroëris. Scale 1:850.

with complete consistency. Even the pylon has two gateways. Similarly the pronaos and hypostyle hall both have two entrances. Opposite these are the two passage-like aisles described above, going through the pronaos and hypostyle hall and on through the three antechambers, which also have two doors each, as far as the two sanctuaries. Thus it was possible to take part in the separate festivals for each of the principal gods and the divinities associated with them.

In addition there are many things which differ from the temple at Edfu and yet are not caused by the main division into two of the arrangements of the temple. Thus there are three instead of two antechambers in front of the complex of the sanctuaries of the two gods. While the layout of the sanctuaries and the chapels surrounding them is in principle similar to that of Edfu, the inner ambulatory is not as wide here: it starts from the sides of the pronaos. There is another, distinctly wider ambulatory round the actual temple building, which leads out of the colonnades of the court. Owing to the pylon's lack of depth and to the thickness of the temple perimeter wall, it is practically impossible to distinguish one from the other, as the ground-plan shows, except that we may assume that the pylon, though it is no longer standing now, was originally considerably higher than the perimeter wall.

At this temple, too, there was a house of birth near the temple. The present house of birth, the Mammisi, largely in ruins now, was built in the reign of Ptolemy VIII Euergetes II or else restored then. An important relief has survived, showing the king journeying with two gods in a punt through a papyrus marsh alive with birds. On the left is the ithyphallic god Min-Amon-Re.

The building dates are less easily ascertained than those of the temple of Horus at Edfu. However, it may be assumed that the building was started, like the temple at Edfu, under Ptolemy III Euergetes I, and at least before the death of Ptolemy IV Philopator in 204? B.C. It is also certain that there was a pause in the building of this temple during the reign of Ptolemy V Epiphanes, that is, between 203 and 180 B.C. Decoration of the temple with reliefs was carried out in the reigns of the brothers Ptolemy VI Philometor (180–145 B.C.) and Ptolemy VIII Euergetes II (145–116 B.C.), and was still being completed as late as the birth of the last Lagid ruler, Cleopatra VII. The last of these reliefs were only completed under the Roman Emperor Macrinus and his ten-year-old son Diadumenianus (together, 217–218 A.D.).

267. *View from the south towards the ruins of the temple.*
The pylon has vanished except for a few fragments. Of the sixteen pillars of the colonnades, which surrounded the paved court, only the stumps are still standing. The pronaos has ten pillars in all, with richly decorated capitals in the form of 'bunches of flowers' and palm-fronds. The ceiling of the hypostyle hall was lower than that of the pronaos, and was supported by ten papyrus pillars with open umbel-shaped capitals.

Fig. 82. *Dendera, the temple of Hathor.*
Mention must be made of the Hathor temple of Dendera, even though it is not illustrated in this book.

There was an ancient sanctuary here, going back at least as far as the Sixth Dynasty of the Old Kingdom; it was added to by the kings of the Twelfth Dynasty and again during the New Kingdom, especially during the reigns of Tuthmosis III, Ramesses II and Ramesses III.

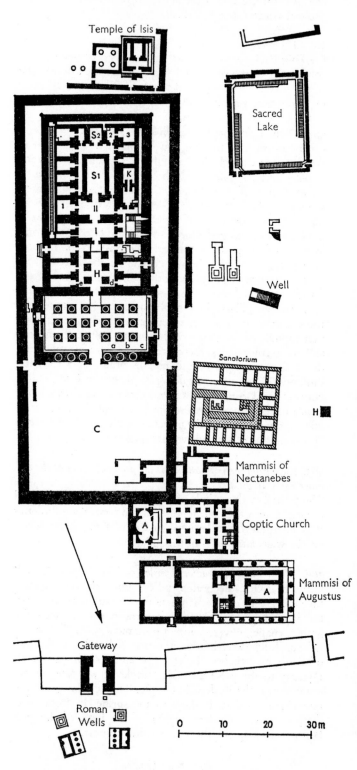

FIG. 82. Dendera. Temple of Hathor and surrounding buildings. C: Court. P: Pronaos. H: Hypostyle Hall. I/II: Antechambers, in front of Sanctuary (S1). S2: Hathor chapel. K: Kiosk of Nut. Scale 1:850.

When this temple was rebuilt in the last centuries before the Christian era by the last of the Ptolemaic rulers, followed by the Emperors Augustus and Tiberius, they created the temple which today is in a magnificent state of preservation.

The significance of the cult of the goddess Hathor, who was one of the oldest of the Egyptian deities, has been thoroughly discussed already on page 381, together with the many aspects of her nature and appearance. Now only the architecture of the temple as such remains to be considered (Fig. 82).

Because there is neither a pylon nor a large court, as there are at Edfu and at Kom Ombo, when one has gone through the north gate of the brick perimeter wall one faces directly the front of the large pronaos. Its front pillars are again joined together by a screen wall, as at Edfu. All the four rows of six pillars in the pronaos (P) have capitals carefully modelled in the shape of a sistrum. The front of the pronaos is crowned by a cavetto cornice, with winged sun-disks in its centre. The carved reliefs on the screen show, as far as can still be ascertained, the presentation of the ruler—whose name is not known—in the sanctuary. On the inner walls of the pronaos are reliefs in four rows one above the other, which show the Emperors Augustus, Tiberius, Caligula, Claudius and Nero as pharaohs presenting sacrificial offerings to the goddess Hathor. There are astronomical scenes on the ceiling of the pronaos, and amongst these is a scene of the sky goddess Nut with the animal shapes and boats personifying the stellar constellations.

The size of the adjoining hypostyle hall (H) is disproportionately small. It has three rooms on each side of it. Some of the scenes on the walls of the hypostyle hall are interesting, like that showing the 'turning of the first sod' when the foundation stone of the temple was laid—with the king digging the ground with a mattock—and another scene showing the king offering the goddess Hathor building stones on a tray.

The route to the sanctuary goes through two antechambers in which there are many reliefs. From the second antechamber (II) there is access to the kiosk (K), which has an impressive ceiling-relief of the sky goddess Nut. The sun rising out of her lap is sending his rays on to the temple of Dendera, which is symbolized by a Hathor head and shown on a hill between trees.

The sanctuary (S1) itself, where once the sacred barks with the gods' images stood, could only be entered by the king or his priestly substitute, and then only during the New Year's festival. The numerous reliefs on the walls show, amongst other scenes, the unlocking of the seals fastening the doors and the king opening the door; then comes the moment when the king sees the goddess; next, when he burns incense in front of the barks of Hathor and her son Harsomtus (Harsamtawy); and finally, as he presents an image of Maat, the goddess of truth, to Hathor and her husband Horus of Edfu. The king is accompanied by Hathor's youthful son Ihi, who as the god of musicians was closely connected with the cult of Hathor in her role as the goddess of love and joy. Chapels were placed round the sanctuary, divided from it by a passage, and the most central of these chapels (S2) contained an image of Hathor, which was actually kept in a chapel-shaped shrine.

It should also be mentioned that an Osiris-shrine was built on the roof of the temple in the form of a separate kiosk.

The large reliefs on the south-eastern exterior wall of the temple are among the most striking there. In front of the gods of Dendera and the cult image of Hathor we see the great Cleopatra and her son, the youthful Caesarion. This was the child born to Cleopatra VII after her liaison with Julius Caesar, and the only male child of the great Caesar. Octavian, the adopted son of Caesar, later the Emperor Augustus, had the boy killed in cold blood for political reasons after his victory at Actium.

There are two houses of birth, Mammisi, near the temple. One dates from the time of the Thirtieth Dynasty and was built by Nectanebes I (378–360 B.C.): the other was built in the reign of the Emperor Augustus. The ground-plan of the latter shows that this is also a peripteral type of building. There are reliefs in its birth-room (A) showing the birth of a child to Hathor, probably her son Ihi. Then one of the wet-nurses is depicted soothing the child, and another scene shows how he was brought up.

The small temple of Isis lying to the south of the temple of Hathor also dates from the period of the Emperor Augustus.

The large well lying to the west of the temple of Hathor was very important: its water linked the cult site to the mystical primordial waters of the world's creation.

Fig. 83. *Esna, the temple of Khnum.*
The temple lies thirty feet below the present level of the city and is barely visible. It is of special interest because of its general architectural concept. Up to the Ptolemaic Period the peripteral arrangement had only been used in the small temple dedicated to the god Amun by Queen Hatshepsut and King Tuthmosis III at Medinet Habu (Fig. 29, page 434 and Fig. 68, page 509). In the Ptolemaic Period at first it was employed in the birth houses of the temples at Edfu, Kom Ombo and Dendera. In the temple of Khnum at Esna the peripteral layout was first used for a large temple.

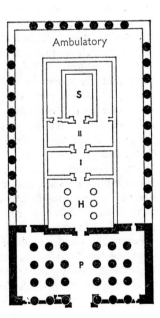

FIG. 83. Esna. Temple of Khnum. P: Pronaos. H: Hypostyle Hall. I/II: Antechambers in front of the Sanctuary (S). Scale 1:850.

Only in its pronaos (P), which faces north-east, and has twelve pillars with flower capitals lying on both sides of a central aisle, does this temple resemble the temples of Edfu, Kom Ombo and Dendera. Then, however, at the corners of its rear wall begins a series of pillars that completely encircles the whole of the remaining temple complex, which consists of a hypostyle hall (H), and two transverse halls (I and II), as well as the sanctuary (S); the plan is wholly in the manner of the pillared ambulatory of Greek temples. This is the architectural feature which distinguishes the temple of Esna from other Ptolemaic temples.

The oldest parts of the temple of Khnum, as is shown by the reliefs and inscriptions on the pylon-like door leading from the pronaos (P) into the hypostyle hall (H), date back to Ptolemy VI Philometor (180–145 B.C.). The pronaos, on the other hand, is as late as the Roman Imperial Period.

Though the temple was dedicated primarily to the ram-headed god Khnum, who was regarded as the principal god of the city of Esna even in ancient times, his companions the lion-goddess Menhit and Nebuut, a goddess resembling Isis, were also worshipped there.

268 left. *The temple of Dendur.*

This small temple is the only Nubian temple which was not dedicated to a deity or to several deities, but instead to two deified dead persons. These were the Nubians Pedesi and Pihor, the sons of a man called Kuper, who was probably one of the local Nubian princes. Certainly the fact that both of these two men suffered death through drowning was the reason for their deification, in accordance with an age-old Egyptian custom, dating back as far as the Osiris myth itself.

The small temple was built about fifty miles south of the First Cataract, probably at the place where the men who were subsequently to be deified were drowned in the flood-waters of the Nile.

The Emperor Augustus ordered the building of the temple in order to show his goodwill towards Nubia, which he had incorporated along with Egypt into the Roman Empire and where he stationed garrisons. It is distinguished by delicate and careful workmanship.

The temple is situated on a platform at the foot of the mountainous country and is linked to the Nile by a terrace in the form of a quay. The entrance is through a pylon, of which only the portal has survived. This is decorated on top with the winged sun-disk, and on both sides of this as on the gateway itself are scenes of the Emperor Augustus making offerings to various deities. Next comes a court, which is also accessible from the north and south through two side doors. A pronaos leads into the temple itself, across two small halls. In this pronaos are two pillars with flower capitals, which are decorated with reliefs showing rustic offering-bearers carrying sacrificial animals on their backs (Plate 268, left). On the pilasters and on the walls of the pronaos there are reliefs showing the Emperor in front of the gods and making sacrifices to the spirits of the two deified drowned men.

On the rear wall of the second of the two halls of the temple, referred to above, is a false door with a picture of Pedesi and Pihor praying to Isis and Osiris. On the northern and southern exterior walls of the building there are reliefs of Emperor Augustus offering a piece of cloth to Pihor and sacrifices to Pedesi and his wife.

The Egyptian Government has assigned the little sanctuary which we have just described to the United States of America as a mark of their gratitude for the large sum placed at Egypt's disposal to rescue the temple of Abu Simbel.

268 left. *View of the two pillars of the pronaos and its right pilaster.*

268 right, 269, Colour Plate LX. *The sanctuary of Isis on the island of Philae near Aswan.*

Although there were certainly sanctuaries on the small island of Philae in early periods, Herodotus of Halicarnassus who visited Egypt in 448 B.C. and came as far as Elephantine, did not mention the island in his reports (cf. page 520). The island of Philae, with its buildings from the Ptolemaic Period and from that of the early Roman Emperors, is one of Egypt's loveliest jewels. The sanctuary of Isis and its important surrounding buildings were the centre of the cult of this divinity and of the goddess Hathor, often associated with her, as well as of Osiris and of Horus. The Isis temple of Philae survived as an active foundation until the sixth century A.D., when under the Emperor Justinian (527–565 A.D.) Christian pressure succeeded in having the cult of the goddess Isis suppressed, although up to that time it had continued to enjoy great veneration.

The oldest of the buildings surviving on Philae today originates from the period of the Thirtieth Dynasty; Nectanebes I (378–360 B.C.) built here on Philae, at the south-west of the island, a sanctuary—the so-called Hall of Nectanebes I—for his 'mother' Isis and the goddess Hathor of Senmet. But this was soon swept away by the flood-waters of the Nile. The sanctuary was not rebuilt until the reign of Ptolemy II Philadelphus (285–246 B.C.). Today only six out of its fourteen pillars remain; they have varied flower capitals and one shaped like a sistrum.

Adjoining this sanctuary lies the extensive outer court of the Great Temple of Isis, flanked by two colonnades. The western colonnade originally had thirty-two plant pillars, 17 feet high, with variegated capitals: of these all are still standing except one. Most of their shafts carry representations of Emperor Tiberius, showing him bringing gifts to the gods. The wall of this colonnade has two rows of raised reliefs showing the Emperors Augustus and Tiberius as pharaohs consecrating gifts to the gods. There are now only six pillars from the original sixteen of the eastern colonnade, with some of their capitals partly unfinished. To the east of this are a few smaller sanctuaries. Of these the Temple of Iry-hemes-nefer—'the good life-companion'—(whose name was turned by the Greeks into Arsenuphis) is largely in ruins, while the Temple of Asclepius, situated behind the northern end of the eastern colonnade, built by Ptolemy II Philadelphus, has been preserved in very good condition. In the Ptolemaic Period they identified this god with the deified Imhotep, the architect of King Zoser, who was later venerated as a priest and doctor

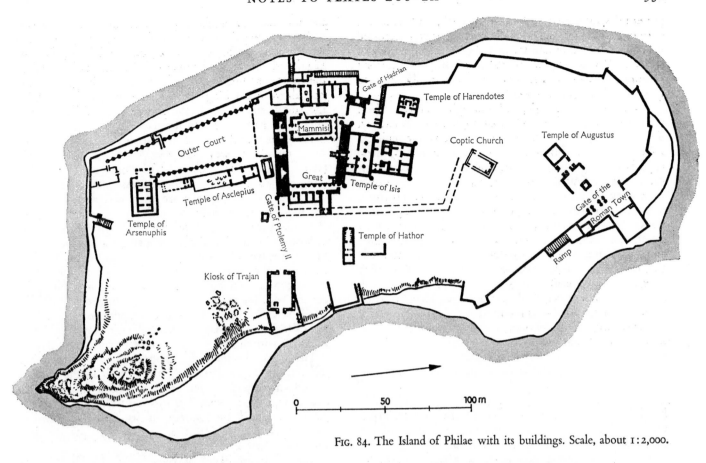

FIG. 84. The Island of Philae with its buildings. Scale, about 1:2,000.

(see page 398). The small temple of Asclepius therefore also served as a temple for Imhotep. Between the two temples just mentioned there are only a few fragments left of a temple dedicated to the Nubian god Mandulis, a god for whom a much larger sanctuary near Kalabsha had been erected (see pages 533–4).

The north side of the great outer court flanked by the two colonnades already described ends in the first pylon of the great temple of Isis. This temple, the chief sanctuary of the island (which was only about 430 yards long), was begun by Ptolemy II Philadelphus and largely finished by Ptolemy III Euergetes I, though it probably occupies the site of an older sanctuary of which nothing can now be identified. It is dedicated to the goddess Isis and her son Harpocrates, who was especially revered during the Ptolemaic Period and who was a form of Horus-the-child.

The first pylon is 150 feet wide and 60 feet high, and its eastern tower has a relief on its front face in the style of the kings Ramesses II and Ramesses III but here even more vainglorious, showing a giant figure of Ptolemy XII Neos Dionysos (80–51 B.C.), who was virtually a vassal of Rome, in front of Isis, Horus of Edfu and Hathor, grasping his enemies by the hair and smiting them with his club. There is a similar scene on the west tower. On the northern wall of the eastern tower, facing the temple, the goddess Hathor is shown receiving the homage of the king: on the north wall of the west tower four priests carry the bark of Isis, preceded by the king. At the very top of both towers are enthroned deities, again carved in incised relief. The details of their thrones were once

painted very richly; but the annual flooding of the island has almost destroyed their colour, so that the deities now look as if they float on invisible clouds (Plate 269).

The second gate leading through the west tower of the

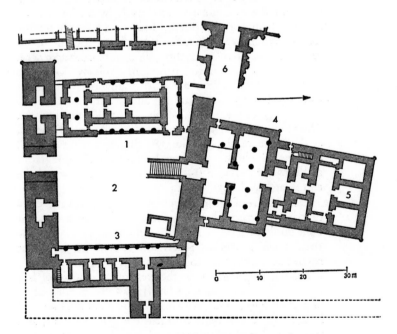

FIG. 85. Philae. The Great Temple of Isis. 1: House of Birth (Mammisi). 2: Forecourt of the Great Temple of Isis. 3: The eastern hall of pillars with the priests' rooms. 4: The Great Temple of Isis. 5: Sanctuary. 6: Hadrian's Gate. Scale 1:850.

pylon goes through to the house of birth, the Mammisi, once more laid out as a peripteral building. It was dedicated to the deities Hathor and Isis united in one, in memory of the birth of their son Horus. Ptolemy XII Neos Dionysos identified himself with him when he eventually assumed the rank of pharaoh.

Access to the house of birth is through an antechamber: from there two halls lead on through to its sanctuary. The hall-like passages which surround the whole building have richly carved flower capitals on their pillars; these capitals are surmounted by Hathor-heads with cow ears, carved on the four sides of cube-shaped blocks; then over these are sistrum capitals, again cube-shaped. This sistrum, a rattle-instrument usually curved into the shape of a horseshoe with metal rods inserted through it, was carried by priestesses to shake at ceremonies in the cults of Hathor and also of Isis. Some sistrums are shrine-shaped and it is this type that is represented above the head of Hathor (Plates 268 right, 269).

As usual, the reliefs inside the house of birth are connected with Hathor-Isis as the mother of Horus-the-child. In the interior of the two antechambers the reliefs show scenes of the maternal divinity in a circle of goddesses, who surround her partly to help her with the birth of Horus and partly to soothe the pains of her labour with the soft sounds of music.

In the sanctuary itself there are scenes from the childhood of Horus: for instance, a scene showing Isis nursing the child Horus, who was reared in the swamps of the Nile Delta hidden from the wiles of Seth, his enemy; and another of the young god flying as a falcon over the thickets of the Delta marshes.

On the east side of the temple forecourt, balancing the birth house, there is a colonnade at the back of which are a number of rooms for the priesthood of the temple.

On the south the forecourt is bounded by the first pylon, on the west and east respectively by the birth house and the halls for the priests, and on the north by the second pylon, with a flight of low steps leading up to its gate. The towers of this pylon are decorated with offering scenes from the period of Ptolemy XII Neos Dionysos. Next there are two transverse rectangular rooms (called the court and the antechamber), leading to the rear part of the temple, which consists of several rooms. The sanctuary is at the centre of the end row of rooms, at the north of the building. At the present time it still contains the plinth—presented by Ptolemy III Euergetes I and his wife Berenice II—for the barks which carried the cult image of the goddess Isis.

From the roof of the temple there is access to the sanctuary of Osiris, with two rooms, one of which was not built until the time of Emperor Antoninus Pius (A.D. 138–161). Their numerous reliefs are related to the Osiris myth and particularly to the death of the god.

Among the buildings to the west of the temple of Isis, mention should be made of Hadrian's Gate, because of its important reliefs. They date from the reign of the Emperor Hadrian (A.D. 117–138), who had the gateway built, and also from that of the Emperor Marcus Aurelius (A.D. 161–180) and his co-emperor Lucius Verus (A.D. 161–169). All the reliefs are connected with the Osiris cult. From the large number of these reliefs we mention one, from

the antechamber on the east of the gate: it is on its east wall and shows the grave of Osiris on the holy place, the Abaton, inaccessible to mortals, on the nearby island of Biga, and shows a crocodile crossing the Nile carrying the corpse of Osiris on its back. Isis is standing on the left, and above everything—surrounded by a little temple—the sun shines through the mountains, while above it appear the half moon and the stars.

A few steps to the east of the temple of Isis is situated the small temple. It was built by Ptolemy IV Philometor (180–145 B.C.) and Ptolemy VIII Euergetes II (145–116 B.C.), and was dedicated to the goddess Hathor-Aphrodite. The pillars of its pronaos are decorated with charming reliefs: these show flautists and harpists, and the dwarf Bes, the protector god of the marriage chamber and of women in childbirth, playing a tambourine, dancing or playing the harp, baboons playing lyres and so on. It is like the entrance to a temple of music, in which all the instruments combined in concert to celebrate the reunion of the creator with his seductive daughter, returned home from afar, in whose figure the old conception of the distant eye of the sun and Hathor, the goddess of love, are intermingled, without whom the men of Egypt cannot live

The kiosk, the most charming building on the island, still remains to be described. It was built in the Roman Period, in the reign of the Emperor Trajan (A.D. 98–117), and, though unfinished, it is—owing to the beauty of its proportions and the variety of its flower capitals—a particularly graceful creation in the style of the late Ptolemaic Period.

The far larger island of Biga has already been mentioned; it lies to the west of Philae, and contains the Abaton, the sacred place of the grave of Osiris. According to legend the left leg of Osiris lies here, and Isis as a little bird flutters over it; for him eternal life was promised, and she breaks the utter silence with her weeping.

268 right. *Philae. The Great Temple of Isis.*
Three columns from the eastern colonnade of the house of birth, with sistrum-capitals and Hathor-heads above the very richly carved plant capitals.

Colour Plate LX. *The island of Philae from the south-west, from the island of Biga.*
On the water's edge, the wall of the western colonnade of the outer court in front of the temple. In one place this wall has collapsed affording a glimpse of a few of the pillars of the colonnade. Behind it is the kiosk. Somewhat left of centre of the photograph is the great temple of Isis with both its pylons and, between them, the house of birth. Of this, the western colonnade is visible. To the left of the second pylon Hadrian's Gate can just be identified and, further to the left, the ruin of the temple of Harendotes, of 'Horus who protects his father (Osiris)'. In the background is the eastern bank of the Nile.

269. *Philae. The Great Temple of Isis.*
View across the temple forecourt towards the north wall of the first pylon and the eastern colonnade of the house of birth (cf. Plate 268 right). Through the gateway of the pylon there is a glimpse of the western colonnade of the outer court.

EPILOGUE: A TEMPLE FROM THE ROMAN IMPERIAL PERIOD
IN THE STYLE OF THE PTOLEMIES

270. *The temple of the Nubian god Mandulis,* formerly at Kalabsha near ancient Talmis on the west bank of the Nile, about 38 miles south of Aswan.

This temple, the largest and, except for the great rock-temple of Abu Simbel, certainly the most impressive of the Nubian temples, dates from the reign of King Amenophis II (1438/36–1412 B.C.) and was rebuilt and enlarged under the Ptolemaic kings. It received its final shape during the reign of the Emperor Augustus (31 B.C.–A.D. 14). It was dedicated to the Nubian god Mandulis, whose name may be Graeco-Nubian in origin, and who seems in many respects to be related to Horus. Until it was transformed into a church in early Christian times it received the homage of the last worshippers of the Egyptian gods.

A jetty built of squared stones formed the entrance to the temple from the Nile in its original site. Now the temple has been moved to a granite hill above the western bank of the Nile, a mile south-west of the high dam of Sadd el-Ali, and has been rebuilt in a new position overlooking the surrounding countryside.

The Federal Republic of Germany in response to an appeal from UNESCO removed the temple from its former position in 1962, and in 1963 rebuilt it stone by stone in a new position—as the memorial tablet announces —'to save it from the floods and preserve it for future generations' and 'as a symbol of friendship with the people of the United Arab Republic'.

In principle the ground-plan of the temple of Mandulis is the same as that of the Ptolemaic temples already described, even though that part of the temple adjoining the pronaos, the hypostyle hall, is lacking, a feature which can be seen developing at Edfu, Kom Ombo and—though in a reduced form—at Esna and Dendera; the whole temple is limited to three rooms.

The front of the temple is as usual formed by the pylon, and on this occasion faces due east. The door of the pylon leads into the court (F), surrounded on three sides by colonnades. Of these the north and south colonnades have been preserved, both having four columns with a variety of plant and flower capitals. The front of the pronaos (P) facing the court is also impressive, with its four pillars with variegated plant and flower capitals and with a screen of half their height between them, as well as the pilasters bordering the front of the hall.

These screen-walls are a characteristic feature of Ptolemaic temples and were also included in the temples built during the Roman Period in the Ptolemaic style, as at Esna, Dendera and Kalabsha. As can be seen in the temple of Amun of El-Hiba, dating from the Twenty-second Dynasty, they originated in plaited mats hung out on crossbeams; later they were transformed into stone and became very convenient places on which to site reliefs.

In the pronaos itself eight pillars with very richly carved capitals supported the roof, which no longer exists. The three adjoining smaller, transverse halls do not differ from each other sufficiently to mention except that in both the front halls the left side is partially flanked by a space for a narrow stairway.

From the southern and northern colonnades of the court a relatively wide ambulatory runs round the group of rooms made up by the pronaos and the three transverse halls.

The western perimeter wall of the lower, outer ambulatory was originally formed by the living rock, and has been replaced now by a free-standing wall. The house of birth (M), with an open court, is situated in the south-west corner: originally hewn out of the rock, it has now only

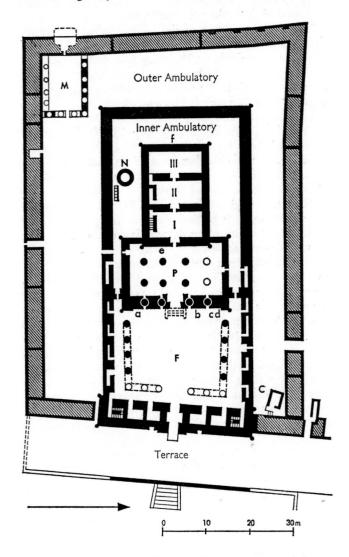

FIG. 86. Kalabsha. Temple of Mandulis. F: Court. P: Pronaos. I–III: Three halls, of which the last corresponded to the sanctuary. M: House of Birth (Mammisi). C: Chapel from Ptolemaic period. Scale 1:850.

been partially restored. In the north-east corner of the outer ambulatory there is a chapel (C), lying somewhat lower and probably dating back to the temple of the Ptolemaic Period.

Turning to the reliefs in the temple, those in the halls (I–III) show the Emperor Augustus before the gods of Talmis and other deities. On the rear wall of Hall III, the sanctuary, there are two scenes of offerings, in both of which the ruler walks towards a trinity of gods, two of which are in each case Mandulis. As both groups are facing away from each other, the decoration of this room achieves a sort of balance. The double presentation of the offering scenes allows the reliefs to terminate with a two-fold appearance of the god Mandulis, one older and the other younger. This again can be accounted for by the fact that Mandulis was identified with the Egyptian Horus, and there were two forms of Horus, an older and a younger one. The double form of Mandulis means that Isis also, as the wife of this Horus-like god, seems here to have two forms of appearance. Sacred birds were of special importance to these divinities, and the pilgrims of later times dedicated birds or their fetishes to them.

The most interesting of the reliefs in the pronaos are those situated on the rear wall south of the doorway. They show, on the left, a Ptolemaic king presenting a field to the divinities Isis, Mandulis and Horus, and on the right King Amenophis II, the founder of the original sanctuary offering wine to the gods Min and Mandulis.

In the inner ambulatory there are some fine reliefs on the exterior surface of the sanctuary wall (III), which are about twelve feet high; on the left, the Emperor Augustus in the ritual attire of a pharaoh stands in front of the gods Isis, Horus and Mandulis, and on the right he makes offering to Osiris, Isis and Horus.

The relief which is in the centre of the west wall of the inner ambulatory is particularly beautiful, and shows the god Mandulis with pharaoh, who is wearing the double crown of Egypt shown front view.

There are interesting inscriptions on the screens, referred to above, between the pillars and the pilasters of the pronaos. Of these the historical text on the right pilaster is particularly interesting. It dates from the fifth century A.D. and is written in bad Greek and was made for Silko the king of the Nubians and of all the Ethiopians, who lauds his victory over the nomad Blemmyes in the eastern desert. He fought them from Primis to Talmis (=Kalabsha) and thus advanced as far as Taphis and Talmis (i.e. the area round Kalabsha). This victory was certainly important, as the Romans had already retreated before the Blemmyes, and because of them the Emperor Diocletian had, in

A.D. 300, abandoned Nubia completely. Another inscription of interest to the social historian is the decree, written in Greek, on the first screen on the right-hand side, of the provincial administrator of Ombo and Elephantine, Aurelius Bessarion, in the year A.D. 248/9, in which the owners of swine are ordered to drive their animals away from the temple of the village of Talmis (=Kalabsha).

270. *The temple of Mandulis.*
Above: The temple on the site where it was originally built in the time of Emperor Augustus, and seen from the west. Across the Nile, the right bank of the Nubian territory.

The photograph was taken in May 1962, before the temple was transferred to its new position. It shows the temple re-emerging from the floods which had completely submerged it for about nine months each winter over a period of more than forty years. Its outline can be seen clearly above the water as can the scaffolding, on the right of the picture, which had been erected ready for the dismantling of the temple building.

Of the temple itself one can recognize the low west wall of the outer perimeter wall, which is not covered by the water, and all the inner surrounding wall as far east as the pylon. Within the ambulatory formed by the latter wall can then be seen the complex of three transverse low rooms, of which the innermost forms the sanctuary, and adjoining these the considerably higher pronaos, with none of its roof remaining. Right to the east, facing the water, is the pylon. In this photograph the part of the wall above the centrally placed gateway of the pylon, a part which is visible in the reconstructed temple, is here clearly missing.

Below: The reconstructed temple in its new position a mile south of the new high dam. The pylon is easily distinguishable, with the adjoining wall of the southern colonnade, and next to that the wall of the inner ambulatory, overshadowed by the tall pronaos, whereas the walls of the three transverse halls can scarcely be seen above the top of the surrounding wall.

In the foreground is the so-called Kiosk of Qertassi, a little temple similar to the Kiosk of Philae, except that this one is only 26 feet square. Its pillars formerly supported the roof on crossbeams, of which one has been preserved. Today only one of the two central pillars with Hathor capitals still stands, together with four of the exterior pillars with their richly carved flower capitals. The kiosk was originally sited at Qertassi, about thirteen miles up the Nile.

THE NUBIAN TEMPLES
by Christiane Desroches-Noblecourt

The reader is referred to Map 1 (page 390) and, for places above the Second Cataract, Map 2 (page 436).

THE PHARAOHS built temples for the gods of Egypt not only in their own country but also in the neighbouring lands, whether these were conquered territories or the lands of allies. The intention was to provide symbols of the power of the pharaohs. In the conquered lands, where garrisons were stationed, it also enabled first the troops, and then later the settlers who followed the initial occupation, to offer their prayers to their own gods, the gods of Egypt.

During the Old Kingdom the attitude of Egypt towards its Asiatic neighbours was purely defensive. Advances towards the north-east were obviously made specifically to clear the copper-mining areas on the Sinai peninsular of encroaching nomads. Equally, other actions, which culminated in a Palestinian campaign, were really only intended to ward off the nomads whose proximity was a threat to Egypt; they did not in any way represent a policy of aggression in the sense of a methodical expansion of Egyptian sovereignty to the north-east.

In the south, too, the authorities in Upper Egypt showed no sign of wishing to extend the kingdom's borders beyond the First Cataract, and the only duty of the border garrisons stationed in Edfu and Elephantine was to supervise the border traffic from Nubia into Egypt and, in reverse, to control the caravans heading south.

On the other hand, that the Egyptians of the Old Kingdom, following the exploitation of many places situated beyond the First Cataract, were pressing ever further south is supported by the fact that a village with workmen's huts and metal foundries has recently been discovered near Wadi Halfa, at the Second Cataract, the foundations of which must date back to the period of the Fourth Dynasty. It has also been established that the diorite quarries near modern Qasr Ibrim, halfway between the First and Second Cataracts, were worked in the reign of Chephren. Equally we know that boats were built above the First Cataract to carry the Egyptians deep into southern Nubia in connexion with the barter trade in incense, ebony, acacia wood, elephant tusks, skins, oil, and even cattle.

There are no traces of buildings from this early period in Nubia beyond the First Cataract, although it would seem almost inconceivable that Egyptians sent so far south into a strange land would have lived without a temple for their gods, who were always held in such high esteem by them.

It is equally possible that the troops dispatched to the north-east for the defensive purposes referred to above put up little temples on foreign soil for their gods, but likewise no fragment of these has so far been discovered.

During the Middle Kingdom, Egypt's political attitude to the area of Western Asia, like that of the Old Kingdom, for a long time was fundamentally only defensive in character. The 'wall of the ruler', which Ammenemes I, the first king of the Twelfth Dynasty, had built, evidently served only to defend the north-east borders of his kingdom as a barrier to close the frontier. Sesostris III was the first to lead a clearly aggressive campaign, which had Shechem, modern Nablus (east-north-east of Jaffa), in the hills of Central Palestine as its objective. It can be established that extensive trade missions penetrated North Syria: it is very probable that they even advanced as far as the Euphrates.

However, as far as the consolidation of the Egyptian state was concerned, the expansion of the kings' power during the Middle Kingdom in the direction of Nubia was of far greater importance, taken with the final safe-guarding, politically and militarily, of the conquered territory as far as the Second Cataract. The gold of Nubia gave Egypt its superiority over the Syrian states and formed the basis of its ever-increasing influence in commercial and foreign affairs, which was ultimately to prove decisive by the beginning of the Eighteenth Dynasty during the New Kingdom.

While the most important gold mines of Upper Egypt were situated near the Wadi Hammamat, accessible from Quft, and in the area between Edfu and the Red Sea, the most important gold mine in Nubia was the mine of Umm Qareiyat, near Wadi Alaki, which was still being worked as late as the Middle Ages, and recently, at

the beginning of our century, was again brought into operation. Access to it and to the Wadi Alaki was controlled by the fort at Quban, lying a little more than seventy-five miles south of the First Cataract.

How firmly the Egyptians of the Middle Kingdom had control over its southern conquests is shown by the fact that they could build forts at Buhen and Mirgissa by the Second Cataract and, about forty-five miles further to the south, the forts at Semna and Kumma, which were designed to ward off all attacks from the south, and which formed the actual southern border, permanently defended, of the Middle Kingdom possessions.

Sesostris III erected a stele at each of the two forts, of which today the strong perimeter walls still stand, and on it the warning of the great ruler reads:

Each son of mine, who will maintain this border which I have made, he is my real son . . .
Whosoever yields it, without fighting for it, he is not my son . . .
I have had an image of myself erected by the border that I have made, so that you may endure for it and fight for it!

All the buildings, whether they were sanctuaries which were built immediately the military had occupied a place, or whether they were the residences of the governor and his staff of officials or of the occupying troops, were built basically according to the Egyptian style of architecture, even though some were adapted to local conditions. But the ability, deeply rooted in the Egyptian, to keep his own methods pure and intact allowed few foreign elements to affect his architecture, just as he accepted no strange divinities into his religion. On the contrary, however, many Nubian divinities assumed Egyptian forms of appearance so that they too could be easily included in the Egyptian pantheon.

In Nubia, where priestly buildings such as small temples and chapels dating from the Middle Kingdom still exist, they naturally are closely related to the siting of the forts. Thus we find in the area of the fort of Mirgissa a small temple from the period of King Sesostris III—one of the few buildings which have survived from the time of the Middle Kingdom.

During the New Kingdom the frontier had advanced, even by the reign of Tuthmosis III, as far as Napata, modern Nuri, just before the Fourth Cataract, and temples began to be built in very large numbers. Thus in Buhen, a place mentioned already, there is still today a temple built by Amosis, founder of the Eighteenth Dynasty though he sprang from the line of the Seventeenth Dynasty, which was replaced by a new building by Amenophis II: in the area of the same fort Tuthmosis III and Hatshepsut built a temple for Horus of Buhen. These same rulers built at Semna, the border fort on the western bank of the Nile, a temple for the Nubian god Dedwen, and in the neighbouring area of the fort at Kumma they founded another temple. Mindful of the achievements of Sesostris III in the colonization of Nubia, Tuthmosis III had a cult established at both these forts for this outstanding ruler of the Middle Kingdom.

Amongst the Nubian temples which were built and equipped during the reign of King Tuthmosis III, the rock-temple of Ellesiya with its laudatory inscription of Tuthmosis III should be mentioned, and also the temple dedicated to the gods Amon-Re and Re-Herakhty at Amada, the most important of all the buildings of the early part of the dynasty. It was built by Tuthmosis III and his son Amenophis II, and Tuthmosis IV had it enlarged further.

Finally, in Soleb, the Nubian Thebes, Amenophis III had a temple built as his personal image on earth. In this temple there are reliefs on the rear side of the pylon and on the doors between the two pillared courts which are connected with the jubilee of this display-loving ruler's accession. And in Sedeinga, situated a little further to the south, he had a temple specially dedicated to his wife Tiy, who was here worshipped as the protector goddess of Nubia.

Here, in colonial territory, there grew up a very distinctive form of worship of the king, which was continued under Ramesses II: the presence of the image of the god-king, and indeed of the deified queen too, in the temple cult, a feature which was not yet customary in Egypt itself, at any rate not at this period, was undoubtedly an ideal method for guaranteeing the throne.

The building of all these Nubian temples was not only motivated by the religious feelings of the ruler, but was due just as much to their very important and concrete political ambitions. Nowhere else had so many temples

and chapels been built on a comparable scale in such a narrow confine as the strip of cultivated territory on both sides of the Nile.

Building activity in Nubia reached its peak during the Nineteenth Dynasty, the great period of Egyptian temple building, an era which excelled in the reign of King Ramesses II with a really vast building programme.

This pharaoh seems to have wished to achieve in Nubia a comprehensive project based on very exact planning. For he founded no less than eight temples between the First and Second Cataract: Beit el-Wali, Gerf Hussein, Wadi es-Sebua, Ed-Derr with its two temples, Abu Simbel with its large southern temple and smaller northern one, and Aksha. In the sanctuaries of these temples the particular divinity was closely linked with the figure of the king, who appeared more than ever as the son of god, and as god himself. Certainly some day we may discover what ties linked these various cult places to each other, and what they had in common: but they are all dedicated to the imperial god Amon-Re and to the other principal gods, as well as to the person of the king.

Each temple had its own individual character but all were related, to a greater or less degree, to the concept of a speos or rock-cut shrine. Beit el-Wali, founded in the early years of the reign of King Ramesses II, and Wadi es-Sebua are hemi-speoses—only the antechamber and side-rooms of the sanctuary with the sanctuary itself are hewn out of the rock: the rest of the temple in front of these rooms is built standing free of the rock. However, in the temple of Ed-Derr, dedicated to Re-Herakhty, which is unusual in that it is situated on the right bank of the Nile, even the hall of pillars is built completely inside the rocks. In the rock-temple of Gerf Hussein, which was dedicated to Ptah, the pillared colonnade round the court was in the open, but the adjoining great hypostyle hall, with its striking statues of the king as Osiris in front of its pillars, is located entirely inside the rocks. Finally the two rock-temples of Abu Simbel, created for Ramesses II and his wife Nefertari, who was also worshipped here, are true speoses, rock-temples cut entirely within the interior of the mountain, the most important of these speoses in Egypt.

The new ideas upon which the temple building of Ramesses II was based and the layout of the temple buildings, in general rooted in tradition, were adapted to the rock-temple and transferred to it in such a way that nothing essential or fundamental to the nature of the sanctuary had to be altered. Even in the case of the temples founded at Abu Simbel, the approach did not make a sudden departure from the usual temple front. Until the last century there were sufficient fragments remaining in Gerf Hussein to support the supposition that in front of the religious buildings there was once a quay for the landing of the barks of the pious visitors and an avenue of sphinxes. A broad terrace, corresponding to the forecourt of a temple, stretched from the temple to the Nile, for, unlike the temples in the wide, fertile valley of Thebes, the Nubian temples lay close to the river bank, scarcely above the normal surface of the water.

Did obelisks once stand in front of these temples, as in the Theban temples? Nothing supports such a supposition.

The façade of a temple normally consisted of a tall pylon composed of two towers, in front of which a pair of colossal statues were placed. And this rule was adhered to when Ramesses II had the temple of Wadi es-Sebua built. But when it came to decorating the façade of the great rock-temples at Abu Simbel this was no longer the case. A narrow approach, hewn out of the mountain dominating the Nile, led to the sacred speos. This had already been devised in the Eighteenth Dynasty, of which an example has been preserved at Ellesiya. Its only embellishment was on the lintel of the gateway, characterized by the winged sun-disk and an inscription. Now, all of a sudden, we find such a development of the façade and such a grandiose decoration of the space round the doorway that, in comparison, the actual entrance itself is almost overlooked. The opening remained narrow: but it was surrounded with reliefs and finished with a cornice, to resemble the classical gateways of Thebes. The outline of the façade of the large temple of Abu Simbel, which was created out of the rocks in the shape of a gigantic trapezium, recalls immediately the shape of the pylon with its twin towers, which normally guarded the temple entrance. The colossal statues, which play such an important part in temple architecture, at Abu Simbel have been hewn out of the rock almost as free-standing statues: the opening cut into the mountain is framed on each side by two of these statues, seated on their archaic-looking thrones. Thus the exterior already embodied the appearance which Ramesses II wished to give to the greatest rock-temple in the kingdom of the pharaohs. Yet in spite of the vast size of the colossi—sixty-five feet high—their faces show proportion and still have an expression of human sensibility. The large hall of pillars, corresponding to the court of a temple built in the

open, is deep in the rock. Its pillars, square in shape, on the front of which are the colossal statues of the king in the form of the god Osiris, are carved directly out of the rock. As in the other Ramesside temples, here too the walls are decorated with reliefs of the traditional scenes of war, in which the king is overthrowing his country's enemies.

The path leads from the court across slightly rising ground, as in the classical temples, into the smaller hall of pillars, of which the supports again are hewn out of the rock and are square in section. Here again we find the walls decorated with reliefs, in which following the old tradition the ruler, sometimes accompanied by the queen, is shown closely associated with the gods in cult scenes. After going through the adjoining transverse antechamber, which, as was customary, contained the ennead of the gods (see page 379) and the escort of those divinities who were not themselves worshipped in the temple, one finally reaches the sanctuary, which does differ from the sanctuary usually found in Egyptian temples. No place has been made for a special shrine, but in the centre of the room there is a podium cut out of the rock, in all probability meant for the holy barks. And then, running along the rear wall of the sanctuary, a wide bench with figures of the temple deities was carved directly out of the living rock. It is in the large temple of Abu Simbel that one finds the most important and best preserved group of this nature, in which Ramesses II can be recognized surrounded by the three principal gods of the kingdom: Re-Herakhty, Amon-Re and Ptah.

These temples constituted vast altars of reception for the barks of the gods, when these took part in certain special ceremonies, prescribed by the most scrupulously observed calendar in the world. The decoration of the sanctuaries was ordained strictly in accordance with the constitutional dualism of Egyptian life: the division into north and south was illustrated here by the right and left sides—as seen in relation to someone entering the temple. On the right everything is dedicated to the god Re-Herakhty of Heliopolis, while the left side belongs to the domain of the god Amon-Re of Thebes or his substitute, Thoth, the god especially venerated in Nubia.

It is rare to find in Nubia traces of important religious buildings built after the Nineteenth Dynasty. Until the end of the period of native dynasties it appears that this country was neglected from that time by the rulers of Egypt, because Nubia during their rule no longer stood at the centre of political events, and was already so closely tied to Egypt that it presented no political or military problems. Also the Egyptians at that time were compelled to concentrate their entire force in the Nile Delta, owing to the repeated attacks from the north.

After the Nineteenth and Twentieth Dynasties the defensive wars against the Peoples of the Sea and the Libyans, together with internal strife, prevented an energetic policy being carried out in the south. This situation permitted the rise of the Ethiopian state around Napata, the capital of which later became Meroë, with an extremely interesting mixed culture of Egyptian-African origin. At the end of the eighth century B.C. this state expanded northwards and was even able for a short time to conquer Egypt itself. The short-lived kingdom of the Ethiopians is of the greatest importance in the social and political history of Africa, because of its medial role between the north and south.

After the collapse of the rule of the Ptolemies—who had followed the conquest of Egypt by Alexander the Great—ancient Nubia awoke once more. This was at the moment when the Romans formed their southern boundary in the area known as the Dodecaschoenus between the First and Second Cataracts. Nubia then regained its former importance, as a very advanced outpost, facing towards a still mysterious Africa, the birthplace of the Nile, on which the boats of traders and officials sailed regularly, and on which tribute and merchandise were brought to imperial Rome. The new masters of the country maintained order in the south, while benefiting from this natural traffic waterway, which started in inner Africa and towards which the wadis, rich in goldmines, converged. The part of Nubia mainly occupied by Roman troops stretched as far as Ed-Dakka. From Philae southwards the temples built or rebuilt by the Roman Emperors, who considered themselves the heirs of the pharaohs, continued to look like the sanctuaries of ancient Egypt. These temples and chapels, built directly on the river, were decorated with the graceful capitals, composed of the flower and leaf motifs, that were so characteristic of the Late Period. Historical themes were no longer the subject of the reliefs: instead, ranging along the temple walls there were scenes showing the ruler paying homage to the various gods. The bodies of goddesses and women shown in the reliefs were drawn with a voluptuous emphasis: the pure, restrained forms of classical Egypt have vanished. And these late reliefs were painted in brighter, lighter colours than those of earlier epochs. The sanctuaries

of Debod, Qertassi, Taffa, Kalabsha, Dendur, Ed-Dakka and Maharraqa mark the area of expansion of Dodeca-schoenus to the north and south. Beyond its borders lay a land in which the 'barbarians' were still the masters. At this time the people from the south were pressing ever further down the Nile, and the Ethiopian queen Candace even threatened Kalabsha itself, the ancient city of Talmis. The Roman Prefect Petronius repulsed her and her troops and pursued them as far as Qasr Ibrim, known as Primis to the Romans: from the battlements of this famous fort he watched their flight back towards the south.

How far away then seemed the age when the troops of the Pharaoh Chephren had protected the expeditions which he sent to the stone quarries south of modern Qasr Ibrim, to cut blocks of diorite for the great seated statues for his valley and funerary temples at Giza! But even in the Roman Period the old fort of Primis continued to dominate the route, and the remains of a podium from this period, on the southern slopes of the rocks, as well as the architectural features of the north gate, demonstrate that Rome was probably able to maintain forces in this key position near the southern border.

Later, when Rome's mastery over Egypt was waning and the frontier regions had become insecure owing to repeated attacks by Nobatae and Blemmyes, in the seventh century A.D., Christianity arrived in Nubia. The last adherents of the ancient gods, Amon-Re and Re-Herakhty, Isis, and Mandulis and Dedwen, who had been accepted into the Egyptian pantheon in some of the Nubian temples, defended with the courage of despair their right of access to their own sanctuaries. But in vain: the temples were transformed into churches, either partially or in some cases entirely. The statues of gods and pharaohs were dashed to pieces, the reliefs from the Pharaonic Period were chiselled away, the Osiris-pillars destroyed, and their fragments were so numerous that, heaped in the temple courts, they even helped to raise the level of the ground. The pictures of the old religion were plastered over and on the new surfaces of the walls they painted new pictures, of the Cross, the Saints and the birth of Christ. The socket-like support for the barks of the gods was transformed into a Christian altar. No doubt purification by consecration and prayers was needed to transform the temple into a Christian church, but the old rite from the foundation period of the temple was absorbed into it. Only with the dedication of the church the symbol laid before the altar was now a different one.

In all the places where new Christian settlements arose in Nubia on the shores of the Nile a special place was reserved for the church. Their architects generally built them according to an interior design of which the main lines recall a basilical arrangement. This is hardly surprising, for one can see in Nubia more clearly than elsewhere how the early Christians had continued to use the sanctuaries of the pharaohs.

This group of Nubian-Egyptian sanctuaries, which lies between the First and Second Cataracts, forms a harmonious whole. They start with the island of Philae with its large temple of Isis and small temple of Hathor, sanctuaries in which the maternal spirit of Isis and the charm of Hathor, the goddess of love, found expression and honour. Right through the years of the Ptolemies and up to the Roman period, Isis enjoyed in Egypt and in the whole of the Mediterranean world the highest place of honour.

Abu Simbel, lying to the north of the Second Cataract, was the other end of the long row of these Nubian temples, with its small rock-temple dedicated to the joint image of the goddess of love, Hathor, combined with Queen Nefertari, the most favoured of the wives of Pharaoh Ramesses II. But near this smaller rock-temple of Hathor-Nefertari stands the large rock-temple of the victor of the Battle of Qadesh, the pharaoh of pharaohs, who ultimately wished to be not only the son of the god Amon-Re, but the sun itself.

All the Nubian temples are scattered over the lower Nubian region of Wawat, the district between the First and Second Cataracts. Between Aswan and Qertassi steep cliffs rise up above the water but south of the stone quarries of Qertassi, where the stone blocks for the buildings on Philae were cut, and especially onwards from the little creek of Taffa, begins a different, gentler landscape. The jade green stretches of cultivated land, framed by the golden sand of the west bank and the brown black rocks of the east bank, line the river, irridescent in the splendour of its gleaming colours. Stretching practically without a break, the white houses of the Nubians, harmoniously blended into the rocks, present façades decorated with bright friezes or with fretted motifs. Faience plates, inset symmetrically into the gables, gleam in the sun. And near the bright houses tower the tall, slender date palms, providing fruit and shade, which form the wealth of Nubia, or the dark leafy crowns of the ancient sacred sycamores, and the waving fan-like crowns of the dom-palms, common in this area. In winter, too, the

landscape presents a different aspect from that of summer. The splitting, thirsty earth is suddenly, even during the hot season, flooded by the river, which brings new life to the land.

The pharaohs of earlier times, in spite of all the measures they undertook, failed to conserve this miraculous gift, the sole source of water for their country, in such a way as would have enabled them to spread it over all the Egyptian soil throughout the whole year. This is why it was necessary to build a dam, which was completed between the years 1898–1902 near Aswan, downstream from Philae. This barrage, which was enlarged still further in 1912 and 1934, stored the surplus water of the Nile and made it possible for Egypt to be irrigated regularly throughout the whole year, even as far as the area of the outer canals. All its gates are opened from the beginning of July, when the Nile starts to rise again, and enable the fields to be flooded without restraint. When, however, the flow of water from the south begins to drop in the autumn, the gates are gradually shut, so that then only the dam reservoir is filled. Until the next overflowing of the Nile, water can thus be drawn from this store from the spring onwards.

Even the first dam, built at the turn of the century, was a threat to Nubia. With the last raising by eighteen feet in 1934 it reached a height of 155 feet. The water level behind the dam could now rise to 510 feet above sea level. From Philae to Wadi Halfa everything that had been built by the hand of man was submerged and only the rock-temples which were hewn out of the cliff walls remained untouched. The Nubians, however, did not want to abandon their beloved country, the country of their ancestors, but were determined not to cut themselves off from their homeland whatever might occur. Though they were driven out of their cultivation area, which no longer existed, and had to earn their living in the cities north of the dam, still in summer they returned to their own land and to their houses, which they had rebuilt high in the cliffs and in which their families continued to live.

The fate of the submerged temples naturally worried archaeologists but the problems and anxieties which troubled them were limited to their own small circle. Pierre Loti, in his book *Le Mort de Philae*, has described the events of that time very movingly.

Because the population of Egypt had since the turn of the century—the time when the first dam at Aswan was built—risen from nine to twenty-seven million, that is, had increased threefold, it was decided to build the new high dam, Sadd el-Ali, six miles south of the Aswan dam. With this new dam a future high water level of 585 feet above sea level was predicted, which meant that even the temples which up to now had been spared—even Abu Simbel, just to name the most important—would be completely submerged, and the other temples, like Beit el-Wali, Wadi es-Sebua and Kalabsha, which up to now had remained clear of the water for at least a short season in the year, would disappear for ever beneath the waters of the Nile.

Even before the increase in water-level caused by the first dam the Egyptian Department of Antiquities together with European scholars started the battle to prevent the tragic disappearance of historic buildings. An endeavour was made to prevent their collapse by strengthening their walls, pylons and terraces, and equally an attempt was made to secure the safety of the reliefs and inscriptions in the threatened temples, at least for scientific publication. Surveys were made of the settlements and necropolises of ancient Nubia which were the most important by archaeological standards. After the first dam was built, most of the temples erected in Nubia were submerged regularly for nine months of the year in the slimy flood water. Only the temple of Amada remained unscathed, because it had been built at a higher level on the western bank of the Nile, almost exactly opposite the place where the great caravan route began which went from Korosko to Abu Hamed in the Sudan. The rock-temples, however, were spared and only the shrine of Ellesiya north of Qasr Ibrim was in danger, and half submerged by the flood-water.

Thus Nubia was not completely destroyed by the first dam. And anyone who braved the torrid summer heat saw the land still completely beautiful, embellished with its full complement of temples, even though some of them had already, owing to the flooding, lost the colouring on their reliefs.

But the most tragic fate of Nubia was still in store, and in the year 1955 the building of the new dam, Sadd el-Ali, was decided on, a project which is now almost completed, and which in 1964 caused the removal of the Nubians from their homes and their resettlement north of Aswan, largely near Kom Ombo.

Resigned to the loss of its archaeological treasures, Egypt decided with the help of foreign Egyptologists to

make a scientific record of all the buildings between the First and Second Cataract which still remained to be studied.

From the end of 1955 the Centre for the Documentation and Study of the History of the Art and Civilization of Ancient Egypt, founded on behalf of Egypt by UNESCO, undertook the task of making a careful study of twenty-four temples and chapels by Egyptologists, archaeologists and architects, with drawings and photographs. To create a comprehensive and accurate archive, casts and models were made: the National Geographical Institute of Paris started a photogrammetric record. It should be mentioned here that this was the first time that this technique had been used for the complete recording of archaeological treasures; by reconstitution in vertical sections it enabled accurate reconstructions to be made.

But all this effort constituted only a moderate beginning in the task of international co-operation to rescue the threatened monuments. UNESCO became convinced of the necessity for this rescue work and launched an appeal to the world to save the buildings. Six years later things had advanced so far that all which made up ancient Nubia had been saved.

The task was multiple: it was not only necessary to remove carefully the monuments already known and to protect them, but in particular to trace, in the area which was going to be flooded, the districts where man had ever lived. The last signs of fortified villages and military outposts had to be unearthed, the remains of little-known or unknown temples tracked down, the numerous graffiti on the rocks had to be discovered, and the search had to be undertaken for signs of pre-historic Nubia, of which there were still unexplored traces on the terraces situated high above the river banks. It was inconceivable to allow Nubia to be submerged without directing a searching light upon the period of the Meroïtic kingdom, to study the traces of that famous, puzzling race the origin and history of which had up to now not been satisfactorily investigated by anyone. And then there were other questions: were the ancestors of the Nubians buried in Egyptian fashion? Did the Christian bishops of Nubia finally vanish after the persecutions in the time of Saladin? Did orthodox Byzantium extend its sovereignty south of the Tropic of Cancer? Were there traces in Nubia of a proto-historic mixing of Libyans with men from the southern area of the Nile?

What was brought to light by the archaeologists and historians far exceeded expectations. Though no treasure was salvaged in the ordinary meaning of the word, yet in other respects the discoveries made were of the greatest value. Thanks to the work of archaeologists digging at 120 sites, stretching from Aswan to the Third Cataract, doomed Nubia revealed its secrets. Scarcely has any region ever been explored with so much care, accuracy and perseverance.

The history of Nubia needs to be re-written: it is now a history beginning in the Old Stone Age and continuing right down to the Christian era, to that period when the small village of Tamit north of Abu Simbel possessed more than seven churches, when the closed town of Ikhmindi was provided with its fortified gate, and its founder engraved on a stone slab—extra muros—an inscription showing the fear of its population for the plundering Nobatae and Blemmyes. And the time when Timothy the Nubian, Archbishop of Ibrim, had himself buried under the choir of his cathedral, and when the Christian clergy at Faras year after year had the walls of its sanctuaries painted with pictures which have survived to this day—the very Faras where Tutankhamun had earlier wished to build a temple.

However the rescue of the temples presented considerable and difficult problems, whether they were built of stone or hewn out of the rock. In order to work out a suitable plan of rescue, eminent specialists made a selection of the most important monuments. First they had to save the temples built of stone, which were generally erected close to the banks of the Nile. Strengthened already forty years ago with hard cement, their walls had defied the yearly immersion. The three main difficulties arising were defraying the cost of dismantling and re-erecting the temples, the short span of time available—only the three summer months when they were not submerged with water—and finally the extraction of individual blocks of stone which—as mentioned above—had already been reinforced with concrete. In spite of all these difficulties the rescue work seemed feasible. From the first the most doubtful temple appeared to be that at Amada, although this small temple, built by Tuthmosis III and Amenophis II and enlarged by Tuthmosis IV, was in exceptionally good condition for a Nubian temple. The difficulty lay chiefly in the reliefs of Amun, plastered over by Akhnaton and renewed by Sethos I. In the pronaos

of this temple also there was the precious inscription of Merenptah, the important Nineteenth Dynasty king, giving a report of his campaign against the Ethiopians. The rooms which surrounded the sanctuary were still completely covered in reliefs painted on fine stucco. Thus the joints of the stone courses were all hidden, and in dismantling the individual blocks of stone, the source of the temple's beauty, the miraculously preserved reliefs, might be destroyed. There was also the problem with this temple that part of it built in the living rock had to be rescued in a single block.

The rescue of the rock-temples of Nubia and the sanctuaries on the island of Philae presented further great difficulties.

Philae, the sanctuary of Isis, with its large temple of Isis, its famous colonnades and all the other smaller but important buildings, had been submerged for the greater part of the year since the turn of the century. Lying between the old and new dams, as though in a large lake, of which the water level was controlled by the dam at Sadd el-Ali, it would have been subjected to irregular but frequent immersion. If it was now to be saved a proposal, which had already been considered, had to be re-adopted, namely to join to the mainland by three embankments the three islands surrounding Philae, including the large island of Biga, and thus to keep Philae itself permanently out of the water.

Likewise it was suggested that the two rock-temples of Abu Simbel, which lay on a slight curve of the river, could be kept in their original positions with the aid of an embankment of rock and earth. The project, for which the preparative work was entrusted to French technicians, and financed by UNESCO, was supported by the majority of the committee of various countries, but was finally dropped in favour of an Italian plan. This Italian plan was that both temples should be lifted in one operation with the help of hydraulic jacks, which could be raised as needed on concrete piles. They were to be raised to the height required to make them safe from further flooding by the barrage water stored behind the new dam: this necessitated that they should be raised nearly 230 feet. After a further year of preparative research this plan too was dropped in favour of a French one, which was based on an improvement of the Italian plan. Now the lifting was no longer to be in stages with the aid of jacks and concrete piles, but in a single movement, by a giant hydraulic sluice which was to be built round each of the two temples in such a way that the sides of the sluice were to reach to the top of the cliffs. The water pressure of the Nile going through the sluices would then lift the two sanctuaries up to the top of the rock, acting like a vast piston. With the aid of the sluices the temples would then have floated on the surface of the water and eventually have been 'stranded' in their final position, the location of the site being chosen later. But once more the plans were dropped, this time only for financial considerations and now—as it were the final solution of despair lest Abu Simbel should not be saved—the simplest method was adopted, that of dismantling the temples by cutting them up into separate pieces and rebuilding them on top of the rocks above the high water mark. By the summer of 1968, the two temples of Abu Simbel had been entirely rebuilt and provided with a rocky setting similar to that which had existed before the Nile began to rise.

As far as the rescue of the other Nubian temples was concerned, it was natural to decide to rebuild the temples when they had been rescued, and indeed this rebuilding would encourage the creation of a new Nubia, a Nubia in three zones, higher than the flood waters of the dam. On the western shore of the new lake, which will be about 300 miles long and in places 20 miles wide, three oases have been planned, which will be watered by artificial wadis—flowing this time from the Nile—and once more settled by Nubian families and surrounded by some of the sanctuaries. These sanctuaries are to be rebuilt as far as possible in a setting corresponding to their original one, and with generally the same orientation as before, when they were established. The first oasis was chosen for the area between the great dam and Kalabsha, the second between Wadi es-Sebua and Amada, and the third, the most southerly, is to embrace the entire hinterland of Abu Simbel. And finally the hill top of Qasr Ibrim should be mentioned, as it towers over the lake opposite the former Nubian capital of Aniba: it is hoped that on this hill will be rebuilt the great cathedral of Nubia, the remains of which are very considerable.

The Egyptian Department of Antiquities has undertaken to carry out the dismantling and removal of various buildings—like the chapels of Taffa and Qertassi and the temples of Debod, Dendur, Maharraqa and Wadi es-Sebua south—and also the cutting out, block by block, of the three rock-temples, Gerf Hussein, Ed-Derr and Abahuda. The United States have put funds at Egypt's disposal to cut out the hemi-speos temples of Beit el-Wali and Wadi

es-Sebua north, and the rock-tomb of Pennut. The Federal Republic of Germany chose the temple of Kalabsha, the greatest building dating from the Roman Period, and transported it stone by stone to an enchanting place south-west of the great dam, whence it dominates the bend of the river. When in a few years' time the waters have risen to the level of the landing place, the visitor will again—like the worshippers of Mandulis—be able to arrive by boat in front of the pylon. To the south, quite near the temple, the charming kiosk of Qertassi, decorated with Hathor capitals, has already been rebuilt.

The work of dismantling has revealed many details of great interest to archaeologists and art historians, relative to the history and building of individual monuments. The greatest surprise was the discovery of cavities under the sanctuaries or the buildings immediately next to them, in which statues and reliefs removed from the temples were stored. There was an exciting discovery under the dromos of the temple of Ed-Dakka, which in its present form dates from the Ptolemaic and Roman Periods. In the ground under it were blocks of stone, which formerly were used for the walls and pillars of a temple dedicated by Tuthmosis III to the god Horus of Baki, which was built at one end of the *wadi* which led to the gold mines. Even the reliefs have still to a certain extent kept their varied colouring. Where the temples have been converted into churches, the frescoes painted by the Christians had first to be removed in order to save them, and the reliefs from the Ptolemaic period were revealed. Covered up for many centuries, these now showed much of interest to the archaeologists.

The temple of Amada still remained a last and particularly difficult problem. The rescue of this temple, which is one of the most ancient sanctuaries in Nubia, was carried through by France without regard to the great financial sacrifice already made towards the rescue of Abu Simbel. The entire sanctuary, with all its rooms, was packed by a very complicated method and then mounted on to a cement platform and transported on a three-railed line to a place situated 200 feet higher and three miles to the west. Round this central core, which fortunately arrived safely, were rebuilt the other parts of the temple complex, after they had been brought there individually.

So in Nubia it will again be possible to see the buildings of the pharaohs, though on new vantage points, erected in an evocative landscape in this remote southern region. And the rescue of the Nubian temples—an inheritance, handed down to us from the pharaohs, representing a cultural achievement stretching over nearly two thousand years, to which the Western World owes so much—has given this world the chance to show its gratitude in a truly great act of co-operation.

INDEX OF PLACES

The numbers in italics refer to the Plates.

It is regretted that in the captions to the plates some of the words have been wrongly translated from the German and some of the proper names wrongly transliterated. In these instances the versions in the notes to the plates should be taken as correct.